More than three million people living in Britain today are members of ethnic minorities. They have many things in common – but there are also important differences within and between ethnic minority groups. Some came to Britain as adults; others were born here. Some have retained a strong allegiance to the customs of their country of origin; others have developed a mixed identity. While some have achieved levels of prosperity similar to those of the white population, others continue to experience disproportionate unemployment and poverty.

This is the fourth in a series of major studies by the Policy Studies Institute which have charted the experiences of ethnic minorities in Britain since the 1960s. It reports on changes in such key fields as family and household structures, education, qualifications and language, employment patterns, income and standards of living, neighbourhoods and housing. And it introduces important new topics which have not been examined thoroughly in the past, including health and health services, racial harassment and cultural identity.

'Provides the most reliable and comprehensive picture of the ways in which ethnic minorities are carving out a place for themselves in British society. No work on the subject that ignores these findings can henceforth be taken seriously'
BHIKHU PAREKH, PROFESSOR OF POLITICAL THEORY, UNIVERSITY OF HULL, AND FORMER DEPUTY CHAIRMAN, COMMISSION FOR RACIAL EQUALITY

'In the great debates about poverty and social reform on "the condition of England", the concerns of minorities risk becoming obscured This in-depth study of the position of ethnic minorities is therefore indispensable for all those wrestling with any part of the social reform agenda'
WILL HUTTON, EDITOR, THE OBSERVER

'The definitive study of ethnic minority experience in Britain and the ways in which it is changing'
PROFESSOR JOHN REX, CENTRE FOR RESEARCH IN ETHNIC RELATIONS, UNIVERSITY OF WARWICK

'No other country in Europe has research that summarises the present and projects the future so well as this'
PROFESSOR MICHAEL BANTON, CHAIRMAN, UNITED NATIONS COMMITTEE ON THE ELIMINATION OF RACIAL DISCRIMINATION

'This excellent study requires us to reappraise the anti-racist approach of the last two decades. At last there is a recognition that the visible minorities are very different from each other. Their success – or lack of success – would appear to be dictated by their pre-migration differences and to the cultural capital they brought with them. The next step is for us as minorities to look at ourselves and also our own discriminatory behaviour – such as sexism'
BARONESS SHREELA FLATHER, COMMISSION ON RACISM AND XENOPHOBIA IN EUROPE

'An indispensable guide to the growing diversity of Britain's ethnic minority population and the evolution of the UK in a multi-cultural society'
PROFESSOR STUART HALL, PRESIDENT, BRITISH SOCIOLOGICAL ASSOCIATION, 1996–97

'This is a remarkable study which goes beyond the crunching of numbers to reveal insights about the changes in our society over the past generation. It is essential not just to those interested in race and ethnicity but to anyone who hopes to understand modern Britain'
TREVOR PHILLIPS, CHAIR, RUNNYMEDE TRUST, AND EXECUTIVE DIRECTOR, LONDON WEEKEND TELEVISION

The Fourth National Survey of Ethnic Minorities

Ethnic Minorities in Britain
Diversity and Disadvantage

TARIQ MODOOD
RICHARD BERTHOUD

JANE LAKEY
JAMES NAZROO
PATTEN SMITH
SATNAM VIRDEE
SHARON BEISHON

POLICY STUDIES INSTITUTE
LONDON

The publishing imprint of the independent
POLICY STUDIES INSTITUTE
100 Park Village East, London NW1 3SR
Tel. 0171 468 0468 Fax. 0171 388 0914

ISBN 0 85374 670 2
PSI Report 843

Reprinted 1998

The Fourth National Survey of Ethnic Minorities was undertaken in partnership by
Policy Studies Institute
Social and Community Planning Research

It was supported by
Department of Health
Department of the Environment
Economic and Social Research Council
Department for Education and Employment/Employment Service
Joseph Rowntree Charitable Trust

Cover design by Andrew Corbett
Laserset by Policy Studies Institute
Printed in Great Britain by BPC Wheatons Ltd, Exeter

Contents

Foreword

Bhikhu Parekh

The Fourth National Survey of Ethnic Minorities in Britain provides the most reliable and comprehensive picture of the ways in which ethnic minorities are carving out a place for themselves in British society. Since the First Survey was published in 1966, these surveys have remained both the most sophisticated sources of information on the subject and important benchmarks against which to assess British progress in integrating its ethnic minorities. While concentrating on discrimination and disadvantages in employment, education and housing as its three predecessors had done, the Fourth Survey casts its net much wider, asking questions about such matters as the minority physical and mental health, life-styles and cultural identity that had not been explored before. Its findings throw considerable light on the nature of the larger economic and social processes as well as the ways in which these are interpreted and experienced by the ethnic minorities. They complement the data provided by such sources as the Census and the Labour Force Survey, and add a qualitative cultural dimension missing in the latter. This makes the Fourth Survey an invaluable source of reference, and no work on the subject that ignores it can henceforth be taken seriously.

A rich survey of this kind can be read in several ways. One important way to read it is to use its findings to elucidate the manner in which the wider society and the ethnic minorities are currently negotiating their relations with each other. In Britain, as in other liberal societies, two main assumptions underpin the relations between the wider society and its immigrants, and form the basis of an unspoken moral covenant. The society expects its immigrants to identify themselves with it, and undertakes in return to treat them equally with the rest of its citizens. These are fair terms of cooperation, for they are embedded in and consistent with the central values of liberal society, reconcile the legitimate claims of the wider society and the immigrants in a reasonably satisfactory manner, and create the conditions of a cohesive and fair society. Much, however, depends on how we understand the two central concepts of identification and equality.

A political community is not a motley collection of individuals but a historical entity with a distinct character, bound together by countless formal and informal ties, and perceiving and conducting itself as a reasonably cohesive entity. As such it is rightly entitled to expect that its immigrants, who have chosen to come and settle in its midst, would make every effort to become part of it and in that sense identify with it. Identification has both a moral and an emotional dimension. It implies that immigrants should value their membership of the community, accept the corresponding obligations and in general conduct themselves as its committed citizens. And it also implies that they should feel attached to the community, wish it well and make it an object of their love. The moral and emotional commitments are

closely related, and equally important. Without the moral commitment, the society lacks a climate of trust, the ability to maintain a dependable system of collective cooperation, and the assurance that none of its members would be a free-rider. Without the emotional commitment the society's moral life lacks depth and energy, as well as the vital assurance that, whatever their ideological disagreements and conflicts of interests, its members care enough about each other to wish to continue to live together.

Identification is often confused with the two related but quite separate ideas of assimilation and integration. Assimilation refers to total absorption into the wider society's culture, and the concomitant surrender of the immigrant's cultural identity. Contrary to what its advocates have argued, assimilation has nothing to do with identification. The immigrant does not have to become like the rest in order to develop a common sense of belonging with them. Indeed, since assimilation demands a culturally unacceptable membership fee, it provokes resentment, a sense of discrimination and even persecution, and hinders identification. Assimilation is also an incoherent notion, for no society, especially not a liberal one, has a unified cultural structure into which the immigrants can be required to assimilate themselves.

Unlike assimilation, a primarily cultural concept, integration is a social concept. Although it is defined differently in different societies, and by different groups in Britain, it minimally implies that immigrants should not live in isolated and self-contained communities and cut themselves off from the common life of the wider society, as also that they should acquire the required degree of conceptual competence to find their way around in the society at large. However, the demand for integration can be taken too far. Every society is articulated at several levels, and immigrants may choose to integrate into some of these but not others. They might fully participate in the economy, the conduct of public affairs, etc., but prefer to marry among themselves or to adhere to their own traditional cultural beliefs and practices. If some of them wish to break out of their communities, neither the latter nor the wider society should place obstacles in their way. But if others decide differently, their choices should be respected. Identification with the wider community does not require destruction of narrower identifications. Just as marriage does not require that one should turn one's back on one's parents, relations and friends, and it would not last long if it did, the immigrant need not be expected to reject his earlier objects of love in order to sustain or prove his commitment to the new one.

Like the concept of identification, that of equality is complex and not easy to articulate. Much of the traditional discussion of equality is predicated on the assumption of a culturally homogeneous society, and does not help us much in discussing multicultural societies. It is also centred on individuals and does not grapple with issues of inter-cultural equality. Broadly speaking, equal citizenship in a multicultural society implies the following.

First, elimination of discrimination. Being new, different and vulnerable, minorities are liable to deliberate or unintended discrimination. And so long as that continues, they are clearly not treated as equal citizens.

Secondly, equality of opportunity. Even when immigrants are not discriminated against, they suffer from obvious economic, political and cultural disadvantages, and

need well-considered help if they are to exercise their rights of equal citizenship and develop a sense of common belonging.

Thirdly, equal respect. If minorities are subjected to insulting stereotypes, made butts of offensive jokes and remarks or viewed with suspicion, they lack a sense of self-worth and self-esteem, feel demeaned and remain outsiders. The demand for equal respect is central to the individual's sense of dignity, and goes far beyond the conventional notions of equal opportunity.

Fourthly, public acceptance of immigrants as a legitimate and valued part of society. If they are resented, if the dominant definition of national identity excludes them, or if the institutions of government, the media and the official ceremonies of the state do not reflect their presence, they remain shadowy, peripheral to the wider society, in it but not of it.

Finally, the opportunity to preserve and transmit their cultural identities including their languages, cultures, religions, histories and ethnic affiliations. Some of their values and practices might be unacceptable and then they need to be changed, by consensus when possible and by law if necessary. However, this is quite different from asking them to abandon their cultural identities as a condition of their acceptance. The identities are integral to their sense of who they are, nurture their self-respect and sense of community and provide the resources on which they rely to find their feet in the new society and to feel secure enough to interact with it creatively.

Each of these five levels or forms of equality has a different logic, and requires distinct measures. The first two are individualist in nature, whereas the other three have quasi-collectivist dimensions. Although anti-discrimination legislation is vitally important, it tackles directly only the first and indirectly the second. Besides, the law is ineffective unless it is embedded in and sustained by a wider strategy to deal with the deeper roots of inequality. Given their distinct traditions and self-understanding, different societies balance and realise the five levels of equality differently and create their own unique patterns of equality. This makes cross-country comparisons difficult and even meaningless. Britain has better anti-discrimination legislation than other European countries, but it would be wrong to conclude, as many do, that its ethnic minorities *therefore* enjoy greater overall equality. We need to take into account the other dimensions of equality as well.

Judged in the light of the moral covenant that guides the relations between British society and its ethnic minorities, the findings of the Fourth Survey reveal a complex picture. Both sides have sought to fulfil their respective obligations. Ethnic minorities increasingly define themselves as British, and identify with and see Britain as their home. For its part, although the latter has endeavoured to eliminate glaring inequalities, it still has a long way to go before it can claim to have ensured full equality to its minorities.

Acknowledgements

The Fourth National Survey of Ethnic Minorities has been undertaken by several partnerships of people and of organisations. It was jointly sponsored by the Economic and Social Research Council, the Department of Health, the Department of the Environment, the Department for Education and Employment with the Employment Service and the Joseph Rowntree Charitable Foundation. The research team was advised throughout the study by an expert group chaired by *Professor Bhikhu Parekh* (University of Hull). Its members were:[1]

Ameer Ali (Commission for Racial Equality)
Yasmin Alibhai-Brown (journalist and broadcaster)
Valerie Amos (Quality and Equality)
Muhammad Anwar (University of Warwick)
Paul Boateng (MP)
Godfrey Brandt (Joseph Rowntree Charitable Trust)
Dennis Brooks (Employment Department)
Ben Brown (Department for Education and Employment)
Bennie Bunsie (Anti-Racist Alliance)
Liza Catan (Department of Health)
Marian FitzGerald (Home Office)
Jenny Griffin (Department of Health)
Sanjay Gupta (Department of Health)
Colin Hann (Commission for Racial Equality)
Angelika Hibbett (Department of Employment)
Mike Hough (Home Office)
Kamaljeet Jandu (Transport and General Workers Union)
Keith Kirby (Department of the Environment)
Hans Kundnani (Commission for Racial Equality)
Juliet Mountford (Department of the Environment)
Kumar Murshid (London Borough of Tower Hamlets)
Ceri Peach (University of Oxford)
Usha Prashar, OBE (Chair, National Literacy Trust)
Bill Sheppard (Employment Service).

Apart from this formal group of advisers, we have had the benefit of advice and commentary from a huge number of friends and colleagues in universities and research institutes, in government, in pressure groups and elsewhere, who

1 Where more than one representative of an organisation is indicated, it means those representatives were able to be members for part of the duration only.

discussed the issues, suggested sections of questionnaire, discussed their own findings, read draft chapters and so on.

The research itself was undertaken in partnership by the Policy Studies Institute and Social and Community Planning Research. PSI had primary responsibility for the overall structure of the study, and for this book. SCPR was responsible primarily for the detailed design of the survey, and especially the sample; and for the massive tasks of data collection and preparation.

At the Policy Studies Institute, *David Smith* (who had undertaken the second survey, and supervised the third) was originally responsible for getting the project off the ground, and led the team through the design phase before taking up a chair at the University of Edinburgh. *Richard Berthoud* then took over the overall responsibility for the study, and especially for its management, analysis and editorship. *Tariq Modood* has been the principal researcher, with special responsibility for linking the design and findings to theoretical considerations. *Jane Lakey, James Nazroo, Satnam Virdee* and *Sharon Beishon* were each responsible for elements of the report, as indicated in the chapter headings, but also participated in the work of the team as a whole. Other PSI staff who made significant direct contributions to the study included *David Halpern* (questionnaire design), *Karen Mackinnon, Lydia Maher* and *Chris Maynard* (data analysis) and *Siân Putnam* (administrative support). We are also grateful to *Karin Erskine* (typesetting) and *Jo O'Driscoll* (publications) for handling a very tight deadline.

At Social and Community Planning Research, *Roger Jowell* held overall responsibility for the SCPR end of the partnership. *Patten Smith* undertook the primary role in designing and managing the survey, working during key periods with *Gillian Prior.*

All of these people and organisations contributed to the success of the research. The responsibility for this report, and its conclusions, lies with the named authors. But our main debt is to the 8,000 people — white, black and Asian – who took part in the survey and provided information about their experiences and opinions. They will have had no immediate payback for their contribution, but we hope that the research will have an important and positive impact on the lives of all groups in Britain.

Introduction

Richard Berthoud, Tariq Modood and Patten Smith

THE PSI SURVEYS

This is the fourth in a series of national surveys of ethnic minorities undertaken by the Policy Studies Institute since the 1960s.

When the first was initiated, very little was known about the population of migrant origin, who at the time numbered less than a million. Now the Census has counted three million members of ethnic minority groups, and they and the topic of 'race' are a major field of study in British social research. Yet the PSI surveys remain the only large-scale national studies designed exclusively with the aim of increasing our knowledge about the circumstances of ethnic minorities and how they compare with those of the white population. Several national surveys include an interest in ethnic minorities, but they are confined to a specific topic such as employment or crime, and the samples have not been designed specifically to represent the minority groups. We shall, however, relate our findings as appropriate to these other sources, as also to the 1991 Census, which for the first time had an ethnic origin question, and provides the basis for checking the accuracy of our sample and some key findings.

At the time of the first survey in 1966 the issue of concern was discrimination. The first Race Relations Act had just been passed; mirroring American civil rights legislation, it prohibited segregated access to public services such as restaurants. Yet discrimination in ultimately more important fields such as employment and housing remained not only legal, but overt: notices specifying 'no coloureds' were openly displayed. The first survey, besides interviewing people about their perception and personal experience of discrimination, devised objective tests of the extent of discrimination (Daniel 1968). For example, white and ethnic minority actors, impersonating job applicants, applied to the same real job vacancies to discover the extent to which the white but not the minority actor were offered jobs. The tests conclusively established that racial discrimination was widespread, and the survey was one of the influences which led to the second Race Relations Act of 1967, outlawing direct discrimination in employment, housing and other fields. Since then discrimination testing has been extended and repeated a number of times, and has consistently shown the persistence of discrimination, even though it was illegal (for example, Brown and Gay 1985; Simpson and Stevenson 1994).

Yet it was clear from the first survey that the inequalities between whites and the minorities were not just produced by face-to-face discrimination but were the outcome of structural disadvantages. Minority groups had different qualifications and

<div style="border: box">

Box 1.1 Four Surveys of Ethnic Minorities

1966 W W Daniel
 Racial Discrimination in England

1974 David J Smith
 Racial Disadvantage in Britain

1982 Colin Brown
 Black and White Britain

1994 Tariq Modood and colleagues
 *Ethnic Minorities in Britain:
 Diversity and Disadvantage*

The first two surveys were undertaken by Political and Economic Planning (PEP), which became the Policy Studies Institute following a merger in 1978. The first and third surveys were done in collaboration with Research Services Ltd (RSL); the second and fourth with Social and Community Planning Research (SCPR).

The first survey covered six towns with significant minority populations. The second covered all enumeration districts with more than 2.2 per cent minority population. The third and fourth were fully representative of England and Wales.

</div>

skill levels, for instance. Indirect discrimination also reduced black and Asian people's chances of success: for example, some employers gave preference in recruitment to relatives of existing employees, thus perpetuating an all-white workforce without intending it. The focus of racial equality in the 1970s therefore shifted to comparing outcomes, regardless of whether they were produced by discrimination or not, to see if the disadvantages faced by the minorities were lessening or persisting. The survey of 1974 found considerable inequality between whites and ethnic minorities in employment and housing conditions (Smith 1977). It was, in turn, one of the influences behind the third Race Relations Act (1976), which broadened the concept of discrimination to include indirect discrimination as the unintended effect of policies and practices, such as those of employers when filling job vacancies.

The third national survey, undertaken in 1982, had a larger sample and widened the comparative socio-economic basis of analysis. While in many respects minority groups were in a much worse position than the white population, there was evidence of upward movement in job levels (Brown 1984). Although the focus of race relations research in the early 1980s was still on a dualistic perspective, distinguishing between the minorities as a group and the white majority, the third survey also provided evidence that some minorities were reporting different experiences from others.

Since 1983 the Labour Force Survey (LFS) has included a question identifying ethnic groups, and has provided a large enough sample of ethnic minorities to allow intensive analysis when the data for three years were aggregated. A detailed analysis of data for 1988–90 carried out at PSI (Jones 1993) confirmed the trends identified in the third survey to the point that some ethnic minority groups (Indians, African Asians and Chinese) were in a position broadly similar to, or sometimes better than, white people. Meanwhile other minorities (Caribbeans, Pakistanis and Bangladeshis), while also experiencing some upward mobility, continued to be distinctly disadvantaged. The 1991 Census suggested that the LFS had been underestimating the size of the various minority groups by about 10 per cent, but confirmed the broad outlines of the LFS findings that the black–white divide had

given way to a socio-economic diversity in which the minorities were as different from each other as they were from the white majority (Ballard and Kalra 1994).

THE 1994 SURVEY

The Fourth National Survey of Ethnic Minorities was undertaken in 1994 by the Policy Studies Institute and Social and Community Planning Research. A nationally representative sample of 5196 people of Caribbean and Asian origin were interviewed in detail, together with a comparison sample of 2867 white people.

Each survey has broadened the scope of investigation compared with its predecessor, and the Fourth Survey continues this trend. Education, employment and housing have always been key issues, and these topics are covered again, with some additional questions. New or more developed sections of questionnaire have been introduced, especially on income, health, harassment and ethnic identity. The subject matter is reviewed briefly in the following paragraphs, outlining the content of the chapters to come. In addition to the wide-ranging analysis reported here, the research team has been engaged in a series of linked but more tightly focused studies, also based on the Fourth Survey. Some of these are mentioned in the text, and a full list appears in Box 2. At the same time the survey data have been deposited in the ESRC Survey Archive, and are available for other analysts to study in detail over the decade or so before the fifth survey is launched. A full set of the survey questionnaires can be found in Smith and Prior, 1996.

People, households and families

The census now provides the most detailed data on the structure of ethnic minority populations and the composition of their households, and it is not necessary to report the demographic findings of the Fourth Survey in great detail. Because much of the migration has occurred since the 1950s, the minority populations contain proportionately more children and fewer elderly people than the white majority. But an increasing number of the children are British born, and many babies are now members of the second British-born generation. It is known that South Asians have high rates of marriage, and that Pakistanis and Bangladeshi families have relatively large numbers of children; meanwhile Caribbeans have low marriage rates and an exceptional number of one-parent families. The analysis here relates these findings to other issues covered by the survey, such as employment, date of migration and area of residence. And a comparison with the 1982 survey provides a much clearer picture of changes over the past decade than is available elsewhere.

There are other family issues for which the Fourth Survey is the sole source of information. There has been increasing interest in the role of the wider family in providing social networks and especially care in old age. The importance of these networks will depend partly on cultural traditions about the role of kin in and outside the nuclear family; and partly on where people's kin live.

Box 1.2 Other studies linked to the Fourth National Survey

This is the main book from the Fourth National Survey of Ethnic Minorities. But other detailed studies are based on the development work for the survey, on secondary analysis of the data or on intensive follow-up interviews with selected members of the sample.

Already published:

- Tariq Modood, Sharon Beishon and Satnam Virdee, *Changing Ethnic Identities*, 1994
- Satnam Virdee, *Racial Violence and Harassment*, 1995
- Patten Smith and Gillian Prior, *The Fourth National Survey of Ethnic Minorities: technical report*, 1996
- Hilary Metcalf, Tariq Modood and Satnam Virdee, *Asian Self-Employment: the interaction of culture and economics in England*, 1996
- Sharon Beishon and James Nazroo, *South Asians and Heart Disease*, 1997
- James Nazroo, *The Health of Britain's Ethnic Minorities*, July 1997
- James Nazroo, *The Mental Health of Ethnic Minorities*, September 1997

Forthcoming:

- Richard Berthoud and Bernard Casey, *Ethnic Minority Incomes*, 1998
- Tariq Modood, Sharon Beishon and Satnam Virdee, *Ethnic Minority Families*, 1998
- Richard Dorsett and Richard Berthoud, *Ethnic Minorities in the Inner City*, 1998
- James Nazroo, *Ethnic Variations in Health: geography, gender and class*, 1998
- Tariq Modood, *Ethnic Diversity and Public Policy*, 1998
- Tariq Modood and Stephen Lissenburgh, *South Asian Women and Employment*, 1999

Qualifications and the English language

It is clear from previous surveys that a significant proportion of South Asians came to Britain with limited facility in English. Recent studies, however, show that at least some South Asian groups are achieving above-average levels of educational attainment, while others are below average. Data over two decades has suggested that there is a persistent qualifications-gap between Caribbean and white boys, though this is not the case for girls (Gilborn and Gipps 1996).

Chapter 3 examines the extent of fluency in English among Asians and identifies those who are least likely to be fluent. It goes on to present the academic and vocational qualification levels of ethnic groups and considers the rise in qualification levels across the generations. The migrants came to Britain very differently qualified to each other. In most groups the second generation had made significant progress, but there is a continuing division between the ethnic minority groups. For some, educational qualifications are a success story, but there are clear points of concern.

Employment

Employment is perhaps the single most important measure of life-chances. It is at the centre of most discussions not just of racial equality but of social justice generally. It is probably also the topic on which the most extensive comparative data on ethnic minorities and white people are available, and on which theorising about 'race' has most focused.

In the 1980s, just as a consensus formed among sociologists of ethnic relations that the ethnic minorities were disproportionately at the bottom of the occupational and incomes hierarchies, the Labour Force Survey started showing that some minority groups were strongly represented at higher job levels (Modood 1992; Jones 1993). The 1991 Census confirmed this, but the data in the census are too limited for a detailed exploration of the topic (Ballard and Kalra 1994). The richly detailed findings of the Fourth Survey allow it to be explored at length, and this is done in Chapter 4. An extensive analysis is offered there of the findings on economic activity and unemployment – in particular, the relationship between unemployment, manual work, qualifications, inner-city residence and ethnicity. A similar analysis is offered of the job levels of employees and of self-employment, a form of economic activity of considerable importance to some minority groups; this is the focus of one our complementary studies (see Box 2). Included also is a discussion of earnings, a topic not covered by the other main data sources, and there are sections on respondents' views and experience of racial discrimination and on participation in trade unions. Finally, an assessment is made of the position of ethnic groups in 1994 relative to 1982, and of the extent and character of ethnic minority disadvantage in employment.

Income and standards of living

Many sources, old and new, have shown that ethnic minorities had high rates of unemployment and low wages. It was not difficult to conclude that minority households probably had relatively low incomes and high rates of poverty compared with the white population, but none of the previous surveys directly measured household income. The Fourth Survey does so for the first time, and has the added advantage of comparison with preliminary results from the new Family Resources Survey. The analysis confirms a hierarchy between prosperity and poverty, with white and Chinese households at one end and Pakistani and Bangladeshi households at the other. A more detailed study is in progress, which aims to disentangle the many factors affecting this key indicator of disadvantage (see Box 2).

There is also new material analysing the interaction between income, ethnicity and living standards, measured in terms of consumer durables, debt and financial stress. This points especially to signs of hardship among Caribbean households, which are greater than can be explained simply by their levels of income.

Neighbourhoods and housing

The original migrants in each wave tended to settle in certain parts of Britain, and in certain areas within each town, and this has affected the geographical distribution of minorities ever since. The 1991 Census provided an unprecedented opportunity to

analyse these patterns of settlement (Peach (ed) 1996; Ratcliffe (ed) (1996) and provides a source of comparison for the Fourth Survey. Both sources show that minorities were much more concentrated than were whites into the metropolitan areas of England, though the patterns of settlement varied between ethnic groups. There is also a significant degree of segregation between white and minority communities, though it is nowhere near as great as that existing in the United States. A more detailed analysis of the survey is in progress, which aims to explain patterns of settlement in terms of social and economic influences as well as demographic factors (see Box 2).

The Fourth Survey also provides new information about the amenities and problems experienced in local areas where whites and minorities were living, on people's satisfaction with their local areas and on their preferences regarding the ethnic mix of their neighbourhoods.

Housing has been a central area of interest throughout the sequence of surveys. The Fourth Survey, like its predecessors, provides detailed information on tenure distributions and housing conditions, with new material focusing on the tenure preferences of the various groups. The analysis includes a detailed comparison of findings from the 1982 and 1994 surveys, showing how tenure patterns and housing conditions of ethnic minority groups have changed relative to whites over a decade. Some groups, notably Indians and African Asians, had significantly improved their housing position, but each of the other minority groups continued to experience substantial disadvantage in one form or another.

Health and health services

An entirely new section is on health, including the use of health services. It provides the first detailed national morbidity survey that allows comparisons across ethnic groups to be made. Most of the previous nationally representative data have been based on immigrant mortality statistics (Marmot et al. 1984). The Fourth Survey is unique not only in its coverage of health but also in its ability to explore the associations between health and a variety of other aspects of the lives of ethnic minority people in Britain. It therefore marks a new context for work on ethnicity and health, as well as an important addition to work on race relations.

The analysis presented here focuses on general health status as well as specific physical health problems that previous research has shown vary between ethnic groups (Balarajan and Soni Raleigh 1996; Smaje 1995). These include heart disease, hypertension, diabetes and respiratory disease. We discuss the possible explanations of the variations suggested by the findings, including explanations based on biology, culture and racism, and test the effects of migration and socio-economic disadvantage. Chapter 7 also examines the use of health services and the accessibility of these services to different ethnic groups. The Fourth Survey's very wide coverage of physical health issues cannot be presented in full in this volume and a more substantial report is being published separately (see Box 2).

The survey also contained a section on mental health. It is very difficult to r cross-cultural comparisons of the incidence of mental illness, and this topic v expanded to become a study in its own right. It is not covered at all in the cu: book. A separate report will address the issue in detail (see Box 2).

Racial harassment

The Fourth Survey has substantially expanded the investigation of racial harassment. There have been several very serious incidents in recent years, including murders, and increased reports of cases of all types, sometimes fuelled by the local activities of racist and ultra-right political parties. As a result, racial violence and harassment are issues of widespread public concern. The topics have merited considerable media attention and were largely behind the establishment of two national anti-racist organisations in 1991: the Anti-Nazi League and the Anti-Racist Alliance. The problem and the measures required to address it effectively have also been the subject of debate within official circles (for example, Home Affairs Committee 1994).

Besides the extremely serious cases of violent assault, there are the more frequent incidents of racial abuse and threatening behaviour. This wider problem of harassment has hardly been studied at all, but is investigated in this survey because the most violent cases may occur where there is a wider culture of racist behaviour. Moreover, the latter could have a cumulative effect, and the distress which it causes needs to be understood in its own right. The development of this part of the survey benefited from an earlier project (Virdee 1995). Our findings here, especially on the 'hidden injuries of racism', the way people's lives are constrained by the fear of being harassed, should be read in conjunction with the previous study.

Culture and identity

For at least some of the migrants and their descendants, new communities have emerged which are capable of sustaining themselves as communities. New cultural practices, especially to do with the family and religion, have become a feature of the British landscape. Meanwhile, ethnic identity, like gender and sexuality, has become politicised and for some people has become a primary focus of their politics (Young 1990). There is an ethnic assertiveness, arising out of the feelings of not being respected or of lacking access to public space. These identities are of different sorts, and not stable. As identities proliferate they compete for priority, and it is not easy to predict which identity a particular individual will espouse. While some assert a racial identity based on the experience of having suffered racism, others choose to emphasise their family origins and homeland, while yet others promote a trans-ethnic identity such as Islam.

It used to be assumed that ethnic minorities would, and perhaps should, integrate into British society, so that eventually they would cease to be separately identifiable. That assumption has not collapsed into a plurality of cultural separatisms, but ethnic identity has become of considerable significance and cannot be ignored by anyone interested in the shape, texture and dynamics of British race relations (Modood 1995). We offer here the first attempt at a quantitative map of minority cultures and identities, focusing on self-projection, the importance of religion, the use of community languages, visits to countries of origin, wearing of distinctive clothes, views about the ethnic mix of preferred schools for one's children, 'mixed' marriages and so on. We also offer an analysis of ethnic identities which are and which are not based on distinctive cultural practices.

The development of this part of the survey was also assisted by a related study which examined the bases of minority ethnic identity and its political implications in greater qualitative depth than is possible here (Modood, Beishon and Virdee 1994). The present study, however, is the first time that this topic has been part of a national survey.

ETHNIC DIVERSITY

The report of the second survey concluded that the results

> *consistently show up not only the contrast between Asians and West Indians, but also the great diversity of origin, language, religion and culture among the Asians. It is only from the egocentric viewpoint of the British that these diverse immigrant groups can be lumped together into a single class as 'coloured people'.* (Smith 1977, 331)

That report argued that, through the structure of its economy and institutions, and through colour consciousness, British society treated Asians and West Indians alike, and if this continued it would tend to cast the immigrants into a common role, give them a common history, and call forth in them a complementary sense of common identity.

Now, 20 years later, we are in a position to evaluate whether, to what extent and in what ways, the tendencies identified in the 1970s have developed.

In the early 1980s, partly because of the disproportionate impact of the recession upon the ethnic minorities, the economic circumstances of people of Caribbean and Asian origin came to be interpreted as broadly similar. Minority political activity and the terms in which issues of racial discrimination and equality were debated also suggested a socio-political convergence. It became commonplace in research, policy and media representations to categorise all the minorities with a common label, 'black', and to depict the new British population in terms of a black–white divide (Modood 1988).

Subsequent research and political developments have made this point of view less influential. The Fourth Survey shows that on many matters the differences between the minorities have become as important, and as significant to life-chances, as the similarities. The research perspective which focused on a black–white divide emphasised the various minorities' common experience of racial exclusion. While that was, and remains, an important theme, it is now clear that the characteristics and experiences of the different minority groups require a more complex analysis. The black–white dualistic view seemed to imply that the condition of not being white in Britain was more important in determining the social position of a minority group than, say, its own educational profile. That would have meant that the jobs they could obtain, the accommodation they could occupy, would be determined entirely by white people, uninfluenced by the minorities' own actions. For many years, these interpretations seemed to have some validity, though there were also warnings against the dangers of over-emphasing racial discrimination in the definition of the subject-matter. For example, as trenchantly put by Robert Miles:

> *The obsession of 'race relations' research with the extent and impact of racial discrimination to the exclusion of most other factors encourages a perspective in which West Indians, Pakistanis, Indians etc, come to be viewed unidimensionally as the objects of other people's beliefs and behaviour.* (Miles 1982, 65)

Yet it was only as the various minority groups began to be publicly assertive and lobby for their own political interests, and as evidence of economic divergence and socio-cultural differences accumulated, that a consensus developed that ethnic diversity was a central element of 'race'.

Diversity does not relate simply to the minorities themselves. It relates also to the character of racial prejudice and discrimination. British racism has always been hostile to and stereotyped cultures that are identified as inferior or primitive. But the cultural dimension is now more explicitly recognised, and in particular the varied stereotypes used to portray different groups (Cohen 1988; Gillborn 1990, 1995; Bonnett 1993). The presence of cultural practices of non-European origin, the political claims made on their behalf and the implicit or explicit challenge to white British norms seem to have provoked a counter-assertion in the form of new layers of racism and hostility (Gilroy 1987). This cultural racism is targeted not at non-whites in general, but at certain groups which are perceived to be assertively 'different' and not trying to 'fit in'. Such racism uses cultural difference to vilify, marginalise or demand cultural assimilation from groups who also suffer colour racism (Modood 1996).

The approach adopted here is to take ethnic diversity seriously. We assume that the various aspects of social life that we investigate are structured by racial exclusion and inequalities, past and present, but that these do not necessarily operate uniformly for all groups or result in uniform outcomes. Above all, ethnic minority groups are not all the same, nor are they contentless and substitutable for one another. Rather, in their distinctive ways, they are part of the social pattern which has to be described and explained (Modood 1992). If a group had a different set of skills and qualifications, a different set of preferences between academic and vocational training, between work and leisure, large and small families, and marrying out and marrying in, or made a different set of choices about home-ownership, personal consumption, self-employment or political activity, then the situation would be different.

The concept of ethnicity to which we are appealing is not one of rigid groups, defined purely in terms of their 'internal' norms and practices. Ethnicity, including the development of group features such as religion, is 'interactive' – shaped partly by its original heritage and partly by racism and the political and economic relations between groups in Britain. For example, current expressions of religion within Muslim communities cannot be understood without taking account of the social locations of Muslims in Britain and the reactive and defensive position Islam has had to adopt (Modood 1990). Similarly, the phenomenon of Asian self-employment cannot be explained without a framework which brings together economic opportunities, racial disadvantage and cultural values, for the three sets of influence interact with each other (Metcalf, Modood and Virdee 1996).

A survey of this kind is too wide-ranging for such explanations to be pursued in

detail. We do, however, present the findings with as much ethnic differentiation as possible, adding groups together only where we are satisfied that we are merging like with like and so producing a meaningful combination. We rarely limit the presentation to an aggregate statistic for all ethnic minority groups. Hence our findings are structured in order to allow maximum scope for testing ideas about ethnic diversity and about interactive ethnicity.

We examine 'diversity' in three distinct ways throughout this analysis – origin, socio-economic position and life styles.

Diversity of origin

First, and obviously, the different minority groups came to Britain with little in common other than the fact that they had once been subject to imperial rule. They had different physical appearances, spoke different languages, professed different faiths and wore different clothes. In some dimensions there was a clear dividing line between people of Caribbean origin and Asians; in some dimensions there were important distinctions between the Asian sub-groups. Some of the migrants (such as Bangladeshis) were often uneducated and poor before they moved; others (such as African Asians) had been well educated and relatively prosperous. All these differences at the point of migration may have been important influences on people's experiences in Britain, and they are therefore included in our analysis.

Diversity of socio-economic position

A central concern of race relations research, including the four PSI surveys, has been the distribution of employment opportunities and of income. A black–white divide made sense when all the minority groups were less likely to have jobs, earned lower wages and suffered more poverty than their equivalents in the white population. That is no longer the case. On many measures of education, employment, income, housing and health, there is a two- or three-way split, with Chinese, African Asian and sometimes Indian people in a similar position to whites, Caribbeans some way behind, and Pakistanis and Bangladeshis a long way behind them. Whatever the explanation for that layering of socio-economic positions, it is not simply racial discrimination. A more complex analysis is required.

Diversity of life styles

Many of the early debates about race relations assumed that assimilation and integration were key objectives – that the children and grandchildren of migrants would eventually become so like the British that the only noticeable difference would be the colour of their skin. The goal of 'equality' was confused with that of 'uniformity'. It is now clear, however, that many members of minority groups not only do, but wish to, retain many of the cultural traditions drawn from their heritage – of language, religion, food, music, family loyalty and so on. The desire that this form of diversity should be not only tolerated but celebrated is encapsulated in the term 'multi-cultural Britain' – a belief that Caribbean and Asian customs have as much to contribute to a rich and plural concept of Britishness as English, Scottish or Welsh.

THE SURVEY DESIGN

The survey is briefly described here, to provide an overview of the methods used. More details are available in the appendix to this volume, and a full technical report has been published separately (Smith and Prior 1996).

The 1991 Census was used to divide all electoral wards in England and Wales into three bands according to the proportion of the population who were members of ethnic minorities: high, medium and low. A sample of wards was selected in each band and, within each ward, a sample of addresses. (Unlike some other surveys of ethnic minorities, our sample included those living in areas of low concentration, in their correct proportion.) Interviewers then visited the addresses to identify any members of the target minority groups living there, or within five addresses on either side. Nearly 130,000 addresses were screened in this way to identify a sample of minorities who could then be interviewed.

At each household containing adults (aged 16 plus) from minority groups, one or two were selected for interview. Where there were more than two eligible adults, two were selected at random. An interviewer who was a member of the same minority group was sent to ask the selected individuals to take part in the survey, using a questionnaire either in English or in the minority language preferred by the respondent. Interviews were successfully obtained in 3291 minority households, involving 5196 adults.

A similar procedure was used to select a sample of wards and addresses containing white households, except that it was not necessary to conduct a preliminary screening exercise. At each selected address, one adult was selected (at random if there was more than one candidate) and interviewed by a (white) interviewer. 2867 white interviews were completed.

The number of adults interviewed from each ethnic group was as follows:

	Achieved sample	Response rate (%)
White	2867	71
Caribbean	1205	61
Indian/African Asian	1947	74
Pakistani	1232	73
Bangladeshi	598	83
Chinese	214	66

Among the ethnic minorities, seven out of eight were interviewed by a member of the same ethnic group as themselves. Among the Asians, half used a language other than English for all or part of the interview.

Presentation of the findings

The survey can be used to describe three different 'populations':

■ households: based on all the households where interviews took place, without regard to the number of people living in them. Households are the base for analysis of household structure (in Chapter 2), of income and standards of living (in Chapter 5) and of housing (in Chapter 6).

■ individuals: based on all the people living in the households where interviews took place. This includes children, and the adults who were not selected for interview, as well as the direct respondents. But white individuals living in households selected for the minority sample, and vice versa, have been excluded. Only limited information is available about these individuals; they are included in the group profiles later in this chapter, and in the analysis of family structures in Chapter 2.

■ respondent adults: based on those who were interviewed in detail, one or two in each household. They provide the base for the great majority of the analysis in this report.

Many questions were asked of both white people and members of minorities, and this allows comparison between the two samples. (But the two samples were selected separately, and the minority sample included a much larger proportion of its population than did the white sample. So the findings for the two samples should never be added together to look for conclusions about the population as a whole.) A small number of questions were asked just of white people. A large number was asked just of members of minority groups. It should always be clear which groups are included in each analysis.

A complication is that there were so many questions to be asked of the minorities that the interview would have been too long if one person had been asked them all. Some important questions were asked of all members of the minority sample. The rest were split into two series, each asked of a randomly selected half of the sample. Thus the minority sample size is 5196 for some questions but only about half that for others.

A second complication is that some rather complex weighting was required to make the survey results as representative as possible of the populations under study. For example, where one or two adults were selected at random from a household containing more than that number of candidates, we had to multiply the results by the number of candidates to compensate. Each table in the report therefore contains two indications of the number of people answering the questions: the 'weighted' figure should be used to add two columns of figures together; the 'unweighted' figure is the one which gives the best indication of the reliability of the findings (though it cannot be used to calculate precise estimates of sampling errors).

DEFINING ETHNIC GROUPS

An important preliminary question is: how do we identify the 'ethnic minorities' who are the focus of this research, and what distinguishes them from the 'white' majority? The answer may seem obvious at first, to the extent that most people might be allocated to the same ethnic categories whichever criteria were adopted. But there are many difficulties at the margins, both in sorting minorities from whites and in distinguishing between particular minority groups. (See Coleman and Salt (eds) 1996, and Bulmer 1996, for a discussion in the context of the 1991 Census, and Ballard 1996 for an alternative view.)

In principle, an ethnic group would be defined as a community whose heritage offers important characteristics in common between its members and which makes them distinct from other communities. There is a boundary which separates 'us' from 'them', and the distinction would probably be recognised on both sides of that boundary. Ethnicity is a multi-faceted phenomenon based on physical appearance, subjective identification, cultural and religious affiliation, stereotyping and social exclusion. But it is not possible to prescribe in advance what the key distinguishing characteristics might be; the components of ethnicity will be different within Britain compared with, say, within Northern Ireland, Belgium, Bosnia, the United States, Rwanda, India or Singapore. So it is necessary to adopt a flexible and practical approach to choosing the specific criteria to identify the important ethnic boundaries in any particular society.

For many years the only statistics regularly available in Britain were based on people's country of birth. This was never reliable, if only because of the number of white people who had been born in such countries as India when they were ruled by Britain. Country of birth has in any case become increasingly irrelevant as a second and third generation of minority children have been born since the main periods of migration. Some destination countries use nationality as their primary criterion, implying that migrants cease to be minorities once they have qualified for citizenship. But it is clear that many of the disadvantages and other experiences associated with minority status continue long after 'naturalisation' has been completed; and besides, the nationality laws associated with Britain's former empire are far too complex for this to be a useful criterion. Skin colour is another option: after all, the majority group is defined as 'white', and some (or even all) minorities are often referred to as 'black'. Colour would also reflect the fact that minority status is likely to follow from generation to generation, whatever changes occur in the cultural behaviour of the people concerned. On the other hand, colour cannot be used to distinguish between minority groups (for example between Caribbeans and Africans, or between Indians, Pakistanis and Bangladeshis). So it is inadequate as a criterion on its own.

The 1991 Census question is shown in Box 3. In summary, it recorded the following numbers in Great Britain:

White	51,874,000
Black Caribbean	500,000
Black African	212,000
Black other	178,000
Indian	840,000
Pakistani	477,000
Bangladeshi	163,000
Chinese	157,000
Other Asian	198,000
Other groups	290,000

The coverage of the Fourth National Survey was slightly narrower. It was confined to England and Wales.[1] It did not cover the categories 'Black African', 'Other Asian' or 'Other groups'.

1 Only a small proportion of the minorities live in Scotland. See Smith (1991) for a report on their circumstances.

Box 1.3 The 1991 Census question

Ethnic group: *(please tick the appropriate box)*

☐ White

☐ Black Caribbean

☐ Black African

☐ Black other *(please describe)*

☐ Indian

☐ Pakistani

☐ Bangladeshi

☐ Chinese

☐ Any other ethnic group *(please describe)*

If the person is descended from more than one
ethnic or racial group, please tick the group to
which the person considers he/she belongs, or tick
the 'Any other ethnic group' box and describe the
person's ancestry in the space provided.

The Census question, although described as 'ethnic group', was not explicit about what considerations people should take into account in deciding which group they belonged to. The words 'white' and 'black' in the answer categories implied that colour was important. Country, region or continent of origin was another clearly labelled criterion. 'Ancestry' and 'descent' were mentioned in a footnote. There was no direct reference to ethnicity in the sense of a set of cultural norms to which one subscribes. It has been shown (Ballard and Kalra 1994), and our survey confirms (Table 1.1), that the category 'Black other' was used mostly by people of Caribbean family origin who perceived themselves as British, but were not 'white'.

The Fourth National Survey asked a group membership question very similar to that used in the Census, but also asked about people's family origins (see Box 4). Table 1.1 shows that there was a very close relationship between the two. The overwhelming majority of people gave equivalent answers to both questions. Apart from those of mixed or 'other' origins, the only significant distinctions between the two questions were for those of black Caribbean origin, a number of whom said they were 'Black British'; and for those of Indian Caribbean origin, most of whom chose 'Black Caribbean' as their ethnic group, though some chose 'mixed', 'Indian' or 'Black British'. Our own view is that family origin is a better basis for demographic analysis than self-assigned group membership. Family origin is in most cases a matter of fact which will remain the same for an individual throughout his or her life, and which can be handed down from parents to children. Group membership is a matter of opinion, which may change over a lifetime, and from generation to generation. We certainly want to know which groups people with family origins outside Europe identify themselves with, but our argument is that this is a matter of sociological enquiry, not of demographic definition.

In our own allocation of individuals to ethnic groups, therefore, we used family origin as the first criterion. If that did not give us an unambiguous answer, we used group membership. If that was not conclusive either, we referred to a check question used by the interviewer to allocate respondents to groups which were to be asked separate sets of questions. A very small number of individuals were still unclassified after this automatic procedure; they were allocated one at a time on the basis of their exact combination of answers.

A problem for all currently used methods of classifying ethnic groups, including our own, is that they do not deal adequately with people of mixed parentage (Berrington 1996) – most of whom have one minority parent and one white one.

Table 1.1 Perceived group membership, by family origins

column percentages

Family origins	White British/ Irish	Black Carib- bean	Indian Carib- bean	Indian	Paki- stani	Bangla- deshi	Chinese	Other	Mixed
Group membership									
White	100	1	1	1	1	2	1	55	13
Black Caribbean	–	81	69	*	–	–	–	–	14
Black African	–	1	*	–	–	–	–	11	1
Black British	–	13	7	*	–	–	–	–	15
Black other	–	1	–	–	–	–	–	–	2
Indian	–	–	8	97	1	*	–	2	4
Pakistani	–	–	–	*	98	2	–	–	*
Bangladeshi	–	–	–	*	*	95	–	–	*
Chinese	–	–	–	–	–	–	98	*	2
British Asian	–	–	*	1	1	1	–	–	5
Mixed	–	2	15	1	–	–	1	7	40
Other	*	*	–	*	*		*	25	4
Weighted count	*7070*	*2780*	*113*	*4147*	*2253*	*824*	*700*	*89*	*660*
Unweighted count	*7110*	*2058*	*74*	*4251*	*3665*	*1939*	*427*	*80*	*488*

Analysis based on all individuals in survey households. Individuals could only be included if they, or another member of their household, had indicated at the screening stage that they were members of one of the ethnic groups to be included in the survey. The table does not, therefore, cover anything like a cross-section of people in the 'other' or 'mixed' categories. The Chinese categories include some who said they were Vietnamese, but who were of Chinese pre-origin.
(–) none at all; * less than 1 per cent.

Both the family origin question and the group membership question encourage respondents either to choose just one element of their heritage or to declare themselves as 'mixed', outside the main classification system. Again, it is important to identify these people directly, by asking separate questions about the family origins of both parents. A subsequent question is: with what ethnic group do people of mixed origin identify themselves most closely? We did not ask about the origin of both parents in this survey, though we now wish we had, and recommend it for use in the next Census. We can, however, identify the parentage of those children who still lived with both their mother and their father. The importance of the issue is illustrated in Chapter 2, where it is shown that more than a third of 'Caribbean' children in the survey households (and who lived with both parents) had one white and one black parent. Neither the Census nor the current survey can identify their adult equivalents.[2]

Those who initially said that their families had originated in the South Asian subcontinent were also asked whether their parents or grandparents had lived in Africa for any length of time, or whether they themselves had been born there. 26 per cent of people of Indian origin, but only 4 and 2 per cent respectively of those of Pakistani or Bangladeshi origin, had this African connection. They have been defined as African Asians. The great majority of them should be thought of as 'African Indians', but just under one in ten members of this group may have many things in common with their cousins originating from Pakistan or Bangladesh.

2 Those who say that they are of mixed origin/group can be analysed separately, but we do not know what combinations they represent; other people of mixed parentage will have chosen one group, and will be indistinguishable from other members of that group.

Box 1.4 The Fourth Survey questions

To which of the following groups do you consider you (person) belong(s)?

Do you (does he/she) have family origins which are…

The answer categories to the first question were the same as for the Census. The categories for the second question are shown as column headings in Table 1.1.

Our definition of ethnic groups means that we have departed in two important ways from the nomenclature used in the Census, with which many readers will be familiar.

■ Our use of family origin as the primary variable means that the term Caribbean in this book covers not only those who called themselves Caribbean in the Census but also others, whose parents had come from the Caribbean, who described themselves in the Census as 'Black other'. We refer to this group as 'Caribbean', as opposed to, say, 'African Caribbean', partly because the group includes a small number of Indo-Caribbeans, and partly because there is continuing debate within the community about the most appropriate term (Modood et al. 1994). We have chosen the simplest term.

■ Our term Indian covers only those whose family appeared to have come direct from India, without a period in East Africa. The Census category called Indian is closer to our combination of Indians and African Asians.

The ethnic group of a household was unambiguous when all the members were from the same group. In mixed households, an ethnic group was assigned in a different way from that adopted by the Census and many other surveys (Murphy 1996). The latter all consider the 'head of the household'; we considered all the members together. A white household was defined as one where all the members were white; a minority household where any of the members were from a minority. Most of the mixed households included white people and members of only one particular minority group, and these were assigned to that minority category. Another type of mixed household included African Asians and people of direct Asian origin. These were called African Asian households if any member reported a family connection with Africa.

One of the important defining characteristics for some ethnic minorities is their religion. Although declarations of non-discriminatory policy often refer to religion as well as to ethnic group, religious discrimination is not covered by the Race Relations Act in Britain, though it is the subject of fair employment legislation in Northern Ireland. Many commentators, especially in the Asian communities, think that the religious dimension should be recognised more explicitly, and the Office for National Statistics is considering adding a question on religion to the Census.

A detailed analysis of the Fourth Survey data on religion, including a comparison of the level of importance people attach to their faith, is included in Chapter 9, which focuses on social identity. But there will be a number of references to religion throughout this book, where it can be used as an alternative way of categorising Asian communities, and it will be useful to have an idea of the prevalence of the most important affiliations. Table 1.2 shows that two-thirds of white people considered themselves Christians (though it will be seen in Chapter 9 that many of them did not

feel that this was very important). A very similar proportion of Caribbeans were Christians, too (but this was often a more important element of their lives). Actually there were more Christians among the Chinese than Buddhists or those who followed other Eastern faiths, but the most notable characteristic of this group was the number who said they had no religion at all.

Table 1.2 Religion by ethnic group

column percentages

	White	Caribbean	Indian	African Asian	Pakistani	Bangladeshi	Chinese
None	30	28	5	2	2	1	58
Hindu	–	1	32	58	–	2	–
Sikh	–	–	50	19	–	–	–
Muslim	–	1	6	15	96	95	-
Christian	69	69	5	3	-	1	23
Other	1	3	2	3	2	1	10
Weighted count	*2865*	*1567*	*1292*	*799*	*862*	*285*	*391*
Unweighted count	*2865*	*1205*	*1273*	*728*	*1185*	*591*	*214*

Analysis based on respondent adults.

It was among South Asians that the non-Christian religions were of greatest importance. The overwhelming majority of Pakistanis and Bangladeshis were Muslims. Among Indians, Sikhs outnumbered Hindus, but for African Asians, Hindus outnumbered Sikhs, and this is a potentially important difference between them. There was a small but significant minority of Muslims in both of these groups.[3] Many of the following chapters show that the experience of Pakistanis and Bangladeshis has been different from that of Indians and African Asians – usually worse. One important question is whether the experiences of Indian or African Asian Muslims were more similar to those of other members of their ethnic group (as defined by country of origin) or more similar to those of the Pakistanis and Bangladeshis.

3 However, this is smaller than the equivalent figures in the third survey (Brown 1984, 24; see page 300 below.)

People, Families and Households

Richard Berthoud and Sharon Beishon

INTRODUCTION

This chapter provides a basic description of members of the ethnic minority groups under study – how old they are, where they were born, and how they have joined together to form families and households. This description is needed for three reasons.

First, a basic knowledge of the people involved is required to understand some of the other main findings of the research. It is important to know, for example, that there are far fewer black and Asian people than whites of retirement age and that many Asian people live together in relatively large households. This background information is relevant to consideration of, for example, family support networks, or housing policy.

Second, detailed knowledge of the age and sex structure of minority ethnic groups and their patterns of marriage and family formation are of importance to a demographic analysis of the size and shape of the relevant populations. In the past, the number of members of each group living in Britain has been determined primarily by immigration. In the future, the number of births, marriages and deaths will be of increasing importance. The demographic models used to predict trends in the majority group may have to be adapted or even replaced to take account of distinctive fertility patterns.

Third, the structures of families and of households are important in their own right as key indicators of people's cultural values, similar to the measures of identity, religion and language described in Chapter 9. What distinctive patterns of family relationship are to be found in each community? To what extent are these patterns either retained or adapted by those whose families have lived for many years in Britain? Do young men and women tend to choose members of their own minority groups as marriage partners, or do many of them marry white people? What are the implications of those choices for the future of ethnic identities?

The inclusion of questions about ethnic group in both the Labour Force Survey and the national census means that there is now far more information about the structure of the minority populations than was available ten years ago (Jones 1993; Owen 1993; Ballard and Kalra 1994; Heath and Dale 1994; Coleman and Salt (eds) 1996; Peach (ed) 1996). Some of the analyses of the census, just cited, go into much more detail about the demography of ethnic groups than is possible here, but the Fourth Survey provides the opportunity to cross-analyse the data in more intricate ways. It also provides, for the first time, data about wider kin relationships, which are reviewed in the last section of this chapter.

Another point of comparison is with PSI's third national survey carried out in 1982 (Brown 1984), which was the only source available at the time based on a true measure of ethnic group (rather than being based, as the census then was, on country of birth).

Much of the potential value of the demographic measures derived in this chapter will be realised later, when it will be possible to assess the experience of ethnic minority groups in such fields as education, employment, health and housing in the light of information about the age and family structures of the populations affected.

The analysis is not always easy to follow, because it moves between three levels.

- The chapter starts by counting *individual* people. This part is easy: everyone in the survey households is included – men, women and children of any age.

- Many individuals have joined together in *family units*, either because they are *married* to each other (or living as married), or because they are *parents with dependent children*. A dependent child is defined as someone aged less than 16; or someone aged between 16 and 18 still in full-time education. This is the definition adopted, for example, by the state in paying child benefit.[1] When they reach 16/18, sons and daughters cease to be considered part of their parents' family unit; they become a unit in their own right.

- Many family units live together in *households*. This is defined as a group of people who live in the same accommodation and share at least some of their catering. Many of the family units in multiple households are related to each other – often as the adult sons and daughters of the householders. But other combinations exist – for example, three single people sharing a flat.

The key to this hierarchy lies in the family unit. It may consist of one adult, or a couple, or a family with children. They may live on their own, or with others in a complex household. The point is that the members of a family unit generally have quite strong personal, financial and legal ties with each other, but a greater degree of independence within the household. They could, for example, choose to set up a home of their own. This is an important demographic point, emphasised by the term 'minimal household units', which has sometimes been used (Ermisch and Overton 1984). Other terms include 'tax unit' (now out of date) and 'benefit unit'.

This chapter follows the hierarchy by describing individuals first; then, by looking at their patterns of marriage and child-rearing, moves on to analyse family units; and finally considers who they live with in households.[2] Most of the data are based on all the individuals recorded as living in the survey households. At the end of the chapter, the analysis of kinship networks is derived from the interviews with adults who were selected to take part in the main survey.

1 Note that this differs from the definition of a family unit commonly adopted in demographic analysis (e.g. Murphy 1996), where an unmarried adult living with his or her parents is considered part of their family unit, even though grown up and not 'dependent'. The advantage of our narrower definition of a family unit is that we can analyse, first, how many couples and single people have dependent children, and then, how many non-dependent children continue to live with their parents.
2 See page 12 of the Introduction for our definition of a household's ethnic group.

AGE AND MIGRATION

The ethnic groups which migrated to Britain in recent decades have a very different age structure compared with a long-term settled population, with relatively few elderly people and many children. A detailed analysis of census data has been provided by Warnes (1996). Table 2.1 provides an overview derived from the Fourth National Survey.

Table 2.1 Age-bands

column percentages

	White	Caribbean	Indian	African Asian	Pakistani	Bangladeshi	Chinese
Children (0–15)	21	32	28	33	42	48	28
Working age (16–59)	60	58	62	61	54	48	67
Elderly (60 plus)	19	10	10	6	4	4	5
Weighted count	*7284*	*3304*	*2709*	*1676*	*2180*	*815*	*753*
Unweighted count	*7316*	*2413*	*2821*	*1690*	*3564*	*1910*	*459*

Analysis based on all individuals in survey households.

All of the ethnic minority groups contained more children, and fewer elderly people, than the white population. This was especially true of the Pakistanis and even more of the Bangladeshis, around half of whom were children. Only 4 per cent of them were over the age of 60 – less than a sixth of the proportion among white people.

Figure 2.1 compares the age distribution from the Fourth Survey, undertaken in 1994, with that of the third survey, from 1982. The latter showed that 40 per cent of all South Asians (the four sub-groups combined) were below the age of 16 in 1982; the proportion had fallen to 35 per cent in 1994. Both Caribbeans and Asians also showed a small increase in their numbers of elderly people. Thus the minorities are

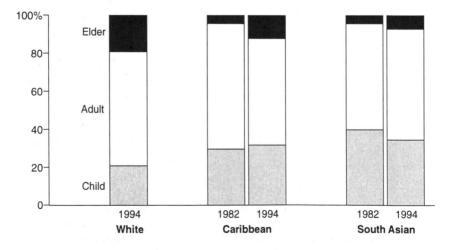

Figure 2.1 Age: 1982 and 1994 compared

converging on the age-structure of the white population (shown as the first bar in the figure), but it will be a long process.

The census data on migration patterns have been analysed by Salt (1996). One third of all the Chinese members of our survey households (adults and children combined) had been born in Britain, most of the remainder having migrated from the Far East. Nearly two-thirds of Caribbeans were British born. The other minority groups ranged in between. But it is important to take account of individuals' current ages. The great majority of the children in every ethnic group were British-born, as Table 2.2 shows – only among the Bangladeshis was there a very significant number of children who were born in their country of origin. Hardly any elderly members of minority groups had been born in Britain, because the migration took place almost entirely after the war.

Table 2.2 Proportion born in Britain, by age

cell percentages

	Caribbean	Indian	African Asian	Pakistani	Bangladeshi	Chinese
Children (0–15)	96	94	94	88	78	88
Working age (16–59)	53	34	14	28	13	14
Elderly (60 plus)	2	1	4	1	–	–
All ages (1994)	62	47	41	52	44	34
All ages (1982)	54	43	24	42	31	n.a.
Weighted count	*3333*	*2722*	*1697*	*2200*	*820*	*753*
Unweighted count	*2429*	*2835*	*1708*	*3599*	*1923*	*459*

Analysis based on all individuals in survey households.

It was among those of working age that the real differences could be seen. Just over half of working-age Caribbeans, between a quarter and a third of working-age Indians and Pakistanis, but only about one seventh of working-age African Asians, Bangladeshis and Chinese people were born in Britain. It is still accurate to describe these last in broad terms as migrant populations in a way that is no longer true of people of Caribbean origin.

Table 2.2 also compares the results of the Fourth Survey with the equivalent information from the third national survey undertaken 12 years earlier (Brown 1984). There has been a clear increase in the proportion of members of minority groups born in Britain, as would be expected in the decades following a migration. The largest shift appears to have been among African Asians and the smallest among Indians (though this may have been caused by differences in the questions used to distinguish African Asians in the two surveys).

The adults in the non-white minority groups who took part in the full survey interview were asked when they had come to Britain (Figure 2.2). About a third of the migrants came as children, presumably with their parents. Half were in their late teens or twenties, and very few people had migrated in middle or old age. The pattern shown in the figure for all minority groups combined was remarkably similar for people migrating in different decades from different parts of the world. In detail,

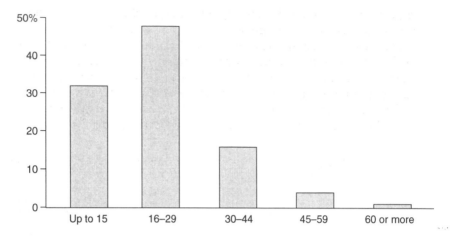

Figure 2.2 Age on arrival in Britain

Indian and Chinese migrants were slightly older than others, but the difference was not large.

Another way to record the same data is to say how many years the migrants had lived in Britain. Figure 2.3 shows substantial differences between the main migrant groups: two thirds of Caribbean migrants arrived 30 years ago or more (that is, before 1964), and could, in principle, have taken part in all four of this series of surveys. The most recent arrivals tended to have been Bangladeshis– three out of ten adults had arrived within the last ten years (since 1984).

Table 2.2 showed that almost all ethnic minority children had been born in Britain. They are often referred to as a British-born generation. Given that a fairly

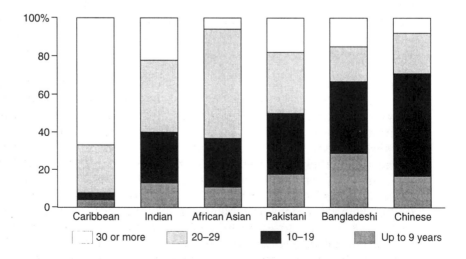

Figure 2.3 Length of residence in Britain

large proportion of ethnic minority adults, especially Caribbean adults, were also born in Britain, new births are increasingly into the second British-born generation. Table 2.3 shows that, the younger the child, the more likely it was that one or both of his or her parents were also born in Britain. For those born in the last five years, a sixth of Pakistani and Bangladeshi babies, a quarter of Indian and African Asian babies, and three-quarters of Caribbean babies had at least one British-born non-white parent. If we count those who migrated as the first generation, their grandchildren can be referred to as third-generation migrants.

Table 2.3 Proportion of children with a parent who was born in Britain, by age of child

cell percentages

	Caribbean	Indian/African Asian	Pakistani/Bangladeshi
Up to 4	75	28	18
5–10	56	15	6
11–15	31	5	4
Weighted count	*1059*	*1325*	*1299*
Unweighted count	*769*	*1365*	*2353*

Analysis based on children in survey households, one or both of whose parents lived in the same household. White parents are excluded from the analysis.

FAMILY FORMATION 1 – MARITAL PARTNERSHIPS

A family group was defined at the beginning of this chapter as either a man and woman in a marital partnership, or parents with their dependent children – or both. The family structures of ethnic minority groups have been described elsewhere, using data from the Labour Force Survey (Jones 1993; Berrington 1994) and the 1991 census (Berrington 1996), and the treatment here focuses on the issues of greatest relevance to aspects of this study. This section analyses how many men and women were single, married or divorced. Children will be covered in the next section.

In the population as a whole, marital partnerships have been changing rapidly (Ermisch 1983; Joshi 1989; Buck et al. 1994). The pattern in the 1950s was that men and women married early and remained together for life. While that model still describes a large number of couples in the 1990s, both men and women have been marrying later than before. A high proportion of marriages end in separation or divorce, though many of the men and women involved marry again. Cohabitation has increased rapidly, especially among the most recent cohorts of young people, though it takes three distinct forms: short-term partnerships; as a prelude to marriage; and as a long-term alternative to marriage (Kiernan and Eastaugh 1993; McRae 1993).

The 1982 survey, like its predecessor, showed that Caribbeans were less likely to be in formal marriages than white people, and more likely to be single, living as married or divorced (Brown 1984). South Asians, on the other hand, were more

often officially married than the white group, and both the Labour Force Survey and the 1991 census reached the same conclusion (Berrington 1994, 1996). These differences have been linked to cultural differences in communities' attitudes to the 'nuclear family' which have been imported from their country of origin (Dench 1996; Modood et al. 1994). But it is unclear how far current patterns of family formation have been, or will be, affected by existing or changing British conventions.

Table 2.4 provides a conventional summary of the marital status reported by adults aged less than 60 in the survey households. Elderly people (most of whom were either married or widowed) have been excluded because there are so few of them in the minority samples that they would cloud a comparison between whites and minorities. There are some striking differences between groups. People of Caribbean origin were much more likely to have remained single than whites or South Asians, although a third of Chinese people were also single. Nearly three-quarters of South Asians were in a formal marriage, compared with three-fifths of whites and Chinese, but only two-fifths of Caribbeans. Cohabitation and separation/divorce were both more common among Caribbean and white people than among those of Asian origin.

Table 2.4 Marital status, adults under 60

							column percentages
	White	Caribbean	Indian	African Asian	Pakistani	Bangladeshi	Chinese
Single	23	41	21	21	19	22	34
Married	60	39	72	72	74	73	62
Living as married	9	10	3	2	3	1	1
Separated/divorced	7	9	3	3	3	1	3
Widowed	1	2	2	1	2	3	–
Weighted count	*4194*	*1834*	*1539*	*960*	*1053*	*344*	*467*
Unweighted count	*4187*	*1298*	*1560*	*951*	*1709*	*815*	*271*

Analysis based on all individuals in survey households, who were neither dependent children, nor 60 or more.

The large number of possible relationships is best dealt with in stages:

- how many people had 'partnered' – that is, had been married or were 'living as married'?

- among those who currently had a 'partner', how many were formally married?

- among those who had been married, how many were now widowed, separated or divorced?

Partnering

Table 2.5 therefore concentrates on the first stage: the proportion of individuals who had formed a partnership. This includes people who were legally married, those who had been married in the past but were separated, divorced or widowed at the time of the survey, and those currently living with a partner. We cannot, though, identify

people who had formerly cohabited with a partner but who had since returned to 'single' status. Nor, of course, does the survey pick up those who were, or had previously been, in a stable relationship which did not include living together. These other forms of union may be of particular importance in communities (such as the Caribbeans) with low rates of formal marriage, but are not analysed here.

Because a large proportion of all partnerships are formed when people are in their twenties, it is essential to take age into account. People of Caribbean origin tended to remain single for much longer than white people or South Asians (Table 2.5). South Asians taken together, on the other hand, had even higher partnership rates than white people, to the extent that a mere 1 per cent of those over the age of 50 remained single.

Table 2.5 Proportion of people who had had a partner, by age

cell percentages

	White	Caribbean	South Asian
16 to 19	7	5	6
20 to 24	35	16	36
24 to 29	68	38	77
30 to 34	85	58	94
35 to 39	93	69	97
40 to 49	94	88	98
50 to 59	95	96	99
60 or more	94	92	99
Weighted count	*5704*	*2222*	*4719*
Unweighted count	*5720*	*1630*	*6227*

Analysis based on all adults in survey households. People were counted as having had a partner if they were married, separated, divorced or widowed, or if they were living as married. Single people who had previously cohabited are not captured by the question.

The interpretation of these variations in partnership rates by age is not certain. Given that moving from 'single' to 'ever had a partner' can happen only once in each lifetime, one would expect the proportion who had experienced it to increase with age. But if opinions of partnership had changed, so that the current generation of young people were much less eager to pair off than their elders had been, that in itself would make the pitch of the slope from twenties to thirties and forties much steeper. So it is not clear from these figures, derived from a snapshot cross-section, whether Caribbeans have always been slower to form partnerships, or whether partnerships have gone out of fashion even more quickly among young black people than among other groups.

Given the rapid change in people's positions over their twenties and thirties, it is difficult to analyse partnership rates precisely without allowing explicitly for the effect of age. This has been done, for each ethnic group separately, by running a logistic regression equation predicting the probability of each person having a partner, using their age as the main predictor variable. In practice, the rate of partnering slows down in the late twenties and through the thirties (as most of the age group are already accounted for), so the equations have assumed a curved

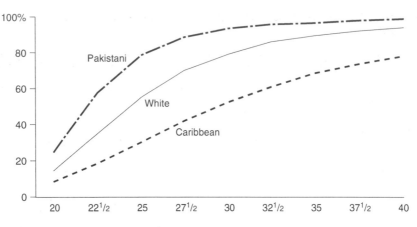

See notes to Table 2.6. The curves plotted here are for women born in Britain.

Figure 2.4 Plot of logistic regression equations predicting partnership rates in three ethnic groups

relationship, where partnering is a function of the logarithm of (age – 15).[3] Figure 2.4 plots the results of these equations (in all cases, for women born in Britain) for three selected groups. It can be seen that Pakistani women were much more likely than white women to have a partner at any age. In contrast, Caribbean women in every age group were much less likely than white women to have a partner.

Table 2.6 provides more detailed results from the logistic regression equations than can be shown in a graph. The first row shows the estimated proportion of women from each ethnic group who had a partner at the age of 25. This is equivalent to reading off a vertical slice of Figure 2.4 at 25 years old. Only 30 per cent of Caribbean women had a partner at 25, but as many as 78 per cent of Pakistani women did so. Most of the South Asian groups showed high rates of partnering, but African Asian women were the exception, very similar to the white majority.

The second row of Table 2.6 shows the age by which it is estimated that half of the members of each group would have formed a partnership. This is the equivalent of a horizontal slice through Figure 2.4, at 50 per cent. In broad terms, it can be interpreted as a median age at marriage.[4] Naturally, the converse of the small proportion of Caribbeans partnering in their early twenties is a late age by which half of the group had paired off; not until they were nearly 30 years old were more than half of Caribbean women living with a partner, compared with less than 22 years old for Pakistani women.

The advantage of this form of analysis is that, having taken age into account, it is possible to look at variations between sub-groups. The third row of Table 2.6 compares men's partnership rates with those of women, showing how much older

3 This formula was chosen to get the right bend in the curve. It can be interpreted as the number of years since the individual became eligible to marry.

4 This is not the same as the singulate mean age at marriage, which is also calculable from cross-section data (Hajnal 1953), though one would expect the two measures to be correlated.

Table 2.6 Detailed results of logistical regression equations predicting partnership rates

	White	Caribbean	Indian	African Asian	Pakistani	Bangladeshi
% of women aged 25 with partner	55	30	67	52	78	71
Age by which 50% of women have a partner	24.3	29.4	23.4	24.7	21.6	23.2
Increase (+) or decrease (–) for men	+0.8	–1.4	+1.1	+0.4	+1.4	+2.4
Increase (+) or decrease () for born abroad	n.a.	nil	+1.2	nil	+1.8	+1.8

Regression equations were run for each ethnic group separately, based on adults aged 20 to 39. The predictor variables were log (age – 15), sex and born abroad.

(+) or younger (–) men reached the 'median' point where half of them had a partner. Bangladeshi, Pakistani and Indian men tended to marry one or two years later than women from the same groups. Because (as will be seen) most of them marry within their own ethnic group, this is consistent with other evidence that South Asian men tend to marry a woman rather younger than themselves (Berrington 1996), but our findings suggest that African Asians were an exception. This age gap was smaller for white people but still apparent. Among Caribbeans, on the other hand, the men were forming partnerships a bit earlier than the women. This does not necessarily mean, though, that the women in the partnerships were older than the men; part of the earlier partnering by Caribbean men was accounted for by the higher rate at which they chose a white partner, as shown later in this section.

The final row of Table 2.6 performs a similar comparison of the partnership rates of members of minority groups who had been born abroad. For Pakistanis, Bangladeshis and Indians (but not for Caribbeans or African Asians) those who had migrated were less likely to have married than members of their age-group who had been born in Britain. Their 'median' age at marriage was therefore later. However, this should not be interpreted as an estimate of the age at which people marry in their countries of origin, as it may be that, age for age, single people were more likely to move to Britain than those who had the ties of a family.

The Chinese sample has not been mentioned so far in this discussion. Table 2.2 showed that a high proportion of them remained single. Their logistical regression analysis suggested a median age of partnering of 32 years for those born in Britain and 39 years for migrants (the same for both sexes). That is, the Chinese appeared to have stayed single even longer than the Caribbeans. This analysis was based on only 155 cases and, although the findings were significant in the statistical sense, we are inclined to treat them with caution. Berrington's census analysis (1996) is not directly comparable, but the Chinese did not stand out there to the same extent as they do here.

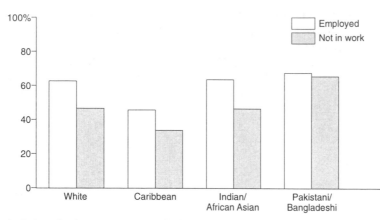

Analysis confined to men aged 20–34. The figures control for variations in employment rates by age within that range. Employed means in full- or part-time work; all other activities are included in 'not in work'.

Figure 2.5 Proportion of young men who had had a partner, by whether employed

It is sometimes argued that there is an association between men's employment and their marital status. This suggestion, which is discussed in particular with respect to young black men both in Britain (Dench 1996) and in the USA (Wilson 1987), is based on alternative hypotheses about the direction of causation: either that young men without family responsibilities place little priority on obtaining work, and may 'drop out' into a culture of alienation; or that young men without work have a poor chance of being chosen as a partner by a woman. The Fourth Survey findings confirm the association: age for age, employed men in their twenties and early thirties were substantially more likely to have a partner than otherwise similar men with no work (Figure 2.5). The difference was particularly marked for men between 25 and 30 (not shown separately in the Figure), that being the age range when marital status was most sensitive to influences other than age itself. On the other hand, the survey does not confirm the idea that this association is peculiar to black men: Figure 2.5 shows that it affected white men and Indian/African Asian men, as well as Caribbeans, although Pakistanis and Bangladeshis were the exception.

Cohabitation

Moving on now to look at those who were currently in partnerships, there were again important differences between ethnic groups. 18 per cent of Caribbean couples and 11 per cent of white couples described themselves as 'living as married'.[5] The proportion was much lower for all the Asian groups – between 2 and 4 per cent. Table 2.7 shows that the rate of cohabitation was high for couples in their early twenties and declined with age to a low for those above the age of 40, a pattern which is probably caused by a combination of an age effect (people cohabit when young, and marry later) and a generation effect (people nowadays are more ready to

5 Cohabiting couples were included under the general heading of 'partnered' rather than 'single'. But, without a full history, we do not know whether some of those categorised as never married may have had a previous relationship.

live together without marrying than they were ten or twenty years ago). Neither of these factors has had much effect on Asian partnerships, though. It is interesting that the rate of cohabitation was similar for Caribbeans and whites at either end of the relevant age-range; the 'extra' Caribbean informal partnerships were mainly between the ages of 25 and 39. This is consistent with evidence later in this chapter that white men and women were more likely than black people to use cohabitation as a prelude to formal marriage.

Table 2.7 Proportion of people with a partner who were 'living as married', by age

cell percentages

	White	Caribbean	South Asian
20 to 24	48	55	7
24 to 29	27	49	3
30 to 34	17	26	5
35 to 39	13	24	4
40 or more	4	5	2
Weighted count	*3702*	*1067*	*3212*
Unweighted count	*3716*	*747*	*4177*

Analysis based on all adults in survey households who currently had a partner.

Mixed-ethnicity partnerships

It is also important to consider people's choice of partners. Mixed marriages have often been a contentious issue (Hall 1996; Alibhai-Brown and Montague 1992). A common form of racism is for the dominant (white) group to object to 'miscegenation' if their daughters and sons marry the oppressed (non-white) minority. In contrast, objections have sometimes been raised from the minorities' point of view if marrying white people is seen as a betrayal of the community identity (Modood, Beishon and Virdee 1994). An intermediate position is to discuss the 'difficulties' a couple from different backgrounds (and their children) are likely to face in practice; this argument tends to the conclusion that mixed marriages are desirable in principle, but you might discourage a friend (or your daughter) from taking the risk. But arguments wholeheartedly in favour of mixed marriages are also strongly expressed: love should not depend on skin colour, it is said, and mixed marriages would be the surest sign of good relationships between ethnic groups.

People's *opinions* about mixed marriages will be discussed in Chapter 9, in the context of the analysis of culture and ethnic identity. It is worth saying at this stage, though, that many respondents said that they personally would not mind if a close relative entered a mixed white/minority marriage, though white people and minorities both thought that other members of their own group probably would mind. These questions indicated that people of Caribbean origin were most favourably inclined to the idea of mixed partnerships, followed by white people; South Asians were relatively unfavourable.

As far as *behaviour* goes, mixed-ethnic marriages form a very small proportion of all partnerships in the population as a whole – about 1 per cent (Berrington 1996).

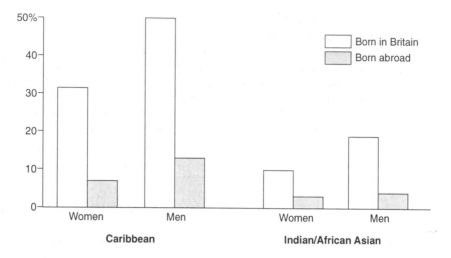

Figure 2.6 Proportion of partners who were white, by place of birth

That is a correct measure from a global perspective, and also signifies that very few white people have a minority partner. Looked at from the minorities' point of view, though, marriages with the much larger white community are potentially more important. In fact one fifth (20 per cent) of Caribbean adults who said they were either married or living as married had a white partner; 17 per cent of Chinese, only 4 per cent of Indians and African Asians, and just 1 per cent of Pakistanis and Bangladeshis.

Brown (1984) reported that 15 per cent of Caribbean heads of household with partners had a mixed marriage; our nearest equivalent figure of 20 per cent for all adults with partners suggests an increase in the number of people choosing white partners – consistent, perhaps, with the increase in the number of young people of Caribbean origin who have been born and brought up in Britain. For South Asians the proportion in 1994 was actually a bit lower than the 1982 equivalent.

Many of those who moved to Britain as adults would already have been married, so the most relevant comparison is for those who were born here. As many as half of British-born Caribbean men, and a third of women, had chosen a white partner (left-hand side of Figure 2.6), and this may be an indication of the likely pattern for future generations. It may be (though the data cannot show) that the proportions would be even higher for Caribbeans whose own parents had also been born in Britain and/or who had been the product of a mixed marriage themselves. Among the Indians and African Asians (who, as a group, came to Britain half a generation later than the Caribbeans) 19 per cent of British-born men, and 10 per cent of women, had a white partner (right-hand side of Figure 2.6), so mixed marriages may be becoming much less rare than previously. Hardly any Pakistanis or Bangladeshis had white partners.

Two-thirds of the Caribbean and South Asian people who had entered mixed ethnic partnerships were men; among the small number of Chinese mixed

relationships, it was the other way round – two-thirds of the Chinese people with white partners were women.

Among Caribbean men who were born in Britain, those in employment were more likely to have a white partner (54 per cent) than those not in work (39 per cent). That limited evidence suggests that mixed partnerships are associated with higher rather than lower socio-economic status.

For Caribbeans (the only ethnic group with enough mixed partnerships to analyse in any detail) the mixed unions were neither more nor less likely to be 'living as married' as opposed to formally married. Again the evidence is not conclusive, but this is not consistent with the hypothesis that members of minorities might cohabit with a white partner but would return to their own community to choose a husband or wife.

Marriage is an important indicator of the distinctness of different ethnic identities. There was virtually no sign that the various minorities saw each other as forming a common pool from which to select non-white partners. There was some intermarriage between Indians and African Asians, but most of the latter said that their families had originally come from India. There were very few partnerships involving both Caribbeans and Asians, or between other Asian groups. There was not a single couple of mixed Pakistani-Bangladeshi origin.

Partnerships between men and women from different ethnic groups will eventually have implications for the definition and concept of ethnic identity. Table 2.8 considers the parents of those children in the survey households whose mother and father both lived with them. This is not a full analysis of mixed parentage, because we do not know the ethnic group of the absent parent in one-parent families, which are (as will be seen) specially important in the Caribbean community. Nevertheless, it is striking that, for two out of five children (39 per cent) with a Caribbean mother or father, their other parent was white. As expected from the analysis of marriage, this was more often a black father and a white mother than the other way round. There was also a significant proportion of children of mixed Chinese–white parentage.

Table 2.8 Proportion of children who had one white parent

Caribbean	Indian/ African Asian	Pakistani/ Bangladeshi	Chinese
39%	3%	1%	15%

Analysis based on children aged less than 16, both of whose parents lived in the same household.

Separation, divorce and widowhood

We turn now to people who had been married in the past but who were now separated or divorced or whose partner was dead. (We did not ask for a full marital history; people who had remarried would be classified as married rather than as widowed or divorced.)

A small number of adults said that they were married but their spouse was not one of the other members of the same household. Analytical tidiness tempted us to call these couples 'separated', but it seems likely that they were living in different places for work reasons and still saw their future together. Only 1 or 2 per cent of 'married' people were living apart in this way in most ethnic groups; but for Pakistanis and Bangladeshis, it was 6 per cent, and these may be people who have come to Britain ahead of their partner, and who hope to rejoin each other either here or in their country of origin.

Differences between groups in the number of people who had ended their marriages through separation and divorce closely paralleled variations in the number who had never formally institutionalised their partnerships in the first place. Of those who had ever been married, 18 per cent of Caribbean people had split up from their former partners (without remarrying). The proportion was down to 9 per cent of white people but only 4 per cent of Asians.

The distribution of ex-married people across age-groups was rather different between the white and Caribbean communities (Table 2.9). For whites, the number of separated and divorced people was broadly similar across most age-groups, but with relatively few among those past retirement age. For those of Caribbean origin, the number of separated and divorced people continued to rise with age. So the two ethnic groups had similar rates of marriage failure in their twenties, but the level was more than four times as high among elderly Caribbeans as among elderly whites. These differences are consistent with the suggestion that Caribbean marriages were ending in separation and divorce long before the rising trend of recent decades affected the white population.

Table 2.9 Proportion of ever-married people who were separated or divorced, by age

	White	Caribbeans
		cell percentages
16–29	10	12
30–39	11	18
40–49	12	17
50–59	8	19
60 plus	5	21
Weighted count	*3692*	*1096*
Unweighted count	*3720*	*773*

Analysis based on ever-married adults in survey households.

As expected, the number of widows and widowers was very low in all ethnic groups for people below the age of 60. Among elderly people, it was very similar for whites (32 per cent) and for Asians (31 per cent), bearing in mind that there were more very elderly people in the white group than among any of the minorities (no table). The rate of widowhood was much lower for elderly Caribbeans – only 17 per cent – possibly because such a high proportion of their marriages had ended in divorce, before either partner died.

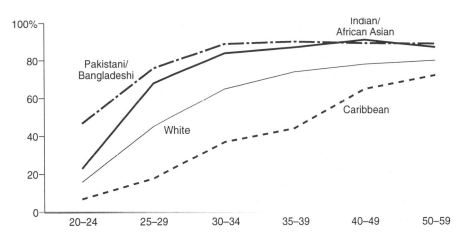

Figure 2.7　Proportion of all adults in formal marriages, by age

Formal marriage

To sum up this complex analysis of marital partnerships, it remains true that, in spite of rapid changes in attitudes and behaviour, the great majority of white adults were in formalised marriages. Leaving aside elderly people (for whom widowhood is an important outcome), 58 per cent of white adults aged less than 60 were in that 'traditional' position (Table 2.4). The proportion was significantly higher for South Asians: 73 per cent. But Caribbeans have been found to differ from other groups on a number of counts: fewer were recorded in partnerships; more of those were cohabiting; more of them had separated or divorced. The 'traditional' relationship was still the most common single outcome for Caribbeans, but only 39 per cent of 16 to 59 year olds had adopted it. Figure 2.7 shows that this variation applied to all age groups, but especially to the younger generations. Young Pakistanis and Bangladeshis (aged 20 to 24) were seven times as likely to be formally married as young Caribbeans.

FAMILY FORMATION 2 – CHILDREN

We can now consider how many 'family units' had dependent children. Couples, whether married or living as married, are treated as one unit for this purpose; where the analysis is based on individual characteristics (such as age) we have used the information about the woman, rather than the man, because her age is more likely to be relevant to child-bearing, and because this also allows direct comparison between couples and lone parents. Mixed-ethnicity couples, though, have been assigned to the relevant minority ethnic group, whether it was the man or the woman who came from that group. Sons and daughters who had grown up and ceased to be dependent (i.e. who had reached the age of 19, or who were over 16 and had left full-time

education) are counted as adults at this stage, even if they continued to live with their family of origin; thus they are analysed as potential parents rather than as dependent children.

Overall trends in child-rearing patterns since the 1950s have been as marked as those affecting marriage and cohabitation (Ermisch 1990; Joshi 1989; Buck et al. 1994). In the population as a whole there have been two types of change: one relating to the number of children per family, the other to the number of parents.

Women have tended to have their first child later, and to have fewer children in total, than used to be the case. Although there has been some rise in the proportion of women who have no children at all, the most striking effect of the trend has been a reduction in the number of large families. This is well illustrated by statistics about family allowance and child benefit – the state payments for all families with children. In 1965, 232,000 families with five or more dependent children claimed benefit, but in 1995 this number had fallen to 77,000. The number with six or more children fell from 94,000 to 17,000 (DHSS 1966; DSS 1996a). Thus the 'large family' which had been the object of concern on such issues as overcrowding (e.g. Land 1969) has practically disappeared from public discussion.

On the other hand, the third survey (Brown 1984), the Labour Force Survey (Jones 1993) and the census (Murphy 1996) have all shown that South Asian families, and Pakistani and Bangladeshi families in particular, were both more likely than other ethnic groups to have children, and much more likely to have a relatively large number of children. They therefore provide an exception to the national trend which is of potential importance not only to Asians' family structures but also to their standard of living. The latter point will be considered in Chapter 5; in this chapter, the Fourth Survey provides an opportunity to consider family size in relation to other factors. Our ability to analyse family units (rather than whole households) is an important advantage here, especially for Asian families – which, as will be seen later, also had more complex household structures.

The second main national trend has been the growth of the number of one-parent families. This was already an issue in the early 1970s, when an official committee reported on the policy implications (Finer 1974), but the total number has risen from 500,000 in 1971 to 1.3 million in 1993 (Haskey 1993). During the earlier part of the period, the increase consisted principally of divorced and separated families; more recently, the number of families with a never-married mother has risen more rapidly, though they still account for less than half the total.[6] It is not clear how many of the single mothers had been cohabiting when their child was conceived or born, and might therefore be considered to have separated.

Whereas South Asians appear from other data to be behind the national trend towards smaller families, Caribbeans might be seen to be ahead of the trend towards lone parenthood. Jones's analysis of the Labour Force Survey, for example, showed that more than half of all Caribbean families with children had one parent (though he did not quote this figure directly), compared with less than a quarter of white

6 In the following narrative we use the term 'single' parent strictly to refer to never-married parents – i.e. those whose marital status was described above as 'single'. The terms 'lone parent' or 'one-parent family' include both single and separated/divorced parents.

families with children (Jones 1993). Census data are consistent with those findings, though its definition of a family unit includes non-dependent children (Murphy 1996).

Whereas race has been at the centre of debate about the equally high rates of lone parenthood among black families in the United States (Wilson 1987), relatively little attention has been paid to ethnicity in the extensive public discussion of one-parent families that has taken place in Britain over the past few years (Burghes 1995). It has long been common in the Caribbean for a woman to bear a child without marrying the father, who may nevertheless retain active paternity through a 'visiting' relationship (Chamberlain et al. 1995). It has been argued, on the other hand, that a social convention imported by migrants to Britain would not explain an increase in the number of lone parents of Caribbean origin over recent decades (Dench 1996).

Table 2.10 provides a full analysis of the proportion of family units who had dependent children at the time of the survey. It takes account of marital status, and excludes the youngest and the oldest adults, very few of whom had children. Note that the existence of children in a family at any time is not the same as a count of the number of people who have children at any stage of their life, as some members of the sample will have children in future, and, for others, all their children had grown up.

Table 2.10 Proportion of family units aged 20 to 59 who had children, by marital status

cell percentages

	White	Caribbean	Indian/ African Asian	Pakistani/ Bangladeshi	Chinese
Couples	49	58	66	79	71
Ex-married women	51	50	58	67	n.a.
Ex-married men	11	17	n.a.	n.a.	n.a.
Never-married women	16	47	4	1	nil
Weighted count	*2159*	*1141*	*1311*	*705*	*250*
Unweighted count	*2162*	*806*	*1312*	*1261*	*141*

Analysis based on family units aged between 20 and 59. For couples, the woman's age is taken. Never-married men are not shown in the table. Hardly any of them had dependent children.

Table 2.10 contains a great deal of information, and it is best to consider it step by step. Take the *couples*, first, shown in the first row. About half of white couples where the wife was aged between 20 and 59 had dependent children. The proportion was nearer three-fifths for Caribbean and two-thirds for Indian and African Asian couples. Four-fifths of Pakistani and Bangladeshi couples had children; in fact (not shown in the table) it was 88 per cent for Bangladeshi couples.

It was shown earlier (pages 28+29) that a significant proportion of young white and especially Caribbean couples were 'living as married' rather than formally married. The first row of Table 2.10 includes both kinds of partnership together, but more detailed analysis showed that cohabiting white couples were rather less likely to have children than fully married white couples (Figure 2.8); but for Caribbeans this was not true – if anything, the cohabitors were more likely to have children than the married couples. These findings are consistent with (though they do not prove)

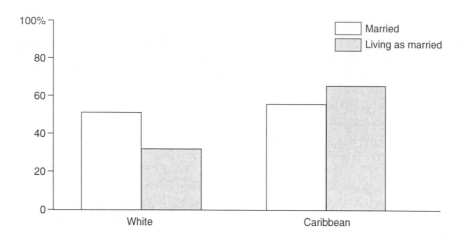

Figure 2.8 Proportion of couples who had dependent children, by whether formally married

the hypothesis that white couples tend to treat cohabitation as a stage which will be converted into full marriage when, or after, children have been born; but that Caribbean couples tend not to move on to marriage in this way.

Returning to Table 2.10, the second line shows the proportion of *widowed, separated and divorced women* (aged 20 to 59) who had dependent children. The interesting comparison is, within each ethnic group, between the formerly married women and the still-married women in couples. Among the white group, there was virtually no difference between the proportion of married and formerly married women who had dependent children living with them in their household. Since (third line of the table) some fathers had retained custody of their children, that is consistent with the rates of separation and divorce being slightly higher among couples with children than among those without. In each of the other ethnic groups, the proportion with children was lower among the formerly married women, and this is consistent either with more fathers retaining custody or with especially low rates of separation when children were involved.

The fourth line of Table 2.10 focuses on *single women* (aged 20 to 59). Nearly half (47 per cent) of all never-married women of Caribbean origin between those ages had dependent children. The proportion fell to one in six for single white women, and was very low indeed for Asian women. Here is detailed confirmation of other sources showing a high rate of single parenthood among Caribbeans. Table 2.5 (above) showed that Caribbean men and women in the child-bearing age-groups were less likely to be married than whites or South Asians. But unmarried Caribbean women were almost as likely to have children as their married sisters and cousins. They appear to have adopted a different opinion of the relationship between getting married and starting a family. It is not so much that many Caribbean single women had had babies; more that many of the mothers had not married.

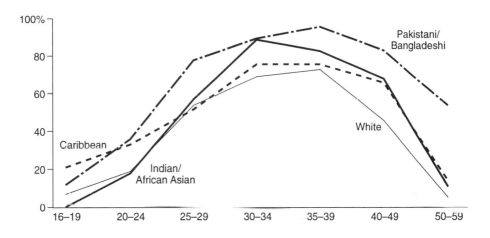

Figure 2.9 Proportion of all women who had dependent children, by age

This suggests that the conventional order of analysis, adopted in this chapter – asking first how many people were married, and then how many had children – is not appropriate when Caribbeans are under consideration; and recent trends suggest that the convention may become increasingly inappropriate for white women too. So Figure 2.9 compares the proportions of all women who had children, by age, regardless of their marital status. Figure 2.10 then looks at the proportion of mothers of dependent children who were (or had previously been) married or were living as married.

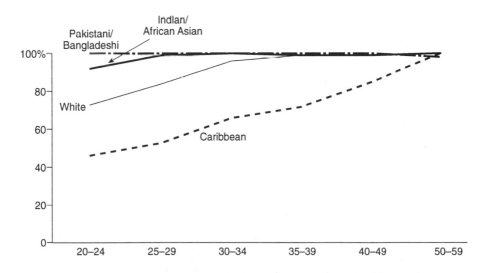

Figure 2.10 Proportion of women with dependent children who had had a partner, by age

In all ethnic groups, the same pattern of motherhood can be seen: women relatively unlikely to have children in their twenties; highly likely to have them by their thirties; and the proportion dropping off among older age groups as children grew up (Figure 2.9). It is variations in the shape of this pattern that are of interest. And all ethnic groups showed the same pattern of partnership among women with children: virtually all older mothers were (or had been) in a partnership, but the proportion was sometimes smaller among younger mothers (Figure 2.10). As discussed in the previous section, this is consistent with either an ageing effect (unmarried mothers enter a partnership after a period as a lone mother) or a cohort effect (the recent generation of mothers less likely to marry than the previous generation).

Take Pakistani and Bangladeshi women first. They were more likely than white women to have children in their twenties, and this can be interpreted in terms of their starting families earlier. Almost all of them were mothers by their late thirties, compared with about three-quarters of white women, and this suggests that rather fewer white women ever had children. An exceptionally high proportion of Pakistani and Bangladeshi women still had dependent children in their fifties (some still had them in their sixties), and this suggests that many of them continued to bear children into their forties. The combination of an early start and a late finish to the child-bearing period suggests large families, and the number of children per family will be analysed later in this section. But the other outstanding feature of Pakistani and Bangladeshi women was that virtually none of those with children reported that she was single – not even among those who had children as teenagers or in their early twenties.

Indian and African Asian women were much more similar in their profile to white women. They were rather less likely to have children at a relatively early age; a bit more likely ever to have children; and more of them still had dependants into their fifties. But fewer of them had children at each stage than Pakistani and Bangladeshi women, and there was no sign of an all-South Asian characteristic pattern of child-rearing. On other hand, the overwhelming majority of Indian and African Asian mothers were married, even in their early twenties, and in this they nearly resembled the Pakistanis and Bangladeshis.

Caribbean women, though, were very different, in two respects. First, a higher proportion of them had children in their teens or early twenties than either white or Indian/African Asian women. At the teenage stage more Caribbean women had had babies than even Pakistani and Bangladeshi women. Over the later age ranges, the proportion of Caribbeans with children was very similar to whites and Indian/African Asians. But in every age group up to the forties, Caribbean mothers were less likely than others to be married or cohabiting. The proportion did reach 100 per cent eventually, in the fifties age group, but it started much lower than for whites and remained lower at all earlier ages. In fact a quarter of all Caribbean women in their late twenties and early thirties were single parents, compared with a tenth of white women in those age groups.

It is important to note that the key difference between Caribbean and other women's parenting patterns is that the former were less likely to have entered a formal marriage. The data do not show how many of the mothers recorded as 'single'

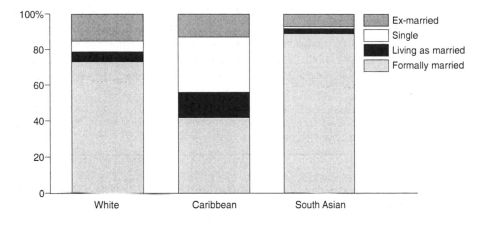

Figure 2.11 Parental status of families with children

had previously been in a cohabiting relationship with the father, nor what 'cohabitation' may have meant in terms of the intended or actual length of the relationship. Increasingly, it will be necessary for censuses and surveys to collect information about cohabitation and marriage as a series of events rather than as a steady state.

As a result of the combined patterns of parenting and partnership, the structure of families with children differed greatly between ethnic groups (Figure 2.11). Nine out of ten South Asian families with children had two formally married parents. For white families, there were important groups where the parents were living as married, had separated or divorced, or had never married at all, but three quarters were still in the 'traditional' pattern with two married parents.[7] For Caribbean families, on other hand, one third had single never-married mothers. Once the numbers living as married, or no longer married, have been added in, fewer than half of Caribbean families with children were headed by a couple in a formal marriage.

The second national survey, in 1974, reported that 13 per cent of Caribbean households with children had only one adult (Smith 1977). This had risen to 31 per cent in 1982 (Brown 1984). The earlier definitions of a one-parent family were different from that used in the analysis here,[8] but the Fourth Survey gives a figure of 36 per cent for Caribbeans, using an identical 'household' definition (Table 2.11). Thus the proportion of Caribbean one-parent households has gone up, but much less rapidly in the recent period than previously. At all stages, though, Caribbeans have been more likely to adopt that family structure than whites. And (as the bottom line

7 These included second marriages, so not all the adults were necessarily the direct parents of all the children.

8 It was based on households, rather than families, so that a single mother living in the same household as other adults (such as her own parents, or even an older child of her own) would not have counted as a lone parent in the 1974 or 1982 surveys. Another difference is that the 1974 and 1982 analyses defined children as under 16 instead of our definition based on leaving school.

of Table 2.11 shows) the household-based definition underestimated the total number of lone parents – nearly half of Caribbean families with children were headed by a single or separated mother at the latest count. The difference between Caribbeans and whites is made up entirely of never-married mothers, because of the distinctive child-bearing patterns reviewed in the preceding pages.

Table 2.11 Proportion of families with children which were lone parents 1974 to 1994

	White	Caribbean	South Asian
1974 (household definition)	n.a.	13	1
1982 (household definition)	10	31	5
1994 (household definition)	16	36	5
1994 (family definition)	21	45	8

Little is known about the fathers of one-parent families, though the recent introduction of child support legislation makes them a matter of intense policy interest. Even less is known about their ethnicity. It can be assumed that many or most of the men who had been in relationships with single Caribbean women were Caribbean themselves, although the fact that a third of British-born black women's live-in partners were white suggests that a number of the live-out partners may have been white as well. By the same token, we have no idea how many single white women had had a baby whose father was black.[9] It is worth recording that, while 40 per cent of single Caribbean women had a child under 16 living with them, 10 per cent of single Caribbean men said, in answer to a direct question, that they had a child under 16 who did not live with them. (Only 1½ per cent of single white men said this.) This provides an indication that a majority of the children were either unknown to or denied by their fathers (unless each of the men had had children by several women). Nevertheless, it also suggests that a proportion of the children may have had at least some form of paternal relationship.

Size of family

All these analyses have distinguished simply between families with and without children. Family sizes have fallen substantially in Britain over the decades, and by the time of the Fourth Survey only 4 per cent of white families had more than three dependent children (Table 2.12). Chinese families were, if anything, slightly smaller than those of whites, Caribbean and African Asians were very similar to the white average, and Indian family sizes were slightly larger. But Pakistani and Bangladeshi families stood out as being far larger than others. 33 and 42 per cent of them respectively had four or more children. Many of them (7 and 9 per cent respectively) had six or more. Most of these children were born in Britain.

9 The children of such a union would have been included in our sample of 'white' people, because households were allocated to one sample or the other according to the ethnic group of the adults.

Table 2.12 Number of children per family

column percentages

	White	Caribbean	Indian	African Asian	Pakistani	Bangladeshi	Chinese
1	38	45	28	31	24	20	44
2	44	34	42	48	23	20	32
3	14	15	19	18	21	18	21
4 or more	4	7	11	3	33	42	3
Weighted count	*914*	*614*	*389*	*350*	*365*	*137*	*141*
Unweighted count	*920*	*435*	*401*	*347*	*592*	*324*	*88*

Analysis based on family units with children.

Remember that the analysis in Table 2.12 is based on current family size, which tends to be less than the total number of children born to the parents – children who have already grown up, or who have not yet been born, are not counted. A better indication of total family sizes is provided by looking at the age of the mother. Typically, family size grows as the mother moves up the twenties and into her thirties, reflecting the addition of more children; and declines as she moves towards and through her forties, as children grow up and become independent. Figure 2.12 shows the distribution by size of families whose mother was aged between 35 and 39, comparing white families and Pakistani and Bangladeshi families. More than half of the latter included four or more children, compared with less than a tenth of the white families.

In both the white and the Caribbean group, single (never-married) women had fewer children than those who lived with a partner (or had done so in the past). This was partly because, being younger, the single mothers could be seen to be earlier in their child-rearing cycle. But a multiple regression equation showed that single women had slightly fewer children than others of their age.[10] A similar regression analysis showed that Caribbean women who had been born outside Britain had slightly fewer children than those who had been born here, again compared with their own age group. In contrast, Pakistani and Bangladeshi women who had been born abroad had slightly more children than their British-born equivalents, though the difference was not statistically significant.

HOUSEHOLDS

Finally, we can consider the composition of households. The great majority of households in Britain consist of one family (as defined here): a single person or a couple with or without children. But a proportion of the 'family units' identified in the previous sections lived together in multiple households. Easily the most common form of complex household consists of adult children living with their parents. Adulthood, as defined here, starts when young people leave school, and many of them live at home until they set up a family of their own.

10 The equation took the form required to match the inverted U shape of rising and falling numbers of children over the age-cycle:

 Kids = A x age – B x age^2 + C x single +D.

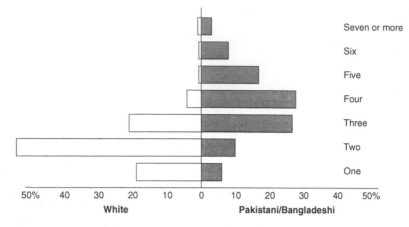

Figure 2.12 Number of children in families whose mother was 35 to 39: white and Pakistani/Bangladeshi families compared

Three-fifths of single white adults without children of their own lived with their parents (Table 2.13). The proportion was very similar for single Caribbean men and women. But more than four out of five South Asian single adults lived with their parents.

Table 2.13 Proportion of family units aged less than 60 living with their parents

cell percentages

	White etc.	Caribbean	Indian/ African Asian	Pakistani/ Bangladeshi	Chinese
Single, no children	59	62	82	87	51
Single parents	12	9	n.a.	n.a.	n.a.
Married couples	2	1	21	22	6
Ex-married individuals	9	2	14	17	n.a.
Weighted count	*2775*	*1495*	*1624*	*875*	*342*
Unweighted count	*2771*	*1070*	*1627*	*1589*	*194*

Analysis based on family units aged less than 60.

Living with one's parents is associated with age as well as with one's own family status. Almost all single teenagers lived with their parents. Even among those who remained single (and without children of their own) the proportion fell off as young people grew through their twenties and thirties; on the other hand, a proportion of single people continue to live with their parents long after they have reached economic independence. The typical pattern for white people is shown in Figure 2.13, converted to a smooth curve using a logistic regression equation rather similar to the one used above to analyse marriage rates.

All the other ethnic groups had similar patterns by age, but the picture is complicated by two factors. First, as shown in Table 2.5 above, South Asians tended to marry earlier, and Caribbeans later, than white people, so the age-profile of those

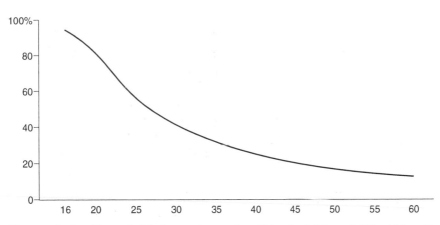

The curve is plotted from a logistical regression equation which estimated the probability of living with one's parents as a function of log (age – 15).

Figure 2.13 Proportion of single white adults without children who lived with their parents, by age

who remain single varies by ethnic group. Second, many members of the minority groups migrated to Britain as adults, and their parents do not necessarily live in this country.[11] Since it was the older members of the current population who were more likely to have migrated, age has to be taken into account in comparing people's household structures. (Another possibility is that parents who previously lived in Britain have since returned to their country of origin – a pattern not uncommon among Caribbeans.) Table 2.14 shows how many people are estimated to remain with their parents at the age of 30, using the logistic regression equation to iron out the age differences. First take single people without children.

- For those who were born here, Caribbean single people were rather more likely to live with their parents than their white equivalents were. The proportion of South Asian single people remaining at home was higher still.

- Caribbean single people who were born abroad were much less likely to live with their parents, presumably because their parents still live in the West Indies. But for South Asians, single people who were born outside Britain still had a high chance of living with their parents. This may have happened in either of two ways: the single people may have been brought here by their parents when they themselves were still children; or the single people may have migrated as adults, but brought their parents to join them (Stopes-Roe and Cochrane 1990). Either way, this indicates a high level of co-residence cohesion among South Asian migrants compared with the low rates of living with parents among migrant Caribbeans.

11 A separate set of questions about where people's parents lived is analysed in the next section of this chapter.

Table 2.14 Predicted probability of living with parents at the age of 30, by marital status and place of birth (selected groups only)

cell percentages

	White	Caribbean	South Asian
Single without children			
born in Britain	42	52	70
born abroad	n.a.	23	61
Married couples	1	1	30

Estimates derived from logistical regression equations which estimated the probability of living with one's parents as a function of log (age–15). For this analysis, a couple's age was based on that of the husband.

For white people and Caribbeans, Table 2.13 (above) showed that the great majority of adults ceased to live with their parents as soon as they had family commitments of their own, even if this was only as a single parent; and hardly any married couples lived with either set of parents. For South Asians, though, it was a different picture. As many as one fifth of South Asian couples lived with (one of) their families. The proportion was again associated with age, but the regression equations in Table 2.14 showed that nearly a third of couples where the man was aged 30 would be living in their parental home. This, in spite of the fact that most of the people concerned had been born in Asia or Africa, and not all of them would have had the chance to live with their parents in Britain. The other striking point was that the great majority of the South Asian couples living with the older generation were found in the same household as the man's parents (no table). Among the few white or black couples who lived with one set of parents, the woman's parents were chosen more often than the man's.

It is interesting to turn this analysis around to ask how many older people were living with their adult children (Table 2.15). Again, there is bound to be a life-cycle effect. No one in their twenties, and hardly anyone in their thirties, lived with an adult child. By the forties, between a third and two-thirds of adults had one or more adult children living with them, as their teenagers reached the stage at which they were defined as 'adults' but had not yet left home. Variations by ethnic group at this stage largely reflect the existence and number of children rather than differences in living arrangements: Chinese, African Asian and white people were least likely to be living with 'grown-up' children; Indians, Pakistanis and, especially, Bangladeshis were most likely to do so.

In the white group, the proportion of people living in the same household as an adult child then declined rapidly as they moved from middle to old age, as their children left home. Only 13 per cent of those in their sixties or seventies shared a household with a son or daughter. The shape of the Caribbean distribution was similar, but the decline in co-residence after the peak age was much less steep, so that a third of elderly black people lived with an adult child. For Asians, in contrast, the proportion of elderly people sharing with their children rose through the fifties and into the sixties, so that two-thirds of Asian elders were in this situation.

At first sight, it seems surprising that a higher proportion of Asian parents lived with their children than children lived with their parents. This is explained by three factors, two natural and one associated with migration:

- In any family, there are potentially more children than parents. If the older generation lives with one son or daughter, all the parents are accounted for, but only a fraction of the younger generation. The larger the average family size, the more important this factor will be.

- When parents die, the proportion of children who can live with their parents is reduced, but the parents are taken out of the reckoning.

- Similarly, parents who have remained in the country of origin are not included in our analysis, but their children are recorded as living apart from their parents.

Table 2.15 Proportion of individuals with an adult child living in the same household

cell percentages

	White	Caribbean	Indian	African Asian	Pakistani	Bangladeshi	Chinese
30-39	5	6	5	5	10	12	3
40-49	35	41	50	30	51	66	30
50-59	31	44	68	62	69	73	69
60 plus	13	31	61	70	61	65	72
Weighted count	*4310*	*1492*	*1257*	*766*	*718*	*234*	*337*
Unweighted count	*4327*	*1125*	*1320*	*776*	*1162*	*544*	*208*

Analysis based on all individuals in survey households aged 30 or more.

Whatever the statistical explanation, the fact remains that a very high proportion of Asian elders lived with a son or daughter. Most of them were not yet of an age when they would require personal care; but when they reached that age, they would be much better placed to ask for help from their family than their white equivalents. (Some direct information about caring for elderly people is analysed in the last section of this chapter.)

The consequence of these living arrangements was that there were significantly more two-generation households among South Asians than among other ethnic groups. Generations are defined here in terms of adults, so that dependent children do not count as a generation. There were very few three-generation households, even in Asian communities; on the other hand, there were very few elderly people of Asian origin, and the number of three-generation households might grow over the years.

It is useful to summarise household structures, combining all the individuals living together, using a classification that is employed as a standard in official statistical publications such as the General Household Survey and the census. This involves counting the number of people in three age groups within each household – children under 16, adults aged 16 to 59, and elders aged 60 or more – as shown in

Table 2.16.[12] The table contains a great deal of information, but the highest figure in each row is highlighted in bold type.

■ A high proportion of white households consisted of one or two elderly people. White people were also more likely than other groups to live in couples.

■ Caribbean adults were most likely to live on their own, with or without children.

■ Indians and African Asians were most often found in small families; as we have pointed out before (Modood, Beishon and Virdee 1994), more of them conform to the stereotype of Mum, Dad and two kids than any other ethnic group. But there were also more households containing several adults than were found in the white community.

■ Pakistanis and Bangladeshis led the field not only in the number of large families, but also in the number of large complex households

Table 2.16 Household structure

column percentages

	White	Caribbean	Indian/ African Asian	Pakistani/ Bangladeshi	Chinese
One or two adults, either over 60	**30**	14	7	3	7
One adult, less than 60	11	**14**	4	3	13
Two adults, both less than 60	**18**	14	9	6	10
One adult, with children	5	**17**	3	3	3
Two adults, with one or two children	15	19	**26**	14	20
Two adults, with three or more children	4	5	9	**21**	8
Three or more adults, with or without children	17	18	42	**49**	40
Weighted count	*2945*	*1246*	*1144*	*577*	*253*
Unweighted count	*2943*	*926*	*1150*	*1008*	*144*

Analysis based on households.

Many of these conclusions are in line with what would have been expected from the findings already reported in this chapter and elsewhere. If there is one worth emphasising, because it has not been pointed out before, it is the social organisation of elderly people. The scarcity of small elderly households among minority groups is not just because most of the migrants have not yet reached old age. That is part of the explanation, but we have also found that minority elders, especially Asians, often lived with their sons and daughters. As Figure 2.14 shows, that means that the majority of elderly Asians live in large complex households, not in the small pensioner households that are normal among white people and common among Caribbeans.

Our analysis of household structures is not identical to that adopted in the third survey (Brown 1984), and we have not been able to make a direct comparison of household types. But a straightforward comparison can be made on the basis of the

12 To be consistent with the standard definition, the boundary between adults and children has been moved to exactly 16 years old for this analysis, rather than the definition of 'dependence' based on leaving school, used in the rest of this chapter.

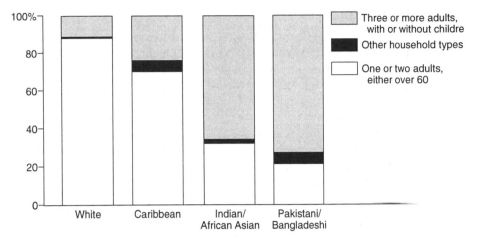

Analysis based on all adults over 60.

Figure 2.14 Household structure of individuals aged 60 or more

numbers of people living together in households (Table 2.17). The differences between the ethnic minorities and whites are affected by the relatively large number of elderly households without children in the majority population. And it is important to remember that household size is the outcome of two types of decision: about the structure and size of the *family,* and about the extent to which families live together in *households.* Nevertheless, there have been some clear changes over the last decade:

- a reduction in the average number of adults in Caribbean households; this almost certainly signifies a trend towards more Caribbeans living on their own (or with just their children);

- a slight fall in the number of adults in Indian and African Asian households; but a substantial rise in Pakistani and Bangladeshi households;

- a reduction in the average number of children in Indian households;

- fewer children, too, in Pakistani households, but the average has held steady in Bangladeshi households.

Table 2.17 Household size

average numbers

	White	Caribbean	Indian	African Asian	Pakistani	Bangladeshi	Chinese
Number of adults							
1982	2.0	2.3	2.7	2.9	2.7	2.4	n.a.
1994	1.9	1.9	2.8	2.7	3.0	3.0	2.4
Number of children							
1982	0.5	1.0	1.6	1.3	2.5	2.6	n.a.
1994	0.5	0.9	1.1	1.2	2.1	2.7	0.9
Weighted count 1994	*2970*	*1289*	*649*	*526*	*445*	*147*	*253*
Unweighted count	*2968*	*952*	*666*	*515*	*703*	*335*	*144*

Analysis based on households.

WIDER KINSHIP NETWORKS

The analysis so far in this chapter has described the people who lived in the same household as the members of our samples of whites and ethnic minorities. This final section analyses some of the links they had with other relatives, outside their household. For this purpose we turn to the detailed interviews with one (or two) adult(s) in each household which provide the data for most of the remainder of this report.

Parents

First, individuals were asked whether their parents were still alive and, if so, where they lived. This complements the earlier analysis of the number of adults who lived with their parents, by showing how many people still had parents, whether in Britain or abroad.

It hardly needed a survey to demonstrate that almost everyone in their twenties or younger, and virtually no one in their seventies or older, had a mother and a father both living. Figure 2.15 shows this for all ethnic minorities combined, and the picture was very similar for whites. There was a hint in the data that middle-aged Pakistanis and Bangladeshis were more likely to have lost their parents than members of that age-band from other ethnic groups. That would be consistent with high rates of adult mortality in their countries of origin, but the number of respondents contributing to the analysis was too small for much weight to be placed upon it. The main point to be made about the link between a person's age and the probability of having living parents is that a high proportion (78 per cent) of all ethnic minority adults had mothers and fathers, simply because not many of them had yet reached the age at which their parents might have died; this was in contrast to the white population (63 per cent), where the large number of people who were elderly themselves meant a relative scarcity of parents.

For migrants, of course, many parents lived abroad, mostly in their country of origin. Three-quarters of Caribbeans, Pakistanis and Bangladeshis who had themselves come to Britain aged 16 or over (and who still had any parents) said that their mother and/or father was abroad (Table 2.18). The proportion was consistently smaller for people who had migrated as children (most of them, presumably, brought by their parents), and very small for those who had been born here (though there is some sign of back-migration in Caribbean families). It is striking, though, that Indians and African Asians were less likely than the other minorities to report that their parent(s) lived abroad, and this is consistent with other evidence that whole families migrated to Britain – either all at once, or 'sending for' senior relatives when the original arrivals had become established (Bhachu 1986; Ballard 1990).

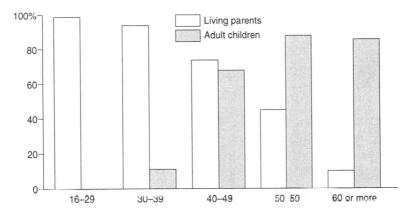

Figure 2.15 **Proportion of minority adults who had any living parents or adult children, by age**

Table 2.18 **Proportion of parents who lived abroad, by respondent's age on migration**

cell percentages

	Caribbean	Indian/ African Asian	Pakistani/ Bangladeshi
Respondent was born in Britain	10	1	5
Respondent migrated as child	31	12	20
Respondent migrated as adult	76	57	76
Weighted count	*606*	*812*	*466*
Unweighted count	*426*	*752*	*676*

Analysis based on respondent adults who had any living parent.

The analysis of co-residence earlier in this chapter (Table 2.16) simply showed how many people lived in the same household as their parents. It is now possible to record how many did so, *as a proportion of those for whom such an arrangement was possible* – those with living parents resident in Britain. Figure 2.16 shows that South Asians were consistently the most likely to adopt that solution, even into middle age. Only 6 per cent of white adults aged over 30 lived with their parents, compared with a quarter of South Asians over 30.

Adult children

The upwards analysis of sample members' parents can now be switched round to look downwards at their adult children (treating all over-16s as adults for this purpose, whether they lived in the same household or elsewhere). Of course none of those in their twenties said that they had an adult child, and few of those in their thirties. Again, there were no real differences between ethnic groups, and Figure 2.15 (above) showed that, for all minority groups combined, nearly nine out of ten of those over 50 had one or more grown-up children. The figure clearly illustrates the

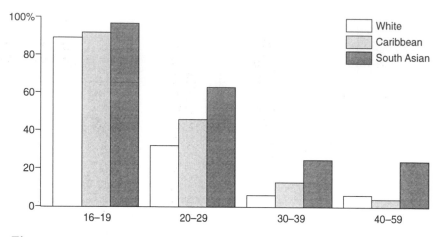

Figure 2.16 Adults who lived with their parents, as a proportion of those with living parents resident in Britain

fact that most adults, of any age, have either a parent or an adult child, with those in their forties likely to have both types of relationship. This basic demography of the family was equally true of all ethnic groups; it implies that the proportion of men and women who had children 20 or more years ago was very similar for all groups.

Most of these children lived in Britain. Figure 2.17 shows what proportion of respondents lived with (one of) their adult child(ren), expressed as a proportion of those for whom it was an option. It is very similar to the previous analysis (Table 2.15). For white people, a high proportion of younger parents lived with their adult children, who will have been in their late teens or early twenties, and had not yet 'left home'; but the proportion of elderly whites who lived with their – by now middle aged – children was very low. Caribbeans had a rather similar pattern of co-residence to whites, except that the proportion of middle-aged and elderly people who had chosen to live with their children was substantially higher. Among South Asians, though, most of those who had any adult children in Britain were living with (one or more of) them.

Contacts between parents and children

This analysis of where people lived in relation to their closest blood relatives may indicate a much closer set of links within South Asian families than is common among white families. Caribbeans were more likely to live with their parents or children than whites were, but less so than South Asians. But what about contacts with those of their close relations who did not live in the same household?

A substantial proportion of the surviving parents of members of the minority samples lived outside Britain, but most respondents were nevertheless in touch with them. Table 2.19 shows what contacts there had been over the previous four weeks. Obviously, given the distances involved, letters and phone calls were much more

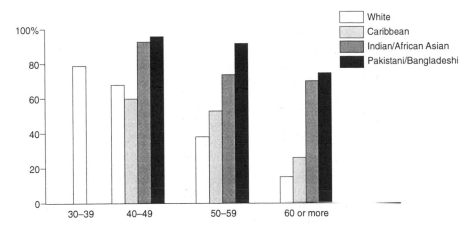

Figure 2.17 **Respondents who lived with their child(ren), as a proportion of those with adult children resident in Britain**

common than direct personal contact, though there were some differences of detail between groups. Taking one means of communication with another, Caribbeans were rather less likely to have been in touch with overseas parents than Asians had been. Chinese people were more likely to have spoken to their parents on the phone than to have exchanged letters; for Pakistanis and Bangladeshis it was the other way round. This may be associated with the low levels of income, and of phone ownership, among Pakistanis and Bangladeshis (as shown in Chapter 5). But the general point is that intercontinental communications now allow migrants to keep in touch with their families, and the majority of them do so.

Table 2.19 **Contacts with parents who lived abroad, within the previous four weeks**

column percentages

	Caribbean	Indian/ African Asian	Pakistani/ Bangladeshi	Chinese
In person	3	5	5	15
By phone	37	43	28	59
By letter	36	63	58	38
Weighted count	*162*	*212*	*174*	*81*
Unweighted count	*126*	*239*	*306*	*49*

Analysis based on respondents with living parents resident abroad.

Similar information is available about contacts between members of the sample and those parents and/or children who lived in Britain (but excluding those who lived in the same household). Most people had had some contact with their parents and/or children within the previous four weeks, many of them frequently. Table 2.20 shows

how many had been in touch by various means; for personal contact and telephone, the cut-off point has been set at four times in that period, equivalent to once a week.

Table 2.20 **Contacts with parents and adult children who lived in Britain, within the previous four weeks**

column percentages

	Caribbean	Indian/ African Asian	Pakistani/ Bangladeshi	Chinese
At least 4 times in person	61	60	61	61
At least 4 time by phone	68	64	68	54
At least once by letter	22	12	10	9
Weighted count	*2363*	*460*	*459*	*170*
Unweighted count	*2424*	*378*	*477*	*279*

The table adds together respondents' contacts with their parents, and with their adult children. Someone who had both types of relationship is counted twice. Analysis based on respondents with living parents or adult children resident in Britain but not in the same household.

Given the strength of South Asian family ties as indicated by the number of parents and children living together in the same house, we rather expected to find that South Asians who did *not* live together would have high levels of contact. In practice, white people and Caribbeans were in regular touch with their families too, and it turned out that Asians were just the same, on this measure. Several different ways of presenting the data have been tested, and none showed substantial differences between ethnic groups in the extent of contact between adult children and their parents.

The survey does not show how far parents and children lived from each other in terms of distance (if they lived in Britain but not in the same house). Research among the general population tends to show that many (white) children live within the same town or neighbourhood as their parents. While social mobility and a wider labour market have drawn people to live further apart than used to be the case, modern communications, especially cars and telephones, mean that longer distances do not necessarily mean less contact (Willmott, 1986 and 1987). We rather expected black and Asian people to have high rates of family contact if they lived in areas where a high proportion of the population came from their own ethnic group, but no such link could be identified. We found that (in all ethnic groups) mothers and daughters reported rather more contact with their close family than fathers and sons did, but, apart from that, the general conclusion was that all ethnic groups had close parent/child ties.

Uncles and aunts

The links so far described are often referred to as 'vertical', but there is some evidence that Asian families have stronger 'horizontal' ties than white families do (Modood, Beishon and Virdee, 1994). The survey chose one horizontal relationship to illustrate this issue: respondents were asked whether they had any uncles or aunts and, if so, what contacts they had had with them in the previous four weeks.

The existence of uncles and aunts[13] followed a very similar pattern to the survival of parents (see Figure 2.15 above). Virtually all young adults had them, in all ethnic groups (perhaps surprisingly, since this implies that there had been hardly any one-child families in the previous generation). The proportion declined with age, until only one eighth of those in their seventies (or older) said they had uncles and aunts. There was very little difference between ethnic groups, except that Pakistanis and Bangladeshis were rather less likely to have them than the others. This is surprising (given the number of brothers and sisters in the most recent generation), and some Pakistanis and Bangladeshis may not have mentioned uncles and aunts they had lost touch with back home.

As with parents (see Table 2.18 above), most of the uncles and aunts of British-born people also lived in Britain, while the majority of migrants who arrived in Britain as adults said that all their uncles and aunts lived abroad. This meant, in turn, that most Caribbean uncles and aunts lived here, while nearly half of the Pakistani and Bangladeshi ones lived overseas.

The interesting point is to compare the extent of contact between the nephews and nieces and the uncles and aunts, for those who lived in Britain. These contacts were notably less common than those between parents and adult children. Nevertheless, a majority of respondents with British resident kin had been in touch with them by one means or another within the previous four weeks (Table 2.21). White nephews and nieces were the most likely to have corresponded by mail, but this was the least popular medium in any case. As far as the more common personal and phone contacts were concerned, Caribbeans were more often in touch with their uncles and aunts than white people were; but it was the South Asians who showed much the most frequent contacts.

Table 2.21 **Contacts with aunts and uncles who lived in Britain, within the previous four weeks**

column percentages

	White	Caribbean	Indian/ African Asian	Pakistani/ Bangladeshi
In person	37	51	70	66
By phone	31	47	64	58
By letter	24	13	13	15
Weighted count	*2020*	*485*	*530*	*244*
Unweighted count	*1907*	*337*	*493*	*326*

Analysis based on respondent adults with aunts and uncles resident in Britain but not in the same household.

Thus there were several measures indicating strong family ties among South Asians. Compared with Caribbeans, Asian (and especially Indian and African Asian) migrants were more likely to have come with, or have been joined by, their parents. Compared with both white people and Caribbeans, Asians were more likely to live in

13 The question asked about 'any uncles and aunts who are alive and not living with you'. It was not possible to work out exactly which members of the household were an uncle or an aunt of the respondent, so the analysis here is concerned with those who did not live in the same household.

the same household as their parents or adult children. And they had exceptional levels of contact with those of their uncles and aunts who lived in Britain. On the other hand, whites and Caribbeans were just as likely to maintain close links between parents and adult children who lived in Britain but not in the same household.

'Caring'

The needs of frail or disabled people have become an increasingly important issue in recent decades, as the number of elderly people in the population has increased (Allen and Perkins 1995). Most 'care' is provided by relatives, though there is sharp debate whether this is a good or a bad thing from either person's point of view (Dalley 1991). In married couples most care is provided by husbands and wives to each other, but widows and widowers rely on their children – commonly, but not exclusively, on daughters.

The Fourth National Survey asked respondents, first, whether there was anyone in their household (apart from young children) whom they looked after or to whom they gave special help and, second, whether they provided regular help or service to anyone not living with them. The analysis here concentrates on care of elderly parents. Figure 2.18 shows, for white people, how the pattern varied by age. The number looking after their parents in some way (whether inside or outside the household) rose from 2 per cent of respondents in their twenties to 18 per cent in their forties, reflecting the increasing age of the parents. It then fell again to 8 per cent of those in their sixties (and hardly any in their seventies), reflecting the smaller number who had any parents to look after. If the same figures are based, instead, on those who still had a parent (resident in Britain), the proportion providing care continued to rise, until two-thirds of white people in their sixties who still had a parent were caring for him or her (or both).

The problem for analysing ethnic minorities is that so few middle-aged Caribbeans and South Asians had a parent who lived in Britain – because, as we have seen, these were migrants, many of whose parents were still in their countries of origin. Table 2.22 (which is confined to the middle age ranges most likely to have caring responsibilities) shows that none of the minority groups was as likely to be caring for a parent as white people (first row). But if the number with a parent resident in Britain is taken into account, it appears that only Caribbeans were less likely to be undertaking this role than whites; South Asians were very similar to

Table 2.22 **Proportion of people aged 40 to 59 who cared for a parent (at home or elsewhere)**

	White	Caribbean	South Asian
As a proportion of all	17	5	8
As a proportion of all those with a parent in Britain	25	8	22
Weighted count	*903*	*209*	*463*
Unweighted count	*811*	*156*	*529*

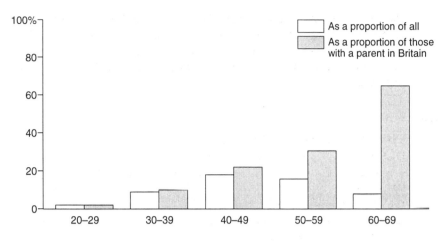

**Figure 2.18 Proportion of white people who cared for a parent
(at home or elsewhere), by age**

whites (second row). Very small samples are involved here, but multivariate analysis supported the conclusion that Caribbeans were significantly different from other groups, while whites and Asians were similar. One other difference is worth noting: the great majority of white parents who were being helped by their children were living in a different household, whereas half of the minority care relationships were within the same household. So the fact that so many minority (and especially Asian) people in their sixties lived with their adult children places them in a good position to receive family care if they need it in their seventies or eighties.

CONCLUSIONS

Families have been changing rapidly over the past thirty years in many parts of the world, not least in Britain. The structures that have seemed appropriate in a particular time and place have been influenced by many factors, including:

- economic influences, such as increasing prosperity, wider social security networks and greater availability of housing;

- technical influences, such as contraception and the introduction of labour-saving devices in the home;

- moral influences, such as attitudes to sex, contraception and abortion;

- social and political influences, such as the balance of power between men, women and children.

These changes mean that the family patterns in the white population, which provide the benchmark against which the minorities are compared, cannot be seen to have any natural or universal validity. The patterns adopted in Britain by people of Caribbean and Asian origin may be affected partly by their own heritage and partly by the conditions and conventions they have observed in this country. An additional set of influences and constraints arises from the fact that the migration has occurred within the lifetimes of many of the people concerned, and this determines the age-structure of their population.

While the basic demographics of each of the minority groups are broadly similar (allowing for the earlier migration of the Caribbeans at one extreme and the recent arrival of the Bangladeshis at the other), black and South Asian family structures each diverge strongly from the white pattern, but in opposite directions.

Taking the Caribbeans first, the most striking characteristic is a low emphasis on long-term partnerships, and especially on formal marriage. In every age-group, black men and women were less likely to be in a partnership than their white equivalents, less likely to have formalised a partnership as a marriage and more likely to be separated or divorced (without remarrying). All of these characteristics have, of course, been on the increase in the white population in recent decades; thus Caribbeans may be seen to be ahead of the trend, rather than adopting an exceptional position.

Another feature of Caribbeans is that, among those who had married or lived as married, a high proportion had chosen a white partner: half of men who had been born in Britain, and a third of women.

Caribbean women were just as likely to have children as white women – indeed, there were signs that they tended to start child-bearing at an earlier age. The main difference was that many of them did not marry until after they had children, if at all. Again, this is a growing trend among white women, but remains far more common in the Caribbean community: nearly a third of Caribbean families with children had a never-married mother – more than five times the proportion among whites.

These patterns of child-rearing raise a number of issues, which we open here for discussion without attempting to answer. First, is the pattern imported from the West Indies, or has it developed in this country? It has long been common for young women in many Caribbean islands to have children without marrying the father (Senior 1991). He might retain links with his children in a 'visiting relationship', but the young family typically lived with, and was partly supported by, the woman's parents – or, specifically, by her own mother. It would not be surprising, therefore, if many young women of Caribbean origin adopted the same form of family in Britain.

A counter argument is that the growth in single parenthood may be a post-migration phenomenon, not explicable in terms of island traditions (Dench 1996). In 1974, the second survey reported that only 13 per cent of West Indian households with children contained a single adult (Smith 1977). That might be explained in three ways. First, Smith's household-based definition under-estimated the number of one-parent families, and would not have counted, for example, a matriarchal household of the type said to be common in the West Indies. Second, an economically vulnerable family structure, such as lone parenthood, might be especially scarce during a period of migration – a single mother could hardly abandon her existing support network to

come to Britain unless she left her children behind. Third, in the 1970s most black men had some kind of a job, and most of them married black women. In the 1990s, relatively few young black men had any job, and quite a large proportion of those who did had married white women. That may have re-created Caribbean conditions in which women had children without marrying if no economically reliable partners were available – the same forces at work as have been identified in black American communities (Wilson 1987).

The second point for discussion is the extent to which one-parent families have to claim state benefits in Britain. It will be seen in Chapters 4 and 5 that Caribbean lone parents were significantly more likely to be in work (and therefore to support themselves) than white lone parents; nevertheless, those with a job were in a minority, and most one parent families would have claimed income support, probably for long periods. At the same time, the number of other types of non-pensioner Caribbean household depending on social security was higher than in the white population, so the increase in state dependence associated with lone parenthood was relatively small. A young woman would be just as dependent on social security if she married an unemployed man as if she had children on her own. And Caribbeans were actually less likely to depend on the state than Pakistanis and Bangladeshis, who epitomise traditional family values.

The third issue concerns the social identity of Caribbean children. We have no data which allow us to contribute to the controversial debate about whether it is good or bad for children to be brought up by only one parent. Our point is a different one, concerned with the Caribbean heritage. A large proportion of boys and girls of Caribbean origin do not live with their father, and may not know him well, or at all. Another significant proportion have one white parent and one black one. Some (unidentified in this survey) may live with a white parent and not their black parent. All of these may be perfectly appropriate relationships, but the small number of children directly raised by two black parents – less than a third of the total – suggests that many children will grow up without the opportunity to observe closely the cultural and other characteristics of Caribbean men and women. It leads to questions about how Caribbean ethnicity will be transmitted and adapted from generation to generation, which will be an important focus for further research on ethnic identity in coming years.

Turning now to South Asian families, they were equally different from white norms, but even further from the Caribbean pattern – actually, not so much different from white norms as different from current white practice. If Caribbeans were ahead of the trend, South Asians – and especially Pakistanis and Bangladeshis – were well behind the trend.

First, South Asians were more likely to marry and married earlier than their white equivalents. Few of them lived as married, and separation and divorce were relatively rare.

South Asians were much more likely to have chosen a partner from among their own ethnic group than were Caribbeans. That is not to say, though, that mixed Asian-white relationships are unheard of. One fifth of married Indian and African Asian men who were born in Britain had a white wife. And since more of them had a

wife (compared with their Caribbean counterparts) the total proportion of adults in mixed partnerships is not insignificant in the second generation.

Indian and African Asian women were rather similar to white women in the age at which they had children and in the total number of children in their families. Pakistani and Bangladeshi women, though, started their families earlier, completed them later, and had more children than is now typical in Britain. Pakistani and Bangladeshi families are just as exceptional, in this respect, as the Caribbean families are in their prevalence of single parenthood. In total contrast, however, virtually all South Asian mothers had married, and almost all of them had remained married.

Whereas it is now normal for white people to live separately from their parents as soon as they have families of their own, a relatively high proportion of South Asian couples, including many with children, lived in the same house as the young man's father. The proportion of adults who can live with their parents may be constrained both by the number of their siblings and by the fact that many of the current generation's parents remain in their country of origin. But it is striking that as many as two-thirds of Asian elders living in Britain reside in the same household as (one or more of) their adult children.

These South Asian family patterns also raise three issues for discussion. The first is concerned with the rate of change which has occurred, and can be expected to occur in future. There is some evidence that South Asians have been moving towards white British patterns: Indian and Pakistani households contain fewer children than they did in the early 1980s; South Asians who were born in Britain had slightly smaller families than those born abroad; it will be seen in Chapter 9 that attitudes to marriage were rather less 'traditional' among younger people and those who had been born in Britain. On the other hand, Bangladeshi households contain just as many children as they did before; and there is no sign that the second generation are any slower to marry than those who migrated to this country. The analytical difficulty is that the current population of South Asians includes a wave of new migrants as well as those who were covered by the 1982 survey; and there are still very few second generation adults on which to base a comparison with the newcomers. Both of these are especially true of the Pakistanis and Bangladeshis. So we would not expect a rapid change to be evident at this stage, even though it can be assumed that a degree of convergence will take place over the generations.

The question is of particular importance for Pakistanis and Bangladeshis, whose family structures are more different from white patterns than any other. On the one hand, it can be expected that the increasing numbers of men and women who have been born and educated in Britain will begin to change some of their views on marriage and the family. The first sign of changes of attitude have begun to appear (Modood, Beishon and Virdee 1994), and some will be reported in Chapter 10. On the other hand, the 'old' values are clearly associated with Islamic teachings about relations between men and women and about contraception. Religious affiliations (also discussed in Chapter 9) may, therefore, slow down the rate of change in Pakistani and Bangladeshi families; or the family may, alternatively, be a subject of discord between and within communities.

The second issue for discussion also applies especially to Pakistanis and Bangladeshis. What are the consequences of large family sizes for the welfare of the community, and especially for children? A large proportion of all children in Britain live on Income Support; analysis of households with no earner (in Chapter 5) suggests that the proportion is much higher for Pakistani and Bangladeshi children. Even when their father has a job, his low earnings have to be stretched across many dependents. So, as recorded in Chapter 5, many members of these communities are in poverty. And, as recorded in Chapter 6, many of them live in over-crowded accommodation. British social policy has lost sight of the large family as a focus of concern, but these findings show that the issue remains.

A third issue has a more positive policy implication. There have been very few elderly people of Asian origin in the past, and the provision of appropriate social care has not yet been urgent. We have found, though, that the majority of Asian people over the age of 60 live in the same household as an adult child. Whereas white elderly people move in with their children (if at all) when they need care, the signs are that many their Asian fellows will already be in a family environment when the need for care arises.

British governments have never had an overarching 'family policy', though there are many policies which affect the family. This analysis has demonstrated a diversity of family structures which clearly has important implications for policy, though it is not so clear what those implications are. The underlying question is whether policy should make practical or moral assumptions about what kind of partnering and parenting patterns are 'normal' and/or should be encouraged. It can be seen that any assumptions built into policy will operate unequally on different ethnic groups in a multicultural society.

Qualifications and English Language

Tariq Modood

FLUENCY IN ENGLISH

It is very likely that a large proportion, probably a majority, of Asian migrants had very limited spoken English at the time of migration, and that they acquired it as they settled in Britain. The 1974 and 1982 surveys found that in the judgement of the interviewer about two-thirds of South Asian men and about half of the women (though much less so among Pakistanis and Bangladeshis) spoke English fluently or fairly well (Smith 1977, 337; Brown 1984, 137–38).

In the judgement of the interviewers in this survey, more than three-quarters of the men in each Asian group spoke English fluently or fairly well, the highest proportion being among African Asians (Table 3.1). There was little gender difference among African Asians and the Chinese, though somewhat fewer Indian women than men, and considerably fewer Pakistani and Bangladeshi women (54 and 40 per cent respectively), spoke English well.

Table 3.1 Fluency in English

cell percentages

	Indian	African Asian	Paki-stani	Bangla-deshi	Chinese	Indian	African Asian	Paki-stani	Bangla-deshi	Chinese
		Men					*Women*			
English spoken fluently or fairly well	81	91	78	75	76	70	86	54	40	76
Weighted count	*593*	*436*	*406*	*155*	*185*	*663*	*354*	*382*	*126*	*205*
Unweighted count	*593*	*382*	*569*	*304*	*101*	*651*	*335*	*505*	*280*	*111*
Migrants only, by years in Britain										
Less than 15	69	90	63	84	64	57	74	24	32	62
15–24	75	90	84	85	85	65	83	50	38	74
25 or more	74	92	64	49	55	53	92	46	60	97
Weighted count	*422*	*377*	*285*	*135*	*146*	*393*	*292*	*262*	*112*	*167*
Unweighted count	*449*	*342*	*443*	*279*	*84*	*474*	*296*	*390*	*251*	*106*

As might be expected, the proportion who speak English well increases with the length of settlement in Britain, though two qualifications have to be made. The minor one is that African Asian men have an equally high rate of fluency regardless of length of residence, suggesting a high level of fluency before their arrival in Britain. The more important qualification is that age is a more significant determinant than length of residence. This helps to account for the anomaly in Table 3.1 that, especially among men, those who have been in Britain more than 25 years have no more and often less facility than those who have been in the country for less time.

Table 3.2 shows that facility in English is strongly linked to age as well as to sex. While nearly all the young in several minority groups speak English well, the proportion of 45–64-year-olds who speak English well is around a half. The proportion is much less for Bangladeshi and Pakistani women. In fact, about a half and about a quarter of Pakistani and Bangladeshi 25–44-year-old women respectively were assessed by the interviewers to speak English well. The low level of facility among older Bangladeshi and Pakistani women, and to some extent men, suggests the combined effect of both age and length of residence, namely persons, possibly dependent relatives of settlers, who entered Britain at an advanced age and have been in Britain for relatively few years. For example, only 4 per cent of Bangladeshi women between 45 and 64 years old speak English well; but as 60 per cent of Bangladeshi women who have been in Britain for 25 or more years speak the language well, it means that the large majority of the 45–64-year-olds have been in Britain for less than 25 years. In fact, Table 3.2 also shows that, in both sexes and all groups, but especially among Bangladeshi, Pakistani and Chinese women, those who came to Britain over the age of 25 are the least likely to have a facility in English regardless of their age today.

Table 3.2 Fluency in English, by age

cell percentages

	Indian	Men African Asian	Paki- stani	Bangla- deshi	Chinese	Indian	Women African Asian	Paki- stani	Bangla- deshi	Chinese
English spoken fluently or fairly well										
16–24 year-olds	99	99	96	97	100	96	98	84	80	98
25–44 year-olds	88	94	81	75	82	73	92	47	27	82
45–64 year-olds	68	87	56	54	50	53	71	28	4	47
Weighted count	*544*	*420*	*388*	*149*	*179*	*583*	*332*	*358*	*123*	*186*
Unweighted count	*534*	*360*	*527*	*291*	*98*	*557*	*304*	*472*	*269*	*101*
Those who came to live in Britain over age 25	60	81	42	59	(48)	42	54	20	5	(34)
Weighted count	*172*	*98*	*70*	*38*	*38*	*144*	*70*	*68*	*37*	*51*
Unweighted count	*185*	*103*	*120*	*78*	*24*	*162*	*82*	*99*	*87*	*29*

Ethnic Minorities in Britain

Table 3.3 Fluency in English, by age on migration to UK (base: South Asians not born in UK, excluding African Asians)

cell percentages

	16–24		Age now 25–44		45–64	
	Men	Women	Men	Women	Men	Women
Age on arrival						
Less than 10 years old	97	99	95	91	*	*
11–15 years old	91	71	76	51	(72)	(24)
16–24 years old	(55)	47	75	49	64	43
More than 25 years old	–	–	71	33	59	33
Weighted count	*321*	*344*	*488*	*574*	*315*	*370*
Unweighted count	*313*	*347*	*718*	*807*	*379*	*292*

– = not applicable
* = nil

Table 3.3 confirms that the critical factors determining fluency in English today, more so than age or length of residence, are age on arrival and sex. The point emerges most clearly when African Asians, whose higher rate of fluency in this and earlier surveys suggests that they had a much higher rate of fluency at the time of arrival than other South Asians, are excluded from the analysis.

A further important correlation with facility in English is the extent to which people live among their own ethnic group. Table 3.4 measures the extent of fluency by reference to the percentage of specific ethnic groups in the neighbourhood, the latter being the electoral ward based on the 1991 census figures. There is a clear pattern that those who live with more people from their ethnic group are progressively less likely to speak English fluently or fairly well. The residential density effect, however, does not alter the differential pattern between the South Asian groups: the differences are apparent at each density level and the rate of fluency declines in different degrees. Hence, for example, fluency among African Asians is hardly affected by the proportion of their own group in a neighbourhood; on the other hand, among Bangladeshis, the drop between the first two levels is large. It is interesting, in fact, that the difference in the rate of fluency is largely between the very low densities and the rest, for after about 5 or 10 per cent of own group density the drop in fluency is comparatively small. Hence it is not the case, as one might have expected, that there was a significant difference in the facility in English of a South Asian person if they lived in a neighbourhood in which their ethnic group consisted of about 10 per cent or about 30 per cent of the locality. Higher levels of concentration made relatively little difference.

Several factors, then, have a bearing on fluency in English: sex, age on arrival, and the proportion of one's own ethnic group in one's neighbourhood. Thus it seems to be the case that women of Pakistani and Bangladeshi origin, aged between 45 and 64, who have been resident in the UK less than 25 years and live in communities where more than 10 per cent of residents are from a similar background are the least likely of all ethnic minority groups to be fluent in English.

Table 3.4 Fluency in English, by residential density of one's own ethnic group

cell percentages

	Indian	African Asian	Pakistani	Bangladeshi
Own group density by ward				
Less than 2%	91	93	86	70
2 <5%	81	88	71	54
5 <10%	62	85	59	56
10 <15%	73	85	59	(41)[1]
15 <25%	74	83	54	50
25 < 33%	69	80	56	(51)[1]
33% and over	60	85	51	37
Weighted count	*1256*	*790*	*788*	*281*
Unweighted count	*1244*	*717*	*1074*	*584*

1 Cell size less than 30.

EDUCATIONAL QUALIFICATIONS

Introduction

The PSI survey of the mid-1970s found that Caribbean and Pakistani men were less qualified than their white peers, while Indians and African Asians were best qualified. There was, however, a considerable polarisation among the South Asians. In each ethnic group they were disproportionately highly qualified as well as disproportionately having persons without any qualifications. Moreover, South Asian women, especially the Pakistanis, were much less qualified than the men. West Indian women, however, were as well qualified as West Indian men (Smith 1977, 58 60).

A decade later it was found that this pattern held for those over 44 years old, but, among 25–44-year-olds, whites were better qualified than the ethnic minority people. On the other hand, among the 16–24-year-olds, South Asian men had higher qualifications than whites (Brown 1984, 145–147). In the period between the two surveys, considerable anxiety about the 'underachievement' of pupils of West Indian origin in British schools had surfaced, leading to a Committee of Inquiry led initially by Anthony Rampton and later by Lord Swann. Research carried out on its behalf found that, while South Asians were achieving similar academic examination results to their white peers, West Indians were performing less well (Swann 1985). This finding was repeated in other major studies in that decade (e.g. Smith and Tomlinson 1989; Drew, Gray and Sime 1992; for a detailed review, see Gillborn and Gipps 1996).

Most of the earlier research failed to distinguish between different South Asian groups. An analysis of the Labour Force Survey of the late 1980s which was able to go beyond the 'Asian' category found that, while African Asians and Indians had higher average qualifications than whites, the position of Pakistanis and Bangladeshis was much worse, in fact was the worst of all ethnic groups. For

example, while African Asian and Indian men were half as likely again as whites to have a degree, more than half of the Pakistanis and Bangladeshis had no qualification (Jones 1993, Table 3.4). About the same time, higher education institutions started recording the ethnic origins of applicants and those who were offered places. This data showed that all minority groups except the Bangladeshis were very well represented in the polytechnics (as they were then called), but only the Chinese and Indian/African Asians were so represented in the universities (Modood 1993). Analysis of applicants in 1992 confirmed this pattern, while revealing that Pakistani and Caribbean applicants, but not those from other ethnic minority groups, were less likely than equally qualified white candidates to have gained admission to the 'old'[1] universities (Modood and Shiner 1994).

The 1991 Census too is a source of relevant information, though only about qualifications higher than A-levels. On the basis of a 10 per cent sample of the population, it found that more than a quarter of adult Black Africans (a group not included in our survey) and Chinese were qualified beyond A-levels, which was double that of whites. Indians and African Asians were also relatively more qualified than whites, but the other minority groups were less so, though Pakistani and Bangladeshi men were more likely than Caribbean men to have degrees. Caribbean women were, however, much better qualified than all except the Black African and the Chinese at the level between A-levels and degrees (OPCS 1993, Table 17).

It should be noted that in the analyses offered below no attempt has been made to evaluate any overseas qualifications; they have been included as stated by respondents. This may have the effect of inflating the qualification levels of some ethnic minority people as compared with previous studies, such as the ones quoted above, which tended to interpret overseas qualifications as being less than their nominal British equivalents. Traditionally, British universities have regarded, for example, an Indian MA as the equivalent of a British BA, though such judgements are not uncontroversial and indeed are potentially discriminatory. We do, however, include in some tables the appropriate finding from the 1991 Census in which overseas qualifications have been matched to what is deemed their British standard. This offers, therefore, an alternative evaluation of the higher qualifications. Additionally, and importantly, it offers a check upon the reliability of our sample. In fact, having used British degrees to test our data against the census, our findings are consistent with the Census – except sometimes, as we shall see later, for the youngest age group.

The findings

This survey too found that ethnic minority people taken together were similarly qualified to the white population, but that this was a misleading aggregate effect because some ethnic minority people were extremely well qualified and others much less so. Tables 3.5 and 3.6 present the findings for men and women of working age (for an explanation of how qualifications have been grouped together see Box 3.1). The Chinese, African Asians and Indians are much the best qualified groups in the

1 In 1992 the polytechnics, as they then were, become universities. 'Old' refers to those that were universities before 1992.

populations we studied, though a high proportion of the degrees of older Indians were not of a British standard. Among men, then, come whites, with Caribbeans and Pakistanis being less qualified, and Bangladeshis the least so. Caribbean women, however, were more likely to be qualified than white women, but much less likely to have a degree (though Caribbean together with Chinese women were most likely to have a higher education qualification below degree level). Pakistani and Bangladeshi women were much less qualified than all other women, except that Pakistani women were quite well represented at degree level.

There was, however, one further important difference, namely that in the pursuit of qualifications some groups were more vocationally than academically orientated. The percentages of persons whose highest qualification, being greater than O level but below degree level, was a vocational one is shown in parentheses. It will be seen that this was the case for three-quarters of white men. The only men more vocationally orientated than whites were the Caribbeans, five-sixths of whose higher qualifications were vocational. Only two-thirds of the Chinese men's higher qualifications, however, were vocational, and the proportions for South Asians were lesser still: half of Indian and Pakistani men's and only a third of African Asian and Bangladeshi men's higher qualifications were vocational.

Table 3.5 Highest qualification of men aged 16–64

column percentages

	White	Caribbean	Indian	African Asian	Pakistani	Bangla-deshi	Chinese	All ethnic minorities
None or below O-level	31	44	35	32	48	60	31	40
O-level or equivalent	14	15	16	20	21	20	20	18
A-level to below degree (vocational in parentheses)	44 (33)	35 (29)	25 (12)	29 (10)	20 (11)	10 (3)	22 (15)	26 (16)
Degree	11	6	24	20	11	10	26	15
Degree (1991 Census)[1]	10	4	15[2]	15[2]	8	7	22	11
Weighted count	1049	648	554	423	418	151	179	2374
Unweighted count	943	453	543	364	573	294	99	2326

1 The Census figures are for 18–64-year-olds and overseas qualifications have been interpreted in the light of British standards.
2 The Census figure for Indians and African Asians is a combined one for these two groups.

Table 3.5a Higher vocational qualification of men aged 16–64

	White	Caribbean	South Asian	Chinese	All ethnic minorities
Trade apprenticeship	6	2	0	1	1
ONC or equivalent	12	13	5	7	8
HNC or equivalent	15	13	5	5	7
Weighted count	1049	648	1551	179	2374
Unweighted count	943	453	1774	99	2326

Table 3.6 Highest qualification of women aged 16–59

column percentages

	White	Caribbean	Indian	African Asian	Pakistani	Bangla-deshi	Chinese	All ethnic minorities
None or below O-level	38	34	40	32	60	73	25	41
O-level or equivalent	25	29	21	25	22	17	29	24
A-level to below degree (vocational in parentheses)	29 (15)	34 (25)	19 (8)	27 (6)	11 (4)	7 (2)	30 (12)	24 (12)
Degree	8	3	19	15	7	3	17	11
Degree (1991 Census)[1]	5	3	7[2]	7[2]	3	2	25	6
Weighted count	1181	773	605	337	396	125	188	2424
Unweighted count	1126	585	573	311	525	273	102	2369

1 The Census figures are for 18–59-year-olds and overseas qualifications have been interpreted in the light of British standards.
2 The Census figure for Indians and African Asians is a combined one for these two groups.

Table 3.6a Higher vocational qualification of women aged 16–59

	White	Caribbean	South Asian	Chinese	All ethnic minorities
ONC or equivalent	7	12	4	5	7
HNC or equivalent	3	4	2	0	2
Nursing	3	6	1	7	3
Weighted count	1181	773	1463	188	2424
Unweighted count	1126	585	1682	102	2369

Women's qualifications were generally less tilted towards the vocational, but there was a similar ethnic group pattern. The Caribbeans were again the most vocational (nearly three-quarters), followed by whites (half). In most other groups of women, of those with highest qualifications at this level, it was a vocational qualification for only two-fifths, except for African Asians, for whom it was less than a quarter.

These ethnic differences, especially the greater academic orientation of South Asians compared with whites and especially Caribbeans, are consistent with the detailed studies of young people's post-school choices and the pathways into which they are channelled (Drew 1995; Hagell and Shaw 1996). Tables 3.5a and 3.6a give a breakdown of the vocational qualifications referred to in the earlier tables. For men they consist almost entirely of HNC, ONC or the equivalents of these, and of trade apprenticeships. The latter have over the years disappeared as an option and were found only among older people; they were also the one pathway which was confined almost exclusively to white men, as can be seen in Table 3.5a. The table also shows that the Chinese and especially the South Asians were less than half as likely to have any of these qualifications as white and Caribbean men.

As Table 3.6a shows, women were less likely to possess any of these qualifications, but a significant number of women, except the South Asians, had a nursing qualification as their highest qualification. This was a particularly popular

Box 3.1 Definition of highest qualification

Degree or equivalent	Higher degree, first degree, other degree-level qualification
Higher education below degree level	BTEC, SCOTBTEC, BEC, SCOTBEC, TEC, SCOTEC, SCOTVEC (higher), HNC, HND, teaching qualification at secondary level, teaching qualification at primary level, nursing qualification
GCE A-level or equivalent	BTEC, SCOTBTEC, BEC, SCOTBEC, TEC, SCOTEC, SCOTVEC (national general), ONC, OND, City and Guilds, A level or equivalent, SLC (higher), SCE (higher), SUPE (higher), Certificate of 6th-year studies, trade apprenticeship
GCE O-level or equivalent	O-level or equivalent excluding D and E passes obtained 1975 or later but including CSE grade 1, GCSE grades A-C, SLC (lower), SCE (ordinary), SUPE (lower or ordinary)
CSE (other than grade 1) or equivalent	CSE (other than grade 1), GCE O-level D and E passes obtained in 1975 or later, GCSE D and E passes
Any other professional or vocational qualification	as written
None	No qualification

option for the Chinese and Caribbeans, for whom it was twice as likely as for white women. It was, however, much more likely to be held by older women, especially among the Caribbeans. For example, it was the highest British qualification of more than half the Caribbean women holding a higher qualification who came to Britain over the age of 16 – in fact it was held by more than one in eight of all Caribbean female migrants. Yet only one in 20 of Caribbean women between the ages of 25 and 44 years had a nursing qualification and virtually none below this age did. This is consistent with other studies that have shown that the nursing profession is no longer as attractive to Caribbean women as it used to be (Beishon, Virdee and Hagell 1995).

Given that our findings broadly confirm what other recent sources have been suggesting, it is of some interest to explore the developments that have led to the current situation – in particular, to examine the extent of the qualifications with which migrants came and how those schooled in Britain have fared in comparison with their elders, as well as in comparison with their white peers.

The migrants

Table 3.7 shows that most migrants, that is to say, ethnic minority persons who came to Britain as adults, were without any formal qualifications (though a few in this majority did have a qualification below O-level). Few had an O-level qualification or equivalent, that is to say, a school exam below university entrance level, but over a quarter had a higher level qualification. Within this pattern, however, there were significant group differences.

Table 3.7 **Highest qualification of migrants (base: persons who came to Britain at the age of 16 or older)**

column percentages

	Caribbean	Indian	African Asian	Pakistani	Bangladeshi	Chinese	All ethnic minorities
Highest qualification of those 16 or older on migration							
None or below O-level	71	52	45	63	75	48	58
O-level or equivalent	8	12	21	20	11	9	14
A-level or equivalent or higher	21 (2)	36 (28)	34 (16)	17 (9)	14 (9)	42 (23)	28 (15)
(degrees in parentheses)							
Proportion with higher British qualifications							
Men	17 (3)	11 (5)	23 (8)	7 (2)	8 (7)	29 (18)	15 (6)
Women	29 (1)	2 (–)	12 (1)	1 (–)	1 (–)	34 (9)	11 (1)
(degrees in parentheses)							
Weighted count	*535*	*673*	*397*	*402*	*160*	*215*	*2281*
Unweighted count	*435*	*720*	*407*	*609*	*351*	*131*	*2673*

The Bangladeshis had the fewest qualifications, but were broadly comparable with the Caribbeans and Pakistanis. A difference between these three otherwise similarly qualified groups was that at least half of the higher qualified Bangladeshis and Pakistanis were to a degree level, while nearly all of the higher qualified Caribbeans were below degree level.

The other three groups, the Indians, African Asians and Chinese, also formed a distinct pattern: about half were without qualifications but more than a third had a higher qualification. About half of these higher qualified African Asians and Chinese, and two-thirds of the Indians, had a degree.

Women were likely to be less qualified than men among South Asians, though the opposite was the case with the Caribbeans and Chinese. It was only at degree level that in each ethnic group men were predominant, but by a factor of up to five in the less qualified groups, so that, for example, while 15 per cent of Pakistani and Bangladeshi migrant men had degrees, only 5 and 3 per cent of their female counterparts did so. This gender gap was much narrower among Indians (a third of migrant men and a quarter of migrant women had degrees) and there was virtual parity among African Asians.

There is one further important difference between the migrants of different origins. Naturally, most of the qualifications of the migrants are from their countries of origin. But this is not always the case, especially regarding higher qualifications. While Pakistani, Bangladeshi and Indian migrant women have very few British qualifications, more than half of the higher qualifications below degree level of African Asian women were British. In each South Asian group significant proportions of the higher qualified migrant men had British qualifications: a quarter of Indians, nearly a third of Pakistanis and Bangladeshis, and half of the African Asians. The

proportion was even higher for Chinese migrant men and women, and in the case of the Caribbean migrants nearly all their higher qualifications were British. Most of these qualifications, especially for those over 20 years old at the time of migration, were acquired before their arrival in Britain. Besides the marked gender differences, some of the differences in the proportion of higher qualifications which are British are due to the extent that the places the migrants came from had an educational and qualification system based on Britain's. Thus, for example, the Indian migrants were among the most qualified but had the smallest proportion of those with British qualifications. India achieved independence in 1947 with a relatively developed educational system with its own public examinations and higher education; this expanded rapidly after independence. In contrast, East African countries such as Kenya and Uganda, and the islands of the British West Indies, achieved independence later, and Hong Kong of course has continued to have a British connection. Most of the Caribbean migrants to Britain came, in fact, before their islands were independent countries or had extensive higher education provision; not just the language of instruction but the school and college curricula and public examinations were identical to or modelled on those in Britain during the years of schooling of the migrants (and beyond). To a lesser extent this was also true of East Africa and Hong Kong; even as some schools came to teach in local languages, most of those in urban areas, and certainly the more elite schools and the higher education system, partly staffed by native English speakers, continued to teach in English syllabuses authorised by or derived from British (and perhaps also American) institutions.

The important qualifications divide among migrants then is between the lesser qualified (Bangladeshis, Pakistanis and Caribbeans) and the better qualified (Chinese, African Asians and Indians), but is complicated by gender and British qualifications. While these two latter factors work to reinforce the position of the Chinese and the African Asians as well-qualified migrant groups, they have the opposite effect upon the Indians. Correspondingly, these two factors reinforce the position of Bangladeshis and Pakistanis as poorly qualified migrant groups, but reveal Caribbean migrants to be better qualified than appears from Table 3.7. Gender differences and the possession of British qualifications (and relatedly of facility in spoken and written English) widen the gulf between the best and least qualified migrant groups, while suggesting that the Indians and Caribbeans occupied a more intermediate position than initially appears.

The second generation

What are the qualification levels of the next generation, those who might be called the second generation, those who had at least some, and in the main most or all, of their schooling in Britain? Table 3.8 presents this information in connection with those who were born in Britain or who came to Britain as children. For the sake of comparability with white people the analysis is confined to 25–44 year-olds, so as to exclude the disproportionate white elderly who (like the rest of their generation) are much less qualified than those younger than them. Before we proceed to compare

the minority groups with the majority, we shall first consider the minority groups separately, comparing them with each other and to their migrants' generation.

The comparison between Tables 3.7 and 3.8 is very striking. Taken as a whole the second generation is much more qualified than that of the migrants: those with no or below O-level qualifications have been halved, those with O-level or equivalent qualifications have nearly doubled and those with higher qualifications have grown by more than 50 per cent. This progress is true for most but not all groups, and not evenly so. Looking first at groups who were not very well qualified, the Caribbeans have greatly increased the proportion of qualified people, from 29 to 74 per cent; the Pakistanis, however, have done so only slightly, and the Bangladeshis have the same proportion of qualified as before.

Table 3.8 **Highest qualification of those born in the UK or 15 years old or less at time of migration (base: 25–44-year-olds)**

								column percentages
	White	Caribbean	Indian	African Asian	Pakistani	Bangla- deshi	Chinese	All ethnic minorities
Highest qualification of those born in UK or 15 years old or less on migration								
None or below:								
O-level	30	26	31	24	54	74	[11]	30
O-level or equivalent	22	30	24	17	18	14	[34]	25
A-level or equivalent or higher	49(12)	45(7)	45(15)	59(23)	26(11)	12(4)	[55(27)]	44(12)
(degrees in parentheses)								
Proportion with higher British qualifications								
Men	62(16)	57(8)	54(18)	64(32)	30(12)	11(5)	[64(42)]	35(17)
Women	39(9)	37(8)	35(11)	52(12)	20(10)	12(–)	[42(7)]	29(8)
(degrees in parentheses)								
Weighted count	*1048*	*663*	*292*	*244*	*192*	*33*	*77*	*1501*
Unweighted count	*1051*	*552*	*303*	*219*	*281*	*90*	*39*	*1484*

Figures in square brackets denote degrees and small sample size.

The Caribbeans, of all groups, have in fact made the greatest advance at both the middle and the higher levels, though less so at degree level. As a group, second generation Caribbeans are now among the best represented at A-level or equivalent qualifications and higher education qualifications below degree level, but, along with Bangladeshis, are least qualified at degree level. The Caribbean progress is particularly striking among men, who now are half as likely again as their second generation female peers to have a higher British qualification. These survey findings about the Caribbeans are quite remarkable, indeed anomalous, in the light of the statistical data and community concern over several decades which has strongly suggested a problem of Caribbean, especially male, 'underachievement' in British secondary schools.

The situation of second-generation Pakistanis and especially Bangladeshis, however, is very different. Among the Pakistanis the proportion without

qualifications continues almost at its previous high level, but those with higher qualifications have grown by half. This marks a very significant increase in the possession of higher British qualifications, especially at degree level, and especially for women. While this reflects the tendency among the migrant generation of South Asians of a qualifications polarisation, of having high levels of unqualified and highly qualified at the same time, it is apparent that the new generation has benefited to some extent from participation in the British education system. This, however, does not seem to be the case for the Bangladeshis. An improvement in the proportion of women with higher qualifications (from a very low starting-point) is evident, but overall the position of this age group of British-educated Bangladeshis is extremely worrying. Up to a point it reflects the fact that the Bangladeshis, being among the most recent of the groups of migrants, contain a larger proportion in this age group who were only partly schooled in Britain, but also strongly suggests a failure in the provision of educational opportunities as they affected the Bangladeshis.

Among the three ethnic minority groups who as migrants were relatively well qualified, there has been more definite progress. Like the other South Asian women, Indian and African Asian women have made major strides at the higher qualifications level, though they have not caught up with their male peers. While both these ethnic groups are generally more qualified than the previous generation, the second generation of Indians is considerably less qualified at degree level than the migrants. Second generation Indians are better than average qualified at degree level compared with the rest of British society, but are less qualified at degree level than the migrants. That is to say, the proportion that have British degrees now is smaller than those among the migrants who had Indian degrees.

African Asian migrants were among the best qualified of all groups, and the second generation has more than maintained this position, especially at the higher level. More than half of this generation of African Asians has a higher British qualification, with nearly one in four having a British degree; African Asian women are more likely to have a degree than any other women. The position of the Chinese is, as it was before, similar to that of the African Asians, though the sample size is too small for any detailed comparisons.

Comparing the two generations, then, it is quite clear that there has been remarkable progress in the acquisition of qualifications, and that nearly every group and both men and women have participated in this. This progress, however, confirms the division observed in the migrant generation. There the Pakistanis and Bangladeshis were among the less qualified, and this is still true of the second generation, especially the Bangladeshis. The Chinese and the African Asians were among the more qualified migrants and this too is found in the new generation. The Caribbeans and the Indians were in a more ambiguous situation. The Caribbean migrants were among the less qualified, and least so at degree level, but their higher qualifications were nearly all to a British standard and model, and were possessed by women as well as men. Above all, and underlying the higher proportion of qualifications that were British, was a facility in English and an understanding of British culture. These factors may perhaps explain why the second generation of Caribbeans has made much more progress than their Pakistani and Bangladeshi

peers, and is almost as well qualified as any group except at degree level – at which this, like the previous generation, is among the less qualified.

Those features that made the Caribbean migrants better placed than other less qualified groups had the opposite effect on Indians. They were a well-qualified group, especially at degree level, but much less so in terms of British qualifications, and the women were similar to Pakistanis and Bangladeshis in the proportion that had higher qualifications. Some men and many women had limited English. These differences are perhaps reflected in the fact that the qualifications profile of second-generation Indians is more like their Caribbean rather than their African Asian and Chinese peers – except at the degree level, where Indians continue to be well represented. The two-way division between ethnic groups of migrants has, then, to be amended with a new middling or mixed category, as the second generation of Caribbeans have become more qualified than Indians at all but the degree level, where the initial divide is still apparent. Moreover, the Bangladeshis have become uniquely disadvantaged.

Table 3.8 also allows us to compare the position of the second generation of these minority groups with that of whites. Taken as a whole, second-generation ethnic minority persons are similarly qualified to white British people of their age. This does not, however, apply to each minority group. UK-educated Pakistanis and Bangladeshis have a much higher proportion than whites without qualifications, and many fewer with higher qualifications. All the other ethnic minority people have a lower (or in the case of Indians, the same) proportion without qualifications than whites; and almost or the same proportion with higher qualifications than whites. Bangladeshi, Caribbean and Pakistani men of this generation are less likely to be graduates than white men of their age, but Indian men are more likely and African Asian men are twice as likely. This applies also to female graduates, except that Pakistani women are more likely to have degrees than white women, and the differences between women are within a much narrower range.

The new generation

To take this generational analysis a stage further, let us consider the qualification levels of the youngest people in our survey, the 16–24-year-olds. These are people who are very likely to have been born in Britain, have overwhelmingly been educated in British schools, and in some cases are children of persons educated in Britain; the ethnic minority members are, as it were, a composite of the youngest of the second generation and the eldest of the next generation.

Nearly a quarter of this age group were still in full-time education, and some of those who were not may have been studying for qualifications on a part-time basis or may study for qualifications at a later stage. Hence, in looking at the levels of their qualifications we have to appreciate that many will not yet have achieved their ultimate highest qualification. This means that the data necessarily understate the ultimate highest qualifications of members of this age group, so that in comparing them with their elders one is not necessarily comparing like with like, especially for example in comparing the relative proportions who have degrees – more than half

the 16–24-year-old sample being of an age that they could not have acquired a degree.

There is one further complication which affects not just comparisons across age-groups but within the 16–24 age group itself. We shall shortly see that ethnic minority, especially South Asian, participation in post-compulsory full-time education is much higher than that of whites; moreover, ethnic minority persons on average acquire some of their qualifications at a later age than whites. The effect of these two factors is that, in the analysis below, ethnic minority qualification levels, especially those of South Asians, are disproportionately understated. One way of avoiding this would have been to exclude from the analysis those who were still in full-time education, but this would have affected the viability of the sample size, and could have risked distorting the sample in other ways.

Table 3.9 shows that far fewer 16–24-year-olds were without any qualifications compared with their elders, though at this age fewer had degrees yet. This is true for all groups, not least for the Pakistanis and Bangladeshis. The latter continued to be the groups with the largest proportions of those without qualifications, but the proportions were a third or more less what they were for the 25–44-year-olds.

Table 3.9 Highest qualification held by 16–24-year-old men and women

column percentages

	White	Caribbean	Indian	African Asian	Pakistani	Bangla-deshi	Chinese	All ethnic minorities
None or below O-level[1]								
Men	22	31	27	22	44	42	[17]	32
Women	26	18	21	17	40	52	[10]	25
O-level or equivalent[1]								
Men	33	31	27	27	22	38	[40]	29
Women	31	30	24	31	31	29	[49]	30
A-level or equivalent or higher (degrees in parentheses)								
Men	46 (6)	38 (5)	46(12)	50 (9)	34 (4)	19 (2)	[44 (5)]	39 (6)
Women	43 (3)	53 (2)	54(13)	51 (17)	31 (10)	19 (5)	[41 (6)]	45 (9)
Degree (1991 Census, 18–24-year olds)								
Men	5	2	7[2]	7[2]	4	3	[13]	5
Women	4	2	5	5	2	1	[12]	4
Weighted count								
Men	*207*	*152*	*132*	*88*	*132*	*51*	*44*	*599*
Women	*196*	*164*	*166*	*63*	*130*	*42*	*51*	*617*
Unweighted count								
Men	*148*	*71*	*93*	*56*	*141*	*75*	*19*	*455*
Women	*165*	*90*	*115*	*42*	*144*	*81*	*21*	*493*

1 O-levels were replaced by GCSEs in 1988.
2 The Census figure for Indians and African Asians is a combined one for these two groups.
Figures in square brackets denote small sample size.

It seems, however, that the overall position of young Caribbean men was not better than that of their elders, and the gender gap, of which there was a hint among the migrants but which was reversed among the second generation, has reopened among the youngest. It consisted primarily of the fact that three-quarters more Caribbean men than women were without qualifications, and that more than half as many more Caribbean women than men had higher qualifications below degree level. Yet, it is possible to exaggerate the gender contrast among this age group of Caribbeans. Three points need to be borne in mind. Firstly, while Caribbean women of this age group were more likely to be qualified than men, there was no difference at the middle level, and at the very highest level, that of degrees, the men were more than twice as likely as women to have degrees – and in this survey (though not in the Census), in fact, were relatively well represented among graduates compared with men of other groups. Admission figures for polytechnics in 1990 and 1991 show that Caribbean women were 50 per cent more likely than Caribbean men to be entering those higher education institutions (Modood 1993, Table 1), so that it may be that the gender ratio at degree level is changing. Secondly, the overall position of 16–24-year-old Caribbean men was by no means the worst among men; it was worse than that of whites or Indians but better than that of the Pakistanis, and especially the Bangladeshis. Thirdly, it is not so much that the qualification levels of Caribbean men have deteriorated as that the position of Caribbean women has considerably improved – not just relative to Caribbean men, but relative to everybody – except in respect of degrees (though it may be that even here dramatic improvement is in the pipeline).

Indian men remain somewhat internally polarised, being more likely than whites to be without qualifications, but the most likely to have degrees. Otherwise, the position of Indians, African Asians and Chinese is comparable to that of whites except at degree level, where the position of these minorities, especially among women, is distinctly better. Though in this age group, as in others, Pakistani and Bangladeshi women continued to be least qualified among both sexes, the Bangladeshis and, especially, Pakistani women were well represented at degree level. Indeed, it is most striking that, except for the Caribbeans, ethnic minority women were much better represented at degree level than white women – in fact better than white men too. Hardly any of these degrees were from overseas, except that a quarter of the highest qualifications of the young Indian graduate men and women consisted of an overseas degree.

It is necessary to state a word of caution about the progress of ethnic minority women. There are some important differences between our findings and that of the Census, which shows the number of 18–24-year-olds who were graduates in 1991. In the Census, for each sex, the proportion of white graduates is about twice that of Caribbeans, and the proportion of Chinese graduates is twice that of African Asians, whereas, as we have seen, we found a rough parity between these proportions. Moreover, the proportion of Pakistani and Bangladeshi male graduates was twice or thrice that of Pakistani and Bangladeshi women in the Census, while the reverse was true in our sample. It is quite possible, then, that our survey sample of young ethnic minority women has an over-representation of graduates. Naturally, a suspicion of over-representation in part of the sample has a possible implication for the total

sample, and it is therefore worth reminding the reader that our findings about the proportions of graduates in each group as a whole were remarkably consistent with the Census (see also Owen, Mortimore and Phoenix 1997).

It should also be borne in mind that the analysis here, as in the rest of this chapter, uses very broad categories and does not tell us about the comparative value of qualifications within a category. For example, it does not tell us how many GCSEs or A-levels a person may have, or the class of their degree. Evidence from other sources, however, does suggest that the ethnic minorities compared with white people currently have on average lower A-level grades, disproportionately have degrees from less prestigious universities and have a lower class of degree (Modood and Shiner 1994; Shiner and Newburn 1995; HESA 1996). Another example of how more refined criteria reveal disparities missed by less refined criteria is of a national study which found that, while whites, Asians and Caribbeans were just as likely as each other to have O-levels, Caribbeans were much less likely than the others to have 5 or more O-levels (Drew 1995, 76).

In any case, even within the limits of the terms of comparison employed here, there remain points of concern in the situation of some ethnic minority people. Bangladeshi and Pakistani young women, especially the latter, were considerably less qualified than average, and four out of ten Pakistanis and half of Bangladeshis had no qualifications. Twice as many Pakistani and Bangladeshi young men as whites were without qualifications, and Caribbeans too were disproportionately without qualifications. The situation of young Caribbean men particularly merits further investigation, not only because of earlier concerns about 'underachievement' (which are not confirmed for 25–44-year-olds by our survey), but because the general trend towards improved qualification levels may be faltering in their case.

The general situation, then, seems to be that the qualification levels of the youngest generation are partly a result of the different levels of groups at the time of migration, but there are at least two other striking processes. One is the strong educational drive found in the ethnic minorities over several generations, which seems to be additional to the general rise in attainment levels in the country. Secondly, there is the special progress of women. While this is not a phenomenon uniquely related to ethnicity, for the closing of the gender gap is evident among whites, it applies particularly to the ethnic minority people – either because at the time of migration the gender gap among some was greater than that for whites of the same age group, or because in some ethnic minority groups women seem to be becoming better qualified than men; or both, as in the case of Indian women.

Actually, the generational analysis presented here significantly understates the extent of ethnic minority commitment to acquiring educational qualifications and the progress some groups are making. For while the tables displaying qualification levels of the older people have some degree of finality about them, because very few of the older people are likely to improve on their existing highest qualification, this is not true of the 16–24-year-olds. To appreciate what the final qualifications level of that generation will be we have to consider not only the qualifications achieved, but also the extent to which people are still studying. It is here that the true extent of the ethnic minority drive for qualifications is revealed.

PARTICIPATION IN POST-COMPULSORY EDUCATION

Perhaps the single most powerful measure of ethnic minorities' drive for qualifications is the proportion of those who choose to remain in or return to full-time higher education after the age of compulsion (Table 3.10). The staying-on rates for 16–19-year-old whites, Caribbeans and Pakistani/Bangladeshi women were similar (just under half the age group for men, over half for women), but higher for Indian/African Asian women, and much higher for South Asian men. The proportions drop considerably among 20–24-year-olds, but they drop most for whites, who had a lower participation rate in this age group than the Caribbeans (Caribbean men being two and a half times as likely to be in full-time education at this age as white men). South Asians were most likely to be continuing in education, and in reverse to whites, men more so than women, though Indian and African Asian women were twice and Pakistani and Bangladeshi women one and a half times as likely to be in full-time study in their early twenties as were white women. No ethnic minority group had a lower participation rate in post-16 education than white people, and some had a much higher rate. The table also suggests that people from ethnic minorities in general are also staying on for longer periods.

Table 3.10 Participation in full-time education, 16–24-year-olds

				cell percentages
	White	Caribbean	Indian/ African Asian	Pakistani/ Bangladeshi
16–19-year-olds in full-time education				
Men	43	46	81	71
Women	56	57	66	54
20–24-year-olds in full-time education				
Men	7	18	38	31
Women	12	18	25	19
Weighted count	*403*	*318*	*456*	*360*
Unweighted count	*313*	*162*	*311*	*447*

Looking at participation by qualification levels shows where the real difference between whites and ethnic minority people is. The proportion of this age group who had not achieved a GCSE or equivalent but were still in full-time education was a quarter for whites and a fifth for the ethnic minority people collectively. It is when we look at those with a GCSE or higher qualification who were continuing in (or had returned to) full-time education that we see a degree of minority commitment quite different from that of whites. Table 3.11 shows that, while among the qualified 16–24-year-old whites, about a quarter were likely to be in full-time education (more for women, less for men), nearly half of the ethnic minority women and well over half of the men were. The commitment to education is manifest in groups that were not particularly well qualified at the time of migration: qualified Caribbeans of both sexes in this cohort were considerably more likely to be in full-time education than their white peers, and the qualified Pakistanis and Bangladeshis had the highest participation rate for each sex.

Table 3.11 Proportion of qualified persons 16–24 years old in full-time education

cell percentages

	White	Caribbean	Indian/ African Asian	Pakistani/ Bangladeshi	All ethnic minorities
Has O-level or higher and is in full-time education					
Men	21	34	63	71	58
Women	28	40	47	48	46
Weighted count					
Men	*163*	*105*	*166*	*105*	*413*
Women	*145*	*137*	*187*	*101*	*471*
Unweighted count					
Men	*116*	*48*	*110*	*119*	*293*
Women	*119*	*73*	*124*	*119*	*334*

Children of parents with higher qualifications are normally more likely to pursue higher qualifications themselves, and so, given what we have seen of the migrant generation's qualifications, the higher staying on rates among some groups is perhaps to be expected. To this might be added the motivational drive for self-improvement that migrants typically have for themselves and their children. Moreover, the presence of high rates of youth unemployment, especially among those without qualifications, and the knowledge that ethnic minorities suffer much higher rates of unemployment, may be thought to add to the explanation of why the ethnic minorities have high staying-on rates. Operative against these factors may perhaps only be the negative experience of schooling encountered by some pupils, especially of working-class origin, and by some groups of ethnic minority people, especially Caribbean males (Mac an Ghaill 1988). A symptom of the latter, for example, is evident in the very high rates of exclusion experienced by Caribbean boys (Gillborn and Gipps 1996, 50–53). The evidence is, however, that the ethnic minority youngsters who do or who are allowed to stay on do so for positive reasons. A study of 16-year-olds in six inner city areas also found that minority ethnic individuals were more likely to stay on than whites; of those that stayed on, half wanted to go to university eventually, while less than a fifth gave as one of their reasons for staying on that it was better than being unemployed (Hagell and Shaw 1996, 88). Further analysis of that survey shows that Asians were no more likely than whites, and Caribbeans little more likely, to say that they stayed on in education because it was better than being unemployed. On the other hand, ethnic minorities were much more likely than whites to say that they wanted to improve their educational qualifications or go to university. The knowledge that qualifications are necessary for getting a (desirable) job may well motivate ethnic minorities more than whites, but it seems to do so positively rather than negatively.

Higher participation rates do not in themselves mean high levels of qualifications and better career prospects. Some of the high level of minority participation in post-compulsory full-time education is likely to be a reflection of the fact that whites, especially white men, are more likely to be in work, and to be pursuing their further education and training while in work, possibly in an apprenticeship or through part-

time participation in education (Drew, Gray and Sime 1992; Drew 1995; Hagell and Shaw 1996). A further reason why ethnic minorities are more likely than whites to be in full-time education is that ethnic minorities may on average take longer to achieve their qualifications, or may be more likely to be 'returners' to full-time education. This interpretation seems to be supported by Table 3.12. It shows the age at which an A-level or equivalent in the previous decade was acquired. It is quite clear that ethnic minorities were less likely to gain that qualification at age 18 or under, were twice as likely as whites to acquire it at age 19, and were more likely to acquire it as a returner or mature student. Some of the lateness in attainment may be owing to taking 're-sits' to improve grades or the number of passes, for there is evidence that ethnic minorities have been more likely to obtain their qualifications in more than one sitting. A special relevance of these differences is where, for example, in university entrance selection, qualifications obtained in more than one sitting are valued less than those obtained in one sitting, this may be to the detriment of ethnic minorities and may perhaps be discriminatory (Modood and Shiner 1994, 29). These two factors, less likelihood of selection for work-based part-time education or training, and late attainment, are, however, unlikely to explain in full the very high levels of ethnic minority participation in post-16 full-time education, especially as there is evidence from this survey that the lateness in attainment may well have been a generational phenomenon and is now disappearing.

Table 3.12 Age at which A-levels were obtained (base: 20–29-year-olds)

column percentages

	White	Caribbean	Indian/ African Asian	Pakistani/ Bangladeshi	All ethnic minorities
Obtained an A-level at age					
18 or under	80	(67)	73	66	70
19	8	(15)	13	15	15
20 or over	12	(17)	14	20	16
Weighted count	*107*	*58*	*159*	*60*	*305*
Unweighted count	*94*	*35*	*113*	*56*	*215*

Figures in parentheses denote small sample sizes.

Table 3.13 shows that, among 16–24-year-olds, some ethnic minority groups are now just as likely to obtain all or most of their O-levels at 16 or under than whites. In fact, for most groups there was no real difference between this age cohort and the older cohort of 25–34-year-olds. The one exception were the Caribbeans; only 56 per cent of the older group with O-levels or equivalent acquired most of them at 16 or under, compared with 86 per cent of the younger group, the same rate as their white peers. For other groups, the improvement among younger people was relatively slight, and in fact, except for the Indians, there is little difference between whites and most minority groups in the age at which GCSEs are achieved. Why only seven in ten Indians should attain these qualifications by or at age 16, compared with eight in ten or better for all other groups, is not at all clear except that it was the case that 16–24-year-old Indians without qualifications were more likely than any other group

(twice as likely as Pakistanis; four times as likely as Bangladeshis) to be in full-time education. Their slower rate of attainment is therefore an indication of their higher level of participation and persistence and, therefore, of a movement away from the qualifications-polarisation of older Indians, which continues to be a characteristic of the Pakistanis.

Table 3.13 Age at which O-levels were obtained (base: 16–24-year-olds)

column percentages

	White	Caribbean	Indian	African Asian	Pakistani/ Bangladeshi	All ethnic minorities
Obtained all or most of O-levels or equivalents at age						
16 or under	86	86	72	88	79	80
17	13	12	22	6	14	15
18 or over	1	1	6	7	8	5
Weighted count	*254*	*201*	*198*	*95*	*162*	*728*
Unweighted count	*191*	*101*	*136*	*53*	*178*	*498*

The evidence that at least some minority groups were strongly committed to higher education has in fact been around for some time (Vellins 1982; Ballard and Vellins 1985). Researchers in the field of race relations have been slow to recognise this and to consider the issues of racial equality in relation to entry into higher education. The topic was opened up only after an institution was found guilty of practising systematic discrimination (CRE 1988). An investigation by the Commission for Racial Equality led to the setting up of a system whereby data on all applications and offers are collected by ethnicity. It is now quite clear that most minority groups are over-represented in higher education. This can be seen in Table 3.14, from the Higher Education Statistics Agency (HESA), which presents the figures of first-year university students in the year 1994–5 by age group, with a comparison of the proportion in the age group in the population. It shows, for example, that twice the proportion of 18–27-year-old Indians entered university as whites. It shows also that the over-representation of black students is considerable, but only among those aged 21 years or more. HESA has linked this to the fact that black students form a larger percentage among part-timers than among full-timers, for part-time students tend to come from the older age groups (HESA 1995, 26). It is likely that the ethnic minority over-representation is found mainly in the less prestigious institutions, for this was the conclusion of a previous analysis (Modood and Shiner 1994). Furthermore, analysis of the 1992 data showed that, even after taking academic and social class related factors into account, significant ethnic differences in the rates of admission remain unexplained. The most worrying of these was that Caribbean and Pakistani applicants were less likely than other candidates to gain admission to the 'old' universities (Modood and Shiner 1994). Moreover, now that ethnic minorities are seen to be a significant component in higher education (there are even some institutions where whites are no longer a majority among the student population), there are wider issues about equal opportunities, pedagogy and the multicultural

Table 3.14 Domiciled first-year full-time and part-time students, by age group, 1994–5 (proportion of age group from 1991 Census figures given in parentheses)

column percentages

Ethnic group	18–20 years		21–27 years		28–37 years		38–47 years		48 years and over	
White	87.8	(97.2)	83.5	(93.1)	86.4	(93.1)	91.8	(94.8)	93.1	(97.3)
Black[1]	1.7	(1.8)	5.8	(2.1)	7.7	(2.5)	3.7	(1.2)	2.8	(0.9)
Indian[2]	4.5	(2.0)	3.6	(1.8)	1.4	(1.8)	0.9	(1.8)	1.1	(0.8)
Pakistani	2.0	(1.4)	2.4	(1.1)	0.6	(0.8)	0.4	(0.7)	0.3	(0.3)
Other groups	4.0	(2.1)	4.6	(1.8)	3.9	(1.8)	3.3	(1.5)	2.7	(0.6)

1 'Black' includes Black Africans as well as Caribbeans.
2 'Indian' includes African-Asians.

Source: Higher Education Statistics Agency.

responsibilities of a university (Cohen 1995). To date, research on ethnicity and educational attainment has concentrated on schools (Gillborn and Gipps 1996), but it is time for researchers to give more attention to further and higher education (Modood and Acland 1997).

Conclusions

The ethnic minorities manifest a radical diversity, indeed extreme contrasts, in their educational attainment levels. On the one hand, some groups have significant proportions of people who cannot speak English, while others have higher qualification levels than white people; indeed, these extremes sometimes exist in the same ethnic groups.

Fluency in English

More than three-quarters of the men in each Asian group were assessed by the interviewer to speak English fluently or fairly well, the highest proportion being among African Asians. There was little gender difference among African Asians and the Chinese, though somewhat fewer Indian women than men, and considerably fewer Pakistani and Bangladeshi women spoke English well.

Age and length of residence were relevant factors, though most critical was age at the time of migration: those who came to Britain after the age of 25 were least likely to have a facility in English regardless of their age today.

Qualifications

Among people of working age, the Chinese, African Asians and Indians were much the best qualified groups. Among men, then came whites, with Caribbeans and Pakistanis being less qualified, and Bangladeshis the least so. Caribbean women, however, were more likely to be qualified than white women.

A further difference between ethnic groups was the extent to which a person's highest qualification was academic or vocational. The qualifications of the Caribbeans were the most vocational, those of the African Asians least so, with the other South Asians being closer to the African Asians, and whites closer to the Caribbeans.

The situation today is a product of the different starting-points of different groups, of different experiences in the educational system, but also of an ethnic minority educational drive. This can be seen by looking at the progress made between the migrants' generation and young adults today.

The migrants

Most migrants were without qualifications but fell into two groupings. The Caribbeans, Pakistanis and Bangladeshis were poorly qualified; but more than a third of Indians, African Asians and Chinese had a higher qualification. This divide was modified by two further factors: the proportion of the qualifications which were British, and the distribution of qualifications between men and women.

Among South Asians, women were likely to be less qualified than men, while the opposite was the case for the Caribbeans and Chinese. Among the higher qualified, South Asians had mainly overseas qualifications, but the Caribbean and Chinese had mainly British ones. In each respect, what was true of South Asians was least true of African Asians.

The net effect of these two factors was to widen the gulf between the best and least qualified migrant groups, while placing the Indians and Caribbeans into a more intermediate position than initially appears.

The second generation

In most groups the second generation (25–44-year-olds who were born in Britain or came as children) had made significant progress. Of all groups, the Caribbeans, especially the men, made the greatest advance at both the middle and higher levels, though less so at degree level. The Pakistanis, by contrast, especially the women, made some progress at degree level, but the proportion without a qualification continued almost at its previous high level. The Bangladeshis had not made any progress.

Indian and African Asian women had significantly narrowed the gender gap at the higher level, and African Asian women were more likely to have a degree than other women of their age. The men from these groups continued to be more likely to have degrees than white men, though Indians were still a polarised group.

The new generation

Far fewer 16–24-year-olds in all ethnic groups were without a qualification than the older generations. Pakistanis and Bangladeshis continue to be the groups with the largest proportions of those without qualifications. The overall position of young Caribbean men is not better than that of their elders, with twice as many men as women without qualifications. The position of Indians, African Asians and Chinese was comparable with that of whites except at degree level, where the position of

those minorities is distinctly better. Ethnic minority women have made particular progress and were, except for the Caribbeans, better represented than white women at degree level.

The points of concern are that Bangladeshi and Pakistani young women were considerably less qualified than the average, and Pakistani, Bangladeshi and Caribbean young men were disproportionately without qualifications.

Participation in post-compulsory education

The full extent of the ethnic minority drive for qualifications is revealed when we consider the rate of participation in post-compulsory education. The participation rates for 16–19-year-old whites, Caribbeans and Pakistani/Bangladeshi women were similar (just under half for men, over half for women), but higher for Indian/African Asian women, and much higher for South Asian men. Among 20–24-year-olds, whites had the lowest, and South Asians the highest rates of participation. Among the qualified, about twice as many ethnic minority as white persons were likely to be continuing in education.

Part of the explanation for the higher participation rates of the ethnic minority people is that they acquire academic qualifications at a later age, but this seems to be declining. The higher participation rate is found at universities, but a separate study has found the Caribbean and Pakistani applicants were less likely than other candidates to gain admission to the 'old' universities.

Qualifications at a higher or any other level are often sought for the improvement in life-chances and employment prospects that they are perceived to offer, especially in a society which strives to be 'meritocratic', a society open to the talents of all regardless of their background, and an economy dominated by advanced technologies and sophisticated skills. It is therefore to the field of employment that we now turn.

Employment[*]

Tariq Modood

INTRODUCTION

The post-war migration to Britain from the Caribbean and the Asian subcontinent, while based upon imperial ties, was very much driven by economic imperatives. The rebuilding of the war-shattered economy created a demand for labour that could not be satisfied by the British population alone. The demand was particularly acute in the National Health Service, in public transport and in many sectors of manufacturing; qualified and unqualified labour, especially young single men, were invited from the Caribbean and the subcontinent to fill the vacancies. Early studies of these migrants in the British economy show that, regardless of their social origins and qualification levels, Caribbean and Asian people were confined very largely to low-paid manual work. Racial discrimination in recruitment was widespread, even after being outlawed (Daniel 1968; Smith 1977).

The predecessor to our survey, undertaken in 1982, found that, while some progress in relative job levels and earnings among these non-white groups had occurred, they were suffering disproportionately from high levels of unemployment, despite some groups participating in the burgeoning self-employment (Brown 1984). Moreover, racial discrimination in the labour market seemed as prevalent if not as overt as before (Brown and Gay 1985). The Labour Force Surveys of the late 1980s (Jones 1993) and the 1991 Census (Ballard and Kalra 1994) confirmed the trends of the early 1980s: the minorities were upwardly mobile and expanding in self-employment, but had much higher levels of unemployment than whites. It was abundantly clear, however, that each of these conditions applied to some rather than all Caribbean and Asian ethnic groups. Economic differences between migrants have become more pronounced and better substantiated by statistical data than was the case at the time of the last survey.

Yet the central thrust within the sociology of race has been to argue against claiming that too much has changed:

Very few writers on race would dispute the facts of racial disadvantage, particularly in relation to economic disadvantage. The data on employment show migrants, particularly Black migrants, as well as the Black British population, to be at the bottom of the occupational and income scale. Despite a number of differences between various groups, such as Asians and African-Caribbeans and between men and

* We would like to thank Pam Meadows, Director of the Policy Studies Institute, for her assistance with this chapter.

women, there exists none the less a class distribution effect. (Anthias and Yuval-Davis 1992, 62).

There has been increasing emphasis on indirect forms of discrimination, and it has been argued that the processes of racial discrimination in employment have become so routine and subtle as to be 'invisible' even to those engaged in discriminating practices (Wrench and Solomos 1993, 159). Others, however, have denied that non-white people could any longer be analysed as a unitary class (Miles 1987). This opens the way for new plural analyses of race, and linkages between race and other bases of discrimination, such as gender (Anthias and Yuval-Davis 1992; Bhavnani 1994), and culture and religion (Modood 1992) have been offered to explain facets of the new ethnic diversity.

In a related way it has been argued that racial exclusion in British society works in a different way regarding Caribbeans and South Asians (Cross 1989 and 1994). Alternatively, and in a more radical vein, it has recently been argued that the British economy is more open and meritocratic than analysts sometimes assume, and that 'race' is of declining salience in explaining opportunities and outcomes in employment (Iganski and Payne 1996). In contrast, work has been done to show that despite a long-term trend in the reduction of differences in job-levels achieved, there is a more or less constant 'ethnic penalty' paid by non-white people measured in terms of the jobs that similarly qualified people achieve (Heath and McMahon 1995). That is to say, ethnic minorities may be getting better jobs, but they are still doing so to a lesser extent than white people with the same qualifications. This sort of analysis, however, also reveals considerable diversity between minority groups, with some having a rate of success closer to whites than to other non-whites.

This chapter will present the findings on employment. The length and complexity of the presentation are based on the belief that employment is at the centre of the issues of life-chances and equality, and also that the nature of the findings is not susceptible to simple black–white analyses, for the differences between the various minority groups are as important for analysis as the points of commonality. The long presentation is followed by a discussion of the implications for ideas such as racial disadvantage, ethnic penalty and differential racisms. In the 1970s and 1980s theorists sought to explain racial inequality; this survey makes clear that what needs to be explained are racial inequality and ethnic diversity. For insofar as there is a fundamental divide in employment by ethnicity, it is not a black–white divide, but a divide between whites, Chinese and African Asians on the one hand, and Bangladeshis and Pakistanis on the other, with Indians and Caribbeans in perhaps an intermediate position.

ECONOMIC ACTIVITY

We begin with an examination of the extent of economic participation and the reasons for economic inactivity.

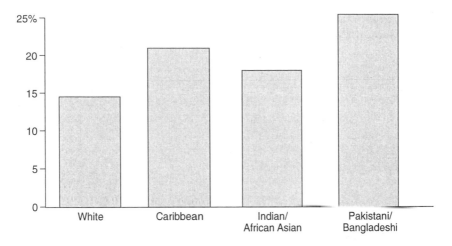

Figure 4.1 Disability and retirement among men

Men

Most men in all ethnic groups were in the labour market (either in work, or looking for work). The main reasons given by men for being economically inactive were disability and retirement. Over the last 20 years inactivity rates for men over 50 have been growing both in Britain and in other industrial countries. However, in Britain ethnic minority men have been affected more than whites. The proportion out of the labour force rose from about one in ten in their late forties or early fifties, to four in ten in their early sixties; for white men, it was similarly one in ten in their early fifties but only three in ten in their early sixties.

On the assumption that some of this male inactivity was not 'normal', we divided men who said they had retired into two groups. If they had worked in non-manual occupations, and if they were between 60 and 64, it was assumed that their retirement was based on a pension scheme that allowed or encouraged people to leave work at 60. These people are deemed to have retired in the normal way. But if they were less than 60 or if their occupation had been in manual work, they were assigned to a group labelled 'pre-retired'. This is a group of people who are likely to prefer to be in work if suitable opportunities were available. The inactivity rates quoted above exclude the normal retirements.

Figure 4.1 shows that Caribbean and Pakistani/Bangladeshi men were considerably more likely to have left the labour force for these reasons in middle age than white men. These were also the groups which suffered relatively high rates of unemployment in middle age. Schmitt and Wadsworth (1995) have found a geographical correlation between inactivity and unemployment. This survey supports the view that disability and pre-retirement are associated with labour market disadvantage as well as ill-health.

Women

Among women aged under 60 who were not in full-time education, there was a much wider range of economic activities both between ethnic groups and within each group (Table 4.1). This is not surprising, since both cultural and economic factors lead women to assume a wider range of roles than men in all ethnic groups. Thus, over 80 per cent of Bangladeshi women were looking after the home or family, as were 70 per cent of Pakistani women. Around a quarter of white, Chinese and African Asian women were in this position, a third of Indians but only 13 per cent of Caribbeans. In addition, for all ethnic groups, a very small proportion were inactive on the grounds of disability or retirement.

Half, or nearly half, of Caribbean, Chinese and African Asian women were in full time work. At the other extreme, only 15 per cent of Pakistani women were in full-time work, and the numbers of Bangladeshi women were too small to be reliable. A quarter of white and Chinese women, but hardly any Pakistanis and Bangladeshis, were in part time work (less than 30 hours per week). Given the importance of part-time work for women in the British economy (Hakim 1993), it is striking that all the minority groups had a much higher ratio of full-timers to part-timers than did white women: 3 to 1 for Caribbeans, 2.5 to 1 for South Asians (taken together), 2 to 1 for Chinese, but less than 1.5 to 1 for whites. Part of the explanation for this is likely to lie in the different age structures of the different groups: part-time workers tend to be older than full-timers, and the minority populations tend to be younger than the whites, but the decision to participate depends both on the alternatives and on the returns to working, and both may vary between groups.

Not surprisingly, the balance between women's employment and home-making was strongly influenced by the structure of their families: whether they were married (or living as married) and whether they had children of school age or younger. Chapter 2 showed some major differences in family formation: Caribbean women were less likely to be married, and more likely to be raising children in one-parent families, than white women; among Asians, most women were married and many – especially Pakistanis and Bangladeshis – had above average numbers of children. However, the relationship between family structure and employment also varied between groups. The white sample showed the familiar pattern, with economic activity highest among non-married women (including those who were widowed, separated and divorced) without children, and lowest among married women with pre-school children.

Table 4.1 Economic activity of women

16–59-year-olds, not in full-time education	White	Caribbean	Indian	African Asian	Pakistani	Bangladeshi	Chinese
Working full time	37	50	38	45	15	6	47
Working part time	27	16	15	19	5	1	24
Looking for work	6	16	8	6	8	8	2
House or family	27	13	36	26	70	81	26
Disabled/retired	4	5	4	3	4	4	2
Weighted count	*1091*	*666*	*517*	*299*	*340*	*105*	*147*

The other groups all reflected this pattern, but Caribbean women were consistently more likely to work, and more likely to work full time, than white women. This was especially noticeable among Caribbean women with both a partner and children – about half of them worked full time, even if their youngest child was under five. At the other end of the spectrum, as we have already seen, Pakistani and Bangladeshi women consistently showed the lowest levels of participation in the labour market. This was especially true of those with children (of any age): only about one in eight were economically active. These patterns hold after standardising for age, education, marital status and standard of English. Indian and African Asian women, however, were remarkably similar to white women, except that more of the married women with children had full-time jobs. This clearly illustrates the inappropriateness of talking about low levels of economic activity among 'Asian' women as a single group: it is Pakistani and Bangladeshi women to whom this applies.

The low level of economic activity of Pakistani and Bangladeshi women is partly a feature of Asian Muslims. The small number of Muslim women from Indian or African Asian backgrounds were much less likely to have jobs than Hindu, Sikh, Christian or non-religious women from India or East Africa; on the other hand, the Muslim Indians were more likely to enter the labour market than Pakistani or Bangladeshi women.

While the cultural norms of Pakistanis and Bangladeshis may have been a factor (for contrasts between Asian men's views about women working outside the home, see Metcalf, Modood and Virdee 1996, 37 41), other factors too are likely to be relevant. One is the interrelationship between the economic position of husbands and wives. It is well established that the wives of unemployed men have lower activity rates than the wives of men who have jobs. One of the key explanations for this is the operation of a household means test by the social security benefit system. This means that, after a small disregard, the earnings of a woman married to (or cohabiting with) a man claiming Income Support, are deducted from the household benefit entitlement. It is possible that part of the explanation of the low activity rates of Pakistani and Bangladeshi women may be the exceptionally high unemployment rates of their male counterparts which are outlined below. This is much less apparent for the Indians and African Asians.

Another contribution to women's participation was their education and knowledge of English. Table 4.2 combines these two factors, to compare, at one end of the scale, those with A-levels or degrees, who spoke English fluently, with, at the other end, those who spoke English slightly or not at all (most of whom had no educational qualifications). In every group, women with higher levels of education were more likely to be in employment than those without. Among the two principal South Asian groupings, poor English was associated with low levels of economic activity, though we cannot say which was the cause and which the effect. At every level of English fluency, Pakistani and Bangladeshi women were less likely to work than Indians and African Asians. But an important point is that, among the (fairly small) number of Pakistani and Bangladeshi women with A-levels or degrees, the proportion in the labour market seemed to be just as high as in other ethnic groups. Holding other factors, such as age and number of children, constant suggests that this result is robust.

Table 4.2 **Economic activity score of women, by education and fluency in English**

16–59-year-olds, not in full-time education	White	Caribbean	Indian/ African Asian	Pakistani/ Bangladeshi
A-level or degree	65	72	65	(74)
Good English	46	63	55	27
Fair English	n.a.	n.a.	46	14
Poor English	n.a.	n.a.	32	5

The economic activity score counts full-time work as 1, part-time work or looking for work as ½. Figures in parentheses denote small cell size.

It is possible that some higher figures for female ethnic minority inactivity contain women who may be 'homeworking' on a part-time or even full-time basis. Ballard, for instance, believes that although such activities seem rarely to have been recorded in census returns or any national surveys, 'many Pakistani women are involved in homeworking, most usually by stitching up clothing for local manufacturers' (Ballard 1996, 135). Specialist researchers argue that 'because so much home-based work is "off the books" many home-based workers are reluctant to declare themselves', and that 'it is only after many years of building trust between the [researchers] and home-based workers that the latter feel able to talk openly about their work' (Phizacklea and Wolkowitz 1995, 32). Phizacklea and Wolkowitz additionally argue that national surveys such as the Labour Force Survey (LFS) underestimate the extent of homeworking for the inner cities, that ethnic minorities are too small in their national samples, and that the surveys have a poor response rate and do not use mother tongue interviewers (Phizacklea and Wolkowitz 1995, 31–32).

These methodological criticisms do not apply to this survey, but we did not specifically probe for homeworking and cannot evaluate the general claim that one-off interviewers, even when ethnically and linguistically matched, are unlikely to be told about homeworking. Nevertheless, we found very little trace of homeworking among Pakistani and Bangladeshi women. Not only did very few report that they were in paid work, but a relatively small proportion of those that were employees were in part-time work, and only a small proportion of the self-employed said they worked at home or under the control of a supervisor.

UNEMPLOYMENT

Since data have been collected on the basis of ethnic origin, ethnic minorities in general have had higher rates of unemployment than whites. Research has also suggested that ethnic minority unemployment is 'hyper-cyclical' (Jones 1993, 112). That is to say, when the economy is contracting, ethnic minority unemployment rises much faster, and to a higher peak, than does white unemployment. Similarly, when the economy begins to expand, unemployment among ethnic minorities falls at a higher rate than among white people. This pattern, first observed in the early

1970s (Smith 1977, 69), has been particularly pronounced since the mid-1970s, when unemployment rates first rose steeply. The very high rate of unemployment among ethnic minorities compared with whites was identified as the single most important development between the PSI surveys of 1974 and 1982 (Brown 1984, 174). Similarly, when in the late 1980s the overall unemployment rate began falling, it fell faster for the minorities; and when in the early 1990s unemployment began rising again, it rose faster for the minorities (Jones 1993). While comparative rates of unemployment have therefore come to be used as indicators of racial equality and of whether the gap between white and non-white people is growing or closing, they have to be seen within the broader cyclical pattern. This survey took place in 1994, shortly after a cyclical peak in unemployment. This means that, if the cycle was following the normal pattern, the differences between the various ethnic minority groups and the white population will be larger than at almost any other point in the cycle.

Men

This survey found that unemployment rates,[1] that is to say, the percentage of economically active persons without work, did vary between groups. Among men under retirement age, around 15 per cent of whites were unemployed. The proportions of Chinese, African Asians and Indians were within the same range (9, 14 and 19 per cent respectively). By contrast, Caribbean men had an unemployment rate double that of whites, 31 per cent, and Bangladeshi and Pakistani rates were even higher at 42 and 38 per cent respectively.

Women

Female unemployment rates were generally lower than men's. The same ethnic pattern occurs as for men, but the differences are smaller. The Chinese had the lowest rate (6 per cent), followed by whites (9 per cent), African Asians and Indians (12 per cent) and Caribbeans (18 per cent). Pakistani and Bangladeshi women had a similar rate of unemployment as their male peers (39 and 40 per cent respectively).

Young people

It is a well-established feature of most labour markets that new entrants are more likely to experience unemployment than those who are already established. Moreover, many young people experiment with a variety of occupations, and so experience higher rates of movement into and out of unemployment than those who are more settled. Both these factors together lead to young people generally having

1 This survey uses a broader definition of unemployment than is applied generally. The Labour Force Survey and the Census use the International Labour Organisation's definition of unemployed people as people without a job who were available to start work and were actively looking for a job. We have included as unemployed those who wanted a job even if they were not actively looking for one. Interestingly, for some groups this does not seem to have much of an effect. But it may contribute to increasing the rate of unemployment among whites, Pakistanis and Bangladeshis. The rates of unemployment for men of these groups in this survey are a third greater than reported in the LFS of the same period. In the case of the rate of unemployment for women, it is a quarter more for white and more than half more for Pakistani and Bangladeshi women than in the LFS. Of course, there may be other factors responsible for or contributing to these differences, some of which are discussed below.

higher rates of unemployment than those over 25. However, ethnic minority young people consistently have higher rates than the white population (Drew, Gray and Sime 1992, 39). This is particularly important given that the age structure of most of the minorities is more skewed towards young people than that of the white population.

The small number of 16–19-year-olds in the sample makes it difficult to compare accurately the unemployment rates of different ethnic minority groups. Analysis is complicated by the fact that the different groups have different economic activity rates, driven for the most part, as we saw in the previous chapter, by their different patterns of participation in full-time education. However, young men appear to fall into two broad groups: whites and Indian/African Asians have unemployment rates of around a third, while Caribbeans and Pakistani/Bangladeshis have rates of over a half. For women in this age group, the white unemployment rate is around a quarter, while those for all the minorities are approaching a half.

If we consider the 20–24-year-old group, the pattern is quite complex. For young men the white unemployment rate falls to under a fifth, while those for the minority groups show only very small falls. This is surprising given that the proportion of well-qualified young people is likely to be much higher in the older age groups. One of the things that seems to be happening for the ethnic minority groups is that the relatively low unemployment rates of the well qualified are concealing very high rates for those who left school at an early age. This is particularly important for Caribbeans, not least because of their relatively high proportion of early leavers. Because the sample size can be increased if we take all ethnic minorities together, we can say that, while white men who left full-time education at the age of 16 had an unemployment rate of 13 per cent at ages 20–24, the rate among ethnic minorities was 43 per cent.

If we distinguish, then, between the high unemployment of recent entrants into the labour market and long-term youth unemployment, especially among those with no or few qualifications, both are more severe for ethnic minority than white men, but the relative position of new entrants is better, and that for early entrants worse, especially for Caribbeans.

Among women, all the 20–24-year-old groups show small falls in unemployment rates compared with those for 16–19-year-olds, but the most striking fall is among Indian/African Asians where it is more than halved, and for this group it is lower than that for whites. This suggests either very rapid returns to investment in education by this group, or an unusually low unemployment rate for those with few qualifications. Their male counterparts do not achieve equal unemployment rates with whites until they are some years older.

Research suggests that all young people who leave full-time education at an early age to enter the labour market may be poorly equipped to compete for jobs, not least because of their lack of qualifications (Payne 1996). A Youth Cohort Survey analysis of labour market activity at the age of 19 found a combined Asian rate of unemployment much higher than the Caribbean rate. This study suggested that the high Asian staying-on rate in full-time education meant that those few Asians at this age who wished to find jobs were poorly qualified, both compared with older Asians, and compared with economically active members of other ethnic groups of the same

age. This would explain why they were more likely to be unemployed (Drew, Gray and Sime 1992, 39). However, our survey breaks down South Asians into the different subgroups, which are thereby shown to have strikingly different unemployment rates, even though both have low rates of labour market entrance.

Age and qualifications

With the exception of the very youngest groups, it is not necessarily the case that younger people have higher rates of unemployment than older people. For example, the average unemployment position of South Asians under 35 years old is about the same as that of their elders. The rate of unemployment for Caribbean men and women seems to have a clearer age pattern, with younger Caribbeans faring worse compared with their elders.

What are the factors that might explain these differential rates of unemployment? One of the ways in which people seek to avoid the prospect of unemployment is to increase their educational qualifications. We have already seen in the previous chapter that ethnic minorities are strongly committed to acquiring qualifications. Does this make a difference to their prospects and are there differential levels of unemployment for equally qualified members of different groups? Tables 4.3 and 4.4 show that for men, and to a lesser extent for women, British qualifications do decrease the likelihood of unemployment. (This does not necessarily mean, however, that people obtain employment commensurate with those qualifications; see below.)

Table 4.3 Rate of male unemployment, by highest British qualification

cell percentages

	White	Caribbean	Indian/ African Asian	Pakistani/ Bangladeshi
All ages				
None	19	42	20	46
O-level or equivalent	11	31	20	36
A-level or higher	12	23	12	17
Under 35 years old				
None	19	61	18	45
O-level or equivalent	13	28	20	43
A-level or higher	15	28	18	15
All under 35 years old	15	34	20	37
Weighted count	*869*	*512*	*721*	*394*
Unweighed count	*778*	*821*	*700*	*641*

However, it remains the case that, at each qualification level, the rate of unemployment for Pakistani/Bangladeshi and Caribbean men is much higher than that for white and Indian/African Asian men. Qualifications progressively reduced the rates of unemployment, and to a lesser extent they reduced the differential between whites and African Asians/Indians on the one hand and Caribbeans and Pakistanis/Bangladeshis on the other, but an overall pattern of difference remained.

The most striking feature of Table 4.3, however, is the very high unemployment of Caribbean men under 35 with no qualifications: 61 per cent. The possession of O-levels or equivalent qualifications was sufficient to halve this rate, although the addition of A-levels or higher qualifications did not lead to more than a marginal improvement thereafter. Indeed, it is only for the Pakistani/Bangladeshi group, for whom O-levels had no impact at all, that there is a difference between having O-levels and A-levels or higher qualifications.

Both the effects of qualifications and the differences between groups were less among women, though the sample size for Pakistani/Bangladeshi women was too small to measure the effect of qualifications upon their high rate of unemployment (Table 4.4). For Indian/African Asian women under 35, the possession of an A-level or higher qualification has no impact on their unemployment rate compared with having O-levels. Yet earlier we noted that their unemployment rate for 20–24-year-olds was well below that for 16–19-year-olds, and concluded that they must either be seeing an early return on their investment in education or that they must have a very low unemployment rate for their least qualified group. This table suggests that the latter explanation, not the former, is the dominant one.

Table 4.4 Rate of female unemployment, by highest British qualification

			cell percentages	
	White	Caribbean	Indian/ African Asian	Pakistani/ Bangladeshi
All ages				
None	13	19	13	54
O-level or equivalent	10	16	10	(42)
A-level or higher	7	16	12	(18)
Under 35 years old				
None	(36)	(36)	21	(65)
O-level or equivalent	14	16	13	(45)
A-level or higher	8	22	14	(20)
All under 35 years old	13	24	15	43
Weighted count	*716*	*506*	*483*	*116*
Unweighted count	*687*	*390*	*446*	*141*

Figures in parentheses denote small cell sizes.

Overall, younger women in all groups and at all qualification levels were more likely to be unemployed than older women, and this was particularly the case with minority women. This may be the product of higher rates of economic participation and higher career expectations among younger women. In other words, older women with poor job prospects will tend to withdraw from the labour market altogether.

People who find themselves unemployed for a certain period have the opportunity and are encouraged to take part in a government training programme. Many of the people in our survey had participated, but there were significant ethnic group differences. Whites and Caribbeans were much more likely to have been on one than the Chinese and South Asians (Figure 4.2). While older people and younger

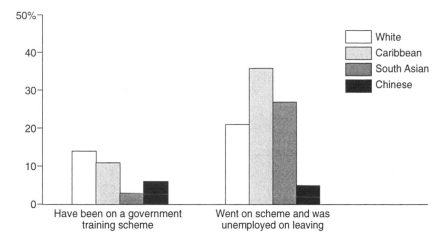

Figure 4.2 Attendance at government training schemes

women were less likely to have participated, this was true for all ethnic groups, and so did not affect the overall pattern. It is not a pattern that can be explained in terms of rates of unemployment, for groups such as Pakistanis and Bangladeshis who are disproportionately young and disproportionately unemployed were no more likely to have been on a scheme than other South Asians, and much less likely than whites. It is, however, consistent with a well-established pattern, evident in the discussion of qualifications and staying-on rates in the previous chapter, that South Asians strongly prefer an academic rather than a vocational qualifications pathway by comparison with Caribbeans and whites (Drew, Gray and Sime 1992; Drew 1995; Hagell and Shaw 1996).

These training schemes did improve the chances of employment. About half of the ethnic minority and six out of ten white trainees had work at the end of the scheme, and a further 10 per cent had started a course of education or self-employment. Nevertheless, a significant percentage returned to unemployment, and this was especially true for Caribbean men.

Occupation

Some of the differences in unemployment rates may be related to occupations, since some occupations generally experience higher unemployment rates than others. Occupation is related to, but not completely correlated with, qualifications. Table 4.5 shows that unemployment was very closely related to whether an individual's last job was manual or not. In general, manual workers were much more likely to be unemployed than non-manual workers, the differential being greater for men than women. The main finding, however, is that group difference persisted in each type of work, the pattern of differences following contours of an ethnic divide for both sexes: the higher rates of unemployment among Caribbeans and Pakistani/Bangladeshis cannot simply be explained by their disproportionate presence in manual work, for they had higher unemployment in non-manual work too.

Table 4.5 **Unemployment rate, by non-manual and manual work**
(base: economically active)

cell percentages

	White	Caribbean	Indian	African Asian	Pakistani/ Bangladeshi	Chinese	All ethnic minorities
Non-manual							
Men	8	24	8	7	19	(1)	12
Women	5	12	3	7	(19)	(2)	8
Manual							
Men	17	28	21	17	34	(13)	25
Women	9	17	11	(9)	(24)	(14)	14
Weighted count							
Men	*892*	*494*	*400*	*320*	*340*	*125*	*1680*
Women	*775*	*520*	*287*	*205*	*85*	*123*	*1220*
Unweighted count							
Men	*809*	*357*	*421*	*287*	*557*	*72*	*1694*
Women	*740*	*399*	*277*	*178*	*97*	*65*	*1016*

Geographical distribution

Nor can the higher unemployment in some groups simply be explained by their disproportionate presence in regions of areas of high unemployment. Figure 4.3 shows the regional variation in unemployment. While unemployment is unevenly distributed across the country, there is no consistent regional effect upon all groups. First, the range in the rates of unemployment varied between groups and was generally wider for the ethnic minority than for white men. Moreover, unemployment did not vary in a uniform way for all groups in a region. Sometimes a low rate for one group is accompanied by higher rates for others. For example, one

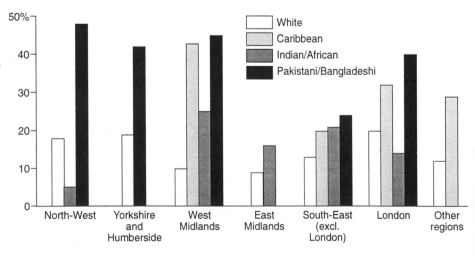

Missing bars due to sample sizes too small for analysis

Figure 4.3 Male unemployment rates in different regions

of the lowest rates of unemployment for white men was in the West Midlands, where the rates for the minorities were among the worst in the country.

On the other hand, there were two regions in which unemployment for African Asians/Indians was substantially lower than that for whites. On the whole, it seems to be the case that the South East, including, though to a lesser extent, London, experienced lower rates of unemployment than the other regions with which comparisons can be made. The situation, however, is clearly not a static one, not least because of general trends in unemployment. For example, setting the situation in 1994 against an analysis based on the Labour Force Survey data of 1988–1990 suggests that the favourable position of London and the South East has deteriorated considerably compared with other regions (Jones 1993, 126). This clearly has considerable implications for the position of ethnic minorities, as all the minority groups except the Pakistanis and the Chinese are concentrated in these regions.

Table 4.6 Male unemployment in two regions at two particular times

	White	Caribbean	Indian/ African Asian	Pakistani/ Bangladeshi
South East (excl. London)				
1988–90	5	13	9	18
1994	13	20	21	24
London				
1988–90	7	14	10	22
1994	20	32	14	40

A comparative analysis of the increase in unemployment in these two regions shows how such increases tend to affect minorities more than whites, but also that not all minorities are equally affected, nor are they all always affected more than whites. White male unemployment in the South East nearly tripled during about five years; the Caribbeans, beginning from a much higher base, went up by only half as much again; but the Pakistani/Bangladeshi figure, starting from a still higher base, increased by only a third (Table 4.6). Yet in London, while the position of white men developed just as in the South East, the unemployment rate for Pakistanis/ Bangladeshis and Caribbeans, beginning from a high position comparable to that in the South East, doubled, and the Indian/African Asian figure suffered the smallest increase, so that in 1994 the Indian/African Asian male unemployment rate in London was considerably lower than that for other groups. A further breakdown of the London figures shows that this low unemployment rate for male Indians/African Asians is due entirely to their position in outer London. The employment rates for all groups are better in outer than in inner London, but the position of Indian/African Asian men in outer London is much better than that of the other groups, including whites.

More, generally, the contrast between inner and outer city is an important one. Table 4.7 shows that, for all groups, employment chances are better still in outer metropolitan areas, though they are sometimes best still in non-metropolitan areas.

While these area differences affect male much more than female unemployment, they are relevant to explaining in part the higher levels of unemployment experienced by ethnic minorities, for, as Table 4.7 also shows, the minorities are much more likely to live in the type of area which suffers higher rates of unemployment. This is particularly relevant in understanding the high rates of Caribbean and Pakistani/Bangladeshi unemployment. For 42 per cent of Caribbeans and 28 per cent of Pakistani/Bangladeshis live in inner metropolitan areas, compared with 11 per cent of whites and Indians/African Asians. Conversely, nearly two-thirds or more of whites and Indians/African Asians live in the type of area where their group has the lowest level of unemployment, and where unemployment generally is lower.

Table 4.7 Unemployment in inner cities

cell percentages

	Inner London and inner metropolitan	Outer London and outer metropolitan	Rest of England and Wales
Unemployment rate			
Men			
White	26	14	12
Caribbean	41	30	23
Indian/African Asian	27	15	20
Pakistani/Bangladeshi	47	40	31
Women			
White	12	8	8
Caribbean	18	18	17
Indian/African Asian	14	12	11
Pakistani/Bangladeshi	48	42	31
Percentage of ethnic group that lives in these areas			
White	11	18	71
Caribbean	41	32	27
Indian/African Asian	11	61	29
Pakistani/Bangladeshi	28	42	30

Nevertheless, the explanatory force of the area effect is limited. Within each type of area, the Caribbean and Pakistani/Bangladeshi groups experience higher unemployment levels, even though they will be confronting similar local economic conditions to the other groups in the same areas. In both inner city areas and the rest of England and Wales, Caribbean men have unemployment rates over 50 per cent higher than whites and Indians/African Asians. In outer metropolitan areas their rates are double.

One further measure of geography on differential rates of unemployment is by comparing wards with a high and low level of ethnic minority residents. This is done in Figure 4.4 from which it is evident that ethnic minorities experience a much higher rate of unemployment in areas of above-average ethnic minority population. These areas have higher rates of male unemployment than the rest of the country, but interestingly the group most affected are white men. The unemployment rate of

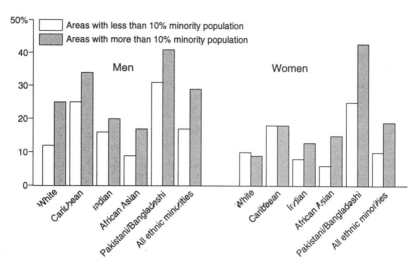

Figure 4.4 **Unemployment rate in areas of different levels of ethnic minority residence**

white men in areas in which the minorities form less than 10 per cent is about the same as the national average, but it is double in areas of higher minority concentration.

This is similar to the finding in relation to the inner city, and there is some coincidence between the areas of high minority density and the inner city. Yet the two types of areas should not be equated with each other. An important proportion of the high minority density areas are in the outer city, where most Indians and African Asians live and have comparable rates of unemployment to whites. Hence, it turns out to be the case that, in areas of above average minority ethnic density, Indian and African Asian men have lower rates of unemployment than white men.

The rate of unemployment, then, is associated with a number of factors. Most of these factors, say, manual work, lack of qualifications and inner city location, are linked: individuals to whom one factor applies are usually also affected by the other factors. Each factor has an independent effect on the position of any individual. Thus manual workers who have no qualifications and live in areas of high unemployment are more likely than those who lack one or more of these adverse characteristics to be unemployed, whatever their origin. However, the scale of the impact varies between groups. For whites, African Asians and Indians the presence or absence of each adverse characteristic has a significant impact, but makes relatively little difference to the unemployment rates of Caribbeans, Pakistanis and Bangladeshis. Similarly, although each group experiences the impact of particular disadvantages, the most disadvantaged ethnic groups always have higher unemployment rates than the more advantaged groups, even where they have similar characteristics.

Whatever the causes of the differential levels of unemployment, it has to be noted that there are additional ways in which unemployment affects minority persons more. This is, for example, the case in relation to the duration of unemployment (Table 4.8). Members of all the main minority groups, men and

women, experienced much longer periods of unemployment than white people. While about half of unemployed white people had been unemployed for less than a year, this was true for less than a quarter of ethnic minorities. On the other hand, well over half the ethnic minorities but less than a quarter of whites had been unemployed for more than two years. These contrasts are particularly sharp between white and Pakistani/Bangladeshi and Caribbean men.

Table 4.8 Duration of unemployment

column percentages

	White	Caribbean	Indian/ African Asian	Pakistani/ Bangladeshi
Men				
Less than 12 months	55	25	38	21
12–23 months	25	19	21	22
24–35 months	9	17	21	18
36 months or more	10	37	20	38
Median length of months	9	24	18	24
Weighted count	*94*	*97*	*83*	*106*
Unweighted count	*86*	*65*	*81*	*193*

	White	Ethnic minorities		
Women				
Less than 12 months	58	38		
12–23 months	17	19		
24–35 months	13	10		
36 months or more	13	33		
Median length of months	6	18		
Weighted count	*51*	*Weighted count*	*150*	
Unweighted count	*51*	*Unweighted count*	*149*	

Women were unemployed for shorter periods of time but the ratio of difference between white and ethnic minority women was even steeper, with the median lengths of unemployment being six and 18 months respectively. The samples were too small for an age analysis but there was a tendency for 16–34-year-old white and Caribbean men to have been unemployed for longer lengths than their older counterparts, and the reverse among South Asian men. Moreover, whites, African Asian and Indian men suffered much longer periods of unemployment if they were unqualified and/or were manual workers and/or lived in inner city areas. Even without these conditions, Caribbean, Pakistani and Bangladeshi men experienced lengths of unemployment that the other groups had only when particularly disadvantaged. As with the rates of unemployment, duration of unemployment can only partly be explained in terms of non-ethnic factors such as educational qualifications, occupational status or inner city residence.

A further factor which compounds the effects of unemployment is among married and co-habiting people where the spouse is also not in work. This was almost invariably the case among Pakistanis/Bangladeshis (Table 4.9). While more than half of unemployed whites did not have a partner in work, this was higher for the

Caribbeans and African Asians/Indians, but hardly any of the Pakistani/Bangladeshi unemployed had a spouse in work. This was partly a reflection of the concentration of unemployment in households, but also of the low participation rate of Pakistani/Bangladeshi women. For, as the table also shows, less than a fifth of Pakistani/Bangladeshi married men in work had a spouse in work, compared with six out of ten Indian/African Asians and three quarters of whites and Caribbeans.

Table 4.9 Employment status of self and partner
(base: economically active married or cohabiting persons)

				cell percentages
	White	Caribbean	Indian/ African Asian	Pakistani/ Bangladeshi
Unemployed with partner not in work	56	61	65	96
Weighted count	*92*	*77*	*100*	*153*
Unweighted count	*75*	*54*	*116*	*270*
Employed men with partner in work	76	76	59	17
Weighted count	*581*	*249*	*558*	*200*
Unweighted count	*501*	*180*	*553*	*318*

EMPLOYMENT

This section examines the distribution of the different ethnic groups between different types of employment. However, we need to bear in mind that the combination of low activity rates and high unemployment rates means that only about four in ten adult, non-retired Pakistani and Bangladeshi men have any form of paid employment. The figure for Caribbean men is about half. Nearly two-thirds of white men are in employment: a higher figure than that for Indians but slightly lower than the one for African Asians and the Chinese.

Generally women were less likely than men to be in paid employment, although the proportion for Caribbean women was the same as for Caribbean men. However, only 15 per cent of Pakistani and 8 per cent of Bangladeshi non-retired women were in paid employment. This means that some of the sample sizes are rather small, and we need to remember that women from these groups who have jobs are unusual.

Type of work

Previous studies have found strong ethnic disparities in type and level of employment, with most of the minorities under-represented in the highest occupational categories. Except for African Asians and Caribbean women, minorities are over-represented in manual work. There has, however, also been evidence over time of a movement up the hierarchy, and from manual to non-manual work, in the workforce as a whole, but this has been more marked for ethnic minorities and for some groups in particular (Brown 1984, 175; Jones 1993, 82–4).

Table 4.10 Job levels of men (base: male employees and self-employed)

column percentages

Socio-economic group	White	Caribbean	Indian	African Asian	Pakistani	Bangladeshi	Chinese
Prof./managers/employers	30	14	25	30	19	18	46
Employers and managers (large establishments)	11	5	5	3	3	0	6
Employers and managers (small establishments)	11	4	11	14	12	16	23
Professional workers	8	6	9	14	4	2	17
Intermediate and junior non-manual	18	19	20	24	13	19	17
Skilled manual and foreman	36	39	31	30	46	7	14
Semi-skilled manual	11	22	16	12	18	53	12
Unskilled manual	3	6	5	2	3	3	5
Armed forces or N/A	2	0	3	2	2	0	5
Non-manual	**48**	**33**	**45**	**54**	**32**	**37**	**63**
Manual	**50**	**67**	**52**	**44**	**67**	**63**	**31**
Weighted count	*789*	*365*	*349*	*296*	*182*	*61*	*127*
Unweighted count	*713*	*258*	*356*	*264*	*258*	*112*	*71*

The definitions of what constitutes manual and non-manual work were drawn up in an era when there were clear differences between the two groups. Broadly, manual workers worked with their hands, mainly in manufacturing industry, mining and utilities, with some jobs in services, particularly local government. Few formal educational qualifications were required, and the work was often dirty. Non-manual workers typically worked in shops or offices, and needed formal educational qualifications, at least to school-leaving level. They worked in clean environments and wore either their own clothes or staff uniform. However, in a service economy with a high technology manufacturing sector, these simple categories become less helpful. For example, shelf stackers in supermarkets are non-manual workers, while technicians educated to HND level may be classified as manual workers. A young man with career aspirations in the 1990s would generally do better qualifying as an electrician than entering clerical work. This background should be borne in mind in the discussion that follows, since sample numbers do not allow detailed analysis by complex job categories. It also needs to be recalled that for women manual work is very much the exception in the economy as a whole. Most types of work traditionally done by women are non-manual. The main exceptions are cleaning, hairdressing and mechanised sewing.

Men

Our survey found that white men in work were quite evenly divided between non-manual and manual work and that the position of Indians and African Asians was similar (Table 4.10), while two-thirds of Chinese men were in non-manual work. In

Table 4.11 **Proportions of male self-employed and employees, by two job levels**

column percentages

	White	South Asian/Chinese
Employers and managers – small establishments		
Employees	55	30
Self-employed	45	70
Weighted count	*87*	*138*
Unweighted count	*76*	*136*
Skilled manual and foreman		
Employees	66	49
Self-employed	34	51
Weighted count	*283*	*304*
Unweighted count	*247*	*322*

contrast about two-thirds of Caribbeans, Pakistanis and Bangladeshis were in manual work.

The Caribbeans at 14 per cent had the lowest representation in the top category of professionals, managers and employers, while nearly half the Chinese men were in this category. Both whites and African Asians had around a third in this group, with Indians a little lower at a quarter. The proportion of most groups in the skilled manual or foreman category was between 30 and 40 per cent. For Pakistanis it was higher at nearly half the total, and for Bangladeshis and Chinese it was markedly lower, although the sample sizes were small, particularly for the former. All ethnic groups had very small proportions who were unskilled manual workers. The most striking differences were in the incidence of semi-skilled manual work. Over half the Bangladeshi men in work were in semi-skilled manual work compared with one in five Caribbeans, one in six Indians and Pakistanis and one in ten whites, Chinese and African Asians.[2]

All the minorities were distinctly less likely than white men to be employers and managers of large establishments. Indeed, insofar as South Asians and Chinese were well represented in the broad professional, managerial and employers category it was significantly because of the contribution of self-employment. For Table 4.11 shows that, while white employers and managers in small establishments were more

2 There may, however, be some uncertainty about the profile of Pakistanis and Bangladeshis, for the 1991 Census figures, based on 10 per cent of the Census, show the Pakistanis and Bangladeshis to have a distinctly higher presence in the top non-manual category, and for the Pakistanis to have a smaller presence in the top manual category than we found. This may just reveal the changed circumstances of 1991 and 1994, or it may reflect on our smaller but more targeted sample structure, which was designed to include to a greater degree some of the 'hard-to-find population that it is estimated that the Census missed (Simpson, 1996). Because the Census under-represents these groups it is not clear whether our sample is more representative of the underlying population, or whether it is skewed in the other direction. The Labour Force Survey over many years has strongly suggested that the Pakistani and Bangladeshi male jobs level profile continues to have a manual skew and a distinctly smaller representation in the top employment category than the African Asian and Indians (e.g. Jones 1993, 99), and that is what our survey too reports. However, our male skilled manual and foreman figures, particularly for Pakistanis, seem higher than they should be, given that there is a very distinct downward trend in the numbers of manual workers.

Table 4.12 Job levels of male employees, by highest British qualification
(base: male employees excluding self-employed)

column percentages

	White	Caribbean	Indian	African Asian	Pakistani/ Bangladeshi	Chinese
% in professional, managerial and employers category						
(prof. workers in parentheses)						
A-level or higher	40 (12)	15 (18)	30 (16)	40 (26)	34 (22)	61 (36)
O-level/CSE/other	21	15	21	17	11	–
No qualification	11	2	10	13	3	9
% in other non-manual category						
A-level or higher	24	29	43	34	36	20
O-level/CSE/other	26	25	37	37	26	62
No qualification	12	2	13	24	11	22
% in skilled manual category						
A-level or higher	27	36	12	20	15	9
O-level/CSE/other	28	37	18	11	9	–
No qualification	43	37	33	31	34	–
% in semi-skilled and unskilled manual category						
A-level or higher	9	20	15	6	16	10
O-level/CSE/other	25	23	24	35	54	38
No qualification	33	60	44	32	51	68
Weighted count	*612*	*314*	*241*	*205*	*167*	*83*
Unweighted count	*561*	*219*	*262*	*189*	*266*	*48*

likely to be employees than self-employed, these minorities were more than twice as likely to be self-employed. The fairly strong presence of ethnic minority men (except Bangladeshis and Chinese) in the top manual work category is also partly explained by a higher incidence of self-employment compared with whites.

Job levels were strongly related to the possession of academic qualifications, but not strictly so. Table 4.12 offers an analysis of job levels of male employees by highest British qualification. As self-employment is often far less determined by formal entry criteria or the possession of qualifications, the self-employed are excluded from the analysis.[3] Even using rather broad qualification levels, we might expect a similar pattern between whites and ethnic minorities and between minorities. However, this expectation is only partially fulfilled. For example, 40 per cent of whites and African Asians with A-levels or a higher qualification were in the top non-manual category, as were over half the Chinese. However, only a third of the Indians and Pakistanis, and only a fifth of the Caribbeans with A-levels or above were in the top occupational category. A much higher proportion of South Asian men than white men with these qualifications were in the lower non-manual category. Nearly half of the highest qualified Caribbean men were in manual work compared with a third of the whites and a fifth of the others. However, in interpreting these findings we need to bear in mind the caveat that the skilled manual category in particular

3 As a matter of fact, in some groups the self-employed were better qualified than employees, and the more successful.

includes an increasing proportion of jobs requiring relatively high-level qualifications. Nonetheless, one in five Caribbean men with higher qualifications were in unskilled or semi-skilled manual jobs, as were one in six Indians, Pakistanis and Bangladeshis.

The distribution of men with O-level or equivalent qualifications across types of jobs also shows some variation, albeit less than at the higher qualifications level. Since a reasonable proportion of both the other non-manual and the skilled manual categories will require qualifications at this level, the evidence for under-use of qualifications is likely to be found at semi-skilled and unskilled manual levels. Around a quarter of whites, Indians and Caribbeans with these qualifications had semi-skilled or unskilled jobs, as did around a third of Chinese and African Asians. The most marked difference occurred with the Pakistanis/Bangladeshis, where more than half had semi-skilled jobs.

There were differences between the groups in the division of those educated to O-level standard between skilled manual work and intermediate and junior non-manual work. The whites were evenly divided. The Caribbeans had over a third in the skilled manual and only a quarter in the other non-manual category. The Chinese (on a small sample) had none in the skilled manual category and nearly two-thirds in the other non-manual. All the South Asian groups had twice the proportion in other non-manual work compared with skilled manual, although the Pakistani/Bangladeshi proportion was lower than for the other groups because of their concentration in semi-skilled manual work.

Ethnic minority men with higher qualifications were more likely than their white peers to be professionals. This could reflect differential career preferences, or that it is easier for ethnic minorities to get a return on their qualifications where higher qualifications are more likely to be a necessary part of a job description. It also seems to be the case that there is a greater propensity among qualified South Asian and Chinese men for non-manual over manual work compared with Caribbeans and whites. For example, more than a third of white men with higher qualifications were in manual work but a quarter or less of Chinese, African Asians and Indians. The latter groups, where they do not achieve employment in the top non-manual category, are more likely to have lower level non-manual work.

Women

Turning to women, it is immediately apparent from Table 4.13 that far fewer women than men were in the top professional, managerial and employers category. Overall the proportion was around half that of men. The variation across groups was, however, similar to that of the men. Chinese women, at 30 per cent, were almost twice as likely as whites to be in this category. Just over one in ten of all the South Asian women in employment, but only one in 20 Caribbeans, were in the top occupational group.[4] Unlike men, however, a large majority of women in all groups

4 The 1991 Census reports that women of all ethnic minorities except the Chinese have a greater presence in the top jobs category, with the result that there is little difference between South Asian and white women. The Census found also that while there was a smaller proportion of Caribbean than other women in the top category, they were as well represented as white women, and much better than all other groups, among employers and managers in large establishments (3 per cent) (OPCS 1993b, Table 16; Abbot and Tyler 1995, Table x). South Asian and Chinese women, in contrast, were

were in non-manual work, ranging from the Chinese (76 per cent) to the Indians (58 per cent). This means that more than half of working women in each ethnic group were in intermediate or junior non-manual work, rising to nearly two out of three for Caribbean and African Asian women. This reflects the economy-wide concentration of women in clerical/secretarial and sales occupations.

Table 4.13 Job levels of women in work (base: female employees and self-employed)

column percentages

	White	Caribbean	Indian	African Asian	Pakistani	Chinese
Professional, managerial and employers	16 (15)[1]	5 (5)	11 (7)	12 (10)	12 (6)	30 (25)
Intermediate non-manual	21	28	14	14	29	23
Junior non-manual	33	36	33	49	23	23
Skilled manual and foreman	7 (2)	4 (2)	11 (3)	7 (3)	9 (3)	13 (–)
Semi-skilled manual	18	20	27	16	22	9
Unskilled manual	4	6	4	1	4	2
Armed forces/inadequately described/not stated	0	1	1	1	0	0
Non-manual	**70**	**69**	**58**	**75**	**64**	**76**
Manual	**29**	**30**	**42**	**24**	**35**	**24**
Weighted count	*734*	*452*	*275*	*196*	*60*	*120*
Unweighted count	*696*	*336*	*260*	*164*	*64*	*63*

1 The figures in parentheses are exclusive of self-employed.

For women, as with men, the Pakistani and Indian women's presence in the top non-manual work category was strongly influenced by self-employment, as the figures in parentheses in Table 4.13 reveal. Excluding the self-employed, only around 6 per cent of Pakistani and Indian women were in the top non-manual category, less than the African Asians (10 per cent) and much less than white (15 per cent) and Chinese (25 per cent) women. On the other hand, the overwhelming majority of women of all groups who were in skilled manual work were self-employed. Apart from the top non-manual category and its mix between employees and self-employed, the differences in job levels between women of different ethnic origins were considerably less than the differences among men, and there was not the division between minorities. This suggests that gender divisions in the labour market may be stronger and more deeply rooted than differences due to race and ethnicity.

Nevertheless, both men and women in nearly all the minority groups shared one fundamental difference from white men and women. They were much less likely to be in the top occupational category, and when they were, they were much less likely to work in large establishments. The explanations for this are likely to be complex. There may be some direct discrimination, but part of the explanation could lie in the

more likely to be professional workers. The difference between our findings and those of the Census may be that our survey includes more women from the 'hard-to-find' categories, such as those with poor facility in English, and as they are more likely to be in manual work (though they are even more likely to be economically inactive) their inclusion will depress the proportion of women of certain minorities in the top category.

continued importance of social-educational networks associated with public schools and Oxbridge in the filling of higher level jobs.

We saw earlier that one significant difference between the sexes is the much larger number of women in part-time work, though here too the difference was not just one of gender but one of ethnicity too. These differences persist when job levels are allowed for. Table 4.14 shows the percentage of women in part-time work. It shows that over a third of white women in non-manual jobs and over half in manual jobs were working less than 30 hours a week. The proportion of Caribbean women working part-time was around half that of white women in each type of job. Around a quarter of South Asian women in all occupational groups were part time.

Table 4.14 Female employees who work part time, by job levels
(base: women employees, excluding self-employed)

cell percentages

	White	Caribbean	South Asian
Non-manual	36	17	26
Senior and intermediate	28	14	27
Junior	45	19	25
Manual	55	35	26
Weighted count	*1100*	*388*	*336*
Unweighted count	*1049*	*277*	*312*

The impact of qualifications is shown in Table 4.15. White and Chinese women had a broadly similar occupational pattern with about a quarter of those qualified to A-level or above in the professional, managerial and employers category; African Asians were not far behind, at one in five. For all the other groups the proportion was closer to one in ten. As with the men, a much larger proportion of the highest qualified ethnic minorities (excluding Caribbeans) in the top jobs category, when compared with whites, were professionals rather than managers. At the other extreme, around one in six whites with A-levels or higher qualifications was in semi-skilled or unskilled manual work. This was much higher than for any other group. The Caribbeans, with one in nine, were the closest. For all other groups the proportion was closer to one in 20. This may reflect different participation decisions. Qualified South Asian women with poor job prospects may choose to remain inactive rather than take unskilled work.[5]

With the exception of Pakistanis, more than three-quarters of employed women from minority groups with O-levels were in intermediate or junior non-manual work. Pakistani women had the smallest proportion of women without qualifications in non-manual work, and the highest proportion with O-levels in semi-skilled manual work. In this instance their pattern resembles that of their male counterparts rather than other women (see Table 4.12).

5 The high Pakistani and Bangladeshi female inactivity also suggests that the poorly qualified are more likely to be keeping house than be in paid manual work outside the home.

Table 4.15 Job levels of female employees, by highest British qualification (excluding self-employed)

	White	Caribbean	Indian	African Asian	Pakistani	Chinese
						column percentages
% in professional, managerial and employers category						
(prof. workers in parentheses)						
A-level or higher	24 (4)	11 (1)	12 (6)	19 (12)	11 (6)	32 (26)
O-level/CSE/other	8	1	6	9	–	14
No qualification	10	–	4	1	–	17
% in other non-manual category						
A-level or higher	60	75	77	77	81	63
O-level/CSE/other	66	74	74	79	58	67
No qualification	44	36	27	39	19	45
% in skilled manual category						
A-level or higher	–	1	4	5	3	–
O-level/CSE/other	2	2	2	5	8	–
No qualification	6	6	3	5	3	–
% in semi-skilled and unskilled manual category						
A-level or higher	17	12	7	–	5	5
O-level/CSE/other	25	23	18	6	34	19
No qualification	39	59	65	54	78	38
Weighted count	*669*	*432*	*233*	*178*	*57*	*88*
Unweighted count	*633*	*322*	*226*	*149*	*66*	*48*

Hours worked, shifts worked and supervision

Among those who worked more than 30 hours a week, there was not much difference in the hours worked by different job levels, except that the highest weekly hours were declared by men and women in the top non-manual category. This is consistent with the general pattern in the Labour Force Survey. Nor were there significant differences between the South Asian groups. Men work about five hours more than women on average, and whites work slightly more than the minorities (Figure 4.5). Interestingly, the hours worked by white men and women are the same as they were in 1982. Among Caribbean men there has been an increase of nearly an hour, and among Caribbean women and South Asian men and women there has been a decrease of almost two hours (Brown 1984, 211). The gap between white and ethnic minority men was greater in the public sector.

There has been a relative decline in the proportion of South Asians doing shiftwork. Earlier surveys found that Caribbeans and South Asians were much more likely to be doing shifts than white workers. The position in 1994 was that, while Caribbean men were still much more likely to be doing shiftwork than whites, this was no longer true of South Asian men, and South Asian women were least likely to be working shifts (Figure 4.5). This may be because many jobs, such as those in the textile industry, which involved shiftwork, and in which Pakistani men were

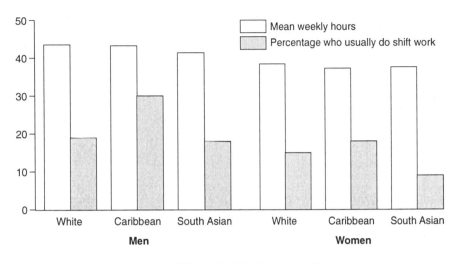

Figure 4.5 **Hours and shiftwork of full-time employees**

concentrated, disappeared during the 1980s, or it may be because of the increased non-manual profile of South Asians, especially Indians and African Asians – or both.

In our survey shiftwork was more common among all men, and among Caribbean women, in the public sector. Shiftworking is, of course, common in a number of public sector industries, most notably the health service, the emergency services and public transport. The PSI analysis of the Labour Force Survey data for 1988-90 found that the likelihood of ethnic minorities being engaged in shiftwork declines sharply the younger the workers (Jones 1993, 74). We found in this survey that 16–34-year-old Caribbean men, unlike South Asians, were just as likely to be doing shiftwork as their elders; younger Caribbean women, however, were much less likely to do shiftwork than their elders.

Another measure of job level is the extent to which people have supervisory responsibilities and whom they supervise. Table 4.16 shows that those in non-manual jobs were much more likely to supervise others than those in manual jobs, and that within each of these categories men were much more likely to be supervisors than women. This was true for all groups. There were, however, group differences. Ethnic minority male non-manual employees (except the Chinese) were only two-thirds as likely to supervise as white men. Among male manual workers there was little difference between whites and Caribbeans, but in varying degrees all the Asian groups were less likely to supervise, with Pakistanis/Bangladeshis the least likely. Interestingly, taking only those working in the private sector, the Caribbean manual workers were more likely to be supervisors than any other ethnic group.

Among female employees the Chinese and Caribbeans were a little more likely to be supervisors than whites, and the South Asians were much less likely to be and had very little likelihood of supervising in manual work. Caribbean women in manual work, on the other hand, were twice as likely as white female manual workers to be

Table 4.16 Supervisors as a proportion of employees, by job type (excluding self-employed)

cell percentages

	White	Caribbean	Indian	African Asian	Pakistani/ Bangladeshi	Chinese	All ethnic minorities
Non-manual							
Men	68	47	47	53	43	61	50
Women	37	37	28	30	(27)	(40)	34
Manual							
Men	28	28	15	17	12	*	20
Women	11	21	4	(6)	*	*	12
All							
Men	49	34	30	37	22	46	33
Women	30	33	18	24	18	34	27
Weighted count							
Men	623	315	242	207	168	90	1022
Women	672	439	237	180	58	88	1001
Unweighted count							
Men	569	220	263	192	268	51	994
Women	636	326	228	151	67	48	820

* indicates that the cell size is too small; if the cell size approaches 40, the figure is given in parentheses.

in supervisory posts. The Caribbeans were the only group in which, taking all employees, women were as likely to supervise as men. This was explained by their strong presence in the public sector, where all women were more likely to have supervisory responsibilities.

Industry

About a third of white men work in manufacturing industries. This is about the same as Caribbeans, Indians and African Asians, though this figure is exceeded by Pakistanis. The Bangladeshis and Chinese, on the other hand, have a much lower representation in manufacturing (Table 4.17). Caribbean and Indian men are disproportionately concentrated in engineering, including the motor industry. One in three of all Pakistani male employees is in other manufacturing (including one in ten in textiles). More than half of Bangladeshi men work in hotels and catering, as do a quarter of the Chinese. Most of the minority groups have a much larger presence in transport and communication than whites, but only the African Asians do so in retailing. More than one in eight of white men is in the financial sector, and this is matched or exceeded by African Asians and Indians.

Our findings are broadly consistent with the PSI analysis of the Labour Force Survey of the late 1980s, although there has been a further decline in manufacturing and an increase in financial services (Jones 1993, Table 4.8; cf. OPCS 1994, Table 14).[6] The situation, then, at this broad-brush level of analysis, is that different

6 There is one important aspect in which our Chinese sample is not consistent with the LFS 1988–90 and the 1991 Census. They found that over half of Chinese men and nearly half of the women were in distribution and catering, which is substantially more than in our sample.

minority groups have quite distinct industrial distributions. None is quite like any other or akin to white males. Moreover, not only does each minority have some economic sectors in which it is particularly concentrated, but each has a more restricted distribution than do white men, although the distribution of Caribbean men is fairly close to that of white men.

Table 4.17 Male employees, by industry (excluding self-employed)

column percentages

	White	Caribbean	Indian	African Asian	Pakistani	Bangladeshi	Chinese
Agriculture, forestry, fishing, energy and water supply	5	0	0	1	1	0	0
Extraction of minerals, metal manufacture	5	9	4	3	3	0	0
Metal goods, engineering and vehicles	11	13	12	6	12	2	2
Other manufacturing	16	14	19	20	30	11	10
Construction	6	7	7	3	1	2	3
Retail distribution	9	6	8	23	11	6	15
Hotels and catering	2	3	2	2	6	60	23
Transport and communication	9	17	18	13	15	0	5
Banking and finance	14	5	13	17	5	1	8
Public administration	9	10	5	4	2	4	5
Education	4	4	3	2	5	1	10
Hospitals	4	5	3	4	2	2	10
Other services	6	7	8	4	8	11	7
Weighted count	*601*	*310*	*239*	*206*	*117*	*50*	*90*
Unweighted count	*552*	*216*	*260*	*190*	*172*	*93*	*51*

Bangladeshis show the most extreme pattern, being concentrated in just one sector, catering. This, combined with their manual work profile, means that more than half of all employed Bangladeshi men have just one occupation: waiting and kitchen work in restaurants. As there is a limit to the availability of these jobs, especially in a given area, this occupational segregation helps to explain the very high levels of Bangladeshi unemployment.

There is, however, only one industrial sector in which all minority groups are consistently under-represented. That is the composite category of agriculture, forestry, fishing, energy and water supply. It is a relatively small sector of the economy, accounting for only 5 per cent of all male employees, but it is one in which ethnic minority men are virtually absent.

Compared with white men, white women are particularly concentrated in retail, medical care and education. Women generally have a much smaller presence in manufacturing, though South Asian women, especially Indians, work in manufacture,

much more so than whites and Caribbeans (Table 4.18). A fifth of Indian and Pakistani women employees are in other manufacturing (half of them in clothing and footwear). Women from most groups are found in large numbers in retail and in finance, though ethnic minorities, except the African Asians, less so than whites.

Table 4.18 Female employees, by industry (excluding self-employed)

column percentages

	White	Caribbean	Indian	African Asian	Pakistani	Chinese
Agriculture, forestry, fishing, energy and water supply	1	0	0	3	0	0
Extraction of minerals, metal manufacture	0	1	1	1	0	0
Metal goods, engineering and vehicles	2	2	**5**	3	0	**5**
Other manufacturing	6	4	**21**	14	**20**	11
Construction	1	0	0	2	0	0
Retail distribution	17	6	13	**22**	11	4
Hotels and catering	5	4	4	2	9	**19**
Transport and communication	3	4	5	**9**	2	3
Banking and finance	**15**	9	11	**15**	4	13
Public administration	7	**15**	12	7	**14**	6
Education	13	9	9	4	**18**	0
Hospitals	21	**39**	12	13	8	**30**
Other services	8	7	6	4	**14**	9
Weighted count	*663*	*434*	*235*	*180*	*51*	*88*
Unweighted count	*627*	*322*	*226*	*151*	*55*	*47*

Four out of ten Caribbean women work in hospitals and medical care, double the proportion of white women. This helps to explain the high level of shiftworking noted earlier. They are also, with Pakistanis and Indians, twice as numerous as whites in public administration. While women from all groups except the Chinese had a higher proportion than men working in education, Pakistani women had the highest proportion there. This, however, was not the finding of the PSI analysis of the Labour Force Survey (Jones 1993, Table 4.9). That showed few Pakistani women working in education and strongly suggests that our small sample may be biased, and probably under-represents Pakistani women in 'other manufacturing' (primarily clothing and footwear) and in retail. Additionally, compared with that analysis and the 1991 Census, our survey has a much larger proportion of women from all ethnic groups working in hospitals and fewer in engineering.

The public sector, comprising central and local government, health authorities, nationalised industries and so on, has contracted as an employer in recent years, with the transfer of ownership and functions to the private sector. It nevertheless still accounts for about a third of those in employment. It is a particularly important source of employment for Caribbeans, as shown in Table 4.19. This emphasises the

unusual employment pattern of Caribbean women, 61 per cent of whom work full time in the public sector, especially in health and local government. They are concentrated in intermediate non-manual jobs, including, particularly, nursing.

Table 4.19 Proportion of full-time employees in the public sector

cell percentages

	White	Caribbean	South Asian
Men	26	33	27
Women	38	61	39
Weighted			
Men	*606*	*157*	*313*
Women	*364*	*171*	*145*
Unweighted			
Men	*554*	*103*	*359*
Women	*355*	*120*	*138*

There were, however, a number of further interesting contrasts in relation to the public sector and ethnicity. For example, ethnic minority men in the public sector were more likely to be in non-manual work compared both with white men and with ethnic minority men in the private sector. Yet those in the private sector have a much better chance of being in the top non-manual category (Table 4.20).

The disparities identified in Table 4.20 apply with greater force to those who are employers and managers in large establishments, although the public sector is likely to have a bigger proportion of large employers. This is an interesting finding given the perception that it is the public sector, especially local government, that has taken the lead in implementing equal opportunity policies. This is not necessarily to say that equal opportunity measures have not been set up; rather, their effectiveness depends upon there being vacancies, and the contraction of the public sector may mean there have been insufficient vacancies, especially in high level positions, to have a noticeable effect (Ward and Cross 1991). The situation of women was somewhat different: ethnic minority women's chances of being in the top category were equal between the two sectors, but white women's chances were better in the public sector.

Table 4.20 Proportion of men in higher non-manual jobs, private and public sectors (excluding self-employed)

cell percentages

	White		Caribbean		South Asian	
	Private	Public	Private	Public	Private	Public
	29	27	17	(5)	20	13
Weighted	*449*	*157*	*95*	*52*	*215*	*75*
Unweighted	*408*	*146*	*64*	*39*	*239*	*81*

Figure in parentheses denotes small cell size.

EARNINGS

Survey respondents were asked about their earnings by being shown a card with 16 bands of earnings, each of which was labelled with a random letter of the alphabet. Respondents were asked to state the letter which labelled the band in which their gross weekly earnings fell. While there was a good response from some groups, there was, as shown in Tables 4.21 and 4.22, a high refusal rate among South Asians, about a quarter of whom, excluding Bangladeshis, declined to indicate their earnings. The comparative earnings analyses offered here need to be read with this limitation in mind. The non-respondents in each ethnic group were spread across the job levels, though the relatively few white and Chinese non-respondents were more likely to be non-manual employees, and South Asians' rate of refusal was higher when they chose to be interviewed in English only. It is possible, therefore, that the aggregate average earnings presented here are a little reduced because of the composition of the non-respondents.[7]

This section looks mainly at the earnings of full-time employees and, while the profits of the self-employed are brought into the discussion at the end of the section, they are covered more fully in the next section on self-employment. While the comparison of employees' earnings provides a basis for comparison with previous surveys, and an indication of equality of opportunity, the complete picture on the financial returns of employment has to include the contribution of self-employment to the relative position of various groups.

Table 4.21 compares the weekly earnings of male employees in two different ways. The upper part of the table shows the distribution of the respondents between the different condensed earnings bands. The lower part gives the mean weekly earnings, calculated from the mid-points of each of the original 16 earnings bands. The mean figures show that the average for all ethnic minority men was below that for white men. However, there was parity between whites, African Asians and Chinese. Caribbean men were a little behind, with Indians even more so, and the Pakistanis and Bangladeshis a third or more below whites.

For some groups the mean is likely to be depressed because of a higher refusal rate among the higher earners; the figure for Indian men in particular is more depressed than one might have expected given their job-level distribution, as shown earlier in Table 4.10. The distribution between bands is particularly interesting in the case of the Caribbeans, for they are fewest in the worst-off as well as the best-off band, and therefore have a more equal distribution of earnings than other groups. African Asian men, by contrast, are much more widely distributed among the earnings bands. Hence even though they are easily the best represented in the highest band of gross earnings of more than £500 a week, being two-thirds more likely to be in that band than whites, their average is the same as that for whites.

The inclusion of religious groups in Table 4.21 allows one to see that the addition of Indian and African Asian Muslims to Pakistanis and Bangladeshis raises the Muslim mean weekly earnings from what it might otherwise be; and the difference

7 It is not unusual for higher earners to be under-represented in surveys of income. It is a long-established feature of the Family Expenditure Survey, for example, which is known to exclude the top 5 per cent (Kemsley, Redpath and Homes 1980).

Table 4.21 Male employees' earnings (base: male full-time employees)

column percentages

	White	Carib-bean	Indian	African Asian	Paki-stani	Bangla-deshi	Chinese	Hindu	Sikh	Muslim	All ethnic minorities
Weekly earnings											
Less than £116	4	1	9	6	13	41	2	6	9	23	7
£116 – £192	14	16	22	18	39	29	23	20	24	31	22
£193 – £289	33	36	30	34	28	10	24	31	38	24	31
£290 – £385	19	28	16	13	9	8	15	15	14	10	18
£386 – £500	14	11	13	4	4	4	25	6	10	6	10
More than £500	15	8	10	25	6	8	10	23	5	6	12
Mean weekly earnings[1]	£336	£300	£287	£335	£227	£191	(£336)	£338	£249	£223	£296
Weighted count	*541*	*255*	*154*	*152*	*76*	*42*	*72*	*162*	*84*	*140*	*751*
Unweighted count	*493*	*179*	*169*	*144*	*113*	*78*	*42*	*154*	*84*	*233*	*726*
Refusal/can't say	6	6	29	16	26	8	3	21	31	18	16

1 Means calculated from mid-points of 16 earnings bands.

between the mean earnings of Hindus and Sikhs is quite substantial, mainly because Sikhs had only 5 per cent in the top earnings band as opposed to 23 per cent of Hindus (though both groups, and especially the Sikhs, had a high refusal rate).

This comparative position of African Asians and Hindus compared with other South Asians is a striking new development which has not been properly recorded before. At the time of the PSI Second Survey of Racial Minorities in 1974, it was clear that the African Asians, many of whom were recent refugees from East Africa, were much better qualified, had a better facility in English and were more likely to be in non-manual work than Indians; correspondingly, Indians were in a much better position than the Pakistanis (Smith 1977). On the other hand, perhaps partly because of their recent arrival in Britain, and perhaps because of their larger numbers in white-collar work in which overtime and shiftwork premiums were not available, the median gross weekly earnings of African Asian men were 15 per cent below those of whites, 10 per cent below that of Indians, and the lowest for all groups (Smith 1977, 83).

The PSI Third Survey in 1982 found that, while average earnings for Asian men were nearly 15 per cent below those of white men, there was little difference between Indians and African Asians, or between Hindus and Sikhs – both these pairs of Asian groups being much better off than Pakistanis and, especially, Bangladeshis (Brown 1984, Tables 109 and 114). The position now is that, while the pattern of earnings differentials between whites, Indians and Pakistanis appears still in place as it has been for two decades, African Asian men have moved from the bottom to the top of the distribution. Two decades ago they were averaging less than the Pakistanis, a decade ago they were equalling Indians, and now they seem to have caught up with the whites.

Similarly, a decade ago Hindu and Sikh men averaged the same earnings, but now Hindus have more than a quarter more than Sikhs. It has to be re-emphasised,

however, that these findings are based on high non-response rates, and moreover that the main difference between African Asians and Indians and Hindus and Sikhs respectively is that the former in each pair (which, of course overlap with each other) have a very high proportion of top earners. Nevertheless, the earnings position of African Asians found here is consistent with earlier findings about their job-levels. As a group they were always highly qualified and were largely in the professions, administration and business in East Africa. After the period of being political refugees and rebuilding their livelihoods and establishing themselves in Britain, they seem to have made considerable progress in re-creating their prosperity.

Table 4.22 Female employees' earnings (base: female full-time employees, excluding self-employed)

column percentages

	White	Carib-bean	Indian	African Asian	Pakistani/ Bangladeshi	Chinese	Hindu	Sikh	Muslim	All ethnic minorities
Weekly earnings										
Less than £116	10	6	19	13	21	16	19	16	19	11
£116 – £192	31	20	25	31	46	23	27	36	34	24
£193 – £289	30	39	33	29	23	20	27	34	28	33
£290 – £385	15	24	9	12	4	19	8	7	11	18
£386 – £500	10	7	4	5	7	8	6	3	5	6
More than £500	4	5	11	9	0	14	14	5	4	7
Mean weekly earnings[1]	£244	£267	£252	£254	(£181)	(£287)	£258	£223	(£221)	£259
Weighted count	345	278	103	90	34	48	93	65	46	552
Unweighted count	337	206	94	72	36	28	81	50	47	436
Refusal/can't say	6	12	29	23	18	–	27	30	10	16

1 Means calculated from mid-points of 16 earnings bands.
Figures in parentheses denote small sample.

The position of full-time women employees was very different to that of men. Female weekly earnings were considerably lower than men's in all ethnic groups, but the biggest gender gap was among whites (Table 4.22). The average earnings of ethnic minority women were higher than those of white women, although this is likely to be inflated by high levels of non-participation by those Pakistani and Bangladeshi women whose potential earnings were very low (Heckman and Sedlacek 1985), and the greater likelihood of higher qualified white women working part-time rather than full-time. This is, nevertheless, an important finding which shows the limits of the idea of 'double discrimination', the view that, besides the general disadvantage of women, non-white women suffer an additional inequality in comparison to white women (Bhavnani 1994). The highest average earnings were of Caribbean women (the Chinese women's were higher but the sample size is small).

The differences between groups of women, however, were less than in the case of men. The averages for Indians and African Asians were similar, yet the earnings for Sikh women were significantly less than those for Hindus. This was because Hindus had a very much higher proportion of top earners than Sikhs, or indeed

whites. As with men, however, there were high non-response rates among South Asians.

The Labour Force Survey started asking an earnings question shortly before our survey, and findings for the same period of time as our fieldwork (December 1993 to November 1994) have now been published (Sly 1995). The two sets of findings cannot, however, be compared in any detail, given the use of different bands. While the LFS analysis is based on much smaller ethnic minority sample sizes than ours, it is perhaps worth noting that the two data sources present a consistent pattern of male differentials. This is complicated, however, by the fact that the LFS adds Black Africans to Caribbeans to create a 'black' category and includes African Asians as Indians. The LFS found that black and Indian men earned about 10 per cent less than white men, similar to our finding in relation to Caribbean men and Indians/African Asians. The LFS finding that Pakistani/Bangladeshi men earn about a third less than white men is comparable to our finding if Pakistanis are considered alone, but is too optimistic for Pakistani and Bangladeshi men taken together. The one ethnic minority category of men with higher average earnings than white men in the LFS was 'Mixed/Other origins', which includes the Chinese, suggesting, as we found, that male Chinese and white earnings are broadly similar. The overall average for ethnic minority men in the LFS was 89 per cent of male white earnings; in our survey it was 88 per cent.

Our survey, on the other hand, leaving aside the Pakistani/Bangladeshi women on account of the small sample sizes, consistently found that ethnic minority women earned more than white women, whereas the LFS found that while black women earned 6 per cent more than white women, Indian/African women earned 10 per cent less (Sly 1995).

Table 4.23 Gross weekly earnings, by job levels (base: full-time employees excluding self-employed)

	Whites		Ethnic minorities		Differential	Differential 25–54 years old only	Differential in 1982[1]
		Weighted count		*Weighted count*			
Prof./managers/employers							
Men	£467	*(165)*	£430	*(146)*	-8%	-8%	-18%
Women	£327	*(68)*	£412	*(61)*	+26%	+21%	(+14%)[2]
Other non-manual							
Men	£325	*(112)*	£302	*(172)*	-7%	-8%	-4%
Women	£243	*(209)*	£260	*(355)*	+7%	+3%	+5%
Skilled manual and foremen							
Men	£278	*(170)*	£290	*(198)*	+4%	-3%	-8%
Women	(£183)	*(13)*	(£245)	*(12)*	(+34%)	(+22%)	+11%
Semi- or unskilled manual							
Men	£208	*(85)*	£211	*(229)*	+1%	-6%	-9%[3]
Women	£162	*(55)*	£177	*(117)*	+9%	+7%	+10%

1 Source: Brown 1984.
2 Non-count figures in parentheses denote small cell sizes.
3 Semi-skilled only.

The differentials are of course partly the result of the different job-level profiles of groups. Our sample was not large enough for an analysis of earnings by job levels by each group, but we are able to compare whites and ethnic minorities taken together by the main socio-economic levels in order to investigate a little further as to where the differences lie. This is done in Table 4.23. Earnings are very clearly stratified by job levels (and so any group, such as the Caribbeans, which is under-represented in the highest jobs level will have a lower average), but what is also interesting is that the male ethnic minority disadvantage is only in the non-manual group. In the manual group (in which ethnic minority men are disproportionately represented) (Table 4.10), ethnic minorities have the advantage over white men in semi- or unskilled manual work. More strikingly, however, among women, ethnic minorities earn more than whites at each job level. As before, we need to exercise caution with this finding, given the propensity of women with very low potential earnings to remain outside the labour force altogether.

Table 4.23 also presents the differentials as they were in our 1982 survey. In the whites–minorities comparison the basic pattern across job levels for each sex has held over this time. More generally, there has been an upward movement among ethnic minorities, with men reducing the size of their disadvantage (except for the other non-manual group) and women increasing their advantage.

The finding of 1982 that ethnic minority women full-time employees had higher average earnings than their white counterparts has been criticised for overlooking the fact that many ethnic minority women, especially in the clothing and hosiery industries, are 'homeworkers' (Bruegel 1989; Bhavnani 1994). That is to say, they manufacture items at home, usually on machines bought by themselves, from materials delivered by an employer or contractor, and are paid a piece rate. The rates of pay are extremely poor, so that any sample which under-represents such workers will overestimate the average pay of groups among whom the incidence of homeworking is high. The suspicion that the 1982 survey may have done this is strengthened by some local studies in places such as London, Leicester and Coventry that found the pay of ethnic minority women to be lower than that of white women (Bruegel 1989; Duffy and Lincoln 1990; Gray et al. 1993). We do however, believe that in our national surveys we are comparing like with like, especially as the new survey supports the earlier one.

All the evidence we have suggests that our survey is representative of the populations from which it was drawn. It is therefore most unlikely that we have seriously under-represented homeworkers in our sample. The question, then, is where are they in our analysis? The women in question could have described themselves as self-employed, but far fewer South Asian than white and Caribbean self-employed women work at home. They could have described themselves as part-time employees, but, as we have seen, far fewer ethnic minority than white women work part-time; and as part-time work is not as well paid as full-time work (absolutely, as well as per hour), to include it in the same analysis would depress white women's averages more than that of the ethnic minorities. It is possible that the answers given by some homeworkers have resulted in their being classified either as full-time employees or (as Bruegel 1989, 50–1, suspects in the case of the 1982 survey) as unemployed or economically inactive. If in the former, they are

included in the earnings analysis. If in either of the other categories, provided they did not work full time, their inclusion does not invalidate the comparison of earnings of full-time employees. In any case, the most striking earnings comparison does not affect South Asian women at all, but only Caribbeans and whites.[8]

Influences on earnings

There are, then, differing patterns of earnings between groups and between men and women, and these clearly relate to job levels, age and a number of other factors. However, in order to understand the patterns we need to look at these effects simultaneously. This enables us to establish, for example, whether the observed disparities between different ethnic and age groups can perhaps be explained by different qualification rates between younger and older people in different ethnic groups.

We undertook some simple regression analysis to examine the simultaneous effects on average weekly earnings of age, local unemployment rates, qualifications, social class, fluency in English, presence of dependent children and ethnic origin. These regressions assume that the effect of any one variable, for example age, is the same for all ethnic groups. Small sample sizes preclude separate analysis for the different groups. We recognise that this may be a problem, since the PSI survey of 1974 found that white and ethnic minority male earnings were differently related to age. In 1974 older manual workers were disproportionately represented among the low earners, but, because the ethnic minority population was much younger than whites, minority average earnings appeared to be higher than if age was not taken into account. On the other hand, for young workers, another low-paid group, minority average earnings were higher than for whites. However, since the simultaneous effect of qualifications, family structure and occupational distribution were not considered, the observed differences may not have been related to age as such. In any case, we believe that the advantages of considering several factors together outweigh the disadvantages, and should give a reasonable indication of the factors that are the most important in explaining earnings differences.

Bangladeshis were the only group of men to have lower weekly earnings than other men of the same age with similar qualifications, social class, family circumstances and local labour market conditions (Figure 4.6). The differences between the earnings of all other ethnic minority men and white men could be accounted for by their different occupational pattern, qualifications, family circumstances and age as well as local labour market conditions.

Taking all groups together, the youngest men had the lowest earnings and the over 35s the highest. Living in an area of high unemployment led to lower earnings, as did a poor standard of English (irrespective of the possession of any formal qualifications). All types of qualifications had a positive effect on earnings, but

8 It has further been argued that the female full-time employees' earnings differentials in the analysis of the 1982 data were misleading, for minority women worked longer hours and were not earning more than white women on an hourly pay comparison (Bruegel 1989, 52; Bhavnani 1994, 84). Maybe this was so in 1982, but, as we have seen, the finding of this survey is that ethnic minority women in full-time work do fewer hours than whites (Table 4.19); an hourly pay analysis would widen the gap.

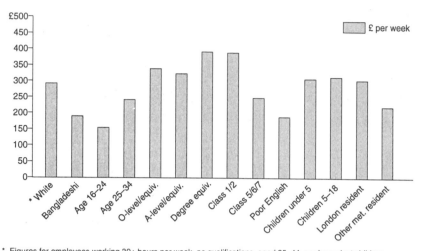

* Figures for employees working 30+ hours per week, no qualifications, aged 35–44, no dependent children, non-metropolitan resident, class 3–4

Figure 4.6 Influences on male earnings

particularly degrees. Those in the highest professional and managerial category earned the most, followed by those in other non-manual and skilled manual employment. Semi-skilled and unskilled manual workers earned the least. Men with children earned slightly more per week than those without.

In 1974, when 25–54-year-old male workers were compared, the earnings of semi- and unskilled minority workers were no different from those of whites. However, for other occupational groups, but especially at professional and managerial level, the white advantage was apparent (Smith 1977, 84–85). When the analysis was replicated a decade later, the white advantage at the highest level considerably narrowed, suggesting that the minorities were making inroads into the highest paid jobs, but slightly widened or remained the same at all other levels (Brown 1984, Table 111). Our findings suggest that the earnings of ethnic minority men, except Bangladeshis, reflect their qualifications and occupational status (although, as we saw earlier, their occupational status is not always commensurate with their qualifications, so that the job level itself may represent the outcome of a discriminatory process). Nonetheless, this is encouraging and suggests that there has been some progress since the early 1980s.

Moreover, it is no longer the case that the pay of ethnic minority men looks comparatively good because of shiftwork. In 1982 part of the explanation for why there was a relatively narrow pay gap between white and minority manual workers was that shiftworkers earned considerably more than other manual workers. White shiftworkers actually enjoyed a greater premium, but because a larger proportion of minority employees worked shifts it raised the latter's average by a larger amount and suggested that the difference in basic wages was greater than in the actual amounts earned (Brown 1984, 168). The situation now, as we saw earlier, is that substantially more Caribbean men than whites and South Asians regularly work shifts. The proportions of shiftworkers among manual workers are in fact very

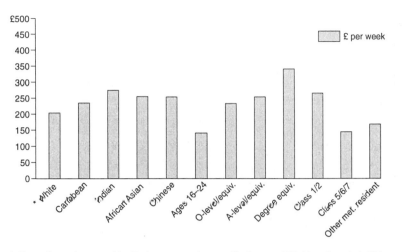

* Figures for employees working 30+ hours per week, no qualifications, aged 35–44, no dependent children, non-metropolitan resident, class 3–4

Figure 4.7 Influences on female earnings

similar, about a third in each group. South Asian male manual workers who never work shifts are the poorest, and those who regularly work shifts earn nearly a quarter more. This is a higher differential for shiftwork than among other groups, but it does not alter the overall pattern, which is that South Asians were the poorest paid shift- as well as non shiftworkers, and Caribbean men were the highest paid in both categories. The earnings advantage of minority male manual workers over white male manual workers is therefore quite independent of shiftwork; it is a reflection of the high earnings of Caribbean men in manual work.

As far as the data on women are concerned, it is more difficult to perform multiple regression to disentangle the effects of different factors such as age, qualifications, job levels, family circumstances and local labour market conditions. For women the difference between weekly and hourly earnings is more important, since it is predominantly a result of the differences in hours worked. Unfortunately, this information was missing in so many cases that we were unable to include it as an explanatory variable. On the other hand, the choice of whether to work full or part time depends in part on the potential rewards from doing so. It is usual in more complex analyses of women's earnings to model the decision to participate in the labour market (and to work full or part time where appropriate) as part of the same process. That is because those with the lowest potential earnings will tend to remain outside the labour market altogether, and the exclusion of their (zero) earnings from the analysis produces an upward bias in the results.

We have not followed this procedure here, mainly because its technical complexity is a deterrent to the general reader, and have confined the analysis to full-time employees. However, it means that the results for women will be biased towards those who have the highest potential earnings, because they are the ones who gain the greatest net advantage from working. In principle, as we are looking at women separately from men, provided those with similar characteristics from all

ethnic groups remain economically inactive, then there will be no effect on the inter-group comparisons. However, if higher inactivity rates for some groups are associated with differential labour market disadvantage, then our findings will tend to understate that disadvantage. As the analysis of women's economic activity rates strongly suggested that the decision to participate in the labour market varied between ethnic groups, the following analysis has to be read with this qualification in mind.

As with men, earnings increased with qualifications and with occupational level (Figure 4.7). Caribbean, Indian, African Asian and Chinese women had higher earnings than those from other ethnic groups of a similar age, and with similar qualifications, job levels, family circumstances and labour market background. The position of Pakistani and Bangladeshi women was not significantly different from that of white women, and this was also true of women with dependent children. However, in view of their low participation rates, those from the former two groups who do have jobs may be unrepresentative. The pattern overall, therefore, is one where there is no apparent earnings discrimination: different groups with similar qualifications doing the same types of jobs in the same areas are paid the same amounts. In fact white women earn substantially less on average than most other groups.[9] The key issue then becomes whether possession of qualifications allows access to better jobs on the same terms as for whites. The analysis of job levels above suggests that it does not always. However, if the differences were large they would be expected to show up in the analysis by increasing the effect (positive or negative) of ethnic group to a point where it becomes statistically significant, and they have not done so (this issue is discussed further below).

These findings, therefore, are encouraging, since they suggest that the apparent labour market advantages of Caribbean women, and the progress made by Indian and African Asian women, are genuine.

In the 1970s it was argued that qualifications did little to improve the earnings prospects of minority groups (Smith 1977, 87). This no longer appears to be true in the 1990s. The possession of qualifications has positive effects for all groups, and the higher the qualification, the greater the impact. This suggests that the strategy pursued by some ethnic minority groups, especially some South Asian groups, of encouraging young people to maximise their qualifications has been the right one, and has been an important factor in the changing pattern of earnings among minority groups. Put at its simplest, higher qualifications double the earnings of Pakistanis and Bangladeshis and enable Indians to catch up with, and African Asians to overtake, white men. They seem to have a similar value for the Chinese. For women the possession of a degree, as compared with A-levels, adds around two-thirds to earnings.

A comparison between the earnings of employees and self-employed is interesting. We will see in the next section that some minority groups have a larger (and some smaller) than average rate of self-employment. It has been argued that, on account of a lack of opportunities in paid employment, partly because of racial

9 For more detailed investigation of comparative earnings, see the follow-up study by Berthoud and
 Casey (forthcoming 1997).

discrimination, some groups have invested disproportionately in self-employment (Aldrich et al. 1981). A consequence may be that the employees' average earnings for those groups are depressed because a higher proportion of qualified and resourceful persons from that group are self-employed. It may also be the case that earnings from self-employment are lower than those from paid employment for those with equivalent qualifications, and so self-employment is confirmed as a second-best option, at least from the point of view of earnings.

Tabler 4.24 Comparison of earnings of full-time employees and self-employed

	White	Caribbean	Indian	African Asian	Pakistani	Bangla-deshi	Chinese	All ethnic minorities
Men								
Employees	£336	£306	£287	£335	£227	£191	£336	£296
Self-employed	£308	(£347)	£361	£321	£232	(£238)	(£466)	£327
Employees and self-employed	£331	£311	£302	£331	£229	£198	£368	£303
Weighted count								
Employees	*541*	*255*	*154*	*152*	*76*	*42*	*72*	*751*
Self-employed	*110*	*33*	*41*	*53*	*44*	*7*	*23*	*202*
Combined	*651*	*288*	*195*	*205*	*120*	*49*	*96*	*953*
Women								
Employees	£244	£267	£363	£254		(£181)	£287	£259
Self-employed	£242	(£349)	(£370)	(£219)		(£251)	(£249)	£290
Employees and self-employed	£244	£270	£268	£251		£189	£274	£262
Weighted count								
Employees	*345*	*278*	*103*	*90*		*34*	*48*	*552*
Self-employed	*46*	*10*	*15*	*9*		*4*	*25*	*64*
Combined	*391*	*288*	*118*	*99*		*38*	*73*	*616*

Figures in parentheses denote small cell sizes.

Table 4.24 compares the earnings of employees and the self-employed. While white male employees earned more than their self-employed counterparts, the reverse was true of ethnic minorities apart from African Asian men. Taken as a whole, self-employed ethnic minority men earned more than whites, and so self-employment, like qualifications, contributes to narrowing the earnings gap,[10] especially for Indians and Caribbeans (and places Chinese men as the highest earners, though the sample is too small for confidence). As with paid employment, ethnic minority women in self-employment on average earned more than their white peers (though the sample sizes are relatively small) and so female self-employment consolidates the earnings advantage of ethnic minority women (except Pakistanis and Bangladeshis). As regards average earnings, self-employment is not a second-best option for the minorities – in fact it is relatively attractive for above-average earners.

10 This is achieved at a cost. A further study of a subset of the sample of self-employed South Asians suggests that they work much longer hours than Asian employees (Metcalf, Modood and Virdee 1996, 88).

SELF-EMPLOYMENT

Between the second and third PSI surveys there was a major growth in self-employment among whites and some minorities. In this period self-employment doubled among South Asians to a point at which they had a higher rate than that of whites and Caribbeans (Brown 1984, 174–5). Subsequently, the Labour Force Survey has consistently shown, as has the 1991 Census, that the economic profile of some minority groups is considerably shaped by self-employment activity. This survey confirms that this is the case. Table 4.25 shows that, as a proportion of the economically active, the Chinese, African Asians and Indians had a greater representation in self-employment than whites; the Pakistanis had about the same proportion as whites, and the Caribbeans and the Bangladeshis about half of that. These were the rates of self-employment, but if we consider the self-employed as a percentage of those who are actually in paid work, a significant variation in the pattern is introduced, namely that the Bangladeshis become almost level with whites, and Pakistanis become the group most dependent on self-employment. This is because of the higher levels of unemployment among Bangladeshis and Pakistanis. A result is that about a third of Pakistani, Indian, African Asian and Chinese men who were in paid work were self-employed. For whites and Bangladeshis it was about a fifth, and for Caribbeans it was nearer one in eight.

Table 4.25 Proportion of persons in self-employment, by gender

cell percentages

	White	Carib-bean	Indian	African Asian	Paki-stani	Bangla-deshi	Chinese	Hindu	Sikh	Muslim
Proportion of economically active										
Men	18	9	25	26	21	10	28	27	25	20
Women	8	2	12	7	8	5	25	12	10	9
Weighted count	*1727*	*1102*	*753*	*555*	*405*	*123*	*257*	*588*	*483*	*614*
Unweighted count	*1603*	*814*	*747*	*491*	*564*	*248*	*143*	*536*	*427*	*940*
Proportion of those in paid employment										
Men	21	14	31	30	35	17	30	30	33	32
Women	8	3	14	8	14	11	26	13	12	15
Weighted count	*1523*	*817*	*624*	*491*	*242*	*68*	*247*	*536*	*388*	*383*
Unweighted count	*1409*	*594*	*616*	*428*	*322*	*125*	*134*	*480*	*345*	*547*

Table 4.25 shows also that, in all groups, women were less likely to be self-employed than men. The gender and ethnic differentials both seem to be operative, for in most groups women had about half the rate of self-employment of the men. Gender and ethnicity seem also to be jointly operative in the exceptions to the common rate. In the ethnic group with the highest rate of self-employment, the Chinese, the women not only had the highest rate of self-employment but one which was very close to that of Chinese men. In the ethnic group with the lowest rate of self-employment, the Caribbeans, the women not only had the lowest rate of self-employment, but one which is only a quarter of that of Caribbean men. The proportion of women in paid

work who were self-employed in 1994 has changed very little since 1982. Female self-employment is, however, directly related to male self-employment. For example, more than half of the married self-employed women had a self-employed spouse.[11] Finally, Table 4.25 shows that, among South Asians, the Hindus have the highest and the Muslims the lowest rate of self-employment, Muslims being only three-quarters as likely to be in self-employment as non-Muslim Asians.

Many people who are self-employed are in fact part of the workforce of a particular employer. They may be a sales representative for just one company and perhaps are even provided with office space om company premises, but are not given employee status and are paid on a commission basis; or they may be working from home but are working for just one employer and possibly under the strict direction of that employer. Up to a fifth of the self-employed were under the overall control of a supervisor or manager from another firm, but this varied between ethnic groups. Interestingly, the groups with the highest proportion of those in self-control were those with the highest rates of self-employment. All the Chinese were in self-control, as were nine out of ten South Asians. Moreover, while the majority of South Asian and Chinese self-employment was conducted from separate business premises, the majority of white and Caribbean self-employment was from customers' premises, from the worker's own home (as when a plumber works from home) or was conducted at home (though the highest proportion conducted at home, a quarter, was by the Chinese).

This suggests that South Asian and Chinese businesses are likely to have a more substantial investment in them, for while some forms of business without separate premises require capital investment, such as the purchase of a car for mini-cab work, the purchase or rental of separate business premises suggests a more substantial business than one conducted on other premises. In relation to the issue of homeworking, it is interesting that less than 10 per cent of South Asian self-employed womem (but more than a quarter of other women) worked at home. This is consistent with the caution expressed elsewhere about the assumption that homeworking is more common among minority than white women (Allen and

11 It has to be noted here, however, that while the findings presented in Table 4.29 are broadly consistent with the results of the Labour Force Surveys and the 1991 Census, there are some differences, primarily that the LFS for 1988–90 shows a much higher rate of self-employment for Pakistani women and for Bangladeshi men (Jones 1993, 92–3). For 1994, the year of our fieldwork, the LFS has not published data separately for Pakistanis and Bangladeshis, but reports their combined rate of male self-employment as 26 per cent (Sly 1995, 257), whereas on our findings it is 18 per cent. The 10 per cent sample of the 1991 Census does not, however, report comparable rates. It recorded a Pakistani self-employment rate of 17 per cent for males and 9 per cent for females, and Bangladeshi rates of 15 per cent for men and 10 per cent for women. That means that, while our findings for the Pakistanis are consistent with the Census and it is the LFS which is discrepant, having overestimated the Pakistani rate of self-employment, our finding for the Bangladeshis under-estimates their self-employment rate by comparison with the Census. While the Census, based on 10 per cent of ideally the whole population, has a much larger sample, OPCS acknowledges that certain categories of 'hard-to-find' people are under-represented. These include ethnic minorities, and perhaps particularly those not able to fill in official forms accurately in English, whom we have endeavoured not to omit. It is possible, therefore, that at least part of the Census overestimation of Bangladeshi self-employment is based on an uneven coverage of the Bangladeshi population.

Wolkowitz 1987, 80), but it may still be the case that South Asian homeworking is less likely to be admitted (Phizacklea and Wolkowitz 1995, 32).

Table 4.26 gives a measure of the size of the economic activity of the self-employed. It shows the distribution of the businesses by the number of employees. Again, those groups with the lowest rates of self-employment were least likely to have employees. Thus, while only a fifth of the Caribbean self-employed had employees, almost half of the Indians and two-thirds of the Chinese did. The Bangladeshis were something of an exception, for while they had a relatively low rate of self-employment, in nearly two-thirds of cases their self-employment involved the employment of staff. The table further shows that, while the large majority of these small businesses employed fewer than five people, the ones most likely to employ more were indeed those of the Bangladeshis (24 per cent), African Asians (15 per cent) and Indians (14 per cent). The last two groups were most likely in our sample to have businesses with more than 25 employees.

Table 4.26 Number of employees

column percentages

	White	Caribbean	Indian	African Asian	Pakistani	Bangladeshi	Chinese
None	71	80	55	56	63	35	36
1 to 5	23	17	31	29	32	40	41
6 to 10	3	1	6	8	2	16	3
11 to 24	4	3	6	2	3	8	0
25 or more	0	0	2	5	0	0	0
Weighted count	*224*	*63*	*140*	*103*	*72*	*11*	*69*
Unweighted count	*199*	*48*	*121*	*84*	*89*	*20*	*35*

Those who are based in customers' premises may be independent contractors such as computer consultants, but it is not unreasonable to suppose that the majority of them are likely to be under the control of a particular employer. If we combine them with those who work to a supervisor we can compare and contrast them with those who are genuinely independent and those who employ staff to get a truer picture of self-employment. While four out of ten self-employed white men and Caribbean men and women were in effect subcontractors, this applies to a much smaller proportion of white women and South Asian men and women (Figure 4.8). More than a third of South Asians and about a quarter of whites were employers, but fewer Caribbeans. While much that might therefore be described as self-employment may not comprise truly independent businesses, this grey status is not associated more closely with groups who are marginal in the labour market. South Asian and Chinese self-employed people are more likely to be fully independent than other groups.

It has to be recognised, however, that ethnic minority self-employment is for the most part located in quite different parts of the economy compared with that of whites. While half of white self-employment is in construction, agriculture and manufacturing, half of minority ethnic self-employment is in retail (South Asians except Bangladeshis) or catering (Chinese and Bangladeshis), though a third of all

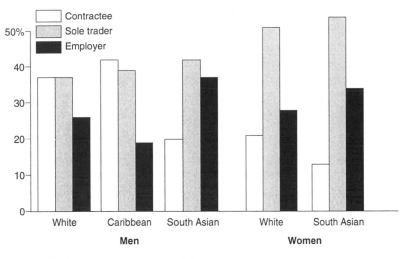

Sample size of Caribbean women too small for analysis

Figure 4.8 Type of self-employment

self-employed Caribbeans were in construction. A fifth of the whites were in the financial sector, as were the Caribbeans and the African Asians, but while only 6 per cent of whites were in the educational and medical sector, Caribbeans, Indians and African Asians were about twice the proportion. One in five of Pakistanis and one in seven of Bangladeshis and Caribbeans were in transportation, primarily as taxi and mini-cab drivers, compared with only 5 per cent of whites.

The highest rates of self-employment for ethnic minorities were not found in the inner city, or even in the large conurbations, the metropolitan areas. In fact it is whites who had their highest rate of self-employment in the inner city areas. Each of the other groups had its highest rate of self-employment away from the large urban areas (Table 4.27). This means that higher rates of self-employment were not located in the areas of higher unemployment. This is confirmed again by Table 4.28, which shows that the ethnic minorities were much more likely to be self-employed if

Table 4.27 Rates of self-employment, by type of area

cell percentages

	White	Caribbean	Indian	African Asian	Pakistani	Bangladeshi	Chinese
Area of residence							
Inner London and metropolitan	15	4	14	19	16	5	14
Outer London and metropolitan	12	6	16	17	16	5	11
Rest of England and Wales	13	8	28	23	23	22	39
Weighted count	*1727*	*1102*	*753*	*555*	*405*	*123*	*257*
Unweighted count	*1603*	*814*	*747*	*491*	*564*	*248*	*143*

they lived in areas of below average ethnic minority density. This was particularly true of African Asians, Indians and Chinese – among whom a third of the economically active in the low minority density areas were self-employed, with the proportion yet higher among men. Local unemployment, therefore, does not seem to be the leading, perhaps not even one of the leading, factors in the rate of self-employment among ethnic minorities, though it may be related to certain forms of self-employment (for a study of why South Asians enter self-employment, see Metcalf, Modood and Virdee 1996). The ethnic minority businesses in the low-density areas were larger and created more jobs: half had employees, compared with only a third among those in above-average minority density areas.

Table 4.28 Rates of self-employment in areas of different levels of ethnic minority residence

	White	Caribbean	Indian	African Asian	Pakistani/ Bangladeshi	Chinese	All ethnic minorities
Areas with up to 5% ethnic minority density	10	11	31	37	19	33	24
Areas with 5%+ ethnic minority density	11	5	18	16	16	23	13
Weighted count	*1727*	*1102*	*753*	*555*	*528*	*257*	*3195*
Unweighted count	*603*	*814*	*747*	*491*	*812*	*143*	*3007*

Consistent with this is the finding of the survey that most ethnic minority self-employment does not involve specialised goods or services associated with the person's own ethnic group or have most of its custom from members of that person's own group. No doubt some forms of self-employment would not be viable without some support from a special ethnic niche, but most minority businesses are more dependent on customers from outside than from within their ethnic group. Figure 4.9 shows that it is only Chinese self-employment which was dependent on specialist ethnic goods or services. This is presumably mainly catering and specialist shops. A significant but much lesser proportion of Bangladeshi and Pakistani businesses were also in this category, but it hardly applied to the other groups at all. Even then, in most of these cases, such as a Chinese restaurant, the customers will not be mainly from the ethnic group of the owner. The ethnic tie between owner and customer is more likely to be apparent if the customer is another business.

The final and perhaps the most important measure of the size of self-employment is income, and this is presented in Table 4.29. Although about two-thirds of all groups except the Indians were willing to state or estimate their pre-tax profits, only about 40 per cent of Indians were prepared to do so. It is worth noting that there is a general tendency for the self-employed to under-record their income in surveys even where they are willing to answer questions about it. The non-respondents were proportionally spread by gender and by business size, except that refusal was more common with those with employees, the more so the larger number of employees. Hence, the analysis almost certainly understates the earnings, especially of South

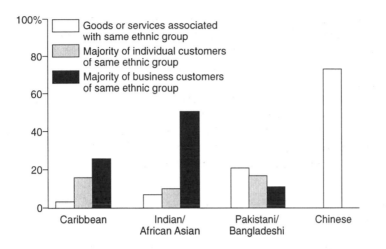

Figure 4.9 Specialist ethnic dimension of self-employment

Asians. As with questions about the earnings of employees, South Asians were more willing to give an answer if an Asian language was used in the interview. As to the earnings, there was in fact relatively little difference between whites and ethnic minorities taken together, except that ethnic minorities were half as likely again as whites to be earning more than £500 per week. There were, however, considerable differences between groups on the basis of the bands in which respondents said their earnings fell. About a quarter of whites and African Asians were earning more than £385 per week, but so were a third of Indians, Chinese and, interestingly, Caribbeans. On the other hand, only an eighth of Pakistanis were (the Bangladeshi sample was too small for analysis but is shown separately because it is too different from the Pakistanis for merging together). A comparison with the earnings of employees (Tables 4.21 and 4.22) suggests that self-employment offered in particular much higher opportunities for earnings over £500 to Indians and Caribbeans (though the sample size is not large in the case of the latter).

Table 4.29 Weekly earnings from self-employment

column percentages

	White	Caribbean	Indian	African Asian	Pakistani	Bangla- deshi	Chinese	All ethnic minorities
Less than £116	19	13	19	18	29	18	16	19
£116 – £192	21	12	12	15	34	16	23	19
£193 – £289	21	21	19	23	9	17	29	20
£290 – £385	16	20	14	17	14	29	0	14
£386 – £500	10	18	11	7	8	10	3	9
More than £500	13	16	24	19	5	10	29	19
Mean	**£288**	**(£347)**	**£364**	**£307**	**£226**	**(£284)**	**(£354)**	**£319**
Weighted count	*156*	*44*	*56*	*62*	*48*	*8*	*48*	*265*
Unweighted count	*142*	*32*	*48*	*49*	*53*	*13*	*23*	*218*
% refusal/can't say	31	31	61	41	34	31	31	43

Nearly two-thirds of the Pakistanis, however, stated earnings below £193, while two-fifths of whites and Chinese did so, a third of Indians and African Asians, and a quarter of the Caribbeans. The mean earnings for Indians, Chinese and Caribbeans were over a fifth higher than those of whites, while for Pakistanis they were a fifth lower than for whites.

The findings strongly suggest, therefore, that, though there may be a strong connection between the rate of self-employment and having no supervisor, having employees and having separate business premises, there is not the same connection between these things and success measured in terms of profits. The Caribbeans had a low rate of self-employment but those who were self-employed had high returns. Conversely, the Pakistanis had a high rate of self-employment but mean low returns. A further implication is that despite some similarities between the main South Asian groups, who by several measures of self-employment are closer to each other than they are to white self-employed, Indians and African Asians on the one hand, and the Pakistanis on the other, are polar opposites in terms of financial rewards. These two important points, the lack of relation between certain key features of self-employment and profits, and the polarity in South Asian profits, are in keeping with the ethnic divide in unemployment and paid employment, and are illustrated in Table 4.30 (for a detailed comparison between these three Asian groups, see Metcalf, Modood and Virdee 1996).

Table 4.30 Comparison of white and South Asian self-employed, by selected indicators

	White	Indian	African Asian	Pakistani
Rate of self-employment	13	19	19	18
Business with 1–5 employees	23	31	29	32
Business with 5 or more employees	7	14	15	5
Separate business premises (incl. van or stall)	37	62	62	70
Involvement of family	41	48	34	47
Mean weekly earnings	**£288**	**£364**	**£307**	**£226**

While self-employment expanded during the period of high unemployment and has grown as unemployment has grown, there is no simple link between the two. For while the rise in the level of unemployment of some groups such as Pakistanis correlates with increases in their self-employment, other groups such as African Asians and Chinese combine a high level of self-employment with low rates of unemployment. Indeed, African Asian men are a group who, having established a high participation in self-employment at an early date (23 per cent in 1982), have

combined continuing success in self-employment, as measured by number of employees and earnings, with success, as we saw earlier, in paid employment. Yet more generally, the view that South Asian self-employment is an 'economic dead-end', 'represents a waste of capital, talent and energy' (McEvoy et al. 1982, 9–10) and results from the desire to avoid unemployment and racial discrimination in the labour market (Aldrich et al. 1981, 175; Jones. McEvoy and Barrett 1994) looks too sweeping in the light of the survey's findings. It is true that unemployment, racism and other 'push' factors seem to be part of the motivation for entry into self-employment for Pakistanis while it is much less significant for African Asians and Indians (Basu 1995; Metcalf, Modood and Virdee 1996), but this is far short of suggestions that the majority of South Asians enter into self-employment because 'they felt they had few alternatives', and entering a family business is almost always a last resort (Ram 1992). For as we saw in the earlier discussion of earnings, the average earnings of ethnic minority men and women, in contrast to whites, are better in self-employment than in paid employment (Table 4.24).

In such circumstances, as much attention needs to be paid to approaches which emphasise cultural factors such as thrift and enterprise, the status that self-employment brings one in some communities, and the kind of community networks which can be utilised to provide business resources such as information, capital, labour, suppliers and credit (Werbner 1990a and 1990b; Waldinger et al. 1990) – in other words, to the 'pull' as well as the 'push' factors. Some studies have found that there is a strong correlation among South Asians between educational qualifications and size of business (Rafiq 1992; Basu 1995). We too found this to be the case, reflecting the fact that while a third of Indian/African Asian self-employed had degrees, less than half that proportion of Pakistanis and Bangladeshis did, and more than four out of ten of them did not have any qualifications. There may, then, be two different kinds of self-employment among South Asians: one closely related to the contraction in employment opportunities for those with few or no qualifications but with the resources of kin and community networks, the other having more the character of small business. If so, Pakistanis and Bangladeshis are much more likely to be in the former category (though their average earnings in self-employment are nevertheless higher than in paid employment), African Asians and Indians in the latter. In a follow-up study we have explored the interaction between the various 'pull' and 'push' factors as they affect different Asian groups with a part of the Fourth Survey sample, and have indeed found that Asian self-employment is far less homogeneous than has been assumed (Metcalf, Modood and Virdee 1996).

EQUAL OPPORTUNITIES AND DISCRIMINATION

For several decades now concern about the extent and nature of racial discrimination in the economy has been central in discussions about ethnic minorities. This topic has been directly explored in the previous surveys in this series and was reinvestigated in the Fourth Survey. At the time of the last survey in 1982, anti-discrimination legislation and the Commission for Racial Equality were in place, but it has been only in the last decade that positive equal opportunity policies have

acquired some prominence. We sought the views of white and minority people on the extent and character, and from minority people details of personal experience of discrimination.

Ninety per cent of economically active white people thought that employers refuse people jobs for racial/religious reasons (Table 4.31). This was more than any ethnic minority group except the Caribbeans, 95 per cent of whom believed that such discrimination existed. About 60 to 75 per cent of most of the other minority groups thought that discrimination in the jobs market existed. The exception was the Bangladeshis, about half of whom thought it existed and nearly a third could not answer the question, perhaps reflecting the group's low participation rate in the labour market. While the analysis is only of the economically active, there is some correlation between a group's belief in discrimination and its economic participation rate, though the Indians and Chinese have a lesser belief than their participation rate might suggest and the Chinese were most likely to give the response that employers do not discriminate.

Table 4.31 Belief about what proportion of employers would refuse someone a job for racial/religious reasons (base: currently economically active)

column percentages

	White	Caribbean	Indian	African Asian	Pakistani	Bangla-deshi	Chinese	All ethnic minorities
Most	5	24	16	13	19	8	7	18
About half	22	31	21	25	20	9	14	24
Fewer than half	44	30	22	29	27	20	22	27
Hardly any	13	4	2	5	2	6	7	4
Some but can't say how many	6	5	4	2	3	8	10	5
None	5	2	16	15	12	21	23	12
Can't say	5	3	19	10	16	29	17	12
Weighted count	*1717*	*555*	*375*	*288*	*237*	*67*	*125*	*1627*
Unweighted count	*1590*	*400*	*370*	*266*	*293*	*131*	*70*	*1524*

While ethnic minority respondents were less likely than white people to believe in the existence of discrimination, it is interesting that the ethnic minorities believed that it was more widespread. Table 4.31 also gives the proportion of employers people believed discriminate. While the Caribbeans were most likely to believe that most employers discriminate, one in five of all ethnic minorities believed this, but only one in 20 whites. Even so, more than a quarter of whites believed that half or more of employers discriminate and more than 40 per cent of the ethnic minorities thought this happened. In general the views of the South Asians were very similar, except for the Bangladeshis, who estimated the lowest levels of discrimination. The Chinese thought more discrimination took place than the Bangladeshis, and were closest in their views to the whites. A further breakdown is not tabulated, but not only did the economically active think that more employers discriminated than the inactive, but the unemployed in all groups, including the Caribbeans, thought that discrimination was less prevalent than the employed.

The answers given mark a significant increase since the previous survey in the belief that employers discriminate, by about a fifth among whites and Caribbeans, and by about a half among South Asians, with an even larger increase in the number of people who believe that half or more employers discriminate (Brown 1984, 219–220). With this increase in perception of discrimination, it is not surprising that over four-fifths of ethnic minority people thought that the present laws on racial discrimination should be enforced more strictly. The same proportion thought that there should be new, stricter laws. These figures were the same for Caribbeans and South Asians and represent a very high level of consensus on the need for political action on racial discrimination. It is perhaps of some interest that the South Asians and Chinese were more likely to concur on the need for stricter laws against discrimination than to state that employers discriminate.

Table 4.32 Persons refused a job for perceived racial/religious reasons (base: those who have ever been economically active)

cell percentages

	Caribbean	Indian	African Asian	Pakistani/ Bangladeshi	Chinese	All ethnic minorities
Perceived discriminatory refusal	28	15	19	5	7	19
Of whom:						
refused more than once	71	67	78	87	49	72
refused in last 5 years	43	39	40	67	32	44
Weighted count	*675*	*469*	*327*	*315*	*151*	*1937*
Unweighted count	*507*	*461*	*296*	*469*	*85*	*1818*

The views of some of the minority respondents were based on personal experience. Table 4.32 shows the number of people who said they had been refused a job for a reason to do with their race or religion. A fifth of those who had ever been economically active thought this had happened. Few Bangladeshis and Chinese reported this experience, while over a quarter of the Caribbeans thought this had happened to them. Again (though not presented in the table) the unemployed were less likely to report discrimination than those in employment. About three-quarters of those who reported suffering racial discrimination in seeking work thought this had happened to them more than once, the South Asians, except the Indians, being more likely than the others to think so. Nearly half said that the most recent time they believed this had happened to them was in the previous five years. This was less so for the Chinese, but two-thirds of Pakistanis and nearly all of the Bangladeshis said that their (last) experience of discrimination was in this recent period. Also consistent with the increase in perceptions of discrimination, it is interesting that taking the minorities together, reported discrimination varied little by age, even though the different age groups had spent a varied number of years in the labour market. In fact, younger Caribbeans were more likely to have perceived discrimination than their elders; among Indians it was the oldest workers and among the other South Asians it was the middle age group, those 35 to 49 years old. There

was a very slight increase in the reports of these perceived acts of discrimination among the Caribbeans in comparison to 1982, but about a 50 per cent increase among South Asians (Brown 1984, 218).

On the whole, then, the belief that employers discriminate is much more widespread than the experience of discrimination; increases are shown in both categories, but the increase in belief is larger. This is not surprising. Testing for discrimination has shown that most acts of discrimination take place without individuals knowing they have been discriminated against (Brown and Gay 1985). As awareness of discrimination grows, it will be the case that the knowledge that it exists will outstrip the actual experience of it. Individuals may also be more likely to attribute discriminatory motives than before. So increases in reports of discrimination are compatible with stable, or even, declining levels of discrimination. Objective tests suggest that the proportion of white people who are likely to carry out the most basic acts of discrimination has been stable at about a third for several decades (Daniel 1968; Smith 1977; Brown and Gay 1985; Simpson and Stevenson 1994). Nor is there any simple correlation between the reports of discrimination and socio-economic disadvantage. Despite their socio-economic difference, South Asians reported comparable levels of discrimination, except that the Bangladeshis, despite (or because of) being the most disadvantaged, reported very little discrimination. Yet the Caribbeans, whose economic position is in the middle range, were seven times as likely to report discrimination as the Bangladeshis.

The fact that these reports have increased in a period when the position of minorities has generally improved, and that the groups in which they have increased the most are those which have made the most progress, suggests that reports of discrimination may be linked to an awareness of the issue and whether the climate of opinion is receptive to such reports. A climate in which equal opportunities issues are being addressed may, at least initially, increase complaints of discrimination and perceptions about the prevalence of discrimination. Moreover, the experience of discrimination may be more linked to competition for prized jobs than relative disadvantage *per se*. For a precondition of the encounters in which discrimination may occur is competition for the same jobs, and that assumes some commonality in qualifications, skill levels and employment experience. As ethnic minorities become more effective competitors for more prized jobs and professions, the salience of the issue of discrimination may, ironically, increase.

Respondents who reported discrimination were asked whether they thought the refusal of the job(s) was on account of their race or their religion, or due to both of these. Three-quarters of the Caribbeans and half of the South Asians thought it was because of their perceived race (Table 4.33). Very few thought it was a result of their religion alone, though one in ten of the Pakistanis/Bangladeshis, and, interestingly, nearly the same number of Caribbeans did, while fewer Sikhs and no Hindus believed this was the case.

The most interesting finding, however, is that a quarter of all the ethnic minority persons who believed that they had been discriminated against in a job application believed that it was for a mixture of reasons to do with their race and religion. In fact over 40 per cent of South Asians, evenly spread across ethnic and religious groups believed this combination of reasons to be operative. Moreover, younger South

Asians were more of this view than the older age groups. This suggests that, for South Asians, the idea of racial discrimination is of a more complex character than it is in many equal opportunities policies, in which it is assumed that racial discrimination is unfair treatment simply of 'people of colour'. Moreover, the perception of South Asians that their religion is relevant to their experience of racial discrimination is not to do with an older generation with limited encounters with British society, but seems to be on the increase. These matters relate to the place which South Asians give to colour and religion in their definition of themselves, and in how they think white people perceive them, as will be discussed in Chapter 9, the chapter on ethnic identity.

Table 4.33 Perceived reasons for the refusal of a job

								column percentages
	All ethnic minorities	Caribbean	Indian	African Asian	Pakistani/ Bangladeshi	Hindu	Sikh	Muslim
Race	65	75	55	51	48	51	51	51
Religion	6	8	2	1	11	–	5	7
Both of these	26	15	37	40	39	38	44	39
Can't say	3	2	6	6	2	9	2	2
Weighted count	*400*	*203*	*70*	*67*	*50*	*69*	*45*	*55*
Unweighted count	*339*	*148*	*67*	*56*	*62*	*56*	*100*	*99*

Here, however, we can pursue further the topic of what people think is the basis of hostility against minority groups. We asked all groups which racial, ethnic or religious group faces most prejudice today. They could give any answer they chose, but they had to name just one group. The answers are presented in Table 4.34. What is really interesting is the contrast between how whites and Caribbeans, on the one hand, identify the victim group, and how the victim group is identified by the others. For whites and Caribbeans the victim group is identified as 'Asians'. Yet, except for the Bangladeshis (the majority of whom were not able to answer the question), the South Asians do not primarily think that the prejudice directed against them is aimed mostly at their Asianness. Almost twice as many Indians/African Asians and three times as many Pakistanis think that Muslims face the most prejudice as think that Asians do. The Chinese too were of the view that Muslims as a group face more prejudice than Asians as a group, but they were exceptional in identifying 'black' people, people of African descent, as the group which faces the most prejudice (considerably more so than the Caribbeans did).

The point here is that there is now a consensus across all groups that prejudice against Asians is much the highest of any ethnic, racial or religious group; and it is believed by Asian people themselves that the prejudice against Asians is primarily a prejudice against Muslims. To date, however, there has been virtually no research on religious discrimination in Britain, nor on how perceptions of religion and race interact to create distinctive forms of prejudice (e.g. stereotypes about 'fundamentalist Muslims') and discrimination. It had been assumed that religious discrimination is quite separate from racial discrimination and is confined to

Protestant-Catholic relations in Northern Ireland.[12] Indeed, the UK legislation against religious discrimination is strictly confined to Northern Ireland and does not extend to mainland Britain. In recent years, however, it has been argued that anti-Muslim prejudice is a central and growing strand of racism (Modood 1992), and the Commission for Racial Equality and others have asked the Home Secretary to revise anti-discrimination laws so that they can more effectively protect ethno-religious minorities (CRE 1991; UKACIA 1993; Runnymede Trust 1996, 11–12). Perhaps it is equally important to note that as many Sikhs and Hindus as Muslims who reported having been discriminated against in recruitment thought their religion was a factor held against them.

Table 4.34 Views on which racial, ethnic or religious group faces most prejudice today

column percentages

	White	Caribbean	Indian/ African Asian	Pakistani	Bangla- deshi	All South Asians	Chinese	All ethnic minorities
Asians	32	37	11	11	10	11	10	19
Muslims	10	8	19	30	5	21	12	16
Pakistanis	12	2	1	4	1	2	5	2
Indians	3	3	1	–	–	1	1	2
Bangladeshis	–	1	1	1	6	1	–	1
Caribbeans/Blacks/ Africans	14	19	10	3	4	8	30	13
Some other answer	10	8	17	13	17	14	13	13
Don't know	21	23	40	38	57	41	29	34
Weighted count	*2867*	*783*	*1037*	*420*	*138*	*1595*	*195*	*2574*
Unweighted count	*2867*	*614*	*988*	*584*	*289*	*1861*	*104*	*2579*

Employees had a more positive view of their own employer than they did of some other employers. Nearly half of the ethnic minority employees felt that 'there are real equal opportunities for everyone regardless of race, colour, or religious or cultural background' where they worked. Those under 35 years old were more likely to believe they had personally experienced discrimination and that there were equal opportunities where they worked.

There were also some interesting contrasts in the answers between those who worked in the private and the public sectors. There was in fact no real difference between whites and ethnic minorities combined, or between men and women. Yet there were considerable differences between the views of the minorities. For example, much larger proportions of African Asian, Pakistani and Bangladeshi men in the private sector thought there were equal opportunities where they worked than did Caribbean and Indian men. Within the public sector, South Asian and Caribbean women took radically different views: only a third of Caribbean but two-thirds of South Asian women thought there were real equal opportunities where they worked. However, one area within the public sector where the ethnic minorities took one view, but white people quite another, was in health: three-quarters of white

12 Interestingly, in Britain, prejudice against a religious minority does not seem to be connected to a strong religious affiliation. The survey found that people who said religion was important to them were much less likely to say that they were prejudiced against ethnic minorities or Muslims.

employees but only a third of the minority employees thought there were equal opportunities in their health authority or hospital. Indeed, of the 32 Caribbean women employees in this sector, 25 denied there were equal opportunities where they worked. This is particularly worrying as the health services are a major employer of ethnic minorities, but is entirely consistent with the results of a large-scale PSI study of the experiences of nurses (Beishon, Virdee and Hagell 1995).

TRADE UNIONS

We also examined participation in and satisfaction with trade unions. Among both men and women, all minority groups except the Pakistanis/Bangladeshis had a higher rate of membership than white people (Table 4.35). The highest rate of membership, approaching half, was among the Caribbeans, though it was also high among the Indians. Nevertheless, in our sample, fewer Caribbean men held an elective post in their union than whites or South Asians, though there were no differences in the case of women. There has been a decline in the level of membership across the board, especially male, since 1982, but an increase in numbers of post-holders, especially among South Asians (Brown 1984, 217). It is not tabulated here, but the youngest are least and the oldest most likely to be members; workers over the age of 50 are about three-quarters as likely again to be members as those under 35, the steepest ratio, of nearly 1.2, being among the Caribbeans. Figure 4.10 shows the rate of membership at different job levels. The pattern is similar across groups, though the semi- and unskilled Caribbeans and Indians were disproportionately members, and the South Asian professionals and managers were disproportionately not members.

Table 4.35 Participation in trade unions/staff associations

cell percentages

	White	Caribbean	Indian	African Asian	Pakistani/ Bangladeshi	All ethnic minorities
Membership						
Men	35 (57)	46 (64)	45 (S Asian: 59)	37	(22)	40
Women	29 (34)	47 (57)	33 (S Asian: 38)	29	(24)	39
Elected post holder				**All South Asians**		
Men	9 (6)	5 (2)		9 (3)		8 (3)
Women	4 (2)	4 (2)		5 (2)		4 (2)
Men						
Weighted count	*623*	*147*	*122*	*118*	*83*	*496*
Unweighted count	*569*	*103*	*134*	*108*	*131*	*491*
Women						
Weighted count	*672*	*239*	*111*	*74*	*35*	*502*
Unweighted count	*636*	*175*	*111*	*69*	*37*	*418*

Figures in parentheses are for 1982.

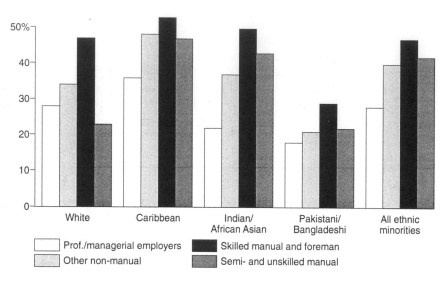

Figure 4.10 Trade union membership, by job level (base: employees)

As might be expected, the rate of union membership was much lower in the private sector. More than half of men and women in the public sector were members, but only just over a quarter of men and a sixth of women in the private sector were members. As a bigger proportion of women work in the public sector (Table 4.21), this had the effect of narrowing the differential rates of membership between men and women, which were quite considerable in the private sector. Ethnic minority women have a much lower rate of membership in the private (18 per cent) than the public sector (59 per cent), and this is especially so among low paid private sector workers. In recent years concern has been expressed that the employment legislation of the last decade and a half has not just weakened trade unions in general, but in particular has left ethnic minorities and women, and especially ethnic minority women, in low-paid unregulated employment, under-unionised and vulnerable (Wrench and Virdee 1995). Table 4.36 shows that, in our survey, low-paid private sector workers were less likely to be union workers than average and above-average paid workers, but this was not just the case with women (who of course are more likely to be low earners) or people from ethnic minorities. Union membership rates for white people were the lowest of all.

Table 4.36 Trade union membership in private firms by earnings (base: full-time employees)

cell percentages

	Men		Women	
	White	Ethnic minorities	White	Ethnic minorities
% of members in weekly earnings band				
Less than £192	15	24	18	23
£193 – £385	34	39	23	35
More than £386	30	30	*	*

* denotes small cell sizes.

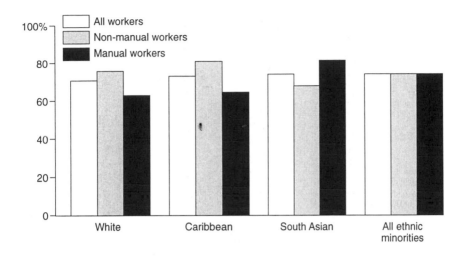

Figure 4.11 Satisfaction with trade union/staff association
(base: trade union/staff association members)

While Asian and Caribbean workers have been more likely than whites to be trade union members, and this is still the case, there is evidence that increasingly minority members feel that their union is not sufficiently committed to racial equality in the workplace, or in the union itself (Virdee and Grint 1994). The 1980s witnessed the emergence of self-organised black groups within some unions, demanding the right to be a forum through which the concerns of non-white workers could be discussed and promoted within the union and ultimately the TUC. This was a movement primarily within white-collar public sector unions, most notably the local government union, NALGO (now merged into UNISON), which was the first to hold a national black members' conference (NALGO 1986). We were, therefore, particularly interested in the satisfaction that ethnic minority trade union members had in their union, and the extent of support there might be for self-organised black workers' groups.

Over 70 per cent of members were satisfied with their union or staff association, more or less evenly across groups (Figure 4.11). Whereas Caribbean and white non-manual workers were more likely to be satisfied with their union, South Asians were least likely. So although office-holding among South Asians has increased considerably and South Asian manual workers were particularly satisfied with their unions, South Asian non-manual workers had the lowest rate of membership and, among members, the highest rate of dissatisfaction. While there is no clear evidence that non-manual ethnic minority union members are the more likely to be dissatisfied, there was a strong level of support for the idea of autonomous black and Asian workers' groups. As Figure 4.12 shows, just over half of the ethnic minorities questioned supported the idea of such groups, support being yet higher among those in work, both in manual as well as in non-manual work.

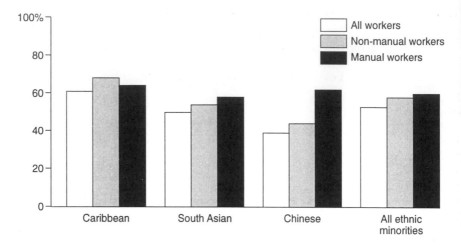

Figure 4.12 Support for autonomous black and Asian workers' groups

UPWARD MOBILITY AND RACIAL DISADVANTAGE

The findings of this chapter depict a pattern of inequality, but also of a divergence in the circumstances of the main minorities. Many aspects of this diversity are not new. The radically differing economic-educational profiles of African Asians and Indians on the one hand, and Pakistanis and Bangladeshis, on the other, were apparent in the 1970s (Smith 1977). They were somewhat obscured in the 1980s, when attention came to be focused on the disproportionate impact of unemployment upon the ethnic minorities and there was a tendency to overgeneralise from the condition of the worst-off groups to the minorities as such; the 'black–white' divide therefore seemed to dwarf other distinctions. Now that the differences between minorities seem as evident as the similarities, it is worth examining whether the differences are consistent over time, and, if not, whether they are narrowing or widening. Are some groups experiencing more mobility across job levels than others?

Table 4.37 presents male job levels as found in the 1982 PSI survey of ethnic minorities and as found in this survey. For the sake of comparison with 1982, the self-employed are not included. The Figure shows that the period 1982 to 1994 was one of structural change and that all groups, though in differing degrees, participated in the change. The main change is an upward occupational shift. In 1982 a fifth of white and African Asian male employees who were in work were in the top employment category. In 1994 it was over a quarter, though with whites overtaking the African Asians. The Caribbeans and Indians, starting from a much lower base, have roughly doubled their representation in the top category of employees, but the mobility of Pakistani employees has been more modest and for Bangladeshis it may even have been proportionately downwards. There are no 1982 data for the Chinese

Table 4.37 Job levels of male employees, 1982 and 1994[1]

column percentages

	White		Caribbean		Indian		African Asian		Pakistani		Bangladeshi		Chinese
	1982	1994	1982	1994	1982	1994	1982	1994	1982	1994	1982	1994	1994
Professional/ managerial/ employers	19	30	5	11	11	19	22	26	10	14	10	7	41
Other non-manual	23	21	10	20	13	28	21	31	8	18	7	22	26
Skilled manual and foremen	42	31	48	37	34	23	31	22	39	36	13	2	5
Semi-skilled manual	13	14	26	26	36	22	22	17	35	28	57	65	20
Unskilled manual	3	4	9	6	5	7	3	3	8	4	12	4	8
Non-manual	**42**	**51**	**15**	**31**	**24**	**47**	**43**	**57**	**18**	**32**	**17**	**29**	**67**
Manual	**58**	**49**	**83**	**69**	**75**	**52**	**56**	**42**	**82**	**68**	**82**	**71**	**33**

1 For the sake of comparison with 1982, the self-employed are not included.

but our survey confirms the Census records that, of the groups under discussion, the Chinese are most represented in professional and managerial employment.

For all groups other than Pakistanis there has been a contraction in work for skilled manual employees and foremen. For all the minorities junior and intermediate non-manual work has grown rapidly, and for Indians, African Asians and Pakistanis the proportion engaged in semi- and unskilled manual work has declined. With the exception of the African Asians, in 1982 about four-fifths of employed South Asian and Caribbean men were in manual work; now it is about two-thirds. The group whose employment profile has shifted most substantially in this period are Indian men. At the start of the 1980s they were preponderantly in manual work, like the Caribbeans, Pakistanis and Bangladeshis. However, while these three groups are still largely in manual work, the Indian profile is now much closer to that of the whites, African Asians and Chinese.

A good way of capturing this lessening of disadvantage among male employees is by scoring the job levels on a common scale. An average can then be derived for each ethnic group for 1982 and 1994 and the degree of movement measured. This has been done, and is presented in Figure 4.13, from which can be seen that all the minority groups made more relative improvement in this period than whites, though only African Asians have achieved parity with whites (the Chinese are best off in 1994 but, again, there are no 1982 data for them).

It is worth reminding the reader that, in this period, there has also been a growth in self-employment. Moreover, this too has benefited ethnic minority men, both within the non-manual and the manual job levels self-employment marks an upward movement for this group. Most of this self-employment, as we have seen, is not of a nominal kind – for example, masking under-employment or employment arrangements whereby employers contract out work to (former) employees.

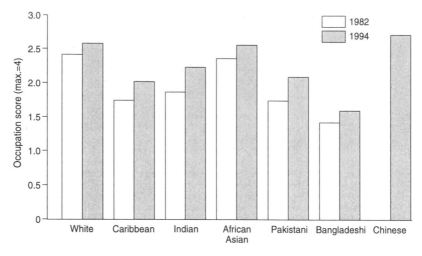

Based on average job-level score derived from the following scale: 4: Professional, managerial, employers;
3: Other non-manual; 2: Skilled manual and foreman; 1: Semi-skilled manual; 0: Unskilled manual

**Figure 4.13 Relative improvement in job levels of male employees between
1982 and 1994**

Table 4.38 Job levels of full-time female employees, 1982 and 1994

column percentages

	White		Caribbean		Indian		African Asian		Pakistani	Chinese
	1982	1994	1982	1994	1982	1994	1982	1994	1994	1994
Prof./managerial/ employers	7	21	1	4	5	3	7	14	7	38
Intermediate and junior non-manual	55	58	52	76	35	61	52	66	60	55
Skilled manual and foremen	5	3	4	2	8	2	3	3	3	–
Semi-skilled manual	21	17	36	18	50	32	36	17	29	7
Unskilled manual	11	1	7	1	1	3	3	–	–	–
Non-manual	**62**	**79**	**53**	**80**	**40**	**64**	**59**	**80**	**67**	**93**
Manual	**37**	**21**	**47**	**21**	**59**	**37**	**42**	**20**	**32**	**7**

The women's pattern of movement across job levels has some parallels with that of
the men, especially in the growth of non-manual work, which has been greater for
women than men, and for some minorities more than white women (Table 4.38).
Taking full-time employees only, while all women continue to have a smaller
proportion than men in the professional, managerial and employers category, there
has been a significant increase among white women. The position of African Asian
women seems to be slightly better than in 1982, but the other minority women are
much more poorly represented in this category, and Indians possibly less so than a
decade ago. The exception are the Chinese, who were not included in the 1982
survey, but who were very much concentrated at the top end of the job levels in

1994.[12] Intermediate and junior non-manual work has grown substantially since 1982 for all minority groups for whom data allows a comparative analysis, and Caribbeans, Indians and African Asians are now disproportionately in this category. Pakistani and Indian full-time women employees are still, however, disproportionately manual workers, especially at the semi-skilled level (they, together with Chinese women, are more likely to be skilled manual as self-employed rather then employees). Our findings, then, about job levels are consistent with the general trends of upward mobility, and from manual into non-manual work, identified in successive Labour Force Surveys (Jones 1993) as well as in the 1991 Census, although they are not as sanguine about the presence of Pakistani and Bangladeshi men, and ethnic minority women in general, in the top jobs category. The general pattern, however, is one of declining differentials between whites and the main ethnic minority groups, as has recently been argued in an analysis which compares LFS data for 1966 with 1991 (Iganski and Payne 1996). This has happened, as Iganski and Payne point out, during a period of substantial growth in the numbers from these groups in the labour market, and so the gains have had to be sustained for many more people (Iganski and Payne 1996, 118). Moreover, given, as we saw in the previous chapter, that all the ethnic minorities have higher, sometimes much higher, levels of participation in post-compulsory education and increasing levels of admission into higher education, it is most likely that the minorities will continue to improve their relative position in the economy. The differentials between minorities may also become more pronounced as some groups consolidate the advantaged profile they have begun to develop.

If today the ethnic minorities cannot be described collectively as being disproportionately confined to low-skill, low-paid work, it is largely because they are returning to their pre-migration occupational levels. It is sometimes asserted that migrants 'have tended to be from the poorest and most underprivileged groups of their countries of origin' (Anthias and Yuval-Davis 1992, 77). This is almost certainly not the case. An analysis of 1972 data from the Nuffield Social Mobility Survey found that nearly a quarter of the non-white migrants had professional-class origins, predominantly higher professional, which was twice the proportion of the native English; and more than half had social origins in either the petty bourgeoisie or the farming classes (the figure for the English was 16 per cent) (Heath and Ridge 1983). The analysis shows that there was, however, a serious downward social mobility as people of professional origins failed to secure professional posts, and the petty bourgeoisie was 'proletarianised': children of self-employed traders, artisans and farmers met the demand for labour in British factories (Heath and Ridge 1983).

12 The reader will recall that the presence of Indian, and to a lesser extent Pakistani, women in the top non-manual category was very much because of their self-employment, as was seen in Table 4.13. A further difference between the two tables is that the analysis under consideration (Table 4.38) is only of full-time employees. This makes a significant difference to the profile of white women, for not only are they more likely to be in part-time work, but as most white women in manual work are part-timers (as we saw in Table 4.14), analysis of only full-time workers increases white women's comparative representation in non-manual work, especially in the top category. The opposite proved to be the case for Indian women in our survey: an usually high proportion of Indian women employees in the top jobs category were part-timers.

Earlier PSI studies, too, found that the initial effect of migration was downward social mobility, as the overwhelming majority of migrants could get only manual work; this included persons with academic qualifications, even degrees, and who may have been in white-collar work before migration (Daniel 1968, 60–61; Smith 1977). Studies in other countries, such as the USA, with large immigrant populations have found similar patterns. We have seen in this survey that, among the first generation, Indian men were among the most qualified, and one might conjecture, therefore, suffered particularly from the racial bias operating in entry into non-manual work. The initial downward mobility was accepted because it still offered much higher earnings than were available in the countries of origin, but it is not surprising that those individuals who have been able to surmount the proletarian character ascribed to migrant labour and their families should have endeavoured to do so. It is, therefore, not inappropriate to see the above-average upward social mobility among some minorities as a process of reversal of the initial downward trend produced by migration and racial discrimination in the early years of settlement in Britain.

Table 4.39 Employment disadvantage of ethnic minority men[1]

	Chinese	African Asian	Indian	Caribbean	Pakistani	Bangladeshi
Employers and managers in large establishments	0.5	0.3	0.5	0.5	0.3	0.01
Professionals, managers and employers	1.5	1.0	0.8	0.5	0.6	0.6
Supervisors	0.9	0.8	0.6	0.7	0.4	0.4
Earnings	1.0	1.0	0.9	0.9	0.7	0.6
Unemployment rates	0.6	0.9	1.3	2.1	2.5	2.8
Long-term unemployed[2]	–	(1.6)	3.1	5.9	7.7	7.7

1 Disadvantage is expressed as a relation to white men, who are taken to represent 1. A figure below 1 gives, therefore, the degree of under-representation in that category compared with whites. The figures include the self-employed.
2 Those unemployed for more than two years as a proportion of economically active in the ethnic group, relative to white men.

There is, then, an overall trend of progress in the job levels of ethnic minorities and a narrowing of the differentials between the ethnic majority and the minorities. We saw the same trend in the earlier analysis of earnings. Yet this certainly has not developed to a point where there is an ethnic parity or where the concept of racial disadvantage is redundant. Table 4.39 sets out the extent of the employment disadvantages of ethnic minority men compared with white men. Six key indicators of advantage/disadvantage have been chosen out of the previous analyses from this chapter. The figures in Table 4.39 are derived from treating the position of whites as a baseline against which the minorities are given a score. Where the positions are the same, this is represented by a 1; where a minority group is under- or over-represented relative to whites, a figure is given showing the scale of the representation in relation to whites. Table 4.39 shows that most, but not all, the groups are still disadvantaged, but not evenly so. There is in fact only one

circumstance in which all the minorities are disadvantaged: they are all substantially under-represented in the most elite jobs, namely as employers and managers in large establishments. This could be said to be a 'glass-ceiling' that affects all non-white men equally.

Beyond that, the differences between the minorities are as important as their position in relation to whites. For, by the rest of the measures, the Chinese are more advantaged than whites, and the African Asians are broadly similar to whites. The Indians are somewhat disadvantaged, but are closer to whites than to the remaining three minority groups, who, despite any progress they may have made, continue to be significantly disadvantaged. Caribbean men at some points are in a similar position or more advantaged than Indians but are significantly more disadvantaged in relation to job levels and unemployment. The Pakistanis are in all respects more disadvantaged than the Caribbeans except that owing to their much higher level of self-employment, which as we have seen yields on average low incomes, they score slightly higher for presence in the professional, managerial and employers category. Finally, the Bangladeshis are as a group the most disadvantaged. Ethnic minority men fall, therefore, into two broad groups, those who are close to parity with whites (the Chinese, African Asians and Indians) and the others who are significantly disadvantaged. It is also possible to represent these six groups of men in three bands, with the Indians and Caribbeans occupying the middle band.

Table 4.38 Employment disadvantage of ethnic minority women[1]

	Chinese	African Asian	Indian	Caribbean	Pakistani	Bangladeshi
In paid work[2]	1.1	1.0	1.0	0.9	0.3	0.1
Professionals, managers and employers	1.9	0.3	0.8	0.7	0.8	–
Higher and intermediate non-manual	1.4	0.9	0.7	0.8	1.1	–
Supervisors	1.1	1.1	0.8	0.6	0.6	–
Earnings	–	1.1	1.0	1.0	–	–
Unemployed	0.7	2	1.3	1.3	4.3	4.4

1 Disadvantage is expressed as a relation to white women, who are taken to represent 1. A figure below 1 gives, therefore, the degree of under-representation in that category compared with whites. The figures include self-employed.

2 Proportion in paid work based on all women aged 16–60 not in retirement, full-time education or long-term illness.

Table 4.38 offers a similar analysis of employment disadvantage for women. The key measures used in this table are not the same as those used for men but reflect the fact that the low participation rate of some groups of women is an indicator and source of disadvantage. Moreover, too few women are managers and employers in large establishments to generate large enough sample sizes for analysis. Table 4.38 shows that the scale of differentials between women of different ethnic groups is much smaller than is the case for men, but otherwise the ethnic groups are stacked up in a similar order as for the men. There are, however, two distinctive features in the comparative circumstances of women. Firstly, the low economic activity rates for

Pakistani and Bangladeshi women create a division between these groups of women and all others which does not exist for men. It could though be said to have some parallel with the high levels of Pakistani and Bangladeshi male unemployment, which also exist among women from these groups. What both Pakistani and Bangladeshi men and women have in common is very low levels of paid work, especially as employees (though, as has been noted, there is a strong anecdotal impression that many self-declared economically inactive women from these groups are engaged in homeworking for the clothing industry). The second difference in employment disadvantage between men and women is that the position of Caribbean women relative to white and other women is much better than that of Caribbean men. While Caribbean women are grossly under-represented in the top jobs category and have a high rate of unemployment, they are strongly represented in intermediate non-manual work, and as a result have an above average share of supervisory posts and above-average earnings.

If we combine the position of the sexes, the position of the minorities in employment relative to whites seems to fall into three bands:

(i) disadvantage confined to top jobs in large establishments: the Chinese and African Asians;
(ii) relative disadvantage: the Indians and Caribbeans;
(iii)severe disadvantage: the Pakistanis and Bangladeshis.

ETHNIC PENALTIES

Racial disadvantage, then, continues to be a fact, even if it does not apply to all ethnic minority groups. Moreover, this disadvantage is attributable partly to discrimination in employment. Controlled tests, whereby white and ethnic minority persons respond to advertised vacancies for which they are equally suitable, have been conducted since the 1960s and tend to reproduce the result that at least one third of private employers discriminated against Caribbean applicants, Asian applicants or both (Daniel 1968; Smith 1977; Brown and Gay 1985; Simpson and Stevenson 1994). Discrimination is found not just in face-to-face encounters, or in telephone calls, but also in tests using written applications where it is clear from the applicant's name or biographical details that they are or are not white (Noon 1993; Esmail and Everington 1993). The Commission for Racial Equality continues every year to publish findings of direct or indirect discrimination in the practices of specific employers, and sometimes whole professions or industries, such as accountancy (CRE 1987) or hotels (CRE 1991). The number of complaints of racial discrimination made by individuals to the CRE and to industrial tribunals has risen over the years (CRE annual reports), and we have seen earlier in this chapter that the belief that some employers discriminate is held by 90 per cent of white people and three-quarters of minority ethnic persons. One in five of the minority ethnic respondents said they had been refused a job on racial grounds, nearly half of whom had had this experience at least once in the previous five years.

One of the alternative ways of relating the socio-economic diversity of ethnic minorities with the idea of racial discrimination and disadvantage is to argue that all

non-white groups, regardless of qualification and the position of groups in the jobs hierarchy, suffer 'an ethnic penalty' (Heath and McMahon 1995). 'Ethnic penalty' refers to 'all the sources of disadvantage that might lead an ethnic group to fare less well in the labour market than do similarly qualified whites... although discrimination is likely to be a major component' (Heath and McMahon 1995, 1). Heath and McMahon submitted data from the 1991 Census to a logistic modelling, in which age and qualifications were strictly controlled, and found that male migrants with higher level qualifications in groups that appeared to be successful in the jobs market such as the Chinese and African Asians/Indians were significantly less likely to be employees in higher or intermediate non-manual work than either British-born white people or Irish-born migrants. While the African Asians/Indians and Chinese were more successful than the other groups of non-white men, nevertheless 'their high qualifications effectively masked their difficulty in gaining access to the salariat' (Heath and McMahon 1995, 18). Migrant women from non-white groups were even more likely to pay an 'ethnic penalty', except for the Caribbean women, who were more successful than Irish-born women.

Heath and McMahon went on to carry out the same logistic regression for the British-born members of the various ethnic groups. Again, while there were differences between groups, there was a clear tendency for second-generation non-white men and women to pay significant ethnic penalties in the competition for the better non-manual jobs. Moreover, the advantage that the first-generation Caribbean women had is not repeated for the second generation, leading Heath and McMahon to suggest that the first-generation pattern was owing to rather special recruitment efforts by the National Health Service to secure nurses from the Caribbean (Heath and McMahon 1995, 26). They conclude, therefore, that, for non-white groups, being born in this country is not associated with any improvement in competitive chances, for 'the second generation experienced the same pattern and magnitude of ethnic penalties in the British labour market as the first generation did' (Heath and McMahon 1995, 29).

There may, then, be a declining racial difference in outcomes, as demonstrated by Iganski and Payne (1996), which as they suggest may be owing to an increase in the supply of the better non-manual jobs and to more 'open', 'meritocratic' competition, but it may still be the case that even the 'over-achieving' groups are being 'under-rewarded' – that is to say, that typically, for the more competitive posts, ethnic minority individuals have to be not just as good but better than their white competitors in order to get the job.

EXPLAINING DIVERSITY

The fact of an ethnic penalty, which Heath and McMahon emphasise includes probably the effects of discrimination but also other forms of disadvantage, suggests that there might be a greater degree of commonality among the non-white groups than the data might at first suggest. Yet, even after controlling for birth in Britain, age and qualifications, Heath and McMahon found that the chances of entry into the salaried posts varied between non-white groups. Black Africans, a group not included

in our survey, have only about one-third of a chance of success as their white peers, while 'Black-Other' (mainly people of at least part Caribbean ancestry who prefer a self-description such as 'Black British' which does not refer to the Caribbean) have almost the same chance as whites, with African Asians/Indians and Pakistanis in between these two groups (Heath and McMahon 1995, 30; the Chinese and Bangladeshi samples were not large enough to be included in this analysis). A similar analysis using LFS data from the 1983–89 surveys also showed diversity in its results: for example, the Chinese suffered no ethnic penalty, the African Asians a small one, but the Indians a much larger one, with Caribbeans and Pakistanis placed in the middle (Cheng and Heath 1993). Comparable analyses of similarly qualified candidates for similar courses in higher education found that Caribbeans and Pakistanis had lower chances of entry to the 'old' universities than other candidates (Modood and Shiner 1994), while, for medical schools, not having a European surname was a stronger predictor of lower chances of entry than not being white (McManus et al. 1995).

How is this diversity in the structure of inequality to be explained? The question has been posed as one of how to 'explain the disparity between groups which share similar skin colour' (Robinson 1990, 284). Robinson suggests the existence of three possible lines of enquiry. One approach 'stresses the differential incorporation or marginalisation of the groups and the impact that this might have upon the desire for social mobility in a society which is perceived as alien' (Robinson 1990, 284). Malcolm Cross, for example, has distinguished between class exclusion and class segmentation as two different socially structured forms of racial inequality (Cross 1994). While high levels of representation among the unemployed and low paid are a symptom of class exclusion, class segmentation takes place when a group is allowed to enter the higher occupational classes, but is confined to an inferior subset of the higher occupations (Cross 1994, 232). Cross believes that the Caribbeans are subject to class exclusion, while the racism against Asians within British employment practices has the effect of incorporation through segmentation of the existing class structure.

The distinction between class segmentation and class exclusion may be an important one, but Cross's application of it through an Asian-Caribbean dichotomy is unfeasible. The 'catching up' by African Asians and the prospect of overtaking whites, with already a stronger representation at the higher earnings levels, does not suggest that they are being confined to an inferior subset of the better classes. On the other hand, Pakistanis and Bangladeshis fit much better Cross's definition of the excluded as given above, especially as the high levels of Pakistani unemployment pre-date those of the Caribbeans and consisted of actual job losses as the textile and related industries collapsed during the 1970s and early 1980s. For the Caribbeans unemployment rose more gradually as successive cohorts of school leavers found that the supply of jobs, especially for those without qualifications, had dried up. Hence Robinson found that, while 5 per cent of all workers who had a job in 1971 did not have one in 1981, 8 per cent of Caribbeans did not, but the figure for Pakistanis was 19 per cent (Robinson 1990, 280).

The reason why Cross thinks that the longer-term prospects of the Pakistanis and Bangladeshis are of class segmentation rather than exclusion is because, in

contrast to the Caribbeans, economic marginalisation has not led to a socio-political alienation. The Pakistanis and Bangladeshis are still committed to economic advancement; the young will acquire, he believes, qualifications that will enable them to compete for the kind of jobs that will be available. The impact of racism and economic disadvantage seems, however, to have blunted the motivation of a sizeable proportion of younger Caribbeans (Cross 1994, Chapters 8 and 10). While there is some truth in this contrast, the prediction that Pakistanis and Bangladeshis will develop a similar class profile to other South Asians grossly understates the current scale of the disadvantage of Pakistanis and Bangladeshis, and takes no account either of the cultural differences between South Asians (Modood, Beishon and Virdee 1994; see also Chapter 9), or of a political alienation, sometimes expressed in terms of a political Muslim identity, which is itself a product of and further stimulates anti-Muslim prejudice (Modood 1990), or of anxiety about a possible trend of criminalisation among young Pakistanis and Bangladeshis, which in some ways parallels the experience of Caribbean male youth (Nahdi 1994).

In any case, the position of young Caribbean men (and to some extent women) is itself paradoxical: they are among those with the highest rates of unqualified and unemployed and yet also among the highest average earners. It is possible that the high earnings averages are a product of the high unemployment, for, by taking out of the earnings sample more potentially lower earners, the sample is biased compared with other groups in favour of higher earners, especially among manual workers. Yet it does not have this effect upon Pakistanis and Bangladeshis who also have high rates of unemployment among 16–34-year-olds. It is more likely that the paradoxical findings are pointing to an economic polarisation among young Caribbean men, who are to be disproportionately found both among the long-term unemployed and the middle-band of earners. Indeed, in this respect the Caribbeans may be becoming more like the Pakistanis and Bangladeshis, rather than vice versa. For the aspect of these latter groups that probably suggests to Cross that they will progress like the other South Asians is the presence within them of a highly qualified professional and business class.[13] Yet this class is not new among Pakistanis and Bangladeshis: it was picked up in the PSI surveys of the 1970s and 1980s (Smith 1977; Brown 1984), and what is remarkable is that it has hardly grown between 1982 and 1994 (see Figure 4.14). Indeed, if the unemployed are added back into the figures on which the analysis is based, there is no growth at all among Pakistanis and Bangladeshis, in contrast to other groups, in the proportion of men in the top jobs category (the 1991 Census, though, does suggest growth). At a time of general upward mobility for men, this would in fact be a relative decline.

In examining the educational qualifications of migrants, the internal polarity among those from the subcontinent, with a disproportionate number having degrees and a disproportionate number having no qualifications and many speaking little English, was a strong contrast to the relative homogeneity of the Caribbeans. This tendency among Caribbeans of disproportionate grouping around the middle is also found in Robinson's longitudinal study of social mobility between 1971 and 1981

13 Anecdotal evidence suggests that this class is from urban Pakistan and, to a lesser extent, rural Punjab: in contrast, the majority of Pakistanis in Britain are from rural Kashmir, especially Mirpur – one of the poorest and least economically developed areas in the region.

(Robinson 1990), as also in the findings about earnings in this chapter. The paradoxical statistics about young Caribbean men may be pointing to a post-migration, indeed, a relatively recent, internal polarisation among Caribbeans, while the class divisions among Pakistanis and Bangladeshis, and the divisions between these two and the other South Asian groups, have deepened by the collapse of those industries that provided jobs to the Pakistanis in the 1970s, but in fact stretch back to pre-migration origins.

So while Cross is right not to want to conflate the disadvantaged profiles of Caribbeans with the disadvantaged profiles of Pakistanis and Bangladeshis, the differences in question cannot be captured by his differential use of exclusion and segmentation, and give no grounds for his Caribbean-Asian dichotomy or for projecting an optimistic view of upward social mobility for Pakistanis and Bangladeshis. If we wanted to explore these questions further, we could perhaps proceed by asking how differently post-industrial long-term unemployment would impact on excluded groups if one was composed of tightly knit, hierarchically organised families and communities and on-going connections with the country of origin, and the other was not. Such a reformulation would not be a basis for reliable predictions (for there are too many other variables to take into account, especially in relation to changes in the economy), but it would bring us closer to raising some of the issues that lie behind Cross's discussion. It also leads us to a form of explanation identified by Robinson.

A second possible explanation for the disparity between minorities 'stresses the groups' histories prior to migration, and the traditions and resources they can therefore mobilise to gain mobility' (Robinson 1990, 284). This is an approach that has been developed most to explain the phenomenon of immigrant self-employment, as found in many countries, especially in North America, and which is often critical in facilitating upward social mobility (Waldinger, Aldrich and Ward 1990). It connects with a sociological tradition that arose through studies of European migration to the large American cities in the early part of this century (Lal 1990). While the resources in question are of a complex sort and relate to culture, religion and gender, one simple measure is qualifications. There does seem to be a strong correlation between the qualifications of the first generation as shown in Table 3.7, and the extent of current disadvantage depicted in Tables 4.37 and 4.38. This lends particular support to the general view that the post-migration social mobility of groups consists of the re-creation of a comparable class profile to the one the group had in the country of origin before migration. We have, of course, seen that similar qualifications do not yield similar occupational advantages for all groups, and that it is likely that some of the differences are explained by forms of direct and indirect discrimination.

This relates to the third possible explanation of disparities mentioned by Robinson: that different groups are stereotyped differently, perhaps influenced by the roles allotted to groups during British colonial rule (Robinson 1990, 285). An important piece of research on middle managers' perceptions of minority workers and their ethnicity in the early 1980s found that stereotypes (not always negative) related to two groupings, Caribbeans and South Asians, and that radically different stereotypes were held of the two groups. The most common view expressed of

Caribbean workers was that they were lazy, happy-go-lucky or slow, while the most common view of Asians was that they were hard workers (Jenkins 1986). It has been argued that similar antithetical images of the main non-white groups are in fact pervasive in common-sense and media representations (Bonnett 1993). In the last decade or so, it has increasingly been argued that contemporary racism cannot be understood in terms of an undifferential colour racism, but that additionally groups are racialised, and praised or condemned, on the basis of alleged cultural traits rather than any kind of biology (Barker 1981; Gilroy 1987; Cohen 1988), and that groups such as South Asian Muslims suffer a distinctive and complex kind of racism (Modood 1992 and 1997). In this chapter we have seen how nearly half of South Asians who complain of racial discrimination in recruitment believe that their religion was a factor in the discrimination; and so do a quarter of Caribbeans, further suggesting the complex nature of discrimination as perceived by those who believe they have direct experience of it. We have also seen that all groups now believe that the most prejudice is directed at Asians and/or Muslims. In a later chapter we will see how that relates to the experience of racial harassment.

It has to be said that it would be wrong to expect racial disadvantage, both its decline and its persistence, to be only, or even primarily, explained in terms of 'race', discrimination or ethnic differences. There is a general agreement that the most important fact is of economic restructuring. The changes in job levels for the minorities, no less than for the majority population, are above all a consequence of the continuing loss of jobs in manufacturing especially those that require low levels of skills, in favour of the service sector, which has seen a continuous growth in higher-level jobs and lower-level part-time work. It is this fundamental and continuing shift, together with the demographic shortages that have increased job opportunities for women and some minorities, that is the cause of the differential advantage and disadvantage experienced by the different minority groups, and it is the context in which the more specific factors that have been discussed are played out.

Income and Standards of Living

Richard Berthoud

INTRODUCTION

The previous chapter examined important elements of ethnic minorities' position in the labour market: the economic activities and employment of men and women, their job levels and their earnings. There were clear indications of economic disadvantage in some groups, with high levels of unemployment among men, low levels of economic activity among women, and – for people in jobs – lower rates of pay than those received by white workers.

This chapter examines the effects of these disadvantages in employment on minority households' income. Although it has long been clear that the employment, earnings and family structures of ethnic minorities were such that they probably had lower incomes and living standards than those of the white majority (Brown 1984; Amin and Oppenheim 1992; FitzGerald and Uglow 1993), until recently there has never been a reliable measure of household income to confirm this directly. This is in contrast to the United States, where all the main sources of data on incomes offer comparisons between whites, blacks and hispanics. The latter two groups are at least three times more likely than whites to fall below the officially defined poverty line (US Bureau of the Census 1995).

In Britain, surveys of ethnic minorities have not estimated household income. Nor has it been possible to analyse the previous main source of income data (the Family Expenditure Survey) by ethnic group. The only previous attempt at measuring household income by ethnic groups was based on the 1990 General Household Survey (Hills 1995):

...based on rather small sample sizes and therefore subject to significant uncertainty... Whereas the Indian group is more concentrated [than whites] in the third and fourth fifths of the distribution, the West Indian and – particularly – Pakistani and Bangadeshi populations are much poorer. More than half of the latter are in the poorest fifth.

But the new Family Resources Survey (DSS 1996b), which covers 25,000 households every year, will soon provide a much more reliable base for analysing ethnic minority incomes. The first results, published at the end of 1996 (DSS 1996c), suggested that black and Indian (including African Asian) households had lower equivalent incomes than whites, and that Pakistanis and Bangladeshis were much worse off than other groups. Where comparison is possible, our own analysis says exactly the same, and the similar findings from different sources lead to some fairly robust conclusions.

The 1994 PSI/SCPR survey asked one person to provide a total for the whole household. This is not an ideal measure, for three reasons.

- The individual who was asked the question would not necessarily have known the incomes of all the members of the household.

- A proportion of respondents would not or could not answer the question: this was especially true among Asian households.

- The answers were provided in 16 income ranges rather than as exact amounts.

Appendix A (at the end of this chapter) discusses these potential problems in some detail, and draws on methodological research undertaken by the Office of Population Censuses and Surveys (Foster and Lound 1993). Our conclusion is that the fourth survey data are sufficiently robust to paint a fairly clear picture of significant variations between ethnic groups. The research team is intending to undertake a more detailed analysis of ethnic minority incomes based on the Family Resources Survey, and the two sources between them would provide better data than have ever been available before.

Economic analysis of 'wealth' and 'poverty' is usually based on households, rather than considering each person separately, because the income of one person may be available to provide for the needs of others living in the household. That is not to say that all income is equally shared; that assumption has been challenged, especially by researchers demonstrating inequalities in the resources controlled by husbands and wives (Pahl 1989; Wilson 1987). There may also be differences between ethnic groups in the way income is distributed within the household (if only because of the very different patterns of economic activity among married women), and some evidence about that is analysed at the end of this chapter. For the moment, the household will be used as the unit of analysis.[1]

The analysis starts by dividing households into two groups: those that are (mainly) supported by earnings; and those that depend heavily on social security benefits. A brief review of information from the survey about the benefits received by members of the sample is followed by the central elements of this chapter – a detailed analysis of household incomes and of 'poverty'. That leads to a comparison between ethnic groups of the living standards that they enjoy, measured by such indicators as possession of consumer durables or avoidance of debt. There has been very little research into ethnic minorities' experience in any of these areas, and much of this chapter will have to take existing analysis of the population as a whole as its starting point.

1 The distinction between individuals, families and households was outlined at the beginning of Chapter 2. Most of the analysis in this book is based on adults, but this chapter, and the one on housing, considers whole households. Where a household contains both white people and members of minority groups, they have usually been analysed under the minority heading, but mixed households are analysed separately where appropriate.

WORKERS AND NON-WORKERS

The single most important influence on a household's income is the availability of earnings from work. The previous chapter's analysis of economic activity and unemployment gives us some idea of the likely difference between ethnic groups in the number of households with no earners. Table 5.1 compares the 1994 survey with its predecessor undertaken in 1982 (Brown 1984). At that time, white households were much more likely than any other group to have no earner at all. The proportion of non-earner households increased among all the minority ethnic groups, but hardly at all for white households. By the 1990s Pakistani and Bangladeshi households were more likely than whites to lack any earner, and Caribbean households were at the same level as whites.

Table 5.1 Proportion of households with no earner, by household type

cell percentages

	White	Caribbean	Indian	African Asian	Pakistani	Bangladeshi	Chinese
Third survey – 1982	37	22	14	13	28	27	n.a.
Fourth survey – 1994	38	36	24	17	44	48	22
Pensioner households	96	96		95			
Lone parents	73	58		68			
Other households	17	25	28	13	42	47	21
Weighted count	*2953*	*1278*	*607*	*550*	*423*	*142*	*242*
Unweighted count	*2952*	*943*	*621*	*549*	*679*	*327*	*1381*

'Pensioner households' are defined as those where all members are of pensionable age, without regard to receipt of a pension.

In all ethnic groups, households consisting entirely of people over retirement age were very unlikely to have any earner. There are many elderly households within the white population, and this explains the relatively high proportion of white households without an earner. The growing number of pensioners among Caribbeans explains the sharp rise in non-earner households there. There are very few pensioners within the Asian communities. Similarly, the majority of households consisting of one adult with children had no earner – whatever their ethnic group. This also helps to explain the relatively high number of non-earner households among Caribbeans.

The most useful comparison is between households which are neither pensioners nor lone parents – the 'other households' in Table 5.1, among whom one would expect the majority to have at least one earner. An extremely important feature of the labour market in the last 15 years has been the increasing division of households and families between 'work rich' and 'work poor' – as more married women have joined their husbands in the workforce, the growth in the number of two-earner families has been counter-balanced by an increase in the number of no-earner families (Gregg and Wadsworth 1995). The figure of 17 per cent for white households (excluding pensioners and lone parents) represents an increase from 13

per cent since the 1982 survey (Brown 1984), and is about typical of measures derived from other sources, such as the Labour Force Survey.

African Asian 'other households' were slightly less likely than whites to have no earner, Indians and Chinese slightly more likely and Caribbeans significantly more likely at 27 per cent. It was Pakistanis and Bangladeshi households, however, which were in a completely different league. Half of their households had no income from employment. Neither old age nor lone parenthood help to explain this: it is entirely down to high rates of unemployment among Pakistani and Bangladeshi men and low rates of economic activity among their wives.

THE INCOMES OF HOUSEHOLDS WITHOUT WORKERS: MAINLY SOCIAL SECURITY

Most households without earnings would be able to claim social security benefits, including national insurance schemes such as the state pension or unemployment benefit, and means-tested schemes such as income support or housing benefit. Many retired people (most of them white) would also have had occupational pensions or other resources derived from savings, but social security is the largest source, if not the only source, of income for the overwhelming majority of non-workers.

Previous analysis has suggested a number of ways in which members of ethnic minorities may be disadvantaged by the social security system (Berthoud 1987). Some of the potential problems are part of the structure of the system: the minorities are treated exactly the same as anyone else in their situation, but that situation is often of a kind that leaves them worse off than other claimants. The state pension, for example, is based increasingly on the assumption that retired people should have built up occupational or other personal provisions over their working lives, but this would clearly have been impossible for people who migrated to Britain well into their adult lives, or who had low earnings or intermittent employment. Another structural problem is that large families and one-parent families are often found to be more reliant than other types of claimant on means-tested schemes: large families are common among Pakistani and Bangladeshi households, and lone parents among Caribbean households.

Other potential problems are not so much intrinsic to the social security system as a result of its failure to adapt its treatment adequately to the needs of ethnic minority groups. A number of studies (Bloch 1993; Law et al. 1994) have suggested that those who have recently arrived, and/or who do not speak English well, need additional information or advice if they are to make sense of the system – a need which has been at least partially addressed by the Department of Social Security and other advice agencies. Another issue, strongly related to 'colour' as well as to migration, is the tendency of social security officials to ask for proof of residence before awarding a claim (Gordon and Newnham 1985; NACAB 1991). There are obvious risks that such a procedure may discourage legitimate claims as well as rooting out illegitimate ones.

Measuring variations in the 'take-up' of social security benefits from survey data is a highly complex task (Craig 1991) which has not been attempted at this stage. But each of the adults in the survey was asked what social security benefits they received. It is a little difficult to sort out the answers to this question in complex households, where perhaps some members of the family were in work while others claimed benefit. The benefits received by adults in non-worker households should nevertheless provide a clear indication of the importance of different social security schemes to members of the ethnic minorities.

Table 5.2 shows the main benefits. Most of the variations can be assumed to depend on differences in the demographic structure of the groups: for example, the retirement pension among white people or the receipt of one-parent benefit by Caribbeans. Whether the penetration of any particular benefit is higher or lower than might be expected would take much more detailed analysis. But one important point should be noted. Around half of the members of each minority group reported that they claimed the safety-net benefit, income support, compared with a third of the whites. Since the whole table is based on members of non-working households, this is not a measure of lower levels of employment among minority households: it shows that non-workers among the minorities were less likely to have adequate national insurance benefits (or other resources) and more likely to have to depend on the minimum safety net. The finding is consistent with the Family Resources Survey (DSS 1996, Table 3.17), which showed that among whites far fewer families claimed income support than received national insurance benefits; among minorities, income support claims heavily outnumbered national insurance payments.

Table 5.2 Benefits received by adults in households with no earner

column percentages

	White	Caribbean	Indian/ African Asian	Pakistani/ Bangladeshi
Child benefit	14	29	31	50
One-parent benefit	3	11	2	1
Disability living allowance	8	5	10	6
State pension	43	19	12	6
Unemployment benefit	4	6	6	10
Invalidity benefit	6	7	7	5
Income support	24	44	39	50
Housing benefit	33	63	26	31
Weighted count	*1700*	*420*	*426*	*609*
Unweighted count	*1111*	*220*	*221*	*420*

Because this table is based on households with no earner, family credit is not included. It is covered in the next section.

The important question for these households – those with no earnings at all – was not what benefits they received, but how much they had to live on. Table 5.3 shows that the average total household income of non-earner households ranged between £118 and £149 per week at 1994 prices. The lowest total was for Caribbean households; the highest was for Pakistani and Bangladeshi households. The pattern

was very largely influenced by the tendency for many benefits, especially income support, to be paid at a rate based on the number of dependents to be supported. The second line of Table 5.3 shows the average 'equivalent' size of households in each group.[2] On this calculation, Bangladeshi and Pakistani households were the largest and needed the most income; white households were the smallest and needed the least.

Table 5.3 Average incomes of households with no earner

	White	Caribbean	Indian/ African Asian	Pakistani/ Bangladeshi
Average total income (per week)	£135	£118	£134	£149
Average equivalent household size	1.38	1.48	1.84	2.61
Average equivalent income	£98	£80	£73	£57
Weighted count	*952*	*395*	*165*	*189*
Unweighted count	*956*	*322*	*186*	*365*

Equivalence is explained in footnote 2.

If the average income of non-earning households is compared with their needs as expressed in the equivalence scale, then (third line of Table 5.3) white non-working households were clearly better off than minority households, averaging £98 per 'equivalent' person per week; and Pakistani and Bangladeshi households were clearly worse off than the other groups, with only £57 per equivalent per week. These differences – with non-earning whites receiving 70 per cent more (in relation to their needs) than non-earning Pakistanis and Bangladeshis – are readily explainable:

- A high proportion of white households without an earner are pensioners, who receive rather higher levels of social security benefit than the unemployed, and may also be in receipt of an occupational pension. Thus the average equivalent income of white all-pensioner households was £108 per week; for other white non-earner households, it was £84 per week.

- Pakistani and Bangladeshi households would depend heavily on the income support allowances paid for each child. Since these were only between £15 and £35 per week (in 1993–4) this would have dragged the average equivalent income down.[3]

2 An equivalence scale is commonly used to relate a household's income to the number of people among whom the income has to be shared. It is assumed that the requirements of a second or third person are less than those of a single person living alone and that children require less than adults. We have used a simple scale, counting 1.00 for a single person, an additional 0.60 for each extra adult, and 0.30 for each dependent child. 'Equivalent income' is the income divided by the scale, so that, for a two-adult household, £160 per week is equivalent to £100.

3 The findings for Pakistanis and Bangladeshis are of course sensitive to the choice of equivalence scale – a scale which allowed less weight to children would have reduced the apparent disadvantage. On the other hand, a considerable body of other research suggests that children are relatively under-weighted in social security provision (Berthoud 1984; Bradshaw 1993).

These findings clearly illustrate the point of principle made at the beginning of this section, that, even though the social security system applies the same rules to the white majority and to ethnic minorities, it can still create quite a wide range of inequalities between groups.

The Incomes of Households with Workers: Mainly Earnings

We turn now to the households where there was at least one earner. These will have received some social security benefits, to the extent that some of the adults in complex households may not have been in employment. One third of the adults in white and Caribbean households said that they received child benefit; a half in South Asian households. A striking finding was that, among Pakistani and Bangladeshi households, a quarter (25 per cent) of families with children where either parent was in full-time work were also claiming family credit,[4] compared with only 5 per cent among white families and in other minority groups. This benefit is for families whose pay is low in relation to the number of children they have (Marsh and McKay 1993), and clearly has a potentially important influence on the living standards of Pakistanis and Bangladeshis.

For households which include workers, it is their earnings which will have the strongest influence on their incomes. Table 5.4 is set out to emphasise the links between household structure and income: in the top three lines, total household income is partly explained in terms of the number of workers per household, and the level of earnings per worker. In the bottom three lines, it is shown how total income has to be divided between a number of people in the household to provide an indication of the overall level of consumption available to individuals.

Looking at total household income first:

- White, Caribbean and Chinese households had similar numbers of adults – just over two per household – and broadly similar rates of employment – about two jobs for every three adults, counting part-time work as half a job. (Remember that all this analysis is based on households containing at least one earner.)

- Indian and African Asian households had rather more adults, but a slightly lower rate of employment among them. Overall, though, this group had more workers per household than whites, Caribbeans and Chinese.

- In Pakistani and Bangladeshi households there were significantly more adults again. But the proportion of them in work was much lower than elsewhere (even among households with at least one worker), so that there were fewer workers per household.

- We calculated an 'income per worker' by dividing total income by the number of workers (again, counting part-time as half). This is not as reliable a measure of

4 Family credit can be claimed if either parent works at least 16 hours per week, but the analysis quoted here is based on those working 30 hours or more.

personal earnings as the direct question analysed in the previous chapter.[5] It suggests, though, taking all workers together (men and women, full-time and part-time, employees and self-employed), that white people were earning more than adults from other ethnic groups, followed, in order, by Chinese, Caribbeans, African Asians, Indians and Pakistanis/Bangladeshis. The position of Indians and African Asians, recording an income per worker lower than Caribbeans, is inconsistent with the earnings analysis in the previous chapter, and could mean that Indian/African Asian incomes may be slightly underestimated.

■ In terms of total household income, though, the Indians and African Asians were slightly ahead of the Caribbeans, because they had more workers per household. All three of these minority groups, ranging between £327 and £380 per week, were rather below white households (£395). Chinese households, at £413, totalled more than the whites. The real outliers, though, were the Pakistanis and Bangladeshis – only £245 per week, £80 less than their nearest neighbours on the income ladder.

Table 5.4 Incomes of households containing at least one earner

	White	Caribbean	Indian	African Asian	Pakistani/ Bangladeshi	Chinese
Number of adults in household	2.11	2.10	2.82	2.75	3.20	2.39
Proportion of adults in work	70%	65%	58%	60%	40%	69%
Average income per worker	£269	£240	£222	£232	£193	£293
Total income (per week)	**£395**	**£327**	**£367**	**£380**	**£245**	**£413**
Equivalent household size	1.76	1.78	2.20	2.21	2.61	190
Equivalent income	£225	£184	£167	£172	£94	£217
Weighted count	*1497*	*664*	*258*	*329*	*213*	*157*
Unweighted count	*1841*	*564*	*453*	*446*	*527*	*104*

In lines 2 and 3 of the table, part-time workers were counted as 'half' a worker. Income per worker is calculated simply as total income divided by number of workers.

The conclusions based on total household income are modified by consideration of the number of people to be supported, as indicated by the 'equivalence scale', but the overall effect was to widen the range of inequality.

■ White households, with among the highest incomes, had the smallest number of dependents. They therefore caught up with the rather larger Chinese households. Caribbean households were also relatively small, so, again, their income position moved up compared with the Asian groups.

■ Indians and African Asians had reported moderate total incomes, but they had larger families, so they moved down the scale based on 'equivalent' income.

5 The comparison is complicated by the fact that the earnings questions asked for gross (pre-tax) earnings, while the income question asked for net income.

- Pakistanis and Bangladeshis, already the lowest on the ladder based on total weekly income, had easily the largest families, so that they moved even further away from other groups. Pakistani and Bangladeshi households *with earned income* were worse off on this measure than white households with *no earner* (see Table 5.3).

OVERALL INCOMES

The previous two sections described the composition of the income of households with and without an earner. We now combine the two to assess the incomes available to all households.

Table 5.5 shows the distribution of total (after tax) income as recorded by the question discussed above. At this stage the measurement covers income from all sources, and from all members of the household, without regard to how many people it has to support. The answers have been allocated to bands which divide white households into four roughly equal groups, and then split the top white group in half. All the minority groups can then be compared with the white distribution.

Three minority groups have moved ahead of the white population. Indians, African Asians and Chinese had slightly fewer households in the lowest income band (up to £115 per week), slightly more in the top band (£621 or more) and a slightly higher average income than whites. The difference was small for Indians, but quite substantial for Chinese and African Asians. They contrast with every previous study of ethnic minorities which has suggested that all immigrant groups were worse off than the white population.

While the slight superiority of Indian, African Asian and Chinese household incomes compared with those of whites is true, it has to be remembered that the white population includes many more pensioners than the other three groups. Once these are taken out of the analysis, the statistics suggest that Chinese and African Asian household incomes were almost identical to those of the white comparison group, while Indians fell slightly behind.

Table 5.5 Total household income

column percentages

	White	Caribbean	Indian	African Asian	Pakistani	Bangladeshi	Chinese
Up to £115 per week	26	32	25	19	27	24	21
£116 to £230	23	24	26	23	48	55	18
£231 to £445	27	27	26	27	17	13	27
£446 to £620	12	12	10	17	3	7	17
£621 or more	12	5	14	14	4	2	18
Average weekly income	£294	£249	£308	£334	£202	£196	£350
Average for non-pensioner households	£343	£259	£317	£338	£203	£196	£354
Weighted count	*2450*	*1059*	*348*	*403*	*285*	*117*	*206*
Unweighted count	*2457*	*778*	*362*	*395*	*454*	*283*	*115*

This parity of income levels did not apply, though, to the other three minority ethnic groups. Among Caribbeans, more households were in the lowest band, and fewer in the highest band shown in Table 5.5, than among whites. For Pakistanis and Bangladeshis, as many as half of all households appeared in the second band in the table (£116 to £230 per week), and very few had reached the upper bands. At first sight it is surprising that there were not more Pakistanis and Bangladeshis with very low total incomes: but social security on its own would provide some of the largest families with more than £115.

HOUSEHOLDS BELOW AVERAGE INCOME: THE EXTENT OF 'POVERTY'

There is no official 'poverty line' in Britain equivalent to that adopted in the United States, though there has been a mass of academic debate about whether one should be defined (*Journal of Social Policy* 1987). We have adopted the analytical conventions set down by the Department of Social Security for its annual analysis *Households Below Average Income* (HBAI) (DSS 1996c). This involves calculating net (after tax) income, adjusting for household size using an 'equivalence scale', and expressing each household's equivalent income as a proportion of the national average. We have used all the same principles, though in practice the details of our analysis are much cruder. The 'national average' used as the benchmark is derived from the survey (in the ratio of 95 from the white sample and 5 from the minorities sample). 28 per cent of our white sample fell below half the national average, compared with the official analysts' 20 per cent (before housing costs) or 25 per cent (after housing costs) (DSS 1996c). This suggests that we have a slightly exaggerated measure of the extent of low incomes in Britain. All the analysis here is based on comparisons within the twin samples selected for this study rather than between our survey and other sources.[6]

Most commentators on the official analysis focus on households whose income is below half the national average. Like them, we use the word 'poverty' to describe this lowest band of incomes, to draw attention to the hardship undoubtedly involved, without taking sides in any theoretical debate about the difference between 'low incomes' and 'poverty'.

Using these definitions, 28 per cent of the individuals in white households in the Fourth National Survey shared an income below half the national average (Table 5.6). 23 per cent of whites were above one and a half times the national average. Thus, in the white population, there was a fairly even split between 'poor' and 'well-off', with about half the population in between.

6 Another element of the DSS convention is that, although income is measured for each household, each individual (within the household) is included in the analysis of the distribution. Thus we say that 'a quarter of people in Britain live in households below half the national average', rather than 'a quarter of households fall below half the average'.

Table 5.6 Households below average income

column percentages

	White	Caribbean	Indian	African Asian	Pakistani	Bangladeshi	Chinese
Below half average	28	41	45	39	82	84	34
Between half and one and a half times average	49	47	43	46	17	15	44
Above one and a half times average	23	12	12	15	1	2	22
Weighted count, persons	*5954*	*2910*	*1322*	*1520*	*1469*	*674*	*660*
Unweighted count, households	*2457*	*778*	*362*	*395*	*454*	*283*	*115*

The closest group to the whites were the Chinese. They were only slightly more likely to fall below the low income threshold adopted in Table 5.6. Next came the African Asians, Caribbeans and Indians – very close to each other, but significantly worse off than the whites and Chinese. About four in ten of people in these three ethnic groups were below half the national average. Low incomes outnumbered high incomes by a factor of about three to one.

On the other hand, it is necessary to classify Caribbean, Indian and African Asian households a little more precisely before the full picture emerges. Mixed households, containing both white people and members of minorities, were defined for most of our analysis, including Table 5.6, according to the minority group. If they are separated out, it can be seen that the mixed white/Caribbean and white/Indian or African Asian households had poverty rates very similar to households where all the members were white (Table 5.7). Households where all the members were Caribbean, or Indian/African Asian, were rather worse off. The comparison has more effect on Caribbeans. There were more mixed households in that group, but all-Caribbean households are now shown to have been in the same position as all-Indian/African Asian households.

But, as the previous sections of this chapter would lead us to expect, Pakistanis and Bangladeshis were far and away the poorest ethnic groups. More than four out of

Table 5.7 Households below half average income: mixed households compared with all-minority households

	White	Caribbean	Indian/African Asian
Single ethnic group	28	44	44
Weighted count, persons	*5954*	*2253*	*2629*
Unweighted count, households	*2457*	*655*	*704*
Mixed white–minority	n.a.	32	28
Weighted count, persons		*658*	*213*
Unweighted count, households		*123*	*53*

five were below the low-income threshold (Table 5.6). Hardly any were above the high-income threshold.

Some types of family have lower incomes than others. As Table 5.8 shows, pensioner households, and lone parents, were more likely to fall below the implicit poverty line of half average income than other types of household – largely because only a minority of those types of household receive any earnings from employment. The white population contains many more pensioners than the minority groups; Caribbeans (and whites) are more likely to have formed one-parent families than any of the South Asian groups. If we take out these types of household who are expected to be poor, the bottom line of Table 5.8 contrasts ethnic groups even more starkly. Pakistani and Bangladeshi households (non-pensioner, non-lone-parent) had four times the poverty rate of similar white households. For Indians and African Asians, the rate was double that of whites; for Caribbeans, poverty was one and a half times as common as for whites.

Table 5.8 Households below half average income: pensioners, lone parents and others

				cell percentages
	White	Caribbean	Indian/ African Asian	Pakistani/ Bangladeshi
Pensioner households	50	67	68	n.a.
One-parent households	70	70	80	78
All other households	21	32	41	83
Weighted count, persons	*5954*	*2910*	*2843*	*2144*
Unweighted count, households	*2457*	*778*	*757*	*737*

The author of this chapter has been analysing household incomes for more than 20 years. Pakistanis and Bangladeshis are easily the poorest group he has ever encountered. They were significantly poorer, as Table 5.8 makes clear, than white pensioners and rather poorer than lone parents. The reasons have been clearly established in previous chapters and in earlier analysis in this chapter. Pakistani and Bangladeshi men have high rates of unemployment. Women in those groups have low rates of economic activity. Those in employment have low wages. And these relatively low incomes have to be spread across large household sizes – more adults per household than whites, and many more children per family than any other ethnic group.

On the other hand, none of these individual factors was so powerful as to explain fully the extra levels of poverty experienced by Pakistanis and Bangladeshis. Table 5.9 shows that important ethnic variations in low incomes were still observed, even when families of about the same size were compared with each other. It is true, for example, that white families with many children were more likely to fall below the low-income threshold than other whites; but the proportion rose to only one third, compared with nearly nine out of ten Pakistani and Bangladeshi large families. Similarly, low incomes were strongly associated with the absence of earnings in all ethnic groups: but, for Pakistanis and Bangladeshis, nearly two-thirds of households

with an earner were in poverty – more than among white households *without* an earner. Thus we cannot say that any one of these factors is mainly responsible for Pakistani and Bangladeshi poverty: the problem is a compound of jobs, and earnings and family size, and *all* of them would have to change before there was a substantial reduction in poverty among this group.

Table 5.9 Households below half average income, by household structure and by availability of earnings

cell percentages

	White	Caribbean	Indian/ African Asian	Pakistani/ Bangladeshi
Small pensioner households	47	58	70	n.a.
Small adult households	16	25	29	n.a.
Lone parents	72	73	n.a.	n.a.
Small families	18	25	36	74
Large families	34	39	56	88
Three or more adults, with or without children	21	39	41	84
No earners	65	81	84	96
Any earner	13	22	34	72
Weighted count, persons	*5954*	*2910*	*2842*	*2144*
Unweighted count, households	*2427*	*778*	*757*	*737*

SOCIAL AND CULTURAL FACTORS ASSOCIATED WITH POVERTY

Type of area

It is often observed that the areas which house a large proportion of ethnic minority families are run down, and this is assumed to show that the areas are also poor in the sense of the residents having low incomes. The fact that minorities have, on average, lower incomes than white households tends to support that interpretation. But it is also of interest to see whether the members of each minority group who live in areas of high minority concentration had lower incomes than members of the same group living elsewhere, in predominantly white areas. Figure 5.1 shows that for Caribbeans there was a fairly clear effect: those living in wards where more than half the population came from minority groups were almost twice as likely to have low incomes (as defined) as Caribbeans who lived in low-density areas. We cannot say, on the basis of the evidence so far, whether this is because better-off Caribbeans have tended to leave the areas of high concentration, or because those who have left became better off.

On the other hand, there was very little evidence that the incomes of either main group of South Asians varied much between areas of high or low ethnic minority concentration.[7] One outcome of this lack of area variation in Asian households'

7 The same conclusion is true if the definition of concentration is based on the number of people of the respondent's own ethnic group living in the ward, rather than the number of all ethnic minorities combined.

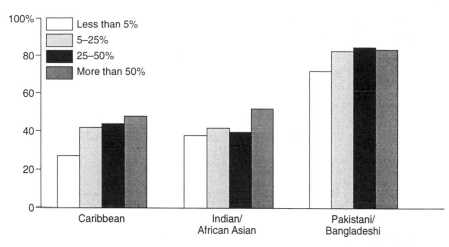

Figure 5.1 Households below half average income, by proportion of minorities resident in ward

income is that Indians and African Asians living in low-concentration (predominantly white) areas were more likely to be in poverty than Caribbeans living in the same types of area.

Religion

It is sometimes suggested that poverty among Pakistanis and Bangladeshis may be associated with their religion, rather than with their ethnicity defined on the basis of their countries of origin. Figure 5.2 shows that, among Indians and African Asians, Muslims were significantly more likely to live in households with low incomes than Sikhs or Hindus. But Indian/African Asian Muslims had a lower risk of poverty (55 per cent) than Pakistanis and Bangladeshis.

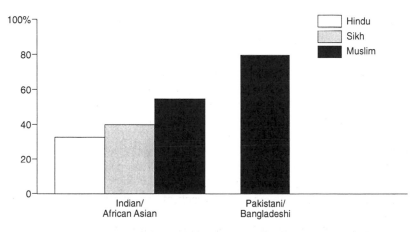

Figure 5.2 South Asian adults in households below half average income, by religion

Generation

We rather expected that people who had migrated to Britain as adults might experience lower incomes, and more poverty, than those who came here as children or who had been born in this country. It is difficult to classify whole households into 'generations' in this way, because different individuals may have arrived at different times, or been born in different countries. However, we can compare the incomes of households where all the adults were born abroad with those where all the adults were born in Britain, and with an intermediate group containing some adults who were born here and others who migrated. Migrant households were neither better nor worse off (on the total income measure or the HBAI measure) than those who had been born in the UK.

A slightly different conclusion can be drawn from an analysis of cultural identity. In Chapter 9 comparisons will be made between South Asians who most emphasised the role of their religion in their daily life, spoke their minority language and wore Asian clothes, and others who paid relatively little attention to their religion, almost always spoke English and wore Western clothes. Without going into the details of that analysis at this stage, we can show that the risk of poverty was significantly higher for South Asians who had most strongly retained the practices of their country of origin than it was for those who had adopted Western cultural practices (Figure 5.3). This finding is potentially important, but it would be unwise to rush into an interpretation of the processes involved. Cultural assimilation might lead directly to a reduced risk of poverty; or poverty might slow down assimilation.

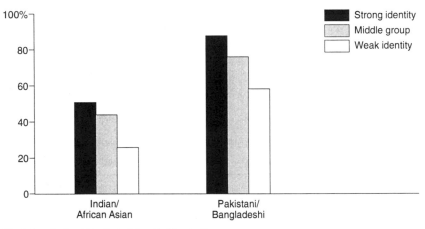

The index of cultural identity is defined in Chapter 9.

Figure 5.3 South Asian adults in households below half average income, by index of cultural identity

Education

There was a strong relationship between individuals' educational attainments and the incomes of the households in which they lived. For white adults (between the

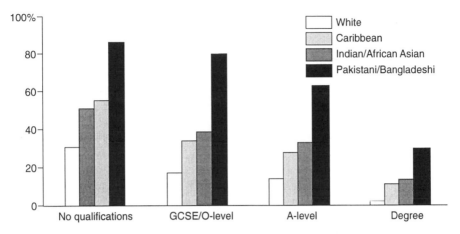

Analysis confined to adults aged less than 60, who came to Britain before the age of 16.

**Figure 5.4 Adults in households below half average income,
by educational qualifications**

ages of 16 and 59), the proportion living below the 'poverty' line used in this analysis fell from nearly a third (31 per cent) of those with no or minimal educational qualifications to half that proportion if they had O- or A-levels (or equivalents), and fell again to hardly any (2 per cent) if they had a degree. Because we are comparing the education of *individual* men and women with the income of the *household* in which they live, this finding is not simply because good education leads to good jobs – a whole series of other processes surrounding marriage, child-bearing and economic activity has to be taken into account as well.

Figure 5.4 shows that this relationship between education and poverty held good for all the ethnic minority groups as well as for whites. The analysis is confined to adults who had come to this country before the age of 16, so that at least some of their qualifications would have been obtained through the British education system. Better educated people had a lower risk of poverty, whatever ethnic group they came from. But there was an ethnic element as well. In every minority group, the proportion living in low income households was higher than among whites with similar qualifications. The extreme case, as before, was that of the Pakistanis and Bangladeshis: the risk of poverty fell from 86 per cent if they had no qualifications to 30 per cent if they had degrees, but that rate was almost identical to the level of poverty among white people with no qualifications.

SENDING MONEY TO OTHER HOUSEHOLDS

One common pattern of migration is for workers to move to another country for employment and to send a large proportion of their earnings home to their families. Typically, they would be either single men (sending remittances to their parents) or married men going on their own, and supporting their wife and children in this way.

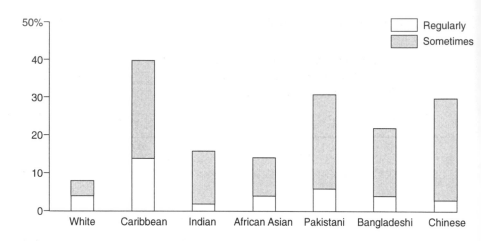

Figure 5.5 **Money sent to family outside the household**

Many return to their country of origin at the end of a contract, but others might settle in the host country and send for their families to join them.

Remittances are an extremely important component of the foreign exchange earnings of a number of labour-exporting countries, such as Bangladesh or the Philippines (Athukorala 1992; Stark 1991). But many of the migrant workers are staying temporarily as single-status workers in labour-importing countries in the Middle East. The pattern in Britain would be different, as most migrants probably expect to settle here permanently. Remittances have nevertheless been identified as an important element of the micro-economy of South Asian communities (Clarke et al. 1990; Gardner and Shukur 1995). A recent small-scale PSI study of ethnic minority credit facilities reported that 13 out of 15 Pakistanis interviewed had borrowed money from local unofficial foreign exchange agents, whose primary business was sending remittances outside the banking system (Herbert and Kempson 1996). But it has never been clear how many migrants send money home, how much they send and to whom they send it.

Few commentators have discussed this issue in relation to those who migrated from the Caribbean. Actually, the 1982 survey (Brown 1984) showed that remittances were more common among Caribbeans than among South Asians – a finding that has attracted little attention.

Exactly the same finding emerged from the Fourth Survey (Figure 5.5). A small number of white households provided support to others; a fifth or a sixth of Indians, African Asians and Bangladeshis; getting on for a third of Pakistanis and Chinese; but well over a third of Caribbeans. And the last-named was the only group where more than a handful of people said that they sent money to other households 'regularly'.

For many of those sending money to other members of their family, this was too irregular to say how much they tended to send; most of those able to give an amount

said that it was less than £100 per month. It was not always clear exactly to whom the money was going:

- For white people, the most common destination was the giver's own children; this could include maintenance payments, as well as support for grown-up children. Very little of the ethnic minority money went to the giver's children.

- Indians and Pakistanis most often mentioned support for their own parents. Other groups mentioned them less often.

- Caribbeans and African Asians most often mentioned 'other relations', which would have included wives. So, to a lesser extent, did other South Asian groups.

- Chinese people most often sent money to their family on 'special occasions'.

All of these findings are consistent with the narrative in the report of the third survey (Brown 1984). The picture is not very clear, but it appears to be stable.

Figure 5.6 suggests that households with total incomes below £115 were less likely to send money to other members of their family than those with higher incomes; but among Caribbeans and South Asians there was little systematic variation by income level above that amount.

The great majority of the money sent to other members of the family by the minority ethnic groups was going abroad – most of it to their countries of origin. Most of the remittances outside Britain were being sent from households where at least one adult had been born abroad (Table 5.10). It seems clear, therefore, that it is migrants who tend to adopt this practice, and in principle it will probably become less common as the years go by. But that makes it all the more surprising that it was Caribbeans – many more of whom were born in Britain – who were most likely to be sending money 'home'.

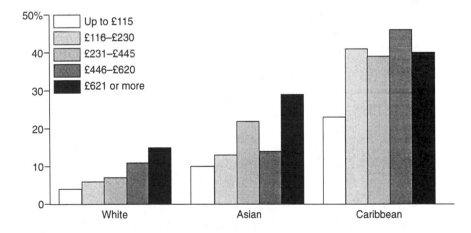

Figure 5.6 Money sent to family, by total household income

Table 5.10 Money sent abroad, by household migration

		cell percentages
	Caribbeans	South Asians
Households with all adults born in Britain	14	4
Households with any adult born abroad	42	20

In only a few Asian households had all the adults been born in Britain.

LIVING STANDARDS

The findings about household incomes suggest that members of the minorities, and especially Pakistanis and Bangladeshis, are likely to have had a lower standard o living than white people. Of course the survey could not obtain full details of people'$ consumption of goods and services, but three important indicators of prosperity and hardship are available: possession and use of consumer durables; problems and arrears in the payment of housing costs; and budgetary stress. These will be reviewed in turn in the following sections.

Indicators such as these are widely used in surveys to show variations in living standards between different groups in the population (Berthoud and Ford 1996) They are, as they should be, very sensitive to variations in income; but household structure, tenure, class and other social factors intervene to explain why some families seem better or worse off than others with the same income. Ethnicity is one of the potential influences, but few previous data sources have been capable o measuring variations in living standards between ethnic groups. There remain, o course, wide variations in consumption and budgeting patterns within each group which can be ascribed to personal taste or, perhaps, to individuals' views about how to manage a budget (Kempson 1996).

Consumer durables

The rapid increase in the proportion of households owning or using various items o modern equipment has become one of the symbols of national economic prosperity in Britain as in many other countries. Goods which were once rare are now common goods which have only recently been invented are already widespread. Table 5.11 shows that nearly all households in the survey had a fridge and a colour television At the other end of the scale, fewer than one in five had a dishwasher. On the whole ethnic minorities had a very similar range of durables to white people. The pluses and minuses in Table 5.11 show which minority groups had more (+) or less (−) of a particular item than the white population: one plus or minus if the gap was at leas ten percentage points, two if it was at least 20 points, and so on. Thus Caribbeans were rather less likely to own a car or a dishwasher, while Pakistanis and (especially) Bangladeshis had very low levels of ownership of several items, ranging from a washing machine to a CD player. On the other hand, Indians and African Asians were well ahead of white households in their use of such things as videos microwaves and home computers. And Chinese households were also above average on a number of items.

Table 5.11 Possession of a range of consumer durables

column percentages

	White	All ethnic minorities	Caribbean	Indian	African Asian	Pakistani	Bangla-deshi	Chinese
Fridge	98	99						
Colour television	96	94						
Telephone	91	89				–		
Washing machine	90	85				–	– – –	
Freezer	82	74				– – –	– – –	
Video recorder	76	84	+	+				+
Car or van	70	67	–		+		–	
Microwave	65	67		+ +	+ +	– –		
Tumble drier	50	36		–		– –	– – –	
CD player	45	39				– –	– – –	+
Home computer	26	34		+	+			+
Dishwasher	19	13	–			–	–	
Weighted count	2953	3349	1278	607	550	423	142	242
Unweighted count	2952	3350	943	621	549	679	327	138

+ means at least 10 per cent higher than whites; + + at least 20 per cent; – at least 10 per cent less than whites; – – at least 20 per cent, and so on. All those reporting the use of a 'freezer or fridge-freezer' were assumed to have the use of a fridge.

Variations between groups in the pattern of use of particular items was nevertheless relatively slight. Durables can be thought of in two groups. First were those which appeared to be treated as 'necessities', which most households had, whatever their circumstances. A television and a fridge are typical examples. Others were treated as 'luxuries': households had bought more or fewer of these, according to their incomes, but items could be substituted for each other, so that one household might choose a tumble drier while another decided on a CD player. We experimented with dividing the items into categories according to whether they were labour-saving household equipment such as a washing machine, or home entertainment facilities such as a TV, but this distinction was not particularly helpful to the analysis. The single item which was most sensitive to income was use of a car; however, the interchangeability of items meant that the best measure of consumption was not possession of any particular durable, but the total number. So the index used for detailed analysis is the number of types of item from the list in Table 5.11. But where the household had two or three cars we added two or three to the number of durables recorded. The total ranged from zero to 14, though very few households were found at the extreme ends of the range.

Deciding cut-off points to distinguish households with 'many' durables from those with 'few' is a matter of judgement, but the choice was strongly influenced by the relationship with income – thus most of those (in Table 5.12) who were recorded as having 11 or more durables had above-average incomes, while most of those with six items or fewer had low incomes.

For the white population, households divided neatly into 30 per cent with relatively few goods, 50 per cent with a medium number and 20 per cent with relatively many. Chinese households, as might have been expected from their incomes, were very similar to whites. At the opposite extreme, Bangladeshis were

far more likely to lack a range of durables than any other group. Again, this is what would have been expected from the analysis of incomes. And Caribbeans, whose income was shown to be rather lower than that of white people, had relatively few consumer durables. But Pakistanis, whose incomes were lower than Caribbeans, were in about the same position as them when it came to consumer goods.

The most unexpected finding concerned Indians and African Asians. Their household incomes were shown to be close to those of the Caribbeans and lower than those of whites. But they were more likely than whites, and much more likely than Caribbeans, to have adequate stocks of durable goods.

Table 5.12 Number of consumer durables

column percentages

	White	Caribbean	Indian	African Asian	Pakistani	Bangladeshi	Chinese
Up to 6	29	40	21	16	43	64	23
7 to 10	50	50	58	60	49	33	55
11 or more	21	9	21	25	8	4	23
Weighted count	*2953*	*1278*	*607*	*550*	*423*	*142*	*242*
Unweighted count	*2952*	*943*	*621*	*549*	*679*	*327*	*138*

Part of the explanation for the relatively high number of goods owned by Indians and African Asians is that ownership of consumer durables does not follow the pattern of relationship with income assumed by the conventional definition of 'equivalence scales'. Those scales reduce the measure of household income in accordance with the size of the household – the number of adults and children whose needs must be met. The assumption is that, at any given income in pounds per week, a larger household will have a lower standard of living than a small one on the same income. This is true of most indicators of living standards, but not of consumer durables. The larger the household, the *more* durables it owns. It has been suggested (Berthoud and Ford 1996) that this is because these goods, especially labour-saving devices such as washing machines and dishwashers, are more valuable to large households because they will get more use out of them; they therefore represent better value for money. This relationship between durable ownership and household size is clearly visible in Table 5.13.

Another point, also illustrated in Table 5.13, is that pensioners tend to have fewer durables than younger families in otherwise similar circumstances. This is likely to be caused in part by a slowness to acquire 'new-fangled' devices.

Given what has just been said about the relationship between durable ownership and household size, it would not be appropriate to use 'equivalent' income as the measure of resources for this analysis. Instead, we have used unadjusted total household income. Table 5.14 confirms (comparing figures up and down the columns) that low-income households had very few durables, while high-income households had many. But (comparing figures across the rows) Caribbean and Pakistani/Bangladeshi households had fewer durables than white households at the same level of income. On the other hand, Indians and African Asians had as many items of equipment as their white equivalents – sometimes more.

Table 5.13 Average number of consumer durables, by household type

	White	Caribbean	Indian/ African Asian	Pakistani/ Bangladeshi
Pensioner households	6.2	4.9	6.2	n.a.
Single adult	6.5	5.4	6.3	n.a.
Two adults	9.0	7.6	8.4	n.a.
Lone parents	7.3	6.5	7.1	n.a.
Small families	9.6	8.5	8.6	6.1
Large families	9.3	9.1	8.7	6.4
Three adults plus	9.9	8.2	9.3	7.1
Weighted count	*2953*	*1278*	*1156*	*566*
Unweighted count	*2952*	*943*	*1170*	*1006*

Household types are defined in Chapter 2.

Table 5.14 Average number of consumer durables, by total income

	White	Caribbean	Indian/ African Asian	Pakistani/ Bangladeshi
Up to £115	5.5	5.4	6.8	5.2
£116 to £230	7.3	6.8	7.4	6.3
£231 to £445	8.9	7.9	8.5	7.8
£446 to £620	10.0	9.0	10.0	n.a.
£621 or more	10.8	9.8	11.0	n.a.
Weighted count	*2450*	*1059*	*751*	*402*
Unweighted count	*2457*	*778*	*757*	*206*

The relationships between durables and household size and income help to explain the apparently anomalous level of durable ownership among Indians and African Asians. In the previous section it was found that their equivalent incomes were similar to Caribbeans because, although they had slightly higher total incomes, they had larger households. These considerations now lead us to expect Indians and African Asians to have more durables than Caribbeans.

This analysis consolidates the picture of ethnic disadvantage experienced by Caribbeans and South Asians, at the same time as showing a difference between Indians/African Asians and Caribbeans, which had not shown up in the poverty index, but which is consistent with some other measures. It is not clear why minorities in general, and Pakistanis and Bangladeshis in particular, should have even fewer durables than could be explained by their relatively low levels of income. Two possibilities might be considered.

■ One hypothesis is that the minorities, and Pakistanis and Bangladeshis in particular, place a relatively low priority on the accumulation of consumer durables in relation to other potential areas of expenditure. There is no way of testing this hypothesis with the evidence available.

■ Alternatively, the minorities, and Pakistanis and Bangladeshis in particular, might have had greater difficulty acquiring durables than white people with the same incomes and household sizes. A high proportion of low-income white families obtain durables on credit or by renting (Berthoud and Kempson 1992); the minorities might face discrimination in these markets, or might prefer, for cultural reasons, not to borrow. There is some evidence for both of these suggestions (Herbert and Kempson 1996), but we cannot directly link them to the data on consumer durables analysed here.

Arrears with housing costs

Inability to meet financial commitments is one of the key indicators of financial stress. Previous PSI research has shown that problem debts divide into three roughly equal categories: arrears with housing costs; non-payment of other household bills such as electricity or gas; and failure to service consumer credit such as loans or hire-purchase agreements (Berthoud and Kempson 1992). The Fourth Survey collected information about just one of these types of debt – arrears on payments of the mortgage or rent – because housing costs are among the most substantial regular commitments facing most households.

Most commentators try to divide debtors into two simple categories: those who *can't pay*, and those who *won't pay*. But the risk of debt has been shown to be influenced by many different factors, often acting in combination (Berthoud and Kempson 1992):

■ younger people are more likely to be in debt than older ones;

■ families with children are more likely to be in difficulty than those without;

■ low incomes are an important influence on ability to pay;

■ the extent to which people have over-committed themselves to credit is an important influence on ability to pay;

■ personal attitudes influence people's willingness to pay.

Although qualitative studies have illustrated the problems of arrears in particular ethnic minorities (e.g., Sadiq-Sangster 1991), there has never been any systematic attempt to compare the extent of debt among members of different ethnic groups. Some of the minority groups contain disproportionate numbers of families whom we would expect to be at risk: non-pensioners with large families and low incomes.

A point which needs to be made at the start concerns the difference between tenures. Public discussion has focused on mortgage repossessions, but (as this survey confirms) a far higher proportion of tenants are in arrears with their rent, than owner-occupiers have missed mortgage payments. This is not just because many tenants have lower incomes than most owner-occupiers (though that is true). It is something to do with the way payments are collected and enforced, and/or with the attitudes of the two groups to their commitments. You can get away with missing the rent, but the mortgage is more difficult to avoid – or perhaps more important to pay. This means that arrears with housing payments are bound to be more common

for those minority ethnic groups (Caribbeans and Bangladeshis) which include many tenants than for other groups (Indians, African Asians and Pakistanis) with high levels of owner-occupation. Housing itself is analysed in the next chapter. For the moment, the analysis will examine variations in payment experiences within each of the two principal tenures.

We start with mortgage payments, confining the analysis to those with mortgages to repay. Rather less than one tenth of mortgage holders said that they were having problems meeting their payments; about a third of those reported that they were in arrears (Table 5.15).

Hardly any Chinese mortgage holders said that they had any problems, and not one was in arrears. Apart from them, all of the minority groups reported more arrears than white owner-occupiers – on average 4¼ per cent over all black and South Asian groups, compared with 2½ per cent for whites. This is a significant difference, in the statistical sense, and an important one – in the sense of another element of ethnic disadvantage identified. But it is difficult to explain analytically, because such very small numbers of householders were involved. Up to a point, as the fourth row of Table 5.15 shows, minority owner-occupiers had lower incomes than white owner-occupiers, so they would have found it more difficult to meet their payments. This was especially true of the Pakistanis and Bangladeshis. At the same time, as the fourth row of the table shows, South Asians whose incomes were below the 'poverty line' were more likely to be in arrears than white or black owner-occupiers with similar incomes. We cannot tell whether this was because of failure to pay by the Asian borrowers or more stringent terms exacted by their lenders.

Table 5.15 Mortgage problems and arrears

column percentages

	White	Caribbean	Indian	African Asian	Pakistani	Bangladeshi	Chinese
Has a problem with mortgage payments	8.6	9.9	11.7	11.4	17.0	12.3	0.9
In arrears	2.6	3.7	4.5	4.6	4.1	5.2	nil
Percentage of owner-occupiers with incomes below half national average	29%	39%	— 41% —		— 78% —		33%
Percentage of low-income owner-occupiers in arrears	3.1%	4.0%	—8.4% —		—5.9% —		nil
Weighted count	*2260*	*1147*	*464*	*460*	*316*	*130*	*215*
Unweighted count	*2247*	*832*	*467*	*449*	*495*	*302*	*124*

For tenants (including private renters as well as the more numerous local authority tenants) about a third said that they found it 'fairly' or 'very' difficult to pay the rent (Table 5.16). South Asians were rather more likely to say this than the other ethnic groups covered by the survey. A detail not shown in the table is that a relatively high proportion of those Caribbeans who had any difficulty said that it was 'very' difficult. But this question, on its own, did not show a strong pattern.

There was, though, an important ethnic factor in rent arrears.[8] Rather less than one fifth of white tenants were behind with their payments – closely in line with national figures (Berthoud and Kempson 1992). For South Asians, the rate of arrears was similar; for Chinese, slightly lower. But two-fifths of Caribbeans tenants said that they had rent arrears – twice the proportion from any other ethnic group.

Table 5.16 Rent difficulties and arrears

	White	Caribbean	South Asian	Chinese
Fairly or very difficult to pay the rent	31	32	41	41
In arrears	17	38	16	17
Weighted count	*930*	*617*	*183*	*143*
Unweighted count	*908*	*468*	*206*	*305*

It will immediately be seen from Table 5.16 that more Caribbeans were in arrears than said that they had difficulty paying the rent. In fact (Figure 5.7) Caribbean tenants who found it easy to pay were slightly more likely to be in arrears than other tenants who said they had difficulty.

Naturally, we expected the rent arrears to be associated with low levels of income. A high proportion of tenants had low incomes anyway. White households showed the expected pattern, with the poorest tenants most likely to fall behind, the better-off ones being up to date (Table 5.17). Asian tenants had lower levels of income, but the poorest of them were not especially likely to have arrears – they were better payers than their white equivalents. Among Caribbean tenants, on the other hand, income had little to do with it: the poorest had high levels of arrears, but the better-off had high levels of arrears too. Our analysis has not yet yielded an explanation for the arrears reported by Caribbeans who found it easy to pay, or who had relatively high incomes.

Table 5.17 Rent arrears, by income in relation to national average

cell percentages

	White	Caribbean	South Asian
Proportion of tenants below half national average	55	56	71
Rate of arrears			
Below half average	25	40	17
Between half and average	12	45	13
Above average	4	36	(8)
Weighted count	*828*	*533*	*251*
Unweighted count	*809*	*402*	*411*

8 The questionnaire initially asked a straight question about rent arrears, and then asked additionally about cases where apparent arrears were due to a problem with housing benefit or other administrative hitches outside the tenant's control. These 'technical' arrears were not associated either with low income or with difficulty of paying the rent, and have therefore been omitted from the definition of arrears analysed here.

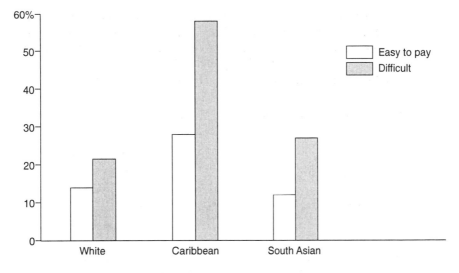

Figure 5.7 Rent arrears, by ease or difficulty of paying

Money worries

Although the possession of consumer durables and arrears of rent or mortgage are reliable 'objective' measures of households' standards of living, 'subjective' questions have often provided sensitive indicators of budgetary stress (Berthoud 1984; Marsh and McKay 1993; Berthoud and Ford 1996). The questions asked of the sample of adults[9] taking part in the survey were as follows:

How often, would you say, have you been worried about money during the last few weeks?

Almost all the time
Quite often
Only sometimes
Never

Taking everything together, which of the following phrases best describes how you (and your family) are managing financially these days?

I (we) manage very well
I (we) manage quite well
I (we) get by alright
I (we) don't manage very well
I (we) have some financial difficulties
I (we) are in deep financial trouble

9 Where there were two or more adults in a household, the answers of a randomly selected person do not necessarily represent the position of the whole household. This should be borne in mind when the answers to this question are cross-analysed against data relating to the household as a unit.

Table 5.18 shows the answers to those questions which indicate financial stress: worrying about money 'all the time'; and 'don't manage very well' or worse. Although different ethnic groups responded slightly differently to the two questions, the overall patterns were very similar. About one in five white people showed symptoms of financial stress according to one or the other of the two questions (third row of the table). For Indians and African Asians, the proportion was very similar; for Pakistanis, slightly higher; for Chinese, rather lower. The two groups which stood out, though, were Caribbeans and Bangladeshis, two-fifths of whom experienced financial stress.

Table 5.18 Indicators of financial stress

column percentages

	White	Caribbean	Indian	African Asian	Pakistani	Bangladeshi	Chinese
Worry about money all the time	16	29	10	15	17	21	5
Don't manage very well (or worse)	11	24	13	16	22	34	10
Either of these	20	38	18	22	29	41	14
Among those below half average income	37	61	26	40	33	46	22
Weighted count	*2797*	*774*	*487*	*453*	*338*	*111*	*176*
Unweighted count	*2815*	*563*	*509*	*452*	*531*	*268*	*101*

It is not surprising that Bangladeshis were the worst-off group on this measure, since they have already been shown to be the worst off on several other counts, especially household income. On the other hand, most measures place Pakistanis very close to the Bangladeshis, but here there is a clear difference of perception.

By the same token, the fact that Caribbeans were more worried about money than white people could be attributed to their relative incomes, if it were not for the fact that Indians and African Asians, with incomes closer to those of the black group, reported no more financial stress than the white group.

The bottom row of Table 5.18 shows how many people, whose household income was below the 'poverty' line used for earlier analysis, reported either kind of financial stress. This confirms that Chinese and Indian people were *less* likely to express concern about these matters than whites. African Asians and Pakistanis took much the same view as white people with similar incomes, while Bangladeshis seemed to be much more worried than Pakistanis, who have been so similar to them in other ways.

Questions such as this are very sensitive to the precise weighting of the words chosen, and it is possible that differences between Asian groups have arisen because one of the translations of the questionnaire used a stronger or weaker word for 'worry' than another. No such explanation applies to the Caribbeans, who were much more likely to express anxiety about living on a low income than any other group. Three out of five of Caribbeans below the half-average-income line showed signs of financial stress.

'Hardship'

Is it possible to generalise about the living standards of ethnic minorities, drawing on the evidence about three rather different indicators: durables, arrears and money worries? Table 5.19 shows the results of parallel analyses of all three indicators. Logistical regression techniques have been used to measure the relative influence of a number of factors on the probability of experiencing different types of 'hardship', defined as six or fewer consumer durables, either mortgage or rent arrears, and either of the 'money worries' analysed in the last section.[10] A plus sign (+) in the table means that the group under consideration is *more* likely to suffer a particular type of hardship; a minus sign (–) means they are *less* likely to suffer hardship.

The top row of the table shows that all three indicators of hardship were less likely to occur, the higher a household's income. This is exactly as would have been expected, and we could not have treated the indicator as a sign of hardship if that relationship had not been true.

The next three rows show that household composition had important effects on the hardship measures, though they were inconsistent. Larger households were less likely to be short of consumer durables, but more likely to have arrears or money worries. Pensioner households were the opposite: they were more likely to lack durables, but less likely to report debt or anxiety. People who rented their homes, though, were consistently more likely to show hardship on all three indicators. All these findings are similar to those derived from other sources (Berthoud and Ford 1996). They are of potential interest in their own right, but they are included here simply to ensure that they have been taken into account before comparisons are made between ethnic groups.

Table 5.19 **Logistical regression analysis of hardship, analysed by income and household characteristics**

			coefficients
	Lack of durables	Arrears	Money worries
Household income (per £100)	–0.51	–0.37	–0.43
Household characteristics			
Number of children	–0.27	+0.22	+0.16
Number of adults	–0.40	+0.14	No effect
Pensioner household	+0.58	–1.43	–1.22
Tenant	+1.26	+1.40	+0.47
Ethnic group (compared with white)			
Caribbean	+0.62	+0.83	+0.53
Indian	+0.69	No effect	–0.53
African Asian	+0.48	No effect	No effect
Pakistani	+1.95	–1.14	–0.38
Bangladeshi	+2.72	-0.86	No effect
Chinese	No effect	–1.31	–0.79

10 The equations are very similar to those used by Berthoud and Ford (1996) in their analysis of 'relative needs'.

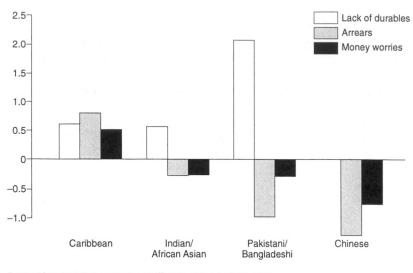

Derived from logistical regression coefficients shown in Table 5.19.

Figure 5.8 Effect of ethnicity on the probability of experiencing hardship

As far as consumer durables are concerned, Chinese households were very similar to white households, but all other minority groups were significantly *more* likely to be short of durables in their home. This was especially true of Pakistanis and Bangladeshis, who had far fewer items of equipment than would have been expected. Remember that this conclusion has been reached after taking account of household incomes, so it suggests that (on this measure) Pakistanis and Bangladeshis were even poorer than could be explained by their lack of money.

For arrears and money worries, though, there was a different pattern of hardship. Once income and household characteristics have been taken into account, the various Asian minority groups were either similar to white households, or rather *less* likely than whites to report these kinds of hardship. In contrast, as indicated in the straightforward tables in the previous sections, Caribbean households were much *more* likely to report arrears and money worries, as well as a shortage of durables.

These findings are illustrated in Figure 5.8, which clearly shows how the Caribbeans were worse off on all three measures. They may not have been far behind white people in a simple measure of income, but there is consistent evidence of financial hardship among Caribbeans which requires more detailed investigation. For Asians, the story is more mixed: at any given level of income they tended to do worse on one criterion (durables), but level with whites, or better, on the other two (arrears and money worries).

MONEY WITHIN THE FAMILY

It was mentioned at the beginning of this chapter that income was measured at the household level on the assumption that the income of one member was available to be spent on the needs of others in the same household. A whole new study would be required to show exactly how resources are (or are not) shared within a household. But we did ask some questions about the roles of husbands and wives.

In every ethnic group, at least half of those taking part in the survey said that financial decisions were shared by husband and wife equally (Table 5.20). But also, in every group, more people said that the man was in charge than said the woman was. The variations were in the gap between male to female leaderships of family finances. In the white sample, a fifth of men and less than a tenth of women were said to take more of the responsibility – almost exactly the same figures as have been reported for the population as a whole by the British Household Panel Survey (Laurie and Rose 1994). Among Caribbean households, the number of women said to accept responsibility for financial decisions was slightly higher, but hardly enough to prompt us to discuss matriarchal relationships imported from the West Indies. In the Asian communities, though, husbands were reported to have much more of the responsibility – especially among Pakistanis, Bangladeshis and Chinese.

Table 5.20 Split of male–female financial influence

column percentages

	White	Caribbean	Indian/ African Asian	Pakistani/ Bangladeshi	Chinese
The man	20	18	28	39	34
Both equally	71	69	69	52	60
The woman	9	13	4	9	6
% male minus % female as reported by					
Men	12	10	24	42	45
Women	11	1	21	18	26
Weighted count	*1877*	*345*	*698*	*389*	*121*
Unweighted count	*1632*	*263*	*726*	*643*	*73*

The question, asked only of men and women in couples, was 'In your household who has the final say in big financial decisions?'

Both married men and married women were asked this question, but not both members of the same couple, so we have no direct comparison of the two views. In many groups men and women gave broadly similar answers. But the more patriarchal groups (as indicated by this question) showed much greater divergence between the sexes in the answers they gave, so that men tended to give a greater impression of their dominance than women conceded. This might suggest either that the dominance is nominal rather than real; or that, if real, it will not be long-lived. Another indication that Asian women may hold a more balanced proportion of financial responsibility in future is that the answers given by those who were born here were more similar to the white pattern than to the responses of those who had been born in their country of origin (not shown in the table).

CONCLUSIONS

This has been the first ever analysis of ethnic minorities' household incomes. Much more needs to be learned when more reliable and detailed data about the composition of households' budgets have been accumulated. But there are two important preliminary conclusions.

The first, and outstanding, finding is the extent of poverty among both Pakistani and Bangladeshi households. We have known from data about employment, earnings and household structure that they must be poor, but the clear measurement has nevertheless been startling. More than four out of five Pakistani and Bangladeshi households fell below a benchmark which affected only a fifth of white non-pensioners. Name any group whose poverty causes national concern – pensioners, disabled people, one-parent families, the unemployed – Pakistanis and Bangladeshis were poorer.

The huge difference between Pakistanis and Bangladeshis and other groups may obscure other important variations in income. While Chinese households were found to be very close to their white equivalents, Caribbean, Indian and African Asian households were all more likely to be in poverty, and less likely to have relatively high family incomes, than whites. The size of this difference would look large if there were no Pakistanis and Bangladeshis in the survey to make it seem small.

The income analysis has, however, put a different slant on ethnic inequality, compared with the findings about employment from the Labour Force Survey, the Census or even this survey. Our findings on disadvantage in employment suggest that the Chinese and African Asians seemed to be upwardly mobile, while Indians and Caribbeans continued to suffer some disadvantage, and the Pakistanis and Bangladeshis suffered severe disadvantage (see 138–144 above). Now we find that not just the Indians but also the African Asians were worse off than the Chinese, and Caribbeans much better off than the Pakistanis and Bangladeshis. The Indians/African Asians were therefore much closer to the Caribbeans than might have been expected from some other analyses (FitzGerald and Uglow 1993; Peach (ed) 1996). This is partly because Indians and African Asians, with rather more adults and children per household than Caribbeans, suffered a fall in 'equivalent' income from having more mouths to feed, backs to clothe and so on (see Tables 5.3 and 5.4). It is partly because relatively more Caribbean people lived in mixed white/minority households with incomes higher than those of all-minority families (Table 5.7).

Whatever the detailed explanation, the analysis suggests that some of the optimism expressed about the progress of Indians and African Asians may have been exaggerated. *All* minorities included in this survey, with the exception of people of Chinese origin, were disadvantaged with respect to the white majority, according to this measure.

Direct indicators of living standards partly supported this conclusion, but also introduced a different perspective.

- Although Indians and African Asians often had more consumer durables than white people, this was explained by their larger than average households. All minority groups, except the Chinese, had fewer durables than would have been expected. This was especially true, again, of Pakistanis and Bangladeshis.

■ When we considered financial problems such as arrears and money worries, the Asian communities seemed no worse off, and sometime better off, than might have been expected, given their incomes. But Caribbeans had exceptionally high levels of rent arrears, and were much more likely to report money worries than any other group.

Thus the main focus for concern should be Caribbeans and Pakistanis and Bangladeshis. But these two broad groups have rather different problems.

APPENDIX A: THE MEASURE OF TOTAL HOUSEHOLD INCOME

One member of the household was asked to report the total net income of the whole household. S/he was shown a card with 16 income ranges offered in either weekly or monthly amounts.

This form of question has been tested by the Office of Population Censuses and Surveys (OPCS) (Foster and Lound 1993), comparing the results with more detailed questioning of each member of the household. The conclusions of that test were as follows.

■ The simple question yielded an answer for total household income more often than did detailed questioning.

■ Although the response rate to the simple question was lower when there were several adults in the household, the response to detailed questioning was even more sensitive to this.

■ The majority of households were allocated to the same income band whichever question was used. But the simple question more often understated than overstated total income.

■ The distribution of total household income was almost identical whichever questions were asked.

■ In larger households (which tended to have higher incomes) the simple question tended to understate total income slightly.

These conclusions suggest that the question asked in the Fourth National Survey was appropriate for providing broad measures of household income, given that detailed questions asked of each individual were not possible. But the slightly lower level of income reported in larger households is a potentially important factor, bearing in mind the relatively large household sizes of South Asian households.

The use of income ranges (rather than exact amounts) should cause no problem if the analyst wishes simply to group households by bands of total net income. For any other purpose it is necessary to assume that the actual incomes of households in each band are at the mid-point of the range. Thus the survey's measure of 'equivalent' income, and the comparison with the national average, will be less precise than would have been possible if the data had provided actual incomes in

pounds. There is, though, no reason to suppose that the mid-point assumption systematically affected one ethnic group more or less than another.

A second potential inaccuracy occurs if a significant proportion of respondents are unwilling to report their income. This applies to all income questions, and indeed the single question with bands is intended to minimise non-response. Random refusals do not matter, but there would be a serious bias if better- or worse-off households were less likely to answer than others. In general it is thought that people with high incomes tend to be more secretive about money. South Asians were more likely to refuse to answer this question than white or Caribbean respondents, but this does not in itself matter as long as the ethnic groups are kept separate. Analysis by social class suggested some tendency for those who probably had higher incomes to have higher refusal rates, but the differences were small and inconsistent. Reweighting the data to counteract the class variations in non-response made virtually no difference to the averages recorded for each group.

The third, and potentially the most serious, possible problem with the income question is that an individual does not necessarily know the total income of the household of which he is a member. Not all information is necessarily freely available to all members. Even where all the facts are known, people may never have bothered to add up all the sources. Thus in a complex household with several sources of income the respondent might have to guess the total, or decline the attempt.

Table 5.21 Response to the income question, by number of earners in household

	White	Caribbean	Indian/ African Asian	Pakistani/ Bangladeshi
Percentage unable or unwilling to answer				
Overall	17	17	35	29
No earner	14	14	31	26
One or two earners	17	17	36	31
Three or more earners	33	41	39	44
Average income (among those reporting it)				
No earner	£135	£118	£134	£119
One or two earners	£385	£321	£353	£231
Three or more earners	£526	£458	£515	£464
Actual average income	£294	£249	£322	£200
After controlling for number of earners	£299	£255	£325	£202

Based on all households.

An indication of the extent of this problem is given in Table 5.21, where the white and Caribbean refusal rates were substantially higher if there were several earners in the household. For South Asians, overall refusal rates were higher, but did not vary so much according to the number of earners. Naturally, total income was also sensitive to the number of earners, so there is a potential source of bias. But, as the final two lines of Table 5.21 show, this would have had only a small influence on

overall comparisons between groups. The greatest bias (for Caribbeans) represented only about 2 per cent of average income.

It can be imagined that, in many households, information about income may be known to 'senior' members of the family but not to the 'junior' members. If so, the accuracy of this question would depend on who was invited to provide the information. The household questionnaire was intended to be asked of the person responsible for the accommodation, a phrase not dissimilar to the OPCS definition of a head of household. But there is some evidence in the data that the interviewers sometimes asked household questions of the randomly selected adult who was about to take part in the personal interview. In about 5 per cent of white and Caribbean households, and about 10 per cent of Asian households, the income question was asked of someone whose parent lived in the same household, and who may therefore have been a 'junior' member of the family. These 'children' were rather more likely than other types of respondent to say they did not know their household's income, though the effect was smaller for ethnic minorities than for whites. But the 'children' who did attempt an answer did not report either higher or lower incomes than other respondents in households with a similar numbers of earners.

While internal analysis of the Fourth Survey answers may provide clues to the validity of the data, the best test is whether we have produced similar answers to other sources. Our pattern of variation between ethnic groups is almost identical to that shown by the Family Resources Survey (DSS 1996c). The DSS survey asked more detailed questions; the PSI survey had a better sample of ethnic minorities. The fact that both give similar results lends credibility to both sources.

Neighbourhoods and Housing

Jane Lakey

INTRODUCTION

The ethnic minority groups surveyed in this report came to Britain, mainly from the late 1950s onwards, to take up employment in industries which had difficulty recruiting sufficient labour from the white population. Different minority groups formed concentrations in different areas of the country depending on the types of industry into which they were recruited. Early migrants in particular faced high levels of discrimination from the white community and its institutions, which affected the areas and accommodation which they could find to live in. Many started their British residence in poor quality accommodation in the private rented sector.

Much has changed since the late 1950s. Slum areas have been cleared, amenity levels increased and levels of overcrowding decreased. Home ownership and social renting have both increased while the private rented sector has dwindled to cater for only a small, though still significant, minority of households. There have been numerous legal and policy initiatives designed to address the problems of individual and institutional discrimination against ethnic minorities in housing, as in other areas (Phillips 1987).

In this chapter, we examine characteristics of the neighbourhoods and housing where white and ethnic minority respondents lived in 1994. We were interested in the extent to which ethnic minority households and individuals were still disadvantaged, in terms of the type and quality of areas and accommodation available to them, and the extent to which they were satisfied with their neighbourhoods and housing. Comparisons are also made with the position of the various ethnic groups in 1982. We were interested in the extent to which minority households had been able to make progress into more desirable areas and types of housing.

PATTERNS OF SETTLEMENT

Various studies have documented the ways in which migrants to Britain initially formed concentrations within particular areas, and the reasons for their doing so. Most importantly, migrant groups from different areas tended to have different profiles of skills and experience, leading them to seek employment in particular industries. Ballard (1996), for example, shows how the tendency of Pakistanis to settle in particular Northern conurbations, such as Greater Manchester and parts of Lancashire, was related to the seeking out of employment opportunities within the

textile and heavy engineering industries. Within such areas, patterns of residence were further constrained initially by dependence on other migrants from the same area of origin for information about and help in acquiring accommodation, and by unwillingness on the part of the indigenous white community to rent or sell accommodation to the newcomers. We would expect to see changes in housing and residential patterns, as migrants and their children (often born in Britain) learned more about the institutions and opportunities within the host country, met residency qualifications and accumulated educational and financial resources (Phillips 1987; Byron 1993).

The issue of ethnic minority concentration into particular areas has been explained in terms of 'choice' and 'constraint' theories. Proponents of the choice theory argue that ethnic minorities may prefer to reside within concentrations of their own group, for reasons of social support, and shared linguistic, cultural and religious traditions (Dahya 1974; Khan 1977; Anwar 1979). Constraint theorists argue that they have been prevented from moving outside these areas by their economic position, by lack of information about housing opportunities elsewhere, and by discriminatory and exclusionary practices on the part of the white community (early evidence of such discriminatory practices was provided by Daniel 1968). Recent authors have drawn attention to the dynamic relationship between individual choice and socio-economic constraints (Phillips 1987; Sarre 1986).

Both ethnic minority and white households experience the interplay of choices and constraints in their decisions over where to live. Economic constraints, for example, include the finance available to pay for accommodation, and the accessibility of employment. Whites and ethnic minorities alike may choose to reside near kin and long-established friends, and may prefer the shared traditions of a familiar community. Nonetheless, we would expect ethnicity to influence the ways in which such choices and constraints are experienced. Members of ethnic minority groups also face constraints with which the white majority do not have to contend, for example, racial discrimination in the allocation of, or direction to, housing within particular areas (e.g. CRE 1988, 1989, 1989/90, 1990a, 1990b).

Table 6.1 shows how ethnic groups were distributed across the nine regions of England and Wales. The distribution was very similar to that shown in the 1991 census results, suggesting that the fourth survey did provide an accurate picture of the pattern of ethnic minority settlement. The most striking feature of Table 6.1 is the concentration of ethnic minorities into the South-East region, and, in particular, into Greater London. Fewer than one out of ten whites lived in Greater London, but more than half of Caribbeans, African Asians and Bangladeshis lived in this area, as did four out of ten Chinese and one third of Indians. Pakistanis were less likely than members of other minorities to live in Greater London, although they were still nearly twice as likely as whites to live in this area. Indians, African Asians and the Chinese were as likely as whites to live in the rest of South-East England, but Caribbeans, Bangladeshis and Pakistanis were less likely than whites to live in this area.

Table 6.1 Region of residence

column percentages

	White	Caribbean	Indian	African Asian	Pakistani	Bangladeshi	Chinese
North	11	0	2	1	9	2	5
Yorks/Humberside	10	6	3	3	25	2	8
East Midlands	7	4	4	10	1	1	4
Greater London	8	51	33	51	17	53	39
Rest of South East	19	12	18	19	7	11	23
South West	16	4	1	0	0	0	4
West Midlands	10	17	33	7	23	14	4
North West	7	1	4	7	16	9	4
Wales	3	0	1	1	1	6	3
East Anglia	9	5	1	1	1	2	6
Weighted count	*2867*	*1567*	*1292*	*799*	*862*	*285*	*391*
Unweighted count	*2867*	*1205*	*1273*	*728*	*1185*	*591*	*214*

Substantial proportions of Pakistanis lived in Yorkshire and Humberside, the West Midlands and the North-West regions. They were also almost as likely as whites to live in the northern region. Outside the South East, the other important concentrations of ethnic minorities were those of African Asians in the East Midlands region, Caribbeans, Indians, Pakistanis and Bangladeshis in the West Midlands region, and Pakistanis and Bangladeshis in the North-West region.

Table 6.2 shows that, whatever the region of residence, ethnic minorities were far more likely than whites to live in metropolitan areas or conurbations.[1] More than two-thirds of Caribbeans, Indians, African Asians, Bangladeshis and Pakistanis lived in metropolitan areas, compared with fewer than one third of whites. Slightly more than half of Chinese respondents lived in metropolitan areas. Caribbean, Bangladeshi and Chinese groups were particularly highly concentrated in inner London. Along with Pakistani respondents, these groups were also more likely than others to live in other inner metropolitan areas. Large proportions of Caribbean, Indian and Chinese respondents lived in outer London, and nearly half of all African Asians lived in this area. Around a third of Indian and Pakistani respondents lived in the outer parts of other metropolitan areas, making them more than twice as likely as other groups to do so.

Research by Robinson (1993), comparing data from the 1981 and 1991 censuses, shows that, far from becoming dispersed more widely across different areas of the country, ethnic minority groups have become more concentrated into urban areas during the last decade. Caribbean, Indian and Bangladeshi groups became more concentrated in the South East; Indians and African Asians became more concentrated in the East Midlands; and Pakistanis became more concentrated in the North West region, particularly Greater Manchester. All four groups became more concentrated in Greater London, although Bangladeshis were the only group to become more concentrated in inner London. However, as Jones (1983) has shown,

1 The conurbations were defined as the seven former metropolitan counties: London, West Midlands, Greater Manchester, South Yorkshire, West Yorkshire, Merseyside and Tyneside. The inner areas were the districts at the centre of these conurbations: the inner London boroughs, Birmingham, Manchester, Sheffield, Leeds, Liverpool and Newcastle.

increased minority concentration need not necessarily result from a lack of mobility out of disadvantaged areas. His research stresses the importance of demographic effects, arguing that, even if mobility out of areas with high minority concentration increases, higher than average birth rates among those who remain may result in increased social segregation.

Table 6.2 Proportion of respondents resident in inner and outer metropolitan areas

column percentages

	White	Caribbean	Indian	African Asian	Pakistani	Bangladeshi	Chinese
Inner London	5	25	6	4	4	41	17
Outer London	3	26	28	47	13	12	23
Other inner metropolitan[1]	6	15	8	2	15	13	11
Other outer metropolitan[2]	14	6	31	14	36	11	4
Non-metropolitan	71	27	28	33	33	22	46
Weighted count	*2867*	*1567*	*1292*	*799*	*862*	*285*	*391*
Unweighted count	*2867*	*1205*	*1273*	*728*	*1185*	*591*	*214*

1 Birmingham, Manchester, Sheffield, Leeds, Liverpool, Newcastle.
2 Tyne and Wear, Merseyside, Greater Manchester, West Yorkshire, South Yorkshire, West Midlands.

Segregation

The Fourth Survey data were linked to Census data about the districts, wards and enumeration districts where respondents lived. Thus it is possible to show how the individuals we interviewed compared with the whole population of people living in their areas. Table 6.3 shows that, in wards where white respondents lived, the average proportion of ethnic minorities was less than one in 20. On the other hand, Caribbeans and Indians/African Asians lived in wards where the average proportion of ethnic minorities was around one quarter, and, in wards where Pakistanis and Bangladeshis lived, the proportion of ethnic minorities was around one third. Chinese respondents lived in wards where one seventh of the population, on average, came from ethnic minority groups.

Table 6.3 Proportion of ethnic minorities (1991) in local authority wards where PSI sample resided

column percentages

	White	Caribbean	Indian/ African Asian	Pakistani	Bangladeshi	Chinese
Less than 10%	90	23	24	17	15	45
10 – 24.99%	10	29	37	35	24	39
25 – 49.99%		34	23	29	39	15
50% or more		14	15	19	22	1
Average (mean)	**4**	**27**	**26**	**29**	**34**	**14**
Weighted count	*2867*	*1567*	*2091*	*862*	*285*	*391*
Unweighted count	*2867*	*1205*	*2001*	*1185*	*591*	*214*

Although Table 6.3 clearly shows that members of ethnic minorities formed concentrations in particular areas, it also shows that, for the most part, they remained 'minorities' in majority white areas. Nearly half of Chinese and nearly a quarter of Caribbean and Indian/African Asian respondents lived in areas where less than 10 per cent of the population came from minority groups. The proportion of ethnic minority respondents who lived in wards where minorities, and not whites, comprised the majority of the population was one in five for Pakistanis and Bangladeshis, and one in seven for Caribbeans and Indians/African Asians. As Peach (1996) has shown, this pattern is quite different from the American model of the black ghetto, in which most black people live in areas where the majority of the residents are also black.

Table 6.4 shows, for each ethnic minority group, the proportion of residents originating from the same ethnic group, in the average ward where that group lived. It shows that, on average, Chinese respondents lived in wards where only 1 per cent of the population was drawn from their own ethnic group, Caribbeans lived in wards where 9 per cent of residents were from their own group, and Indian/African Asian, Pakistani and Bangladeshi respondents lived in wards where 13 to 14 per cent of residents came from their respective groups.

Table 6.4 Own ethnic group (1991) in local authority wards where PSI sample resided

column percentages

	Caribbean	Indian/ African Asian	Pakistani	Bangladeshi	Chinese
Less than 2%	21	18	14	30	91
2 – 4.99%	16	14	11	20	9
5 – 9.99%	25	21	27	14	0
10 – 24.99%	34	26	25	18	0
25% or more	3	20	23	17	0
Average (mean)	**9**	**13**	**14**	**13**	**1**
Weighted count	*1567*	*2091*	*862*	*285*	*391*
Unweighted count	*1205*	*2001*	*1185*	*591*	*214*

Asians were more likely than Caribbeans to live in wards where at least a quarter of the population came from their own group. Only 3 per cent of Caribbeans lived in such wards, compared with around 20 per cent of each South Asian group. Although a substantial number of Bangladeshis lived within a high concentration of their own ethnic group, Bangladeshis were also the most likely of any minority group (except the Chinese) to live in wards where less than 5 per cent of the population came from their own group. Half of Bangladeshis lived in such areas, compared with around one third of Caribbeans and Indians/African Asians, and a quarter of Pakistanis.

We would expect that the concentration of ethnic minorities, and of each minority's own group, would vary according to the type of area lived in, with residents of non-metropolitan areas having low proportions of co-residents from their own and other minority groups, and residents of inner metropolitan areas tending to have high proportions of co-residents from these groups. Table 6.5

confirms that this was the case for the PSI sample. However, it also shows that, whatever the type of area, white and ethnic minority populations were relatively segregated.

Table 6.5 Average percentage of ethnic minorities (1991) in local authority wards where PSI sample resided, by ethnic group and type of area

	White	Caribbean	Indian/ African Asian	Pakistani	Bangladeshi
Inner London	20	30	38	43	43
Outer London	12	38	38	34	–
Other inner metropolitan	4	39	42	45	–
Other outer metropolitan	3	23	18	30	–
Non-metropolitan	3	8	13	13	–

Table 6.5 shows that whites resident in inner London lived in wards where, on average, 20 per cent of residents came from ethnic minorities. Caribbean residents of inner London lived in wards where the average proportion of ethnic minorities was 30 per cent, and South Asian inner London residents lived in wards where the average proportion of ethnic minorities was around 40 per cent – twice that of the wards where the whites lived. Segregation was more pronounced in outer London, where whites lived in wards with an average of 12 per cent of the population coming from ethnic minorities, but Caribbean and South Asian residents lived in wards with around three times this proportion of ethnic minorities.

The most pronounced segregation of all occurred in metropolitan areas outside London. Whites resident in these areas tended to live in wards where only 3 to 4 per cent of the population came from ethnic minorities. By contrast, ethnic minorities resident in inner metropolitan areas outside London lived in wards where around 40 per cent of the population was drawn from ethnic minorities, and those resident in outer metropolitan areas lived in wards with an average of 20 to 30 per cent of the population drawn from ethnic minorities. Ethnic minorities also formed concentrations in non-metropolitan areas, but the degree of segregation in these areas was less pronounced than that in the metropolitan areas outside London.

Tables 6.6 and 6.7 show preferred proportions of co-residents from ethnic minorities, and from each minority's own group, giving some indication of the degree to which ethnic minorities resided together by choice. Respondents were asked to say if they preferred to live in an area where fewer than half the people were of ethnic minority origin, where about half were of minority origin or where more than half were of minority origin. They were also asked the same question regarding their own ethnic group.

The first point to note about Table 6.6 concerns the high percentage of respondents who said that they had no preference regarding the proportion of ethnic minorities living in their area. This was the case for around four out of ten white, Caribbean, Pakistani and Bangladeshi respondents, nearly half of Chinese respondents, and considerably more than half of Indian and African Asian respondents. Half of white and a third of Chinese respondents said that they would

prefer fewer than half of local residents to come from ethnic minorities (almost all white and Chinese respondents lived in wards where fewer than half of residents were from minority groups). On the other hand, only around one in six Caribbean and South Asian respondents said that they would prefer fewer than half of local residents to come from ethnic minorities, although the vast majority of Caribbeans and South Asians lived in this type of ward. More than four out of ten Caribbean, Pakistani and Bangladeshi respondents stated a positive preference for half or more residents to come from ethnic minorities, although fewer than 2 out of 10 Caribbean, Pakistani and Bangladeshi respondents actually lived in this type of ward.

Table 6.6 Preferred proportion of ethnic minorities in local area

column percentages

	White	Caribbean	Indian	African Asian	Pakistani	Bangladeshi	Chinese
No preference	39	42	60	55	38	38	46
Fewer than half	51	16	16	16	16	18	34
Half or more	10	41	24	29	46	44	20
Weighted count	*2778*	*763*	*624*	*375*	*401*	*134*	*192*
Unweighted count	*2773*	*595*	*614*	*331*	*558*	*280*	*103*

Table 6.7 Preferred proportion of own ethnic group in local area

column percentages

	Caribbean	Indian	African Asian	Pakistani	Bangladeshi	Chinese
No preference	41	56	50	35	42	42
Fewer than half	12	15	17	13	16	32
Half or more	47	29	33	51	42	25
Weighted count	*772*	*636*	*379*	*405*	*135*	*195*
Unweighted count	*604*	*623*	*335*	*567*	*281*	*104*

Turning to preferred proportions of residents from each minority's own group, Table 6.7 shows a somewhat different pattern. With the exception of the Bangladeshis, respondents from each ethnic group were more likely to express a positive preference for half or more residents to come from their own group than they were to express a preference for half or more residents to come from ethnic minorities. In actuality, the proportion of ethnic minorities living in wards where half or more residents were from their own group was very small indeed.

UNEMPLOYMENT IN MINORITY AREAS

As we mentioned earlier, it is important to look not only at the degree of segregation in areas where ethnic minorities lived but also at the social and economic characteristics of those areas. Census data about unemployment rates were used to provide an indication of socio-economic disadvantage. Table 6.8 shows that the

average white respondent lived in a ward where the unemployment rate was around 9 per cent. By comparison, average African Asian, Chinese, Indian and Caribbean respondents lived in wards with unemployment rates of between 11 and 14 per cent, and average Pakistani and Bangladeshi respondents lived in wards with unemployment rates of 17 per cent and 19 per cent respectively.

Table 6.8 Unemployment rates (1991) in local authority wards where PSI sample resided

cell percentages

	White	Caribbean	Indian	African Asian	Pakistani	Bangla-deshi	Chinese	All ethnic minorities
Unemployment rate								
All ethnic groups	8.7	14.4	12.7	11.1	17.0	19.0	11.8	14.0
Whites	8.1	8.9	8.1	7.0	10.5	10.8	9.1	8.8

Although general rates of unemployment were much higher in areas where minorities were concentrated, the rates for whites living in these areas were only slightly higher than white unemployment rates in typical white areas. This would suggest that high unemployment rates among ethnic minorities in general were a major factor behind the high unemployment rates in areas where they were concentrated.

Figure 6.1 shows how the relationship between unemployment rates and the percentage of ethnic minorities in the local ward varied for Caribbeans, Indians/African Asians and Pakistanis/Bangladeshis. Caribbeans living in wards with half or more residents from ethnic minorities had a significantly higher chance of unemployment than those living in areas of lower minority density. Indians and African Asians living in wards with the lowest concentration of ethnic minorities

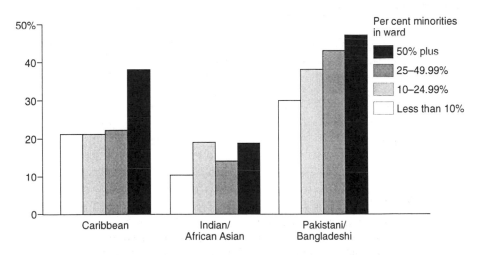

Figure 6.1 Unemployment rate of Fourth Survey respondents, by percentage of ethnic minorities in ward (1991)

(less than 10 per cent) had lower than average rates of unemployment, but those living in wards with half or more residents from ethnic minorities were no more likely to be unemployed than those living in wards with 10 to 25 per cent minority residents. For Pakistanis and Bangladeshis, the likelihood of unemployment increased with each increment in the degree of minority concentration.

Our analysis suggests that the relationship between unemployment rates and concentration of ethnic minorities is complex and would merit further exploration. High rates of unemployment in areas where minorities were concentrated reflected high rates of unemployment among minorities in general. Higher densities of minority residence were also associated with increases in unemployment chances, although the precise relationship between minority concentration and the likelihood of unemployment varied between ethnic groups.

AMENITIES AND PROBLEMS

Respondents to the Fourth Survey were asked to rate their local areas as good, poor or neither for a range of ten amenities: ease of getting to work, access to public transport, provision of schools, places of worship for their faith, shops, leisure facilities and parks/green areas, safety from burglaries, safety on the streets, and opportunities for being with people of their own ethnic group. They were also asked about a range of possible problems that might have occurred in their local areas, from unkemptness to crime and harassment.

Ethnic minority and white respondents gave similar ratings to their areas for ease of getting to work, public transport access, provision of schools, shops and parks, safety from burglaries, and safety on the streets. With one exception, those differences which did occur disappeared when we took account of the higher proportion of ethnic minorities living in urban areas. The one result which did stand out was that Bangladeshis were substantially less likely than other groups to say that they had good access to parks or green areas (Table 6.9).

Table 6.9 Perception of local amenities, by ethnic group

	White	Caribbean	Indian/ African Asian	Pakistani	Bangladeshi	Chinese	All ethnic minorities
Access to parks	79	76	76	71	49	73	74
Places of worship for your faith[1]	90	75	64	80	68	–	70
Leisure facilities	22	38	52	51	31	31	45
Being with people of own ethnic group	–	62	71	87	78	46	70

1 Excluding those with no religion.

Whether they lived in inner cities, suburbs or more rural areas, members of ethnic minorities were less likely than whites to rate their areas good for the provision of

appropriate places of worship. There was considerable variation between ethnic minority groups on this issue, with eight out of ten Pakistanis, three-quarters of Caribbeans, but only around two-thirds of Bangladeshis and Indians/African Asians saying that their areas had good provision of places of worship (Table 6.10). Differences appeared to be related to discrepancies in the availability of places of worship for the various religions: nearly nine out of ten Christians said that their areas had good provision of appropriate places of worship, compared with three-quarters of Sikhs and Muslims and only half of Hindus and members of other religions (Table 6.11). The high proportion of Hindus in the Indian/African Asian group (see Table 1.2) is likely, therefore, to have been a factor contributing to their experience of relatively poor provision of places of worship. On the other hand, the majority of Bangladeshis were, like Pakistanis, of the Muslim religion (see Table 1.2). The relatively poor provision of places of worship in Bangladeshi areas, compared with Pakistani ones, could be related to the fact that the Pakistani community is longer established in Britain.

Table 6.10 Perception of local amenities, by area of residence

Score[1] for	*All inner metropolitan*		*All outer metropolitan*		*Non-metropolitan*	
	White	Minority	White	Minority	White	Minority
Places of worship						
for your faith	1.8	1.6	1.9	1.5	1.8	1.4
Leisure facilities	0.7	1.0	0.6	1.0	0.5	1.0
Being with people						
of own ethnic group	–	1.7	–	1.6	–	1.3

1 2=good, 1=neither good nor poor, 0=poor.

Members of ethnic minorities were significantly more likely than whites to rate their areas as good for the provision of leisure facilities, a difference which remained true when we took account of variations between inner metropolitan, outer metropolitan and non-metropolitan residents (Table 6.10). There was also considerable variation between minority groups on this issue. Half of Indian/African Asian and Pakistani respondents rated their areas good for the provision of leisure facilities, compared with just under four out of ten Caribbean respondents, around three out of ten Bangladeshi and Chinese respondents, and only around two out of ten white respondents (Table 6.9). Cultural differences, in the types of leisure facilities desired, may have been responsible for the variation here.

Table 6.11 Percentage of respondents saying that local area has good provision of places of worship for their faith, by religion

Religion	
Hindu	49
Sikh	77
Muslim	75
Christian	87
Other	50

Among ethnic minorities, Pakistanis were the most likely to rate their areas as good for being with other members of their own ethnic group, followed, in order, by Bangladeshis, Indians/African Asians, Caribbeans and finally Chinese respondents (Table 6.9). This is the result we might expect from our findings shown earlier (Table 6.6), that Pakistanis lived in areas with the highest concentration of their own ethnic group, followed by Indians, African Asians and Bangladeshis, then Caribbeans, and finally the Chinese. As we would also expect from analysis of minority concentration levels in different areas (Table 6.5), ethnic minority respondents living in non-metropolitan areas were less likely than metropolitan dwellers to rate their areas good for being with members of their own ethnic groups (Table 6.10).

The English House Condition Survey (DoE 1993) categorised neighbourhood environmental problems as those of: being unkempt, i.e., subject to problems of litter, rubbish, dumping, scruffy gardens, vandalism or graffiti; in poor maintenance, i.e., with roads, pavements, paths or street furniture in poor condition; close to industry, with associated problems of waste, pollution or noise; abandonment, i.e., with vacant sites and non-conforming uses; heavy traffic and nuisance from street parking; and noise, e.g., from railways or aircraft.

The Fourth Survey asked about all of these environmental problems except the last (noise), and also investigated nuisance from dog mess and infestations of vermin. In addition, respondents were asked about the extent of crime and harassment in the local area, in terms of problems with burglaries, car theft, assaults, harassment, troublesome children and troublesome teenagers.

There was considerable variation between ethnic groups regarding the perception of environmental problems. Caribbeans were generally the most likely to mention problems with the local environment, except litter, which was mentioned most often by Pakistanis. Whites and Caribbeans were the most likely to mention problems with street parking and the condition of roads and pavements. Indians/African Asians were generally the least likely to mention environmental problems in their local areas (Table 6.12).

Table 6.12 Reported environmental problems in local area

	White	Caribbean	Indian/ African Asian	Pakistani	Bangladeshi	Chinese	All ethnic minorities
Percentage saying area has problems with							
Run-down gardens, run-down open space or vacant properties	23	33	19	24	15	21	24
Graffiti or vandalism	26	33	20	31	26	31	27
Litter/rubbish	24	27	19	34	19	23	24
Dog mess	44	57	33	41	35	34	42
Vermin infestation	5	14	8	13	13	11	11
Condition of paths/ roads	35	31	18	20	6	16	21
Street parking	44	41	33	36	27	28	35

Table 6.13 shows that ethnic minorities were more likely than whites to report problems with property crime, personal assaults and nuisance from troublesome children or teenagers. Pakistani respondents were the most likely to report problems with each of these items, and also with harassment (this issue is dealt with in more detail in Chapter 8). Bangladeshi and Chinese respondents were also more likely than Indian, African Asian and Caribbean respondents to report that harassment was a problem in their local areas. Indian and African Asian respondents were less likely than those from other ethnic minority groups to mention problems of troublesome children and teenagers.

Table 6.13 Reported problems of crime and nuisance in local area

	White	Caribbean	Indian/ African Asian	Pakistani	Bangladeshi	Chinese	All ethnic minorities
Percentage saying area has problems with							
Burglaries or car theft	52	59	54	64	56	47	57
Assaults	10	18	14	20	16	14	16
Harassment	–	11	12	21	16	15	14
Troublesome children or teenagers	23	31	21	36	26	33	28

In addition to the questions about local amenities and problems, the Fourth Survey asked respondents how satisfied they were overall with the areas in which they lived, and whether they would prefer to move from or stay in those areas. Table 6.14 shows that around nine out of ten whites, Indians and African Asians said that they were satisfied with their local areas, as did more than eight out of ten Pakistanis and Bangladeshis and almost eight out of ten Chinese and Caribbeans. There were more substantial differences in the proportion saying that they were very satisfied with their local areas: nearly half of whites, four out of ten Indians, one third of African Asians and Chinese, but only just over a quarter of Caribbeans, Pakistanis and Bangladeshis gave this response.

Table 6.14 Satisfaction with area

column percentages

	White	Caribbean	Indian	African Asian	Pakistani	Bangladeshi	Chinese
Very satisfied	49	26	40	34	28	27	32
Fairly satisfied	39	51	49	56	57	55	46
Neither satisfied nor dissatisfied	5	11	6	5	8	10	13
Fairly dissatisfied	5	8	4	3	3	6	6
Very dissatisfied	3	4	2	3	4	3	4
Weighted count	*2859*	*783*	*644*	*391*	*420*	*137*	*194*
Unweighted count	*2860*	*613*	*636*	*349*	*584*	*288*	*103*

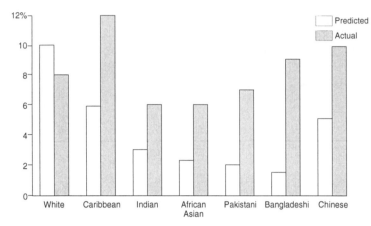

Predicted percentages are for respondent aged 25–34, owner-occupier, terraced house, occupational density equal to bedroom standard, average unemployment rate in ward.

Figure 6.2 Respondents dissatisfied with current area
(actual percentages and predicted percentages when age, tenure, type of accommodation, crowding, unemployment rate held constant)

Indian, African Asian and Pakistani respondents were slightly less likely than whites to express dissatisfaction with their areas. Caribbeans were the most likely to express dissatisfaction, followed by Chinese and Bangladeshi respondents. Caribbean, Chinese and Bangladeshi respondents were also more likely than others to say that they were neither satisfied nor dissatisfied with their local areas.

Levels of satisfaction might reflect characteristics of the areas in which respondents lived, or they might reflect characteristics of the respondents themselves. To examine these factors, we fitted a logistic regression model of the likelihood of being dissatisfied with the local area, including variables for sex, age, income, ethnic group, housing tenure and housing type. A variable representing the ward unemployment rate was also included in the model.

Dissatisfaction with the local area increased as the level of unemployment increased, and was more common among council tenants than those in other forms of tenure. Those in detached or semi-detached houses were less likely than those in terraced houses or flats to be dissatisfied with their local areas. Those living in overcrowded accommodation were more likely than others to express dissatisfaction with their local areas. Young people, aged 16 to 24 years, were more likely than those from other age groups to express dissatisfaction.

Figure 6.2 gives an indication of the extent to which varying levels of dissatisfaction among ethnic groups were related to differences in the variables described above. The striped columns show that, when these variables were held constant, the pattern of variations between ethnic groups was quite different from that seen in the actual percentages (spotted columns).

The model results showed that, given similar areas and housing and similar age profiles, all ethnic minority groups would be significantly less likely than whites to express dissatisfaction with their local areas, with Bangladeshis the least likely of all to do so. The results strongly imply that higher levels of dissatisfaction among

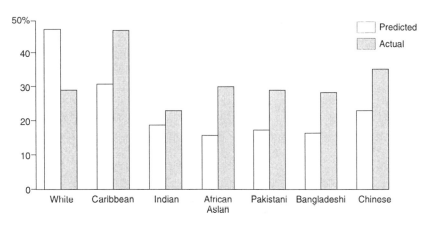

Predicted percentages for male, 25–34, terraced house, average unemployment rate in ward.

Figure 6.3 Respondents preferring to move from current area
(actual percentages and predicted percentages when sex, age, type of accommodation, unemployment rate held constant)

Caribbean, Bangladeshi and Chinese respondents were the result of living in disadvantaged areas, and that, given similar circumstances, ethnic minority groups actually had a lesser propensity to express dissatisfaction than whites did.

Figure 6.3 shows the proportion of respondents who would have liked to move from their current areas, by ethnic group. Caribbeans were the most likely to want to move (nearly half wanted to), followed by Chinese respondents (35 per cent). Pakistanis, Bangladeshis and African Asians were about as likely as whites to want to move (three out of ten wanted to), but fewer than a quarter of Indian respondents wanted to do so.

As with area satisfaction, preferences for moving or staying may be expected to reflect a broad range of factors, including the nature of the area resided in and the characteristics of the respondent. These were examined by means of a logistic regression model. The results of this model showed that influences on the preference for moving or staying were somewhat different from those on the likelihood of expressing dissatisfaction with the local area. The likelihood of expressing dissatisfaction did not vary significantly by sex, but women were found to be less likely than men to want to move. Age was also more strongly associated with preferences for moving or staying than it was with the likelihood of expressing dissatisfaction. The older respondents were, the less likely they were to want to move from their current areas.

Respondents in areas of high unemployment were more likely to want to move than those in areas with lower unemployment. Respondents whose homes lacked amenities were also more likely than others to want to move from their current areas. As we might expect, those living in detached or semi-detached houses were less likely to want to move than those living in terraced houses or flats. While council tenants were significantly more likely than others to express dissatisfaction

with their areas (Figure 6.2), preferences for moving or staying did not vary with housing tenure.

The striped columns in Figure 6.3 show that, when circumstances were similar, whites were the group most likely to express a preference for moving, with all ethnic minority groups more resistant to the idea (perhaps because of a stronger desire to remain close to their own communities). The results suggest that, where ethnic minorities appeared more likely than whites to want to move from their current areas, this was probably a result of poor conditions in the areas where they currently lived.

TENURE PATTERNS AND PREFERENCES

Housing tenure is linked in complex ways with economic, social and political structures. This section explores some of these links and their relationship with ethnicity. There have been various attempts to theorise housing tenure differences as a hierarchical system of housing classes, analogous to the class system derived from economic activity. However, the sensitivity of the housing system to political, economic and social change means that tenure patterns themselves are continually changing. The original 'housing class' theory, developed by Rex and Moore (1967), has since been revised and developed by other researchers (e.g., Rex and Tomlinson 1979; Saunders 1984; Byron 1993) to incorporate the changing complexities of tenure patterns and changing understanding of the ways in which they relate to social and economic structures.

Besides placing the various tenure and accommodation types in a hierarchy of desirability, another important contribution of housing class theory was to place housing at the centre of a politics of consumption (Dunleavy 1979; Saunders 1984) distinct from the politics of economic production and reproduction. This aspect of the theory is particularly relevant to the study of ethnic divisions in housing, since differences and inequalities, such as those arising from historical discrimination against ethnic minorities, are clear examples of factors leading to disjuncture between the systems of production and consumption. For example, early studies of race and housing in various parts of Britain showed that, even when ethnic minority households had secure employment and incomes, they were often barred from the types of housing held by whites in a similar economic position (Rex and Moore 1967; Karn 1978). Evidence suggests that discrimination continues to exist, in both rented and owner-occupied sectors, albeit generally in forms which are less overt than they used to be (e.g., Fenton 1984; CRE 1988; 1989; 1989/90; 1990a; 1990b).

The choice versus constraint debate, discussed already in relation to patterns of ethnic minority settlement, also has an application to the study of tenure patterns. One of the main strands of this debate centres on reasons for the consistently high level of owner-occupation among Indians and Pakistanis. In the late 1970s, authors such as Rex and Tomlinson (1979) and Smith (1977) argued that owner-occupation was the only option available to ethnic minority households wanting to improve their housing, since discriminatory practices led to effective exclusion from local authority accommodation. Other authors, however, drew attention to the positive reasons for

choosing owner-occupation, even when the housing so occupied was of poor quality. For households who migrated to the UK with the aim of earning and saving money, perhaps hoping for an eventual return to their countries of origin, the nature of home ownership as a financial investment seemed to make it a more attractive option than renting (Dahya 1974). Studies have also shown that ethnic minority households valued the sense of autonomy and independence which home-ownership offered (Karn et al. 1985). As with settlement patterns, however, it is increasingly argued that tenure patterns reflect a complex interaction between the forces of individual choice and social constraint (Sarre 1986; Saunders 1990).

Table 6.15 shows the way in which housing tenure varied between households of different ethnicity.[2] Like the 1991 Census, the Fourth Survey showed that home-ownership was most prevalent among Indians, African Asians and Pakistanis. Around eight out of ten households from these groups owned their homes, compared with two thirds of white, just over half of Chinese (six out of ten in the census) and around half of Bangladeshi and Caribbean households. The Fourth Survey also showed that mixed Caribbean/white households were more likely than Caribbean-only households to own their homes, whereas mixed South Asian/white households were less likely than South Asian-only households to do so.

Table 6.15 Housing tenure

column percentages

	White	Carib-bean	Carib/ white	S Asian/ white	Indian	African Asian	Paki-stani	Bangla-deshi	Chinese	All ethnic minorities
Owner-occupier	67	50	58	70	85	84	79	48	54	66
Council tenant	20	33	29	10	7	10	13	35	19	20
Housing assoc. tenant	3	13	7	3	2	2	2	10	5	6
Private tenant	9	4	6	17	7	5	6	8	22	7
Weighted count	*2800*	*992*	*230*	*132*	*605*	*408*	*404*	*132*	*184*	*3245*
Unweighted count	*2799*	*751*	*150*	*119*	*628*	*417*	*657*	*311*	*104*	*3251*

Nearly half of Bangladeshi and Caribbean households, and more than a third of mixed Caribbean/white households, were in some form of social housing, compared with

2 Because white and ethnic minority households were sampled separately, it was not possible to combine mixed ethnicity households from the two samples. Households from the sample of white respondents which contained ethnic minority as well as white members have been omitted from this analysis for the sake of clarity, while households from the ethnic minority sample which contained white as well as ethnic minority members have been included in some tables. The largest groups among these households were mixed Caribbean/white households and mixed South Asian/white households. While mixed Chinese/white households also formed a substantial proportion of the households of Chinese respondents, the group was too small to allow a separate analysis. There were also insufficient numbers in the other mixed groups to allow separate analysis, so they have not been included in the tables. In logistic regression models, these groups were included in an 'other mixed ethnicity' category. Throughout the chapter, categories of Caribbean, Indian, African Asian, Pakistani, Bangladeshi and Chinese households include only those households where all members came from the named ethnic group.

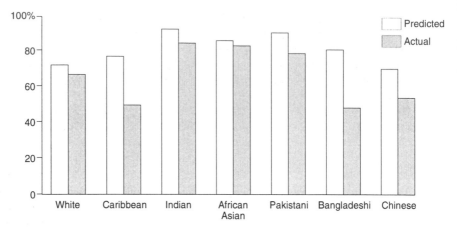

Predicted percentages are for a small family, average equivalent income, living in a non-metropolitan area

Figure 6.4 Households in owner-occupation
(actual percentages and predicted percentages when household type,
income and area held constant)

around a quarter of white and Chinese households and fewer than one out of six
Indian, Pakistani and African Asian households. Caribbean, Bangladeshi and mixed
Caribbean/white households were the most likely to have housing association
tenancies, followed by Chinese households.

Chinese and mixed South Asian/white households were more than twice as likely
as others to occupy privately rented accommodation. Research on the Chinese
community in Britain (House of Commons 1985) has found that the tendency of
Chinese households to live near their work, and, indeed, to occupy accommodation
tied to their employment, was a major reason for their concentration in low-quality
privately rented accommodation.

Differences in housing tenure between ethnic groups are likely to be related to
differences in areas of residence, income and type of household (Peach and Byron
1993; Howes and Mullins 1994; Brown 1984). Figure 6.4 shows the results of a
logistic regression model of the likelihood of owner-occupation by ethnicity,
controlling for household type, equivalent income and type of area. The chart shows
the actual level of owner-occupation for each ethnic group (spotted columns)
compared with the level of owner-occupation for each ethnic group when household
type, income and area of residence were held constant (the example shown, in the
striped columns, is for a small family, with average income,[3] living in a non-
metropolitan area). The striped columns show that the level of owner-occupation
among Indian, African Asian and Pakistani groups was significantly higher than that
of other groups, even when type of household, income and area were taken into
account.

In contrast, low levels of owner-occupation among Caribbean, Bangladeshi and
Chinese groups were clearly related to their household types, levels of income and

3 Gross income adjusted for the number of people in the household.

areas of residence. Caribbean, Bangladeshi and Chinese groups all had high concentrations in inner London (see Table 6.2), where the proportion of owner-occupiers was low; they all had high proportions of households on low incomes (see Table 4.6), for whom the chance of owner-occupation was reduced; and Caribbean and Chinese groups had high proportions of lone parent and single adult households (see Tables 1.4 and 1.11), both types with relatively low probabilities of owner-occupation. When households in similar circumstances were compared, both Caribbeans and Bangladeshis appeared slightly more likely than whites to be owner-occupiers. Chinese households appeared about as likely as white households to be owner-occupiers, given similar circumstances.

Table 6.16 shows that white, Pakistani and Indian owner-occupiers were the most likely to be outright owners of their homes. Given the higher proportion of older people among the white population than among the ethnic minority population, and given that older people are more likely to have completed their mortgage repayment terms, we may expect that Indian and Pakistani owners were more likely than whites to have bought their properties outright in the first instance, or with short-term loans rather than conventional mortgages.

Table 6.16 Outright ownership and mortgage/loan holding (owner-occupiers)

column percentages

	White	Caribbean	Indian	African Asian	Pakistani	Bangla-deshi	Chinese	All minorities mixed
All owner-occupiers								
Owning homes outright	35	21	30	18	33	22	21	23
Weighted count	*1879*	*496*	*516*	*339*	*315*	*63*	*100*	*2146*
Unweighted count	*1900*	*365*	*523*	*331*	*511*	*127*	*54*	*2143*
Mortgage/loan holders								
Source of largest mortgage/loan								
Building society	81	82	84	78	76	85	73	80
Bank	13	12	14	18	19	12	27	15
Finance/insurance company	3	3	0	3	1	0	0	2
Local authority	2	4	1	1	2	2	0	2
Other	1	0	0	0	0	1	0	0
Weighted count	*1188*	*388*	*353*	*276*	*206*	*49*	*79*	*1624*
Unweighted count	*1197*	*270*	*348*	*261*	*326*	*101*	*43*	*1526*

Karn (1978) showed the importance of looking not just at the distinction between outright ownership and mortgage/loan holding, but also at the percentage of the purchase price covered by the loan and at the source of finance. Her paper argued that, in the early 1970s, home-buyers in inner-city areas (where ethnic minority buyers were concentrated) were much less likely than other buyers to gain access to building society mortgages and loans. This placed them at a considerable disadvantage, since bank loans, which tended to be used instead, had generally higher interest rates and shorter repayment periods, and covered a considerably smaller percentage of the purchase price.

The 1982 PSI survey showed that differences in the sources of housing finance used by whites and ethnic minorities continued to exist in the early 1980s. At that time, only around two-thirds of Caribbean and Asian mortgage/loan holders used a building society as their main source of finance, compared with more than three-quarters of whites. Caribbeans were more likely than the other groups to use local authority mortgages, whereas Asians were more likely to use bank mortgages.

Comparison of the 1982 and 1994 surveys shows that proportions of households using the various types of finance changed considerably over that decade, with a reduction in the differences between whites and ethnic minorities. In 1994, around eight out of ten whites and ethnic minorities used building societies as their main source of finance. However, Table 6.16 shows that African Asian, Pakistani and Chinese mortgage-holders remained more likely than other groups to hold bank mortgages. Caribbean households were still more likely than others to hold local authority mortgages, but these formed the main source of finance for only 4 per cent of Caribbean mortgage-holders and 2 per cent of white mortgage-holders in 1994, compared with figures of 28 per cent and 12 per cent respectively in 1982. The percentage of white and Caribbean households with bank mortgages had increased, from less than 5 per cent in 1982 to around 12 per cent in 1994. The proportion of Asian households with such mortgages remained about the same.

The 1980 Housing Act, which offered local authority tenants the right to buy their accommodation at subsidised rates, provided many with the opportunity to become owner-occupiers. It has been argued that these opportunities were gained at the expense of ethnic minorities, who were concentrated in less desirable accommodation, much of it unsuitable for purchase. For example, Forrest and Murie (1988) argue that, as the best parts of the social housing stock were sold off to tenants and others, a process of residualisation occurred, leaving only the poorer, less desirable housing for those in social need. As a result of their disadvantaged economic position, ethnic minority families were over-represented among the residual group which remained in local authority accommodation (Clarke 1989; Solomos and Singh 1990).

Table 6.17 Whether property was previously in council ownership (owner-occupiers)

cell percentages

	White	Caribbean	Indian	African Asian	Pakistani	Bangla-deshi	Chinese	All minority mixed
Property previously belonged to council	14	23	4	11	9	12	13	13
Don't know whether property previously belonged to council	2	13	9	5	17	13	8	10
Present owner previously rented this property from council	8	15	3	9	5	9	5	8
Weighted count	*1885*	*499*	*517*	*341*	*318*	*63*	*100*	*2156*
Unweighted count	*1906*	*367*	*525*	*333*	*516*	*128*	*54*	*2156*

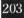

However, research has also shown that ethnic minority council tenants have had a high propensity to buy their properties, despite concentration into less desirable accommodation and areas (Peach and Byron 1994). Peach and Byron suggest that there is likely to be polarisation within the ethnic minority communities between those able and those not able to buy their council properties, with lone parent households, those on the lowest incomes and those in particular types of accommodation, such as high-rise flats, disadvantaged by the legislation, while others take advantage of the opportunities it offers.

Table 6.17 shows that Caribbean owners were significantly more likely than those from other ethnic groups to be living in ex-council properties, a result which reflects the disproportionately high proportion of Caribbeans living in council properties before the introduction of 'Right to Buy' legislation. Nearly a quarter of Caribbean owners said that their properties had previously belonged to the local authority, compared with 14 per cent of white owners and 13 per cent of ethnic minority owners generally. A further 2 per cent of white owners and 10 per cent of ethnic minority owners did not know whether or not the property had previously been owned by the local authority. Fifteen per cent of Caribbeans were living as owner-occupiers in properties that they themselves had previous rented from the local authority, compared with around half this proportion of whites and ethnic minorities in general.

Table 6.18 Council tenants: entitlement to buy and action taken

column percentages

	White	Caribbean	Indian	African Asian	Pakistani	Bangla-deshi	Chinese	All minority mixed
Entitled to buy	65	62	63	66	63	44	–[1]	62
Not entitled to buy	22	22	18	21	22	27	–	21
Don't know whether entitled to buy	13	16	19	13	15	28	–	17
Of those entitled to buy: Per cent who have taken steps to buy in last two years	7	9	12	19	14	2	–	12
Weighted count	*640*	*453*	*51*	*47*	*61*	*58*		*859*
Unweighted count	*650*	*352*	*65*	*59*	*91*	*156*		*863*

1 There were insufficient numbers of Chinese council tenants to allow an analysis of their perceptions of entitlement to buy.

Table 6.18 shows the proportion of council tenants from various ethnic groups who said that they were entitled to buy their properties, and the proportion of those entitled who had taken active steps to buy them. The table shows that just under two-thirds of white and ethnic minority council tenants thought that they were entitled to buy their properties, with a further 13 per cent of white and 17 per cent of ethnic minority tenants not knowing whether or not they were entitled to buy. Bangladeshi tenants were significantly less likely than those from other ethnic groups to say that they were entitled to buy their properties and almost twice as likely not to know whether they were entitled to buy. Of those who were entitled to

buy, Bangladeshis were the least likely to have taken steps to do so. However, other council tenants of Asian origin (Indians, African Asians and Pakistanis) were more likely than white and Caribbean tenants to have taken active steps to buy their properties in the last two years.

The past decade and a half of British government have been marked by a drive towards the promotion of home-ownership as the most desirable form of housing tenure, not only for the better off, but for the vast majority of citizens. Table 6.19 shows that the proportion of each ethnic group saying that all or most of their family and friends were home-owners was very similar to the proportions of each group who were home-owners themselves (see Table 6.17). Indian and African Asian households were most likely to say that all or most of their family and friends were home-owners (more than eight out of ten did), followed by Pakistani, mixed South Asian/white and white households (around three-quarters). By contrast, only a third of Bangladeshi households said that all or most of their family and friends were home-owners, fewer than half of Caribbean households said so, and only around six out of ten Chinese and mixed Caribbean/white households said so.

Table 6.19 Percentage of households saying that all or most of their family and friends owned their homes, and saying the proportion of family and friends owning their homes had increased in the last three years

cell percentages

	White	Carib-bean	Carib/white	S.Asian/white	Indian/African Asian	Pakistani	Bangla-deshi	Chinese	All ethnic minorities
All/most of family/friends home-owners	74	48	61	79	84	78	32	58	66
Per cent of home-owners increased in last three years	16	25	24	25	32	39	29	21	29
Weighted count	*2807*	*995*	*228*	*133*	*1017*	*405*	*133*	*187*	*3258*
Unweighted count	*2804*	*752*	*150*	*120*	*1050*	*657*	*312*	*106*	*3262*

Table 6.19 also shows that, despite the relatively small proportion of home-owners among the families and friends of Bangladeshi households, this group was one of the most likely to say that the number of their family and friends owning their own homes had increased over the past three years. This was the case for almost four out of ten Pakistani households and around three in ten Bangladeshi, Indian and African Asian households. Caribbean and Chinese households were the next most likely to have seen an increase (around one quarter and one fifth respectively). Whites were less likely than ethnic minority groups to have seen home-ownership among their family and friends increase: only 16 per cent had done so.

Respondents were asked whether, taking everything into account, and assuming they lived in their ideal type of home, they would prefer to rent it or own it. Table 6.20 shows that the vast majority of white and ethnic minority households stated a positive preference for owner-occupation (as opposed to a preference for renting or being unable to make a choice). Bangladeshis were, overall, the least likely to prefer

to own their homes (around two-thirds preferred to own). Around 85 per cent of Chinese and white householders preferred to own their homes, and more than 90 per cent of Caribbean, Indian, African Asian and Pakistani householders preferred to do so.

Table 6.20 Percentage of households who preferred to own their accommodation, by tenure

	White	Caribbean	Indian/ African Asian	Pakistani	Bangladeshi	Chinese	All ethnic minorities
All households	84	90	95	91	66	86	91
Owner-occupiers	96	97	99	96	92	–	98
Social tenants	55	85	66	82	40	–	80
Private tenants	75	–	–	–	–	–	77
Weighted count	*2813*	*998*	*1020*	*409*	*133*	*187*	*3271*
Unweighted count	*2809*	*756*	*1052*	*663*	*313*	*106*	*3277*

Tenure preferences were closely related to current housing tenure, with almost all owner-occupiers stating a preference for their own tenure. Among social tenants, those of Bangladeshi origin were the least likely to state a positive preference for ownership (40 per cent), followed by white households (55 per cent) and Indian/African Asian households (66 per cent). More than 80 per cent of Caribbean and Pakistani social tenants said that they would prefer to own their homes. Around three-quarters of private tenants, from white and ethnic minority groups, said that they would prefer to own their homes.

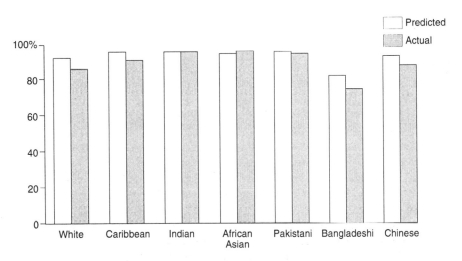

Predicted percentages are for a small family with average income

Figure 6.5 Households preferring to own their homes
(actual percentages and predicted percentages when household type and income are held constant)

A logistic regression model of the preference for owning one's home was used to see how far differences between ethnic groups were related to differences in their incomes and predominant household types. The results showed, as we might expect, that poor households were less likely than those on high incomes to prefer ownership. Type of household also had a significant influence on preferences, with pensioner households the least likely to prefer ownership, followed by single adult households, two adult households and lone parent households.

Figure 6.5 shows that taking account of differences in income and household type did even out distinctions in the level of preference for ownership between ethnic groups – with the exception of the Bangladeshis. Even when their generally low incomes had been accounted for, Bangladeshi households were considerably less likely than those from any other ethnic group to state a preference for owner-occupation.

QUALITY OF ACCOMMODATION

Differences in the types of housing tenure predominating among the various ethnic groups are important in themselves and for the ways in which they contribute to patterns of socio-economic stratification. However, it is just as important to look at differences in the quality and type of housing occupied by households from the various ethnic groups, because these aspects of housing are likely to have a direct impact on the households' health and quality of life (see Chapter 5).

The relationship between housing tenure and housing quality is also of interest. Housing class theorists have tended to assume that owner-occupiers are in an advantageous position relative to tenants, and the high proportion of respondents who preferred to own their homes might suggest that the general public agrees with this. However, research on the types of properties owned by ethnic minorities (Karn 1978; Karn, Kemeny and Williams 1985) suggests that the poor condition of many makes them a liability rather than an asset.

Ward (1982) argues that housing is increasingly becoming a commodity which reflects market principles and interests, the consequence of which is additional social polarisation. He draws the main distinction, not between home-owners and tenants, but between those in a position to buy good quality housing and maintain a good life style and those who have to resort either to renting or to the purchase of cheap, poor quality housing. The disadvantage experienced by owners in the latter group has been increased by the withdrawal of subsidies for the improvement of poor housing. The identification of cleavages within the owner-occupied sector has been shown to be of particular importance in explaining the housing position of Asian groups, whose over-representation among owner-occupiers could otherwise give a misleading impression of wealth and housing success (Cater and Jones, 1987).

To be deemed of good quality, accommodation would normally be expected to meet certain basic standards, such as being structurally sound; having basic amenities such as hot and cold running water, bath/shower room and inside toilet; and being free from damp and serious disrepair. Other aspects of accommodation quality, such as available space and location, should be considered in relation to the

needs of the occupying households. For example, a one- or two-bedroomed flat on the third floor of a block might be appropriate for a single adult or couple, but is less likely to be appropriate for a family with children. In this section, we examine variations by ethnic group in the distribution of accommodation types (detached and semi-detached houses, terraced houses and flats), floor level of accommodation, basic amenities and degree of overcrowding, taking account of area of residence, tenure, household type and household income.

Table 6.21 shows differences in the types of accommodation occupied by households from the various ethnic groups. It shows that more than half of white, Indian, African Asian and mixed South Asian/white households lived in detached or semi-detached houses, compared with just over a third of Chinese households, fewer than a third of Caribbean and Pakistani households, and only a quarter of Bangladeshi households. White and mixed South Asian/white households were the most likely to occupy detached houses, with Caribbean, Pakistani and Bangladeshi households the least likely to do so.

Table 6.21 Type of accommodation

column percentages

	White	Carib-bean	Carib/white	S Asian/white	Indian	African Asian	Paki-stani	Bangla-deshi	Chinese	All ethnic minorities
Detached house	23	9	18	23	21	18	9	9	16	15
Semi-detached house	33	20	23	39	34	37	19	11	19	25
Terraced house	27	33	34	28	33	31	64	42	31	36
Flat/bedsit	16	38	26	9	13	13	7	37	35	23
Weighted count	*2809*	*995*	*231*	*133*	*610*	*409*	*404*	*133*	*187*	*3262*
Unweighted count	*2805*	*754*	*151*	*120*	*633*	*418*	*658*	*311*	*106*	*3267*

Nearly two-thirds of Pakistani households lived in terraced houses, making them around twice as likely as other households to occupy this type of accommodation. Bangladeshis were also somewhat more likely than other groups to live in terraced houses (around four out of ten households did so, compared with at most a third from any other ethnic group). Caribbean, Chinese and Bangladeshi households were the most likely to occupy flats. Nearly 40 per cent of households from these groups occupied this type of accommodation, compared with 16 per cent of white, 13 per cent of Indian and African Asian, and just 7 per cent of Pakistani households.

Table 6.22 shows that Caribbean flat-dwellers were the most likely to live on the tenth floor or higher: just under one out of 20 did so, compared with one out of 100 Bangladeshi flat-dwellers and hardly any from other groups. Caribbean flat-dwellers were also the most likely to live in 'tower-blocks' of more than ten floors. On the other hand, Bangladeshi flat-dwellers were by far the most likely to live in accommodation that was more than three stories high: nearly six out of ten did so, compared with a third of Caribbean flat-dwellers and fewer than a fifth of flat-dwellers from other ethnic groups. A fifth of Bangladeshi flat-dwellers actually lived above the third floor, compared with just over one in ten Caribbean flat-dwellers, and well under one in 20 from other ethnic groups.

Table 6.22 Floor level and number of storeys in block

column percentages

	White	Caribbean	Indian/ African Asian	Bangladeshi	All ethnic minorities
Flat-dwellers					
Basement	2	6	5	1	5
Street level	39	29	35	20	28
1st–3rd floor	56	52	56	60	58
4th–9th floor	3	8	3	18	7
10th floor or higher	0	4	0	1	3
No. storeys in block					
1–3	85	67	81	42	71
4–10	13	24	18	54	24
More than 10	1	9	1	4	6
Weighted count	*457*	*382*	*123*	*49*	*752*
Unweighted count	*419*	*299*	*132*	*132*	*726*

Research suggests that ethnic variations in the types of accommodation occupied reflect differences in area of residence, tenure, household income and household structure (Peach and Byron 1993; Howes and Mullins 1994; Brown 1984). A logistic regression model of the likelihood of occupying detached or semi-detached accommodation was fitted, to control for the effects of these variables. Figure 6.6 shows a comparison between the actual proportion of households from each ethnic group occupying detached or semi-detached houses and the pattern of ethnic differences occurring when household type, income, area of residence and tenure were held constant (the figures given are for owner-occupying small families, with average equivalent income, living in a non-metropolitan area).

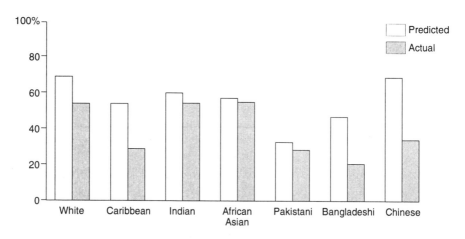

Predicted percentages for a small family, average equivalent income, living in a non-metropolitan area, owner-occupiers

Figure 6.6 Households in detached/semi-detached houses
(actual percentages and predicted percentages when household type, income, area and tenure are held constant)

Although, in actuality, Indian and African Asian households were about as likely as white ones to occupy detached/semi-detached houses, the model suggested that their likelihood of occupying such accommodation was related to their tendency to reside in suburban areas (with a high proportion of this type of accommodation), their high proportion of owner-occupiers, and their need for accommodation spacious enough to cater for large families. When households in similar circumstances were compared, whites were shown to be more likely than any other group, except the Chinese, to occupy detached/semi-detached accommodation.

The relatively low percentages of Caribbean, Bangladeshi and Chinese households occupying detached/semi-detached accommodation were explained partly by the high proportions of households from these groups living in inner London, the high proportion of tenants among them, and the high proportion of households on low incomes. When area, tenure, income and household type were held constant, households of Caribbean and Bangladeshi origin were still less likely than white, Indian or African Asian households to occupy detached/semi-detached accommodation, but, for Caribbeans in particular, the size of the gap between them and whites was reduced. Pakistani households, somewhat more likely in actuality than Bangladeshi ones to occupy detached/semi-detached houses, were the least likely to occupy this type of accommodation, given similar circumstances.

Turning to basic housing amenities, Table 6.23 shows that just 3 per cent of white and 4 per cent of ethnic minority households were without a bathroom or inside toilet. Indian, mixed South Asian/white and Chinese households were the most likely to be without these basic amenities. The relatively high proportion of Chinese and South Asian/white households without bathrooms or inside toilets was related to the high proportion of households from these groups in private tenancies (Table 6.15). As Table 6.24 shows, private tenants were by far the most likely of any tenure group to lack basic amenities, and ethnic minority private tenants were more likely to lack them than white ones were. No more than 1 per cent of social tenants, from any ethnic group, lacked a bathroom or inside toilet, and only 1 per cent of white and Caribbean owners lacked these amenities. However, owner-occupiers of Indian/African Asian, Pakistani and Bangladeshi origin were three to four times as likely as social tenants or white or Caribbean owners to lack these basic amenities.

Table 6.23 Housing amenities

cell percentages

	White	Carib- bean	Carib/ white	S Asian/ white	Indian	African Asian	Paki- stani	Bangla- deshi	Chinese	All ethnic minorities
Lacks bathroom and/ or inside toilet	3	2	3	7	6	2	3	4	6	4
Lacks central heating	15	15	10	13	10	7	30	15	14	14
Shared hall, landing or staircase	5	6	3	7	5	4	5	10	8	6
Lacks private garden, yard or patio	13	31	17	18	11	13	14	32	31	21
Weighted count	*2809*	*988*	*231*	*133*	*610*	*409*	*406*	*133*	*187*	*3257*
Unweighted count	*2805*	*749*	*151*	*120*	*633*	*417*	*659*	*312*	*106*	*3262*

From being a relative luxury (enjoyed by around six out of ten white and ethnic minority households in 1982), central heating is rapidly becoming seen as a basic amenity. In 1994, fewer than one in six white and ethnic minority households were without central heating, although twice this proportion of Pakistani households still lacked this amenity (Table 6.23). As with the basic amenities mentioned above, it was private tenants who were most likely to lack central heating (Table 6.24). However, in contrast to the pattern observed for lack of basic amenities, white private tenants were more likely than those from ethnic minorities to lack it. Around one in six social tenants from white, Caribbean, Indian/African Asian and Pakistani groups were without central heating, with Bangladeshis somewhat less likely than other social tenants to lack it. Among owner-occupiers, on the other hand, there was a large variation between ethnic groups. More than three out of ten Pakistani owners were without central heating, making them about twice as likely as Bangladeshi owners, and about three times as likely as other owner-occupiers, to lack this amenity.

Table 6.24 Housing amenities, by tenure

	White	Caribbean	Indian/ African Asian	Pakistani	Bangladeshi	Chinese	All ethnic minorities
Lacks bathroom or inside WC							
Owner-occupiers	1	1	4	3	4	2	3
Social tenants	1	1	1	1	0	–	1
Private tenants	16	–	–	–	–	–	23
Lacks central heating							
Owner-occupiers	10	12	7	31	16	6	12
Social tenants	17	16	14	17	10	–	16
Private tenants	37	–	–	–	–	–	27

Bangladeshi and Chinese households were the most likely to share a hall, landing or staircase with other households (Table 6.23). About one out of ten households from these groups was in this position, compared with around one out of 20 households from other groups. Bangladeshi, Caribbean and Chinese households were most likely to lack sole use of a garden (Table 6.23), reflecting the comparatively high proportions of these groups which lived above street level (Table 6.22). More than three out of ten households from these groups lacked sole use of a garden, compared with just 12 to 14 per cent of other groups.

There are various ways of defining density of occupation – some, such as that used in the Census, based on relating the number of people in the household to the total number of rooms in their accommodation (excluding bathrooms and toilets), others based on the number of household members per bedroom. The way that data were collected in the PSI survey meant that the most suitable measure was the bedroom standard as defined by the General Household Survey (GHS) and English House Condition Survey (EHCS). This was calculated as follows: a separate bedroom for each cohabiting couple, any other adult aged 21 or over, each pair of young persons aged 10 to 20 of the same sex, and each pair of children under 10 (regardless of sex). Unpaired young people aged 10 to 20 were paired with a child

under 10 of the same sex, where possible. Remaining unpaired young people and children were allocated separate bedrooms. The calculated standard for the household was then compared with the actual number of bedrooms available.

Table 6.25 shows that nearly three-quarters of white and half of ethnic minority households had more bedroom space available than that allocated by the standard. The pattern found by the 1994 PSI survey, for white households, was very similar to the 1991 EHCS findings for all dwellings, shown in column 1. Only 2 per cent of white households and 14 per cent of ethnic minority households had less than the standard amount of bedroom space. However, Pakistani and Bangladeshi households stood out as having much less bedroom space available than other ethnic groups. A third of Pakistani and more than four out of ten Bangladeshi households had less space than the bedroom standard.

Table 6.25 Overcrowding and under-occupation (bedroom standard)

column percentages

	EHCS all dwellings	White	Carib-bean	Carib/ white	S Asian/ white	Indian	African Asian	Paki-stani	Bangla-deshi	Chinese	All ethnic minorities
2+ above standard	30	33	19	24	22	24	22	13	12	20	18
1 above standard	38	39	35	32	39	30	36	24	12	34	32
Equal to standard	29	26	39	34	29	33	34	29	34	36	36
1+ below standard	3	2	6	9	10	13	8	33	43	10	14
Weighted count		*2745*	*946*	*209*	*126*	*569*	*379*	*374*	*118*	*183*	*3052*
Unweighted count		*2739*	*712*	*136*	*114*	*589*	*388*	*607*	*279*	*104*	*3037*
1991 Census More than 1 person per room		2	5		13			30	47	11	13

The bedroom standard measure may underestimate differences in density of occupation, since households with less space available are probably more likely to turn living rooms into bedrooms. However, the bottom row of Table 6.25 shows that proportions of each ethnic group with occupation densities below the bedroom standard were very similar to proportions with more than one person per room as shown by the 1991 Census (Owen 1993).

A regression model of bedroom standard scores was run, including variables for ethnicity, number of people in the household, income and housing tenure. The model showed that by far the most important influence on the amount of bedroom space available was the number of people in the household, with large households having less space than smaller ones. As we would expect, those on high incomes had somewhat more space available than those on low incomes.

Figure 6.7 presents a comparison of actual bedroom standard scores for each ethnic group with those predicted for households of similar size and income from each ethnic group (the example shown is for three-person owner-occupying households on average income who, as can be seen by the higher level of the striped columns, had more space than the average household). The large differences between ethnic groups were substantially reduced once household size and income

Predicted scores for three-person household, average equivalent income, owner-occupiers

Figure 6.7 Level of overcrowding
(actual bedroom standard scores and those predicted when income, household size and tenure held constant)

were held constant, although Pakistani and Bangladeshi households still had the least space available. The model results suggest that problems of overcrowding are related to the lack of availability of housing units appropriate for the needs of large households. This problem, which particularly affects ethnic minority households, has also been identified in previous research, such as that on the housing problems of the Bangladeshi and Chinese communities (House of Commons 1986; House of Commons 1985).

Just as we concluded our discussion of ethnic minority settlement patterns with an examination of variations in satisfaction with the area of residence, so we conclude this discussion of housing patterns with a look at housing satisfaction. Table 6.26 shows that white respondents were the most likely to be very satisfied with their current housing, followed, in order, by Indians and African Asians, Chinese, Pakistani, Caribbean and, finally, Bangladeshi respondents. As well as being the least likely to say they were very satisfied, Bangladeshis and Caribbeans were the most likely to say that they were dissatisfied with their accommodation.

Table 6.26 Satisfaction with housing (individual respondents)

							column percentages
	White	Caribbean	Indian	African Asian	Pakistani	Bangladeshi	Chinese
Very satisfied	53	27	46	43	32	23	36
Fairly satisfied	37	52	44	47	52	47	48
Neither satisfied nor dissatisfied	4	5	5	5	7	9	9
Fairly or very dissatisfied	6	16	5	6	8	21	8
Weighted count	*2860*	*783*	*641*	*392*	*419*	*136*	*195*
Unweighted count	*2859*	*613*	*634*	*350*	*581*	*286*	*104*

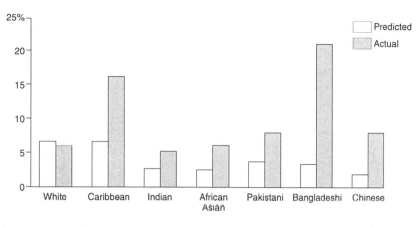

Predicted percentages for male, aged 25–34, owner-occupier, occupational density equal to bedroom standard.

Figure 6.8 Respondents dissatisfied with current housing
(actual percentages and predicted percentages when sex, age, tenure, and occupation density are held constant)

The pattern of lower housing satisfaction among ethnic minorities than among whites was not surprising given the differences in accommodation type and quality that we have described already. To see what part these differences played, a logistic regression model of the likelihood of being dissatisfied with one's housing was fitted, including variables for sex, age, ethnicity, tenure, type of accommodation, degree of overcrowding, floor level and the lack of basic amenities. The results showed that tenure had the largest influence on the probability of being dissatisfied with one's housing, with all tenants more likely to express dissatisfaction than owner-occupiers, although housing association tenants were somewhat less likely to do so than council and private tenants. Overcrowding also increased the probability of expressing dissatisfaction. Women and people of pensionable age were somewhat less likely than men and younger people to say they were dissatisfied with their accommodation.

Figure 6.8 shows the percentage of individual respondents from each ethnic group who expressed dissatisfaction with their housing (spotted columns) compared with the percentage predicted to express dissatisfaction when the variables listed above were held constant (striped columns, with figures given for male owner-occupiers, aged 25 to 44, with occupation densities equal to bedroom standard). The results suggest that the relatively high levels of dissatisfaction expressed by Caribbean and Bangladeshi respondents could be put down largely to factors such as the high proportion of council tenants among these groups and, for Bangladeshis, the high level of over-crowding experienced. When respondents of similar age and sex in similar housing circumstances were compared, the figure shows that Caribbeans were no more likely than whites to express dissatisfaction, and that members of all other ethnic groups were less likely than whites to express dissatisfaction with their housing. This fits with our findings on satisfaction with area (Figure 6.2), which showed that, given similar circumstances, ethnic minorities were generally less likely than whites to express dissatisfaction.

CHANGE AND MOBILITY

We know that ethnic minority migrants originally had different patterns of settlement and housing to those of the white community, that they were disadvantaged by living in less desirable areas and accommodation, and that they were discriminated against in their attempts to gain better housing. Even in the 1980s, when many Caribbean, Indian and Pakistani migrants had lived in Britain for two decades, research showed that members of ethnic minorities occupied housing that was significantly poorer, on average, than that occupied by white households (Brown 1984).

In this section, by means of a direct reanalysis of data from the PSI 1982 survey, we examine how the housing circumstances of ethnic minorities have changed, relative to those of whites, over the past decade. The analysis provides an indication of changes in tenure patterns, types of accommodation occupied and levels of overcrowding, although the households interviewed in 1994 were not the same ones that were interviewed in 1982.

Census data from 1981 and 1991 show changes in the distribution of households from each ethnic group across the four broad types of area (inner London, outer London, other metropolitan and non-metropolitan) over the past decade. There was a slight decrease in the proportion of Caribbeans living in inner London, an increase in the proportion of Bangladeshis living in inner London, and a small increase in the proportion of Indian/African Asian and Pakistani households living in metropolitan areas outside London (Table 6.27).

Table 6.27 Area of residence (households), 1981 to 1994

column percentages

	White	Caribbean[1]	Indian/ African Asian	Pakistani	Bangladeshi
Inner London					
1981 census	4	37	11	7	37
1991 census	4	34	9	6	44
1982 PSI	5	31	13	6	60
1994 PSI	5	29	6	5	38
Outer London					
1981 census	9	20	29	12	10
1991 census	7	21	33	13	9
1982 PSI	7	18	22	10	3
1994 PSI	3	25	35	12	11
Other metropolitan					
1981 census	23	21	23	49	28
1991 census	21	23	26	52	25
1982 PSI	16	17	18	39	19
1994 PSI	20	24	29	49	25
Non-metropolitan					
1981 census	64	22	37	31	26
1991 census	67	22	32	29	22
1982 PSI	73	33	47	44	18
1994 PSI	71	21	30	33	26

1 The figures given for the 1991 Census combine 'Black Caribbean' and 'Black Other' groups.

Area distributions from the PSI surveys differed in several ways from those of the 1981 and 1991 censuses. For example, the proportion of Bangladeshi households shown by the 1982 PSI survey to be living in inner London was much higher than that shown by the census, as were the proportions of Caribbeans and Pakistanis shown to be living in non-metropolitan areas (Table 6.27). Since housing tenure and accommodation type both vary with area of residence, these discrepancies mean that we need to be cautious in interpreting patterns of housing change as shown by the two PSI surveys. Logistic regression models were used in the analysis to control for the effects of area.

Changes in the distribution of household types and household incomes among ethnic groups may also underlie changes in housing circumstances. The overall size of Caribbean, Indian and African Asian households decreased over this period, while there was little change in the average size of white and Pakistani households, and that of Bangladeshi households increased (Table 2.17). The proportion of households with no earner increased for each ethnic group, but the increase was particularly large for Caribbean, Pakistani and Bangladeshi households (Table 4.1).

Table 6.28 shows changes in tenure patterns by ethnic group between 1982 and 1994. Levels of owner-occupation rose for all groups except the Pakistanis, who saw a decrease of 1 per cent. Bangladeshis, with the lowest proportion of owner-occupiers in 1982, saw the largest increase in owner-occupation, bringing their level close to that of Caribbeans in 1994. Despite these small changes, the overall broad pattern of ethnic differences, with Indians, African Asians and Pakistanis having the highest levels of owner-occupation and Bangladeshis and Caribbeans having the lowest levels was similar in 1982 and 1994.

Table 6.28 Housing tenure, 1982 and 1994

column percentages

	White	Caribbean	Indian	African Asian	Pakistani	Bangladeshi
1982 survey						
Owner-occupier	60	40	76	75	80	30
Social tenant	31	55	19	19	13	58
Private tenant	9	4	5	6	6	13
1994 survey						
Owner-occupier	67	50	85	84	79	48
Social tenant	23	46	9	12	15	45
Private tenant	9	4	7	5	6	8
Change 1982–94						
Owner-occupier	+7	+10	+9	+9	-1	+18
Social tenant	-8	-9	-10	-7	+2	-13
Private tenant	0	0	+2	-1	0	-5

The proportion of households with social tenancies decreased for all groups except the Pakistanis, who saw a very slight increase. However, the broad pattern of ethnic differences did not change substantially: Caribbeans and Bangladeshis continued to have relatively very high levels of social tenancy compared with other groups, and Indians, African Asians and Pakistanis continued to have the lowest levels of social tenancies.

Looking at private tenancies, the main point to note was the decrease in the proportion of such tenancies among Bangladeshi households. Their relatively high levels of private tenancy in 1982 were almost certainly related to their recency of arrival in Britain at that time. Research has shown that private tenancy is often the preferred or only option available to new arrivals, while they seek properties to buy or establish eligibility for social housing (Smith 1977; Brown 1984). Our survey suggests that this remained the case in 1994: members of ethnic minorities who had been resident in Britain for less than five years were significantly more likely than other minority members to live in households with private tenancies (Table 6.29).

Table 6.29 Housing tenure by years since migration to Britain (respondents from ethnic minorities)

column percentages

	Years since migration to Britain		
	Less than 5	5 – 14	15+/born in Britain
Owner-occupied	44	55	71
Social rented	17	37	24
Private rented	40	8	5
Weighted count	*106*	*305*	*2799*
Unweighted count	*101*	*368*	*2730*

Figure 6.9 presents the results of two logistic regression models showing differences in the predicted levels of owner-occupation in 1982 and 1994, by ethnic group for households of similar type, with similar numbers of earners (data on total household income was not available for 1982) and living in broadly similar areas. The chart shows that, in 1982, households of the various ethnic groups had very different

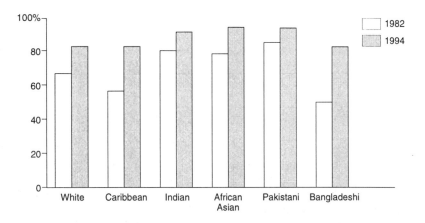

Predicted percentages for a small family, 1 to 1.5 full-time earners, living in a non-metropolitan area

Figure 6.9 Households in owner-occupation, 1982 and 1994
(predicted percentages when household type, number of earners and area held constant)

levels of owner-occupation, even when we compared those of similar type, income and area. In particular, levels of owner-occupation were much lower than would be expected for Bangladeshis and Caribbeans in similar circumstances to whites. By 1994, Bangladeshis and Caribbeans had a similar chance of owner-occupation to that of whites in similar circumstances, while Indians, African Asians and Pakistanis continued to have somewhat higher owner-occupation rates.

Table 6.30 shows how the likelihood of living in owner-occupied, socially rented or privately rented housing changed for the same generation of individuals who had been aged 20 to 50 in the 1982 PSI survey and who had reached the ages of 30 to 62 by the time of the 1994 survey. 1994 survey respondents who had not been resident in Britain in 1982 were excluded from the table. In each ethnic group, members of this generation increased their chance of owner-occupation over the decade. Caribbeans saw the largest increase (30 per cent), followed by Indians and Bangladeshis (almost 20 per cent), then whites and African Asians (around 10 per cent) and finally Pakistanis (5 per cent). All ethnic groups from this pseudo-cohort saw a fall in the level of social tenancies over the period, although it was small for Pakistanis, and all the ethnic minority groups saw some fall in the level of private tenancies.

Table 6.30 Housing tenure of persons aged 20 to 50 in PSI 1982 survey and of persons aged 32 to 62 in PSI 1994 survey

column percentages

	White	Caribbean	Indian	African Asian	Pakistani	Bangladeshi
1982 survey aged 20–50						
Owner-occupier	65	36	77	76	80	31
Social tenant	27	60	17	19	14	57
Private tenant	8	4	5	5	6	12
1994 survey aged 32–62						
Owner-occupier	76	66	94	89	85	50
Social tenant	16	32	4	8	11	47
Private tenant	8	2	2	3	4	3
Change 1982–94						
Owner-occupier	+11	+30	+17	+13	+5	+19
Social tenant	-11	-28	-13	-11	-3	-10
Private tenant	0	-2	-3	-2	-2	-9

Comparing the tenure change for this generation with that of each ethnic group as a whole, as measured in 1982 and 1994 (Table 6.28), it is clear that, for all groups except the Bangladeshis, the increase in owner-occupation for this generation was considerably greater than the increase overall. This pattern is likely to reflect the relationship between age and housing tenure: as individuals grow older, and their households become more established, we would generally expect them to accumulate more resources and thus increase their chances of becoming owner-occupiers.

Further information about this issue is given by Table 6.31, which compares the 1994 tenure distributions of younger and older households. Comparing households

with at least one member aged 45 years or over with those where all members were younger than 45, we see that levels of owner-occupation were slightly lower among the younger households for whites, Indians, Pakistanis and the Chinese, and considerably lower among younger Caribbean households. On the other hand, among African Asians and Bangladeshis, younger households had a slightly higher rate of owner-occupation than older ones.

Table 6.31 Housing tenure, by whether household includes members aged 45 years or over

column percentages

	White	Caribbean	Indian	African Asian	Pakistani	Bangladeshi	Chinese
Some in household aged 45+ years							
Owner-occupier	69	61	88	82	82	46	57
Social tenant	25	37	8	14	15	48	30
Private tenant	6	2	4	4	4	6	13
All in household under 45 years							
Owner-occupier	65	40	82	85	76	50	52
Social tenant	20	55	9	9	16	38	19
Private tenant	15	6	9	6	8	12	29

Younger African Asian, Bangladeshi, Chinese and white households had lower rates of social tenancy than older ones did, whereas, among Indians and Pakistanis, rates of social tenancy were about the same for younger and older households. Among Caribbean households, in contrast, younger households had much higher rates of social tenancy than older ones did (55 per cent among households with all members under 45 years, compared with 37 per cent among households with at least one member aged 45 or over). As expected, younger households had higher rates of private tenancy than older ones, and this was the case for each ethnic group.

Table 6.32 shows changes in the distribution of accommodation types among ethnic groups between 1982 and 1994. In 1982, whites were substantially more likely than any of the ethnic minority groups to occupy detached or semi-detached properties and were less likely than any of the ethnic minority groups to occupy terraced properties. More white households than Indian, African Asian and Pakistani households were living in flats, but they were much less likely than Caribbean and Bangladeshi households to be occupying this type of accommodation.

The profile of accommodation types occupied by whites hardly changed between 1982 and 1994, but the types of accommodation occupied by ethnic minority groups changed substantially. All minority groups increased their chance of occupying detached or semi-detached houses over this period, and all except the Bangladeshis decreased their chance of occupying terraced housing. The proportion occupying flats increased slightly among Caribbeans and decreased substantially among Bangladeshis. These findings reflect the Bangladeshis' move away from social housing and into ownership at the lower end of the property market. One marked result of the changes was that, in 1994, Indians and African Asians were as likely as whites to be occupying detached or semi-detached houses.

Table 6.32 Type of accommodation, 1982 and 1994

column percentages

	White	Caribbean	Indian	African Asian	Pakistani	Bangladeshi
1982 survey						
Detached/semi detached	54	22	30	38	13	9
Terraced	31	45	57	48	80	39
Flat/other	15	34	13	13	7	52
1994 survey						
Detached/semi detached	56	29	55	55	28	20
Terraced	27	32	33	31	64	42
Flat/other	16	38	13	13	7	37
Change 1982–94						
Detached/semi detached	+2	+7	+25	+17	+15	+11
Terraced	-4	-13	-24	-17	-16	+3
Flat/other	+1	+4	0	0	0	-15

Average levels of overcrowding decreased considerably between 1982 and 1994, as a comparison of Figure 6.7 and Figure 6.10 shows. In 1982, only whites had an average occupation density above that of the bedroom standard; all ethnic minority groups were below this level. Of the ethnic minority groups, Caribbean households were the least crowded, followed by African Asian and Indian households, with Pakistani and Bangladeshi households the most crowded (more than 1 below the bedroom standard, on average). By 1994, only Bangladeshi households had occupation densities below the bedroom standard; Pakistani households had a level more or less equal to this standard. Indian and African Asian households were no more crowded than Caribbean ones, although on average all minority groups remained more crowded than white ones.

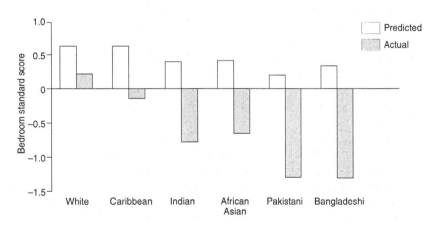

Predicted scores for three-person household, owner-occupiers

Figure 6.10 Levels of overcrowding, 1982
(actual and predicted bedroom standard scores when household size and tenure held constant)

Figure 6.10 shows that the large differences in levels of over-crowding between ethnic groups in 1982 were very much reduced when we compared households of similar size and tenure type (the number of earners did not make a significant difference). The model results show a clear slope, with white and Caribbean households of similar size the least crowded, followed by African Asian and Indian households and, finally, Pakistani and Bangladeshi households. By 1994 (Figure 6.7), these differences had been largely ironed out.

The regression models of occupation density showed that, both in 1982 and 1994, household size was the factor with the largest influence on levels of overcrowding. The reduction of crowding levels among Indian and African Asian households relative to other groups was probably linked to a reduction in the average size of their households over this period. Conversely, the worsening of Bangladeshi crowding levels, relative to the Pakistani group, was probably related to the fact that the average size of Bangladeshi households increased over the period, while that of Pakistani households remained constant (see Table 2.17).

CONCLUSIONS

It is well known that members of the ethnic minorities have residential settlement patterns which differ from those of the white community, and that there are also differences in their patterns of tenure and accommodation type. This chapter has given an indication of the extent of such differences in 1994. It has also examined some of the factors underlying ethnic difference in neighbourhoods and housing. These include historical processes, involving settlement and residential mobility, economic constraints, different patterns of household structure and the preferences of individuals and households for living in particular areas, within or close to particular communities, or in particular types of housing.

The chapter showed that ethnic minority households were not simply different from white ones in their neighbourhoods and housing, but that they were also disadvantaged. The extent of disadvantage was greater for some ethnic minority groups than for others, and the forms of disadvantage also varied between ethnic groups. Housing and neighbourhood disadvantage was compounded by a number of other problems faced by ethnic minority households, including low incomes and a history of settlement in poor areas. The survey did not ask directly about experiences of discrimination in the search for housing, or as a factor influencing the choice of residential area. However, this chapter did include an examination of the extent to which members of the various minority groups were living in the type and quality of housing that would be expected, given their incomes and size of household.

Members of ethnic minorities were much more likely than whites to live in urban areas. Caribbeans, Bangladeshis, the Chinese and Pakistanis had a particularly high presence in the inner cities, whereas Indians and African Asians tended to live in outer city areas. The concentration of minorities into urban areas obviously gave rise to a certain degree of segregation between them and whites. Minorities were also found to be concentrated into specific wards within such areas. For example, the inner metropolitan wards (outside London) where Caribbeans and Asians lived had

ten times more residents from ethnic minorities than did the inner metropolitan wards where whites lived.

Although residential segregation was clearly evident, the degree of segregation was much lower than that pertaining in the United States, for example. Only one in five Pakistanis and Bangladeshis lived in wards where the majority of residents were from ethnic minorities, and only one in seven Caribbeans, Indians and African Asians lived in such wards. The survey also found that many ethnic minority individuals preferred to live alongside other people from ethnic minorities, and, in particular, alongside others from their own ethnic group. This suggests that, for many members of ethnic minorities, concentration, in itself, was not a problem. It became a problem where concentrations of ethnic minorities coincided with the concentration of disadvantage.

Ethnic minorities tended to live in areas with higher than average levels of unemployment, they were more likely than whites to mention environmental problems such as graffiti, vandalism and vermin infestation, and they were more likely than whites to report problems of personal and property crime and nuisance from troublesome young people. Although we found that, given similar circumstances, members of all the ethnic minority groups were significantly less likely than whites to say that they preferred to move from their current areas, disadvantaged conditions in the areas where many ethnic minorities were concentrated pushed them towards mobility.

One of the most important features of housing policy, over the last two decades, has been the promotion of owner-occupation as the ideal form of tenure, not just for the comfortably off, but for all those who wish to have a 'stake in society'. We were interested in the way that this policy had affected the owner-occupation rates of the various ethnic minority groups compared with whites. Comparing PSI data from 1982 and 1994, we found that rates of owner-occupation had increased for all groups except the Pakistanis, who saw little change. Bangladeshis, starting from the lowest base, saw the largest increase in levels of owner-occupation. Despite the evidence of different degrees of change for different ethnic groups, this was not sufficient to alter the broadly established pattern of ethnic differences in owner-occupation levels: Indians, African Asians and Pakistanis continued to have the highest levels of owner-occupation, followed by whites and the Chinese, with Caribbeans and Bangladeshis continuing to have the lowest levels of owner-occupation.

A comparison between the tenure patterns of younger and older households showed that younger Caribbean households (with all members under 45 years of age) had particularly low rates of owner-occupation and high rates of social renting, compared both with older Caribbean households and with younger households from other groups. This reflects partly the high proportion of lone parent families among young Caribbean households, but, given the residualisation of social housing as a form of tenure, the increasing concentration of Caribbean households in this sector gives some cause for concern.

Differences in tenure distributions among the various ethnic groups, like differences in settlement patterns, reflect the effects of a large number of influences: historical, geographical, economic and cultural. Our analysis suggested that the relatively low level of owner-occupation among Chinese, Bangladeshi and Caribbean

households was related to their concentration in inner London, their lower than average incomes, and, for Caribbean and Chinese groups, the predominance of small (lone parent and single adult) households.

On the other hand, Indian, African Asian and Pakistani households had high levels of home ownership despite having relatively low incomes. Research has suggested that the preference for ownership among these groups might be motivated by factors such as the wish for autonomy and by the nature of ownership as a form of investment. Our survey did not examine these issues in detail, but did find that Indians, African Asians and Pakistanis were more likely than whites, Bangladeshis and the Chinese to express a positive preference for owner-occupation. Indian, African Asian and Pakistani council tenants were also more likely than those from other groups to have taken steps towards owner-occupation under the Right to Buy scheme.

More surprising, given their high representation in social housing, was the finding that Caribbeans were as likely as Indians, African Asians and Pakistanis to express a preference for ownership. Although a high proportion of Caribbean owners were living in ex-council properties, Caribbeans as a group were less likely than Indians, Pakistanis and African Asians to have taken steps to buy their council accommodation.

Housing theorists have traditionally allotted owner-occupation top place in the hierarchy of tenure types, although, more recently, distinctions have been drawn between owners of poor and good quality housing. Some researchers have expressed concern that the concentration of Indian, African Asian and Pakistani households into owner-occupied housing gives a misleading impression of their wealth and housing success. Our analysis explored differences in the quality of accommodation occupied by the various ethnic groups, and the extent to which this could be related to housing tenure. Had the Indians, African Asians and Pakistanis, through their high levels of owner-occupation, managed to secure better quality accommodation for their households? Conversely, how many ethnic minority owners were in housing of poor quality? Were they better or worse off than similar households with social and private tenancies?

The most obvious distinction between owner-occupiers and tenants, in terms of accommodation, was that most owner-occupiers lived in houses, either semi-detached or terraced, whereas many tenants lived in flats. The Caribbean, Bangladeshi and Chinese groups, concentrated in inner London and with high proportions of tenants, had much higher proportions of flat-dwellers than did other groups. Bangladeshi and Caribbean flat-dwellers were over-represented in medium- and high-rise accommodation.

Indian and African Asian households, on the other hand, appeared to be reaping some reward from their investment in owner-occupation. In 1994, they were as likely as white households to occupy detached or semi-detached properties. This represented a significant improvement on their position in 1982, when they were much less likely than whites to occupy this type of accommodation, and more likely to be living in terraced houses.

In contrast, Pakistani and Bangladeshi owners tended to be concentrated in terraced housing, and they were more likely than other owners to lack central

heating, bathrooms and inside toilets, indications of the poor quality of their accommodation. There was also evidence that Pakistani and Bangladeshi owner-occupiers were occupying properties with significantly poorer amenities than those available to social tenants from the same ethnic groups. Pakistani and Bangladeshi households had particularly low incomes, so those who did undertake owner-occupation were almost invariably doing so at the lower end of the market. The preference of many Bangladeshi households for rented accommodation, and the slight increase in the number of Pakistani households moving into the socially rented sector (set against a corresponding decrease for other groups), suggests that these low-income groups have found it extremely difficult to provide their families with housing of adequate quality through owner-occupation.

Levels of overcrowding were found to have decreased considerably over the last decade for all ethnic groups. Differences in overcrowding levels between ethnic groups, on the other hand, remained intact, with Pakistani and Bangladeshi households living in the most overcrowded accommodation and whites having the most space. The size of the household was more important than its tenure in determining the likelihood of overcrowding, suggesting that this problem was associated with a general inability to access accommodation spacious enough for the needs of large households.

Overall, whites were the most likely to say that they were very satisfied with their current neighbourhoods and housing; Caribbeans, Bangladeshis and the Chinese were the most likely to be dissatisfied with their local neighbourhoods, and Caribbeans and Bangladeshis were the most dissatisfied with their accommodation. However, analysis showed that higher levels of dissatisfaction among ethnic minority groups were related to the disadvantaged conditions in which they lived. When we compared those living in similar circumstances, whites were more likely than any ethnic minority group to express dissatisfaction with their local areas, and they were more likely than all groups except the Caribbeans to express dissatisfaction with their accommodation.

Health and Health Services

James Y. Nazroo

INTRODUCTION

In an investigation, description and explanation of the position of ethnic minority groups in Britain, health is a crucial experience. Variations in patterns of health across and within ethnic groups are a reflection both of the social position of these groups and of the individual experiences of members of ethnic minority groups. There has been considerable interest in the health of ethnic minority populations in Britain (see, for example, Balarajan and Soni Raleigh 1995; Smaje 1995a; Ahmad 1993a; Donovan 1984; Marmot et al. 1984). However, this interest has suffered from a shortage of nationally representative data to investigate these issues. Much of the available work has had to depend on information recorded on death statistics, resulting in studies of immigrant mortality rates. In such studies health is measured by mortality rates and ethnicity by country (perhaps more accurately described as subcontinent in many cases) of birth (e.g., Balarajan 1991; Marmot et al. 1984). Other studies have been based in particular localities (e.g., Pilgrim et al. 1993), often, although not always, using treatment populations that may be unrepresentative of both that locality and the national pattern (e.g., Ahmad, Kernohan and Baker 1989). The only other national survey of the health of ethnic minority groups, the Health Education Authority's *Health and Lifestyles: Black and Minority Ethnic Groups in England* (BMEG) (Rudat 1994) did not have a directly comparable white sample and, because it only sampled from areas with relatively large ethnic minority populations, was not fully representative of the groups considered.

In addition to these problems with available data, much of the interest in this field has been in understanding disease processes rather than the position of ethnic minority groups. Consequently, studies have focused on the extent to which ethnic variations in a particular disease can lead to an understanding of the causes of that disease, which has inevitably involved a focus on the cultural and biological attributes of the ethnic (minority) group that is more likely to suffer from the disease. The exploration of apparently high rates of coronary heart disease among South Asians is typical of this approach (Gupta, de Belder and O'Hughes 1995; McKeigue, Shah and Marmot 1991). Unfortunately the focus on disease rather than health experience often obscures rather than enlightens an understanding of the position of ethnic minority groups in Britain.

The Fourth National Survey presents the first opportunity to explore health variations in a large nationally representative sample of the main ethnic minority

groups in Britain, together with a comparison sample of whites. The survey is unique not only in its coverage of health, but also in its ability to explore the associations between health and a variety of other aspects of the lives of ethnic minority people in Britain. The data presented in this chapter can therefore be seen as providing a new context for work on ethnicity and health, as well as an important addition to work on race relations.

The Fourth National Survey's coverage of health was more substantial and encompassed more new ground than that of many of the other topics. Consequently, here only an overview of the main findings relating to physical health and health service use will be presented. A more detailed analysis of the data on physical health will be published in a companion volume (Nazroo 1997). None of the material on mental health that was included in the survey will be covered here; it will also be published separately.

Three central issues will provide the focus for this chapter. The first of these will be a comparison of the health of different ethnic groups, using both an indicator of overall health and indicators of particular diseases that previous work has shown to be of relevance to studies on ethnic variations in health. These include heart disease, hypertension, diabetes and respiratory disease. Unfortunately, this emphasis on comparative rates of ill-health across ethnic groups means that absolute rates of ill-health in particular ethnic groups, and how these vary by gender and age, will not be explored. Obviously, a consideration of absolute rates is imperative if the relative importance of a particular disease to the health of a group is to be assessed, regardless of whether that disease is more or less common in the group compared with others (see Bhopal 1995 for a full discussion of these issues). Nevertheless, space prevents such an exploration here, although it will be found in the more detailed discussion of these data (Nazroo 1997).

The second of the issues on which this chapter will focus is an exploration of possible explanations for ethnic variations in health. Certain explanations will be discussed, including whether differences are the result of a statistical artefact, a consequence of biological/genetic or cultural differences, or a direct result of the experience of racial harassment or discrimination. Other explanations will be empirically tested – here the importance of migration effects and socio-economic disadvantage in contributing to ethnic variations in reported general health will be examined.

The third area that will be covered in this chapter concerns the use that ethnic minority groups make of health services and their experience of these services. While there has been some exploration of these issues recently, most notably in the BMEG survey (Rudat 1994), the data presented here will provide additional dimensions to what is already available and, in the context of this volume, will also add to a discussion of areas of possible disadvantage faced by ethnic minority groups.

METHODOLOGICAL ISSUES

Using a survey to measure 'health' and 'ethnicity'

Much of the work that has explored the social patterning of health has concentrated on mortality rates. These have the advantage of being clearly defined, reasonably easily available from a combination of death certificate and Census data, and reasonably disease specific. However, they are a narrow reflection of what is clearly a complex concept. For example, the Health and Lifestyles Survey (Blaxter 1990) showed the multi-dimensional nature of lay concepts of health, which included, among others, notions of: 'not being ill', not having or overcoming disease, a reserve or a source of energy, physical fitness or functional ability and a sense of well-being. Certainly mortality reflects only a small element of these concepts. In addition, mortality rates may not reflect even the narrowly defined disease-based definitions of health. The relationship between disease and death depends on a number of factors, including whether the disease is fatal, the types of treatment offered and used, and the more widely defined health resources available to individuals in affecting the prognosis of a disease. The fact that such resources may vary across social groups is particularly important to investigations of the social patterning of health.

A variety of strategies could be adopted to assess health in a survey such as this. First, health could be considered in a medical sense as the absence or presence of recognised disease, and questions can be asked directly about the presence of particular diseases. This is one of the strategies adopted here. Data presented later will include responses to questions asking about the diagnosis of heart disease, hypertension and diabetes. However, this strategy does raise certain problems, which result partly from how opportunities for the diagnosis of particular diseases may vary by social group. Certainly, a study of ethnic variations in health that relies solely on the identification of already diagnosed disease is vulnerable to the criticism that differences in treatment rates and quality of treatment between ethnic groups may have produced the pattern of results reported. Such questions are also dependent on the accuracy of respondents' knowledge and recollections of diagnoses that have been made, which may also vary by social group.

Second, questions on disease can be extended beyond those on diagnosis to include symptoms. This helps to get around problems relating to differences in the access to or the use of medical services. Questions on symptoms were included in this survey, and will be reported later in this chapter in relation to both heart disease and respiratory disease. However, such an approach cannot overcome possible differences between social groups in how these questions are interpreted and answered. An assessment of whether a particular symptom is severe enough to be worth mentioning might vary across social groups, particularly if the questions have been translated into different languages for different groups. Answers to such questions, consequently, may produce misleading conclusions about differences between these groups.

A third possibility, also included here, is to ask respondents to provide a global self-assessment of their health. It has been suggested that the subjective nature of

health makes this the most valid approach to assessing health (Benzeval, Judge and Solomon 1992), and there is some evidence that such self-assessments predict mortality rates (Mossey and Shapiro 1982). However, like reports of symptoms, differences in the pattern of reports of self-assessed health may be a result of differences in the interpretation of questions.

Despite these difficulties, some confidence in the responses to this survey can be taken from the fact that, where comparisons can be made, all three modes of questioning produce similar patterns of response across ethnic groups. A fourth type of questioning about health, whether the performance of certain functions is limited by the respondent's health, which was used in this survey but is not reported on here, also shows a similar patterning of difference across ethnic groups (see Nazroo 1997)

Ethnicity is also a multi-dimensional concept, and one that is neither stable nor pure, as the exploration of ethnic identity in Chapter 9 of this volume illustrates. Despite this, most research on health and ethnicity has taken a crude approach to the allocation of individuals into ethnic groups. This has partly been a consequence of the limitations of available data. For example, because country of birth is recorded on death certificates and in the Census, much of the published data in this area have relied on immigrant mortality statistics. However, the allocation of ethnicity according to country of birth, particularly when the quality of data often means that subcontinent rather than country of birth is used, is clearly inadequate. In particular, ethnic minority people born in Britain and white people born elsewhere are misclassified. Both mortality and morbidity surveys also use categories such as 'Black' or 'South Asian' to describe the ethnicity of those studied. However, such categories are heterogeneous, containing ethnic groups with different cultures, religions, migration histories and geographical and socio-economic locations. Combining them leads to differences between them being ignored. In addition, local studies that contain representatives of only one component of such groups – such as Punjabis or Bangladeshis – but nevertheless describe the population in broader terms – such as South Asian – are potentially even more misleading, because the findings for one ethnic minority group become generalised to others.

It seems that, in order for work on ethnicity and health to progress further, assessments of ethnicity must be more sensitive. One way forward is to allow individuals to assign themselves into an ethnic group. This was the strategy adopted by the 1991 Census, but it suffers from a lack of stability. Individuals often move themselves from one category to another when the question is repeated at a later date (Sheldon and Parker 1992). An alternative, and the option used here, is to assign ethnicity according to family origin. The most obvious problem with this approach is how to deal with respondents who identify themselves as having mixed origins. We have allowed ethnic minority status to over-ride white status. Although the use of country of family origin to allocate ethnicity in this one-dimensional way is limited, it does enable a level of clarity to be maintained when making initial explorations of ethnic variations in health. And, importantly, it allows the exploration of this topic to move beyond the crude assessments of ethnicity that are based on country or continent of birth, or overarching categories such as 'Black' or 'South Asian'.

Comparing ethnic groups – age and gender standardisation and relative risk

Given the large differences in the age profiles of ethnic minority compared to white groups and the relationship between age and health, the data in the figures and tables for this chapter have been both age and gender standardised in order to allow a straightforward comparison between the health of whites and that of the various ethnic minority groups. This involved using a weighting procedure to give each ethnic group the same age and gender structure. However, to prevent any amplification of a chance response, this procedure is dependent on having a reasonably large number of respondents in each age and gender group. Unfortunately some ethnic groups had too small a sample size to be handled in this way. Consequently, Indians and African Asians have been combined, and Pakistanis and Bangladeshis have been combined. The differences in health between the groups that have been combined are small, so this combination will not greatly affect the conclusions drawn (see Nazroo 1997). Even though the number of Chinese respondents is small, and the standardisation procedure consequently more unreliable for them than for others, it was impossible to combine them with any other group because their health profile was very different. They have been included in figures and tables where possible in this chapter, although results for them should be treated with caution.

Comparisons between ethnic minority groups and whites have been made using the relative risk statistic, with lower and upper 95 per cent probabilities calculated. Relative risk is simply the chance of a member of one group being in a particular illness category compared with a member of the other group, while the lower and upper limits give a range within which there is a 95 per cent probability that the true difference between the two populations lies. These comparisons are represented graphically in most of this chapter (the tables on which the figures are based can be found in Nazroo 1997). All comparisons in Figures 7.1 to 7.9 were made with the white group, who are consequently represented by a solid horizontal line at the value of '1'. The relative risk for each ethnic minority group compared with whites is represented as a range, with the top and bottom points of the 95 per cent probability range and the mid point indicated. Differences are statistically significant only if the full range of values does not cross the line indicating the white value.

COMPARING THE HEALTH OF ETHNIC MINORITY GROUPS WITH THAT OF WHITES

General health

Preliminary analysis of the 1991 Census, which for the first time included questions on health and ethnicity, suggested that the age-corrected rate of limiting long-standing illness is lower among whites than among all ethnic minority groups apart from the Chinese (Dunnell 1993). The Health and Lifestyles Survey also suggested that ethnic minority groups reported poorer health than whites, with non-whites being almost 25 per cent more likely than whites to say that their health was fair or poor, although ethnicity for this survey was assessed only through interviewers'

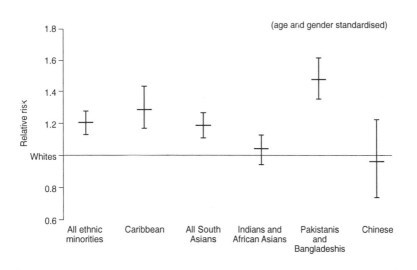

(age and gender standardised)

Figure 7.1 **Relative risk of reporting fair or poor health compared with whites**

observations (Benzeval, Judge and Solomon 1992). Regional studies in Bristol and Glasgow confirm these reports of poorer health among ethnic minority groups (Pilgrim et al. 1993; Williams, Bhopal and Hunt 1993).

In the Fourth National Survey several questions about general health were asked of all respondents (Nazroo 1997). The question considered here is a standard one which asked the respondent to rate his or her health on a five-point scale in relation to others of the same age. Most reports divide responses to this question between those who reported 'excellent' or 'good' health and those who reported 'fair', 'poor' or 'very poor' health. Figure 7.1 is also based on this dichotomy, and shows that Pakistanis and Bangladeshis were 50 per cent more likely to have described their health as fair or poor compared with whites, that Caribbeans were also more likely than whites to have reported fair or poor health, while Indians and African Asians, and Chinese were very similar to whites. The difference between the overall South Asian grouping and whites was significant, but entirely as a result of the high rates among the Pakistani and Bangladeshi group.

Cardiovascular disease

Cardiovascular disease has received the most attention from those interested in ethnic variations in health. It is also a major cause of ill-health, with around 40 per cent of deaths occurring in Britain being attributed to it. Both Marmot et al. (1984) and Balarajan (1991), using mortality data from 1970-78 and 1979-1983 respectively, demonstrated ethnic variations in deaths attributed to cardiovascular disease. From this work two issues emerged as important – heart disease and hypertension.

Heart disease

Balarajan (1991) showed that both men and women born on the Indian subcontinent had higher mortality rates from coronary heart disease than the national average (36 per cent and 46 per cent higher respectively). He was also able to demonstrate that this excess mortality was particularly significant for younger age groups, with South Asians aged between 20 and 40 having more than twice the national average mortality rate. In addition, the data he presented suggested that these ethnic variations in coronary heart disease had not narrowed over time. This evidence is supported both by worldwide reports of higher rates of coronary heart disease among South Asians (McKeigue, Shah and Marmot 1989) and the greater prevalence of indicators of coronary heart disease morbidity (rather than mortality) among South Asians in Britain. For example, McKeigue (1993) demonstrated higher rates of abnormal Electro-cardiograms in South Asian men, and hospital admissions for coronary heart disease also appear to be higher for South Asians (Fox and Shapiro 1988; Cruickshank et al. 1980). In contrast, the data presented by Balarajan (1991) suggest that those born in the Caribbean had lower rates of mortality from coronary heart disease than the general population, with Caribbean men having less than half the national average rate and Caribbean women having three-quarters of the national average rate.

In this study all respondents were asked whether they had ever been diagnosed as suffering from angina and whether they had ever been diagnosed as suffering from a heart attack, 'including a heart murmur, a damaged heart or a rapid heart'. There were no great variations in relative risk when the two questions on diagnosis that were used were compared, and Figure 7.2 shows the relative risk for ethnic minority groups to have either of these compared with whites.

There were only small and statistically non-significant differences between whites and Caribbeans and Chinese. Somewhat surprisingly, given the mortality data

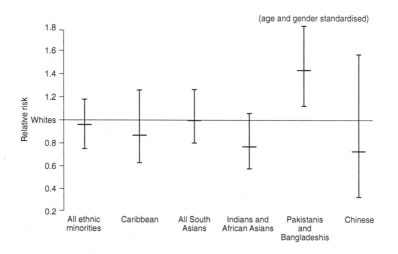

Figure 7.2 Relative risk of diagnosed heart disease compared with whites

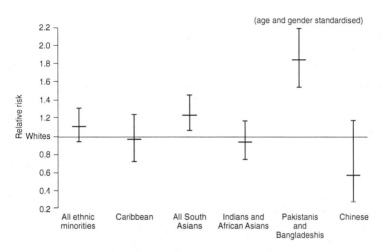

(age and gender standardised)

Figure 7.3 **Relative risk of diagnosed heart disease or severe chest pain compared with whites**

just discussed, Figure 7.2 also shows that the South Asian group overall had a similar rate of diagnosed heart disease to whites, and that the rate for the Indian and African Asian group was close to being statistically significantly lower than that for whites. The Pakistani and Bangladeshi group, however, had much higher rates than the other groups, close to 50 per cent greater than that for whites. This raises the possibility that all of the reported difference in coronary heart disease between South Asians and whites can be attributed to greater rates among Pakistanis and Bangladeshis.

The questions on diagnosis may have been misleading because they depend on respondents having consulted a doctor about cardiac symptoms and being aware of and remembering the diagnosis given. As discussed in the introduction to this chapter, both of these factors could be related to ethnicity. Consequently, those who had not reported diagnosed heart disease, and who were aged 40 or more, were asked whether they had experienced any chest pain and, if they had, whether the pain was severe and lasted more than half an hour. Figure 7.3 shows the relative risk, for those aged 40 or over, for ethnic minority group compared with whites to have either diagnosed heart disease or severe chest pain.[1]

Chinese respondents had lower rates than whites, although the difference was not statistically significant. Caribbeans had a rate very similar to that for whites, while the combined South Asian group had a rate that was 25 per cent higher, which is consistent with mortality data. However, splitting the South Asian group shows that Indians and African Asians had the same rate as whites, while Pakistanis and Bangladeshis had a rate that was much higher, more than 80 per cent greater than that for any of the other ethnic groups. If the relative risk of having diagnosed heart disease or severe chest pain is explored across three age groups (40 to 44, 45 to 59 and 60 or older), the overall pattern remains stable. Caribbeans and Indians and

1 For all ethnic groups, about one third of these said only that they had severe chest pain.

African Asians had the same rate as whites across the age groups and Pakistanis and Bangladeshis had a higher rate than whites. (There were too few Chinese respondents to be analysed by age.) However, the relative risk for the Pakistani and Bangladeshi group was particularly large for those aged 40–44, being three times the white rate. For those aged 45–59 and 60 or older, the rate for the Pakistani and Bangladeshi group was 70 per cent greater than for the white group (full details are shown in Nazroo 1997).

The two figures presented in this section confirm previous findings that suggest that South Asians have higher rates of coronary heart disease than whites, but they also imply that all of this difference can be attributed to higher rates among Pakistanis and Bangladeshis. In fact, whites and Indians and African Asians seemed to have almost identical rates of coronary heart disease. The result appears robust in that it is repeated at each stage in the questioning, from questions addressing experience of symptoms to those asking about diagnosed heart disease, and across age and gender groups. The figures also suggest that Caribbeans have similar rates of heart disease to whites, rather than the lower rates implied by mortality data. Chinese respondents appeared to have lower rates than whites, although the difference was not statistically significant. Also confirmed is that much, but not all, of the greater heart disease morbidity among Pakistanis and Bangladeshis appears to occur among younger age groups.

Hypertension

Balarajan (1991) also demonstrated that men and women born in the Caribbean were at much greater risk than others of dying from a stroke (76 per cent and 110 per cent higher respectively), and the rates of mortality from stroke were also higher for those born on the Indian subcontinent (53 per cent higher for men and 25 per cent higher for women). One of the key risk factors for strokes is hypertension, and it has also been reported that those born in the Caribbean have much higher rates of hypertension than the general population. The rates of mortality from hypertensive disease are four times greater for men born in the Caribbean and seven times greater for women born in the Caribbean (Balarajan and Bulusu 1990). Those born on the Indian subcontinent are also reported to have higher rates of hypertension than the general population, though relative mortality rates from hypertensive disease are not as great as they are for those born in the Caribbean (Balarajan and Bulusu 1990; Marmot et al. 1984; Cruickshank et al. 1980).

Figure 7.4 shows responses to the question that asked respondents whether they had been diagnosed as having hypertension. It is broadly consistent with other studies on hypertension. Whites and Pakistanis and Bangladeshis reported similar rates, Indians and African Asians and Chinese had lower rates than whites, and Caribbeans had rates almost 50 per cent higher than whites. However, the relatively high rate for Caribbeans showed an interesting gender variation. Figure 7.5 shows that, for men, the Caribbean rate was only slightly and not significantly higher than the white rate, while for women it was almost 80 per cent higher. Mortality data also suggest that the difference between Caribbean and white women is greater than that between Caribbean and white men (Balarajan and Bulusu 1990), but, unlike the data presented here, do show a difference for men.

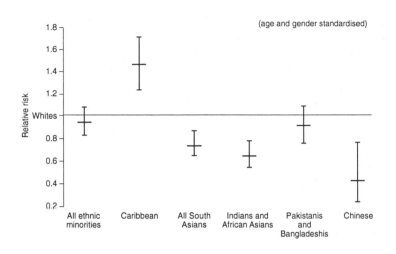

Figure 7.4 Relative risk of diagnosed hypertension compared with whites

The data presented on hypertension need to be treated with some caution. Questioning was only on the diagnosis of hypertension, which is an asymptomatic condition. Consequently, we have no knowledge in this sample of undiagnosed hypertension, nor how the process of diagnosis may be associated with ethnicity. It is worth pointing out that there are more opportunities for women to have their blood pressure checked, as this is routine prior to the prescription of oral contraceptives and as part of an ante-natal consultation. This may have contributed to the findings shown in Figure 7.5.

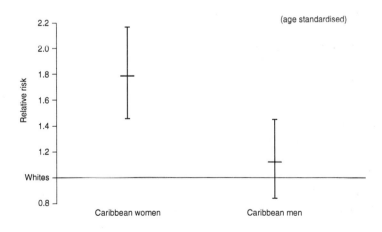

Figure 7.5 Relative risk of diagnosed hypertension among Caribbean men and women compared with whites

Non-insulin dependent diabetes

As well as being directly associated with morbidity and mortality, non-insulin dependent diabetes is also considered a risk factor for a variety of other diseases, such as cardiovascular disease and renal failure. Indeed, it has been suggested that insulin resistance, a syndrome leading to non-insulin dependent diabetes, may be responsible for the higher reported rates of coronary heart disease among those born in South Asia (McKeigue, Shah and Marmot 1991). Previous research has reported that the prevalence of diagnosed non-insulin dependent diabetes among South Asians is over four times greater than that among the white population (McKeigue, Shah and Marmot 1991; Simmons, Williams and Powell 1989; Mather et al. 1987; Mather and Keen 1985). If undiagnosed diabetes is also considered, this may well be an underestimation of the true differences in prevalence (Simmons, Williams and Powell 1989). Also, mortality directly associated with diabetes among those born on the Indian subcontinent is three times that in the general population (Balarajan and Bulusu 1990). Those born in the Caribbean have a similar excess of mortality associated with diabetes (Balarajan and Bulusu 1990), and the prevalence of diagnosed diabetes among Caribbeans is thought to be twice the rate in the general population (McKeigue, Shah and Marmot 1991; Odugbesan et al. 1989). However, the relatively high rate among Caribbeans has not been linked to an increased risk of coronary heart disease.

All respondents were asked whether they had ever had diabetes. Figure 7.6 shows that all ethnic minority groups had higher rates than whites, although differences were small and not significant for the Chinese group. The Indian and African Asian and the Caribbean groups had similar rates – about three times the white rate. The Pakistani and Bangladeshi group had much higher rates than any other group – over five times the white rate.

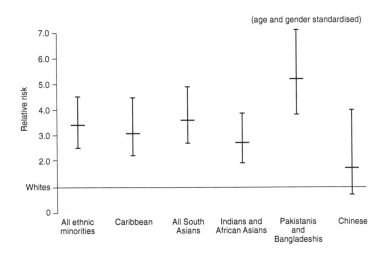

Figure 7.6 **Relative risk of diabetes compared with whites**

Additional questions on type of diabetes were not asked, so distinctions cannot be made between insulin dependent and non-insulin dependent diabetes, nor can those who had diabetes only during pregnancy be identified. Like other reports of specific illness, it is again worth pointing out that responses to the diabetes question relied on the respondent consulting a doctor about possible symptoms and being aware of the diagnosis made.

Respiratory disease

Immigrant mortality studies have shown that ethnic minority groups have lower rates of mortality from respiratory disease (bronchitis, emphysema, asthma and pneumonia) than the general population (Balarajan and Bulusu 1990; Marmot et al. 1984). This appears to be particularly true of chronic obstructive airways disease (bronchitis and emphysema), and it has been suggested that this is a result of lower rates of smoking among the various ethnic minority groups (Marmot et al. 1984). However, mortality data are available for South Asians only as a combined group, and it has more recently been shown that some of the South Asian groups, particularly Pakistani and Bangladeshi men, have relatively high rates of smoking (Nazroo 1997; Rudat 1994). Whether the high prevalence of smoking among particular South Asian ethnic groups translates for them into high rates of chronic obstructive airways disease has not previously been investigated. It is also worth noting that Chinese men have similar rates of smoking to white men, and both Caribbean men and women are as likely to be smokers as their white counterparts (Nazroo 1997).

Half of the ethnic minority and all of the white respondents were asked several questions about symptoms suggestive of respiratory illness. Figure 7.7 shows the relative risk for members of ethnic minority groups compared with whites either to wheeze or to cough up phlegm on most days for at least three months a year (respiratory symptoms). All of the Asian groups had a statistically significant and

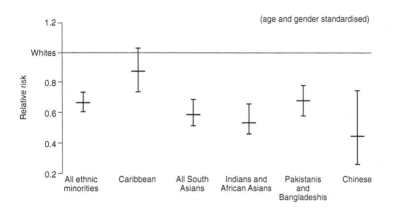

Figure 7.7 Relative risk of respiratory symptoms compared with whites

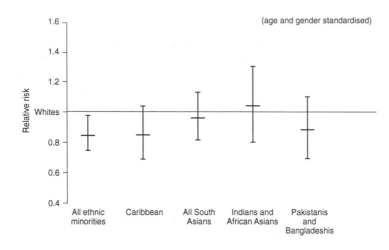

**Figure 7.8 Relative risk of respiratory symptoms for those who have
ever regularly smoked compared with whites**

markedly lower risk of respiratory symptoms than whites. Caribbeans, however, had
a similar risk to whites.

It is possible that these differences are related at least partly to the variations in
rates of smoking across ethnic groups that have just been described. Figures 7.8 and
7.9 show the relative risks for both those who had ever regularly smoked and those
who had never smoked. For smokers, South Asians were just as likely as whites to
have respiratory symptoms, with the lower risk among South Asians applying to
non-smokers only. (Numbers were too few for the Chinese respondents to be
analysed in this way.)

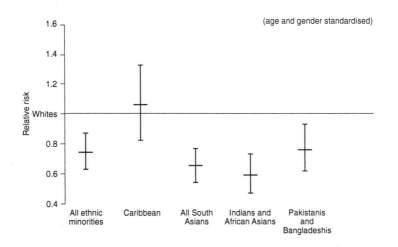

**Figure 7.9 Relative risk of respiratory symptoms for those who have
never regularly smoked compared with whites**

Data presented in this section illustrate important health variations between ethnic minority groups and whites. They broadly confirm differences suggested by other studies of morbidity and those suggested by mortality data. However, there are also some important differences between the data presented here and conclusions reached elsewhere. As far as general health is concerned, Pakistanis and Bangladeshis were particularly disadvantaged compared with whites, having reported a 50 per cent greater risk of fair or poor health. Caribbeans were also disadvantaged compared with whites, having been about 30 per cent more likely to have reported fair or poor health. Although previous research has indicated that all ethnic minority groups have poorer general health than whites (Pilgrim et al. 1993; Williams, Bhopal and Hunt 1993; Benzeval, Judge and Solomon 1992), the differences between Indians and African Asians, Chinese and whites reported here were small and not statistically significant.

Mortality data suggest that those born on the Indian subcontinent have higher rates of coronary heart disease than the general population, and that those born in the Caribbean have lower rates. The morbidity data presented here indicate that Caribbeans had slightly lower rates of coronary heart disease than whites, but not statistically significantly so, as did the Chinese. Of the South Asian ethnic minority groups, somewhat unexpectedly Indians and African Asians also appeared to have similar rates of coronary heart disease to whites. Pakistanis and Bangladeshis, however, had considerably higher rates of coronary heart disease than whites according to the measures used in this survey, and this difference fully accounted for the difference between whites and a combined South Asian group. When considering the differences between the morbidity data presented here and the mortality data presented elsewhere, it is important to keep in mind three factors. First, ethnicity for mortality data is not adequately collected, being based on country of birth and combining South Asians into one group (e.g., Balarajan 1991; Marmot et al. 1984); real differences in mortality rates between the various South Asian groups may not therefore have been identified by previous studies. Second, mortality rates and morbidity rates need not necessarily show the same variations. As a result of differences in access to treatment, in the natural progression of the disease or in exposure to environmental or social factors which may influence the progression of the disease, coronary heart morbidity may lead to different rates of mortality among different ethnic groups. Third, the morbidity rates reported here and the mortality rates reported elsewhere refer to two very different cohorts of ethnic minority groups, and patterns of health may be different between these groups.

The data presented on rates of hypertension confirm previous findings of higher rates of hypertension among Caribbeans compared with the general population (Balarajan and Bulusu 1990), although here the difference was restricted to women. Chinese respondents had lower rates of hypertension than white respondents. Among the South Asians in this sample, the rate of hypertension for Indians and African Asians was lower than that for whites, while it was about the same as whites for Pakistanis and Bangladeshis. This is again in contrast to data on mortality from hypertensive disease, mortality from strokes and smaller population surveys. All of

these suggest that South Asians have higher rates of hypertension than whites (Balarajan and Bulusu 1990). Some of the explanations presented in the previous paragraph may apply to this discrepancy. However, it is also worth noting that recognition of hypertension in a survey such as this is totally dependent on a previous diagnosis made by a doctor. Different ethnic groups may have different opportunities for such a diagnosis to be made.

In this sample, rates of diabetes showed the expected ethnic variation, with all of the ethnic minority groups having higher rates than whites. Interestingly, the difference was much greater for the Pakistani and Bangladeshi group than for the Indian and African Asian group. Also the Indian and African Asian and Caribbean groups had similar rates of diabetes.

For the indicator of respiratory disease, whites did worse than the other ethnic groups. This is consistent with data on both mortality and morbidity (Balarajan and Bulusu 1990). However, if patterns of smoking are considered, among those who had ever regularly smoked the size of the difference was much reduced and not significant, suggesting that the differences reported overall were largely a result of different patterns of smoking.

EXPLAINING ETHNIC VARIATIONS IN HEALTH

If the health outcomes described above are considered jointly, it seems that in Britain ethnic minorities as a whole have poorer health than whites. However, this relatively poor health is not uniformly distributed across the groups that are represented in this sample. Overall, Chinese, Indian and African Asian respondents' reports of their health were similar to those of whites and better than those of the other ethnic minority groups. In contrast, Caribbeans, Pakistanis and Bangladeshis were the ethnic minority groups that reported poorer health than whites. These findings clearly indicate that members of ethnic minority groups cannot be considered as uniformly disadvantaged in respect of their health and, consequently, that investigations of the health of ethnic minority people need to consider carefully which ethnic groups they are dealing with. They also suggest a need to consider the extent to which factors that may result in a health disadvantage might vary across ethnic minority groups.

A number of factors may play an important role in determining ethnic variations in health. These include the following possibilities: they are an artefact resulting from the way data have been collected; they are a result of cultural differences between ethnic groups; they are a consequence of biological/genetic differences in risk; health related selection into a migrant group or the consequences of migration itself might be responsible; they are a direct consequence of racism; or they are the result of the relationship between socio-economic status and both health and ethnicity. (See Smaje 1995a for a detailed discussion of most of these possibilities, but note that to date there has been only limited empirical exploration of these issues.)

I will now explore these possible explanations for ethnic variations in health, noting how they have been dealt with in previous research and examining how useful they might be in explaining the variations shown here. Where possible, particular explanations will be examined empirically with a focus on the question that asked for a self-assessed rating of overall health, responses to which are shown in Figure 7.1.

Artefactual explanations

Concerns that uncovered ethnic variations in health are a result of an artefact of the way in which data have been collected have centred largely upon the possibility that members of ethnic minority groups are under-counted in the population from which the ill group have been identified. This would produce a smaller denominator in the calculation of rates of illness for ethnic minority groups, consequently elevating the percentage ill. An alternative possibility is that members of ethnic minority groups are over- or under-counted in the ill group, perhaps as a result of differences in the likelihood of being treated compared with equivalent white people. Given the population-based, rather than treatment-based, nature of the sample used here, the first of these concerns does not apply to the data presented in this volume. The second might have some bearing on the questions concerning the diagnosis, rather than symptoms, of particular conditions, especially where the condition may be asymptomatic – as in the case of hypertension.

A further concern regarding the quality of the data may, however, apply. As discussed earlier in this chapter, members of different ethnic groups may interpret differently and respond differently to the same questions about their health. There is some evidence to support this possibility. For example, Howlett, Ahmad and Murray (1992) suggest that Caribbeans and whites are likely to describe their health in terms of strength and fitness while Asians are likely to describe their health in terms of functional ability. Similarly, Pilgrim et al. (1993) suggest that questions asking about the presence of a long-standing illness are interpreted differently by different ethnic groups, a suggestion that is confirmed by a detailed exploration of responses to questions on general health in this survey (Nazroo 1997). This evidence suggests that this is an issue that merits consideration. However, as far as it has been possible to explore the validity of the questions used here, the data suggest that they operate consistently across the ethnic groups under consideration (Nazroo 1997).

Explanations relating to race – biological/genetic and cultural factors

The contribution that biological/genetic and cultural factors might have made to the ethnic variations in health reported here could not be directly considered. Biological indicators could not be estimated in a survey of this kind. Cultural factors relating to health, such as diet, are also difficult to estimate, so, with the exception of smoking, no attempt was made. Although factors relating to both culture and biology are commonly used as explanations for the health disadvantage of particular ethnic groups, just as in this survey, they are rarely assessed. This means that postulated cultural and biological differences are assumed rather than directly considered, and typically assumed on the basis of cultural/biological stereotypes (Ahmad 1993b provides a useful critique of this approach). So, once other factors have been

'controlled' for,[2] culture and biology are used to explain 'residual' differences between ethnic groups in ethnocentric and simplistic ways that rely on notions of culture and biology that are divorced from the contexts in which they operate.

Of course there is merit in considering cultural or biological factors as important, particularly if this is done in a dynamic way that considers how they might interact with other factors, such as socio-economic status. However, it seems unlikely that they would play the key role in explaining the health disadvantages shown here of the Caribbean and Pakistani and Bangladeshi groups compared with the white, Indian and African Asian and Chinese groups. This is because the cultural and biological variations between the different 'unhealthy' ethnic groups and between the different 'healthy' ethnic groups are likely to be just as great as the variations across the 'unhealthy' and 'healthy' divide.

Direct effects of migration

There have been a number of discussions of how the process of migration could be directly related to health. The first issue of relevance here is a consideration of how health is possibly related to the selection of individuals into a migrant group. On the one hand, those who are in poor health may, because of the difficulties they will face, be less likely to migrate than those who are healthy – a 'healthy migrant effect'. Marmot et al. (1984) were able to present some data in support of this possibility, although it was not entirely adequate. Alternatively, migration may be inversely related to health. It certainly seems possible that those who are more marginal in society, and consequently more disadvantaged, will be more likely to migrate if an opportunity arises. In addition, poor health itself may lead directly to migration – perhaps as a result of exclusion because of the presence of a stigmatising illness, or possibly in search of better health care. There is, however, little empirical evidence to support any of these possibilities. It is also the case that, where whole communities have been forced to migrate, as happened to African Asians in the late 1960s and early 1970s, neither negative nor positive health selection would have played a role in the process.

The second issue is the direct effect of the process of migration on health. Migration involves a great deal of social disruption and stress. Social networks break down and are often re-formed in new and unexpected ways (Khan 1979). This will have implications for the extent and nature of the social support that exists in migrant communities. There will also be changes in economic position and economic opportunity once migration has occurred, and the movement into an unfamiliar and potentially hostile environment will undoubtedly cause considerable stress. All of these factors may have an adverse impact on the health of migrant populations.

The third issue concerns the impact of environmental factors during childhood on adult health. This is a topic that has raised considerable interest (Vågerö and Illsley 1995; Barker 1991) and may be of particular relevance to ethnic variations in health. Relative environmental deprivation in the country of birth may be one of the explanatory factors for the ethnic variations in health that have been reported in

2 Later in the chapter there is a discussion of the process of controlling out 'confounding' factors to expose an ethnicity/race effect.

immigrant mortality studies. In support of this possibility, Williams, Bhopal and Hunt (1993) concluded that differences in the physical development of members of the Punjabi population in Glasgow compared with the white population were the result of childhood environmental deprivation in the Punjab. If this is the case, we would expect such variations to diminish as new generations are born in Britain. In fact, there is some evidence from the USA to suggest that within one or two generations the health of ethnic minority populations becomes similar to that of others in the country to which they migrated (e.g., Gordon 1982; Krueger and Moriyama 1967).

A more direct test of the health consequences of possible disadvantage associated with migration is to compare the health of migrants with that of members of ethnic minority groups who were born in Britain. These data will be presented next. However, a number of technical problems occur when a comparison of this sort is made. First, should respondents who migrated in childhood be regarded as migrants, or, because of their exposure to British schooling and a British childhood environment, should they be considered as non-migrants? If we agree with the latter decision, at what age should the cut-off between migrants and non-migrants be made? For the purposes of the comparison made here a distinction has been drawn between those who were born in Britain or who migrated below the age of 11 and those who migrated aged 11 or older. This is somewhat arbitrary and chosen to provide as balanced a sample as possible. However, perhaps because of the small number of respondents affected by such a decision, the results presented are similar to those that are produced if the cut-off is made at the age of five or based on country of birth.

The second and perhaps most obvious problem is that the age distributions of migrant and non-migrant ethnic minority populations in Britain are very different, with little overlap in age groups. This means that only respondents within specific age bands can be used to make the comparison between migrants and non-migrants, and even within these fairly narrow age bands the data need to be age and gender standardised. As before, small sample sizes mean that for the process of standardisation certain ethnic groups have had to be combined, and here the Chinese group has had to be dropped.

Third, because different ethnic groups migrated to Britain in different periods, the age bands that have been chosen vary from ethnic group to ethnic group. For Caribbeans the age band is 30 to 44, for Indians and African Asians it is 25 to 39, and for Pakistanis and Bangladeshis it is 20 to 34.

Fourth, the need to focus on these relatively young age groups means that the prevalence of ill-health among the respondents included for this comparison is low. Together with the small sample sizes used, this means that differences found will inevitably be small. We consequently need to be sensitive to the risk of type II statistical errors, where relevant differences between groups are ignored because they do not meet the criteria for statistical significance. (See Blalock 1985 for a full discussion of this issue.)

Figure 7.10 shows that, for all ethnic minority groups considered, those who migrated aged 11 or older were less likely than those who had lived in Britain since birth or early childhood to report that their health was fair or poor. However, differences were statistically significant only for the Caribbean group. Taking into

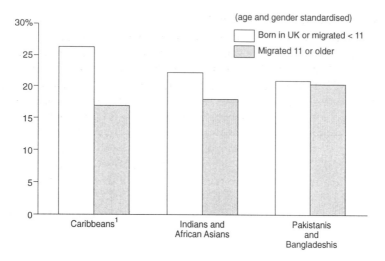

Figure 7.10 Reported fair or poor health, by age on migration to the UK

account the small size and relatively young age, with consequent low rates of ill-health, of the samples considered (which, as has just been described, leads to an increased risk of statistical tests missing important differences between groups), this evidence strongly suggests that for ethnic minority populations in Britain, the health of migrants is at least as good as that of non-migrants, and may be better.

This finding supports certain general conclusions. First, the possibility that selection into migrant groups was dependent at least partly on good health or factors associated with good health is consistent with these data, as such an effect would be expected to be diminished for those born in Britain. Second, the fact that migrants did not report worse health than non-migrants and, in fact, possibly had better health is inconsistent with the hypothesis that ethnic variations in health can be attributed to the stresses and disruptions produced by the process of migration itself. Third, the data also indicate that the ethnic variations in health, suggested by the findings reported earlier in this chapter and immigrant mortality data published elsewhere (e.g., Marmot et al. 1984), are not the result of environmental factors operating before entry to Britain. Such a hypothesis would suggest that those born in Britain or who migrated at an early age should be advantaged compared with the migrant population, which is clearly not the case.

The suggestion that migrants have better health than non-migrants raises an interesting further possibility, that ethnic variations in health could be the result of the negative impact of the British environment on the health of ethnic minority groups. This could be a result of greater poverty, living in disadvantaged inner-city environments, or experiences of discrimination and harassment. This possibility is strengthened by evidence suggesting that the length of time spent in Britain is directly related to poorer health for South Asians living in Glasgow (Williams 1993), with the implication that something about the British environment is damaging their health.

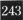

Direct effects of racial harassment and discrimination

In addition to racial discrimination and harassment possibly having a detrimental effect on health as a result of the consequent socio-economic disadvantages, it is possible that they might directly affect health. For example, Benzeval, Judge and Solomon (1992) demonstrated that experiencing racial harassment was significantly associated with reported acute illness (after controlling for other relevant variables) and that experiencing any form of discrimination at work was significantly associated with both acute and long-standing illness. However, Chapter 8 in this volume shows that variations across ethnic minority groups in the reported experience of racial harassment did not match those for health. For example, Bangladeshi respondents were less likely than both African Asian and Chinese respondents to report that they had been racially harassed. So, although the experience of racial harassment may be related to health, it cannot explain the pattern of ethnic variations in health reported here.

Socio-economic effects

Although the review of the evidence for the possibilities so far discussed suggests that they are not crucial to explaining the described ethnic variations in health, it is by no means a robust rejection of their contribution. In fact, each warrants a more detailed exploration. However, given the clearly documented relationship between socio-economic status and health (see, for example, Benzeval, Judge and Whitehead 1995; Blaxter 1990; Davey Smith, Bartley and Blane 1990a; Blaxter 1987; Townsend and Davidson 1982) and the relatively deprived position of many ethnic minority groups, it seems that any exploration of ethnic variations in health needs to consider socio-economic effects in some detail. The fact that variations in socio-economic status across ethnic groups (shown in Chapters 4, 5 and 6 of this volume) are similar to the pattern for health, while the other potential explanatory factors are not, adds weight to the suggestion that this may, on prima facie grounds, be a fruitful avenue to explore.

However, attempts to explore the relationship between socio-economic status, ethnicity and health have not generally lent support to this perspective. For example, the classic study of immigrant mortaility by Marmot et al. (1984) found that there was no, or an inconsistent, relationship between immigrant mortality rates and Registrar General's class for most of the immigrant groups. Indeed, for one group, those born in the 'Caribbean Commonwealth', the relationship was the opposite of that for the general population. In addition, Marmot et al. (1984) found that once they had controlled for class, ethnic differences in mortality rates remained the same, leading them to conclude that: 'differences in social class distribution are not the explanation of the overall different mortality of migrants' (p. 21). Other studies have also found that standardising for socio-economic status across ethnic groups did not greatly diminish the relationship between ethnicity and health (e.g., Fenton, Hughes and Hine 1995; Smaje 1995b).

It is possible that these negative findings are a result of a crude assessment of ethnicity (such as the use of country of birth in immigrant mortality statistics) and the use of socio-economic indicators that inadequately reflect the position of

ethnic minority groups. In fact, there has been an increasing recognition of the limitations of traditional class groupings, which are far from internally homogeneous (Davey Smith, Shipley and Rose 1990b), so it is possible that within an occupational group ethnic minorities could be found in lower or less prestigious occupational grades. Alternative measures of material circumstances – typically housing tenure and car ownership – which are easy to collect and apparently universally applicable, have also been used as socio-economic indicators in epidemiological work. An increasing number of studies report large variations in health associated with these measures of socio-economic status (e.g., Townsend, Phillimore and Beattie 1988). However, advocates of the use of such measures have often failed to consider how ethnicity interacts with them. For example, the proportion of home owners is higher in most South Asian groups than among whites, but the quality of their accommodation tends to be poor (Brown 1984; Chapter 6 this volume). In fact, the most disadvantaged, who undoubtedly include a large proportion of certain ethnic minority groups, probably suffer disproportionately from the cumulative impact of different forms of deprivation, an effect which cannot be identified by a one-dimensional indicator of socio-economic status.

Class and tenure

Clearly these issues require detailed consideration, and the Fourth National Survey provides a unique opportunity to do this. This section explores the relationship between the two standard indicators of socio-economic status mentioned, class and tenure, and reported general health for each of the ethnic groups. For tenure a simple distinction will be made between owner-occupiers and renters. For class a distinction will be drawn between households that are manual and non-manual according to the Registrar General's criteria,[3] and a third group of respondents from households containing no full-time worker will be included. Once these issues have been explored, the limitations of these standard indicators of socio-economic status will be examined, a possible way forward will be developed, and the effect of controlling for socio-economic status in different ways on the extent of ethnic variations in health will be shown.

Once again the data presented have been age and gender standardised to allow immediate comparisons across both socio-economic and ethnic groups. This means that, as well as combining Indians with African Asians and Pakistanis with Bangladeshis, the Chinese group cannot be considered separately because of small numbers of respondents in particular age/class/gender weighting cells, although it is incorporated into the 'All ethnic minorities' group. In addition, because of the small numbers of respondents in particular weighting cells, the 65 and older age group have not been included in the data presented in this section, which means that they are not directly comparable with those shown in Figure 7.1.

3 Class was assigned using the head of the household's occupation. Where it was not clear which household member was the head of the household (e.g. where there was more than one working adult), class was allocated on the basis of gender (with men's occupations being used in preference to women's) and generation (e.g. a father's occupation being used in preference to a son's if the father was below retirement age).

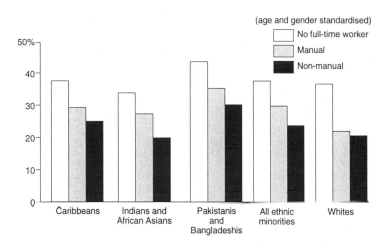

Figure 7.11 Reported fair or poor health, by class

Figure 7.11 shows the percentage of respondents who said that they had fair, poor or very poor health by class and demonstrates a very clear and statistically significant relationship between this indicator of socio economic status and health for all ethnic groups. Interestingly, the difference between individuals in manual and non-manual households was much more marked for ethnic minority respondents than for white respondents.

Figure 7.12 looks at how reported health varied according to tenure and shows that, for all ethnic groups, those who owned their homes were less likely than those who rented to report fair or worse health.

Figure 7.12 Reported fair or poor health, by tenure

These data, then, show a clear and consistent relationship between socio-economic status and health for each of the ethnic groups covered. And this pattern is repeated if the other health assessments used in this survey are considered (Nazroo 1997).

Controlling for socio-economic effects

Given that there is such a strong relationship between socio-economic status and health within particular ethnic groups, it would seem to make sense to explore how far ethnic variations in health remain once socio-economic differences between ethnic groups have been controlled. This is the strategy adopted by Marmot et al. (1984), but, as previously described, they found that, once they had standardised for class differences in the immigrant mortality data they used, it remained more or less unchanged. A similar impression might be formed from the data presented in Figures 7.11 and 7.12. Within each socio-economic group Pakistanis and Bangladeshis were more likely than the equivalent white group to report fair or poor health. Consequently, it seems that it can be concluded that, while there are important socio-economic effects within ethnic groups, differences between ethnic groups remain once they have been accounted for. That is, socio-economic factors do not explain ethnic variations in health.

However, some thought has to be given to how adequate variables such as class and tenure are for controlling out socio-economic effects when exploring ethnic variations in health. In effect, we have to ask ourselves whether individuals from different ethnic groups but within the same broad socio-economic band – such as non-manual or owner-occupier – are really in an equivalent socio-economic position. It certainly seems likely that, as a result of the racialisation of disadvantage, within these broad bands ethnic minority groups will be worse off relative to the equivalent white group. This issue is explored in Table 7.1.

The first part of the table shows the mean equivalised household income for individuals within particular classes by ethnic group, i.e., income adjusted for the number of people in the household. The Caribbean and Indian and African Asian groups appeared to have similar locations within each class band, while whites were better off and Pakistanis and Bangladeshis were worse off. The second part of the table shows the median length of unemployment for those who were currently unemployed at interview. It again shows diverse patterns across ethnic groups, with whites and Indians and African Asians having been unemployed for a considerably shorter period than Caribbeans and Pakistanis and Bangladeshis. The third part of Table 7.1 gives an indication of the quality of housing occupied by owners and renters for different ethnic groups. It shows the percentage of respondents who reported not having sole access to certain household amenities: a bath or shower, a bathroom, an inside toilet, a kitchen, hot water from a tap and central heating. Again the table shows interesting variations across ethnic groups. For both owners and renters the white, Caribbean and Indian and African Asian groups showed a similar pattern, while the Pakistani and Bangladeshi group were far more likely than any other group in both the owner and the renter category to be lacking exclusive use of such an amenity. In addition, while owners appeared to have better housing than

renters for the white, Caribbean and Indian and African Asian groups, this was not the case for the Pakistani and Bangladeshi group.

Table 7.1 Variations within socio-economic bands

	White	Caribbean	Indian/ African Asian	Pakistani/ Bangladeshi
Mean income by Registrar General's class[1]				
I/II	£250	£210	£210	£125
IIIn	£185	£145	£135	£95
IIIm	£160	£145	£120	£70
IV/V	£130	£120	£110	£65
Weighted count	*1937*	*1144*	*1173*	*600*
Unweighted count [2]	*1894*	*869*	*1142*	*969*
Median duration of **unemployment (months)**	7	21	12	24
Weighted count	*134*	*126*	*92*	*100*
Unweighted count	*128*	*91*	*91*	*166*
Percentage lacking one or **more basic housing amenities[3]**				
Owner-occupiers	11	12	14	38
Renters	27	23	28	37
Weighted count	*2867*	*1567*	*2091*	*1147*
Unweighted count[3]	*2867*	*1205*	*2001*	*1776*

1 Based on bands of equivalised household income. The mean point of each band is used to make this calculation, which is rounded to the nearest £5 (see Chapter 5 for a more detailed discussion of this).

2 This is a household property and, strictly speaking, households should be used as the base for this table (as in Chapters 5 and 6.) Here individuals are used as the base because later in this chapter the relationship between household class and an individual's health will be explored. The same point applies to Tables 7.2 and 7.3.

3 i.e., exclusive use of bath or shower, bathroom, inside toilet, kitchen, hot water from a tap and central heating.

The overall conclusion to be drawn from Table 7.1 is that, while class and tenure might have some use for making comparisons within ethnic groups, they are of little use for 'controlling out' the impact of socio-economic status when attempting to reveal a 'pure' ethnic/race effect. This leads to two related problems with approaches that attempt to adjust for socio-economic effects when making comparisons across ethnic groups. First, if socio-economic status is regarded simply as a confounding factor that needs to be controlled out to reveal the 'true' relationship between ethnicity and health, data will be presented and interpreted once controls have been applied. This will result in the impact of socio-economic factors becoming obscured and their explanatory role lost, just as gender and age effects are not apparent in the majority of the figures shown earlier in this chapter. The second is that the presentation of 'standardised' data allows the kind of problems illustrated by Table 7.1 to be ignored, leaving both the author and the reader to assume that all that is

left is an 'ethnic/race' effect, be that cultural or biological/genetic. Here it is important to remember not only that such indicators deal inadequately with socio-economic effects for cross-group comparisons, they also do not account for other forms of disadvantage that might play some role in ethnic variations in health, such as those related to geographical location and the direct effects of racism and discrimination (see Chapters 6 and 8 for a discussion of these forms of disadvantage).

Nevertheless, if these cautions are considered there are some benefits in attempting to control for socio-economic effects. In particular, if controlling for socio-economic effects alters the pattern of ethnic health variations, despite the limitations of the indicators used, we can conclude that at least part of the variations we have uncovered are a result of such effects. To do this we need to consider carefully which indicators to use in the process of standardisation for socio-economic status. There are a number of alternatives to those typically used in epidemiological research, including income. However, there was a sufficiently large number of respondents who did not answer the relevant question to make income less useful than it at first appears in this context (see Chapter 5). Instead, making use of the extensive information this survey collected on the circumstances of its respondents, an index of 'Standard of Living' will be used in addition to class and tenure for the process of standardisation.

This index, like the other indicators of socio-economic status used, is household based, using information on: overcrowding of accommodation, the presence of basic household amenities, the number of consumer durables the household has and the number of cars to which the household has access. The index has three mutually exclusive points to it, poor, medium and good, that are inevitably broad, but have been selected both because of their face validity and because each one contains a reasonably large sample size for each ethnic group. Simplifying the index slightly, the 'poor' group consists of those with any of the following:

■ overcrowded accommodation (one person per room or more)

■ lacking sole access to one or more amenity (out of: a bath or shower, a bathroom an inside toilet, a kitchen, hot water from a tap and central heating)

■ few consumer durables (fewer than four of: a telephone, television, video, fridge, freezer, washing machine, tumble-drier, dishwasher, microwave, CD player and personal computer).

The 'good' group consists of those with all of the following:

■ fewer than 0.75 people per room

■ sole access to all of the basic amenities listed above

■ many of the consumer durables listed above (nine or more, or five or more and two cars).

The relationship between this index and ethnic group is shown in Table 7.2. This indicates that the white group was the best off, followed closely by the Indian and African Asian group. The Caribbean group was clearly worse off than either of these two, but the Pakistani and Bangladeshi group was by far the worst off.

Table 7.2 Standard of living

				column percentages
	White	Caribbean	Indian/ African Asian	Pakistani/ Bangladeshi
Standard of living[1]				
Good	43	23	34	9
Medium	49	63	52	41
Poor	8	14	14	50
Weighted count	*2865*	*1567*	*2083*	*1147*
Unweighted base	*2865*	*1205*	*1996*	*1776*

1 See text for a definition of this index.

The small percentage of people in the poor band for the white group and the good band for the Pakistani and Bangladeshi group shows why it was necessary for the three bands that make up this index to be relatively broad. However, this raises the possibility that, once again, different ethnic groups have different locations within a particular band. This is explored in Table 7.3, which looks at the equivalised household income for each band by ethnic group. As expected, within ethnic groups there was a clear relationship between income and the standard of living index. Comparisons across ethnic groups show that the white, Caribbean and Indian and African Asian groups were similar, except for the relatively low income for Indians and African Asians in the medium group. However, for each band the Pakistani and Bangladeshi group had a lower average income. This suggests that the standard of living index still does not control adequately for socio-economic status. Nevertheless, a comparison between the figures presented in Table 7.1 and those in Table 7.3 shows that the ratio between the incomes of the Pakistani and Bangladeshi and whites groups for each socio-economic band is smaller in the latter table, suggesting that it should be an improvement over the other indicators of socio-economic status – which are, if anything, even cruder than Registrar General's class.

Table 7.3 Mean equivalised household income[1], by standard of living

				column percentages
	White	Caribbean	Indian/ African Asian	Pakistani/ Bangladeshi
Standard of living				
Good	£225	£195	£210	£155
Medium	£145	£140	£115	£80
Poor	£105	£100	£95	£65
Weighted count	*2330*	*1274*	*1307*	*824*
Unweighted count	*2410*	*991*	*1283*	*1327*

1 Based on bands of equivalised household income. The mean point of each band is used to make this calculation which is rounded to the nearest £5.

The data in Table 7.4, as in the earlier figures in this chapter, are presented as relative risk scores in comparison with the white group. Each of the four rows shows

the relative risk score once a particular type of standardisation has been applied. The first row has only age and gender standardisation, while the other three control for various indicators of socio-economic status in addition to age and gender. Ninety-five per cent confidence limits are shown in parentheses below each figure. If these limits are both above 1.0, the relevant ethnic minority group can be considered to be statistically significantly more likely than the white group to have fair or poor health, while if they are both below 1.0, the ethnic minority group can be considered to be statistically significantly less likely than the white group to have fair or poor health.

Table 7.4 **Relative risk among ethnic minorities compared with whites of reported fair or poor health, by ethnic group standardised by socio-economic factors**

	Caribbean	Indian/ African Asian	Pakistani/ Bangladeshi	All ethnic minorities
Type of standardisation				
Age and gender	1.25	0.99	1.45	1.17
	(1.1–1.4)	(0.9–1.1)	(1.3–1.6)	(1.1–1.3)
Class, age and gender	1.15	1.00	1.36	1.14
	(1.03–1.3)	(0.9–1.1)	(1.2–1.5)	(1.1–1.2)
Tenure, age and gender	1.17	1.04	1.45	1.18
	(1.04–1.3)	(0.9–1.2)	(1.3–1.6)	(1.1–1.3)
Standard of living, age and gender	1.15	0.94	1.24	1.08
	(1.03–1.3)	(0.9–1.04)	(1.1–1.4)	(0.99–1.2)

The most striking finding shown in Table 7.4 is that standardising for class or tenure made no difference to the relative risk of reporting fair or poor health for either the Pakistani and Bangladeshi group or the 'All ethnic minorities' group. However, controlling for standard of living reduced the difference between the 'All ethnic minorities' group and the white group to a level that was not statistically significant, and reduced the difference between the Pakistani and Bangladeshi group and the white group to one that was only just statistically significant. For the Caribbean group, all three methods of standardising for socio-economic status reduced the relative risk to a level that was barely significantly greater than that for whites. For the Indian and African Asian group, standardising for class and tenure again made little difference, but controlling for standard of living very nearly brought the risk to statistically significantly lower than that of whites.

The finding that the relative risk of all ethnic minority groups to report fair or poor health compared with whites was reduced once standard of living had been controlled for (compare the first and last rows in the table) is strongly supportive of a hypothesis that claims that the relatively deprived socio-economic position of ethnic minority groups compared with whites contributes to their poorer health. Once again, this pattern of results is repeated for the other health outcomes explored in this survey (Nazroo 1997). Here it is worth reconsidering the fact that the index of

standard of living is not a perfect tool for controlling for socio-economic status – see Table 7.3 – even if it is an improvement on the indicators of socio-economic status traditionally used by epidemiologists. Nevertheless, despite these limitations relative risks that were significantly greater for ethnic minorities compared with whites become no longer or only just significantly different once standard of living had been controlled.

Summary

The data presented in this section show that, as for the general population, socio-economic status is an important predictor of health for ethnic minority groups. Figures 7.11 and 7.12 show that those in poorer socio-economic groups had poorer health in each ethnic group. In contrast to this, the only comparable study of the health of ethnic minority groups, that on immigrant mortaility by Marmot et al. (1984), came to the conclusion that 'the relation of social class (as usually defined) to mortality is different among immigrant groups from the England and Wales pattern' (p. 21). The discrepancy between the conclusions reached here and those reached by Marmot et al. (1984) needs careful consideration. Here it is worth highlighting some points that suggest that the data used by the two studies are not directly comparable.

- The definition of ethnicity here is based on country of family origin, while that in the Marmot et al. (1984) study was based on country of birth.

- Data used here are based on self-reports, or diagnosis, of morbidity, while Marmot et al. (1984) used mortality. While the two are related, there are also important differences, as discussed earlier in this chapter.

- Socio-economic status was defined here according to *current* occupation, tenure or standard of living, while Marmot et al. (1984) used occupation as recorded at time of death. The use of occupation as recorded on death certificates may cause particular problems for immigrant mortality data. This is because the inflating of occupational status on death certificates (where, according to Townsend and Davidson 1982, occupation is recorded as the 'skilled' job held for most of the individual's life rather than the 'unskilled' job held in the last few years of life) will be a particularly significant problem for such data if migration to Britain was associated with downward social mobility for members of ethnic minority groups. In this case the occupation on the death certificate may be an inaccurate reflection of experience in Britain before death. In addition, given the socio-economic profile of ethnic minority groups in Britain, this inflation of occupational status would need to happen in only relatively few cases for the figures representing the small population in higher classes to be distorted.

- Finally, differences between the data reported here and by Marmot et al. (1984) may reflect genuine differences between the populations studied. Important cohort effects may have operated between the exclusively immigrant ethnic minority population who had their health assigned by mortality rates and the ethnic minority population interviewed about 20 years later that included both

migrants and those born in Britain, and who had their health assessed by self-reported morbidity.

These points suggest not only that the data used in the two studies are not directly comparable, but that the data used here are an improvement on the mortality data used by Marmot et al. (1984), being nationally representative of the ethnic minority groups used, having more accurate assessments of socio-economic status and ethnicity and, consequently, being less likely to suffer from artefact effects.

The data presented here also show that traditional indicators of socio-economic status, such as class and tenure, are inadequate for controlling out socio-economic effects when making comparisons across ethnic groups. Table 7.1 shows that within particular socio-economic bands members of ethnic minority groups were worse of than whites, and that the extent of this varied by ethnic minority group. Table 7.4 shows that controlling for class or tenure made little or no difference to ethnic variations in health, while controlling for an alternative indicator of socio-economic status, standard of living, gave a large improvement in the health of ethnic minority groups compared with whites.

Again, it is worth pointing out that 'controlling' for socio-economic status cannot be completely done, even if specifically tailored indicators such as standard of living are used. Table 7.3 shows that within bands of standard of living important differences in income between ethnic groups remain. It is also important to recall that taking account of socio-economic status deals only with part of the disadvantage faced by ethnic minority groups. Other important features of the lives of ethnic minority groups may adversely affect their health in comparison with the white population, such as their experiences of racism and discrimination, and their geographical concentration in urban locations. Nevertheless, the conclusions to be reached are that socio-economic status is an important predictor of health within ethnic groups and that it also makes an important contribution to the pattern of ethnic health variations that have been reported here and elsewhere.

USE OF HEALTH SERVICES

Access to and the ease of use of health services is an important potential source of inequality in the health experience of different ethnic groups in Britain. If such inequalities do exist, they may have important influences on both the quality of care experienced and the outcomes of that care. However, despite the possibilities for inequalities in access to the health service for ethnic minority groups, most of the studies that have attempted to explore variations in health service use have found that, on the whole, ethnic minority groups make greater use of the health service than the white majority. For example, the BMEG survey (Rudat 1994) showed that, apart from Caribbean men, people from ethnic minority groups were more likely to be registered with a GP than the general population. It also showed that consultation rates with GPs were higher among ethnic minority groups, particularly Pakistanis and Bangladeshis, than the general population. Similar differences in consultation rates were uncovered in analysis of the General Household Survey data (Balarajan,

Yuen and Botting 1989) and the third national GP Morbidity Survey (McCormick and Rosenbaum 1990). These findings have also been supported by smaller scale regional studies, such as the one carried out in the West Midlands (Johnson, Cross and Cardeur 1983).

Nevertheless, such studies have one crucial drawback. Differences in the use of health services can be fully understood only in the light of differences in need. Earlier sections of this chapter have clearly illustrated differences in need both between and within ethnic groups, and it may be that differences in use disappear or are even reversed when differences in need are taken into account. In the analysis carried out here, the respondents' perception of their overall health has been used as an indicator of need. This is, of course, also an indicator of potential demand for services.

Table 7.5 explores consultation rates with General Practitioners once the respondents' reported level of general health had been taken into account. As consultation rates are also dependent on age and gender (Nazroo 1997) the data have once again been standardised for these factors. As expected, the table shows that consultation rates increased for all groups as perceived health became poorer. The table also shows that Chinese respondents at all levels of health status were less likely than others to have consulted with their GP, although the small sample size for the Chinese group makes some of these figures unreliable. In contrast, the other ethnic minority groups were all more likely than whites to have had one or more consultations, whatever their health status, and the Pakistani and Bangladeshi group had the highest consultation rates.

Table 7.5 Visits to general practitioner in the past month, by self-assessed general health

percentages: age and gender standardised

	White	Caribbean	Indian/ African Asian	Pakistani/ Bangladeshi	Chinese
Spoken to GP about own health in the last month					
Good/excellent health	24	32	27	35	19
Fair health	48	50	55	66	29[1]
Poor/very poor health	69	81	83	89	45[1]
Total	**33**	**42**	**38**	**51**	**23**
Weighted count	*2856*	*1555*	*2055*	*1124*	*388*
Unweighted count	*2848*	*1194*	*1957*	*1736*	*212*

1 Small base numbers in the cell make the estimate unreliable.

Table 7.6 uses the same procedure as Table 7.5, but to explore differences in rates of hospital admission in the year prior to interview. Again, for all groups there was the expected rise in the rate of admission with poorer perceived health. Also, as for GP consultation rates, the Chinese group appears, given the small sample size, to have had lower rates of admission than the other groups. All of the other ethnic groups had remarkably similar rates of hospital admission across all levels of perceived health. This is similar to the findings reported by Benzeval and Judge (1993), who also found

no significant differences across ethnic groups in the use of hospital services once they had accounted for self-reported ill-health.

Although the data in Table 7.6 are age and gender standardised, this may not have completely ruled out gender effects, as hospital admission rates may have been influenced by differences in fertility rates across ethnic groups. Indeed, data from this survey suggest that white, Indian, African Asian and Caribbean women had similar rates of admission for childbirth, while Chinese women appear to have had lower rates, and Pakistani and Bangladeshi women had higher rates (Nazroo 1997). This implies that, in terms of making a comparison across ethnic groups, the rates of hospital admission shown in Table 7.6 could be considered an overestimate for the Pakistani and Bangladeshi group and an underestimate for the Chinese group.

Table 7.6 Hospital in-patient stays in the past year, by self-assessed general health

percentages: age and gender standardised

	White	Caribbean	Indian/ African Asian	Pakistani/ Bangladeshi	Chinese
Stayed overnight as a hospital in-patient in the last year					
Good/excellent health	7	7	6	7	6
Fair health	16	13	11	14	7[1]
Poor/very poor health	30	31	31	28	9[1]
Total	**11**	**11**	**10**	**12**	**6**
Weighted count	*2863*	*1560*	*2081*	*1141*	*390*
Unweighted count	*2856*	*1197*	*1992*	*1769*	*214*

1 Small base numbers in the cell make the estimate unreliable.

The data so far presented in this chapter suggest that ethnic minority groups, except possibly the Chinese, do not underuse either their GPs or hospital in-patient services. Even after the respondents' perceived quality of health was taken into account, ethnic minority respondents were more likely than whites to consult a GP and equally likely to have been admitted to hospital. The process of comparing individuals within the same health category should be regarded with some caution, however. These are broad categories, and the extent of ethnic variations in health may mean that within such categories different ethnic groups may have different average levels of health.

However, there is an interesting discrepancy between GP consultation rates and the hospital admission rates. Differences between ethnic minority groups and whites for the former are larger than for the latter. Two possible explanations seem likely. First, it may be that ethnic minority respondents were more likely to consult their GPs for less serious complaints and, consequently, were less likely to be referred on for hospital treatment. However, this explanation relies on the assumption that all of the ethnic minority groups considered behaved similarly in this respect, despite the diversity of their cultures, and that, within the broad health categories used in the tables, all ethnic minority groups had better health than whites. Second, it may be possible that ethnic minority people are less likely to be admitted to hospital than

white people when they have a similar level of illness. If this is correct, differences in GP consultation rates should be interpreted as reflecting real differences in level of illness (which are not adequately controlled for by the broad categories of health status used) that are not translated into differences in hospital admission rates. There are a number of reasons why this might be so – such as not being taken seriously by health care workers, or not being able to communicate symptoms effectively to them – but all would suggest that although ethnic minority people do consult with their GP, the quality of that consultation is less adequate than that for the white majority.

There is some evidence to support this possibility. Both the BMEG survey (Rudat 1994) and this survey (Nazroo 1997) found that there were important communication difficulties between some ethnic minority groups and their doctors. The BMEG survey also showed that ethnic minority respondents were less likely than the general population to believe that the time their GP spent with them was adequate. This was particularly the case for Bangladeshis, for whom as many as a third of respondents felt that the time spent with them was inadequate compared with about one in eight of the general population. In addition, this survey showed that the preferences that some ethnic minority patients had for doctors of a similar ethnicity and gender to themselves were unlikely to be met (Nazroo 1997). All of these factors could damage the quality of the consultation.

So far this chapter has concentrated on differences in the use of medical services. However, all of the white and half of the ethnic minority respondents were asked about their use of a variety of other health and social services in the past year. Responses to these questions are shown in Table 7.7.

Table 7.7 Other health and social services used in the past year

percentages

Service used	White	Caribbean	Indian	African Asian	Pakistani	Bangladeshi	Chinese
Dentist	62	53	45	46	50	25	47
Physiotherapist	9.0	6.5	5.8	4.1	3.9	0.6	7.9
Psychotherapist	1.1	0.7	0.5	0.8	0.8	0.6	1.3
Alternative practitioner	5.7	2.9	1.7	3.0	1.3	0.6	3.8
Health visitor or district nurse	7.4	8.7	4.2	4.1	4.8	6.9	6.8
Social worker	3.8	5.2	2.2	1.1	1.7	1.7	2.5
Home help	2.1	1.0	0.3	0.1	1.8	0.8	0
Age and gender standardised	0.7	0.9	—	0.2 —	—	1.7 —	0
Meals on wheels (aged 65+)	3.2	1.8	0	*	3.1*	*	*
Age and gender standardised	2.2	1.7	—	0 —	—	2.0 —	*
Other	6.9	4.4	1.2	2.9	1.3	2.7	2.3
Weighted count	*2863*	*777*	*646*	*390*	*417*	*138*	*195*
Unweighted count	*2862*	*609*	*638*	*348*	*578*	*289*	*104*

* Small base numbers in the cell make the estimate unreliable.

Of the services listed in the table, only dental services should be routinely used. The responses shown in the first row of the table are in marked contrast to those shown for GP consultations, which ethnic minority respondents were more likely to have had than white respondents. While more than three-fifths of white respondents had seen a dentist in the past year, only about half of the Caribbean, Indian, African Asian, Pakistani and Chinese respondents had. Particularly worrying was the fact that only a quarter of the Bangladeshi respondents had seen a dentist in the last year, a figure also reported in the BMEG survey (Rudat 1994).

In fact, white respondents were more likely than all of the ethnic minority respondents to have made use of nearly all of these services, including alternative practitioners, for which the questioning included the examples of hakims, homeopaths and osteopaths. The only exception to this was the relatively high use made by Caribbeans of health visitors or district nurses, and social work services. Whether this is the result of beliefs regarding which clients need these particular services, or the result of genuine differences in need, is impossible to determine from these data.

CONCLUSION

The Fourth National Survey of Ethnic Minorities offers a unique opportunity to explore ethnic variations in health. It is a large nationally representative survey of the main ethnic minority groups in Britain providing detailed coverage of general health and specific illnesses, and it also provides a detailed exploration of other aspects of the lives of ethnic minority people in Britain. As a result, the survey has been able to overcome a number of the limitations of other research in this area.

One of the most important findings is that levels of ill-health vary markedly across ethnic minority groups, as well as between ethnic minority and majority groups. Of the ethnic minority groups represented in this survey, Indians, African Asians and Chinese had similar levels of health to whites, while Caribbeans, Pakistanis and Bangladeshis had worse health than whites. (Figures 7.1 to 7.6 show this overall pattern, but see also Figures 7.7 to 7.9, which show that this does not hold for symptoms suggestive of respiratory disease, which, perhaps as a result of differences in rates of smoking, are more likely to be reported by whites.) This has important implications for the interpretation of previous work, which has typically used ethnic minority categories such as 'Black' and 'South Asian' to describe those researched. On the one hand, if the respondents to these studies represented only one element of such groupings, as is the case for certain regional surveys of 'South Asians', the generalisation to other South Asians is clearly misleading. On the other hand, important differences will be ignored if several ethnic minority groups are studied as if they were a homogeneous category.

This is certainly the case for studies that have shown that ethnic minorities in general have poorer health than whites, such as the analysis of ethnicity in the Health and Lifestyles Survey (Benzeval, Judge and Solomon 1992). It also applies to studies that have investigated the possibility of high rates of heart disease among South Asians. On the whole these had failed to investigate adequately the possibility

that such high rates may not apply uniformly to all South Asians, largely because early studies had limited data available and assumptions made at that stage have rarely been investigated. This has led to an investigation of what it might be about being South Asian that leads to greater risk, often with a focus on crude stereotyped generalisations (see, for example, Gupta, de Belder and O'Hughes 1995). However, the data presented here show that only those South Asians with Pakistani and Bangladeshi origins had higher rates of heart disease than whites, Indians and African Asians had rates that were very similar to the white rate (Figures 7.2 and 7.3).

The quality of the data available from the Fourth National Survey has also allowed an examination of several of the possible explanations for ethnic variations in health. Although the data are cross-sectional, so causal direction cannot be determined with any certainty, the data show that within each ethnic group there was a clear relationship between socio-economic status and health (Figures 7.11 and 7.12). While studies that have used immigrant mortality data have not shown this effect – probably because of the limitations of such data – other local morbidity studies have also found a relationship between socio-economic status and health for ethnic minority groups (Fenton, Hughes and Hine 1995; Smaje 1995b; Ahmad, Kernoham and Baker 1989).

However, both immigrant mortality data and local morbidity surveys have found that ethnic variations in health persist after socio-economic status has been controlled for. Investigators have consequently assumed that there remains a large, significant and 'pure' ethnic or race effect – that is, an effect that is presumed to be the consequence of biological/genetic or cultural differences between groups. Data presented in this chapter suggest that this is based on the mistaken assumption that the indicators of socio-economic status traditionally used in epidemiological studies, such as class and tenure, effectively control out socio-economic effects when making comparisons across ethnic groups. In fact, within the broad bands of socio-economic status used in this process important differences between the positions of different ethnic groups remain. For example, ethnic minority people in each class group had a lower equivalised household income than equivalent whites (see Table 7.1). If a more appropriate indicator of socio-economic status is used to control for socio-economic effects, as the index of standard of living was used here, the relative risk of all ethnic minority groups compared with whites to report that their health was fair or poor was reduced (Table 7.4). This finding was particularly strong for the most disadvantaged (in terms of both health and socio-economic status) group, Pakistanis and Bangladeshis. This leads to the conclusion that socio-economic factors made an important contribution to the ethnic variations in health that were reported earlier in this chapter.

Previous research has consistently reported that ethnic minority people do not underuse health services, although this work had not taken into account the relatively poorer health of certain ethnic minority groups. However, the data presented in the final section of this chapter showed that even after their self-reported level of health had been taken into account, all ethnic minority groups except for the Chinese were still more likely than whites to have consulted with their GP in the previous month (Table 7.5). Interestingly, this did not translate into greater use of in-patient hospital facilities by members of ethnic minority groups.

Once the respondents' self-reported level of health had been taken into account, there were no differences in hospital admission rates between whites and all of the ethnic minority groups, except for the Chinese, who had lower rates (Table 7.6). (However, increased hospital admission rates for childbirth for Pakistani and Bangladeshi women may have led to an 'overestimation' of their rates of admission for the purposes of this comparison.) This suggests a lower referral rate from primary to secondary care for ethnic minority patients.

Data presented elsewhere from this survey (Nazroo 1997) showed that of those Chinese respondents who had consulted a GP in the past month almost one third did not understand the language he or she used. It seems possible that communication difficulties could be one of the factors that accounted for the low use made by Chinese respondents of primary health care, and possibly influenced their low referral rates on to secondary health care.

Indeed, data from this survey (Nazroo 1997) and data presented by Rudat (1994) suggest that despite the greater use of primary health care made by most ethnic minority groups compared with whites, the quality of the care offered to them was poorer, particularly in terms of meeting language needs and preferences for the gender and ethnicity of doctors consulted. The importance of the preference for a GP of a similar ethnicity to themselves for ethnic minority respondents can be seen from the fact that many of those South Asians who did not speak English as their first language attempted to overcome this by using a GP who shared another language with them (well over half of such respondents used a South Asian language with their GP according to Rudat (1994), and this survey showed that those who could not speak English well were three times more likely than others to prefer to see a doctor of the same ethnic background as themselves (Nazroo 1997)). It seems possible that communication difficulties could have had some role in the apparent under-referral to secondary health care for ethnic minority groups compared with whites.

Racial Harassment

Satnam Virdee

INTRODUCTION

The political background to the problem

Several political developments in the 1990s have served to bring racial violence and harassment to the fore in Britain. The most important of these has been the public concern over a number of particularly brutal assaults. People such as Rohit Duggal, a schoolboy stabbed and killed in Eltham, south-east London, were attacked because they were negatively signified as 'different' from the white population by virtue of their alleged 'race', colour, ethnicity or nationality. Between 1992 and 1994, 15 people died in Britain as a result of what are believed to be racially motivated attacks (CARF 1991–95).

The second political development has been the emergence in Britain of a far-right political party – the British National Party (BNP) – for the first time since the National Front of the mid-1970s. The election of the BNP candidate, Derek Beackon, in a Millwall ward of the London borough of Tower Hamlets in September 1993 gave the far right their first seat on a local council since the National Front won two seats in Blackburn, Lancashire, in the local elections of May 1976 (CARF 1993, 9). Although the BNP candidate lost his seat to the Labour Party in the May 1994 local elections, he still managed to come second with 28 per cent of the total votes cast, and the two other BNP candidates in Millwall also each received over 25 per cent of the votes. In the neighbouring London borough of Newham, the BNP received between 24 per cent and 33 per cent of the votes in the five seats they contested in the same local elections (Mann 1994, 22–3). The relevance of the far right is twofold. First, its electoral support is not evenly spread across the country but is restricted to particular geographical localities. In the May 1994 local elections the BNP gained over 10 per cent of the vote in only three seats outside the east London boroughs of Newham and Tower Hamlets. Second, the electoral potential of the BNP is arguably of less importance than the way in which its activities help to create a local climate that encourages racial violence among some white working-class young men who are themselves not members of organised political parties (Husbands 1994). These two points suggest that the significance of these parties in Britain may not be at the level of electoral politics but on localised conditions which relate to racial violence and harassment.

The third political development has been the response from the ethnic minority community and others. Many sections of the ethnic minority community have actively sought to address the problem using different strategies. One reaction has

been for minority representatives to put such pressure as they could on the government to address the issues more effectively, on the police to treat racial violence more seriously than they have to date and on local councils to implement more effectively their housing policies on racial harassment. Another approach has been the formation of local anti-racist groups providing advice and support to those racially attacked or harassed. Such groups established in east London include the Newham Monitoring Project (NMP) and the Greenwich Action Committee Against Racial Attacks (GACARA). The recent period has also seen the establishment of self-defence groups for the first time since the late 1970s, particularly in those localities where the BNP have been active. One such group is Shadwell Community Defence, established to protect local South Asians in Tower Hamlets under threat from racial violence from the BNP in a local council by-election in September 1994 (Virdee 1995a). The concern in some parts of the wider community over racial violence and harassment in east London, coupled with the presence of the BNP there and the belief that it might be the precursor to racial violence elsewhere, also played an important part in the establishment of two national anti-racist organisations in 1991: the Anti-Nazi League (ANL) and the Anti-Racist Alliance (ARA).

The fourth political development has been in continental Europe. Following the collapse of the Stalinist regimes in Eastern Europe and the subsequent reunification of Germany in 1989–90, there have been outbreaks of racial violence in several countries, including Germany itself. Such racial violence, although not always directly attributable, cannot be divorced from the growth of far-right electoral parties in some countries for the first time since the end of the Second World War. It is evident that the far right is now a significant political force in many countries. The last decade has seen the rise of major far right parties in France, Russia, Belgium, Austria and Italy. After the March 1994 general election in Italy, the Fascists in the form of the National Alliance Party led by Gianfranco Fini entered the government as coalition partners with Silvio Berlusconi for the first time since Mussolini was overthrown by the partisans in 1943. Baimbridge et al. (1995, 129) suggest that such 'formal acceptance into national administration has endowed the National Alliance Party with an increased degree of legitimacy', which contributed in part to them gaining 13 per cent of the national vote in the May 1994 European parliamentary elections and increasing their representation in the European Parliament from four seats in 1989 to 11 seats in 1994.

Overview of this chapter

These related developments have contributed to an unprecedented level of public debate about the problem of racial violence and harassment in many parts of Europe (Bjorgo and Witte 1993). In Britain, a wide range of organisations, including the main political parties, the Commission for Racial Equality (CRE) and campaigning organisations such as the Anti-Racist Alliance have discussed possible solutions to the problem. As part of this heated debate about the action needed to combat racial attacks and harassment, there has been much dispute over their precise extent in Britain, with different bodies basing their arguments on different sets of local and

national figures (see the two volumes of the Home Affairs Committee's report on racial attacks and harassment, 1994).

This chapter comprises the following parts. First, it critically reviews official figures on the scale of racial violence and harassment based on police statistics and the British Crime Survey. Both of these national data sets are analysed to see what insights they provide and the difficulties associated with each of them are fully discussed, in particular those relating to reported statistics and 'low level' racial harassment. The chapter then moves on to an analysis of the major findings from the Fourth National Survey of Ethnic Minorities. In addition to ascertaining a measure of the proportion of attacks and property damage that were racially motivated, this survey provides a national measure of the extent of 'low-level' racial harassment. Little is known about the type of ethnic minority person that is most likely to report being racially harassed and the nature of the harassment to which individuals are subjected. This survey addresses these important aspects of the problem by exploring the relationship between harassment and key social and demographic indicators such as areas of residence, social class, tenure, age and gender and establishes what proportion of the ethnic minority population is subjected to repeat victimisation.

Unlike on mainland Europe, where research on racial harassment has concentrated on understanding those factors that motivate people to undertake acts of violence against minorities, in Britain, attention has overwhelmingly concentrated on those who are subjected to such harassment (see Bjorgo and Witte 1993; Witte 1996a, 1996b). This national survey seeks to address this gap within the British research by exploring victim's accounts of the types of people who have undertaken such harassment and goes on to discuss whether such people draw their moral legitimacy from the wider current of racism that exists among parts of the white population.

A subject that has generated some debate has been the relationship between the police and ethnic minorities (see Hall et al. 1978; Smith and Gray 1985; Solomos 1988; Smith 1991; Keith 1993). This survey explores three different aspects of this relationship: the extent to which ethnic minorities report incidents of racial harassment to the police; their rates of satisfaction with the police response, including whether they have confidence in the police to protect them from racial harassment; and the extent to which the police themselves are reported to be involved in acts of racial harassment. This chapter ends on another, often neglected, aspect of the problem – how the lives of Caribbean and South Asian people are affected beyond the actual racial harassment that takes place.

INTERPRETING OFFICIAL DATA SETS

Since 1988, there have been two national data sets which provide information on levels of racial violence and harassment in Britain: police statistics and the British Crime Survey. These are discussed at some length in my earlier analysis of the issue (see Virdee 1995a, 1995b) and only the main points will be summarised here.

Racial incidents reported to the police

The first of the two data sets consists of the statistics of racial incidents reported to the police. These recorded nearly 12,000 racially motivated incidents in 1994–5 compared with 4300 in 1988 – an apparent 175 per cent increase in six years. But the figures need to be treated with caution (see, for example, the discussion in Bottomley and Pease 1993). Criminologists have established that such police statistics do not accurately reflect the scale of offences, including racially motivated offences (Mayhew et al. 1993).

First, a large body of evidence suggests that well over half of all victims of such offences do not report them to the police. For example, the third PSI national survey of ethnic minority groups found that 60 per cent of victims did not report racially motivated incidents (Brown 1984), and the British Crime Surveys (discussed below) show that more than half of both Caribbeans and South Asians did not report such incidents. Part of the explanation is that, although the police definition of a racial incident allows for the recording of 'low level' racial harassment (racial abuse and other types of insulting and nuisance behaviour), recent research suggests that people who have been subjected to such forms of harassment are unlikely to report them to the police because they believe they will not be treated seriously (Virdee 1995a).

An additional limitation, and one to which attention has rarely been paid, concerns the degree to which the police recognise racial motivation in incidents reported to them. The 1992 British Crime Survey found that levels of reporting by Caribbeans and South Asians of racially motivated offences were 34 per cent and 45 per cent respectively (Aye Maung and Mirrlees-Black 1994, 20). This suggests that, of the 130,000 racially motivated crimes against Caribbeans and South Asians, about 54,000 were reported to the police. But the figures recorded by the police for the relevant year of 1991 show only 7882 racial incidents reported. This large discrepancy remains despite the fact that the police definition of racial harassment is broader than that used by the British Crime Surveys, and includes incidents not only of 'low-level' racial harassment but also of racial harassment experienced by whites (Virdee 1995b).

In summary, the evidence suggests that police statistics on racial harassment are inaccurate because more than half of all people who have been subjected to such racial harassment do not report them to the police. Those people who do report racial incidents to the police either are not having them recorded by the police or are not mentioning 'race' as the motivation behind them; possibly such incidents are being recorded by the police as other types of crime. Thus it is not possible to conclude accurately from the police statistics what the scale of the problem is. The sharp rise in the statistics is likely to result from an increase in reporting rates or in recording rates, and should not be interpreted as proof that the level of harassment has been rising.

The British Crime Survey

The second data set consists of the 1988 and 1992 British Crime Surveys (BCS).[1] By covering people's experience of racially motivated crimes, irrespective of whether

they were reported to the police, this victimisation survey gives a more accurate picture of the scale of the problem. The most recent survey estimated that nationally there had been a total of 130,000 racially motivated crimes against South Asians and Caribbeans in 1991. Of these, 89,000 were against South Asians and 41,000 against Caribbeans. This represents 18 per cent of the estimated total of 730,000 crimes against them, which in turn represents just under 5 per cent of the total estimate of almost 17 million incidents of criminal victimisation and threats experienced by the national population in England and Wales in 1991 (Aye Maung and Mirrlees-Black 1994, 13–15). These figures greatly exceed the estimates based on police records. But the surveys show only a slight increase in the number of racially motivated crimes between 1987 and 1991. The conclusion which emerges after detailed analysis of the BCS is that the level of racial harassment has been more stable than the level of racial incidents reported to the police, but also that the number of incidents throughout the period has been far higher than many had realised (Virdee 1995a).

'Low-level' racial harassment

Although the BCS represents an important step forward in providing a more accurate estimate of the scale of the problem than has been provided by the police statistics, it remains only a partial picture. By focusing on a number of selected criminal incidents that ethnic minorities might have experienced and asking whether they were racially motivated, the surveys do not capture all the different forms of harassment, especially 'low-level' racial harassment. This is understandable, since their main purpose is to measure long term trends in crime, but it means that they fail to address an important form of harassment, and cannot therefore provide a fully accurate and comprehensive measure.

'Low-level' racial harassment has been an aspect of the problem that has been greatly neglected when attempting to understand the nature of the phenomenon. It is important to establish the scale of this form of harassment because it holds the key to a more informed understanding of the problem more generally. The more we learn about racial violence and harassment, the clearer it becomes that the publicly reported police statistics represent the visible tip of the iceberg. The 10,000 reported incidents no doubt include the majority of the violent cases. However, the British Crime Survey revealed more than ten times that number of criminal events which appeared to the victims to have been racially motivated. Recent research suggests that there are other, and potentially much more common, forms of racially insulting and threatening behaviour which are not seen as criminal events in themselves (Virdee 1995a; Beishon et al. 1995). This pyramid of violence and harassment may be based on a continuing level of racism in sections of the white population of which harassment is only a symptom.

1 The 1988 BCS comprised a nationally representative 'core' sample of 10,392 households aged 16 or older, and an additional 'booster' sample of 1349 Caribbeans and South Asians to allow a more reliable picture of criminal victimisation against them (Mayhew, Elliot and Dowds 1989, 6). The 1992 BCS comprised a nationally representative 'core' sample of 1654 Caribbeans and South Asians (Mayhew, Aye Maung and Mirrlees-Black 1993, 7).

For the first time in a national survey, PSI's Fourth National Survey of Ethnic Minorities addresses this important gap in the research by providing a measure of the extent of 'low-level' racial harassment to which ethnic minorities have been subjected in the past year. It is important to understand the relationship between these types of racial violence and harassment. Incidents of 'low-level' racial harassment should not be seen just as individual events. When they are linked together as a series, they create a continued climate of insecurity among the victims. As the former minister of state at the Home Office said,

> *people should be concerned about smaller incidents and harassment. Although each incident is not very significant, with repetition they become corrosive, deeply hurtful and destructive. (Hansard, column 438, 10 February 1994)*

Second, the widespread experience of 'low-level' harassment is likely to show that overt hostility is not confined to a handful of white people, affecting only a few members of ethnic minorities. The really serious cases are not just isolated incidents – they may be part of a pattern of hostility in which a significant proportion of the white community resent and possibly confront the minority community as a whole. Relatedly, this underlying level of harassment is serious not only in its own right, but possibly as a potential breeding ground for future violence.

When discussing results from this survey, it should be noted that the BCS data sets are not directly comparable with the PSI national survey; the BCS provides a measure of the extent of crime using the number of incidents as the key indicator, whereas the fourth national survey as shown above uses the indicator of prevalence, that is, the number of people that are subjected to harassment.

THE PREVALENCE OF CRIME VICTIMISATION AGAINST WHITE AND ETHNIC MINORITY GROUPS

Apart from the British Crime Survey, little is known about ethnic minorities' experience as victims of crime, that is, irrespective of whether or not the crime was racially motivated. Both the 1988 and 1992 British Crime Surveys showed that South Asians and Caribbeans were at a greater risk of being victims of crime than whites. Although much of this difference in relation to Caribbeans was explained by social and demographic factors such as age, gender, type of accommodation and area of residence, these factors were not sufficient in explaining the differential rate of victimisation between South Asians and whites, with South Asians remaining at greater risk of certain crimes such as household and vehicle vandalism, robbery and thefts from the person. Hence, Aye Maung and Mirrlees-Black (1994, 8) argued that ethnicity for South Asians 'appear[s] to contribute directly to their higher risks for some crimes' (see also FitzGerald and Hale 1996).

In this survey, both the white and ethnic minority samples were asked whether anyone had physically attacked them in the last 12 months. The question covered any kind of attack, irrespective of the motive. As shown by Table 8.1, there was little

major difference in the extent of physical attacks to which whites and South Asians were subjected in the previous 12 months. Three per cent of whites, and a similar proportion of South Asians said that they had been attacked. However, a higher proportion of Caribbeans and a lower proportion of Chinese reported being attacked. The survey also found that a significantly lower proportion of both white and ethnic minority women than men said they were attacked.

Table 8.1 People who were physically attacked in the last 12 months, by gender

cell percentages

	White	Caribbean	Indian	African Asian	Pakistani	Bangla-deshi	Chinese	All ethnic minorities
Male	5	6	3	4	5	3	1	4
Female	2	4	1	1	2	2	1	2
Total	3	5	2	2	4	3	1	3
Weighted count	*2867*	*1567*	*1292*	*799*	*862*	*285*	*391*	*5196*
Unweighted count	*2867*	*1205*	*1273*	*728*	*1185*	*591*	*214*	*5196*

Respondents were also asked whether anyone had deliberately damaged any of their property in the last 12 months – again, without reference to the motive. Table 8.2 shows that, apart from the Bangladeshis, about one in seven of whites and ethnic minorities said they were subjected to deliberate property damage in the period. However, the Bangladeshis were only half as likely to have suffered deliberate property damage. Again, a higher proportion of the victims were men.

Table 8.2 People who had property damaged in the last 12 months, by gender

cell percentages

	White	Caribbean	Indian	African Asian	Pakistani	Bangla-deshi	Chinese	All ethnic minorities
Male	16	18	15	15	16	8	14	15
Female	14	12	10	12	11	7	11	11
Total	15	14	13	13	13	7	12	13
Weighted count	*2867*	*1567*	*1292*	*799*	*862*	*285*	*391*	*5196*
Unweighted count	*2867*	*1205*	*1273*	*728*	*1185*	*591*	*214*	*5196*

THE PREVALENCE OF RACIAL VIOLENCE AND HARASSMENT

Those members of ethnic minorities who said they had been physically attacked or had had property damaged were asked whether they thought this had taken place owing to reasons to do with 'race' or colour. To ascertain a measure of the extent of 'low-level' racial harassment, respondents were asked whether anyone had insulted

them for reasons to do with 'race' or colour in the same period. By insulted, it was meant verbally abused, threatened or been a nuisance to them. The overall measure of harassment consisted of physical attacks if they were racially motivated, damage to property if it was racially motivated and racial insults.

As shown by Table 8.3, 13 per cent of the ethnic minority sample had been subjected to some form of racial harassment in the last 12 months. A significantly higher proportion of Caribbeans, African Asians, Pakistanis and Chinese reported being subjected to some form of racial harassment than Indians and Bangladeshis.

Table 8.3 **People who were subjected to some form of racial harassment in the last 12 months**

							cell percentages
	Caribbean	Indian	African Asian	Pakistani	Bangladeshi	Chinese	All ethnic minorities
Racially attacked	1	1	1	1	1	0	1
Racially motivated property damage	2	2	3	3	1	1	2
Racially insulted	14	9	12	11	8	16	12
Any form of racial harassment	15	10	14	13	9	16	13
Weighted count	*1567*	*1292*	*799*	*862*	*285*	*391*	*5196*
Unweighted count	*1205*	*1273*	*728*	*1185*	*591*	*214*	*5196*

The ethnic minority group that reported least racial harassment in the period were the Bangladeshis. This is a surprising finding in the light of the disturbing nature of physical attacks that have taken place in parts of east London, where half the total population of this group resides (Owen 1993). One part of the explanation relates to this survey's attempt to measure not only racial attacks but also 'low-level' racial harassment. This type of harassment may in fact be more prevalent against minority populations who are more geographically dispersed than the Bangladeshis are. The second part of the explanation relates to the media's focus on east London as the centre of the problem. The main reason for this has been the sometimes explicit and often implicit link made by many between racial violence and the far right. It is only in parts of east London that the far right British National Party have made electoral gains. As a result, much attention has been given to the plight of ethnic minorities in this area (Virdee 1995a).

By breaking down the overall measure of the problem of racial harassment into its three constituent parts, it becomes clear that these differences between ethnic minority groups can be explained largely by the variation in the level of racial abuse and insulting behaviour to which these groups are subjected. Table 8.3 shows that 1 per cent of the ethnic minorities said they had been racially attacked in the previous year, with no difference between the Caribbeans and the South Asian groups. Two per cent said they had had their property, usually their home or car, damaged in the same period for reasons to do with their 'race' or colour. However, the form of racial harassment to which ethnic minority groups were most likely to be subjected was racial abuse and other types of insulting behaviour. Twelve per cent reported such

incidents, with a higher proportion of Caribbeans, African Asians, Pakistanis and Chinese reporting racial abuse than Indians or Bangladeshis.

What do such prevalence rates suggest about the scale of the problem faced by ethnic minorities in England and Wales? By extrapolating from the total adult ethnic minority population in England and Wales (nearly 2 million), it is possible to estimate the total number of people who have experienced any of these different forms of racial harassment. Broadly, the results from the survey would suggest that in a 12-month period between 1993 and 1994, there were about 20,000 people who were racially attacked, 40,000 people who had been subjected to racially motivated property damage and 230,000 people who were racially abused or insulted. Overall then, the survey results would suggest that over a quarter of a million people were subjected to some form of racial harassment in a 12-month period. These estimates are approximate, but it is interesting to compare them with the 10,000 incidents reported to the police and the 130,000 identified by the British Crime Survey.

Why racial motivation was suspected

When an incident was thought to be racially motivated in the 1988 and 1992 BCS, the victim was asked to provide reasons why they believed this to be the case. Both South Asians and Caribbeans cited the use of racist language as the major reason why they thought an individual incident was racially motivated. Another major reason cited in almost half the racially motivated episodes against Caribbeans and a third of those against South Asians was that only people who were not white were subjected to such types of incident (Aye Maung and Mirrlees-Black 1994, 16; see also FitzGerald and Hale 1996).

Similar results emerged from this survey. When asked to explain why they thought the most serious incident was racially motivated, the major reason cited by those who had been attacked was that it had been accompanied with some racial abuse. Similarly, one third of those who reported racially motivated property damage believed it to be racial because it had been accompanied with racial abuse. A further third of those subjected to racially motivated property damage believed it was racial because they felt such incidents took place only against people who were non-white, and a quarter said they had 'assumed the incident was racial'. The latter is understandable because, in many cases of property damage, the victim was not present when the home or car was damaged. It was in cases of insulting behaviour that racial motivation was easiest to establish because the abuse was always 'racial' in nature.

An important methodological question which arises from the preceding discussion is whether research can really provide a precise measure of the 'true' scale of the problem. The data would seem to suggest that in the absence of an account from the perpetrator, researchers are unlikely to achieve a completely accurate measure of the problem for the following reasons. First, racial motivation is likely to be more evident in some types of harassment than others: a victim of racial abuse, by definition, will be able to state categorically that the incident was racial in nature. On the other hand, in cases of property damage, the victim is often forced to make a subjective judgement as to whether an incident was racially motivated. This

decision is likely to be influenced by a multitude of factors, each different for every individual. These will include their personal histories and exposure to racism in the recent past, the experience of racial harassment of their family and friends in the area and whether they have suffered similar incidents when 'race' was a clear motivating factor. Conversely, there may be incidents of property damage and attack where the motive was racial but the victim has no reason to believe it was so. Hence, although the results from this survey represent the most accurate measurement of the problem to date, it would seem that it is unlikely that racial harassment can ever be captured with complete statistical precision.

Variations by gender, age, class and tenure

Although it has been well established that ethnic minorities are subjected to racial harassment, there is little research to inform us about the types of ethnic minority people who are most likely to experience the problem. Tables 8.4 and 8.5 from this national survey will provide some useful insights into these issues for the first time. These tables present combined results for the three different types of racial victimisation identified in the survey, collectively referred to as racial harassment. Table 8.4 shows that for all ethnic groups, a higher proportion of men in the survey were racially harassed in the previous 12 months than women.

Table 8.4 **People who were subjected to some form of racial harassment in the last 12 months, by gender**

							cell percentages
	Caribbean	Indian	African Asian	Pakistani	Bangladeshi	Chinese	All ethnic minorities
Male	17	12	16	15	10	19	15
Female	14	8	10	11	7	14	11
Total	**15**	**10**	**14**	**13**	**9**	**16**	**13**
Weighted count	*1567*	*1292*	*799*	*862*	*285*	*391*	*5196*
Unweighted count	*1205*	*1273*	*728*	*1185*	*591*	*214*	*5196*

A clear divide emerged between the prevalence of racial harassment against ethnic minorities aged under 45 and those aged 45 and over: approximately one in seven of the sample of ethnic minority people aged from 16 to 44 years old said they had suffered some form of racial harassment in the last 12 months compared with one in ten of the sample aged over 45. Table 8.5 also shows that the proportion of Caribbeans and African Asians reporting racial harassment did not vary significantly with social class. However, Indian, Pakistani, Bangladeshi and Chinese non-manual workers were between one and a half and two times more likely to report being racially harassed than manual workers from the same minority groups.

Table 8.5 People who were subjected to some form of racial harassment in the last 12 months, by age, social class and housing tenure

cell percentages

	Caribbean	Indian	African Asian	Pakistani	Bangladeshi	Chinese	All ethnic minorities
Age							
16–44	18	11	14	14	11	18	15
45+	15	9	12	9	3	12	9
Total	**15**	**10**	**14**	**13**	**9**	**16**	**13**
Weighted count	*1567*	*1292*	*799*	*862*	*285*	*391*	*5196*
Unweighted count	*1205*	*1273*	*728*	*1185*	*591*	*214*	*5196*
Social class[1]							
Non-manual	15	11	14	16	13	18	14
Manual	17	8	13	11	7	10	12
Total	**15**	**10**	**14**	**13**	**9**	**16**	**13**
Weighted count	*1402*	*1133*	*723*	*618*	*191*	*334*	*4402*
Unweighted count	*1057*	*1122*	*650*	*856*	*406*	*187*	*4278*
Housing tenure							
Owner-occupied	16	8	13	12	10	16	12
Council rented	17	18	15	19	7	16	16
Total	**15**	**10**	**14**	**13**	**9**	**16**	**13**
Weighted count	*1373*	*1187*	*719*	*776*	*247*	*307*	*4611*
Unweighted count	*1060*	*1159*	*641*	*1057*	*515*	*173*	*4605*

1 Social class calculated on basis of head of household.

The extent of racial harassment in local authority housing has been the subject of much debate and concern in policy circles (FitzGerald and Ellis 1989). Guidelines about how best to deal with the phenomenon have been issued by central government departments as well as by local authorities (CRE 1987; Department of the Environment 1989; Love and Kirby 1994; Dhooge and Barelli 1996). Caribbeans, African Asians and Chinese were subjected to similar levels of racial harassment in the previous 12 months in both owner-occupied and council-rented accommodation, whereas Indians and Pakistanis living in council rented accommodation were one and a half times as likely to be racially harassed as Indian and Pakistani owner-occupiers. A smaller proportion of Bangladeshis living in council property reported being subjected to racial harassment in the past year than Bangladeshis living in owner-occupied accommodation.

Table 8.5 highlights what appears to be a contradictory finding: that Indians and Pakistanis in the non-manual occupations were more likely to be racially harassed than Indians and Pakistanis working in manual jobs, while at the same time, Indian and Pakistani owner-occupiers were less likely to be racially harassed than Indian and Pakistani tenants. However, further analysis revealed that both these relationships work independently of each other, so that non-manual workers experience more racial harassment, irrespective of the type of accommodation they

live in, and council renters experience more racial harassment than owner-occupiers, irrespective of their social class. As a result, the social group among Indians and Pakistanis that is most likely to report being racially harassed is non-manual workers living in council-rented accommodation. Conversely, the group least likely to report being subjected to racial harassment is manual workers who are also owner-occupiers.

It should be borne in mind that the different ethnic minority groups have very different social class and tenure profiles. Indians, African Asians, Pakistanis and Chinese have much higher rates of owner occupation than Caribbeans or Bangladeshis (see Chapter 6). On the other hand, Indians, African Asians and Chinese are proportionately more likely to be represented in non-manual occupations than Caribbeans, Pakistanis and Bangladeshis (see Chapter 4).

The effect of area on the prevalence of racial harassment

The residential patterns of ethnic minorities show that they are unevenly distributed across Britain. Over half of the ethnic minority population is resident in the South-East (including Greater London) and one in seven are resident in the West Midlands region (Owen 1993). Data from a Department of the Environment study carried out in the late 1980s showed that the problem of racial harassment varied between areas. The study was based upon 200 interviews, with a quota sample of Caribbean, South Asian and white council tenants in each of six selected local authority areas. It found that the racial harassment of South Asian households varied from 10 per cent in one local authority to 28 per cent in another. Similarly, for Caribbean households, the level of racial harassment varied from 4 per cent in one local authority to 22 per cent in another (FitzGerald and Ellis 1989, 53).

This survey found that ethnic minorities living in the South East were one and a half times more likely to be racially harassed than ethnic minorities living in the West Midlands region. The lower proportion of people racially harassed in the West Midlands region was explained almost entirely by the relatively small proportion of Indians and African Asians who were subjected to racial harassment. The four main ethnic minority groups in the West Midlands region are Indians, African Asians, Pakistanis and Caribbeans. It was found that Pakistanis were twice as likely and Caribbeans were almost three times more likely to report racial harassment in the region than Indians and African Asians.

A second method compares the extent of the problem between people living in the main conurbations and elsewhere. The survey found that similar proportions of minorities residing in the inner cities of the country were subjected to racial harassment as those minorities not residing in conurbations. The only important difference to note was in relation to Outer London, where Pakistanis in particular reported being subjected to a relatively high level of racial harassment in the past year.

The notion that high levels of racial violence and harassment are restricted to particular areas of relatively high ethnic minority concentration also needs to be explored. Since most studies have looked at areas of high ethnic density it has been assumed that racial violence and harassment was not a problem in areas of low or

medium ethnic minority concentration. However, some authors have contended that minorities living in low ethnic density areas may be even more at risk (FitzGerald and Ellis 1989) because of their isolation from fellow ethnic minorities as compared with those living in areas of relatively high minority concentration. Some anecdotal evidence is emerging to suggest that levels of racial harassment may indeed be worse in such areas (Jay 1992; Wrench, Brar and Martin 1993; Norwich and Norfolk Racial Equality Council 1994). More recently, Paddy Ashdown, the Liberal Democrat leader, has received much media coverage in his campaign to tackle racial harassment faced by Indian and Turkish restaurant owners in Yeovil, Somerset – an area of low ethnic minority concentration.

Table 8.6 shows that a greater proportion of ethnic minorities living in areas of low ethnic minority density reported being subjected to racial harassment than those living in areas of medium and high ethnic density.[2] This was particularly the case for Caribbeans living in areas of low ethnic density, who were twice as likely to report being racially harassed as those Caribbeans living in areas of medium and high ethnic density. This finding was substantiated by a recent reanalysis of the 1988 and 1992 BCS, which showed that, for all ethnic groups, a higher proportion of offences were seen as racially motivated in non-inner-city areas than in the inner city (FitzGerald and Hale 1996).

Table 8.6　Percentage reporting racial harassment, by density of all ethnic minorities living in their ward

cell percentages

	Caribbean	Indian/ African Asian	Pakistani	Bangladeshi	All ethnic minorities
Less than 5%	21	18	n.a.	n.a.	18
5 – 25%	17	10	15	10	13
25 – 50%	14	11	10	8	12
50% or more	8	10	10	n.a.	9
Weighted count	*1567*	*2091*	*862*	*285*	*5196*
Unweighted count	*1205*	*2001*	*1185*	*591*	*5196*

Repeat victimisation

A qualitative study undertaken by the Home Office in 1992 in an east London estate, showed that two in three ethnic minority families were subject to repeat victimisation. Twenty-three Bengali and Somali families had suffered a total of 136 incidents of racial harassment in a six-month period. The most heavily victimised family was harassed once every nine days on average (Sampson and Phillips 1992, 5–6). Similarly, another study funded by the Home Office, and undertaken in the east London borough of Newham, recorded a total of 724 incidents among the 114

2　The analysis compared the relative importance of the density of all ethnic minorities in the area with the density of the particular ethnic group of which the respondent was a member. The former was a better indicator, which suggests that the ratio of whites to minorities is the key factor.

respondents who had experienced some form of racial harassment in an 18-month period (Saulsbury and Bowling 1991). The types of racial harassment

> *ranged from insulting behaviour and threats to assaults, property damage and arson... There were a very large number of 'less serious' incidents and many 'very serious' ones. Some appeared to be one-off events while others were said to be part of a pattern of repeated attacks and harassment.* (Saulsbury and Bowling 1991, 118)

Before going on to discuss the findings regarding repeat victimisation from this national survey, it is worth pointing out some of the methodological difficulties in accurately capturing cases of repeat victimisation through survey techniques using structured interviews. Hesse et al. (1992) have argued that, although surveys are able to provide firmer evidence on the extent of the problem, they are not capable by themselves of giving a detailed and fully-rounded picture of the nature of racial violence and harassment and its underlying causes. This is because of

> *the incapacity of the crime survey to capture victimisation experiences which are processual, that is regular occurrences; they simply cannot quantify this. The cyclical and multiple features of particular forms of victimisation are therefore not reflected in crime surveys.* (Hesse et al. 1992, 160)

As a result, a survey reduces what is really a pattern of repeat victimisation to apparently isolated acts of racial hostility devoid of any social context or location in time (Hesse et al. 1992; Bowling 1993). This 'events-oriented approach' runs the risk of failing to capture those acts of 'low-level' racial harassment that form part of an integral and on-going process of victimisation, which serves to create a climate of continuous insecurity for the victims (Virdee 1995a). Indeed, in an earlier research study carried out by the author (Virdee 1995a), it became clear that some victims were combining a whole series of events into what appeared at first sight to be a report on a single incident.

Table 8.7 The extent of repeat victimisation faced by those who had been racially harassed in the last 12 months

						column percentages
	Caribbean	Indian	African Asian	Pakistani	Bangladeshi	All ethnic minorities
Number of times racially harassed						
1	40	41	36	42	33[1]	41
2	26	23	13	18	31[1]	21
3	9	13	14	12	8[1]	10
4	7	5	5	5	2[1]	6
5 or more	18	19	32	24	26[1]	22
Weighted count	*241*	*126*	*108*	*110*	*25*	*673*
Unweighted count	*172*	*134*	*91*	*140*	*43*	*614*

1 Cell size (unweighted count) less than 50.

The study showed that three-fifths of the people that had been subjected to racial harassment said they had been victimised more than once in the past year. Furthermore, nearly a quarter of the ethnic minority sample who had been racially harassed were victimised five or more times in the past year. There was some variation in the extent of repeat victimisation when compared across the different ethnic minority groups. Caribbeans and Indians were subjected to less extensive repeat victimisation than African Asians and Pakistanis.

THE PERPETRATORS OF RACIAL VIOLENCE AND HARASSMENT

Apart from the findings of the 1988 and 1992 British Crime Surveys, there is little in the way of systematic national evidence on the type of person that perpetrates acts of racial violence and harassment. The Fourth National Survey will be useful in providing a detailed outline profile of the type of person that engages in this type of activity so that further research on perpetrators themselves can then begin to provide a clearer understanding of the motives of such people.

We asked those who had been racially harassed to describe the people who had been responsible for the most serious incident. It needs to be borne in mind that owing to the relatively small number of respondents who reported being racially attacked or having property damaged, the conclusions drawn about the perpetrators of these especially serious incidents should be treated with some caution and should be seen as being indicative rather than definitive. Moreover, as Table 8.8 shows, only three-quarters of the people who reported being subjected to racially motivated property damage saw the perpetrator; the others could not provide any kind of description.

Table 8.8 The type pf perpetrator involved in the most serious incident of racial harassment

column percentages

		Racial attacks	Racially motivated property damage	Racial insults
Perpetrator seen:	Yes	98	75	99
	No	2	25	1
Of those seen				
Neighbours		7	52	13
Acquaintances		7	5	6
People at work		8	1	16
People in shop		0	0	11
Place of entertainment		12	2	4
Police officers		6	1	3
Other officials		2	0	2
Complete strangers		67	36	62
Others		7	10	6
Weighted count		*57*	*78*	*600*
Unweighted count		*51*	*79*	*529*

It should be noted that because the victims, in some cases, identified more than one type of perpetrator for any single incident, the figures will not always total 100 per cent.

Table 8.8 goes on to show that two-thirds of the people involved in racial attacks were complete strangers. One in eight were identified as either staff or customers in places of entertainment, while a further fifth were identified as people the victim knew before the attack such as neighbours, acquaintances or people at work. Table 8.8 also shows that almost three-fifths of the people engaged in racially motivated property damage were identified as neighbours and acquaintances. This reflects the fact that property damaged was normally the victim's home or car. However, in over a third of these cases of racially motivated property damage, the perpetrator was said to be a complete stranger. The types of people who engaged in racial insults and other types of insulting behaviour were more varied, reflecting a wider range of locations in which such incidents took place. Three-fifths of the people who had been racially abusive were complete strangers. One in five, however, was described as being neighbours or acquaintances and a further one in six were people who were abusive at work.

The combined data from the 1988 and 1992 BCS provides information on the characteristics of offenders in incidents of racially motivated violence and threats only. It found that in three-fifths of all incidents of racial violence and threats against Caribbeans the perpetrator was identified as a complete stranger, whereas for South Asians the comparable figure was two-thirds (Aye Maung and Mirrlees-Black 1994, 17).

Data from the 1988 and 1992 British Crime Surveys also found that three-quarters of South Asian victims were involved in racially motivated incidents of violence and threats where more than one offender was involved, and two-fifths were subject to incidents involving groups of four or more. For Caribbeans the equivalent figures were 50 and 10 per cent respectively (Aye Maung and Mirrlees-Black 1994, 18).

Table 8.9 shows the response of victims in this national survey when they were asked to state how many people were involved in what they believed to be the most serious incident. Racial violence and harassment were often undertaken by groups of individuals. Approximately half of the people who were victims of a racial attack said it had been carried out by more than one person; a fifth of them by groups of more than five people. Over four-fifths of people who said they had suffered from racially motivated property damage in the past year, said it had been carried out by more than one person, while nearly two-fifths said it had been undertaken by more than five people. Over three-fifths of the people who had been racially abused in the past year said there was more than one person involved; one in five by a group of more than five people.

Data from the 1988 and 1992 British Crime Surveys suggest that in more than a third of all cases of racially motivated violence and threat against Caribbeans and in more than half of the cases of racially motivated violence and threats against South Asians, the perpetrator was described by the victim as being aged between 16 and 25 (Aye Maung and Mirrlees-Black 1994, 17).

Table 8.9 also shows that half the perpetrators of racial attacks in our survey were thought to be aged between 20 and 29; a quarter were teenagers and, perhaps surprisingly, a third were identified as being aged over 30. Of those who carried out racially motivated property damage, three-quarters were identified as being

teenagers or younger and a quarter were between 20 and 29. Two-fifths of the people who racially abused members of ethnic minorities were identified as being teenagers or younger; almost two-fifths as being aged between 20 and 29 and a further third as being aged over 30. The data strongly suggest that racial violence and harassment is not undertaken merely by a small proportion of 'anti-social' youth and young adults but also by a small but significant minority of adults over the age of 30.

Table 8.9 Characteristics of perpetrators involved in the most serious incident of racial harassment

column percentages

	Racial attacks	Racially motivated property damage	Racial insults
Number of perpetrators			
1	48	14	37
2 – 4	34	48	45
5 or more	18	38	19
Weighted count	*59*	*64*	*503*
Unweighted count	*54*	*65*	*442*
Age of perpetrators[1]			
Under 13	2	15	9
Teenage	25	60	30
20–29	49	25	37
30+	35	13	34
Weighted count	*59*	*71*	*528*
Unweighted count	*54*	*70*	*459*
Gender of perpetrators			
Male	87	79	66
Female	7	0	12
Both	6	21	22
Weighted count	*59*	*73*	*554*
Unweighted count	*54*	*73*	*486*

1 In some cases of racially motivated property damage and racial abuse which were undertaken by more than one person, the victims have identified perpetrators in different age bands. Consequently, the figures will not always total 100 per cent.

The 1988 and 1992 BCS found that three-quarters of the racially motivated violence and threats against Caribbeans and nine out of ten incidents of racially motivated violence and threats against South Asians were carried out by males (Aye Maung and Mirrlees-Black 1994, 17). We also found that the overwhelming majority of people who were racially attacked in the previously 12 months identified the perpetrator as a male, although one in eight identified them as females or females acting with males (see Table 8.9). Of the people who were subjected to racially motivated property damage in the past year, four-fifths identified the offender as being a male. No one identified solely women being involved in this type of racial harassment, although one in five did identify women acting together with men to

damage property. Two-thirds of those people who had been racially abused were insulted by men acting alone. However, one third stated they had been racially abused by women, either acting alone or alongside men.

The 1988 and 1992 BCS showed that, in the case of Caribbeans being racially attacked or threatened, the perpetrator was normally white. However, in just under a sixth of cases of violence and threats against Caribbeans, the perpetrator was identified as being 'black'. In the case of South Asians, the perpetrator was almost always white (Aye Maung and Mirrlees-Black 1994, 17). Table 8.10 shows clearly that the perpetrators responsible for racial attacks, racially motivated damage to property and racial abuse were almost always white. However, in a small proportion of racial attacks and racial insults, the offender was described as being 'black'.[3]

Table 8.10 **The ethnicity of perpetrators involved in the most serious incident of racial harassment**

			column percentages
	Racial attacks	Racially motivated property damage	Racial insults
Ethnicity of perpetrators			
White	93	92	90
Black	5	1	3
Asian	0	0	1
Chinese	0	0	1
Mixed:			
Mainly white	1	6	4
Mainly black	1	1	1
Mainly Asian	0	0	<1
Weighted count	*59*	*77*	*552*
Unweighted count	*54*	*75*	*485*

The white population and racial prejudice

The preceding section has demonstrated that the people most likely to subject ethnic minorities to racial harassment were young white men, often acting in groups. Attempts have been made to explore those factors that motivate such people to commit such acts of racial harassment. One explanation put forward is that acts of racial harassment represent the most extreme component and expression of the racism faced by Britain's ethnic minorities more generally. It is contended that it is from this much wider and deep-rooted racist culture, present among sections of the white population, that some draw the moral legitimacy they require to act upon these beliefs (Husbands 1994; Virdee 1995a).

This survey investigated to what degree the white population held such racist beliefs. It asked our sample of whites whether they were prejudiced against four

3 In approximately half those cases where the perpetrator of racial harassment was identified as black, the victim was of Caribbean origin.

non-white groups: the Chinese, South Asians, Caribbeans and Muslims. A measure of prejudice against Muslims was sought because the past 15 years have witnessed growing academic interest in the Muslim population (Modood 1992). Some of the more important factors which have served to place this important issue at the forefront of current debate have been the Honeyford Affair in Bradford, the Rushdie Affair and the Gulf War. Among some elements of society, these events (coupled with others external to Britain) have served to create an atmosphere where Islam has been demonised in the public consciousness and a wave of 'Islamophobia' launched.

The findings that are reported upon ought to be interpreted with some caution because of the limitations associated with the question asked: first, the question seeks to capture a measure of racial prejudice in a direct and somewhat crude manner and, second, past research has suggested that these types of questions are likely to provide an underestimate of the scale of racial prejudice among the white population (see Airey 1984).

As shown by Table 8.11, a quarter of whites admitted they were prejudiced against Asians and Muslims compared with 20 per cent who said they were prejudiced against Caribbeans. These findings are consistent with those of the annual British Social Attitudes Survey which, since the early 1980s, has regularly recorded that white people think there is more racial prejudice against South Asians than against Caribbeans. In 1991, 58 per cent of whites thought that there was considerable prejudice against Asians compared with 50 per cent against Caribbeans (Young 1992, 181). The ethnic group that whites were least likely to be prejudiced against were the Chinese (10 per cent). Additionally, the table clearly shows that white men are more likely to be prejudiced against the main ethnic minority groups than white women.

Table 8.11 **White people who said they were racially prejudiced against ethnic minorities, by gender**

cell percentages

	White men	White women	All whites
Asian	28	24	26
Caribbean	23	18	20
Muslim	28	23	25
Chinese	9	8	8
Weighted count	*1276*	*1591*	*2867*
Unweighted count	*1201*	*1666*	*2867*

The data also showed that a smaller proportion of young white people aged between 16 and 34 were prejudiced against Caribbeans than older whites. However, this was not the case with South Asians and Muslims, against whom similar proportions of young whites and older whites were prejudiced. The lower level of reported racial prejudice against the Caribbean population (but not against South Asians) among the young white population may be explained in part by the increasing adoption of a hybrid Caribbean/white identity by sections of the young white population resident

in urban areas and mediated through the cultural forms of popular music and sport (Modood et al. 1994). At the same time, there is research evidence to suggest that this process has been accompanied among parts of the white population by a hardening of racial prejudice against other ethnic minority groups (Back 1993).

The data suggest that a current of racist beliefs is clearly evident among a significant proportion of the white population. It may be that the small minority of mainly young white men who carry out acts of racial harassment have been informed and influenced by this current of opinion to act upon their beliefs. It is a certainly an aspect of the problem that requires further investigation.

REPORTING RACIAL HARASSMENT TO THE POLICE

The BCS suggests that the major factor in whether victims report incidents of crime to the police is the relative seriousness of the offence – irrespective of whether there was any racial element involved. However, three other factors also play an important part in this decision. These include practical considerations of self-interest (often to do with insurance claims). A second is victims' expectations of the part the police will play, and a third is victim–offender relationships.

The 1992 BCS found that, taking all types of crime together, South Asians were more likely to report to the police, whereas Caribbeans and whites reported similar levels. However, when account was taken of the characteristics of offences against each group, it was found that Caribbeans were significantly less likely to report than whites. For South Asians there was no significant difference after type of crime had been taken into account (Skogan 1994, 52–4). When asked why they had not reported a crime, the Caribbeans disproportionately cited fear or dislike of the police.

Caribbeans, but not South Asians, were less likely to report racially motivated crimes to the police than other types of crimes (Aye Maung and Mirrlees-Black 1994, 19). Overall, the BCS found that levels of reporting by Caribbeans and South Asians of racially motivated incidents increased between 1988 and 1992. In the 1988 BCS, 27 per cent of offences against Caribbeans were reported compared with 34 per cent in the 1992 survey; for South Asians it rose from 39 per cent to 45 per cent (Aye Maung and Mirrlees-Black 1994, 20).

This national survey found that just under a quarter of people who had been racially attacked in the previous year said they had reported the incident to the police (16 out of 59 people). South Asians were more likely to report the incident than Caribbeans: two-fifths of South Asians (14 out of 36) but only a tenth of Caribbeans (two out of 23) reported it. However, these findings should be seen as being indicative rather than definitive because of the small numbers involved, and no firm conclusions should be drawn from them. Nevertheless, the limited data do support the findings from the BCS regarding the relative rates of reporting to the police of racially motivated offences by the different ethnic minority groups. People were, however, much more likely to report racially motivated property damage to the police (63 out of 103). Again, South Asians were more likely to report these incidents: fewer than half of Caribbeans (11 out of 23) had reported it compared with two-thirds of all South Asians (49 out of 75). Finally, 8 per cent of people who had

been racially abused in the past year said they had reported the incident to the police (48 out of 608). At first glance, this may appear an unusually high proportion considering the relatively unserious nature of the crime. However, previous research has suggested that individual incidents should in some cases be seen not as isolated acts, but as part of a systematic campaign of harassment against a particular individual or family (Virdee 1995a). Unlike the other two forms of racial harassment covered in this study, broadly similar proportions of Caribbeans and South Asians reported such racial abuse to the police.

The police response to reported racial harassment

The survey found that about half of those respondents who had reported being subjected to some form of racial harassment were dissatisfied with the police response. After detailed investigation of the verbatim transcripts, two broad explanations emerged as to why these individuals felt dissatisfied.

First, the police were perceived to have shown a lack of interest or indifference towards addressing the problem even though the incident constituted a criminal assault. One person who was racially attacked recounted how 'the police did nothing at all. They just asked me to write a letter to Ealing Council.' Similarly, another person was told to 'go and see your solicitor'. One respondent recalled how, when he reported the incident to the police, they 'said I had no proof because there weren't any witnesses'. A fourth respondent stated how the police 'came really late They didn't really want to know.'

The second explanation given by the victims of racial harassment as to why they were dissatisfied with the police response to the reported incident was that they thought the police had acted in a manner which was unreasonable and which they interpreted as being racist or, at best, in implicit sympathy with the actions of the perpetrators. For example, an individual who had been racially attacked recounted what took place when he reported the incident to the police:

> *I think the police only believe white people... I told them who attacked me but the police did not even give a warning to them. The police said that even if they had hit your children we couldn't do anything at all. One police officer who was standing behind the one I was talking to started laughing at me and said to me that 'we'll take you to prison instead'. The incident happened on a weekend and the police also said we cannot do anything at all during the weekend.*

In another incident, the individual recounted how he had pointed out to the police officer the white men that had attacked him. However, the 'police officer did not take any action even though they were swearing in front of the police officer.'

These findings are consistent with past research which has shown that parts of the ethnic minority population have little confidence in the police's ability to tackle the problem of racial violence (Smith and Gray 1985; Brown 1984). PSI's Third National Survey of Ethnic Minorities, carried out in 1982, found that two-thirds of Caribbeans and two-fifths of South Asians did not think that people of Asian and Caribbean origin could rely on the police to protect them from racial violence (Brown 1984, 262).

In order to establish the degree to which perceptions regarding confidence in the police to address the problem of racial harassment may have changed over the past decade, respondents were asked whether they agreed or disagreed with the statement that 'black and Asian people can rely on the police to protect them from racial harassment' (Table 8.12a). The most striking, yet perhaps unsurprising, finding was that 75 per cent of Caribbean respondents disagreed with the above statement. Furthermore, 85 per cent of Caribbeans aged between 16 and 34 thought black and Asian people could not rely on the police to protect them from racial harassment. Only 14 per cent of the total sample of Caribbeans said they agreed with the statement. These findings suggest that there has been a further deepening of the antagonistic relationship between young Caribbean men and the police that has existed since the early 1970s (Hall et al. 1978; CCCS 1982; Smith 1991). However, a finding that has not been noted in past research is that Caribbean women were just as likely to lack confidence in the police as Caribbean men. It shows that almost four-fifths of Caribbean women believe they cannot rely on the police to protect them from racial harassment.

Lack of confidence in the police has also emerged to a smaller but significant degree among South Asians, with over two-fifths reporting they disagreed with the statement (Table 8.12a). As Table 8.12b illustrates, a greater proportion of South Asians aged between 16 and 34 took this view. Over a third of South Asians, however, still retain some confidence in the police to protect them from racial harassment.

Table 8.12a 'Black and Asian people can rely on the police to protect them from racial harassment', by gender

column percentages

	Caribbean			South Asian		
	Men	Women	All	Men	Women	All
Agree/agree strongly	19	11	14	36	34	35
Neither agree nor disagree	5	8	6	13	12	13
Disagree/disagree strongly	72	78	75	44	44	43
Can't say	5	4	4	7	11	9
Weighted count	*355*	*428*	*783*	*785*	*811*	*1595*
Unweighted count	*275*	*339*	*614*	*921*	*940*	*1861*

Table 8.12b 16–34 year old ethnic minorities who believe they can rely on the police to protect black and Asian people from racial harassment

column percentages

	Caribbean	South Asian
Agree/agree strongly	9	33
Neither agree nor disagree	4	11
Disagree/disagree strongly	85	50
Can't say	2	6
Weighted count	*407*	*806*
Unweighted count	*274*	*867*

Racial harassment: the police as perpetrators

A related issue is the assertion made by parts of the ethnic minority community, and confirmed by academic research, that the police, one of the most important agencies responsible for tackling the problem of racial harassment, have also been found to be responsible for actually engaging in it (Smith and Gray 1985; Graef 1989, 117–44; Virdee 1995a, 38–9).

In this survey, three of the 59 people who had been racially attacked and two of the 103 people who reported racially motivated property damage, identified the offender as a police officer. A further 3 per cent of all people who had been racially abused in the past year identified the perpetrators as police officers (21 out of 608). Few of the people who had been subjected to such racial abuse had actually complained to the police. Unlike racial abuse in general (to which South Asians and Caribbeans were subjected in equal proportion), reports of racial abuse from the police came mainly from Caribbeans. This finding needs to be treated cautiously because of the small sample sizes involved, but it does tend to lend strength to the view that there is an antagonistic relationship between Caribbeans and the police (Hall et al. 1978; CCCS 1982; Gilroy 1987; Smith 1991).

About half of the incidents of racial abuse from police officers arose in the course of their duty, while in the other half of the incidents it arose with no pretence that it was in the line of duty. Examples of these incidents, recorded verbatim, are produced below.

Racial abuse from police officers in the course of their duty

Respondent A:

I was stopped in my car because I think they thought it was stolen. They spoke to me in a very rude way calling me racial names.

Respondent B:

An offence was committed by a white person who the police officer arrested. But because I was also there, the officer tried to find out what involvement I had in the event. He referred to me using racist remarks. He was trying to shift the blame off the white person and onto me. He asked the white person something like 'What's the nigger's involvement?' and said that 'All muggers are black'.

Respondent C:

[The police officer] stopped my car, checked it for drugs and called me a 'black bastard'.

Respondent D:

I was involved in an accident and seized by the police while the other driver (who was white) was allowed to go. The police officer kept hold of my wrist. When I asked him to let go, he wouldn't. I was taken to the police station where another officer asked the arresting officer if I had been a problem. The officer replied 'These lot always are', meaning blacks. I was charged.

Respondent E:

> *I was parked on a yellow line with the hazard lights of my car on, waiting to put a new washing machine in the back of the car. The police pulled up and asked me to move. I explained what I was doing and they remarked, 'I don't need explanations like in your country. Here, you do as I say.' They then racially abused me by referring to my turban, the colour of my skin and my beard.*

Respondent F:

> *My friend and I got arrested because we tried to buy cigarettes and got 'lippy' when the man wouldn't serve me. The police came in and got us by the arm and dragged us out of the shop and into the van. We were arguing to the police and saying, 'you lot are racist', and one police officer replied that 'you lot are polluting this country'. They handled me roughly and my arms were cut from the [hand]cuffs.*

Racial abuse from police officers not in the course of their duty

Without further information on the following incident reported by a respondent, it is difficult to judge the context in which this systematic harassment of an ethnic minority family by the police was taking place. Nevertheless, it is an incident which is worth recounting in full.

Respondent G:

> *It's too much to say. Not only have I been visited in the past 12 months but over eight years... [pause as tears begin to flow]. I'll never forget how I was here with my son and his girlfriend having a drink when the police car came up [more tears from the respondent]. They knocked on the door, came into the house and immediately began to search as they always do. Then to add to this, they insulted all of us. It seems as if they pick on me and my family. Every day and every night they are constantly driving up to the house. See outside yourself – there is one parked there. I can't take this anymore.*

The respondent described why he believed this harassment to be racial:

> *I know it has to do with my colour because even my white neighbours say so. The police are wicked. Why don't they go to the homes of the neighbours who are white? No, they pick on us and especially my sons because they have something against this family... because our surname is unusual.*

Respondent H:

> *Two police officers were just driving past me and called me abusive names and comments like 'Paki'.*

Respondent I:

> *I was driving down the road and one [police officer] shouted, 'black bastard', and the other put two fingers up. Both the officers were in a police car.*

Respondent J:

We were walking past a police training centre. A police officer was dressed like the 'Ku Klux Klan' and acted in a threatening manner and tried to intimidate me. The KKK stands for white supremacy. He called me 'black bastard' and mimicked Indian voices.

Respondent K:

I was walking along in the early hours of the morning. A police officer in a car stopped beside me and said 'Where are you going this time of the morning, you black bastard?' and then drove off.

The police as perpetrators of racial harassment: the views of white people

The data from this survey suggest that a significant proportion of white people also agree that the police harass young black and Asian people more than young white people. Figure 8.1 shows that just over a third of whites agreed that the police harass young black people more than young white people. This was especially true among younger whites. Just over a quarter of whites believed the police harass young Asian people more than young white people. Similar proportions of white men and white women believe this. However, it should be noted that, although a significant proportion of white people clearly think that ethnic minorities, and in particular young Caribbeans, are treated worse by the police than young whites, about two-fifths of white people do not believe the police treat people differently because of their ethnicity.

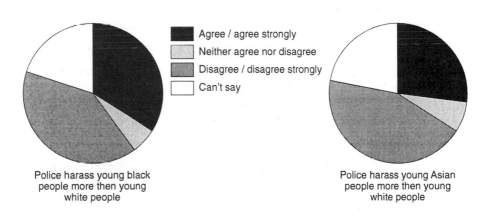

■	Agree / agree strongly
	Neither agree nor disagree
	Disagree / disagree strongly
□	Can't say

Police harass young black people more then young white people

Police harass young Asian people more then young white people

Figure 8.1 **White people who think the police harass young black people more than young white people**

THE EFFECT OF RACIAL HARASSMENT ON PEOPLE'S LIVES

Little is known about what Gordon (1989) has referred to as the 'hidden injuries of racism', that is, how the lives of ethnic minority people are affected beyond the actual harassment to which they are subjected. It is an aspect of the problem that requires attention, as the Home Affairs Committee (1989, viii) noted when it recommended that

> *One priority should be to develop ways to reduce fear among ethnic minorities, since the fear of racially motivated incidents, just as much as racial attacks and harassment themselves, casts a blight on the lives of members of ethnic minority communities in the UK.*

An important distinction to be made about racially motivated crime as against some other forms of crime is that it is often seen as an attack on the community as a whole. If an incident of racial violence results in the murder or serious injury of an ethnic minority individual, its repercussions may often go far beyond the immediate family and friends of the individual concerned. It can serve to create a climate of fear and insecurity among large sections of the non-white community (Virdee 1995a). We do know from recent research that, for all ethnic groups, the emotional impact of racially motivated incidents was markedly greater than it was for offences which were not racially motivated (FitzGerald and Hale 1996).

Figure 8.2 shows that nearly a quarter of the respondents worried about being racially harassed, two-thirds of whom worried a great deal. In the case of African Asians, one third reported worrying about racial harassment. It is worth noting that a greater proportion of the sample reported being worried about racial harassment than had actually experienced it in the past year. This suggests that the impact of having suffered some form of racial harassment at any time in the past, or having

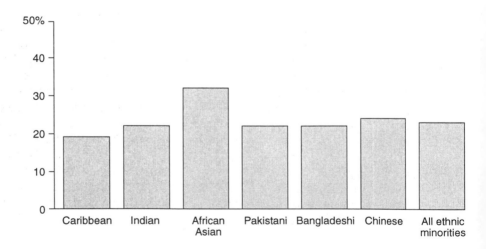

Figure 8.2 Percentage of people who worry about being racially harassed

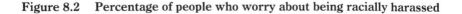

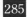

heard about an incident of racial harassment even though it may be unrelated to the respondent themselves, can still have an influence in creating an atmosphere of fear and anxiety.

Another important aspect of the problem of how the lives of people can be constrained by their fear of racial harassment is what measures they take to avoid racial harassment. To explore this, respondents were asked if they had changed their behaviour. Of course, it should be borne in mind, there may well be actions that the respondents take of which they are no longer conscious, but this question still provides us with some measure of the ways in which ethnic minorities have to adapt their lives. One in seven (14 per cent) of the ethnic minority population reported having taken measures in the past two years to avoid being racially harassed.

Table 8.13 Actions taken in the past two years by those who worry about racial harassment

cell percentages

Started to avoid going out at night	58
Made home more secure	54
Started to visit shops at certain times only	35
Stopped children from playing outside	23
Stopped going out without partner	23
Started to avoid areas where mostly white people live	20
Changed travel routes	17
Stopped going to particular pubs	14
Weighted count	*349*
Unweighted count	*320*

Of those respondents who had taken measures to avoid racial harassment in the past two years, over half reported that they had started to avoid going out at night. Disturbingly, over half reported that they had taken measures to make their home more secure. A further third of respondents reported that they had started to visit shops at certain times only. Almost a quarter said they had stopped their children from playing outside. Similarly, a quarter of these respondents said they had also stopped going out without their partner. The wish to avoid racial harassment had also resulted in a fifth of these respondents saying that they had started to avoid areas where mostly white people lived. And just over one in seven of these ethnic minorities also reported saying they had either changed their travel routes or stopped going to particular pubs to avoid being racially harassed (Table 8.13). The data suggest that a significant proportion of the ethnic minority population in the survey worry about being racially harassed. The actions they took to avoid some common everyday scenarios in order to lessen their chances of being racially harassed clearly demonstrate that the problem has a significant impact on the quality of life they are able to lead.

The strategy of self-defence to tackle racial harassment

Although worrying about racial harassment has affected the quality of life that some ethnic minorities can lead, some have sought to tackle it actively. Ethnic minorities in Britain have not been passive victims of racial harassment but have a long history of resisting it (Sivanandan 1982). Given the weakness of the police and other forms of state help to protect them from racial violence, ethnic minorities have sometimes felt the only strategy remaining to them is one of self-defence. This is a strategy based on the view that ethnic minority communities under threat of violence from either the far right or non-affiliated groups of whites intent on racially harassing them have the right to resist such a threat by organising themselves into self-defence groups. The tactic has been used by South Asian and Caribbean communities over many years (Sivanandan 1982; CCCS 1982; Gilroy 1987). It has been the subject of much controversy, with the police disapproving of it because, in their opinion, it involves citizens taking the law into their own hands. A number of high profile cases have gone through the courts in the past 25 years, including those of the Bradford 12 and Newham seven, where the slogan of 'self-defence is no offence' has been tested. Self-defence groups have recently been established for the first time since the late 1970s with groups such as Shadwell Community Defence being set up to protect local Asians under threat from racial violence in east London in 1994 (see Virdee 1995a).

In the third PSI national survey, Brown (1984, 262) found that just over half of South Asians and just over two-fifths of Caribbeans believed that people of South Asian and Caribbean origin should if necessary organise self-defence groups to protect themselves from racial violence. More than a decade on, the tactic of self-defence continues to be strongly supported, with about half of both Caribbeans and South Asians agreeing with the statement that black and Asian people should organise self-defence groups to protect themselves from racial attacks (see Table 8.14). Only Caribbean men were significantly less likely to agree with this strategy. Similarly, it was only slightly more likely to be supported by young Caribbeans and South Asians aged between 16 and 34 than by the groups as a whole. However, it should be stated that nearly a third of Caribbeans and a quarter of South Asians said they disagreed with the tactic of self-defence as a method by which to counter racial attacks.

Table 8.14 'Black and Asian people should organise self-defence groups to protect themselves from racial attacks'

		column percentages
	Caribbean	South Asian
Agree/agree strongly	49	52
Neither agree nor disagree	11	14
Disagree/disagree strongly	31	24
Can't say	9	9
Weighted count	*783*	*1595*
Unweighted count	*614*	*1861*

CONCLUSIONS

Although racial violence and harassment is a phenomenon that has existed within Britain since at least the end of the First World War (Fryer 1984), the problem arrived on the public policy agenda only in the early 1980s. It led to a demand among policy makers for accurate statistics on the scale of the problem. It was argued that it needed to be reliably quantified to ensure that appropriate resources and measures could be introduced towards tackling it effectively. However, it was not until 1988 that reliable national statistics, in the form of the British Crime Survey, first emerged.

'Low-level' racial harassment has been an aspect of the problem that has been greatly neglected when attempting to understand the nature of the phenomenon. It is important to establish the scale of this form of racial harassment because it holds the key to a more informed understanding of the phenomenon more generally. The more we learn about racial violence and harassment, the clearer it becomes that the publicly reported police statistics represent the visible tip of the iceberg. Recent research suggests that there are other, and potentially much wider spread, forms of racially insulting and threatening behaviour which are not seen as criminal events in themselves (Virdee 1995a; Beishon et al. 1995). This pyramid of violence and harassment is probably based on a continuing level of racism in sections of the white population of which harassment is only a symptom. For the first time in a national survey, PSI's Fourth Survey of Ethnic Minorities addressed this important gap in the research by providing a measure of the extent of 'low-level' racial harassment to which ethnic minorities have been subjected in one year.

Racial harassment has, however, to be seen in the context of the experience of crime more generally. This survey found that there was considerable diversity among the various ethnic groups and their experience of crime. Similar proportions of whites and South Asians reported being attacked, whereas a significantly higher proportion of Caribbeans and a significantly lower proportion of Chinese were subjected to physical attacks. When it came to reported property damage, the survey found that, apart from Bangladeshis, about one in seven of all ethnic groups (including whites) reported having had property damaged in the previous 12 months. The Bangladeshis were only half as likely as the rest of the sample to report property damage.

This survey showed clearly that within this experience of crime the prevalence of racial harassment was widespread. A total of 13 per cent of the total ethnic minority sample reported being subjected to some form of racial harassment in the past year. There was some variation in the overall extent of racial harassment to which the different ethnic minority groups were subjected. A significantly higher proportion of Caribbeans, African Asians, Pakistanis and Chinese reported being subjected to some form of racial harassment than Indians and Bangladeshis, but this difference refers only to the reports of racial abuse and insulting behaviour and not racial attacks and racially motivated property damage. One per cent of the total sample of ethnic minorities in the national survey said they had been racially attacked in the previous year and 2 per cent said they had had their property

damaged for reasons to do with their 'race' or colour. Twelve per cent, however, reported they had been racially abused or insulted in the previous 12 months.

By extrapolating from the total adult ethnic minority population in England and Wales (nearly 2 million), it is possible to estimate the total number of people who have experienced any of these different forms of racial harassment. The results from the survey would suggest that, in a 12-month period, there were about 20,000 people who were racially attacked, 40,000 people who had been subjected to racially motivated damage to property and 230,000 people who were racially abused or insulted. Overall, the survey results would suggest that more than a quarter of a million people were subjected to some form of racial harassment in a 12-month period.

In addition to providing a quantification of the problem, the survey shed some light on the type of person that was most likely to report being subjected to racial harassment. Although the data suggest that it is not wise to construct a profile of a 'typical' victim, men under the age of 45 seem to be most vulnerable. Repeat victimisation was a problem for well over half of all people who were racially harassed in the previous 12 months. Indeed, nearly a quarter of those who had been racially harassed were victimised five or more times – 3 per cent of all members of the sample, representing about 60,000 people. These findings suggest that further work needs to be undertaken to understand why particular individuals from ethnic minorities are subjected to such harassment.

This national survey also provided valuable insights into another aspect of the problem, that is, those who undertake harassment. Most of the findings from this part of the survey confirmed what many have suspected from anecdotal evidence: about three-fifths of people that had been racially attacked or abused said the perpetrator was a complete stranger, whereas in those cases where people had been subjected to racially motivated property damage the perpetrator was most likely to be a neighbour or acquaintance. A disturbing finding to emerge was the degree of racial harassment that took place at work: one in six people who were racially abused said it had taken place at work. The data also strongly suggest that racial violence and harassment is not undertaken merely by a proportion of 'anti-social' young men, but also a by small but significant minority of adults over the age of 30.

South Asians were more likely to report racially motivated attacks and damage to property to the police than Caribbeans. On the other hand, similar proportions of Caribbeans and South Asians reported being racially abused to the police. About half of those respondents who had reported being subjected to some form of racial harassment were dissatisfied with the police response. After detailed investigation of the verbatim transcripts, two broad explanations emerged as to why these individuals felt dissatisfied with the police response. First, the police were perceived to have shown a lack of interest or indifference towards addressing the problem even though the incident constituted a criminal assault, and, secondly, the police response was interpreted as being racist or in implicit sympathy with the actions of the perpetrators.

No doubt in part informed by such negative contact with the police on this problem, this survey showed clearly that there has been a further strengthening of the historically antagonistic relationship between Caribbeans and the police. The

study showed that three-quarters of Caribbean respondents believed they could not rely on the police to protect them from racial harassment. This lack of confidence in the police being able to protect ethnic minorities from racial harassment was also expressed by over two-fifths of South Asians.

On an important and related matter, this survey found that the police, rather than being one of the most important agencies responsible for tackling the problem of racial harassment, were sometimes responsible for actually engaging in it. Three of the 59 people who had been racially attacked and two of the 103 people that reported racially motivated property damage identified the offender as a police officer. A further 3 per cent of all people who had been racially abused in the previous year identified the perpetrators as police officers (21 out of 608). Few of the people who had been subjected to such racial abuse had actually complained to the police. Unlike racial abuse in general, reports of racial abuse from the police came mainly from Caribbeans.

A significant proportion of the ethnic minority population in the survey worried about being racially harassed. The actions taken by them to avoid some common everyday scenarios in order to lessen their chances of being racially harassed clearly demonstrate that the problem has a significant impact on the quality of life they are able to lead.

Culture and Identity

Tariq Modood

INTRODUCTION

Out of an immigration process which was conceived primarily as the importing of labour to take up jobs in the British economy which white people did not wish to do, there have emerged, for at least some of the migrants and their descendants, new communities capable of and perhaps wanting to maintain themselves as communities. New cultural practices, especially to do with the family and religion, have become a feature of the British landscape; skin colour, identities, place of origin or cultural community continue to shape the personal lives and relationships of even British-born individuals. The importance of cultural and ethnic differences, however, runs much deeper. Ethnic identity, like gender and sexuality, has become politicised and for some people has become a primary focus of their politics (Young 1990). There is an ethnic assertiveness, arising out of the feelings of not being respected or of lacking access to public space, consisting of counterposing 'positive' images against traditional or dominant stereotypes. It is a politics of projecting identities in order to challenge existing power relations; of seeking not just toleration for ethnic difference but also public acknowledgement, resources and representation. Moreover, these identities are of different sorts, and not stable.

For some time ethnic minority identities were studied by two rival, indeed hostile, approaches. The older approach derived from anthropology and emphasised differences between what were sometimes regarded as discrete cultures, usually studied in terms of their own internal logic and traditions, and worried about an 'identity clash' for those of Asian and Caribbean descent but born and brought up in Britain, who were supposed to be 'between two cultures' (Watson 1977). Partly in reaction to this form of anthropology, a post-Marxian approach was developed which understood the formation of 'blackness' in terms of societal racism, cultural oppression and anti-racist struggles (CCSS 1982). More recently, new perspectives have been sketched. Stuart Hall has argued that from the mid- to late 1980s 'a significant shift has been going on (and is still going on) in black cultural politics' (Hall 1988, 27). Not only does this entail a recognition of a diversity of minority identities but also an understanding that ethnic identities are not 'pure' or static. Rather, they change in new circumstances or by sharing social space with other heritages and influences.[1] Moreover, this also challenges existing conceptions of Britishness (Gilroy 1987). For, if ethnic minority identities are not simply products of cultures of extra-British origin, but owe something to the stream of British life,

1 For recent debates and attempted reconciliations between some of these points of view, see Benson 1996, Eade 1996 and Werbner 1996.

then they too contribute to that stream, and so their existence belies the dichotomy of 'essentially black' and 'essentially British'. In the same period of time there has also emerged an 'Asian' identity based on a hybridic Asianness, rather than a regional, national, caste or religious identity derived from one's parents, and sometimes directly influenced by or modelled on forms of 'black pride' and black hip-hop or rap music (Baumann 1990). Additionally, and more recently, there has been an increase in Muslim activism and consciousness, giving rise to intense debate about identity and the emergence of new magazines such as *Q-News* which emphasise a British Muslimness and reject ethnicity as un-Islamic (Modood 1994).

This section of the Fourth Survey was developed through a preliminary study that has been published separately as *Changing Ethnic Identities* (Modood, Beishon and Virdee 1994). We were there able to discuss topics in greater depth than is possible in a national, omnibus survey, and this chapter should be read together with the previous publication. Even so, further important caveats have to be entered here. Ethnic minority individuals have of course numerous non-ethnic identities based on occupation, neighbourhood, consumption, leisure and so on, but we do not here look at ethnicity as relative to other dimensions of personal and social identity. Nor is this the place to study the processes of racialisation, or even all the sources of ethnic identity (for example, at the contribution of Rastafarianism to black identification with Africa, or at the impact of the Rushdie Affair on Muslim identity today). The purpose of this innovative chapter is much more modest. What is offered is a quantitative discussion of some of the components of ethnic identity, how they vary between and within ethnic groups, and how they may be changing, especially across generations. The aspects of culture and minority identity that were surveyed were self-description, religion, language, visits to country of origin, marriage, choice of schools, clothes and identification with Britishness. The concluding discussion suggests that, while the groups studied here differ in many respects, a new form of ethnic identity does seem to have emerged.

DESCRIBING ONESELF

How do ethnic minority people think of themselves? How salient is their ethnic background in their conception of themselves; and what is the relative importance of different components of ethnicity – 'racial' grouping, skin-colour, extra-British origins, religion – in the self-image of ethnic minority persons?

These matters are of course highly complex and not at all easy for a survey of this kind to elicit data on. For a start, it is obvious that they are matters to which people may not have given much explicit thought or have a limited degree of self-consciousness about, and so their answers may be of a poor quality or may require a length of interview time not available in a survey covering so many different topics. Moreover, they are matters which are highly context-dependent. Some things may be much more salient in some contexts than others; indeed, the topic may make sense only when a context is chosen for purposes of illustration and yet will influence the answers elicited.

We decided therefore to create a question which outlined a specific, if rather unusual, situation, but which at the same time was as context-free as possible. Or, more precisely, a situation as independent as possible from social structure, social roles, community life or a pre-existing relationship. We asked interviewees to:

> *suppose you were describing yourself on the phone to a new acquaintance of your own sex from a country you have never been to. Which of these would tell them something important about you...*

The interviewer then read out 12 personal attributes, and the interviewee was asked to say 'yes' or 'no' to each (they could therefore say 'yes' or 'no' to as many as they liked). In this way a non-threatening situation of potential friendship was projected and complications to do with sexual norms and behaviour minimised.[2] While the scenario the question depicts is somewhat unusual, it is meant to approximate to a neutral context, or at least a context where the British social pressures to project a particular identity or group label are not emphasised.

Table 9.1 Elements of self-description

percentages

	Caribbean	Indian	African Asian	Pakistani	Bangladeshi	Chinese
These would tell a new acquaintance something important about me						
Nationality	81	78	69	74	63	77
White, black, Asian etc	76	68	60	56	64	74
Country your family came from	63	67	62	67	76	65
Age	61	57	50	65	57	50
Job	56	57	65	64	54	61
Education	47	49	60	57	53	54
Height	31	30	26	26	26	13
Colour of hair or eyes	30	25	24	26	19	13
Level of income	16	19	17	19	14	6
Father's job	10	14	15	19	7	7
Weighted count	*765*	*606*	*290*	*297*	*141*	*183*
Unweighted count	*580*	*595*	*361*	*538*	*289*	*101*

One important attribute that was deliberately omitted was gender. It was assumed that nearly everybody would in fact regard their sex as something important about themselves, but that as some respondents would assume that the other person (who by definition is of the same sex as the interviewee) would know their sex (at the very least, have a good idea by the sound of their voice over the telephone), nothing useful would be gained by respondents saying 'yes' or 'no' to a gender item in the list of personal attributes. Most people would say 'yes', but if they did not, it would be difficult to interpret the 'no' as important.

2 The question can perhaps be seen as a much shortened adaptation of the psychological Twenty Statements Test (TST), in which the subject, usually an adolescent, is given 12 minutes to respond to the question 'who am I?' on a sheet containing 20 unnumbered blanks, which has been used on British Asian schoolchildren (Hutnik 1991).

Table 9.2 Religion and colour in self-description

percentages

	Caribbean	Indian	African Asian	Pakistani	Bangladeshi	Chinese
These would tell a new acquaintance something important about me						
Religion	44	73	68	83	75	25
Skin colour	61	37	29	31	21	15
Weighted count	*765*	*606*	*290*	*397*	*141*	*183*
Unweighted count	*580*	*595*	*361*	*538*	*289*	*101*

The answers suggest that their ethnicity is of considerable importance to minority persons in their self-descriptions. Most of the ethnicity items in fact received the most number of 'yes' by each of the minority groups. With ten of the 12 items, there is a common pattern in the frequency of positive answers which can be banded into four, as in Table 9.1. Nationality, 'broad ethnicity' and country of family origins were almost uniformly the items thought most important to mention about themselves to a new acquaintance in an unknown country; two-thirds or more of respondents from each ethnic group chose these items, except that fewer Pakistanis would mention their broad ethnicity, and fewer Chinese would mention the country their family came from. Roughly about half in each group would mention their age, job and education; less than a third would mention their height or the colour of their hair or eyes; and less than a fifth would mention their level of income or their father's job. This leaves two items on which there was a division in the responses of ethnic groups. The two items are religion and skin colour, responses to which are to be found in Table 9.2. In each case there is a three-way pattern. While well over two-thirds of the South Asians would mention religion, making it their first or second most mentioned item, less than half of Caribbeans would do so, and only a quarter of the Chinese. Six out of ten Caribbeans would, however, mention their skin colour, while about a third or less of the South Asian groups would do so, and few Chinese would.

Bearing in mind that the context is of personal information to someone from another country who does not know what you look like, it is perhaps not surprising that nationality received the primacy that it did. Nevertheless, it is still of some interest that it should do so, as in our development work we found some evidence of a reluctance among British Caribbeans and British Asians in calling themselves 'British' in a British context but finding it easier to do so when abroad (Modood et al. 1994). Nor is it surprising that the level of one's income or one's father's occupation should not be thought as likely for inclusion in the hypothetical telephone conversation. It is, however, of some importance that two-thirds or more of interviewees thought their ethnic and family origins as important things to mention about themselves in such a conversation, more important than their job or education, or even their age – surely an important basis of relating to persons and forming friendships. In all groups, however, those in higher occupational classes mentioned their job more often than any other item.

Perhaps the most significant finding was the primacy of religion in self-description in personal contexts for South Asians, in contrast to skin colour which

was of little more significance than height. On the other hand, skin colour was of considerable importance to the Caribbeans. These findings are strengthened by responses to the question as to which two of the 12 features were most important. Nationality continued to be stressed, but in the case of South Asians religion was held to be equally or more important, while relatively few Caribbeans (12 per cent) chose it as among the most important and hardly any Chinese at all. Similarly, skin colour emerges as the third most important item for the Caribbeans but insignificant for the Asians.

Respondents were also asked how 'a white person who knew and liked you would describe you to another white person'. The difference from self-description was not great. The item which was most affected was skin colour, which for South Asians moved from 30 per cent to 45 per cent; even so, only 10 per cent of South Asians thought it was one of the two most important items likely to be mentioned about them. As in the self-descriptions, religion continued to be the most highlighted item for South Asians, except for African Asians, for whom job continued to enjoy primacy.

Asians thinking of themselves as 'black'

From the 1960s onwards many anti-racists and sociologists have argued that, as racial discrimination was a commonly experienced problem by those whom white people thought of as 'coloured' or 'black', analysis and anti-racist action would be enhanced if all potential victims of white racism were to be described primarily as 'black'. Some analysts acknowledged that not all of the victims, especially among South Asians, would go along with their suggestion (e.g., Sarre 1989, 127; Abbot and Wallace 1990, 35), a few protested that the suggestion was a form of political coercion not worthy of anti-racism (Banton, 1976; Hazareesingh 1986; Modood 1988, 1994), but most expressed confidence that enough people would be persuaded by their point of view. The only test of South Asian opinion has been a telephone poll on a BBC South Asian television programme, *Network East*, in March 1989. After opposing points of view were put, viewers were invited to telephone; nearly two-thirds of the more than 3000 who rang in rejected the term 'black' for Asians. It has been suggested, however, that the majority of Asians do think of themselves as 'black', but this cannot be elicited in questioning which is insensitive to the fact that this is an identity which comes alive only in some contexts and not in others, that it is a 'situational identity' (Drury 1990). Others have suggested that it is a political identity forged by working class Asians through anti-racist and class struggle (Sivanandan 1985), or more found among younger Asians (Rex 1994, 15), and that the opposition to the self-label 'black' is from middle-class Asians (Ratcliffe, 1994, 120) or, alternatively, from Muslims (Husband 1994, 11).

In our development work we found even less use of 'black' by South Asians than in the *Network East* poll, even though it was prevalent among Caribbeans in the same localities. It was found that the Punjabi Indians, especially the young and British-born, were more likely than other Asians to argue, sometimes passionately, for political 'blackness' as the basis of anti-racist unity among the victims of racism and to prevent a divisive emphasis on separate cultural identities (Modood et al.

1994, 95). We decided to survey South Asian and Chinese opinion on this topic by asking them: 'Do you ever think of yourself as being black?' The answers, as presented in Table 9.3, show that about a fifth of South Asians answered 'yes' (only one Chinese person out of 118 so answered). As can be seen, there was only slight variation between South Asian groups: Indians were slightly more likely, Bangladeshis least likely to respond in the affirmative. Some other variations are worth mentioning too. Contrary to the expectations created by our developmental fieldwork, 16–34-year-olds, as well as the over fifties were slightly less likely to consider themselves black, as were women. The unemployed were less likely than the employed, but differences between occupational classes were negligible. Those without qualifications were more likely than those with qualifications, and migrants, especially those of more than 25 years residence, were more likely than the British-born to identify themselves as black. Those resident in wards of high minority density were a little less likely to think of themselves as black than those in wards with lower concentrations of ethnic minorities. The biggest variations were regional. About a third of South Asians in the West Midlands and the North West identified with 'black', while less than half this proportion in the South East and even less in London.

Table 9.3 'Black' as an element of self-conception of South Asians

	Indian	African Asian	Pakistani	*column percentages* Bangladeshi
Do you ever think of yourself as being black?				
Yes	26	21	23	18
No	68	75	68	74
Can't say	6	4	9	8
Weighted count	*497*	*337*	*334*	*120*
Unweighted count	*493*	*310*	*450*	*252*

It has been mentioned that it has been argued that blackness for Asians is a situational identity. We wanted to test this idea and identify the kinds of situation in which this identity becomes prominent for South Asians. The interviewer asked 'On what occasions do you think of yourself as black?' and was instructed to probe fully and record verbatim. The answers, sorted into a number of categories, are presented in Table 9.4. A few respondents gave answers that had too little support from other respondents and are not included, and some respondents gave an answer with more than one aspect, in which case each aspect has been included. Other respondents gave a 'don't know'. The answers in Table 9.4 do not therefore add up to the total number of affirmative responses. One of the most frequent responses was 'all/most of the time'; another was 'because I am black'; and a third one was a combination of these two. We have therefore taken these three answers together, for they each represent the same total acceptance of a black identity. As such they represent the most common response. Others said they thought themselves black because they were Asian or when they were participating in events to do with their cultural background. While the first is not situational and the latter is, we have combined

these two types of answer because in practice they were sometimes difficult to separate, as in the following example:

> *I know I am Asian and Indian all the time because I always wear saris and whenever I go out to the shops or I'm in public I know I look different because of my clothes and culture.*

This quotation also illustrates a third category: those who felt 'black' when in public places where there are many white people. This category of answer was as common as references to applying for jobs or one's work. One other situation that was of some importance was where respondents were being racially harassed or suspected that they were being given the cold shoulder because of their race. A significant number also explained their idea of blackness by reference to not being white, and some referred to how they were labelled by others and to discussions about 'race' with friends and family.

Table 9.4 South Asians: 'On what occasions do you think of yourself as black?'

1	*'All the time. I am black.'* Further example: *'All the time. I wouldn't class myself as anything else.'*	125
2	*Because I am Asian, or when I am with Asian people, or participate in Asian community events.* Further examples: *'When I'm out with Asian mates.'* *'When I'm put into a position when my culture, creed, is under discussion. All the time.'*	71
3	When in public places where there are many white people.	43
4	When applying for jobs or at work.	43
5	*Because I am not white.* Example: *'I'm never going to be white.'*	34
6	*When I am being racially harassed or suspect prejudice.* Example: *'When a white person swears and calls you a name, then you become conscious of colour.'*	31
7	*'It's what others call us in this country.'* Further example: *'Because English people say you are black.'*	18
8	In a discussion about race relations.	8

Items without quote marks are paraphrases or composite quotes from more than one respondent.

It is interesting that some contexts hardly got mentioned at all. For example, only two persons mentioned looking for accommodation and only one dealing with officialdom, as more might well have done, especially in relation to immigration, permission to stay in Britain and nationality procedures, or the police or other aspects of the criminal justice system. Nor, given that 'black' as an inclusive categorisation was developed to express and build a political solidarity between people of Caribbean and South Asian origin, is there any explicit mention of Caribbeans or of solidarity. Indeed, what is most striking is that the majority of this group of Asians did not refer to situations at all. They answered 'all or most of the time' or gave an extremely common situation ('when in public places'), or they

answered the 'when' question by a 'why' answer. For answers 1, 5, 7 and partly 2, representing about two-thirds of the answers, do not list types of situation; rather they are statements about the respondents themselves or clarify what they mean by 'blackness'. For many, then, blackness, especially for those who gave the most emphatic answers ('all the time'), is not an identity which relates to some but not other contexts, but is perceived to be a fundamental aspect of themselves (at least in Britain). This tallies with our development fieldwork in which we found that while only a minority of Asians thought of themselves as 'black', for those who did this was an important identity, often subsuming all others (Modood et al. 1994, 95).

What was less clear in our development work, is that for some Asian people, not only is 'blackness' compatible with their ethnicity and culture, it is also rooted in their sense of being and/or being treated as Asians, that is to say, as people having a certain physical appearance ('not white') and of being visibly cultural outsiders (wearing a sari, for example). For some Asians identification with blackness is not just a product of the suspicion of discrimination and explicit racial abuse, it is also produced by the experience of being made self-conscious about being *Asian*. This is particularly interesting because it means that even some of those Asians who think of themselves as black do not take the view that skin colour is the attribute of blackness. Rather they think that their cultural attributes are, both in their own eyes and in those of white people, part of their stigmatisation, part of their racial identity. This complex understanding of how some South Asians perceive they are 'racialised' is consistent with the discussion in the employment chapter with what the victims of perceived discrimination said they believed was the ground of the discrimination against them (see Chapter 4, pages 132–3).

An anomaly that emerges from these questions, however, is the discrepancy between the South Asians who thought that white people saw them in terms of skin colour (45 per cent), the South Asians who themselves would include skin colour in self-descriptions (30 per cent), and the South Asians who thought there were sometimes occasions when they thought of themselves as black (22 per cent). In our development work we found that some South Asians referred to themselves and other South Asians as 'brown' (Modood et al., 1994, 94–5, 99). It may be, therefore, that while most Asians do not see their ethnicity in terms of a 'colour', those who do are as likely to think of themselves as 'brown' as much as 'black'.

RELIGION

As we have already seen, religion is central in the self-definition of the majority of South Asian people, and we wished to gather data on religion: whether the respondent had a religion, and, if so, what it was, how important religion was to the way they led their lives, and how often they attended a place of worship. There are some national data on some of these matters but in the case of the larger churches they are collected, otherwise they are simply estimated, by the religious organisations themselves, who often have different methods of counting; or are based on small opinion poll samples. The data are particularly inadequate as regards minority faiths, especially as the estimates vary widely (the Muslim population is estimated

by some to be about a million and by others to be well over 2 million), and there is no question about religion in the census. The Fourth Survey is therefore an important data source for the most basic statistics of religion, as well as for the wider discussion about religion and ethnic minority identities and culture. The significance of this survey as a statistical data source about religious practice is enhanced by the fact that these questions were asked of the full white sample (2867) as well as half the ethnic minority sample; and the questions about having a religion and identifying it were asked of the full ethnic minority sample (5197).

Table 9.5 shows who has a religion. It has been known for some time that a growing number of white people have no religious affiliation. Among our white respondents the figure is 31 per cent, which is a little lower than in some other recent surveys (e.g, Greeley 1992, 56), though by separating out those who were born in Ireland we see that, among that group, those without religion are only half as many as the other whites. In the non-white minority which is Christian, the Caribbeans, the proportion without religion is similar to the whites (though much higher than the Irish-born). In radical contrast, for most South Asian groups it is only 2 per cent, except for Indians for whom it is 5 per cent. More than half of the Chinese, on the other hand, do not have a religion. Not shown in the table is that, in most groups, the young were most likely to say they did not have a religion. The effect was negligible among South Asians, but in some groups there was a large age-effect. For example, half of British-born white 16 to 34-year-olds said they had no religion, compared with a third who mentioned the Church of England. Gender too was a factor, with women more likely to have a religion, this being most pronounced among the Caribbeans, among whom less than two-thirds of men but three-quarters of the women said they had a religion.

Table 9.5 Religion

column percentages

	White (excl. Irish)	Irish	Caribbean	Indian	African Asian	Pakistani	Bangla-deshi	Chinese
None	31	14	28	5	2	2	1	58
Hindu	–	–	1	32	58	–	2	–
Sikh	–	–	–	50	19	–	–	–
Muslim	–	–	1	6	15	96	95	–
Christian	68	85	69	5	3	–	1	23
Other	1	1	3	2	3	2	1	19
Weighted count	*2755*	*110*	*1567*	*1292*	*799*	*862*	*285*	*391*
Unweighted count	*2746*	*119*	*1205*	*1273*	*728*	*1185*	*591*	*214*

Table 9.5 also shows that most ethnic groups are virtually mono-religious, but there are exceptions. The Indians, and especially the African-Asians, are multi-religious. Just over half of the Indians were Sikh and nearly a third Hindus, and there were also Muslims and Christians. Similarly, more than half of the African Asians were Hindus, a fifth were Sikh, almost as many were Muslim, and there were some Christians. About a quarter of the Chinese are Christian (mainly Church of England), and about a fifth are Buddhist, with more than half, as has already been noted, having no religion.

The primacy of religion in South Asian identities is owing at least partly to community relations as much as to personal faith, so it is perhaps not surprising that there is very little if any movement from a religion to 'none' among the younger members of these groups. Among the other groups, the dominant pattern is of a movement from the historic churches to no religion, but there may also be a movement from some Christian denominations to others, and the loss of adherents is much stronger in some churches than others. This can be shown by analysing the answers of white and Caribbean Christians by three generations and by denominations, as in Table 9.6. It will be seen that the steepest decline by age among our respondents was in the old Protestant churches, by which we mean pre-twentieth-century sects such as Presbyterians, Baptists, Methodists and so on. Other denominations were increasing their following, either by holding on to more of their young, or by converting the young and middle-aged, or both. Catholicism, for example, is actually increasing down the generations. This is not just on account of the addition of young Irish migrants, for in fact, while the majority of Irish-born of all ages are Catholic, the proportion of Irish Anglicans and Protestants is highest among the youngest.

Table 9.6 Christian denominations, by age

column percentages

	White				Caribbean			
	All	50+	35–49	16–34	All	50+	35–49	16+34
Church of England	70	72	71	65	30	32	36	25
Roman Catholic	16	12	15	24	16	14	18	18
Old Protestant	10	12	9	7	24	37	22	13
New Protestant	1	1	1	2	25	15	20	37
Other Christian	3	3	3	2	4	2	4	6
Weighted count	*1975*	*889*	*563*	*521*	*543*	*205*	*101*	*235*
Unweighted count	*1993*	*993*	*509*	*489*	*431*	*176*	*88*	*166*

The biggest proportionate generational increase is taking place among the new Protestant churches, by which we mean twentieth century sects such as the Seventh Day Adventists, New Testament Church of God and the Church of God of Prophecy. These have, proportionately, very small followings outside the Caribbean community, and so represent a distinctive black or Caribbean contribution to contemporary Christianity. A quarter of Christian Caribbeans (just over one in eight of all Caribbeans) declared affiliation to these churches, which have increased their share of generations while all other churches (including the Roman Catholic) had declined, with the net result that more than one in three of young Caribbean Christians belonged to them. To put this into perspective, however, one has to note that more than half of the Caribbeans of this generation did not have a religion – second only to the Chinese. Moreover, our finding that more than two-thirds of Caribbean Christians are members of a 'historic' church, principally the Church of England, suggests that some observers have grossly over-estimated the size of the black-led churches at the expense of the 'historic' churches (Howard 1987, 7, 10;

Parsons 1993, 246–7). Nevertheless, it can safely be said that the black-led churches represent one of the few growth-points in Christianity in Britain today.

Our Chinese sample is too small for any detailed analysis but it does seem that Buddhism is not being transmitted across the generations: of the 33 believers aged more than 50, eight were Christian and 25 were Buddhist; but among the 72 believers under the age of 50, 47 were Christian and only 20 Buddhist.

The decline of religious affiliation has as yet hardly affected the South Asians, at least not at the level of nominal identification (though it is worth noting that in 1982, the time of our last survey, only 1 per cent, as opposed to the 5 per cent of Indians in the Fourth Survey said they have no religion (Brown 1984, 24)). The South Asian religious identification is so high that it varies little by factors such as age, gender and class. This survey, however, suggests that the South Asian distribution between the religions may be different to the findings of the last survey. One might have expected, for demographic reasons, the proportion of Muslims in 1994 to be larger than in 1982, but in fact the proportions of Muslims among Indians and African Asians is less and that of Sikhs more than in the last survey, with the net result that Sikhs and Hindus both now represent nearly a quarter each of South Asians, while Muslims account for 40 per cent.

On the importance of religion in their lives there is once again little difference between the South Asian groups (Table 9.7). About nine out of ten Sikhs, Hindus and Muslims said religion was important to the way they led their lives; but while, for Muslims, nearly three-quarters of this group said it was very important, for the Sikhs and Hindus about as many said 'fairly important' as 'very important'. The New Protestants, nearly all of whom are Caribbeans, gave a similar answer to the Muslims. The Roman Catholics and Old Protestants divide roughly into three parts: for one-third religion is not important, for one third it is fairly important, and for one-third it is very important. Caribbean Old Protestants, however, were more likely to give religion importance than white Old Protestants. Indeed, 85 per cent of Caribbean Old Protestants said religion was important to them in comparison with just over six out of ten white peers. Least importance was expressed by white Anglicans, less than half of whom thought religion important to the way they led their lives (this is nearly a quarter of the white population), and for only 11 per cent was it very important. It is interesting, however, that white Anglicans are a category apart, for the non-white Anglicans (predominantly Caribbeans) were more than three times as likely to say that religion was very important than white Anglicans, and half as likely to say that it was not at all important. Indeed, three-quarters of Christian Caribbeans gave importance to religion, which brings them closer to the South Asians than to white Christians, with the New Protestants giving religion more importance than any other faith community.

Not shown in the table is that more than half of all Caribbean Christians in London said religion was very important to how they lived (interestingly, a high 'very important' answer was also given by white Christians in London but was half of the magnitude of the Caribbeans). In fact, the concentration of the new religious minorities in London, the South East and the Midlands may well affect the overall geography of the religion in Britain; it may tilt the balance towards the South East so

that it will not necessarily be the case that 'Britain is a more religious country... the further north and west one travels from London' (Green 1994, 96).[3]

Religion was valued less by the young of nearly every faith except the New Protestants and Hindus: slightly less by the Muslims and Sikhs, much less by the Christians (only half of Catholic and Old Protestant 16–34-year-olds gave it importance, and less than a third of Anglicans), and valued most by those over the age of 50. The most marked generational difference was in the 'very important' response among Sikhs, which declined from two-thirds among the oldest to a third among the youngest, though nearly half of all 16–34-year-old Sikhs also answered 'fairly important'. South Asian, especially Muslim, men were more likely to say 'fairly important' as opposed to 'very important' compared with women; among all Christian churches, too, women were more likely to agree to 'very important' and 'fairly important' except in the New Protestant churches. For all groups the view that religion is very important in how they lead their life declines with the possession of qualifications, except that for Christians it picks up again at the degree level. This suggests, in the light of our findings in Chapter 3 of the increasing proportions of higher qualified among Asians, a possible decline in the importance of religion, especially among Hindus and Sikhs.

Table 9.7 Importance of religion (base: those who have a religion)

column percentages

	Hindu	Sikh	Muslim	Church of England		Roman Catholic		Old Protestant		New Protestant
				White	Others	White	Others	White	Others	Caribbean[1]
How important is religion to the way you live your life?										
Very important	43	46	74	11	37	32	35	32	43	71
Fairly important	46	40	21	35	32	37	38	30	42	24
Not important	11	14	4	53	30	32	27	38	15	5
Weighted count	453	410	677	1379	164	317	89	198	129	138
Unweighted count	419	363	1033	1395	131	317	75	201	102	101

1 The non-Caribbean New Protestants were too few for analysis.

We come then, to the final religious question, the frequency of attendance at places of worship. This is obviously one of the basic measures of adherence, but it is not without its problems as a basis of comparative analysis. The requirements of communal worship vary considerably. For example, while Muslims are enjoined to pray five times a day, alone or with others, Muslim men alone have a duty to join a mosque congregation once a week for Friday afternoon prayers, and even this can be discharged by praying with others at any suitable venue. Muslim women are under no obligation to attend a mosque (not even to wed: the service is usually performed at home or wherever the family is gathered); indeed, some mosques, including some

3 It has been suggested that the North-West is the most religious region in England (and therefore is more like Scotland and Wales than the rest of England), and that this is owing to the higher number of Catholics and Presbyterians in that region relative to Anglicans (Greely 1992). Interestingly, we found the region with the highest proportion of Catholics and Old Protestants who thought religion was very important was the South East.

in Britain, do not allow women to enter, and many make no provision for them (*Q-News*, 20 January 1995). Sikhs, too, may pray at home or in a *gurdwara*, individually or collectively; some homes may have a room set aside for worship, but weekly congregational worship in a *gurdwara* too is considered important for both sexes. Hindu practice is different again. Most homes have their own private shrine and most worship, including in large gatherings, is carried on there; there is no requirement for weekly congregational prayers in a temple, though many Hindus would do so on a regular basis. Within each of these religions, the place of worship may also be a venue for religious instruction and provision of welfare, and may be a general community meeting point as well as the base for specific voluntary groups such as youth clubs. Again, for all groups collective worship has a social function, but this is likely to apply more to minority groups. For example, a recent survey of British Jewry concluded, 'levels of ritual observance are far more closely related to ethnic identity than to strength of belief. For most Jews therefore, religious observance is a means of identifying with the Jewish community rather than an expression of religious faith' (Miller et al. 1996, 10). It has also to be borne in mind that Christian religious services appear on a daily and weekly basis on radio and television (BBC TV's *Songs of Praise* on Sunday evenings has regular ratings of 6.5 million viewers) and that, for many Christians, especially Anglicans, such services have become a substitute for church attendance on at least some occasions. On the other hand, it is probably the case that Christians, especially Anglicans, are more likely to have a church or place of worship of their denomination in their neighbourhood or otherwise conveniently located than non-Christians.

Table 9.8 presents the data on the frequency of attendance at services or prayer meetings or a place of worship. The variations are quite considerable. While fewer than one in ten white Anglicans attends once a week or more, and nearly half go less than once a year, three in ten and six in ten of Caribbean Anglicans and Caribbean New Protestants, respectively, attended at least once a week. The Roman Catholic and Old Protestant patterns are broadly similar to each other, with about 40 per cent attendance at least once a month and around 25 per cent less than once a year, though, among Old Protestants, Caribbeans are more regular church-goers than whites. These denominational differences, in line with the pattern of other religious answers, are based on predictable ethnic differences: 24 per cent of whites, 44 per cent of Irish-born and 53 per cent of Caribbeans attend church once a month or more. The level of church attendance that this represents is higher than that recorded in a British Social Attitudes Survey, which found that 20 per cent of all Christians attended once a month or more, and half never or practically never went (Jowell et al. 1992, 269).

More than half the Hindus and 70 per cent of Sikhs attend once a month or more, and while nearly two-thirds of Muslims attend at least once a week, 15 per cent never attend. As expected from the nature of these different religions, Sikh attendance is much higher than Hindu, and, as revealed in Table 9.9 Muslim attendance is closely related to gender, with most men attending once a week, but fewer than half the women under the age of 50 doing so; nearly a third of women never attended the mosque and/or prayer meetings (despite, as we saw, Muslim women being more inclined than men to think religion very important). The Muslim

responses, especially those of women, have to be interpreted with some
qualification, for it is very likely that they refer to prayer meetings and readings of
the Qur'an (probably in community centres and private homes rather than in
mosques) rather than to mosque services. For while there is some anecdotal
evidence of a recent rise in mosque attendance among young women and women
from professional classes, informal observation suggests that most mosques,
especially those run by South Asians, do not welcome women, and few women visit
mosques at prayer times. So that for example, the response of 'once a week or more'
by 97 per cent of Muslim women in the North-West is wholly counter to experience.
On the other hand, some Muslim women known to the authors have related that
many Muslim women meet on a regular basis to hear recitations of the Qu'ran and
sermons and to pray together. It is therefore most likely that most of the female
responses to our question 'How often do you attend services or prayer meetings or
go to a place of worship?' refer to these kinds of meetings. If this is indeed the case,
it suggests a development with at least two novel elements: the growth of frequent
religious gatherings among Muslim women, and an autonomous movement among
Muslim women outside the mosques.

Table 9.8 Attendance at religious service

column percentages

	Hindu	Sikh	Muslim	Church of England		Roman Catholic		Old Protestant		New Protestant Caribbean
				White	Others	White	Others	White	Others	
How often do you attend services or prayer meetings or go to a place of worship?										
Once a week or more	27	39	62	9	30	29	26	28	25	57
More than once a month but less than once a week	24	32	7	7	13	12	16	11	28	17
More than once a year but less than once a month	29	19	6	38	36	29	30	31	31	15
Less than once a year	18	7	17	45	30	29	21	30	13	9
Can't say	3	2	7	–	–	1	6	1	3	1
Weighted count	453	410	677	1379	164	317	89	198	129	138
Unweighted count	419	363	1033	1395	131	317	75	201	102	101

In all religious groups, the younger generation were less likely to attend a place of
worship: young Christians who went once a week or more were half in proportion to
those in Table 9.8, except for the New Protestants, for whom the drop was about 25
per cent, as it was for the Sikhs and Hindus too. With the notable exception of
Muslims, in most faiths women were more frequent attenders than men, though
there was more or less parity in the Roman Catholic and the black New Protestant
churches. The widest gender gap was among the Caribbeans, with 44 per cent of
women attending church once a week or more compared with 26 per cent of men. In
terms of social class, Christian attendance was highest among classes 1 and 2 and
lowest among 4 and 5, the relative decrease being severest in the Church of
England, with only 4 per cent attending once a week or more in the latter classes.
The pattern for other religions was quite different. Among Hindu combined classes 1
and 2 attendance of once a week or more was particularly low, with Asian attendance

highest among class 4. Similarly, among the three South Asian faiths and the New Protestants, the more qualified were less committed attenders than those with lesser or no qualifications, while with the other Christians the most committed attendance was with the highest qualified. For example, 30 per cent of white Christians with degrees attended church once a week or more. When comparing the relative proportions of those who answered similarly in different faith communities, it is important to remember not just that congregational worship is not of the same importance in different faiths, but that some faith communities already represent extremely shrunken populations compared with those who were (nominally) brought up in that religion. If, therefore, the weekly attendance of whites with degrees seems high, it is perhaps because 57 per cent of whites with degrees had declared they had no religion and are therefore not in the present analysis.

Table 9.9　　Muslim visits to mosque, by sex and age

percentages

	16–34	35–49	50+
Men			
Once a week or more	65	83	78
Never	5	2	5
Women			
Once a week or more	48	46	67
Never	32	29	12
Men			
Weighted count	*175*	*88*	*88*
Unweighted count	*245*	*159*	*140*
Women			
Weighted count	*183*	*88*	*54*
Unweighted count	*272*	*145*	*71*

Church attendance was much higher in some parts of the country than others. Weekly church attendance among all Christian groupings was more common in outer than inner London. Weekly worship among Anglicans was lowest in the West Midlands (6 per cent) and highest in the East Midlands (13 per cent). Though the Catholics in the South East were pre-eminent in saying that religion was very important, they were only two thirds as likely to attend church weekly as Catholics in the West Midlands and North West. Weekly attendance among Old Protestants was highest in the South East, a little lower in the North West and a good deal lower in all other regions. Muslim male weekly attendance was lower in the South East than other areas with significant Muslim populations, and, similarly, Sikh weekly attendance was higher in the West Midlands (45 per cent) than in the South-East (37 per cent).

The proportion of Caribbean people in Christian congregations, however, also varies between different kinds of localities. Sixty per cent of the Caribbean church-goers attend services where half or more of the congregation is black, including 22 per cent where nearly all are black (Table 9.10). While the sample sizes by different churches are relatively small, they suggest that the figures are over 90 per cent in

the New Protestant churches (in which more than half the individuals were in congregations where almost everybody was black), over 60 per cent in the Old Protestant churches, about half in the Church of England and about 40 per cent in the Catholic Church. Interestingly, almost twice as many women (30 per cent) as men (16 per cent) said that at their services almost everybody was black.

Table 9.10 Proportion of black people at a typical church service attended by Caribbeans

Alll or almost all	22
About three-quarters	18
About half	20
About one quarter	18
Hardly any	16
Can't say	5
Weighted count	*524*
Unweighted count	*408*

Religion and British socialisation

Religion is particularly important and worth exploring in relation to British socialisation. For, firstly, it marks a significant dimension of cultural difference between the migrants and British society. Not only did most of the migrants have a different religion to that of the natives, but all the indications are that they, including the Christians among them, were more religious than the society they were joining. Not only was this likely to have been the case at the time of migration and in the early years of settlement but, as we have just seen, it is true today. For example, in respect of not having a religion the Caribbeans are similar to whites, but otherwise they are much closer to the South Asians than to the native whites. Moreover, this is also true of the identifiable group of white migrants in this survey, the Irish-born, thus further highlighting the relation between religion and post-war immigration. Secondly, one of the major social changes that has taken place in Britain during the lifetime of most Asian and Caribbean settlers has been the decline of indigenous religious observance and faith, and so religion among ethnic minorities is an important test case of the effect of British socialisation. Thirdly, generally speaking, most of the cultural practices of migrants usually decline with the length of their stay in the society to which they have migrated. This is usually so with language, dress, arranged marriages and so on. It is also the case with religion, though perhaps descendants of migrants are more likely to keep alive a distinctive religion rather than a distinctive language (this has certainly been the case with the Jewish and Indian diasporas, for example, though perhaps not with the Chinese diaspora). Rather, what makes religion exceptional is that, if not generally, at least in British society, religion is now strongly correlated with age: the older a Briton is, the more religious they are likely to be. Yet, the longer a migrant has been in Britain the greater the likelihood of a decline in their original culture. So, in the particular case of religion, age and length of residence in Britain work against each other.

Is there some simple statistical way of expressing the effect of residence in Britain upon our respondents' valuation of religion? First, one has to identify a particular answer that will stand as representative of 'religion', or a number of answers from which a composite measure can be derived. The answer that is sometimes used for this purpose is attendance at a place of worship. However, given, as has been explained above, that the requirement, meaning and practice of communal worship varies between faiths, we did not think this was a suitable measure for cross-religious analysis. Similarly, a composite measure built up out of constituent parts of doubtful comparative utility would not be appropriate. We decided to use the answers to the question 'How important is religion to the way you live your life?' This question does not measure a strict behavioural practice, or something which has been purchased through some degree of effort and commitment. On the other hand, it is a question which in its generality can be interpreted by members of different faiths in ways appropriate to their own faith. The question may not tell us how much real commitment there may be behind the positive answers, but it is neutral between religions and so enables us to use a common currency.

Table 9.11 **'Religion is very important to how I live my life', by proportion of life spent in UK and by age at entry into UK**

	Caribbean	Indian	African Asian	Pakistani	Bangladeshi	Total
Born in Britain	17	32	24	57	50	27
67–100% in Britain	41	44	28	67	62	41
34–66% in Britain	55	53	49	80	80	56
1–33% in Britain	43	63	66	88	86	64
Entered Britain before 16	39	44	34	69	74	43
Entered Britain after 16	55	57	53	83	81	58
Weighted count	*779*	*637*	*400*	*437*	*145*	*2398*
Unweighted count	*587*	*627*	*373*	*595*	*298*	*2570*

Table 9.11 shows those who said religion is very important to how they live in relation to the proportion of their life spent in Britain, and also, for migrants, by whether they entered Britain before or after the age of 16. While there is not a uniform linear pattern, a very strong pattern is evident regardless of ethnic group: the more a person's life has been in Britain, the less likely they are to say that religion is very important. Moreover, this is not simply because the younger people, including those born here, have spent a greater proportion of their life in Britain. For while, within each band of proportion of time spent in Britain, younger people were less likely than older people to say religion is very important, nevertheless within each age group the answers moved away from 'very important' roughly in proportion to the time spent in Britain. In short, both the age and the length of residence factors were at work. We do not show in Table 9.11 that this pattern holds regardless of age, because for some groups and for some age bands the cell sizes were becoming too small for significance. Instead, we did an analysis by logistic regression to show the

independent effects of age and length of residence in Britain. The results, presented in Table 9.12, show that it is exceptional for these factors not to have an effect (residence in Britain has a very small effect upon Caribbeans). Age has roughly the same effect on all groups but a very big effect on the Chinese. In some cases the age and length of residence effects more or less cancel each other out (Indians and Pakistanis), but in others age has much the greater effect (Caribbeans), and in others length of residence has about twice the effect as age does (Bangladeshis and African Asians). This means that, in the case of the last-mentioned group, the decline in religion through British socialisation is being reversed only partially by age.

Table 9.12 'Religion is very important to how I live my life': results of logistic regression, by age and by length of residence in Britain at entry into UK

	Caribbean	Indian	African Asian	Pakistani	Bangladeshi	Chinese
Age	0.04	0.03	0.03	0.06	0.03	0.10
Years in Britain	-0.01	-0.04	-0.07	-0.05	-0.06	-0.13

These at least are the overall patterns for each ethnic group. We have seen, however, from other material in this section that this overall pattern hides internal variations and contrary trends. Some of these are much better captured in Table 9.11. The decline in the importance of religion takes place in an uneven way, though sometimes there is a particular moment or two of steep decline. For example, for the African Asians the 'British effect' begins early and accelerates to a loss of 21 percentage points between those who have spent between a third to two-thirds of their lives in Britain (say, migrants who came to Britain in their early twenties in 1970), and, say, those who came to Britain about the same time as children, before plateauing off. Yet this pronounced 'British effect' may have been caused by the fact that among South Asian migrants, especially migrant children, African Asians may have been the least religious. For the Bangladeshis the effect manifests itself disproportionately at one point, thus dividing the group into two: those with more and those with less than two thirds of their lives in Britain (the same appears to be the case with the Chinese, but the sample size is too small for generalisation). As nearly all the Bangladeshis with two-thirds of their lives in Britain are under the age of 35, this means the sharpest generational gulf among the South Asians.

These hypothesised generational contrasts are confirmed in Table 9.13, which presents the data by age. It shows that the religious generational divide among African Asians is at the age of 50 and for Bangladeshis and Indians it is at the age of 35. For Pakistanis, too, the divide is at 35, but they seem least to have a divide. Table 9.13 also shows that there are generational contrasts between Caribbeans, mainly because there is no length of residence in Britain effect, so the contrast is very much one of age. Unlike the Caribbeans, in each South Asian group, those who have been in Britain for more than 30 or 35 years are, despite their age, less religious than those settled for slightly shorter lengths, suggesting perhaps that the former were originally not so religious, possibly because religious feelings may have increased among those groups in recent decades. Or, perhaps, when the earlier

South Asian migrants came in the 1950s and early 1960s, the number of co-
religionists, their places of worship and the general religious and community
infrastructure were limited. In either case, the lesser importance of religion for the
longest settled may possibly be explained by when they came and the circumstances
of that time, rather than how long they have been here. So while their case seems
the best example of the residence effect being stronger than the age effect, perhaps
the British effect cannot simply be measured in terms merely of length of residence.

Table 9.13 'Religion is very important to how I live my life', by age

cell percentages

	White	Caribbean	Indian	African Asian	Pakistani	Bangla-deshi	Chinese	All ethnic minorities
All	13	34	47	43	73	76	11	46
16–34	5	18	35	37	67	67	7	35
35–49	13	43	56	40	81	92	8	52
50+	20	57	59	64	83	81	31	62
Weighted count	*2857*	*779*	*637*	*400*	*437*	*145*	*194*	*2592*
Unweighted count	*2857*	*587*	*627*	*373*	*595*	*298*	*109*	*2589*

A further interesting point to note about ethnicity and British socialisation is that the
minority group who in one respect may have most been influenced by majoritarian
social processes may also be indicative, or even at the forefront, of some changes in
the relevant trends. In the proportion of people who do not have a religion, the
Caribbeans are similar to whites. It is also clear from both groups that the proportion
of people without religion is greatest among young people, higher occupational
classes and the higher qualified. It is particularly among these categories that over
the last few decades there has been a massive decline in religious belief and worship,
especially in the Church of England. Yet, our survey also shows that for Christian
denominations, there is a correlation between 'religion is very important to how I
live' and high church attendance and the level of support that a denomination gets
from the younger generation, non-manual classes and the higher qualified. That is to
say, the churches which are growing, or declining most slowly, are those which are
proportionally best represented among these categories of people. This is
particularly true in the black-led New Protestant churches, and, if it marks a new
trend, it is one in which these churches are at the forefront.

LANGUAGE

It will be seen from Table 9.14 that, with the exception of the Caribbeans, nearly all
ethnic minority persons speak a language other than English. Even the Caribbeans
are not fully an exception, for more than a fifth speak in a language other than
English. Table 9.15 shows the use of the six relevant South Asian languages in
Britain, from which it can be seen that, typically, more than one language is
prevalent in each South Asian group, though sometimes the languages in question
are not distinct from each other.

Table 9.14 Persons in Britain who speak and write a non-European language

cell percentages

	Caribbean	Indian	African Asian	Pakistani	Bangladeshi	Chinese
Speak	22	88	92	92	97	77
Write	4	58	60	58	85	64
Weighted count	*784*	*646*	*408*	*442*	*147*	*196*
Unweighted count	*591*	*635*	*378*	*601*	*307*	*110*

Punjabi is easily the most commonly used South Asian language among British Asians, being spoken by a large majority of Indians as well as Pakistanis and a third of the African Asians (Table 9.15). Very few Pakistanis, however, can write in Punjabi (6 per cent only, compared with a third of Indians). While there is little difference between the Punjabi spoken by Indians and Pakistanis, it is written in a script, Gurmukhi, derived from Sanskrit and unfamiliar to Pakistani Punjabis. For Pakistani Punjabis usually also speak Urdu and, rather than developing a Punjabi literary language, have made Urdu, one of the national languages of Pakistan, their own. Urdu in fact is the minority language in which the largest proportion of South Asians in Britain can write. Many older educated Bangladeshis too can understand Urdu (having been taught it before 1971 when Bangladesh was part of Pakistan, or before 1947 when Britain ruled over the whole subcontinent), but most Bangladeshis in Britain, coming as they do from the remote poor rural province of Sylhet, cannot do so. About two-thirds of Bangladeshis speak the broader regional language, Bengali, and about the same proportion speak the provincial dialect, Sylheti. About a third of the Bangladeshi respondents stated they could speak both Bengali and Sylheti, and most Sylheti speakers claimed to be literate in Bengali (for Sylheti does not have a script of its own and is written as a variant of Bengali). The fact that most Sylheti speakers are literate in Bengali and that many have an oral facility in both these languages suggests that they may not always be distinguished from each other. This would perhaps explain why the Black and Minority Ethnic Groups Survey (BMEG) found that only a quarter of its Bangladeshi respondents said they spoke Sylheti and 90 per cent said they spoke Bengali (Rudat 1994, 26).

Hindi and Urdu share a common oral base. This is sometimes called 'Hindustani' and is also understood by some speakers of other Asian languages such as Punjabi (it is thus the medium which enables the Bombay film industry to reach the largest film audience in the world). Hence even those people who would not call themselves Hindi or Urdu speakers can often understand some of these languages. As literary languages, however, Urdu and Hindi are very different. For while Urdu is written in an Arabic script and owes much to Persian, Hindi, especially written Hindi, is derived from Sanskrit. Gujarati is the language of the western Indian province of Gujarat from which the majority of African Asians originate, but a significant proportion (nearly all Sikhs) originate from the Indian Punjab. As a result of these various histories, South Asian linguistic communities are not sharply delineated. In fact nearly a half of South Asians, especially the non-Indians, understand more than one community language.

Table 9.15 Use of South Asian languages

	Indian	African Asian	Pakistani	Bangla-deshi	Hindu	Sikh	Muslim	*cell percentages* All
Hindi								
Speaks	33	44	5	22	53	29	11	27
With younger family	5	3	–		13	4	1	4
Used in interview	8	4	1	–	9	5	2	8
Gujarati								
Speaks	20	67	–	–	70	5	8	25
With younger family	17	44	–	–	54	–	5	18
Used in interview	8	17	–	–	20	–	3	7 ·
Punjabi								
Speaks	62	30	74	4	21	95	52	52
With younger family	43	17	51	1	10	69	34	34 ·
Used in interview	21	4	28	1	3	31	20	17
Urdu								
Speaks	13	18	73	21	9	15	59	31
With younger family	4	3	41	3	1	2	32	14
Used in interview	4	5	32	5	3	3	24	11
Bengali								
Speaks	2	1	–	56	2	–	13	5
With younger family	1	–	–	42	1	–	9	4
Used in interview	–	–	–	20	–	–	4	2
Sylheti								
Speaks	–	1	–	60	–	–	14	5
With younger family	–	–	–	55	–	–	12	5
Used in interview	–	–	–	50	–	–	11	5
Weighted count	*646*	*408*	*442*	*147*	*453*	*410*	*671*	*1654*
Unweighted count	*635*	*378*	*601*	*302*	*419*	*363*	*1026*	*1925*

Having noted the high level of facility, especially among South Asians, in one or more community language, allowing for overlapping languages and membership in more than one minority linguistic community, one has also to note two further features. Firstly, that there is evidence of a process of linguistic decline; secondly, that most South Asians on further inspection in fact belong to only one South Asian linguistic community, which is strongly connected to their ethnic and/or religious community. Both these features emerge when one examines the use of these languages within the family and the languages the respondents used in the interview (Table 9.15). We found that, within each ethnic group, a language other than English is more likely to be used when speaking to family members older than oneself rather than younger than oneself. This suggests the latter either cannot comfortably speak that language or prefer to use English; in any case, it is now the practice even among those groups where nearly everybody can speak a community language, and does so with family elders, that English is used by some when talking to younger family. In fact about a third of Indians, African Asians and Pakistanis normally spoke to younger family members in English. Moreover, the majority of African Asian,

Chinese and Indian respondents, and nearly half of the Pakistanis, chose or were happy to be interviewed entirely in English, even though nearly all of the South Asians were offered the opportunity to be interviewed in a community language. The Bangladeshis were the only South Asian group not yet to have experienced a linguistic decline – a decline which has perhaps gone furthest with the Chinese.

Analysis by particular South Asian languages shows more clearly among whom and in which languages the decline in use is occurring. Table 9.15 shows that, while a quarter of South Asians understand spoken Hindi, for only 4 per cent is it the language used with younger family members. In fact this is not simply a case of decline in use, for only 5 per cent of South Asians use it within the family. It suggests Hindi's status as an inter-community rather than a community language. It is one of the two languages used among Hindus. The other is Gujarati. Yet Gujarati, unlike Hindi, is very much a community language; it is the principal language used among Hindu families in Britain. As such, it is, however, experiencing some decline in the principal Gujarati-using ethnic group, the African Asians, among whom there is a decline of over a quarter between those who use it at all (i.e., use it with older family) compared with those who use it with younger family members. Interestingly, there is hardly any decline among Indian Gujarati speakers, who were also proportionately more likely to use this language in the interview.

Table 9.15 shows that Punjabi speakers are found in all the three religions, but consist mainly of Sikhs and Pakistani Muslims – especially the former, as nearly all Sikhs in the survey regularly used Punjabi. There is, however, a decline in the use of Punjabi within the family similar to that of Gujarati. Urdu, the language of nearly 60 per cent of South Asian Muslims, is spoken mainly by Muslims, and by some Muslims in all ethnic groups, but as a community language is almost entirely that of Pakistanis. While three-quarters of Pakistanis regularly used Urdu (as they did Punjabi), it is a familial language for slightly less than half of Pakistanis. Punjabi, in fact, is the familial language of two-thirds of Pakistanis, though about a fifth of Pakistanis use both Urdu and Punjabi among their family. There seems, therefore, to be relatively little decline in Urdu as a familial language compared with Punjabi or Gujarati. Bengali and Sylheti are spoken almost exclusively by Bangladeshis, and as such, with the Bangladeshis being the most recent of all the migrant groups, are hardly experiencing any decline. It seems that, given the choice, the Bangladeshis are the most likely to use their community languages in preference to English, for half of the Bangladeshis in the survey used Sylheti in the interview and a fifth used Bengali. This is a further reason to doubt the validity of the BMEG survey finding, mentioned above, that only a quarter of Bangladeshis speak Sylheti compared with nine in ten who speak Bengali (Rudat 1994, 26).

On closer analysis, then, Table 9.15 shows that within each group there is really only one core language, or at the most two, and that these are strongly related to religious communities. The four or possibly five main South Asian linguistic communities in Britain can, therefore, be characterised as follows:

1. Indian and East African Sikh and Indian Hindu Punjabi speakers (with a Gurmukhi literary heritage)

2. Pakistani Urdu/Pakistani Punjabi speakers and Indian Muslim Urdu speakers (with an Urdu literary heritage)

3. Gujarati speakers, predominantly African Asian Hindus, with some African Asian and Indian Muslims (with a Gujarati literary heritage)

4. Bangladeshi Bengali and Sylheti speakers (with a Bengali literary heritage)

5. Indian Hindu Hindi speakers (with a Sanskrit literary heritage).

While, as can be clearly seen, ethnic, religious and linguistic communities are by no means identical with each other, and allow for overlapping between different types of community, nevertheless the large majority of South Asians belong to one and only one of the five linguistic communities or groups outlined above.

Facility in and use of these languages varies little by most of the standard variables. Where there is variation it tends to be of a similar pattern across groups. Hence, for example, in most South Asian groups about 60 per cent of people in occupational classes 1–3 use a community language when speaking to younger family, but about three-quarters of people in classes 4–6 do so (the Bangladeshi figure is higher and hardly varies between classes). Analysis by age perhaps shows most clearly a common pattern. While nearly all the younger generation of 16–34-year-olds still sometimes use a familial language in talking to family members older than themselves, only about half of Indians and African Asians, six out of ten Pakistanis and 85 per cent of Bangladeshis use an Asian language with family of their own age. This marks a considerable linguistic decline in some communities and is broadly consistent with the BMEG survey finding that over half of 16–29-year-old Indians and African Asians, and nearly half of Pakistanis of that age, now have English as their main spoken language, compared with a fifth of their Bangladeshi peers (Rudat 1994, 27).

The Chinese in Britain too speak a number of languages and dialects. Cantonese is, however, as shown in Table 9.16, the most prevalent. It is the language of Hong Kong, from which the majority of Chinese migrants came. Among the Chinese too there was evidence of linguistic decline with just over four in ten of the 16–34-year-olds using a Chinese language with family of their own age, and nearly a quarter of all respondents not able to speak a Chinese (or Vietnamese) language.

Table 9.16 Facility in spoken Chinese languages among Chinese

cell percentages

	Any	Cantonese	Mandarin	Hakka	Hokken	Vietnamese
	77	66	10	11	2	6
Weighted count	196					
Unweighted count	110					

The Caribbeans are of course all English speaking. People in the Caribbean have additionally a number of languages and dialects called Creole and Patois. These are ultimately descended from the languages of those who were taken from West Africa to the Caribbean in slavery, though they evolved to include vocabulary from the

indigenous Caribbean peoples and European slave-masters. They have a literature of their own, especially folk tales and folk poetry, in an English script. Twenty-two per cent of Caribbeans in this survey said they regularly spoke Patois-Creole (Table 9.14). As with all the other community languages, the primary site of use is the family, and it is used more with family older than younger than oneself; but, untypically, it is used slightly more with family of one's own age. This is because it is used much more by the 35 to 49-year-olds (28 per cent) than by the other two age groups. In fact, more than twice as many 35 to 49-year-olds understand Patois-Creole than their elders, and two-thirds of that age group use it, especially with own-age family, but only half of those who know it in the other age groups use it. This suggests a remarkable revival in Patois-Creole among a generation largely born and/or schooled in Britain. Yet it is a revival that may be past its peak. Even though more women (29 per cent) than men (22 per cent) understand Patois-Creole, and a greater proportion of women use it, and women bear a special responsibility for bringing up the young, they are only partly successfully passing the language on to the younger generation, only a fifth of whom said they spoke it – though that is still more than their grandparents.

VISITS TO COUNTRY OF ORIGIN

We have seen that people in our survey from ethnic minority groups had a strong sense of identity based on their origins. To what extent do they actually keep in touch with those places of origin? Nearly half of people belonging to ethnic minority groups had visited their family's country of origin in the last five years, many of them more than once (Table 9.17). The Chinese and the Pakistanis were the most likely to have done so. The African Asians were the least likely, which is perhaps understandable as, having been settled in East Africa for one or more generations and then having been expelled, they have the weakest connections to the countries of their origin. Bangladeshis were no more likely to have visited their family's country than the Caribbeans, even though the former have been settled in Britain for much a shorter time, and there is probably more involvement in family matters in Bangladesh and more marriages with a spouse who has migrated for that purpose. Perhaps the low Bangladeshi figure is explained by financial constraints (this group being the poorest of the ethnic minorities). The same may explain why those from the higher social classes were more likely to have made visits. Even among the British-born a third had visited their parents' country in the previous five years. The Chinese and the Pakistanis were most likely to have done so, followed by the Caribbeans.

The Caribbeans were also well represented among those who made more than one visit in this period. One in five of all Caribbeans had done so, the same as Pakistanis, but a higher proportion than the other South Asians. The Chinese, however, were most likely to have made more than one visit, with a third having done so. The differences in the extent to which members of these groups had visited their country of origin paralleled the variations in the extent to which they sent money to family abroad, except that the Caribbeans were not as likely to visit the Caribbean as the extent of their remittances, as discussed in Chapter 3, might suggest.

Table 9.17 Visits to country of origin

cell percentages

	Caribbean	Indian	African Asian	Pakistani	Bangladeshi	Chinese
Have visited family's country of origin in the last 5 years	44	47	38	58	43	60
Of whom: twice or more	43	32	32	32	25	53
Weighted count	*779*	*643*	*406*	*437*	*147*	*196*
Unweighted count	*587*	*630*	*376*	*591*	*301*	*110*

MARRIAGE

Marriage is one of the principal ways in which ethnic boundaries are drawn and maintained: by a group being excluded from the pool of eligibility or, alternatively, by members of a group seeking partners only from within their own group. Our development study had indicated that, while attitudes to 'mixed marriages' were in a process of flux, in most groups, based partly on perceptions of white prejudice and partly on concerns to do with community identity, the issue was an important topic of debate. Of even greater personal relevance to our South Asian respondents in the development study were modifications to the practices of 'arranged marriages'. The Fourth Survey included attitudinal questions on marriages across the boundary of own ethnic minority group and white groups, and factual questions on choosing a partner, as well as on cohabitation, marriage and remarriage. Family relationships were discussed in Chapter 3, and here we present attitudes to marriage as they relate to racial and ethnic exclusion and inclusion, including some of the attitudes of white people.

Table 9.18 gives a breakdown of opinion of minority individuals on whether their group would mind a close relative marrying a white person. A small majority of Caribbeans and Chinese thought people from their group would not mind, but most South Asians thought it would be minded. The greatest number of Pakistanis thought that it would be minded (72 per cent) and the least number of Bangladeshis (50 per cent), but they also found it difficult to answer the question (25 per cent). By religion, the group that most thought it would be minded was Sikhs (73 per cent). In most groups, the young were more likely to state that it would be minded, perhaps because they were more honest; women, too, were more likely to say it would be minded and, in the case of the Caribbeans, the more qualified and individuals in non-manual work.

About a quarter to a third of respondents in each group said that, even though most of their group minded, they personally did not. This meant that, except in the case of the Pakistanis, a majority in each group said they personally did not mind, though the Caribbeans and the Chinese reflected this position most (Table 9.19).

Table 9.18 How ethnic groups view 'mixed' marriage

column percentages

	Caribbean	Indian	African Asian	Pakistani	Bangladeshi	Chinese
If a close relative were to marry a white person, most people of my ethnic origin						
Would not mind	57	23	30	15	25	48
Would mind a little[1]	18	16	23	8	15	22
Would mind very much[1]	15	52	35	64	35	21
Can't say	10	11	12	13	25	9
Weighted count	784	646	408	442	147	196
Unweighted count	591	635	378	601	302	110

1 Those who said 'would mind' but could not choose between 'a little' and 'very much' are evenly distributed between the two.

While the Pakistanis were the most disapproving of mixed marriages, this was not necessarily because of their religion, for Bangladeshi Muslims took a similar position to Sikhs (42 per cent), though Hindus were considerably less disapproving (32 per cent), as indeed were Bangladeshis in the South East. The difference between the Indians and African Asians was almost entirely among older people, for among 16–34 year-olds, those who minded were the same proportion (25 per cent). In general, there was a strong age factor, with the older minding more than the younger, but the 35–49-year-olds sometimes minded the most, as in the case of the Caribbeans (18 per cent). The age factor was most operative among Sikhs: the answers of Sikhs over 35 were almost identical to Muslims of the same age, but the answers of Sikhs under 35 were almost the same as that of Hindus of their age. Caribbean (18 per cent), Bangladeshi (52 per cent) and Pakistani (56 per cent) women minded more than the men (7 per cent, 31 per cent and 48 per cent respectively), but there was no gender difference among Indians and African Asians.[4] On the whole, people without qualifications and people in manual occupations minded more, though the reverse was true of Caribbeans.

Table 9.19 Personal view of 'mixed' marriage

column percentages

	Caribbean	Indian	African Asian	Pakistani	Bangladeshi	Chinese
If a close relative were to marry a white person						
I would not mind	84	52	68	41	52	84
I would mind a little[1]	5	11	11	11	9	5
I would mind very much[1]	7	28	14	40	31	8
Can't say	3	8	8	8	8	2
Weighted count	784	646	408	442	147	196
Unweighted count	591	635	378	601	302	110

1 Those who said 'would mind' but could not choose between 'a little' and 'very much' are evenly distributed between the two.

4 A new survey found that Asian (combined) and Jewish rates of disapproval of mixed marriages was similar, and was not confined to marriages with white people (IPPR, 1997, 22–25). For Jewish women's opposition to a son or daughter marrying a non-Jew, see Schmool and Miller 1994, 75–6.

Table 9.20 White people's view on 'mixed' marriage

	column percentages
	White
If a close relative were to marry a person of ethnic minority origin, most white people	
Would not mind	33
Would mind a little[1]	24
Would mind very much[1]	28
Can't say	15
Weighted count	*2867*
Unweighted count	*2867*

1 Those who said 'would mind' but could not choose between 'a little' and 'very much' are evenly distributed between the two.

What was the view of marriage from the other side of the colour boundary? How did white people respond to the idea of inter-racial marriages? Table 9.20 sets out the view that white respondents thought was prevalent. A third thought that white people would not mind if a close relative were to marry an ethnic minority person, while more than a quarter thought it would be minded very much. Just over half thought it would be minded. This is significantly different to the results obtained by other surveys using the same or very similar questions. The British Social Attitudes (BSA) surveys have reported on different occasions over the period of 1983 to 1991 that about three-quarters of white people have said that they think white people would mind if a close relative were to marry a black or Asian person (Young 1992, 184). It is unlikely that as many as a quarter of the white population could have changed their minds in such a short period of time. That the BSA figure is more reliable is suggested by a telephone survey carried out for the BBC in May 1995, which reported that, while the proportion saying it would be minded a lot was declining, it was still the case that three-quarters of white respondents thought that most white people would mind a mixed marriage within their close family (Dawar 1996, 22–5).[5] That means that our white respondents mirrored most closely the African Asians, being far more negative to such unions than the Caribbeans or Chinese, but less so than the other South Asians. As with the minorities, opinion varied by age and job level, though less so by gender. Younger people were more likely to identify disapproval than older people. The higher the job level or level of educational qualifications, the more likely the interviewee thought that white people would mind. Again, even more so than with the minorities, when it came to whether they personally minded, half of the white respondents who thought most white people would mind said they themselves did not mind. The result is that only a quarter of white people said that they themselves would mind, which is half of what the British Social Attitudes surveys were finding in the 1980s (Young 1992,185). There probably has, however, been some decline in the number of white people minding inter-ethnic marriages in their close family, for in the BSA survey of 1991 only 44 per cent of whites minded (Young 1992, 185), in the survey of 1995 a third did so (Dawar 1996, 22–5) and the most recent survey has the same findings as ours

5 Telephone surveys miss out people without telephones and so undersample people on low incomes.

(IPPR, 1997). Nevertheless, we are conscious that our finding that only a quarter of whites disapprove of such marriages may understate the true picture (although cf. pp. 29–31). Age, however, as can be seen from Table 8.21, was a radical factor (as it was in the other surveys). Nearly nine out of ten 16–34-year-olds said they would not mind, while nearly four out of ten people over the age of 50 said they would and a quarter said they would mind very much. The view of all younger people has therefore been moving in the same direction, but that of young whites, perhaps in the security of being the majority, has moved fastest, being now the same as that of the young Caribbeans and the Chinese. While there was no gender difference, employment class and education were important, as they were with the minorities.

Table 9.21 Personal views of white people on 'mixed' marriage, by age

column percentages

	16–34	35–49	50+	All
If a close relative were to marry a person of ethnic minority origin				
I would not mind	86	75	54	71
I would mind a little[1]	5	9	14	10
I would mind very much[1]	6	12	24	14
Can't say	3	4	8	5
Weighted count	*985*	*792*	*1085*	*2867*
Unweighted count	*916*	*724*	*1221*	*2867*

1 Those who said 'would mind' but could not choose between 'a little' and 'very much' are evenly distributed between the two.

One of the most fundamental socio-cultural differences between the South Asian migrants and the society they settled in was the difference in custom and practice in how marriage partners were selected or selected each other. It is commonly known that in some South Asian families the parents, and possibly some other family elders, play a role in the selection of a partner and in 'arranging' the marriage in a way not (any longer) common in Britain. There have been some studies looking at the extent of this practice, current changes within it and how younger Asians as well as their parents view it (e.g., Stopes-Roe and Cochrane 1990). These matters, however, have not been surveyed with a large national sample, and, while there is much stereotyping and journalistic discussion about them, the basic facts have not been available until now. Table 9.22 shows that, excluding African Asians, a majority of South Asians over the age of 35 had their spouses chosen by their parents. This practice is most common among Pakistanis and Bangladeshis, with whom it is still the majority, albeit declining, arrangement among the young. The majority of Sikhs (56 per cent) too were married in this way, but not Hindus (36 per cent). The practice has been even less common among the African Asians and is now the exception among younger members of that group. It is now also a minority practice among younger Indians (27 per cent) and Sikhs (32 per cent), marking a very significant generational shift. Women of all groups were much more likely than men to say that their parents had chosen their spouse, except among younger Sikhs and Hindus (see Table 9.23). While parental choosing was among all groups more likely among those with fewer or no qualifications, with Pakistanis and Bangladeshis it was

evenly spread across occupational classes; with Indians and African Asians it was found more in the lower than the higher occupational classes. There were also considerable regional differences. For example, more than three-quarters of Pakistanis in the North-West, but less than two-thirds in Yorkshire/Humberside and only half in the South-East had had a parentally arranged marriage. The region in which the highest proportion of South Asians had had their parents choose their spouse was the West Midlands.

Table 9.22 Parental involvement in choice of marriage partner, by age

column percentages

	Indian		*African Asian*		*Pakistani*		*Bangladeshi*	
	16–34	35+	16–34	35+	16–34	35+	16–34	35+
Parents made the decision	18	55	9	23	57	68	45	57
I had a say but parents' decision	9	4	6	8	8	7	5	7
Parents had a say but my decision	24	11	21	22	15	9	25	12
I talked to my parents but my decision	27	11	33	22	11	4	6	3
I made decision on my own	20	12	27	22	8	8	8	13
Can't say	3	7	5	3	2	4	11	7
Weighted count	*159*	*324*	*95*	*215*	*144*	*188*	*41*	*71*
Unweighted count	*169*	*350*	*88*	*217*	*199*	*286*	*99*	*149*

Table 9.23 Parental decision over marriage partner, by religious group and age

cell percentages

	Hindu		*Sikh*		*Muslim*	
	Men	Women	Men	Women	Men	Women
50+ years old	50	74	72	86	62	87
35–49 years old	21	51	49	77	59	78
16–34 years old	18	20	41	27	49	67
Weighted count	*187*	*164*	*133*	*133*	*242*	*247*
Unweighted count	*179*	*160*	*138*	*137*	*401*	*396*

For some time now there has been evidence that the attitudes of young South Asians on 'arranged' marriages and 'mixed' marriages have been moving away from those of their parents (Stopes-Roe and Cochrane 1990; Anwar 1994) and this is much more the case among Sikhs and Hindus than among South Asian Muslims (Francome 1994). We too found supporting evidence for both these propositions in our preliminary ethnographic work (Modood et al. 1994, 71–5). What has been far less clear is the effect of these changes in attitudes on behaviour. The large data sources on inter-racial marriages and cohabitation, such as the Labour Force Survey and the 1991 Census, show very little proportionate increase in these unions among any of the South Asian groups although the Fourth Survey suggests that these relationships may be becoming significantly more likely among younger African Asians and Indians (pp. 30–31). Our survey findings show not only that the attitudinal changes are continuing to move in the same direction, but are also now beginning strongly to

show themselves in how young married people describe the role of their parents in the choice of their spouse. Many respondents do not see the issues in the stark terms of 'parents' decision' and 'my decision', and it is clear that, even where individuals make their own decision, parents are closely involved (perhaps in even introducing the prospective partner). Nevertheless, the traditional parentally arranged marriage is in decline, consultation and negotiation are prevalent, and most young Hindus and Sikhs are now, at least in their own estimation, the final arbiters in the choice of their marriage partner. The evidence for the translation of an attitudinal trend into behaviour is important, as to date it did seem that when it came to the crunch reluctant obedience by the young adults was common (Stopes-Roe and Cochrane 1990, 31–6). We should not overlook though that these descriptions are offered by the individuals themselves, who may not only interpret the actual words of the question quite differently, but also put a certain post-hoc gloss on what actually happened. Where parents may be allowing new but limited freedoms, the children may, comparing the innovation to past restrictions, overemphasise the degree of their participation in the decision process, or alternatively, they may continue to feel that their 'say', not being decisive, does not count. How one judges one's contribution to a decision process depends upon some expectation of what the contribution ought to be. In which case it is worth bearing in mind that in their study Stopes-Roe and Cochrane found that parents and their children's interpretations of how the decision concerning the choice of a child's spouse had been arrived at differed in a quarter of cases. In those cases 'most of the discrepancies arose because young people gave a version of what had happened that was more traditional than that given by their parents; while parents viewed themselves as being more accommodating than their young people thought they had been' (Stopes-Roe and Cochrane 1990, 32).

Some recent concern about the increased incidence of certain diseases among a population which marries within a narrow 'gene pool' led some researchers to identify Pakistanis and/or Muslims as such a population because of their preference for marrying cousins (Bundey and Alam 1993). While it is still unclear whether there is indeed a causal connection between consanguinity and any medical condition (Bittles and Neal 1994), we sought to establish some relevant facts about the extent of consanguinity. We did not, however, distinguish between first cousins and other cousins, though this could be medically significant. In our sample we found that 54 per cent of married Pakistani and Indian Muslims were married to a cousin, a practice which may well be increasing for the proportion among younger Pakistanis was 64 per cent. It was very much a class-related practice for it was twice as common among manual workers (62 per cent) as among non-manual workers (31 per cent). Religious affiliation was a relatively small factor, for only 15 per cent of married Bangladeshi and African Asian Muslims reported that their spouse was a cousin; on the other hand, Pakistanis of all age groups were more likely to be married to a cousin the more important religion was in their lives. The regional variations paralleled those of parentally arranged marriages, so while around 60 per cent of married Pakistanis in the North West, Yorkshire/Humberside and West Midlands were consanguineous, only a third of those in the South East were.

CHOICE OF SCHOOLS

A number of questions were asked in order to assess the relevance of ethnicity in influencing the kind of school that people wanted for their children. Four sets of questions were asked. They were about schools and the preference for one's ethnic groups; the preference for ethnic minorities; the preference for a single-sex school; and the preference for a school of one's own religion. In each case respondents were asked to suppose that they were choosing a school for an 11-year-old child of theirs.

The first set of questions asked if their choice would be influenced by how many children of their own ethnic group were in the school (Table 9.24). The most common answer in each group was that it would be of no influence. This was the view of more than two-thirds of the Chinese, more than half the African Asians and Indians and over 40 per cent of the other groups. It would be an important consideration for only about a quarter of African Asians, Indians and Bangladeshis, and for about a third of Pakistanis and Caribbeans. On the whole, the numbers who think it important rise with age (e.g., 41 per cent of Pakistanis over the age of 50), except the reverse is true for the Caribbeans (only 16 per cent of the over fifties thought it important, but 44 per cent of the younger generation did). Women were slightly more likely than men to think it important, except Sikh women, who were much less likely. Men with children, controlling for age, were less likely to say 'no influence'.

Table 9.24 Importance of ethnicity in choosing a school

column percentages

	Caribbean	Indian	African Asian	Pakistani	Bangladeshi	Chinese
Very important	15	9	8	13	12	3
Fairly important	19	16	14	20	15	6
Not very important	15	14	13	14	16	18
No influence	46	54	59	44	44	70
Can't say	4	6	6	9	13	4
Weighted count	*784*	*646*	*408*	*442*	*147*	*196*
Unweighted count	*591*	*635*	*378*	*601*	*302*	*110*

The Indian affirmative responses decreased with qualification levels, while the opposite was true for Caribbeans and African Asians, especially for the latter, rising to nearly a third among the highest qualified. Again, except for Indians, in most groups the affirmative responses were higher among the British-born than not, especially the Caribbeans (45 per cent against 23 per cent of Caribbean-born). For all groups except the Pakistanis more affirmative responses were given in wards with more than 10 per cent of ethnic minorities, but the 26 per cent of Pakistanis in such wards who said 'important' were much outnumbered by the 40 per cent in wards with lesser ethnic minority density. For Pakistanis there was also an important regional difference: the number of Pakistanis in a school was very important to 27 per cent in the West Midlands, 22 per cent in Yorkshire and Humberside, but only 7 per cent in the South East. In fact, the number of 'very important' responses in all groups was least in the South East. The religious groups for whom this issue was of

most importance were the New Protestants, but it was more important still for Caribbean people without a religion.

So, in choosing a school for their 11-year-old, if the number of children from their own ethnic background in a school was of importance to some ethnic minority people, what was the proportion of such children they would like to see in the school? The answers are presented in Table 9.25. The first point to make is that, when asked to specify a figure, in nearly every group there is an increase in those who opt for 'no preference', as can be seen by comparing the 'no preferences' in Table 9.25 to the 'no influences' in Table 9.24. Fifty-five per cent, in fact, of the respondents stated 'no preference', though this varies from 44 per cent of Caribbeans to 64 per cent of Chinese. Except for the Chinese, of those who had a preference the majority wanted a school where their ethnic group made up about half the school. This was particularly true of the Caribbeans (36 per cent) and the Pakistanis (31 per cent). Nearly all of the remainder preferred a school where their ethnic group formed a quarter or less, though a few also wanted a school where their ethnic group was in a majority.[6] The one third of Chinese who had a preference were for schools in which they were a minority (13 per cent favouring a school with less than 5 per cent Chinese).

Table 9.25 Preferred proportion of one's ethnic group in a school

column percentages

	Caribbean	Indian	African Asian	Pakistani	Bangladeshi	Chinese
5%	2	4	3	2	3	13
10%	3	1	3	3	6	6
25%	11	8	9	9	8	6
50%	36	21	21	31	24	9
50+%	4	1	3	7	5	2
No preference	44	63	61	47	54	64
Weighted count	*752*	*612*	*380*	*407*	*128*	*189*
Unweighted count	*566*	*593*	*346*	*544*	*264*	*106*

Not shown in the table is that, among younger people, except Indians, there is a slight movement away from 'no preference', quite strongly so among African Asians and Caribbeans, for whom this decreases to 49 per cent and 37 per cent. The preference for a school with fewer than half their own ethnic group rises in the younger generation of South Asians, though no fewer prefer a school with half from their ethnic group. Among the younger generation Caribbeans there is a movement away from a preference for Caribbeans constituting less than 10 per cent of the school (preferred by 10 per cent of the middle generation but only 4 per cent of the younger) in favour of constituting about a quarter (favoured by 12 per cent) and about a half (favoured by 45 per cent). This might just reflect the fact that younger

6 The proportions wanting more than half the school to be from their ethnic group were very much smaller than those who wanted half or more of their ethnic group in the local area (Tables 6.7 and 6.8). But, as with area, so with school; the interest was primarily in one's own ethnic group density rather than the minorities as such.

people's experience will have been of a larger proportion of their own group and other minorities in their school than would have been the case for older people or for the migrant generation vis-à-vis their children. It might also be related to the findings of several studies that 'suggest that where blacks are a very small minority in a school or class, this may damage their self-esteem, perhaps because they feel threatened and heavily outnumbered and lack the social network of support that a larger group would provide' (Field 1984, 11). Interestingly, however, religion was also a factor among the Caribbeans. Those without a religion most preferred a school with half the children from their own ethnic group (43 per cent) and Catholics the least (26 per cent). It may be that those with a strong religious identity are not so dependent upon a strong ethnic or racial identity.

Table 9.26 Importance of ethnic mix to white people in choosing a school, by age

column percentages

	16–34	35–49	50+	All
Very important	11	20	27	19
Fairly important	17	21	19	19
Not very important	10	8	7	8
No influence	59	45	36	46
Can't say	4	5	11	7
Weighted count	*985*	*792*	*1085*	*2867*
Unweighted count	*916*	*724*	*1221*	*2867*

Table 9.27 White people's preferred proportion of ethnic minorities in a school, by age

column percentages

	16–34	35–49	50+	All
Fewer than a tenth	15	27	39	27
About a tenth	8	10	9	9
About a quarter	12	11	9	10
About half	21	16	11	16
No preference	39	29	26	31
Can't say[1]	6	8	7	7
Weighted count	*956*	*759*	*980*	*2699*
Unweighted count	*889*	*694*	*1084*	*2673*

1 'Can't say' includes some unspecified 'fewer than half'.

The ethnic composition of the school is on the whole of more importance to white people than minorities. Even so, nearly half of all white people said that the number of ethnic minorities in a school would not be a consideration in choosing a school, which is more than for those for whom it would be an important consideration. The white response, presented in Table 9.26, varied considerably between generations. While for 46 per cent of the oldest generation it was an important consideration, it was so for only 28 per cent of the youngest generation. The preferred proportion of children from minority groups varied in the same way (Table 9.27). Four out of ten

16–34-year-olds had no preference; while 15 per cent wanted the proportion to be less than a tenth, 21 per cent wanted it to be about half – a proportion larger than the respondents are likely to have had in their own school or are likely to have in the school of their children. The preference for a school with less than a tenth of its roll consisting of ethnic minority children was much greater among older people, but, even among the older age groups, over a quarter had no preference and the actual preferences were for proportions of ethnic minorities greater than the individuals in question were likely to have experienced in their own or their children's schools.

The third set of school questions were about single-sex schooling, the answers for which are in Table 9.28. About one in five white people preferred a single-sex school for an 11-year-old daughter, and slightly less for a son (not shown in the table, but in each case slightly more in the South East than any other part of the country). The Caribbean preferences were broadly the same, as were the Indian and African Asian for single-sex schools for a son, but slightly more for a daughter. The Chinese and the Irish-born had a stronger preference for single-sex schooling, especially for daughters, but the strongest preferences were among the Pakistanis and Bangladeshis. Fifty-nine per cent of Pakistanis preferred a single-sex school for their daughters (more than twice as many as for sons) and 46 per cent of Bangladeshis. Religion was clearly a factor, with Muslims most preferring single-sex schooling and those without religion least, and with Hindus a little more so than Sikhs and Christians.

Table 9.28 Preference for single-sex schooling for daughters and sons

column percentages

	White		Irish		Caribbean		Indian		African Asian		Pakistani		Bangladeshi		Chinese	
	D	S	D	S	D	S	D	S	D	S	D	S	D	S	D	S
Single sex	19	16	29	27	19	12	26	17	23	19	59	27	46	33	29	17
Mixed	52	55	44	51	52	58	36	41	33	34	16	33	12	18	32	35
No preference	26	26	26	22	26	27	34	38	40	42	20	35	29	36	34	42
Can't say	3	3	0	0	4	3	5	4	5	5	6	5	13	13	5	5
Weighted count	2757		110		147		784		442		408		646		196	
Unweighted count	2748		119		302		591		601		378		635		110	
Preference for single-sex among 16–34-year-olds	10	7	22	18	19	10	19	12	17	15	48	19	37	27	21	10
Weighted count	944		41		76		421		252		184		316		104	
Unweighted count	872		44		152		274		313		152		276		44	

D= Daughter; S = Son

These are very clearly age-related preferences, though not always to the same extent. The preference for such schooling for daughters drops by about ten points among the 16–34-year-olds compared with their group average (and so, for example, is halved for whites), except in the case of the Caribbean young whose preference is the same as the average for the group, as can also be seen in Table 9.28. The women in most groups, except Pakistanis and Indians, had a slightly higher preference for

single-sex schooling than men. While in most groups there was no particular occupational class pattern, among white and Caribbean people the single-sex option was especially preferred among non-manual workers. Geography too was a factor, with, for example, the West Midlands having the lowest Indian preference (16 per cent) and the highest Pakistani preference (71 per cent) for single-sex girls' schools.

The last set of school questions sought to measure the extent of preference among people with a religion for schools for children of only their religion. The answers, in total, by religious groups and by some important variables are presented in Table 9.29. The range between the different faiths is quite large, with Catholics most preferring own-religious schools for their children and Hindus least. This preference is also high among the New Protestants or black-led churches and Muslims. There are also significant differences between levels of preference within groups. Thus among the younger generation there is less support, except among Protestants. Similarly, there is a lesser preference for religious schools among the higher qualified among the non-Christians and Anglicans, but a markedly stronger preference for schools based on their religion was expressed by the higher qualified members of the non-established Christian churches. The preference for schools based on their religion was particularly absent among younger Hindus and especially Sikhs, but was well represented among younger Muslims. The more in-depth interviews at the development stage had, however, suggested that, while this indeed was very important to younger Muslims, it was ultimately outweighed by the wish that their children learn to operate in multicultural environments (Modood et al. 1994, 54–5).

Table 9.29 Preference for schools of one's own religion

cell percentages

	Hindu	Sikh	Muslim	Church of England		Roman Catholic		Old Protestant		New Protestant
				White	Others	White	Others	White	Others	Others
All	6	9	28	17	11	38	37	12	13	30
16–34-year-olds	9	1	23	13	10	34	24	15	15	30
Persons without qualifications	11	21	35	20	10	36	37	9	5	26
Persons with A-levels or higher education	3	2	18	14	13	41	45	11	23	37
Weighted count	*453*	*410*	*677*	*1379*	*164*	*317*	*89*	*198*	*129*	*138*
Unweighted count	*419*	*363*	*1033*	*1395*	*131*	*317*	*75*	*201*	*102*	*101*

In line with other answers to questions about religion in this survey, Muslim women were more likely to prefer own-religious schools, as were Caribbean people in non-manual occupational classes 1–3, and those born in Britain. The regions in which Christians, both black and white, most expressed this preference were the North-West and the South East (not unrelated to the higher number of Catholics in these regions); among Pakistanis, the region with the highest preference for own-religious schools was the West Midlands, where half the respondents gave this answer. The reasons that respondents gave for their preference included religious instruction,

moral behaviour and standards of discipline, but also an expectation that such schools may have less racial prejudice. A further possible connection is that, it has been argued, 'the development of some independent Muslim schools is partly due to Muslim parents' worries about non-availability of single-sex schools for their girls, as these schools are fast disappearing' (Anwar 1994, 32). Of those who preferred a girls-only school for their daughters, only Muslims and Catholics expressed a high preference for 'own religion' schools, but even so it was less than half in each case. For Muslims, but not for Catholics, there was, however, a very strong connection the other way round: more than four out of five Muslims, but less than a third of Catholics, who preferred an 'own religion' school preferred also a single-sex school for their daughter. This suggests that, while twice as many Muslims want a girls' school for their daughters than want a Muslim school, for perhaps up to a fifth of Muslims the preference for a girls' school may be based on a religious view of education which is unlikely to be fully satisfied with non-religious, single-sex schools.

Table 9.30 Support for religious schools within the state sector

column percentages

	People without religion		Hindu	Sikh	Muslim	Church of of England		Roman Catholic		Old Protestant		New Protestant
	White	Others				White	Others	White	Others	White	Others	Others
Yes	23	22	13	20	48	26	21	41	35	20	20	36
No	69	62	72	61	28	64	70	50	57	71	67	51
Can't say	8	17	15	19	24	10	9	9	8	9	13	13
Weighted count	*870*	*219*	*453*	*410*	*677*	*1379*	*164*	*317*	*89*	*198*	*129*	*138*
Unweighted count	*850*	*144*	*419*	*363*	*1033*	*1395*	*131*	*317*	*75*	*201*	*102*	*101*

A related question was whether there should be state schools for people belonging to particular religions. About one third of all state schools have voluntary status and are denominational; the pupils at these schools account for about a quarter of all pupils in state schools. Nearly all of these schools are Anglican or Roman Catholic, though there are also some Jewish schools, and a few are Methodist (CRE 1990, 4). Apart from the few Jewish schools, there are no voluntary maintained schools of minority religious faiths.[7] The issue has become politically contentious in recent years with the unsuccessful applications of some private Muslim schools to seek state funding (CRE 1990; Dwyer and Meyer 1995). Our survey suggests that the existence of denominational state schools does not necessarily enjoy majority support. For among all groups, except Muslims, there was a majority against state funding, even among the Catholics, with most of those who themselves did not prefer to send their children to a religious school being against state support for such schools (though among Irish Catholics the majority were in favour). Quite a large number were undecided, and it is interesting that there was more support for state funding from those without a religion than from Hindus, Sikhs and members of the historic Protestant churches.[8]

7 Newspaper reports suggest that the first state-funded Muslim school may be approved in 1997.
8 For a debate among minority faiths on the broader relationship between religion and the state, see Modood (ed.), 1997.

CLOTHES

One of the visible features of 'difference' is dress. Clothes, ornaments, badges, make-up, hairstyles and so on are all subject to cultural styles and norms, and, whether explicitly intended or not, can signify membership of a group or adherence to a religion. While on the one hand the wearing of traditional clothes by newly settled communities can be an important element of self-identity, of being oneself, they can also be resented by the indigenous peoples as a refusal 'when in Rome, [to] do as the Romans do' and to perpetuate differences. Third world origin clothes are often considered a sign of backwardness, and (unless they have been taken up by Western fashion and are also worn by white youth) their wearers are deemed to be stupid or lacking linguistic or job skills: such clothes become a form of stigmata. The issues are far from merely 'private' ones. Industrial tribunal cases have been based on the right of Asian women to wear *shalwar-kamiz* (baggy cotton trousers and knee-length top), Rastafarian men to wear dreadlocks at work and Muslim women the hijab (respectively, *Malik v. British Home Stores* 1980; *Dawkins v. Crown Supplies* 1989; and *Shakoor v. Anne Gray Associates* 1996; see Poulter 1990). Matters become particularly controversial and are said to be critical to 'race relations' when a religion is involved, as in the legal battles over the Sikh turban which have required a House of Lords ruling (*Mandala v. Dowell Lee* 1983) and incorporation into new legislation (Employment Act 1989, ss11 and 12). More recently, in France, some Muslim girls, to the consternation of the authorities, have demanded to be allowed to wear headscarves in school, provoking national debates involving senior members of the government (Hargreaves 1995).

We thought it useful therefore to establish some facts about the extent to which South Asian people wear Asian clothes and where they wear them, as this has never been done before. Initially, we were also interested in devising some measure of the extent to which Asian people thought that the clothes they wore in different places were influenced by the pressures to conform (by their own community, as well as by the wider society), and of the perceived linkage between assimilationist pressures over dress, racial prejudice and direct and indirect discrimination. Given, however, the limitations of interview time and the difficulties in devising some of these measures, we confined our questions to behaviour, so that it would at least be possible to have some base of factual knowledge in relation to the elusive but emotionally charged issues of dress, social pressures, cultural freedom and adaptation. Our main concern in this section, consistent with the theme of the chapter as a whole, was to what extent dress was a feature of certain ethnicities.

Table 9.31 displays the extent to which South Asian men and women wear Asian clothes. There are three major contrasts. The first is one of gender. A very small number of Asian men always wear Asian clothes, and a third never do. On the other hand, the majority of women always do, and very few never do. There is, however, a major difference between groups. The Pakistanis and Bangladeshis are much more likely to wear Asian clothes than Indians and especially African Asians. There is also a significant generational factor. These differences are constant threads at all levels of analysis. For example, while among 16–34-year-old African Asians and Indians very few men, and less than a fifth of women, always wear Asian clothes, nearly

three-quarters of Pakistani women do. While Indians and African Asians who always wear Asian clothes are disproportionately in semi- and unskilled manual work, the Pakistanis are more evenly spread across occupational levels, but less so geographically. For example, while nearly one in five Pakistani men and nine out of ten women in Yorkshire/Humberside always wore Asian clothes, no men and less than two-thirds of the women did so in the South-East – the region in fact in all groups with the smallest proportion of those who always wear Asian clothes.

Table 9.31 The wearing of Asian clothes

percentages

	Indian		African Asian		Pakistani		Bangladeshi	
	Men	Women	Men	Women	Men	Women	Men	Women
Always	6	43	1	27	7	79	7	85
Sometimes	51	48	41	63	77	18	69	14
Never	43	8	58	10	16	3	24	0
16–34-year-olds								
Always	2	18	1	9	1	72	4	78
Sometimes	47	73	37	78	79	26	61	21
Never	52	8	62	13	20	2	34	1
All ages, if sometimes, then:[1]								
In own home	86	65	81	71	94	95	95	90
At social events	44	95	73	94	61	98	55	78
Weighted count	*304*	*340*	*245*	*163*	*216*	*225*	*90*	*57*
Unweighted count	*300*	*334*	*215*	*163*	*308*	*293*	*172*	*130*

1 Cell percentages.

Asian clothes are worn predominantly at home, in the homes of other Asians and on social occasions, though here too the gender and group contrasts are evident. The men who do not wear Asian clothes all the time are more likely to wear them in their own home or in the homes of other Asians. The women, especially Indians and African Asians, and young women are, however, more likely to wear them at social events (above all, probably at wedding receptions). The men, as it were, change into Asian clothes to relax; the women for special occasions. For most men Asian clothes mean informality, for many women 'dressing up' and being on display at a social function. Bearing in mind also the much larger number of women than men who always wear Asian clothes, it seems that the 'projection' of Asianness by means of clothes falls particularly on women. The one area where Asian clothes are unlikely to be worn by those who do not always wear Asian clothes is at the workplace. Only 1 per cent of men and 12 per cent of women sometimes wear Asian clothes at work. The workplace, therefore, separates out those who always wear Asian clothes and those who do not.

The decline by age in the use of Asian clothes among Hindus and Sikhs extends also to religious items. Interviewers observed that, while 28 per cent of Sikh men wore a turban, the number was much smaller for young men (16 per cent of people under 35 years compared with 37 per cent over that age). While this was perhaps partly why it was more common among African Asians (39 per cent) than among

Indians (24 per cent), despite the fact that the former were less likely to wear Asian clothes than the latter, it does confirm reports that the turban is more important to the African Asian Sikhs (Bhachu 1993, 180). Similarly, while 35 per cent of Hindu women were wearing bindi (a red spot on the forehead), twice as many of the over 35-year-olds as the young generation were doing so, and more African Asians than Indians, suggesting again that, while African Asians wear Asian clothes less than Indians, they are more likely to wear items with a religious significance.

Fifty-seven per cent of Muslim, 20 per cent of Sikh and 6 per cent of Hindu women had their head covered during the interview (as did 10 per cent of Muslim men). The Sikh and Hindu women were nearly all among the older group, but 46 per cent of the under 35-year-olds as well as 69 per cent of the older Muslim women had their head covered (we are unable to break this observation down by reference to whether the women in question were being interviewed by men or women).

We also sought some information on whether dress or hair was being used by Caribbean people to mark a cultural or political dimension of their ethnicity. To the question 'Do you ever wear anything or wear your hair in a style meant to show a connection with the Caribbean or Africa?', a quarter answered 'yes' (of whom 60 per cent said they only occasionally did so). Unlike the case of Asian clothes, however, this grew rather than declined by generations: a third of those under the age of 50 but less than 10 per cent of those older, said they behaved in this way. It was more likely to take the form of a hairstyle than an item of clothing. Yet, contrary to the stereotype that associates this phenomenon with an unemployed male Rasta, it was found much more among women (32 per cent) than men (18 per cent) and in non-manual (37 per cent) than manual classes (20 per cent). The strongest correlation was with those who spoke Patois-Creole (42 per cent).

If some Asians are increasingly of the view that clothes are not a necessary feature of their ethnic identity, some of their Caribbean counterparts are increasingly seeking to express a new sense of ethnicity through their clothes and hair. There is also a common ground, however. From very different starting-points, a significant number of young Asians and Caribbeans, especially females and those in the higher occupational classes, are choosing on certain kinds of occasion, rather than out of everyday routine, to wear clothes that project or display their ethnicity.

ETHNICITY AND BRITISHNESS

As a final measure of the importance of ethnic identification, we used ethnic identification in an explicit pairing with 'being British'. Modifying a pair of questions used by Hutnik with British Indian schoolchildren (Hutnik 1992, 134), we read out the following two statements to interviewees:

In many ways, I think of myself as being British.

In many ways, I think of myself as... [respondent's ethnic group].

Respondents were asked, of each statement, if they agreed or disagreed, and, if so, whether strongly or just a little. Unlike the original self-description question there

was no international dimension, no sense of having to tell someone from another country where you live. Moreover, the question was clearly not about legal status, passports or right of residence, it was about identification with a country, with a place and its ways of living. Leaving the Chinese aside for a moment, just under two-thirds agreed with the statement 'In many ways I think of myself as being British' (Table 9.32). The group who agreed most were the African Asians (71 per cent), and those who agreed least the Bangladeshis (60 per cent). Slightly over a quarter disagreed, the African Asians being the least likely to do so (20 per cent) and the Caribbeans the most (31 per cent). The Chinese were the exception to this pattern. Nearly half thought of themselves as British and nearly half did not. The Chinese sample is not of a size amenable to much analysis, but it does seem that the answers reflect the view of migrants: 15 of the 16 Chinese born in Britain thought of themselves as British.

Table 9.32 Minority ethnicity and British nationality in self-conceptions

column percentages

	Caribbean		Indian		African Asian		Pakistani		Bangladeshi		Chinese		Total	
	British	Afr-Carib.	British	Indian	British	Indian	British	Paki-stani	British	Bangla-deshi	British	Chinese	British	Ethnic group
In many ways I think of myself as (i) British; (ii) respondent's ethnic group														
Agree	64	87	62	91	71	88	66	90	60	92	44	94	63	89
Disagree	31	9	27	5	20	6	23	4	23	5	46	5	28	6
Neither	5	4	12	5	9	6	12	6	17	3	10	1	10	4
Weighted count	760		639		398		428		760		195		2565	
Unweighted count	576		627		366		576		576		109		2554	

Table 9.32 also confirms the strong sense of ethnic identity among these minority groups – indeed, a higher sense of identification than that revealed in the hypothetical telephone conversation experiment. More than 40 per cent strongly, and more than another 40 per cent of each group agreed that they thought of themselves in terms of an ethnic grouping, with usually 5 per cent or less disagreeing, the most being those who denied that they were Caribbean (9 per cent). While a significant minority, then, are not sure about thinking of themselves as British, this is not the case with their ethnic identity. It may seem surprising that 'being British' and 'being Pakistani' etc. do not strongly compete with each other in the minds of most interviewees as evidenced by the large number of affirmative responses to both questions, but this in fact accords with our development work and other research (e.g., Hutnik 1991; Modood et al. 1994). The British-born were more likely to think of themselves as British, but in most groups only a little less likely than the first generation to identify with their origins. It is of note, however, that just over a quarter of British-born Caribbeans did not think of themselves as being British, given that most accounts attest that the West Indian migrants in the 1940s and 1950s did think of themselves as British and often spoke of coming to 'the mother-country' (e.g., Carter 1986; Western 1992). It is just as notable that one in

six of the British-born Caribbeans did not think themselves as being part of an Afro-Caribbean ethnic group (this was not particularly connected to mixed parentage).

That more than a quarter of British-born adults from families of Caribbean and South Asian origins do not think of themselves as being British may seem counter-intuitive but, again, it accords with our in-depth interviews at the development stage. We found that most of the second generation did think of themselves as mostly but not entirely culturally and socially British. They were not, however, comfortable with the idea of British being anything more than a legal title, in particular they found it difficult to call themselves 'British' because they felt that the majority of white people did not accept them as British because of their race or cultural background; through hurtful 'jokes', harassment, discrimination and violence they found their claim to be British was all too often denied (Modood et al. 1994, Chapter 6). Related to the findings about the British-born is that the weakest identification with 'British' for most groups was in the area where they are most numerous, namely, the South East and West Midlands. A contrary feature, however, was that the strongest sense of being British among Pakistanis was in Yorkshire/Humberside and the North-West.

In her research Nimmi Hutnik used answers to these questions to identify four strategies of self-identification (Hutnik 1992, 134):

- *The dissociative strategy:* where categorisation is in terms of ethnic minority group membership and not in terms of the majority group dimension of their being.

- *The assimilative strategy:* where self-categorisation primarily emphasises the majority group dimension and denies the ethnic minority roots.

- *The acculturative strategy:* where the self is categorised approximately equally in terms of both dimensions.

- *The marginal strategy:* where neither dimension is important or salient to self-categorisation. Here, the self may be categorised primarily in terms of other relevant social categories: student; squash player, etc.; or there may be a conscious decision not to choose an ethnic identity or a majority group identity.

Table 9.33 presents the answers of the respondents analysed in this way. With the exception of the Chinese, the minorities have responded in similar ways. Despite some journalistic talk about 'identity crisis' and 'identity confusion', a minute number of people have no identification with their ethnic origins or with British society. This is very largely because few reject an ethnic identification. Hence more than 90 per cent of respondents fall into two categories: those who identify with their ethnicity but not Britishness, and those who identify with both. This latter category, the acculturative strategy of 'adding on' rather than an 'either/or' approach, has a majority in each ethnic group except the Chinese. There are, however, some important differences too.

The longest established groups, the Caribbeans and Indians, have lower acculturative and higher dissociative figures. The Pakistanis and Bangladeshis, often regarded as culturally conservative and separatist, are more likely to think of

themselves as being culturally mixed than some groups. Interestingly, while the 16–34-year-olds thought of themselves as more British (except in the case of African Asians) than some older people, the age group that identified least with Britishness were not the oldest (their position was very similar to the group average), but the 35–59-year-olds, whose disassociation was sometimes twice that of the younger group. While the highest assimilation was registered by British-born Caribbeans (18 per cent), the highest disassociation was expressed by 35–49-year-old Caribbeans (47 per cent), suggesting not only a high degree of intra-group difference but, more specifically, that some of the younger Caribbeans are reviving the assimilative hopes of the earliest West Indian migrants.

Table 9.33 Strategies of self-identification

column percentages

	Caribbean	Indian	African Asian	Pakistani	Bangladeshi	Chinese	All ethnic minorities
Dissociative	32	30	21	26	29	51	30
Assimilative	9	4	5	4	6	6	6
Acculturative	57	65	72	69	66	43	63
Marginal	2	1	2	1	0	0	1
Weighted count	*676*	*544*	*348*	*365*	*115*	*172*	*2221*
Unweighted count	*515*	*529*	*319*	*488*	*232*	*97*	*2180*

There was little gender difference on this measure among Indians, African Asians and the Chinese, but in the other three groups women were about half as more likely than men to be dissociative. With their lower levels of economic activity and facility in English, this is perhaps not surprising for Pakistani and Bangladeshi women, but it is significant in the case of Caribbean women. It is, however, consistent with the gender differences among Caribbean people in connection with use of Patois-Creole, worship in predominantly black congregations, attitudes to mixed marriages and the use of clothes and hair to express ethnicity.

There was no clear class pattern, except that Indians in manual work classes were likely to be more dissociative than other Indians. Indian Hindus were more dissociative than African Asian Hindus, but the reverse was the case for Sikhs. The high level of Chinese dissociativeness is quite surprising and cannot be explained by the fact that only a small proportion of the Chinese are British-born (16 per cent), for the figures for the Bangladeshis and African Asians with whom their length of residence in Britain approximates are still lower (9 per cent and 11 per cent respectively).

CONCLUSIONS

We are aware that in this survey we have explored only certain dimensions of culture and ethnicity. For example, we did not explore youth culture and recreational activities such as music, dance and sport. These cultural dimensions are likely to be as important to the self- and group-identities of some of our respondents, especially

the Caribbeans, as the features on which we gathered data. Moreover, almost all the questions asked in the survey provided indications of how closely people affiliated to their group of origin. We did not explicitly explore ways in which members of the minorities had adopted, modified or contributed to elements of ways of life of other groups, including the white British.

With these important provisos in mind, we can group together the data on some of the cultural dimensions we have examined as a way of achieving an overview of the minority groups and the bases of identity. This is done in Table 9.34 by reference to nine indicators of minority ethnicity or 'difference'. The value for each item in the table is simply a rounded figure from the earlier tables of percentages, so that a score of 9 means that between 85 and 94 per cent gave that answer. The items are listed roughly in the order of items which received the highest 'yes' answers going down to those which received the least.

It emerges that the most common expression of ethnicity is not what people do but what people say or believe about themselves. The overwhelming majority of minority people said they thought of themselves as a member of their minority group. This self-description may involve but is clearly not just a description of distinctive cultural traits. It is primarily an expression of 'whom one belongs with', of membership, and so might be called an associational or community identity and contrasted with aspects of identity implicit in cultural practices or behaviour. As such, it is possible for people to have a sense, even a strong sense, of an associational minority identity without participation in many distinctive cultural practices.

Our additional measures of ethnic identity are based primarily on religion, language, clothes, marriage, schools and visits to country of origin. Out of this limited list, the only items which suggest a sense of distinctive Caribbean identity are visits to the Caribbean and a preference for one's children to be in a school where a quarter or more of the children are African-Caribbean. Both of these, especially the latter, however, are as much associational as cultural. It has already been noted that the survey was limited in probing Caribbean cultural identity. The importance of the associational component of ethnic identity, however, is not simply a by-product of this limitation, as can be seen if we turn to the South Asians.

South Asians do score highly on cultural features such as religion, language and clothes, but the very high scores refer to membership (religion) or to occasional rather than routine participation (clothes, language). While, as we saw earlier, religion was more important to South Asians than to white British people, religious identification among South Asians marks community membership and not just an active sense of religion. We have also seen that, despite the fact that nearly all South Asians have facility in at least one South Asian language, the use of such languages is experiencing some generational decline. As for clothes, Table 9.34 itself shows the radical drop in proportions, especially among men, between those who sometimes wear Asian clothes and those who usually do.

It is important, then, to appreciate that the most widely shared sense of a minority ethnic identity is related only partly to cultural practices, and may not involve routine personal participation in those practices. Table 9.34 also shows, however, that considerable numbers of South Asians participate in distinctive

cultural practices. Here the table indicates only partly what has become clear in the chapter, that in relation to cultural distinctness there is an important division between South Asians. The contrast is between the African Asians and Indians on the one hand, and the Pakistanis and Bangladeshis on the other, especially in relation to the following:

■ religion 'very important'

■ parentally 'arranged' marriages among the young

■ preference for single-sex school for daughters

■ preference for schools of one's own religion

■ wearing of Asian clothes

■ marriage between cousins (mainly Pakistanis).

Some of these differences between South Asians are owing to the fact that Indian and African Asian families have been settled in Britain longer than Pakistanis and, especially, Bangladeshis. Yet, given that Indian families have been settled in Britain not much longer than many Pakistanis, it may also suggest a higher degree of cultural retentiveness or conservation among the Pakistanis.

Table 9.34 Ethnicity as 'difference': an overview

	Caribbean	Indian	African Asian	Pakistani	Bangladeshi	Chinese
Thinks of self as member of ethnic group	8	9	9	9	9	9
Has a religion other than one of the historic Christian churches	1	9	10	10	10	3
Women sometimes wear 'ethnic' clothes/ adornments (figures in parentheses refer to those who usually do)	3(1)	9(5)	9(3)	10(8)	10(9)	–
Men sometimes wear 'ethnic' clothes/ adornments (figures in parentheses refer to those who usually do)	1(–)	6(1)	5(–)	9(1)	8(1)	–
Uses a language other than English	2	9	9	10	10	8
Has visited country of origin of family in last 5 years	4	5	4	6	4	6
Parents chose one's spouse (16–34-year-olds only)	–	2	2	6	5	–
Would like quarter or more of pupils at child's school to be from own ethnic group	5	3	3	5	4	1
Would mind if a close relative were to marry a white person	1	4	3	5	4	1
Does not think of oneself as British	4	4	3	4	4	6

The figures in this table are rounded up or down from percentages in tables in this chapter.

In the earlier study *Changing Ethnic Identities,* we had noted the importance of some of the cultural and familial bases of ethnic identity, as well as the importance of ethnic minority identity to those who described themselves as 'culturally British' (Modood et al. 1994). That study was based on in-depth discussion with a small sample. The much larger sample of this survey gives us the opportunity to examine quantitatively the relationship between the associational and cultural or behavioural elements of identity. We tested the degree of correlation between some of these different elements of identity.

Seven elements of South Asian identity were considered. Three of the topics were concerned with people's daily behaviour: the strength of their commitment to their religion of origin; the clothes they wore; and the languages they spoke. The other four topics were more a matter of opinion: about mixed marriages; about schooling; about how one would describe oneself to a stranger; and about what label one attached to one's identity. These were grouped together as an associational identity. The questions on each topic were reduced to a single measure (for details see Table 9.38 in the Technical Note).

Table 9.35 Correlations between seven potential indicators of South Asian identity

	Clothes	Religion	Language	Marriage	Description	Self-identity	School
Cultural behaviour							
Clothes	–	0.45	0.38	0.24	0.19	0.18	0.16
Religion	0.45	–	0.44	0.21	0.21	0.21	0.12
Language	0.38	0.44	–	0.13	0.14	0.22	0.08
Associational behaviour							
Marriage	0.24	0.21	0.13	–	0.15	0.14	0.21
Description	0.19	0.21	0.14	0.15	–	0.13	0.10
Self-identity	0.18	0.21	0.22	0.14	0.13	–	0.14
School	0.16	0.12	0.08	0.21	0.10	0.14	–

See Table 9.38 for definitions of the seven indicators.

Table 9.35 shows the extent to which the answers to each of the seven question-sets correlated with each other: how far respondents who answered positively (or negatively) on one question gave a similarly positive (or negative) answer to another. Correlation coefficients can range from 0.0 to 1.0; for answers to survey questions, a coefficient above 0.2 is quite interesting, and one above 0.4 very strong. The table shows that the three cultural questions about religion, clothing and language were very closely associated with each other; the average correlation coefficient between these three was 0.42. The four associational or identificational questions were also linked, but much less so; the average coefficient between the four was only 0.15; between them and the four cultural-behavioural questions, 0.17. This means that the importance of religion in one's life, routine wearing of Asian clothes and the use of an Asian language move together; changes in one usually meant changes in another. The other elements of identity are more free-floating, and do not necessarily depend upon or entail a certain profile on other questions. There

were, however, some exceptions to this. Because of the high proportion of Pakistanis and Bangladeshis who gave importance to religion, this correlated less with variations among other elements of identity. Other analyses we did suggested that those with the highest scores of cultural difference were also more likely to object to mixed marriages.

To identify what divided those South Asians who lived in culturally distinctive ways from those whose behaviour is less culturally distinctive, we focused on the three cultural questions. Adding the three together, we calculated which individuals were most likely to ascribe importance to religious observance, to wear Asian clothes and to speak Asian languages. The quarter of the sample of South Asians with the highest scores on this index were labelled as showing a relatively strong cultural-behavioural identity; the quarter with the lowest scores were labelled as having a relatively weak cultural-behavioural identity. The remaining half of the South Asian sample were allocated to a middle category. (It is important to note that the allocation of a quarter of the answers to the strong and the weak cultural identity groups was purely artificial, and is not a finding of the analysis.)

Easily the strongest influence on South Asians' identity, measured in this way, was their age at the time they came to Britain. Getting on for half of those who migrated after they had reached the age of 35 were in the 'strong' behavioural identity group; one eighth of them were in the 'weak' group. In contrast, half of the South Asians who had been born in Britain were members of the 'weak' behavioural category. The interesting feature of the relationship shown in Table 9.36 is that, while cultural identity was clearly differentiated quite finely according to the stage of their childhood that they reached Britain, there was one important divide. Those who arrived before starting school were almost indistinguishable from those who had been born here; those who arrived during the secondary school years were very similar to their immediate elders who came as young men and women. This was true for both of the broad groupings of South Asians, namely, Indians and African Asians, and Pakistanis and Bangladeshis, even though, as the table shows, the latter had at each step a much greater retention of their cultural practices. We do not have the data to explain why there should be this difference between Indians and African Asians, on the one hand, and Pakistanis and Bangladeshis on the other. The fact that the latter are more likely to come from rural backgrounds, and, in particular, from poorer rural backgrounds, is bound to be relevant (Ballard 1990), as are the educational, linguistic and occupational differences between the migrant groups in question (see Chapters 3 and 4). It has been suggested that also relevant are attitudes and practices in relation to gender-roles, marriage and ties of kinship (Ballard 1990) and the sense of 'seige' and 'threat' that some Muslim peoples have historically felt in the context of Western colonialism and cultural domination, and to which rural peoples in particular responded through a 'defensive traditionalism' (Modood 1990).

A strong associational identity among South Asians was, however, much more loosely related to age on migration, as can be seen from Table 9.37. Perhaps the more striking difference between the behavioural and associational identity indices is the much narrower range of distribution between the stronger and weaker associational identities at each step. Taking Tables 9.36 and 9.37 together, it is quite

clear that some second generation Asians (those born or who have grown up in Britain) have moderate or strong associational ethnic identity even where they do not engage in core cultural practices.

Table 9.36 South Asian behavioural identity, by age at migration

	Born in UK	Up to 4	5–10	11–15	16–24	25–34	35 plus
Weak behavioural identity							
Indians and African Asians	60	49	41	26	21	17	17
Pakistanis and Bangladeshis	28	31	16	3	5	15	2
Strong behavioural identity							
Indians and African Asians	4	6	16	24	25	24	35
Pakistanis and Bangladeshis	11	11	33	47	47	52	56
'Strong' minus 'weak'							
Indians and African Asians	−56	−43	-25	-2	+4	+7	+18
Pakistanis and Bangladeshis	−17	−20	+17	+44	+42	+37	+54

Table 9.37 Associational identity, by age at migration

	Born in UK	Up to 4	5–10	11–15	16–24	25–34	35 plus
'Strong' minus 'weak'							
Indians and African Asians	−18	−3	−16	+6	−1	−5	+1
Pakistanis and Bangladeshis	−11	−17	+14	-28	+20	+20	+27
Caribbeans	−3	+12	+14	+24	0	+6	−4

Table 9.37 also contains a Caribbean associational identity index. It displays a clear age correlation, but not a simple linear one. Those who migrated as children and have grown up in Britain seem to have a stronger associational Caribbean or black identity than those who grew up in the Caribbean. Those born in the UK have a relatively weaker Caribbean or black identity, but may have a stronger ethnic group identity than their Asian peers.

It suggests that the Caribbean or black associational identity was not something brought over from the Caribbean but developed in Britain, especially among the Caribbean-born children of migrants. This middle-generation of Caribbeans seems to have felt a considerable degree of racial rejection (see, for example, Carter, 1986) and, as we have seen in this chapter, has developed, particularly the women, an ethnic distinctiveness through the black churches, Patois-Creole and use of hair and dress – and, no doubt, in other ways outside the scope of this chapter. At the same time the processes of assimilation and 'racial' mixing seem also to have developed, evidenced for example in the high levels of Caribbean–white partnering, initially by Caribbean men, but now also by women (Chapter 2). Hence, while the Asians present a relatively linear process of declining cultural distinctiveness, the development of a black or Caribbean identity in Britain is more complex and seems

to contain more internal contrasts and tensions, as evidenced in the fact that nearly half of the 35–49-year-olds do not think of themselves as British, and one in six of British-born Caribbeans do not think of themselves as being part of an Afro-Caribbean ethnic group (see previous section)

These generational shifts, particularly the Asian change, in cultural practices and their implications for a shift in emphasis from a more cultural practices based identity to a more associational identity confirm the findings of *Changing Ethnic Identities*. There we distinguished between the cultural content of an ethnicity and strategies of ethnic self-definition (what people call themselves). We found that while for the migrant generation the two were intimately linked, for the second generation the two were more loosely connected. Ethnic identity for the second generation was very important but was influenced by a number of factors. Their cultural practices did not just reflect the influence of their families but were acquired from the wider British society shared with the white British. In discussing their ethnic identity some young South Asians explicitly affirmed what they took to be the family-centred and religion-centred values of their community; some recognised the efforts of parents, family and community in providing the second generation with its educational and economic opportunities. Yet for many the strength of their ethnic identity was owed to a group pride in response to perceptions of racial exclusion and ethnic stereotyping by the white majority. The consequent sense of rejection and insecurity was instrumental in assertions of ethnic identities, often in forms susceptible to forging new anti-racist solidarities (such as 'black') and hyphenated (such as British-Pakistani) or even multiple identities.

The ethnic identities of the second generation may, then, have a weaker component of behavioural difference, but it would be misleading to portray them as weak identities as such. In the last couple of decades the bases of identity-formation have undergone important changes and there has come to be a minority assertiveness, as described briefly in the introduction to this chapter. Identity has moved from that which might be unconscious and taken for granted, because implicit in distinctive cultural practices, to conscious and public projections of identity and the explicit creation and assertion of politicised ethnicities. This is part of a wider socio-political climate which is not confined to race and culture or non-white minorities. Feminism, gay pride, Quebecois nationalism and the revival of Scottishness are some prominent examples of these new identity movements which have come to be an important feature in many countries in which class-politics has declined. Identities in this political climate are not implicit and private but are shaped through intellectual, cultural and political debates and become a feature of public discourse and policies, especially at the level of local government. The identities formed in such processes are fluid and susceptible to change with the political climate, but to think of them as weak is to overlook the pride with which they may be asserted, the intensity with which they may be debated and their capacity to generate community activism and political campaigns. In any case what is described here as cultural practices-based identities and associational identities are not mutually exclusive. They depict ideal types which are usually found, as in this survey, in a mixed form. Moreover, a reactive pride identity can generate new cultural practices or revive old ones. We reported, for example, in *Changing Ethnic*

Identities that for some Caribbean people a black identity meant a reclaiming of the African-Caribbean cultural heritage and had stimulated a new interest in Patois-Creole languages. Even where associational ethnicity is seen to be largely symbolic and an 'ethnicity of last resort', as in the case of white minorities in America, such as American Jews, it is still argued that, even in the absence of racism, it 'could nevertheless persist for generations' (Gans 1979, 1). An important strand in contemporary sociology of identity in fact emphasises that minority identities are continually changing and reinventing themselves through fusing with elements of majority cultures and that this process of mixing, of hybridisation, will increasingly be the norm where rapid change and globalisation has made all identities unstable (Hall 1992; for a debate see Werbner and Modood (eds) 1997). It looks, therefore, as if the minority cultures described in this book may be long-term features of British society, but the ways in which minorities conceive of themselves and the cultural syntheses that are taking place are various, changing and generating new mixed forms of ethnicity.

TECHNICAL NOTE (referred to on page 334)

Table 9.38 Definitions of the seven elements of South Asian identities

Topic	*Maximum*	*Minimum*
Clothing	Wears South Asian clothes all the time.	Never wears South Asian clothes.
Religion	Religion 'very important' to way of life; and religion is Muslim, Sikh, Hindu or Jain.	Religion 'not at all important' or religion is not Muslim, Hindu, Sikh or Jain.
Language	Speaks South Asian languages in all three circumstances (see Table 9.15).	Does not speak any South Asian language.
Marriage	Most people of own group would mind very very much if close relative married a white; and respondent would also mind very much.	Neither respondent nor other members of group would mind at all.
Description	Would mention religion, ethnic group, country of origin and colour of skin in describing self to stranger; and two of these are the most important two.	Would not mention any of these things.
Self-identity	Strongly agree that 'I think of myself as [ethnic group]'.	Strongly disagree.
Schooling	Would prefer to send child to school where more than half are from own ethnic origin; and this would be a very important influence.	Ethnic mix would be of no influence in choice of school.

1 Because women wore Asian clothes far more often than men did, the clothes measure was scaled separately for men and women. This forces men and women to have similar positions on the overall index.
2 The language measure is based entirely on use of Asian languages, and does not necessarily reflect fluency in English.

Conclusion: Ethnic Diversity and Disadvantage

Tariq Modood

It is appropriate to start our review of the findings of the Fourth National Survey by assessing the long-term progress, or lack of progress, made by ethnic minorities in the key dimensions of socio-economic disadvantage identified by the first three studies. The first section outlines the main issues as they appeared to our predecessors; the second summarises the outcome in the 1990s for different ethnic groups; and the third discusses the processes underlying the emerging diversity. We then review other issues, including some analysed in detail for the first time on this occasion: health, racial exclusion and cultural identity. The final section of this concluding chapter focuses on the challenge of formulating a new ideal of multicultural citizenship in Britain.

ETHNIC DISADVANTAGE FROM THE 1960s TO THE 1980s

The first three surveys were concerned mainly with a concept of social and economic disadvantage in such areas as education, employment and housing. These issues are the focus of the first half of this chapter.

At the time of the First Survey, conducted in 1966 (Daniel 1968), the West Indian migration was almost complete, but only about a third of those who were to come from India and Pakistan had arrived, and very few African Asians and Bangladeshis (or East Pakistanis as they were until 1971) had yet come to Britain. Among the Caribbeans there were the same numbers of men and women, but among the Asians men outnumbered women three to one. The survey found that the migrants were overwhelmingly in manual work, certainly in jobs below the level to which they were qualified, and confined to a limited number of industries (Daniel 1968, 61–3). Some employers flatly refused to employ any 'coloureds', and generally the Caribbeans and Asians were employed only where there were insufficient white workers to fill the posts.

The survey also found widespread, often overt, exclusion from access to rental accommodation and houses for sale. Less than 1 per cent of the migrants were in council housing, while there was evidence of great difficulty in obtaining a mortgage loan on anything like normal terms. The result was that these groups were in the

worst available private rented housing in slum areas that white people were vacating, and this led to a degree of racial segregation (Daniel 1968, 220-22).

The objective tests suggested that 'colour' was the focus of discrimination, and that darker groups suffered the worst discrimination, so that, it was conjectured, suitably educated Asians might progress upwards over time, but there was a real danger that a new proletariat defined by colour would be formed (Daniel 1968, 209, 218).

By the time of the Second Survey in 1974 (Smith 1977), following further migration, family reunification and entry of Asian refugees from East Africa, Asians had a numerical superiority over Caribbeans, but Asian men still outnumbered women by six to four. There were still very few ethnic minority people in professional and managerial jobs. Many had penetrated into the better, skilled manual jobs, though all the minority groups were disproportionately concentrated in semi-skilled and unskilled manual work (Smith 1977, 73–4).

Objective tests showed that, despite the legislative changes, a similar level of discrimination persisted: in one in three cases, where a white man and a non-white man applied for a job, only the white man was offered an interview or a job. There was, however, little difference between the minority groups in this regard (Smith 1977, 120).

New data on qualification levels from the Second Survey showed that there was great diversity among the ethnic minorities. Even after allowing for the possibility that overseas qualifications might be seen to be rather less valuable than British ones, Asians were well represented at A-level or above, but men more so than women, and African Asians and Indians more than Pakistanis. Two-thirds of Pakistani men had no qualifications, and in this respect they were like Caribbean men rather than the other Asians. Very few Caribbeans had attained A-level or higher, but men and women were about equally qualified (Smith 1977, 58-9). While the Caribbeans were fairly homogeneous, there was stark polarisation between and within Asian groups. The majority of Asian women, and about a third of men, could speak English only slightly or not at all. Yet:

> there is, among Asian men, a substantial proportion who are qualified for professional or white-collar jobs, but very few indeed who are qualified for skilled manual jobs; on this basis, we might expect to find a polarization between those doing non-manual jobs and those doing the least attractive unskilled manual jobs. Among West Indians, on the other hand, there are few men qualified to do non-manual jobs, but a substantial number who have training for one of the better manual jobs. (Smith 1977, 58-9)

What is particularly important to note is that the process of movement up the jobs hierarchies in line with qualifications had not gone very far by 1974. Thus, for example, a fifth of all ethnic minority men with degrees of British standard were in manual jobs.

The ethnic minorities continued to be in cheaper, older inner-city properties and were more overcrowded and had poorer amenities than white people. Yet between 1966 and 1974 important changes had taken place as regards housing tenure. The Caribbeans had become owner-occupiers and council tenants at a rate which brought

them up to parity with whites, namely, half of households were owner-occupiers, a quarter in council housing, and a quarter in private rental accommodation. Only 4 per cent of Asian households, however, were council tenants, but three-quarters had become owner-occupiers. While the massive increase in home ownership was partly a result of exclusion from desirable rented accommodation, and the quality of the homes they had bought was on average poor, home ownership was a goal in its own right, at least for Asians. While the proportion in owner-occupation among Caribbeans reached half only among those who had been in Britain ten years or longer, four-fifths of Asians who had been in Britain five years or more owned their own home in 1974 (Smith 1977, 22). This suggests a much higher priority on home ownership or a much higher rate of saving on the part of Asians, or both.

The Third Survey, which took place in 1982 (Brown 1984), was at a low point in a severe and protracted economic recession which affected particularly the labour-intensive manufacturing industries in which some ethnic minorities worked, and so created massive and disproportionate unemployment among them. While Indian and African Asian men had a similar rate of unemployment as whites, unemployment among the other minorities was twice as high.

Nevertheless, some of the trends identified in the earlier surveys were also visible. There was some movement up the jobs ladder for minority men, especially for the better qualified, young people and African Asians. The minorities were still concentrated in a limited number of occupations and industries. But Asians who were fluent in English were no longer in manual work, though they still fell far short of work appropriate to their qualifications. There was some improvement in the earnings of ethnic minority men relative to whites, but ethnic minorities were still more likely to work shifts, less likely to supervise, and, with the exception of Caribbean women, received lower wages.

The late 1970s had seen the take-off of Asian self-employment, partly as a direct response to the economic downturn and the block on mobility into higher paid work. While in 1974 only 8 per cent of Asians were self-employed compared with 12 per cent of whites (Smith 1977, 92), by 1982 the percentages were 18 and 14 respectively (Brown 1984, 165). This no doubt contributed to the relatively low rate of unemployment among Indians and African Asians at that time and subsequently.

Unemployment and low wages widened the gulf between whites and minorities when households were used as the basis of comparison. One in five Asian households had no wage earner, compared to one in 12 white families; in families that did have at least one earner, each Asian worker supported 2.8 other people, compared with the 1.8 supported by whites (Brown 1984, 300).

The Third Survey found that a fifth of Asian men and nearly half of Asian women spoke English slightly or not at all, though, as before, the proportions were much higher among Pakistanis and Bangladeshis than among the African Asians and Indians. That the proportions should have been as high as this in 1982 was mainly because of the continuing flow of new arrivals (Brown 1984, 314). The qualifications polarity between Asians was as evident as before, though the gender gap was beginning to narrow. The survey found that Asian young people were orientated to an academic educational route, while the Caribbeans tended to opt for vocational training. Despite this heterogeneity, education had clearly emerged as a major

commitment among all ethnic minority groups: in each group both sexes had a higher rate of staying on in post-16 education than among whites, except for Caribbean males, who had the same rate as their white peers (Brown 1984, 313).

The private rented housing sector had shrunk considerably between 1974 and 1982. For white people this corresponded with a rise in home-ownership, whereas for the Caribbeans the increase was in council and housing association accommodation; among Asians, home-ownership remained high, but they had also begun to be council tenants. Regardless of tenure, the quality of housing enjoyed by ethnic minorities was not equal to whites, but it was improving as renters moved into social housing and home-owners moved to better houses (Brown 1984, 307). These movements tended to be within the same areas, so that even though the ethnic minority population grew by 60 per cent between 1974 and 1982, the proportional distribution of the ethnic minorities in the country changed hardly at all (Brown 1984, 310).

In 1974 Asians and Caribbeans who thought that life in Britain had improved for their ethnic group in the past five years had greatly outnumbered those who thought the opposite (Smith 1977); in 1982 this had reversed (Brown 1984, 277). Pessimism was, perhaps, associated with the recession. Looking beyond a five-year time-span to, say, a 20-year period might have suggested that qualifications, and the changing climate of opinion, as reflected in legislation, were capable of loosening the barriers of discrimination and altering the initial allocation of migrants to the bottom of the pile; and self-employment offered an alternative to racism and poor prospects in the jobs market. But for those who did not have qualifications, or who were not in a position to set up their own business, the prospect of reversing disadvantage looked bleak: after nearly two decades of political concern, the minorities continued to be in low-status and low-paid work, and now to be disproportionately out of work.

ETHNIC DISADVANTAGE AND PROGRESS IN THE 1990s[1]

Much of the analysis in the main chapters of this book has shown diversity and divergence between ethnic groups.

- Pakistanis and Bangladeshis are consistently at a disadvantage with respect to white people, and often with respect to the other minorities. Their position of serious disadvantage is described first.

- People of Caribbean and Indian origin (excluding African Asians) are often found to experience disadvantage, though it is usually less serious for these groups than for Pakistanis and Bangladeshis. These two groups occupy a middle position, though are dissimilar in the details of their circumstances.

- Chinese people and African Asians have reached a position of broad parity with the white population – behind on some indicators perhaps, but ahead on others. It would not be appropriate to describe them as disadvantaged groups. Their findings are discussed at the end of this section.

1 The results of the 1994 survey have been reported in the past tense in the previous chapters. We now switch to the present tense to compare the current situation with previous decades.

Pakistanis and Bangladeshis: serious poverty

The Pakistanis and, especially, the Bangladeshis continue to be severely disadvantaged. While the men in these groups have experienced some improvement in their job levels since 1982, it is from a very low base. They continue to be disproportionately in manual work, with twice as many in manual work as in non-manual work, while white men are now evenly split between these kinds of jobs. Indeed, Pakistanis are twice as likely, and Bangladeshis more than five times as likely, as white men to be in semi-skilled manual work. Self-employment reduces these ratios a little, but, even so, Pakistani and Bangladeshi men are less than two-thirds as likely to be professionals, managers and employers as white men. They are less than half as likely to supervise staff, and as employees have only two-thirds the pay packet of white men, and as self-employed only three-quarters of the incomes of whites.

While the Bangladeshis are strongly represented in self-employment with employees, this is owing largely to their concentration in one business, namely, restaurants. Self-employment among Bangladeshi men is half as common as among white men; Pakistani men on the other hand have the same rate of self-employment as white men. For both these groups, though, self-employment is relatively more important than it is for whites because so few of them have jobs as employees.

Bangladeshi and Pakistani men had unemployment rates of about 40 per cent in 1994. This was the highest of all groups; more than two and a half times higher than white men.[2]

Only a third as many Pakistani women and only a tenth as many Bangladeshi women are in paid work compared with other women. This is the probably the single most important economic division between women from different ethnic groups. It is a result of very low levels of economic activity as well as very high levels of unemployment among these two groups of women.

The full scale of the economic plight of the Bangladeshis and Pakistanis becomes apparent when one analyses household incomes and standard of living. The new data reveal that there is severe and widespread poverty among these two groups. Thus more than four out of five Pakistani and Bangladeshi households have an equivalent income below half the national average – four times as many as white non-pensioners.

Pakistanis nevertheless continue to have high levels of home-ownership. The proportion of Bangladeshis who own their own house is still low, though it has increased since 1982; many of them rent from councils or housing associations. Regardless of tenure, however, and despite the general improvements in amenities and accommodation space, Pakistanis and Bangladeshis continue to be the worst housed, and, when owners, continue to be concentrated in terraced housing. They are also still disproportionately located in inner-city areas, and are the most residentially segregated of all groups. Six out of ten Bangladeshi women, nearly half of Pakistani women and more than a fifth of the men in these groups do not speak or have only limited English. In each case this is much higher than for other Asians.

2 The unemployment rates in our studies are based on a broader definition of unemployment than the ILO definition (see Chapter 4, page 89).

Indians and Caribbeans: good news and bad news

The circumstances of these two groups are far from identical. The point of grouping them together is that they occupy a middle position: their circumstances are better than those of the Bangladeshis and the Pakistanis, but they continue to experience some disadvantage. By some measures one or the other of these groups can be as poorly placed as any group studied here, but by other criteria they may have parity with the white population.

Job levels are a case in point. Caribbean men have a similar manual work profile to the Pakistanis and, despite some progress, are less likely to be professionals, managers and employers than Pakistanis. Indian men on the other hand are distinctly better represented in that category, as well as in more junior non-manual work. While of all men they have probably made the most progress up the jobs hierarchy in this period, Indians remain disadvantaged compared with white men. Yet Caribbean male employees are slightly better placed than Indians in relation to supervisory duties and earnings, with Caribbeans averaging just over 90 per cent, and Indians 85 per cent, of white male employees' earnings.

The position of Caribbean women relative to white and other women is much better than that of Caribbean men compared with other men. For though Caribbean women are much less likely to be in senior non-manual jobs than white women, they are also much less likely to be in manual work (or part-time work). In fact, of all groups, Caribbean women are most likely to be in intermediate and junior non-manual posts. Indian women, by contrast, are more likely to be in manual work – in fact they have a similar jobs profile to the Pakistanis. Despite these differences, Indian and Caribbean women have slightly higher average earnings from full-time work than white women, and Caribbean women are also more likely to be supervisors. These are not new developments, for the same was true in 1982; then, as now, Caribbean women averaged the highest female earnings (the Chinese female earnings may be higher: the sample size is too small for confidence). The Indian average earnings, however, hide a polarisation: Indian women were twice as likely as white women to be earning less than £115 per week in 1994, but were also three times as likely to earn more than £500 per week.

The gender asymmetry in the comparisons between these two minority groups and whites does not manifest itself so much in unemployment. Indian men and women were nearly a third more likely to be unemployed than whites in 1994; Caribbean men and women had double the white unemployment rate. The unemployment rate of younger Caribbeans, especially men, is a particular cause of concern.

Self-employment is a further point of divergence between these two groups. While Caribbeans have the lowest rate of self-employment, the Indians have among the highest. Caribbean men are half as likely and women a quarter as likely to be self-employed as whites, while the proportion of Indian men and women who are self-employed is 50 per cent higher than whites. However, both Indians and Caribbeans on average achieve higher financial returns from self-employment than their white counterparts. Combining employees' and self-employed earnings still leaves these two groups below white men, but self-employment considerably

increases the opportunities of Indian and perhaps Caribbean men (the sample size is relatively small) to earn more than £500 per week.

The average Indian household has a slightly higher total income than a white household, but this is largely only because the white population includes many more pensioners. If pensioners are excluded, Indian households are 8 per cent worse off than whites. By the same measure, Caribbean households are as much as a quarter worse off than whites. This is certainly because of the high proportion of lone parent Caribbean households. Yet even among non-pensioner, non-lone-parent households, once household size is taken into account, Caribbeans have one and a half times and Indians twice the poverty rate of whites.

Despite these inequalities, Indians have significantly improved their position in the housing market. They have added to an already high rate of home-ownership, and are now as likely as whites to occupy detached or semi-detached properties. The Caribbeans, from a low base, have increased their level of home ownership. Many younger Caribbeans, however, rent in the social sector. Though improvements are discernible, both these minority groups experience housing disadvantage relative to white people in terms of quality of areas and of accommodation.

African Asians and Chinese: upward social mobility[3]

African Asian men are as likely as white men to be professionals, managers and employers, and Chinese men half as likely again. Chinese women are nearly twice as likely as white women to be so placed, though African Asian women are only three-quarters as likely. This is reflected in the employee earnings of these minority groups, which are now equivalent to those of white men and women.

Similarly, African Asians and whites have similar rates of unemployment, and the Chinese have the lowest of any ethnic group. The position of these two minority groups in the economy certainly owes something to self-employment, for both have among the highest rates and report better financial returns than whites.

A comparison of non-pensioner household average incomes confirms this picture, showing the African Asians to be only slightly worse off than whites and the Chinese to be the best off of all. Income distribution among the minority groups, however, is more polarised. For example, African Asian employees are much more likely than whites to be earning more than £500 per week in 1994, and African Asian and Chinese self-employed more likely to be making profits of £500 per week. Conversely, once family size has been taken into account, more African Asian and Chinese than white households are in poverty.

The African Asians still have an above-average proportion of households in poorer accommodation and in less desirable areas. There have, however, been considerable improvements, and, like the Indians, they have increased an already high rate of home ownership, and are now as likely as whites to own and live in detached or semi-detached houses. The Chinese, despite their high income levels,

3 Our findings for the Chinese are broadly consistent with the 1991 Census and the LFS, but our relatively small sample size makes our findings indicative rather than conclusive.

have a low rate of home-ownership, and are concentrated to a surprising extent in poor quality rented accommodation.

PROGRESS AND ITS LIMITS

The trends identified by the earlier surveys seem, then, to continue. On the one hand, there is some improvement for most groups by most measures, and roughly along previous lines. The disadvantaged location, exacerbated by the loss of manufacturing jobs from the mid-1970s, has not entirely disappeared for any of these minorities, but it continues to characterise strongly only some of them. These two features, improvement and persisting disadvantage, were also simultaneously present in the previous decades and applied to different groups in different degrees, but the cumulative effect has been to deepen socio-economic divergence.

This divergence is reflected in whether people thought that life in Britain had got better or worse for their ethnic group in the previous five years. This is about a general sense of well-being (or lack of it), and may reflect as much the mood prevalent in the country as any thing specifically to do with race relations. It is worth bearing in mind, therefore, that the economy performed well in the late 1980s, but unemployment rose again between 1990 and the end of 1993. So 1994 was not a time of deep gloom, but the 'feel-good factor' was still proving elusive. What is interesting is that, while in 1974 there was optimism in each of the minority groups, and in 1982 there was across-the-board gloom, there was no such uniformity in 1994. About a third in all groups thought that the previous five years had not resulted in any change for their group. Of the remainder, Indians and African Asians were evenly divided on whether life for Asians in Britain was better than it was five years ago, while twice as many Pakistanis and Bangladeshis thought it had got worse than thought it had got better. The Caribbeans were mid-way between the Asian groups, thus revealing a three-way split roughly corresponding to the actual fortunes of the various groups in the previous decade.

Having emphasised divergence, it is important to add something missing from the previous section. The survey found one important point in common between all the ethnic minorities. Men from all minorities are seriously under-represented as managers and employers in large establishments. These represent the top 10 per cent of all jobs in terms of status, power and earnings. Even the best-off minorities are only half as likely to hold these top jobs as white men. Even so, the minorities are better represented in these top 10 per cent of jobs today than they were in the top 25 per cent of jobs in 1974. While some minority groups are better represented in professional occupations than white people, there may nevertheless be a 'glass ceiling' effect, holding back all groups that are not white. Insofar as there is a continuing 'black–white' boundary in employment today, this is where it may be said to be. It is partially compensated by the success in self-employment that some groups have achieved: the Chinese, African Asians and Indians combined are almost twice as likely as whites to make profits of over £500 per week.

Education offers another example of similarity between the minorities. While attainment levels and progress are uneven, all minority groups have responded to

their circumstances and to discrimination in the jobs market by staying on in or returning to post-compulsory education. Moreover, relative to group starting-points, the greatest progress in getting qualifications has been made by women and by Caribbean men. Qualification levels continue, however, to vary between groups. For example, the Chinese, African Asians and Indians are much more likely to have degrees than white people, while Bangladeshis and Pakistanis, especially women, are much less likely than whites to have any qualifications at all. Educational achievement, therefore, encapsulates the twin phenomena of progress and disadvantage. Perhaps the most important point here is that the progress at least partly reflects the varied educational profile of the migrant generation.

The second report's expectations (quoted above) about the consequence of education for the employment prospects of different groups seem to have proven true. The qualifications, job levels and earnings spread in 1994 are roughly what one would have predicted from the spread of qualifications in 1974, if racial exclusion was relaxed. Those ethnic groups that had an above-average middle-class professional and business profile before migration seem to have been able to re-create that profile despite the occupational downgrading that all minority groups initially experienced.

Our chapter on employment showed that ethnic minorities are still to some extent in jobs below their qualifications levels, but that some minority groups are more likely to be in professional occupations than their white peers, and the possession of qualifications, especially higher qualifications, strongly shaped earnings in 1994. The growing influence of qualifications on employment is therefore one of the factors in the reduction of racial disadvantage. An increase in educational achievement does not guarantee socio-economic equality, but it seems to be a prerequisite. It has the potential to feed directly into job levels and thence to earnings, to household income, and thus to housing, health and standard of living. These effects take different periods of time (entering a professional career will bring those other improvements in its train rather than on day one), but all can be seen in this survey to be taking place for some groups. Or, sometimes, for parts of groups: internal polarisation means that Indians, and perhaps other South Asians, are well represented simultaneously among both the prosperous and the poor. Indians are nearly twice as likely as whites to be financially in the top seventh of self-employed, and yet also twice as likely as whites to be in the poorest fifth of non-pensioner households.

It is worth pointing out that qualification attainment levels have depended not just upon the minorities themselves. They have, for example, depended also upon how white people – especially teachers, but also white peers, employers, sporting fraternities, the music and fashion industries, the police and so on – have identified the characteristics of various minorities and encouraged or excluded them in respect of various spheres of activity. There is considerable evidence that, for example, teachers, fellow pupils and others have encouraged black males to excel in sports and discouraged them from commitment to academic goals (Gillborn 1990). Young black men have been stereotyped as violent and disruptive, challenging the authority of teachers and the police; or they have been praised and emulated as macho, 'cool' and exemplars of youth culture (Cohen 1993; Boulton and Smith 1992; Back 1993). It has recently been argued that young black men's success as leaders of youth

cultures and fashion has been socially self-defeating for it has taken them away from a 'classroom culture' to a 'street culture' (Wambu 1996).

South Asians' perceived commitment to classroom discipline and academic goals has made them particularly vulnerable to racial harassment at the hands of fellow pupils, but it has also made them more attractive to teachers (Gillborn and Gipps 1996, 49–50, 56–7). Hence minority groups have been stereotyped, often in contrast to each other, in ways which have a positive as well as a negative dimension (Bonnett 1993, 25–6). Insofar as ethnicity is a factor in explaining the various minorities' qualifications profile, it is an interactive ethnicity, shaped partly by and in reaction to white people, institutions and society. Nor has it just depended upon race relations. Ethnic minorities' access to higher education has been assisted by the major expansion in the number of places available in the system.

If qualifications, and in particular the proportion of a group with degrees, are as important to the socio-economic advancement of ethnic minorities as our analysis suggests, then the qualifications profile of the young and admissions into higher education give a strong hint of the kind of socio-economic profile we should expect in ten or 20 years' time. This survey found that ethnic minority men aged 16–24 who already had some qualifications are nearly three times as likely as white men, and ethnic minority women more than one and a half as likely as white women, to be in full-time education. This applies to the disadvantaged groups, especially the Pakistanis and the Bangladeshis, as much as to those whose adult members have been relatively successful. Recent admissions data for higher education show movement in the same direction: for example, in 1994 nearly twice the proportion of young Pakistani men entered university as white men. Yet among men aged 16–24 this survey also found that twice as many Pakistani men were without an O-level equivalent GCSE pass as white men. Other research continues to show that young Caribbean men experience disproportionate problems in school (Gillborn and Gipps 1996). We found that younger Caribbeans have very high rates of unemployment, especially if they have no qualifications. So there is a continuing pattern of disadvantage and advantage not just between the ethnic minorities but within them too.

If the progress of ethnic minorities has depended on their studying harder and longer than their white peers, it has historically also depended on their working harder and longer in their jobs. Previous surveys in the series showed that ethnic minority employees worked longer hours, and were more likely to work shifts, than white employees. While this survey suggests that neither of these may any longer be true for employees, women from some ethnic minority groups are more likely to be working full time or to be looking for full-time work. This is especially true of Caribbean women; the exceptions, of course, are Pakistani and Bangladeshi women.

The high representation of most of the Asian groups in self-employment are a part of the same phenomenon. We have already noted how self-employment has helped some groups either to cope with unemployment or to increase their earnings. Typically the full-time self-employed work much longer hours than employees (Butcher and Hart 1995, 220), and a secondary study of a sub-set of South Asian self-employed from the survey found that more than a quarter worked more than 60 hours a week (Metcalf, Modood and Virdee 1996, 88). The same study also found

that self-employment depended (like education) on supportive families, and may have supplied, in turn, support for family members who used it as an inter-generational 'springboard' into the professions. The tangible and aspirational support that people are able to give each other, not least to maintain a culture of hope and improvement, may be critical. Perhaps the unit of analysis, especially for the South Asians, should be families rather than individuals. Certainly, our follow-up study found that Asian self-employment was not determined simply by exclusionary and financial factors but also was sought for the status it conferred on the self-employed among family and community members, and in addition was influenced by motivational factors affected by religion (Metcalf, Modood and Virdee 1996).

Of course group characteristics and motivational factors do not by themselves determine economic outcomes. Other things being equal, period of settlement in Britain must be a factor, though it clearly does not outweigh other influences. Comparing whole groups, the Caribbeans have been here longest, but are only in the middle of the rankings; the Chinese and Bangladeshis arrived most recently, but one group is prosperous and the other very poor. Nor have we systematically found that, within groups, people who were born in Britain reached higher in the socio economic scale than those who had migrated either as children or as adults. Nevertheless, it has been seen how most forms of disadvantage have diminished from decade to decade. Given in particular the relative similarities between Pakistanis and Indians – in their family structures at the time of migration, their reasons for coming, the propensity for home-ownership and family-orientated life styles, willingness to take up self-employment and so on – it may be thought quite likely that Pakistanis will follow a similar trajectory to the Indians, perhaps a decade later. The recent rise in the proportion of young Pakistani university entrants might be seen as an indication of this. The important point to be made here is that if the hypothesis of a common trajectory proves to be true, it will be because of group similarities and not just time.

As a matter of fact there have been some important differences in the circumstances of different Asian groups that seriously qualify the idea of a common trajectory. It is a difference that points to the importance of economic divisions, especially geographical, in Britain. More so than any other group the Pakistanis settled in northern textiles towns, and were particularly dependent upon manual jobs in those towns. The rapid shrinking of the textile and related industries in those locations in the late 1970s and early 1980s had a particularly adverse effect upon the Pakistanis. In contrast, the Indians, and especially the African Asians, seemed to have suffered much less from the economic restructuring. Indeed, African Asians, and to a lesser extent the Indians, being predominantly London and South-East based, seem to have benefited significantly from the development of the service sector in that region. The Caribbeans, too, are mainly in London and the South-East, though they are more likely to be found in the poorer run-down parts of the region. Nevertheless, the Caribbean concentration in the London area means, as discussed in Chapter 4, that the group experienced economic change differently from the Pakistanis. High unemployment came relatively suddenly for the Pakistanis and meant job losses for those in work, especially middle-aged men; for the Caribbeans it built up more slowly and affected primarily successive cohorts of school-leavers

looking for work. Economic geography is relevant to the plight of the Bangladeshis too. For while they are based in the prosperous South-East, they are overwhelmingly concentrated in the borough of Tower Hamlets, an area offering few new opportunities for low-skilled workers.

A further factor which may account for the diverging fortunes of different groups is differential discrimination. This was discussed in Chapter 4, and we have noted above the fact of differential stereotyping and its possible effect on educational attainment levels. There is some evidence of differential prejudice, in which white society perceives and relates to different minorities in different ways – prejudice which some minorities can have of others (IPPR 1997). The dividing line seems to be primarily between Caribbean and Asian people; there is a new antipathy towards Muslims but it is unclear to what extent it is in practice distinct from a generalised anti-Asian sentiment (Modood 1997). There is, however, no hard data on whether differential stereotyping affects discrimination in employment. In the past, discrimination testing has indicated few differences between members of different non-white groups. Nevertheless, the rise of an anti-Muslim prejudice is a worrying development which could exacerbate the disadvantage of the Pakistanis and Bangladeshis and prevent the formation of goodwill required to act against their chronic disadvantage.

On a more positive note, it is worth recognising that the progress of at least some minority groups suggests a relative, if belated and only partial, openness in British society. Cheng, for example, found that Chinese migrants in Britain were just as likely as native white Britons to achieve higher level posts, and that this was comparable with the achievements of Chinese migrants in the USA (Cheng 1994). Other non-white groups in Britain did not enjoy this equality of opportunity, and a similar exercise with the 1991 Census data found, as we saw in Chapter 4, that even the Chinese suffered an 'ethnic penalty' (Heath and McMahon 1995). But there are signs that this country combines continuing racial exclusion with gradual racial openness. At the time of the first survey, Daniel wrote of the danger of the formation of a new proletariat defined by colour (Daniel 1968, 218). That has not come to pass, but there are inter-generational proletarian formations directly linked to ethnic and racial disadvantages.

One of the most important tests of race relations policy will be whether the jobs commensurate with increasing qualifications will be achieved, and whether the glass ceiling is cracked. But neither result will improve the circumstances of those unable to run up the ladder of qualifications.

It has already been mentioned that poverty in some South Asian minority groups is linked to their internal polarisation. This is also true of Caribbeans. While many members of that group seem to have escaped from disadvantage, others are probably worse off in some ways than their equivalents surveyed 20 years ago. Young black men are disproportionately without qualifications, without work and a stable family life and (not researched here) disproportionately in trouble with the police and in prison. Many young black women are in work, with earnings higher than white women's; but they are disproportionately likely to be lone parents, with direct implications for household incomes, while other lone mothers are unemployed and in social housing – with all that implies for poverty. While for most groups disadvantage may be

diminishing across the generations, this is less clearly the case for the Caribbeans. It would therefore be naive to expect racial disadvantage simply to wane over time. Some problems require targeted intervention to reverse trends. It should also be recognised that these same problems are also growing in white British society, so the disadvantage at issue is not a simple white/black divide.

The diversity at issue, then, suggests that the promotion of economic racial equality requires, beyond anti-discrimination enforcement, not one set of policies but three. Different sets of policies need to focus on:

(i) the glass ceiling (increasing the representation of the ethnic minorities in the top 10 per cent of jobs);

(ii) the circumstances of the disadvantaged South Asians, especially Bangladeshis and Pakistanis;

(iii) the circumstances of the disadvantaged Caribbeans, especially young men.

HEALTH: NEW TOPIC, SIMILAR FINDINGS

This is the first time that detailed information on the health of the ethnic minorities has been available from a large, fully representative national survey. It shows that the relative health of groups follows the general socio-economic pattern. The Chinese, African Asians and Indians have a similar state of health to that of whites, and the Bangladeshis, Pakistanis and Caribbeans have poorer health than whites. The analysis shows that the categories used in previous surveys ('Black' or 'Asian') are extremely misleading because they combine minorities with very different health profiles. They thereby suggest that some 'healthy' groups have poor health and, most importantly, obscure the extent of the unhealthy circumstances of the worst-off groups.

We also found some medical conditions which are more prevalent in some groups than in others. Pakistanis and Bangladeshis are more likely to have heart disease symptoms than anyone else. The relative risk of diagnosed hypertension among Caribbean women is much higher than for other men and women. Diabetes is one condition that all minority groups seem to suffer more than whites; while white people and Caribbeans are more prone to respiratory problems than other minority groups.

Nevertheless, the main finding was that the health differences between ethnic groups follow socio-economic contours. The differences seem to be less connected to the distinctive cultural practices of each group than to divisions in employment, income and standards of living. The more we can refine our economic measures, the stronger the correlation between ill-health and disadvantage appears to be.

RACIAL PREJUDICE AND EXCLUSION

There are several indicators suggesting that British society, both white people and minorities, believes to an increasing extent that there is racial prejudice and discrimination. Most people think that employers discriminate, and many members

of minority groups think that they personally have been discriminated against. Increases in these beliefs since 1982 have been greatest among South Asians - the group which was least concerned about the issue in the previous survey. It is not clear, however, that increased reports of discrimination represent a change in the actual extent of discrimination rather than a rising level of consciousness. Objective tests show that it is still common, but no more so than in earlier periods (Brown and Gay 1985; Simpson and Stevenson 1994). Nor does there seem to be a simple correlation between the reports of discrimination and the extent of disadvantage in employment. Bangladeshis report little discrimination– less than that of Indians and African Asians far above them in the occupational ladder. It was Caribbeans, whose economic position is in the middle range, who were most likely to report discrimination. The perception of discrimination may be affected by the extent to which the different minorities feel themselves to be defined by 'race' or 'colour'.

This survey is the first of its kind to indicate a religious component of racial discrimination. Nearly a quarter of Caribbeans and more than 40 per cent of South Asians who felt that they had been discriminated against believed that the refusal of a job was due to their religion, usually in combination with their race.

The PSI studies in the 1960s were quite clear that racial discrimination included a cultural component (Daniel 1968, 14). Yet a comparison of white immigrants, such as Hungarians and Cypriots, with Caribbeans and South Asians left no doubt that the major component in discrimination was colour. This was supported by the finding that West Indians experienced more job refusals than South Asians (Daniel 1968, 209). It seemed reasonable to conclude that, while the cultural component of racial discrimination would decrease in the case of British-educated and qualified second-generation South Asians, the most persistent discrimination would be against the darker-skinned Caribbeans (Daniel 1968, 209). A decade later, however, it was argued that perceptions of cultural identity and social interaction were relevant to such predictions. Michael Banton observed that 'the English seem to display more hostility towards the West Indians because they sought a greater degree of acceptance than the English wished to accord; in more recent times there seems to have been more hostility towards Asians because they are insufficiently inclined to adopt English ways' (Banton 1979, 242). Evidence from the fourth survey, as well as social attitude surveys (Sachdev 1996; Dawar 1996), suggests that young white people are beginning to express more prejudice against Asian than against Caribbean people: while those over the age of 34 are only slightly more likely to say they are prejudiced against Asians and Muslims than Caribbeans, those under 35 are half as likely again to say they are prejudiced against Asians and Muslims than Caribbeans.

As the quote from Banton suggests, minorities are dependent on the twists and turns of majority attitudes. Yet, minorities are not merely passive objects of white opinion; they can play a role in shaping white attitudes. Several studies have pointed to aspects of how Caribbean people have contributed to forging a common social, recreational and cultural life with white British people. It is most evident in contemporary youth culture and the sociability among young black and white people (Cohen 1988; Back 1993). This cultural synthesis and sociability goes well beyond colour-blind assimilationism. For some young people admire their black contemporaries, not in spite of, but because of their blackness, for their aesthetics,

style and creativity as well as for their anti-racist resistance. Yet Asians have been much less involved in this pattern of sociability, and white individuals who prize friendships with black people can be hostile to Asians (Cohen 1988; Back 1993).

This has become possible because differential stereotypes about black people and Asians were implicit in racial prejudice, and these have grown to the point where many analysts of 'race' in Britain speak of multiple racisms. Certainly, it seems that it is no longer adequate to think all non-white people, when treated unfavourably by white people or by the important institutions of society, experience a single kind of racism based upon perceptions of their 'colour'. Besides 'colour-racism', there seem to be various forms of prejudice and discrimination which use cultural difference to vilify or marginalise or demand cultural assimilation from groups who also suffer colour-racism (Modood 1996). It is the development of these 'cultural racisms' in ways unanticipated by the pioneering studies of racial discrimination which may account for the differential prejudice against Asians. South Asians themselves, however, were more likely to identify Muslims, rather than Asians as a whole, as the group against whom there is most hostility. In line with Banton's hypothesis, anti-Muslim prejudice seems to be a white reaction to the revival of Islamic self-confidence and self-assertion in Britain and internationally.

Racism can go beyond mere prejudice and discrimination. This survey found that individuals in all ethnic minority groups suffer from racial harassment and violence from those in their immediate neighbourhoods, at their workplace, from strangers in public places and sometimes even from police officers. In contrast to reports of discrimination in employment, there is much less variation in the extent of harassment reported by different minority groups, with the South Asians nearly as likely to mention incidents as the Caribbeans; as with discrimination in employment, however, the Bangladeshis are the least likely to mention it. For the first time in any survey, we were able to gauge the extent of racial insults and abuse, as well as of more directly criminal attacks on people or on property. As many as 12 per cent of the ethnic minorities interviewed said they had been racially abused or threatened in these ways at least once in the previous year. This suggests a minimum of a quarter of a million racist incidents a year. Nearly a quarter of those who had been racially harassed had been victimised five or more times in the past year.

Not surprisingly, therefore, a quarter of all ethnic minority adults worry about being racially harassed. A measure of the effect of racial harassment upon them – and upon ethnic relations in this country – is that many take steps to reduce their vulnerability: making their home more secure and avoiding going out at night or travelling in areas where mostly white people live.

White people too, of course, worry about crime and about being victimised and this damages the quality of life among people generally. Yet racial victimisation has additional dimensions. First, it is not random: victims are chosen on the basis of their group characteristics. The victim cannot console themselves by saying 'it could have happened to anybody'. You know you were chosen because of what you are, because of a malice directed at a part of yourself. Thus racial attacks are both more deeply personally damaging and frighten not just the individual victims but groups of people. All the members of that group are indirectly affected by the each incident. Second, victimisation may not be an isolated event but can be persistent. Certain people in a

street or housing estate may regularly threaten violence and insults against the black or Asian people who live there. Third, harassment may be seen not as exceptional but as normal – a particularly distressing symptom of an underlying current of prejudice and racism. The survey shows, perhaps surprisingly, that the perpetrators are not confined to the sorts of young men whose actions can be written off as 'yobbish' and untypical. Perhaps most white people do not actively harass members of minority groups, but, if they fail actively to condemn and resist it, they may contribute to the minorities' sense of isolation; conversely, the perpetrators may consider that they are only taking to an extreme conclusion what many white people actually feel.

A specially worrying example of this wider culture of racism is what the interviewees said about the police. Among the 98 attacks on the person in which the perpetrator was seen, it was claimed that three were by police officers. Only a quarter of people who had been racially attacked in the last year had reported the incident to the police. Half of those who had reported an incident to the police were dissatisfied with the police response, the predominant feeling among them being that the police had shown a lack of interest in the victim's complaint, or even an implicit sympathy with the perpetrators. The majority of young members of the minority groups do not believe they can rely on the police to protect them from racial harassment. In fact, regardless of age, a majority of Caribbeans and (especially) of South Asians believe that they should organise self-defence groups.

The number of racial incidents recorded in police statistics has been increasing. This may be attributable to a raised awareness about racism in the population at large and to greater confidence among victims to publicise their situation. Certainly, one has to balance the admissions of prejudice among white people (which on the whole are declining, especially among younger people) with the fact that white support for laws against racial discrimination has increased from about two-thirds in the mid-1980s to three-quarters in the mid-1990s (Sachdev 1996, 62). These developments should be seen in the context of changes in the concept of racial equality, which will be discussed in the last section of this chapter.

LIFESTYLES AND IDENTITIES

The differences between minority groups, and their relation to white people, extend to family structures, behavioural norms, cultural practices and community identities. Caribbeans, with their low emphasis on marriage and large number of one-parent families, have very different family structures than the white majority. South Asians, and especially Pakistanis and Bangladeshis, are at the opposite end of the spectrum. The latter are characterised by parental authority and large numbers of children, almost invariably within marriage, and the household often includes grandparents and/or adult children. These different family structures approximate to family structures and parenting practices in the Caribbean, and in Pakistan and Bangladesh, respectively. Yet they are clearly influenced by conditions in Britain. Caribbean lone parenthood strongly coincides with the same, if less pronounced, trends among their white peers. There has been a marked fall in the number of children in Indian and Pakistani families since the Third Survey, though this has not (yet) affected

Bangladeshis. Among Asians, the younger arrivals and British-born are less likely to have had an 'arranged' marriage than those who were born (and may have married) in the subcontinent.

Another aspect of family life which is clearly influenced by residence in Britain is the choice of white partners in cohabitation, marriage and child-rearing. This has always been more prevalent among Caribbeans than among Asians, but it is clearly on the increase, so that (for people who were born in Britain) half of Caribbean men, a third of Caribbean women and a fifth of Indian and African Asian men had a white partner. This will have a direct effect not only on the life styles of the men and women concerned, but also on their children, and on other members of that generation. Getting on for half of 'Caribbean' children have one white parent. That means there are more people who have a family connection with the Caribbean or Asia, but fewer who can trace all their heritage from those regions. No one has studied mixed-origin adults in any detail (they are included in our survey, but the questionnaire did not identify them clearly), and important questions will be raised about the nature of Caribbean, and eventually Asian, identity.

We found that members of minority groups strongly identified with their ethnic and family origins – including among adults who had been born and raised in Britain. This might mark the point of maximum similarity between ethnic minority groups. Behind this, however, lies a complexity which is best approached through the following three points.

First, the primary items in self-description are radically different for Caribbeans and South Asians. Religion is prominent in the self-descriptions of South Asians, and skin colour in the self-descriptions of Caribbeans. Despite the various forms of anti-racist politics around a black identity of the last two decades, only a fifth of South Asians think of themselves as black.

Second, the ethnic self-identification is not exclusive; it does not conflict with a British self-identification. Half of the Chinese but more than two-thirds of the respondents in the other groups also said that they felt British, and these proportions were, as one might expect, higher among young people and those who had been born here.

Third, ethnic identification is not necessarily connected to personal participation in distinctive cultural practices, such as those of language, religion or dress. Some people expressed an ethnic identification, and sometimes also express a preference for association with members of their ethnic or religious group, even though they do not participate in distinctive cultural practices. This is particularly true among younger South Asians who, compared with their elders, are less likely to speak to family members in a South Asian language, regularly attend a place of worship or have an arranged marriage. Hence it can be seen, most clearly in the generational contrast among South Asians, but also among the Caribbeans, that a new conception of ethnic identity has emerged. If the traditional conception is of ethnic identity as that which is implicit in distinctive cultural practices, this still exists and is the basis of a strong expression of group membership. Additionally, however, especially among the British-born, an associational identity can be seen which takes the form of remembrance or pride in one's origins, identification with certain group labels and sometimes a political assertiveness (Modood, Beishon and Virdee 1994).

While the process of change and adaptation in cultural practices and orientation, especially as manifested across generations, is a central finding, so too is the fact that the relevant cultural heritages are often still alive. Nearly all South Asians can understand a community language, and over two-thirds use it with family members younger than themselves. More than a quarter of 35–49-year-old Caribbeans can understand Patois-Creole, as can a fifth of the 16–34-year-olds. Nearly all South Asians said they have a religion, and 90 per cent said that religion was of personal importance to them.

Religion is perhaps the key area where the minority groups manifest a cultural dynamic which is at least partly at odds with native British trends. It is true that as many Caribbean as white people, and even more Chinese, do not have any religion, and that the general trend down the generations within every ethnic group is for younger people to be less connected to a religion than their elders (though perhaps to become more like their elders as they age). Nevertheless, while only 5 per cent of whites aged 16–34 said that religion was very important to how they led their lives, nearly a fifth of Caribbeans, more than a third of Indians and African Asians, and two-thirds of Pakistanis and Bangladeshis in that age group held that view. Non-white Anglicans are three times more likely than white Anglicans to attend church weekly, and well over half of the members of black-led churches do so. Black-led churches are a rare growth point in contemporary Christianity. The presence of ethnic minorities is changing the character of religion in Britain.[4]

A further important difference between groups, perhaps related to the influence of religion, is between African Asians and Indians (about 90 per cent of whom are Sikhs and Hindus) and Pakistanis and Bangladeshis (over 95 per cent of whom are Muslims). On a range of issues to do with religion, arranged marriages, choice of schools and Asian clothes, the latter group take a consistently more 'conservative' view than the former, even when age on arrival and economic position are taken into account.

All minority groups nevertheless feel a certain amount of anxiety about cultural loss, and whatever the adaptations people are making in their own lives, there is a strong support for preservation of minority cultures. Over three-quarters of ethnic minority respondents agreed that Caribbean and Asian people should try to preserve their culture and way of life – the highest support coming from the Caribbeans. Some of this support may be anxiety about change, and some of it may be sentimental rather than practical, but, like the high levels of associational identification, it indicates that support for the culture of one's origins is seen by some as a form of group solidarity.

EQUALITY AND ETHNICITY

People who are not white in Britain are often conceived as sharing similar circumstances. Yet this study of the six main groups of immigration-based minorities shows that the differences are even more important. This diversity is not a hotch-

4 Including how we view the relationships between religion, the state and national identity: see the debate in Modood (ed.) 1997.

potch, with different groups being better or worse off than each other in different areas of social life. There is an element of this kind of random or extreme diversity, but in the main there is a systematic pattern with particular groups being severely disadvantaged across a number of measures. While the fundamental division cannot be characterised as black–white, or as black–Asian–white, there continues to be evidence of racial inequality. Some of the processes involved, such as the under-employment of the talents and resourcefulness of minority persons, contribute directly to diversity – to the high level of business ownership among some groups, for example.

It would be wrong to attribute diversity simply to the various elements of racism and racial exclusion. It would be equally mistaken, though, to attribute it simply to the characteristics and distinctive traits of the various groups. For these characteristics are not stable but change with circumstances, as new challenges and opportunities present themselves. Minority patterns of behaviour can be reinforced or undermined by, say, the attitudes of white people, or by the disappearance of certain industries. Moreover, whatever cultural heritage migrants bring with them, it inevitably becomes simplified or fragmented in the process of transplantation and reinterpreted in the adjustment to the new socio-cultural environment. Minority practices will of course also be influenced by various aspects of dominant British cultures and by the currents of thinking and feeling that are simultaneously influencing all social groups across British society. Hence the important context for understanding contemporary ethnic diversity is the interaction between pre-migration group characteristics and British conditions, which will include, but not be confined to, the processes of racial and other forms of inequality.

The concept of equality has been under intense theoretical and political discussion, especially in the English-speaking world; what is often claimed today in the name of racial equality is more than would have been recognised as such in the 1960s. Iris Young expresses well the new political climate when she describes the emergence of an ideal of equality based not just on allowing excluded groups to assimilate and live by the norms of dominant groups, but based on the view that 'a positive self-definition of group difference is in fact more liberatory' (Young 1990, 157). She cites the examples of the black power movement, the gay pride assertion that sexual identity is a matter of culture and politics, and the feminism which emphasises that women's experiences should be celebrated and valued in their own right. These movements have not had the same impact in Britain as in parts of North America, but are certainly present here. In particular there is an ethnic assertiveness in Britain which has parallels in North America. It has been less evident among recent migrants and their descendants in other European Union countries, where cultural assimilation is still regarded as essential to citizenship and political equality (Baldwin-Edwards and Schain 1994). This assertiveness counterposes positive images against traditional or dominant stereotypes, and projects identities in order to challenge existing power relations or to negotiate the sharing of physical, institutional and discursive space. Anti-racists have challenged the presumed stigma associated with not being white or conventionally British (Modood, Beishon and Virdee 1994).

The shift is from an understanding of equality in terms of individualism and cultural assimilation to a politics of recognition, to equality as encompassing public ethnicity. Equality is not having to hide or apologise for one's origins, family or community but expecting others to respect them and adapt public attitudes and arrangements so that the heritage they represent is encouraged rather than contemptuously expected to wither away. There seem, then, to be two distinct conceptions of equal citizenship, each based on a different view of what is 'public' and 'private'. These two conceptions of equality may be stated as follows:

- the right to assimilate to the majority/dominant culture in the public sphere; and toleration of 'difference' in the private sphere;

- the right to have one's 'difference' recognised and supported in both the public and the private spheres.

These are not, however, alternative conceptions in the sense that to hold one, the other has to be rejected. Multiculturalism requires support for both conceptions. For the assumption behind the first is that participation in the public or national culture is necessary for the effective exercise of citizenship, the only obstacle to which are the exclusionary processes preventing gradual assimilation. The second conception, too, assumes that groups excluded from the national culture have their citizenship diminished as a result, offers to remedy this by accepting the right to assimilate, yet adds the right to widen and adapt the national culture and the public symbols of national membership to include the relevant minority ethnicities.

It may be thought that the second conception of equality involves something of a contradiction: it accepts that participation in the national or shared culture(s) is necessary for effective equality, but encourages individuals to cultivate minority identities and practices. There is indeed a genuine tension here, and perhaps it can only be resolved in practice, through finding and cultivating points of common ground between dominant and subordinate cultures, as well as new syntheses and hybridities. The important thing is that the burden of change (or the costs of not changing) are not all on one party.[5]

Britain has undoubtedly made some progress towards developing multiracial equality in the last three decades. This has included a movement away from the policy of colour-blindness – the idea that equality could be achieved by simply outlawing colour-discrimination – to a recognition of racial disadvantage as a multi-dimensional condition that sometimes requires positive, targeted policies if a level playing-field is to be created. Concurrently, there has been increasing recognition that minorities cannot simply be understood in terms of racism. The latest period of ethnic minority settlement has seen the maturation of groups with distinctive values, cultures, social orientations, economic niches and policy agendas. Two decades ago, at the end of his PSI survey report, David Smith asked whether the uniformity of treatment in Britain would turn out to be more important to Asians and Caribbeans than the diversity of their origins and heritages (Smith 1977, 331). The conclusion of this survey has to be that, while the circumstances of the minorities show some

5 For further discussion of these issues, see Modood and Werbner (eds) 1997.

common sources of inequality, the diversity is proving to be extremely resilient and is far from confined to aspects of private culture.

Yet, it seems to us that equality and social cohesion cannot be built upon emphasising 'difference' in a one-sided way. Also required is a recognition of shared experiences. There is no reason to confine that just to what non-white minorities have in common, or even to the similarities between non-white and white minorities such as the Jews or the Irish in Britain - groups also identified as victims of 'racisms' (Cohen 1996). Nor does the idea of class offer a practical basis of a unifying politics, as in the idea that the groups studied here have more in common with white working-class people rather than the population as a whole. The emphasis needs to be on common rights and responsibilities. Membership of a specific ethnic community has to be accorded a greater political importance than it has had hitherto, but should be complemented with an equally meaningful membership that brings all citizens together regardless of their ethnic group. It has to be a form of citizenship that is sensitive to ethnic difference and incorporates a respect for persons as individuals and for the collectivities to which people have a sense of belonging. For many people, members of minorities and of the majority alike, the existing images of Britishness do not embrace the new mix of cultures and communities that exist today. We need to reform and renew conceptions of Britishness so that the new multiculturalism has a place within them.

We need, then, to develop a more plural approach to racial disadvantage, and to formulate an explicit ideal of multicultural citizenship appropriate to Britain in the next decade and beyond. Our successors, responsible for the Fifth National Survey of Ethnic Minorities, will look for progress in these directions.

Survey Methods

Patten Smith

INTRODUCTION

The survey was designed to obtain data on a range of topics from a nationally representative sample of the principal minority ethnic groups resident in England and Wales[1] and from a comparison sample of white people. The minority groups covered were Caribbeans, South Asians and Chinese.[2]

Important considerations informing the design were: consistency with the 1982 survey (Brown 1984); adequate sample sizes of each main minority group; the potential to link the survey findings with census data; broad coverage of question topics; translation of questionnaires; and use of ethnically matched interviewers. In the event, interviews were completed with 5196 minority adults living in 3291 households, and with 2867 whites (in 2867 households). A detailed account of the survey methods is provided in the technical report on the study (Smith and Prior 1996).

SAMPLE DESIGN

1991 Census data were used to divide all electoral wards in England and Wales into three strata, according to the proportion of their population who were members of the ethnic minority groups covered by our survey:

■ Stratum A: 10 per cent or more minorities

■ Stratum B: 0.5 per cent or more, but less than 10 per cent

■ Stratum C: less than 0.5 per cent

The procedures differed between the white and minority samples. For the *white* sample:

■ Wards in strata A and B were selected with probability proportional to the number of white people living there. An approximately equal number of addresses was sampled in each ward.

1 Only a very small proportion of the population of Scotland belongs to a minority ethnic group. A survey was carried out by SCPR in 1988/9 and has been reported elsewhere (Smith 1991).

2 Our category 'Caribbeans' included those who had family origins in the Caribbean; thus they covered the black Caribbean census category, plus those from the census 'Black Other' group with Caribbean family origins. Our South Asian category included 'African Asians'. The largest group omitted by the survey was therefore Black Africans.

■ Wards in stratum C were selected with equal probability. Addresses were sampled in each ward using a constant sampling fraction.

In both cases, the sampling frame for selecting addresses was the Postcode Address File (PAF). At each household found to contain white adults, one of them was selected at random to be the respondent.

For the *minority* sample, the procedure was much more complex. The following is a summary, but it omits some important details which are recorded in the technical report.

■ Wards in stratum A (high concentration) were selected with probability proportional to the estimated number of members of the relevant minorities living there. Within each selected ward, four census enumeration districts (EDs) were sampled, also with probability proportional to the estimated number of members of relevant minorities living there. Addresses were then selected in each enumeration district from the postcode address file (PAF). Larger numbers of addresses were selected in enumeration districts with lower concentrations of minority households, with the intention of achieving approximately equal numbers of ethnic minority interviews in each.

■ Wards in stratum B (medium concentration) were subdivided into 'area units' containing approximately equal numbers of minority households. Area units were then selected with equal probability.

■ Within strata A and B, in order to ensure an adequate sample size for the smallest of the South Asian groups under study, wards where more than 1 per cent of the population were Bangladeshis were oversampled by a factor of three.

■ In stratum A (high concentration), an interviewer visited each selected address (i) to identify whether or not any minority adults lived there and (ii) to obtain names and other details of those who did.

■ In stratum B (medium concentration), an interviewer visited every sixth address in the area to find out whether any minorities lived there, *or in the five addresses on either side*. If there were, details of minority adults were obtained from each address in the row. This procedure, known as *focused enumeration*, was developed for the third survey, and has been shown to achieve a very high level of coverage (Brown and Ritchie 1981).

■ The lists of minority adults obtained by the screening exercise were returned to the office. Up to two adults were selected at each address (at random where there were more than two candidates) to be respondents. An interviewer, as often as possible a member of the same ethnic group as the respondent, was sent to conduct the interview.

■ In stratum C (low concentration), the same wards were used as for the white sample (see above). At the same time as interviewers conducted the white

sample fieldwork, they sought to establish whether any eligible ethnic minority individuals lived in *any address in the ward,* again by means of focused enumeration. At eligible households they selected one or two (at random) eligible minority adults and conducted interviews on the spot.

QUESTIONNAIRE DESIGN

The questionnaires were compiled on the basis of four kinds of input:

- questions that had been used in previous surveys in the series

- questions that had been used in the census, or in other substantial surveys

- development work based on depth or group interviews with 74 members of minority groups (Modood et al. 1994; Virdee 1995)

- pilot testing.

It eventually became clear that the number of questions to be asked of minority groups would be too large to be included in a single interview without fatigue and possible loss of response. It was therefore decided to establish a core set of important questions which had to be asked of everyone; and to divide the remaining detailed questions into two sets, each to be asked of a randomly selected half of the minority sample. Where two interviews were to be conducted within the same household, the two questionnaires were allocated to the two respondents. It was not necessary to split the questionnaire in this way for the white sample.

The minorities questionnaire was translated into six minority languages – Punjabi, Urdu, Bengali (Sylheti), Gujarati, Hindi and Chinese (Cantonese) – and checked and corrected by a second translator.

FIELDWORK

The survey of white people was conducted by SCPR's normal field force, most of whom are white. Wherever possible, members of the minority sample were interviewed by an interviewer from the same ethnic group as themselves. There were two exceptions: members of the minority sample identified in stratum C (low concentration) were interviewed by the (white) interviewer who had located them and, towards the end of the survey, white interviewers were used to obtain interviews which might not otherwise have been achieved at all.

The great majority of the minority interviewers were recruited and trained specifically for this survey. In some areas, and for some minority groups, this proved a difficult and time-consuming task, and it was for this reason that the fieldwork spread over a 12 month period, between the end of 1993 and late 1994.

In the event, 87 per cent of all respondents in the minority sample were interviewed by a member of the same broad ethnic group as themselves.[3] Half (51 per cent) of the Asian interviews took place wholly or partly in a language other than English.

For the screening exercise in strata A and B, it is difficult to be precise about the success rate with which ethnic minority households were identified. Out of a total of 76,748 households covered directly or indirectly, the best estimate is that 5676 contained members of the target minority groups. Of these, it was possible to obtain information from 4162 (73 per cent), so that the list could be compiled from which the actual sample was drawn.

The main fieldwork response rates were as shown in Table A.1

Table A.1 Fieldwork response rates

	Minorities	%	Whites	%
Issued individuals (minorities)				
In scope addresses (whites)	7129	100	4066	100
Address problems	193	3	n.a.	
Not traced	484	7	n.a.	
No contact	188	3	126	3
Refused	944	13	904	22
Ill, old, away	138	2	47	1
Other non-response	146	2	8	*
Interview completed	5038[4]	71	2867	71

0 < * <0.5

Although the outcomes for minorities and whites are shown in the same table, for convenience, they are not really comparable to each other, because the minority fieldwork had been preceded by a screening exercise. The number of address problems in the minorities sample is higher than would have been expected, given that the individuals had already been identified. The proportion of refusals is higher in the white sample. This is partly because many members of minority groups who were unwilling to take part would already have been missed at the screening stage; partly because white people might not think a survey about ethnicity would be relevant to them.

The numbers achieved in each ethnic group are shown in Table A.2. The response rates varied along lines very similar to those reported for the third survey in 1982, which reported 82 per cent for whites, 67 per cent for Caribbeans and 81 per cent for South Asians. The lower response among Caribbeans is consistent with a number of other surveys such as the pre-tests for the 1991 Census (Bulmer 1996).

3 For this purpose, a Pakistani being interviewed by an Indian would count as a broad match, but not if the interviewer was a Caribbean or a Chinese.

4 158 additional minority interviews were obtained in the course of a secondary screening exercise, and cannot be included in this analysis.

Table A.2 **Response rates for different ethnic groups**

	Achieved sample[5]	Response rate
White	2867	71%
Caribbean	1205	61%
Indian/African Asian	1947	74%
Pakistani	1232	73%
Bangladeshi	598	83%
Chinese	214	66%

WEIGHTING

Six weighting factors were applied to the data in order to ensure that the survey results represented the populations under study as closely as possible.

The first two corrected known inequalities in the probability of selection: of individuals within households, and of wards within strata. The third and fourth corrected for observed variations in response rates: between enumeration districts at the screening stage, and by ethnic group, age, sex and stratum at the main fieldwork stage. The fifth ensured that the sample matched the 1991 Census by age within ethnic group, and the sixth set the weighted sample size equal to the actual number of interviews.

CENSUS DATA

Since Census Small Area Statistics had been used in the selection of the sample, it was possible to attach information about the area in which each respondent lived to the individual records in the final data file. This was done at the county, district, ward and ED levels, using data about ethnic composition, housing, unemployment and car ownership.

ACCESS TO THE DATA

Anonymised data from the survey have been lodged at the ESRC Data Archive. Researchers who wish to carry out further analysis should apply to the Archive for access.

5 The response rates are based only on strata A and B because the ethnic origin of the *issued* sample was not known for stratum C. However, the sample sizes quoted include both the stratum C interviews and the 158 additional interviews mentioned in footnote 4.

References

Abbot, P. and C. Wallace (1990) *An Introduction to Sociology: feminist perspectives.* Routledge

Abbott, P. and M. Tyler (1995) 'Ethnic variation in the female labour force: a research note', *British Journal of Sociology,* 46 (2), pp.339–351

Ahmad, W I U (1993) *'Race' and Health in Contemporary Britain.* Open University Press

Ahmad, W.I.U. (ed.) (1993) 'Making black people sick: "race", ideology and health research'. In W.I.U. Ahmad (ed.)

Ahmad, W.I.U., E.E.M. Kernohan and M.R. Baker (1989) 'Influence of ethnicity and unemployment on the perceived health of a sample of general practice attenders', *Community Medicine,* 11 (2), pp.148–156

Airey, C. (1984) 'Social and moral values'. In R. Jowell and C. Airey (eds) *British Social Attitudes: the 1984 Report.* Gower

Alibhai-Brown, Y. and A. Montague (1992) *The Colour of Love: mixed race relationships.* Virago

Aldrich, H.E., J.C. Cater, T.P. Jones, and D. McEvoy (1981) 'Business development and self-segregation: Asian enterprise in three British cities'. In C. Peach, V. Robinson and S. Smith (eds) *Ethnic Segregation in Cities.* Croom Helm

Allen, S. and C. Wolkowitz (1987) *Homeworking: Myths and Realities.* Macmillan

Allen, I. and E. Perkins (1995) (eds) *The Future of Family Care for Old People.* HMSO

Amin, K. and C. Oppenheim (1992) *Poverty in Black and White: deprivation and ethnic minorities.* CPAG/Runnymede Trust

Anthias, F. and N. Yuval-Davis (1992) *Racialised Boundaries: Race, Nation, Gender, Colour, Class and the Anti-Racist Struggle.* Routledge

Anwar, M. (1979) *The Myth of Return: Pakistanis in Britain.* Heinemann

Anwar, M. (1994) *Young Muslims in Britain: Attitudes, Educational Needs and Policy Implications.* The Islamic Foundation

Athukorala, P. (1992) 'The use of migrant remittances in development: lessons from the Asian experience', *Journal of International Development,* 4 (5)

Aye Maung, N. and C. Mirrlees-Black (1994) *Racially Motivated Crime: a British Crime Survey analysis.* Home Office Research and Planning Unit

Back, L. (1993) 'Race, identity and nation within an adolescent community in South London', *New Community,* 19 (2), pp.217–233

Baimbridge, M., B. Burkitt and M. Macey (1995) 'The European Parliamentary Elections of 1994 and Racism in Europe', *Ethnic and Racial Studies,* 18 (1), pp.128–130

Balarajan, R. (1991) 'Ethnic differences in mortality from ischaemic heart disease and cerebrovascular disease in England and Wales', *British Medical Journal,* 302, pp.560–564

Balarajan, R., P. Yuen and B. Botting (1989) 'Ethnic differences in general practitioner consultations', *British Medical Journal,* 299, pp.958–960

Balarajan, R. and L. Bulusu (1990) 'Mortality among immigrants in England and Wales, 1979-83'. In M. Britton (ed.) *Mortality and Geography: A review in the mid-1980s, England and Wales.* OPCS

Balarajan, R. and Soni V. Raleigh (1995) *Ethnicity and Health in England.* HMSO

Baldwin-Edwards, M. and Schain, M.A. (1994) (eds) 'The politics of immigration in Western Europe', *West European Politics,* 17 (2), special issue

Ballard, R. (1994) (ed.) *Desh Pardesh, the South Asian presence in Britain.* Hurst and Co

Ballard, R. (1990) 'Migration and kinship: the differential effect of marriage rules on the process of Punjabi migration to Britain'. In C. Clarke, C. Peach and S. Vertovec (eds) *South Asians Overseas*. Cambridge University Press

Ballard, R. (1996a) 'Negotiating race and ethnicity: exploring the implications of the 1991 Census', *Patterns of Prejudice*, 30 (3)

Ballard, R. (1996b) 'The Pakistanis: stability and introspection'. In C. Peach (ed.)(1996a)

Ballard, R. and V.S. Kalra (1994) *The Ethnic Dimensions of the 1991 Census: A Preliminary Report*. Census Dissemination Unit, University of Manchester

Ballard, R. and Vellins, S. (1985) 'South Asian Entrants to British Universities: A Comparative Note', *New Community*, 12 (2), pp.260–265

Banton, M. (1976) 'On the use of the adjective "black"', *Network*, 6, pp.2–3. Reprinted in *New Community*, 5, 1977, pp.480–483

Banton, M. (1979) 'It's our country'. In R. Miles and A. Phizacklea (eds) *Racism and Political Action in Britain*. Routledge, pp.233–246

Barker, M. (1981) *The New Racism*. Junction Books

Barker, D. (1991) 'The foetal and infant origins of inequalities in health in Britain', *Journal of Public Health Medicine*, 13, pp.64–68

Basu, A. (1995) *Asian Small Businesses in Britain: An Exploration of Entrepreneurial Activity*. University of Reading, Discussion Paper No.303, Series A, Vol.VII

Baumann, G. (1990) 'The re-invention of *bhangra*: social change and aesthetic shifts in a Punjabi music in Britain', *The World of Music*, 2, Berlin, pp.81–98

Beishon, S., S. Virdee and A. Hagell (1995) *Nursing in a Multi-Ethnic NHS*. Policy Studies Institute

Benson, S. (1996) 'Asians have culture, West Indians have problems: discourses of race and ethnicity in and out of anthropology'. In T. Ranger et al. (1996)

Benzeval, M. and K. Judge (1993) *The Development of Population-Based Need Indicators From Self-Reported Health Care Utilisation Data*. King's Fund Institute

Benzeval, M., K. Judge and M. Solomon (1992) *The Health Status of Londoners*. King's Fund Institute

Benzeval, M., K. Judge and M. Whitehead (1995) *Tackling Inequalities in Health: an agenda for action*. King's Fund Institute

Berrington, A. (1994) 'Marriage and family formation among the white and ethnic minority populations in Britain', *Ethnic and Racial Studies*, 17 (3)

Berrington, A. (1996) 'Marriage patterns and inter-ethnic unions'. In D. Coleman and J. Salt (1996a)

Berthoud, R. (1984) *The Reform of Supplementary Benefit*. Policy Studies Institute

Berthoud, R. (1987) *Social Security and Race: an agenda*. PSI working paper

Berthoud, R. and R. Ford (1996) *Relative Needs: Variations in the living standards of different types of household*. Policy Studies Institute

Berthoud, R. and E. Kempson (1992) *Credit and Debt: the PSI report*. Policy Studies Institute

Bhachu, P. (1986) *Twice Migrants*. Tavistock.

Bhachu, P. (1993) 'Twice and direct migrant Sikhs: caste, class, and identity in Pre- and Post-1984 Britain'. In I. Light and P. Bhachu (eds) *Immigration and Entrepreneurship: Culture, Capital and Ethnic Networks*. Transaction Publishers

Bhavnani, R. (1994) *Black Women in the Labour Market: A Research Review*. Equal Opportunities Commission

Bhopal, R. (1995) 'Ethnicity, race, health and research: racist black box, junk or enlightened epidemiology'. Paper presented at Society for Social Medicine Scientific Meeting

Bittles, A.H. and J.V. Neel (1994) 'The costs of human inbreeding and their implications for variations at the DNA level', *Nature Genetics*, October, 8, pp.117–121

Bjorgo, T. and R. Witte (1993) *Racist Violence in Europe*. Macmillan

Blalock, H.M. (1985) *Social Statistics*. Singapore: McGraw-Hill

Blaxter, M. (1987) 'Evidence of inequality in health from a national survey', *The Lancet*, 4 July, pp.30–33

Blaxter, M. (1990) *Health and Lifestyles*. Tavistock/Routledge

Bloch, A. (1993) *Access to Benefits: the information needs of ethnic minority groups*. Policy Studies Institute

Bonnett, A. (1993) *Radicalism, Anti-Racism and Representation.* Routledge

Bottomley, A.K. and K. Pease (1993) *Crime and Punishment: Interpreting the Data.* Open University Press

Boulton, M.L. and P. Smith (1992) 'Ethnic preferences and perceptions among Asian and white British middle school children', *Social Development,* 1 (1), pp.55–66.

Bowling, B. (1993) 'Racial harassment and the process of victimisation: conceptual and methodological implications for the local crime survey', *British Journal of Criminology,* 33 (2), pp. 231–249

Bradshaw, J. (1993) *Budget Standards for the United Kingdom.* Avebury

Breugel, I. (1989) 'Sex and race in the labour market', *Feminist Review,* 32, pp.49–68

Brown, C. (1984) *Black and White Britain.* Heinemann

Brown, C. and P. Gay (1985) *Racial Discrimination: 17 Years After the Act.* Policy Studies Institute

Brown, C. and J. Ritchie (1982), *Focused Enumeration. The Development of a method for sampling ethnic minority groups.* Policy Studies Institute/Social and Community Planning Research

Buck, N., J. Gershuny, D. Rose and J. Scott (1994) *Changing Households: the British household panel survey 1990–1992.* University of Essex

Bulmer, M. (1996) 'The ethnic group question in the 1991 Census of population'. In Coleman and Salt (1996a)

Bundey, S. and H. Alam (1993) 'A five-year prospective study of the health of children in different ethnic groups, with particular reference to the effect of inbreeding', *European Journal of Human Genetics,* (1), pp.206–219

Burghes, L. (1995) *Single Lone Mothers: problems, prospects and policies.* Family Policy Studies Centre

Butcher, S. and Hart, D. (1995) 'An analysis of working time, 1979–1994', *Employment Gazette,* May

Byron, M. (1993) *The Housing Question: Caribbean Migrants and the British Housing Market.* University of Oxford, School of Geography, Research Paper 49

Carter, T. (1986) *Shattering Illusions: West Indians in British Politics.* Lawrence and Wishart

Cater, J. and T. Jones (1987) 'Asian ethnicity and home-ownership'. In P. Jackson (ed.) *Race and Racism: Essays in social geography.* Allen and Unwin

Centre for Contemporary Cultural Studies (1982) *The Empire Strikes Back: Race and Racism in 70s Britain.* Hutchinson

Chamberlain, M., H. Goulbourne, D. Plaza and D. Owen (1995) 'Living arrangements, family structure and social change of Caribbeans in Britain', *Changing Britain,* 4, Economic and Social Research Council

Cheng, Y. (1994) *Education and Class: Chinese in Britain and the United States.* Avebury

Cheng, Y. and A. Heath (1993) 'Ethnic origins and class destinations', *Oxford Review of Education,* 19 (2), pp.151–165

Clarke, C., C. Peach and S. Vertovec (1990) *South Asians Overseas: migration and ethnicity.* Cambridge University Press

Clarke, V (1989) 'Bleak prospects for black tenants', *Housing Review,* 38 (5), pp.128–129

Cohen, P. (1988) 'The perversions of inheritance: studies in the making of multi-racist Britain'. In P. Cohen and H.S. Bains (eds) *Multi-Racist Britain.* Macmillan

Cohen, P. (1995) *For a Multicultural University.* New Ethnicities Unit Working Paper 3, University of East London

Cohen, P. (1996) 'A message from the other shore'. Symposium on anti-racism in Britain, *Patterns of Prejudice,* 20 (1), pp.15–22

Coleman, D. and Salt, J. (1996) (eds) *Ethnicity in the 1991 Census: Volume 1: Demographic characteristics of ethnic minority populations.* HMSO

Coleman D. and Salt, J. (1996) 'The ethnic group question in the 1991 Census: a new landmark in British social statistics'. In Coleman and Salt (eds) (1996)

Commission for Racial Equality (1987a) *Chartered Accountancy Training Contracts: Report of a Formal Investigation into Ethnic Minority Recruitment.* CRE

Commission for Racial Equality (1987b) *Living in Terror: a report on racial violence and harassment in housing.* CRE

Commission for Racial Equality (1988a) *Investigation into St George's Hospital Medical School.* CRE

Commission for Racial Equality (1988b) *Racial discrimination in a London estate agency: Report of a formal investigation into Richard Barclay and Co.* CRE

Commission for Racial Equality (1989) *Racial Discrimination in an Oldham Estate Agency.* CRE

Commission for Racial Equality (1989/90) *Housing Policies in Tower Hamlets: an investigation.* CRE

Commission for Racial Equality (1990a) *Out of Order: Report of a formal investigation into the London Borough of Southwark.* CRE

Commission for Racial Equality (1990b) *Sorry it's gone: testing for racial discrimination in the private rented housing sector.* CRE

Commission for Racial Equality (1990c) *Schools of Faith: Religious Schools in a Multicultural Society.* CRE

Commission for Racial Equality (1991) 'Second Review of the Race Relations Act 1976: Consultative Paper'. CRE

Craig, P. (1991), 'Costs and benefits: a review of research on take-up of income-related benefits', *Journal of Social Policy,* 20 (4)

Cross, M. (1989) 'Afro-Caribbeans and Asians are affected differently by British racism, *New Statesman and Society,* 7 April 1989, p.35

Cross, M. (1994) *Ethnic Pluralism and Racial Inequality.* Netherlands: University of Utrecht

Cruickshank, J., D. Beevers, R. Osbourne, J. Haynes, J. Corlett and S. Selby (1980) 'Heart attack, stroke, diabetes, and hypertension in West Indians, Asians and whites in Birmingham, England', *British Medical Journal,* 281, p.1108

Dahya, B (1974) 'The nature of Pakistani ethnicity in industrial cities in Britain'. In A. Cohen (ed.) *Urban Ethnicity.* Tavistock

Dalley, G. (1991) (ed.) *Disability and Social Policy.* Policy Studies Institute

Daniel, W.W. (1968) *Racial Discrimination in England.* Penguin

Davey Smith, G., M. Bartley and D. Blane (1990a) 'The Black report on socioeconomic inequalities in health 10 years on', *British Medical Journal,* 301, pp.373–377

Davey Smith, G., M.J. Shipley and G. Rose (1990b) 'Magnitude and causes of socioeconomic differentials in mortality: further evidence from the Whitehall study', *Journal of Epidemiology and Community Health,* 44, p.265

Dawar, K. (1996) 'Racism in Britain: a survey of the attitudes and experiences of Black, Asian and white people'. BBC unpublished

Dench, G. (1992) *From Extended Family to State Dependency.* Middlesex University

Dench, G. (1996) *The Place of Men in Changing Family Cultures.* Institute of Community Studies

Department of the Environment (1989) *Tackling racial violence and harassment in local authority housing: a guide to good practice for local authorities.* HMSO

Department of the Environment (1993) *English House Condition Survey 1991.* HMSO

Department of Health and Social Security (1966) *Social Security Statistics 1966.* HMSO

Department of Social Security (1996a) *Social Security Statistics 1996.* HMSO

Department of Social Security (1996b) *Family Resources Survey 1994–95.* HMSO

Department of Social Security (1996c) *Households below Average Income 1979 to 1993/4.* HMSO

Dhooge, Y. and J. Barelli (1996) *Racial Attacks and Harassment: the Response of Social Landlords.* HMSO

Donald, J. and A. Rattansi (eds) (1992) *'Race', Culture and Difference.* Sage/Open University

Donovan, J. (1984) 'Ethnicity and health: a research review', *Social Science and Medicine,* 19 (7), pp.663–670

Drew, D. (1995) *'Race', Education and Work: The Statistics of Inequality.* Avebury

Drew, D., J. Gray and N. Sime (1992) *Against the Odds: The Education and Labour Market Experiences of Black Young People.* England and Wales Youth Cohort Study. Report R&D No.68, Youth Cohort Series No.19, Employment Department

Drury, B. (1990) 'Blackness: A Situational Identity'. Paper given at New Issues in Black Politics conference. University of Warwick 14–16 May

Duffy, K.B. and I.C. Lincoln (1990) *Earnings and Ethnicity.* Leicester City Council

Dunleavy, P. (1979) 'The urban bases of political alignment', *British Journal of Political Science,* 9, pp.409–443

Dunnell, K. (1993) *Sources and Nature of Ethnic Health Data.* North East and North West Thames RHA

Dwyer, C. and A. Meyer (1995) 'The institutionalisation of Islam in The Netherlands and in the UK: the case of Islamic schools', *New Community,* 21 (1)

Eade, J. (1996) 'Ethnicity and the politics of a cultural difference: an agenda for the 1990s'. In T. Ranger et al. (eds) (1996)

Ermisch, J. (1983) *The Political Economy of Demographic Change.* Heinemann

Ermisch, J. (1990) *Fewer Babies, Longer Lives.* Joseph Rowntree Foundation

Ermisch, J. and E. Overton (1984) *Minimal Household Units.* Policy Studies Institute

Esmail, A. and S. Everington (1993) 'Racial discrimination against doctors from ethnic minorities', *British Medical Journal,* 306, pp.691–692, March

Fenton, M. (1984) 'Costs of discrimination in the owner-occupied sector'. In R. Ward (ed.) *Race and Residence in Britain: approaches to differential treatment in housing.* ESRC Research Unit on Race Relations

Fenton, S., A. Hughes and C. Hine (1995) 'Self-assessed health, economic status and ethnic origin', *New Community,* 21 (1), pp.55–68

Field, S. (1984) *The Attitudes of Ethnic Minorities.* Home Office Research Study Report No.80. HMSO

Finer, M. (1974) *Report of the Committee on One-Parent Families.* HMSO

FitzGerald, M. (1995) *'Race' and Crime: the facts?.* Paper presented at the British Criminology Conference

FitzGerald, M. and T. Ellis (1989) 'Racial harassment: the evidence'. In C. Kemp (ed.) *Current Issues in Criminological Research: British Criminology Conference 1989 Vol. 2.* Bristol and Bath Centre for Criminal Justice, pp.51–64

FitzGerald, M. and C. Hale (1996) *Ethnic Minorities, Victimisation and Racial Harassment.* Research Findings No.39, Home Office Research and Statistics Directorate

FitzGerald, M. and G. Uglow (1993) 'Ethnic minority income', *Home Office Research Bulletin,* 33

Forrest, R. and A. Murie (1988) *Selling the Welfare State.* Routledge

Foster, K. and C. Lound (1993), 'A comparison of questions for classifying income', *OPCS Survey Methods Bulletin,* 32

Fox, K. and L. Shapiro (1988) 'Heart disease in Asians in Britain', *British Medical Journal,* 297, pp.311–312

Francome, C. (1994) *The Great Leap: A Study of 107 Hindu and Sikh Students.* Middlesex University

Fryer, P. (1984) *Staying Power: The History of Black People in Britain.* Pluto Press

Gans, H. (1979) 'Symbolic ethnicity: the future of ethnic groups and cultures in America', *Ethnic and Racial Studies,* 2 (1), pp.1–20

Gardner, K. and Shukur, A. (1995), 'I'm Bengali, I'm Asian, and I'm living here'. In R. Ballard (ed.) *Desh Pardesh: the South Asian presence in Britain.* Hurst and Company

Gillborn, D. (1990) 'Race', *Ethnicity and Education,* Routledge

Gillborn, D. (1995) *Racism and Anti-Racism in Real Schools.* Open University Press

Gillborn, D. and Gipps, C. (1996) *Recent Research on the Achievements of Ethnic Minority Pupils.* Office for Standards in Education

Gilroy, P. (1987) *There Ain't No Black in the Union Jack.* Hutchinson

Gordon, T. (1982) 'Further mortality experience among Japanese Americans', *Public Health Reports,* 97, pp.973–984

Gordon, P. (1989) 'Hidden injuries of racism', *New Statesman and Society,* 12 May, 2 (49), pp.24–25

Gordon, P. and A. Newnham (1985) *Passport to Benefits: racism in social security.* CPAG/Runnymede Trust

Graef, R. (1989) *Talking Blues: The Police in their own words.* Collins Harvill

Gray, P. et al (1993) *Access to Training and Employment for Asian Women in Coventry.* Coventry City Council Econ. Development Unit, Research Paper

Greeley, A. (1992) 'Religion in Britain, Ireland and the USA'. In R. Jowell et al (eds) *British Social Attitudes: the 9th report.* Dartmouth

Green, S. (1994) 'The Revenge of the Periphery? Beyond the Satanic Verses: conservative religion, multiculturalism and the irony of the liberal state in modern Britain', In R. McInery (ed.) *Modernity and Religion.* University of Notre Dame Press

Gregg, P. and J. Wadsworth (1995) *More Work in Fewer Households*. National Institute for Social and Economic Research

Gupta, S., A. de Belder and L. O'Hughes (1995) 'Avoiding premature coronary deaths in Asians in Britain: Spend now on prevention or pay later for treatment', *British Medical Journal*, 311, pp.1035–36

Hagell, A. and C. Shaw (1996) *Opportunity and Disadvantage at Age 16*. Policy Studies Institute

Hajnal, J. (1953) 'Age at marriage and proportions marrying', *Population Studies*, 7 (2), pp.111–136

Hakim, C. (1993) 'The myth of rising female employment', *Work, Employment and Society*, 7 (1), pp.97–120

Hall, A. (1996) *Mixed Race Relationships in the UK: an annotated bibliography of sources*. Centre for Research in Ethnic Relations, University of Warwick

Hall, S. (1988) 'New ethnicities'. In K. Mercer (ed.) *Black Film, British Cinema*. ICA, pp.27–31; also in Donald and Rattansi (eds) 1992

Hall, S. (1992) 'The question of cultural identity'. In S. Hall, D. Held and T. McGrew (eds) *Modernity and Its Futures*. Polity Press in association with the Open University

Hall, S., C. Critcher, T. Jefferson, J. Clarke and B. Roberts (1978) *Policing the Crisis: Mugging, the State and Law and Order*. Macmillan

Hargreaves, A. (1995) *Immigration, 'Race' and Ethnicity in Contemporary France*. Routledge

Haskey, J. (1993) 'Trends in numbers of one parent families in Great Britain', *Population Trends*, 71, pp.26–33

Hazareesingh, S. (1986) 'Racism and Cultural Identity: An Indian Perspective', *Dragon's Teeth*, 24, pp.4–10

Heath, A. and D. McMahon (1995) *Education and Occupational Attainments: The Impact of Ethnic Origins*. Paper 34, Centre for Research into Elections and Social Trends, February; also in Karn (ed.) (forthcoming 1997)

Heath, A. and J. Ridge (1983) 'Social mobility of ethnic minorities', *Journal of Biosocial Science Supplement*, 8, pp.169–184

Heath, S. and A. Dale (1994) 'Household and family formation in Great Britain: the ethnic dimension', *Population Trends*, 77, Autumn 1994, pp.5–13

Heckman, J.J. and G. Sedlacek (1985) 'Heterogeneity, aggregation and market wage functions: an empirical model of self-selection in the labour market', *Journal of Political Economy*, 93 (6), December

Herbert, A. and E. Kempson (1996) *Credit Use and Ethnic Minorities*. Policy Studies Institute

HESA (1995) *Students in Higher Education Institutions*. Higher Education Statistics Agency

HESA (1996) *Course Results in Higher Education*. Research Datapack, Higher Education Statistics Agency

Hesse, B., D. Rai, C. Bennett and P. McGilchrist (1992) *Beneath the Surface: Racial Harassment*. Avebury

Hills, J. (1995) *Inquiry into Income and Wealth*. Vol. 2, Joseph Rowntree Foundation

Home Affairs Committee (1989) *Racial Attacks and Harassment*. HMSO

Home Affairs Committee (1994) *Racial Attacks and Harassment*. Vols 1 and 2, HMSO

House of Commons (1985) *Chinese Community in Britain*. Second Report from the Home Affairs Committee, Session 1984–5, HMSO

House of Commons (1986) *Bangladeshis in Britain*. First Report from the Home Affairs Committee, Session 1986–7, HMSO

Howard, V. (1987) *A Report on Afro-Caribbean Christianity in Britain*. Community Religions Project Research Papers, University of Leeds

Howes, E. and D. Mullins (1994) *Ethnic Minority Tenants*. Paper presented at OPCS Authors' Conference, 5–6 September 1994, University of Leeds

Howlett, B., W. Ahmad and R. Murray (1992) 'An exploration of white, Asian and Afro-Caribbean peoples' concepts of health and illness causation', *New Community*, 18 (2) pp.7–13

Husband, C. (1994) 'General Introduction: Ethnicity and Media Democratization within the Nation-State'. In C. Husband (ed.) *A Richer Vision: the Development of Ethnic Minority Media in Western Democracies*. UNESCO: Libbey

Husbands, C. (1994) 'Following the "continental model"?: Implications of the recent electoral performance of the British National Party (BNP)', *New Community*, 20 (4), July, pp.563–579

Hutnik, N. (1991) *Ethnic Minority Identity. A Social Psychological Perspective*. Clarendon Press

Iganski, P. and G. Payne (1996) 'Declining Racial Disadvantage in the British Labour Market', *Ethnic and Racial Studies,* 19 (1), Routledge

Institute of Public Policy Research (IPPR) (1993) *A Report on a Survey Conducted by NOP.* IPPR

Jay, E. (1992) *Keep them in Birmingham.* Commission for Racial Equality

Jenkins, R. (1986) *Racism in Recruitment.* Cambridge University Press

Johnson, M., M. Cross and S. Cardew (1983) 'Inner-city residents, ethnic minorities and primary health care', *Postgraduate Medical Journal,* 59, pp.664–667

Jones, T.P. (1983) 'Residential segregation and ethnic autonomy', *New Community,* 11 (1/2), pp.10–22

Jones, T. (1993) *Britain's Ethnic Minorities.* Policy Studies Institute

Joshi, H. (1989) (ed.) *The Changing Population of Britain.* Basil Blackwell

Journal of Social Policy 16 (2) (1987) Special issue devoted to poverty measures

Jowell, R., L.Brook, G. Prior and B. Taylor (eds) (1992) *British Social Attitudes: the 9th report.* Dartmouth

Karn, V. (1978) 'The financing of owner-occupation and its impact on ethnic minorities', *New Community,* 6 (1/2), pp.49–63

Karn, V. (ed.) (forthcoming, 1997) *Ethnicity in the Census, Vol. 4: Employment, Educaiton and Housing Among Ethnic Minorities in Britain.* Office of National Statistics

Karn, V., J. Kemeny and P. Williams (1985) *Home Ownership in the Inner City: Salvation or Despair.* Gower

Keith, M. (1993) *Race, Riots and Policing: Lore and Disorder in a Multi-racist Society.* UCL Press

Kempson, E. (1996) *Life on a Low Income.* Joseph Rowntree Foundation

Kemsley, W.F.F., R.V. Redpath and M. Homes (1980) *Family Expenditure Survey Handbook.* HMSO

Khan, V. S. (1977) 'The Pakistanis: Mirpuri villages at home in Bradford'. In J.L. Watson (ed.) *Between Two Cultures: Migrants and Minorities in Britain.* Blackwell

Khan, V. (1979) *Minority Families in Britain: Support and Stress.* Macmillan

Kiernan, K. and V. Eastaugh (1993) *Cohabitation, Extra-marital Childrearing and Social Policy.* Family Policy Studies Centre

Krueger, D.E. and I.M Moriyama (1967) 'Mortality of the foreign born', *American Journal of Public Health,* 57, pp.496–503

Lal, B.B. (1990) *The Romance of Culture in an Urban Civilisation.* Routledge

Land, H. (1969) *Large Families in London.* Bell

Laurie, H. and D. Rose (1994) 'Divisions and allocations within households'. In N. Buck et al. (eds) *Changing Households: the BHPS 1990 to 1992.* University of Essex

Law, I., C. Hylton, A. Karmani and A. Deacon (1994) *Racial Equality and Social Security Service Delivery.* University of Leeds

Love, A.M. and K. Kirby (1994) *Racial Incidents in Council Housing: the local authority response.* HMSO

Mac an Ghaill, M. (1988) *Young, Gifted and Black: Student-Teacher Relations in the Schooling of Black Youth.* Open University Press

Mann, N. (1994) 'The next campaign starts now', *New Statesman and Society,* 13 May, pp.22–23

Marmot, M.G., A.M. Adelstein, L. Bulusu and OPCS (1984) *Immigrant mortality in England and Wales 1970-78.* HMSO

Marsh, A. and S. McKay (1993) *Families, Work and Benefits.* Policy Studies Institute

Mather, H.M. and H. Keen (1985) 'The Southall diabetes survey: prevalence of known diabetes in Asians and Europeans', *British Medical Journal,* 291, pp.1081–1084

Mather, H.M., N.P.S. Verma, S.P. Mehta, S. Madhu and H. Keen (1987) 'The prevalence of known diabetes in Indians in New Delhi and London', *Journal of Medical Association of Thailand,* 70, pp.54–58

Mayhew, P., D. Elliot and L. Dewds (1989) *The 1988 British Crime Survey.* HMSO

Mayhew, P., N. Aye Maung and C. Mirrlees-Black (1993) *The 1992 British Crime Survey.* Home Office Research Study 132. HMSO

McCormick, A. and M. Rosenbaum (1990) *Morbidity statistics from General Practice, Third National Study: Socioeconomic analysis.* HMSO

McEvoy, D., T.P. Jones, J. Cater and H. Aldrich (1982) 'Asian Immigrant Businesses in British Cities'. Paper presented to the British Association for the Advancement of Science, Annual Meeting, September

McKeigue, P. (1993) _Coronary heart disease and diabetes in South Asians_. North East and North West Thames RHA

McKeigue, P., G. Miller and M. Marmot (1989) 'Coronary heart disease in South Asians overseas: a review', _Journal of Clinical Epidemiology_, 42 (7), pp.597–609

McKeigue, P.M., B. Shah and M.G. Marmot (1991) 'Relation of central obesity and insulin resistance with high diabetes prevalence and cardiovascular risk in South Asians', _Lancet_, 337, pp.382–386

McManus, I.C., P. Richards, B.C. Winder, K.A. Sproston and V. Styles (1995) 'Medical school applicants from ethnic minority groups: identifying if and when they are disadvantaged', _British Medical Journal_, 310, pp.496–500

McRae, S. (1993) _Cohabiting Mothers: changing marriage and motherhood_. Policy Studies Institute

Metcalf, H., T. Modood and S. Virdee (1996) _Asian Self-Employment: the Interaction of Culture and Economics in England_. Policy Studies Institute

Miles, R. (1982) _Racism and Migrant Labour_, Routledge and Kegan Paul

Miles, R. (1987) 'Class relations and racism in Britain in the 1980's', _Revue Européenne des Migrations Internationales_, 3 (1 and 2)

Miller, S., M. Schmool and A. Lerman (1996) _Social and Political Attitudes of British Jews: some key findings of the IJPR survey_. Institute for Jewish Policy Research

Modood, T. (1988) '"Black", racial equality and Asian identity', _New Community_, 14, pp.397–404

Modood, T. (1990) 'British Asian Muslims and the Rushdie affair'. _Political Quarterly_, 61 (2), pp.143–160; reproduced in J. Donald and A. Rattansi (eds) (1992) pp.260–267

Modood, T. (1992) _Not Easy Being British: Colour, Culture and Citizenship_. Runnymede Trust and Trentham Books

Modood, T. (1993) 'The number of ethnic minority students in British higher education: some grounds for optimism', _Oxford Review of Education_, 19 (2), pp.167–182

Modood, T. (1994) 'Political blackness and British Asians', _Sociology_, 28 (4) pp.859–876

Modood, T. (1995) 'The limits of America: rethinking equality in the changing context of British race relations'. In B. Ward and T. Badger (eds) _The Making of Martin Luther King and the Civil Rights Movement_. Macmillan

Modood, T. (1996a) 'If races do not exist, then what does? Racial categorisation and ethnic realities'. In R. Barot (ed.) _The Racism Problematic_. Edwin Mellen Press

Modood, T. (1996b) 'The Changing Context of "Race" in Britain'. Symposium on Anti-Racism, _Patterns of Prejudice_, 30 (1), pp.3–13

Modood, T. (1997) 'Difference, cultural racism and anti-racism'. In P. Werbner and T. Modood (eds) _Debating Cultural Hybridity: multi-cultural identities and the politics of anti-racism_. Zed Books

Modood, T. (ed.) (1997) _Church, State and Religious Minorities_. Policy Studies Institute

Modood, T. and T. Acland (eds) (forthcoming 1997) _Race and Higher Education: Experiences, Challenges, and Policy Implications_. Policy Studies Institute

Modood, T., S. Beishon, and S. Virdee (1994) _Changing Ethnic Identities_. Policy Studies Institute

Modood, T. and M. Shiner (1994) _Ethnic Minorities and Higher Education: Why are There Differential Rates of Entry?_ Policy Studies Institute

Modood, T. and P. Werbner (eds) (1997) _The Politics of Multiculturalism in the New Europe: Racism, Identity and Community_. Zed Books

Mossey, J. and E. Shapiro (1982) 'Self-rated health: a predictor of mortality among the elderly', _American Journal of Public Health_, 72, pp.800–808

Murphy, M. (1996) 'Household and family structure among the ethnic minority groups'. In Coleman and Salt (1996a)

NACAB (1991) _Barriers to Benefits: black claimants and social security_. National Association of Citizens Advice Bureaux

Nahdi, F. (1994) 'Focus on crime and youth', _Q-News_, 3 (3), April, pp.15–22

National and Local Government Officers Association (1986) *Proceedings of the First National Black Members Conference.* NALGO

Nazroo, J.Y. (forthcoming 1997) *The Health of Britain's Ethnic Minorities: findings from a national survey.* Policy Studies Institute

Noon, M. (1993) 'Racial discrimination in speculative applications: evidence from the UK's top one hundred firms', *Human Resource Management Journal,* 3 (4), pp.35–47

Norwich and Norfolk Racial Equality Council (1994) *Not in Norfolk: tackling the invisibility of racism.* Norwich and Norfolk REC

Odugbesan, O., B. Rowe, J. Fletcher, S. Walford and A.H. Barnett (1989) 'Diabetes in the UK West Indian community: the Wolverhampton study', *Diabetic Medicine,* 9, pp.641–45

Office for National Statistics (1996a) *Housing in England, 1994/95.* HMSO

Office for National Statistics (1996b) *Social Focus on Ethnic Minorities.* HMSO

OPCS (1993) *1991 Census: Ethnic Group and Country of Birth (Great Britain)*

Owen, C., P. Mortimore and A. Phoenix (forthcoming 1997) 'Higher Educational Qualifications'. In V. Karn (ed.) (forthcoming 1997). ONS

Owen, D. (1993a) *Ethnic Minorities in Great Britain: Housing and family characteristics.* Centre for Research in Ethnic Relations, University of Warwick, 1991 Census Statistical Paper No.4

Owen, D. (1993b) *Ethnic Minorities in Great Britain: Settlement Patterns.* Centre for Research in Ethnic Relations, University of Warwick, 1991 Census Statistical Paper No.1

Pahl, J. (1989) *Money and Marriage.* Macmillan

Parsons, G. (ed.) (1993) 'Filling a void? Afro-Caribbean identity and religion', *The Growth of Religious Diversity: Britain from 1945.* Vol.1, *Traditions.* Routledge and Open University

Payne, J. (1996) *Education and Training for 16–18-Year-Olds: Individual Paths and National Trends.* Policy Studies Institute

Peach, C. (ed.) (1996) *Ethnicity in the 1991 Census. Volume 2. The Ethnic Minority Populations of Britain.* HMSO

Peach, C. (1996) 'Does Britain have ghettos?', in *Transactions of the Institute of British Geographers,* 21, pp.216–235

Peach, C. and M. Byron (1993) 'Caribbean tenants in council housing: "Race", class and gender', *New Community,* 19 (3), pp.407–423

Peach, C. and M. Byron (1994) 'Council House Sales, Residualisation and Afro-Caribbean Tenants', *Journal of Social Policy,* 23 (3), pp.363–383

Phillips, D. (1987) 'Searching for a decent home; ethnic minority progress in the post-war housing market', *New Community,* 14 (1/2), pp.105–117

Phizacklea, A. and C.Wolkowitz (1995) *Homeworking Women: Gender, Racism and Class.* Sage

Pilgrim, S., S. Fenton, T. Hughes, C. Hine and N. Tibbs (1993) *The Bristol Black and Ethnic Minorities Health Survey Report.* University of Bristol

Poulter, S. (1990) 'Cultural pluralism and its limits: a legal perspective', In *Britain: A Plural Society.* Commission for Racial Equality

Rafiq, M. (1992) 'Ethnicity and Enterprise: A Comparison of Muslim and Non-Muslim Owned Asian Businesses in Britain', *New Community,* 19 (1), pp.43–60

Ram, M. (1992) 'Coping with Racism: Asian Employers in the Inner-city', *Work, Employment and Society,* 6 (4), December, pp.601–618

Ranger, T., Y. Samad and O. Stuart (eds) (1996) *Culture, Identity and Politics: ethnic minorities in Britain.* Avebury

Ratcliffe, P. (1994) 'Conceptualizing "race", ethnicity and nation: towards a comparative perspective'. In P. Ratcliffe (ed.) *'Race', Ethnicity and Nation: International Perspectives on Social Conflict.* UCL Press

Ratcliffe, P. (1996) (ed.) *Ethnicity in the 1991 Census. Volume 3: Social geography and ethnicity in Britain: geographical spread, spatial concentration and internal migration.* HMSO

Rex, J. (1994) 'The Place of Ethnic Mobilisation in West European Democracies'. In J. Rex and B. Drury (eds) *Ethnic Mobilisation in a Multi-Cultural Europe.* Avebury

Rex, J. and R. Moore (1967) *Race, Community and Conflict.* Oxford University Press

Rex, J and S. Tomlinson (1979) *Colonial Immigrants in a British City: a class analysis*. Routledge and Kegan Paul

Robinson, V. (1990) 'Roots to mobility: the social mobility of Britain's black population, 1971-87', *Ethnic and Racial Studies*, 13 (2), pp.274–286

Robinson, V. (1993) 'Ethnic minorities and the enduring geography of settlement', *Town and Country Planning*, March, pp.53–56

Rudat, K. (1994) *Health and lifestyles: Black and minority ethnic groups in England*. Health Education Authority

Runnymede Trust (1996) *The Multi-Ethnic Good Society – Vision and Reality*. Runnymede Trust

Sachdev, D. (1996) 'Racial prejudice and racial discrimination: whither British youth?' In H. Roberts and D. Sachdev (eds) *Having Their Say: the views of 12–19-year-olds*. Young People's Social Attitudes. Barnardos

Sadiq-Sangster, A. (1991), *Just about Surviving: life on income support. An Asian Experience*. Family Service Units

Salt, J. (1996) 'Immigration and ethnic group', in Coleman and Salt (1996a)

Sampson, A. and C. Phillips (1992) *Multiple Victimisation: racial attacks on an east London estate*. Home Office Police Department

Sarre, P. (1986) 'Choice and constraint in ethnic minority housing', *Housing Studies*, 1, pp.71–86

Sarre, P. (1989) 'Race and the Class Structure'. In C. Hamnett et al. (eds) *The Changing Social Structure*. Sage

Saulsbury, W. and B. Bowling (1991) *The Multi-Agency Approach in Practice: the North Plaistow racial harassment project*. Home Office

Saunders, P. (1984) 'Beyond housing classes: the sociological significance of private property rights in the means of consumption', *International Journal of Urban and Regional Research*, 8, pp.202–227

Saunders, P. (1990) *A Nation of Home-owners*. Unwin Hyman

Schmool, M. and S. Miller (1994) *Women in the Jewish Community*. Survey Report, Women in the Community, Office of the Chief Rabbi

Schmitt, J. and J. Wadsworth (1995) *Why are 2 million men inactive? The decline in male labour force participation in Britain*. Centre for Economic Performance Working Paper No.338. London School of Economics and Political Science

Sheldon, T.A. and H. Parker (1992) 'Race and ethnicity in health research', *Journal of Public Health Medicine*, 14 (2), pp.104–110

Shiner, M. and Newburn, T. (1995) *Entry into the Legal Professions. The Law Student Cohort Study Year 3*. Law Society, Research Study 18

Simmons, D., D.R.R. Williams and M.J. Powell (1989) 'Prevalence of diabetes in a predominantly Asian community: preliminary findings of the Coventry diabetes study', *British Medical Journal*, 298, pp.18–21

Simpson, A. and J. Stevenson (1994) *Half a Chance, Still? Jobs, Discrimination and Young People in Nottingham*. Nottingham and District Racial Equality Council

Simpson, S. (1996) 'Non-response to the 1991 Census: the effects on ethnic group enumeration'. In D. Coleman and J. Salt (eds) (1996)

Sivanandan, A. (1982) *A Different Hunger*. Pluto Press

Sivanandan, A. (1985) 'RAT and the degradation of the black struggle', *Race and Class*, XXVI (4)

Skogan, W. (1994) *Contacts between Police and Public: findings from the 1992 British Crime Survey*. Home Office Research Study 134, HMSO

Sly, F. (1995) 'Ethnic Groups and the Labour Market: Analyses from the Spring 1994 Labour Force Survey', *Employment Gazette*, pp.251–61

Smaje, C. (1995a) *Health, 'Race' and Ethnicity: Making sense of the evidence*. King's Fund Institute

Smaje, C. (1995b) 'Ethnic residential concentration and health: evidence for a positive effect?', *Policy and Politics*, 23 (3), pp.251–69

Smith, D.J. (1977) *Racial Disadvantage in Britain*. Penguin

Smith, D.J. (1991) 'The origins of black hostility to the police', *Policing and Society*, 2, pp.1–15

Smith, D.J. and J. Gray (1985) *Police and People in London*. Gower

Smith, D.J. and S. Tomlinson (1989) *The School Effect: A Study of Multi-Racial Comprehensives.* Policy Studies Institute

Smith, P. (1991) *Ethnic Minorities in Scotland.* Social and Community Planning Research

Smith, P. and Prior, G. (1996) *The Fourth National Survey of Ethnic Minorities: technical report.* Social and Community Planning Research

Smith, S.J. (1989) *The Politics of 'Race' and Residence.* Polity Press

Solomos, J. (1988) *Black Youth, Racism and the State.* Cambridge University Press

Solomos, J. and G. Singh (1990) *Housing, racial equality and local politics: policy making in a changing context.* Policy paper No.19, Centre for Research in Ethnic Relations, University of Warwick

Stark, O. (1991) *Migration in Developing Countries: risk, remittances and the family.* David Horowitz Institute for the Research of Developing Countries

Stopes-Roe, M. and R. Cochrane (1990) *Citizens of this Country: The Asian-British.* Multilingual Matters

Swann, Lord (1985) *Education for All: Final Report of the Committee of Inquiry into the Education of Children from Ethnic Minority Groups,* Cmnd 9453, HMSO

Townsend, P. and N. Davidson (1982) *Inequalities in Health (the Black report).* Penguin

Townsend, P., P. Phillimore and A. Beattie (1988) *Health and Deprivation: inequality and the north.* Routledge

UK Action Committee on Islamic Affairs (UKACIA) (1993) *Muslims and the Law in Multi-Faith Britain: Need for Reform.* A Memorandum to the Home Secretary

US Bureau of the Census (1995) *Statistical Abstract of the United States*

Vågerö, D. and R. Illsley (1995) 'Explaining health inequalities: beyond Black and Barker', *European Sociological Review,* 11 (3), pp.219–239

Vellins, S. (1982) 'South Asian Students in British Universities: A Statistical Note', *New Community,* 10 (2), pp.206–212

Virdee, S. (1995a) *Racial Violence and Harassment.* Policy Studies Institute

Virdee, S. (1995b) 'Racial Violence and Harassment: a case for national survey?', *Policy Studies,* 16 (3)

Virdee, S. and K.Grint (1994) 'Black Self-Organization in Trade Unions', *Sociological Review,* 42 (2), pp.202–225

Waldinger, R., H. Adrich, and R.Ward (1990) *Ethnic Entrepreneurs.* Sage

Wambu, O. (1996) 'Students of the street academy', *Voice,* 4 June, p.12

Ward, R. (1982) 'Race, housing and wealth', *New Community,* 10 (1), pp.3–15

Ward, R. (1990) 'South Asian Employment Patterns and Business Development'. In C. Clarke et al. (eds) *South Asian Communities Overseas.* Cambridge University Press

Ward, R. and M. Cross (1991) 'Race, Employment and Economic Change'. In P. Brown and R. Scase (eds) *Poor Work. Disadvantage and the Division of Labour.* Open University Press, pp.116–31

Warnes, T. (1996) 'The age structure and ageing of the ethnic groups'. In D. Coleman and J. Salt (eds) (1996)

Watson, J.L. (1977) *Between Two Cultures: migration and minorities in Britain.* Blackwell

Werbner, P. (1990a) *The Migration Process.* Berg

Werbner, P. (1990b) 'Renewing an Industrial Past: British Pakistani Entrepreneurship in Manchester', *Migration,* 8, pp.7–39

Werbner, P. (1996) 'Essentialising the other: a critical response'. In T. Ranger et al. (eds) (1996)

Werbner, P. and T. Modood (eds) (1997) *Debating Cultural Hybridity: Multicultural Identities and the Politics of Anti-racism.* Zed Books

Western, J. (1992) *A Passage to England: Barbadian Londoners speak of home.* UCL Press

Williams, R. (1993) 'Health and length of residence among South Asians in Glasgow: a study controlling for age', *Journal of Public Health Medicine,* 15 (1), pp.52–60

Williams, R., R. Bhopal and K. Hunt (1993) 'Health of a Punjabi ethnic minority in Glasgow: a comparison with the general population', *Journal of Epidemiology and Community Health,* 47, pp. 96–102

Willmott, P. (1986) *Social Networks, Informal Care and Public Policy.* Policy Studies Institute

Willmott, P. (1987) *Kinship and Urban Communities: Past and Present,* Ninth H.J. Dyos Memorial Lecture. Victorian Studies Centre, University of Leicester

Wilson, G. (1987) *Money in the Family*. Avebury

Wilson, W.J. (1987) *The Truly Disadvantaged: the inner city, the underclass and public policy*. University of Chicago Press

Witte, R. (1996a) *Racist Violence and the State*. Longman

Witte, R. (1996b) 'Racist violence in western Europe' *New Community*, 21 (4), pp.489–500

Wrench, J., H. Brar and P. Martin (1993) *Invisible minorities: racism in new towns and new contexts*. Monographs in ethnic relations, No.6. Centre for Research in Ethnic Relations, University of Warwick

Wrench, J. and J. Solomos (eds) (1993) *Racism and Migration in Western Europe*. Berg, Oxford/Providence

Wrench, J. and S. Virdee (1995) 'Organising the unorganised: "race", poor work and trade unions'. In P. Acker, C. Smith and P. Smith (eds) *The New Work Place and Trade Unions*. Routledge

Young, K. (1992) 'Class, race and opportunity'. In R. Jowell et al. (eds) (1992)

Young, I.M. (1990) *Justice and the Politics of Difference*. Princeton University Press

List of Illustrations

Chapter Three: Qualifications and English Language

Chapter Four: Employment

CHAPTER FIVE: INCOME AND STANDARDS OF LIVING

CHAPTER SEVEN: HEALTH AND HEALTH SERVICES

CHAPTER EIGHT: RACIAL HARASSMENT

APPENDIX: SURVEY METHODS

Index of Subjects

Index compiled by Frank Pert

Index of Names

Index compiled by Frank Pert

Further Reading

CHAPTER 1: INTRODUCTION

For recent historical background on many of the topics studied in this book, see the previous PSI survey analyses:

Daniel, W. W. (1968) *Racial Discrimination in England.* Penguin

Smith, D. J. (1977) *Racial Disadvantage in Britain.* Penguin.

Brown, C. (1984) *Black and White Britain.* Heinemann.

See also Hiro, D. (1991) *Black British, White British: A History of Race Relations in Britain* Third Edition. Grafton.

The 1991 Census was the first time an explicit ethnic origin question was asked in a UK census. The Office of National Statistics (ONS) (previously called OPCS – Office of Population Censuses and Surveys) has commissioned four collection of essays, including on groups (e.g. Africans) not covered in the Fourth Survey, which can be consulted in connection with the topics of most of the chapters:

Ethnicity in the Census:

Vol. 1: Coleman, D. and J. Salt (eds) (1996) *Demographic Characteristics of the Ethnic Minority Populations.*

Vol. 2: Peach, C. (ed.) (1996) *The Ethnic Minority Populations of Great Britain.*

Vol. 3: Ratcliffe, P. (ed.) (1996) *Social Geography and Ethnicity in Britain.*

Vol. 4: Karn, V. (ed.) (forthcoming, 1997) *Employment, Education and Housing Among Ethnic Minorities in Britain.*

Mason, D. (1995) *Race and Ethnicity in Modern Britain.* Oxford University Press.The best short sociological introduction to the subject.

Anthias, F. and N. Yuval-Davis (1992) *Racialised Boundaries: Race, Nation, Gender, Colour and the Anti-Racist Struggle.* Routledge. A useful theoretical overview of the intellectual and political debates about 'race' in Britain.

CHAPTER 2: PEOPLE, FAMILIES AND HOUSEHOLDS

The ONS books mentioned above, especially volumes 1 and 2, provide a detailed analysis of the demographic structure of the main minority ethnic groups.

Coleman, D. and J. Salt (1992) *The British Population: patterns, trends and processes,* Oxford University Press. A review of demographic trends in the population as a whole.

Modood, T., S. Beishon and S. Virdee (forthcoming 1998), *Ethnic Minority Families.* Policy Studies Institute. Complements the statistical analysis in this chapter using in-depth interviews to probe minorities attitudes to the family.

CHAPTER 3: QUALIFICATIONS AND ENGLISH LANGUAGE

Gillborn, D. and C. Gipps (1996) *Recent Research on the Achievements of Ethnic Minority Pupils.* Office for Standards in Education. An excellent OFSTED research review of ethnic minorities in the educational system.

Gillborn, D. (1995) *Racism and Anti-Racism in Real Schools.* Open University Press. A wide-ranging discussion of new thinking on racism and anti-racism in schools.

Drew, D. (1995) *'Race', Education and Work: The Statistics of Inequality.* Avebury. A thorough analysis of the linkages between 'race', academic and vocational qualifications and the labour market among 16–19 years old (unfortunately the simplistic categories used in the data collection do not allow for breakdown of the Asian category).

Modood, T. and T. Acland (eds) (forthcoming 1997) *Race and Higher Education: Experiences, Challenges and Policy Implications.* A collection of essays giving a good sample of the latest research in relation to ethnic minorities and higher education.

CHAPTER 4: EMPLOYMENT

The ONS volume 2 offers analyses which look separately at each minority group and assesses the evidence for social mobility; it takes a more optimistic view of the Pakistanis than is possible from the Fourth Survey.

Bhavnani, R. (1994) *Black Women in the Labour Market: A Research Review.* Equal Opportunities Commission. A review of the literature on ethnic minority women and employment.

Iganski, P. and G. Payne. (1996) 'Declining Racial Disadvantage in the British Labour Market', *Ethnic and Racial Studies,* 19(1); Heath, A. and D. McMahon (1997) 'Education and Occupational Attainments: The Impact of Ethnic Origins' in ONS Vol. 4. Two statistical evaluations of whether racial disadvantage is declining or remaining at its previous levels.

Metcalf, H., T. Modood and S. Virdee (1995) *Asian Self-Employment: The Interaction of Culture and Economics.* Policy Studies Institute. A further survey of a sub-sample of Fourth Survey respondents in order to explore further the differing self-employment profiles of three South Asian groups.

CHAPTER 5: INCOMES AND STANDARDS OF LIVING

It was pointed out at the beginning of this chapter that there has not been any direct analysis of ethnic minority incomes before now. The books referred in relation to the last chapter give information about employment patterns.

Joseph Rowntree Foundation (1995) *Inquiry into Income and Wealth.* JRF. A review of the changing distribution of resources in Britain, with a discussion of policy. It covers the whole population, with little reference to ethnic minorities.

Berthoud, R. and B. Casey (forthcoming, 1998), *Ethnic Minority Incomes.* Policy Studies Institute. A more detailed analysis of minority earnings and incomes, using the Family Resources Survey as well as the Fourth Survey.

CHAPTER 6: NEIGHBOURHOODS AND HOUSING

The ONS volumes, especially vols 3 and 4, contain a number of probing essays on these subjects utilising the 1991 Census data.

Peach, C. (1996) 'Does Britain have ghettos?', *Transactions of the Institute of British Geographers,* 21, pp.216–235. A comparison of racial segregation in the United States and Britain, concluding that the two countries are very unlike each other in this respect.

Dorsett, R. and R. Berthoud (forthcoming, 1998) *Ethnic Minorities in the Inner City.* Policy Studies Institute. A further analysis of the Fourth Survey and the Census in order to inquire further into the linkages between ethnic minority residential patterns and social deprivation.

CHAPTER 7: HEALTH AND HEALTH SERVICES

Ahmad, W. I. U. (1993) *'Race' and Health in Contemporary Britain.* Buckingham: Open University Press. Contains a series of critical commentaries on key issues in the ethnicity and health field.

Balarajan, R. and V. Soni Raleigh (1995) *Ethnicity and Health in England.* London: HMSO. A short review of ethnic variations in health.

Smaje, C. (1995) *Health, 'Race' and Ethnicity: Making sense of the evidence*. London: King's Fund. A detailed review of the evidence on the relationship between ethnicity and health.

Marmot, M.G., A. M. Adelstein, L. Bulusu and OPCS (1984) *Immigrant mortality in England and Wales 1970-78: Causes of death by country of birth*. London: HMSO. The classic study of immigrant mortality.

Davey Smith, G., M. Bartley and D. Blane (1990) 'The Black report on socioeconomic inequalities in health 10 years on', *British Medical Journal*, Vol. 301, pp. 373–377. A commentary on the relationship between socio-economic position and health.

Benzeval, M., K. Judge and M. Whitehead (1995) *Tackling Inequalities in Health: an agenda for action*. London: King's Fund. A discussion of policy options aimed at decreasing inequalities in health.

Nazroo, J. (1997) *The Health of Ethnic Minorities*. London: Policy Studies Institute. Provides a more detailed analysis of material in the Fourth National Survey on health and health service use.

Nazroo, J. (1997) *Ethnicity and Mental Health*. London: Policy Studies Institute. Presents the data on mental health from the Fourth National Survey.

CHAPTER 8: RACIAL HARASSMENT

Virdee, S. (1995) *Racial Violence and Harassment*. Policy Studies Institute. A critical analysis of existing sources on the extent and nature of the problem.

FitzGerald, M. and C. Hale, C. (1996) *Ethnic Minorities, Victimisation and Racial Harassment*. Research Findings No. 39, Home Office. The latest data on the extent of racially-motivated crimes as recorded in the British Crime Survey.

Bjorgo, T. and R. Witte, R. (eds) (1993) *Racist Violence in Europe*. Macmillan. An excellent introduction to the problem as a European phenomenon.

CHAPTER 9: CULTURE AND IDENTITY

Modood, T, S. Beishon and S. Virdee. (1994) *Changing Ethnic Identities*. Policy Studies Institute. This is an essential qualitative companion to the quantitative analyses in this chapter.

James, W. (1993) 'Migration, Racism and Identity Formation: The Caribbean Experience in Britain' in W. James and C. Harris (eds) *Inside Babylon*. Verso. A revised version of an older essay offering a historical overview of Caribbean identity developments.

Ballard, R. (ed.) (1994) *Desh Pardesh: The South Asian Presence in Britain.* Hurst. A collection of local ethnographic 1980s studies of a high standard, particularly strong on the older generation of Asians.

Donald, J. and A. Rattansi (eds) (1992) *'Race', Culture and Difference.* Sage/Open University; Ranger, T., Y. Samad and O. Stuart (eds) (1996) *Culture, Identity and Politics: ethnic minorities in Britain.* Avebury. These two collections, containing varied and occasionally opposing views are a good starting point for a theoretical discussion of the political nature of contemporary ethnicisation and its relationship to multiple forms of racism.

Back, L. (1996) *New Ethnicities and Urban Culture: Racism and Multiculture in Young Lives.* UCL Press. An ethnographic local study which discusses aspects of urban youth cultures, especially music, not discussed in the chapter.

CHAPTER 10: CONCLUSION

Solomos, J. and L. Back (1996) *Racism and Society.* Macmillan. A tightly argued overview of the subject in Britain, reflecting how the 'race and class' debates of about 1970-1985 have given way to an interest in political identities.

Symposium on Anti-Racism in Britain, *Patterns of Prejudice,* 30(1), 1996, pp 3–42. Offers alternative versions of identifying the ground on which anti-racism may be built following the demise of political blackness.

Barot, R. (ed.) (1996) *The Racism Problematic: contemporary sociological debates on race and ethnicity.* A rather good collection of essays which encompasses many of the leading perspectives on the study of racism and ethnic relations in Britain.

Parekh, B. (1995) 'Cultural Pluralism and the Limits of Diversity', *Alternatives,* 20, pp 431–457. An exploration of some of the issues that multiculturalism is raising for liberalism, including a fascinating discussion of polygamy.

Blackstone, T., B. Parekh and P. Sanders (eds) (forthcoming 1998) *Race Relations in Britain: a developing agenda.* Routledge. An assessment of various aspects of race relations in Britain by a number of academic and policy authors.

Modood, T. and P. Werbner (eds) (1997) *The Politics of Multiculturalism in the New Europe.* Zed Books. A collection of studies of the discourses and political structures that are emerging across Europe as new minority communities settle and negotiate a civic space for themselves.